The Fauve Landscape

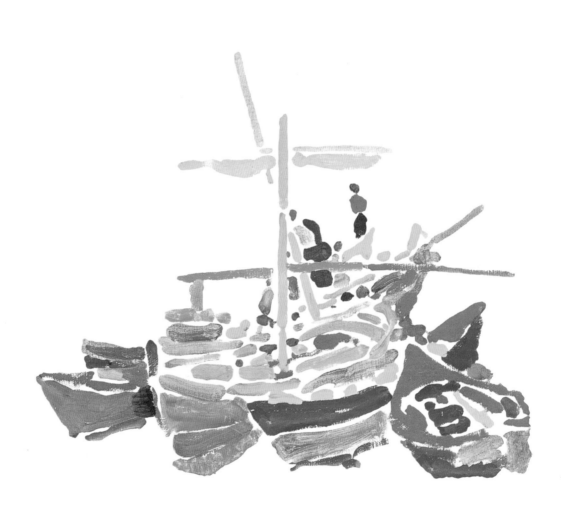

The Fauve Landscape

Judi Freeman

with contributions by

Roger Benjamin

James D. Herbert

John Klein

Alvin Martin

LOS ANGELES COUNTY MUSEUM OF ART · ABBEVILLE PRESS, PUBLISHERS, NEW YORK

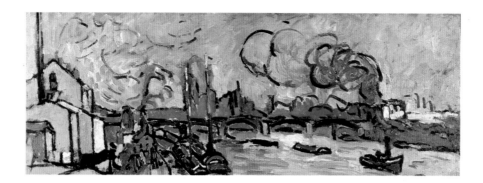

This publication accompanies the exhibition *The Fauve Landscape: Matisse, Derain, Braque, and Their Circle, 1904–1908*, organized by the Los Angeles County Museum of Art. It is made possible by Ford Motor Company. Additional support is provided by the National Endowment for the Arts.

A note about the captions
The titles given to most Fauve landscapes at the time of their creation tended to be fairly non-descript—e.g., *Paysage* or *Marine* or *Composition*. As the paintings were exhibited, they acquired more descriptive titles, referring usually to the place, if easily identifiable. In this publication we have used the French title by which a painting has become known (accompanied by an English translation), unless we can clearly assign a title used in one of the exhibitions of 1904–8. Titles have been altered if the place name previously assigned to the painting is incorrect. For works by artists outside the Fauve circle, commonly accepted titles, in English, are used.

Photography credits and copyright information for illustrations appear on page 350.

Cover: André Derain. Detail of *L'Estaque, Route tournante*, 1906. See page 40, plate 41.
Frontispiece: André Derain. Detail of *Collioure*, summer 1905. See page 280, plate 291.
Above: Maurice de Vlaminck. Detail of *Le Pont du Pecq*, 1906. See page 323, plate 345.

Library of Congress Cataloging-in-Publication Data
Freeman, Judi.
The fauve landscape / Judi Freeman ; with contributions by
Roger Benjamin...[et al.]; Los Angeles County Museum of Art.
352 p. cm.
Published in conjunction with an exhibition held at the
Los Angeles County Museum of Art.
Includes bibliographical references (p. 324) and index.
1. Fauvism—France—Exhibitions. 2. Landscape painting. French—Exhibitions. 3. Landscape painting—20th century—France—Exhibitions. I. Los Angeles County Museum of Art. II. Title.
ND1356.6.F74 1990 758'.1'094407479494—dc20 90-664 CIP
ISBN 1-55859-025-0
ISBN 0-87587-151-8 (pbk.)

Exhibition Itinerary
Los Angeles County Museum of Art
October 4–December 30, 1990

The Metropolitan Museum of Art, New York
February 19–May 5, 1991

Royal Academy of Arts, London
June 10–September 1, 1991

Editor: Nancy Grubb
Designer: Tracey Shiffman, Shiffman Young Design Group
Production supervisor: Hope Koturo
Production editors: Laura Lindgren and Philip Reynolds·
Production artist: Jenny Ford
Cover: Roland Young, Shiffman Young Design Group

Typeset in Janson Text and Caslon 540 by
Andresen Typographics, Tucson, Arizona
Printed by Arti Grafiche Motta, Milan, Italy

Copublished by
the Los Angeles County Museum of Art
5905 Wilshire Boulevard
Los Angeles, California 90036
and
Abbeville Press, Inc.
488 Madison Avenue
New York, New York 10022

Contents

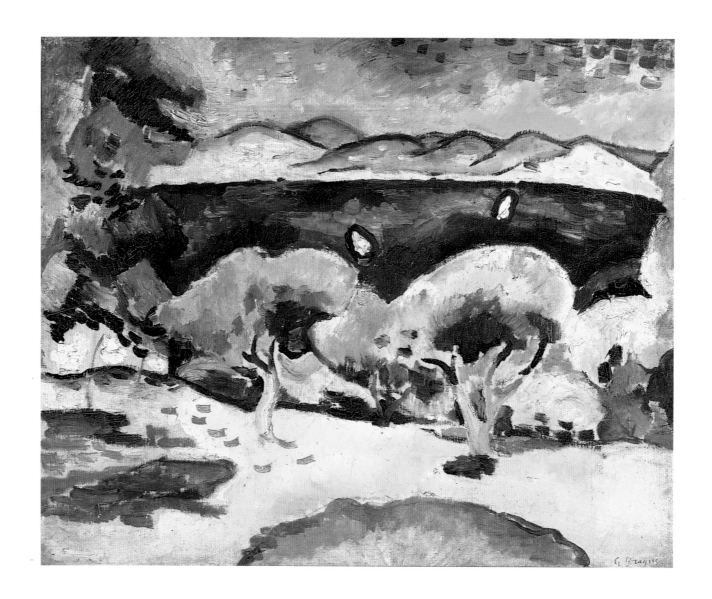

Foreword

When Matisse observed, "Fauve painting is not everything, but it is the foundation of everything," he acknowledged the key position that Fauve painting occupies in the history of modern art. When these artists were recognized by contemporary critics eighty-five years ago for having achieved something new, "wild," and daring in their imagery, little did they know that the landscape paintings in which most of their stylistic breakthroughs occurred would still strike such a resonant chord as we head into the next millennium.

In their work from 1904 through 1908 the Fauves pioneered a sense of the new through their assertive application of saturated color. One critic suggested that their painting represented a "pot of paint...thrown in the face of the public," but it also paid homage to the tradition of French painting, particularly Impressionism and the later efforts of the second half of the nineteenth century. Nowhere is this more apparent than in the landscapes painted by the Fauve artists. When they began painting villages, the countryside, and seaside resorts, the Fauves injected a distinctly modern vision into imagery that had dominated nineteenth-century art in France. Indeed, their images of nature transformed painting as it developed in the succeeding decades of the twentieth century; their achievement is all the more fascinating when one recognizes the diminution of the grand tradition of landscape painting later in this century.

The Los Angeles County Museum of Art is extremely proud to present this sweeping survey of Fauve landscape painting. The first comprehensive examination of the Fauve period in more than fifteen years, the exhibition is, with its more than 175 paintings, the largest ever mounted on the subject. The scholarly catalog accompanying it, copublished by the museum and Abbeville Press, promises to be the reference source on the Fauve period for future generations. Judi Freeman, associate curator of twentieth-century art, organized this exhibition and conceived and contributed extensively to its catalog. I would like to express my gratitude for her excellent work.

We are especially pleased that this exhibition will be presented at the Metropolitan Museum of Art in New York and, in a reduced form, at the Royal Academy of Arts in London. I wish to thank Philippe de Montebello, director, and Roger de Grey, president, of these distinguished institutions for their support of this enterprise.

An exceptionally generous grant from Ford Motor Company has made this exhibition possible. We are very grateful to Harold A. Poling, chairman and chief executive officer, James E. N. Huntley, corporate contributions officer, and

Georges Braque
Le Golfe, Les Lecques
(The Gulf, Les Lecques),
autumn 1906
Oil on canvas
14 $^{15}/_{16}$ x 18 $^{1}/_{8}$ in. (38 x 46 cm)
Musée National d'Art
Moderne, Centre Georges
Pompidou, Paris

Mabel Brandon, director of corporate programming. It is thanks to the enlightened commitment of corporations such as Ford that this museum and its sister institutions can present ambitious programs such as *The Fauve Landscape*. We are equally indebted to the National Endowment for the Arts for a special exhibitions grant and a personal professional grant for Ms. Freeman. Indemnities received from the Federal Council of the Arts and Humanities and Her Majesty's Government under the National Heritage Act of 1980 and the Museums and Galleries Commission were essential to the exhibition's realization.

Exhibitions and catalogs are inconceivable without works of art. In this age of the increasing identification of art as a commodity, it takes a rare individual to lend a work of art to an exhibition, particularly one that will be on view for nearly a year. We are deeply indebted to each of the lenders to this exhibition for generously parting with these exceptional works of art and sharing them with a very grateful public.

Earl A. Powell III
Director
Los Angeles County Museum of Art

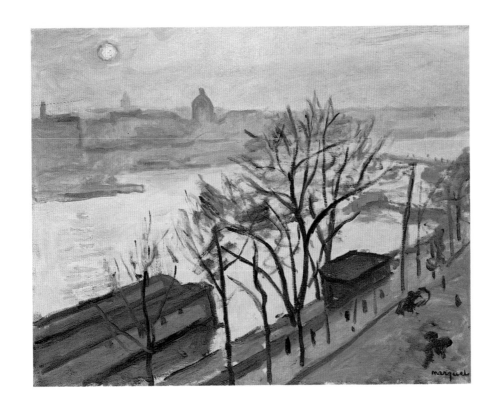

Albert Marquet
Le Soleil à travers les arbres
(*The Sun across the Trees*), 1905
Oil on canvas
25 9/16 x 32 1/4 in. (65 x 82 cm)
State Pushkin Museum,
Moscow

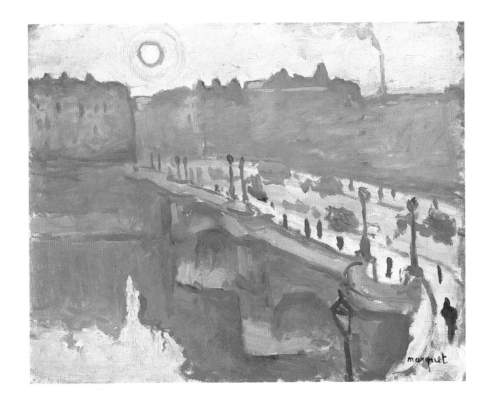

Albert Marquet
La Seine au Pont-Neuf,
effet de Brouillard
(*The Seine at Pont-Neuf,*
Fog Effect), 1907
Oil on canvas
25 9/16 x 31 7/8 in. (65 x 81 cm)
Musée des Beaux-Arts,
Nancy, France,
Galilée Bequest

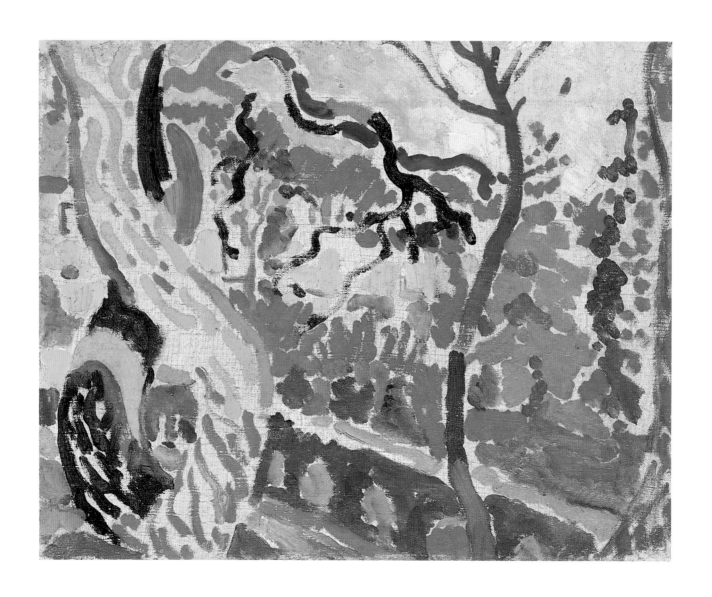

Sponsor's Statement

Ford's sponsorship of *The Fauve Landscape* caps a remarkable six-year period in the annals of the company, during which we have sponsored such notable exhibitions as *Treasure Houses of Britain, Diego Rivera, The Drawings of Jasper Johns, Beatrix Potter: Artist and Storyteller, Anselm Kiefer, The New Vision*, and most recently, *Impressionism: Selections from Five American Museums*.

The Fauve Landscape will be seen first in Los Angeles, where its vibrant colors and daring forms seem remarkably at home. The exhibition will then move to the Metropolitan Museum of Art in New York and the Royal Academy of Arts in London, where it will open the newly renovated Jill and Arthur Sackler Galleries.

As a corporate partner in *The Fauve Landscape*, Ford Motor Company continues its commitment to internationalism in the arts and education with this truly global exhibition.

The innovations in form and color that the Fauves brought to their work are an inspiration to us today. We hope that all those who are able to view these remarkable paintings—and to learn from the superb catalog by the exhibition's curator, Judi Freeman, and her colleagues—will be moved and encouraged to continue their exploration of our shared cultural heritage.

It is by learning from the past that we can move forward as individuals, as corporations, and as a society at large.

Harold A. Poling
Chairman of the Board and Chief Executive Officer
Ford Motor Company

André Derain
Paysage de Collioure
(*Landscape at Collioure*),
summer 1905
Oil on canvas
14 ¼ x 17 ½ in.
(36.2 x 44.4 cm)
Joanne and Ira Kirshbaum,
Los Angeles

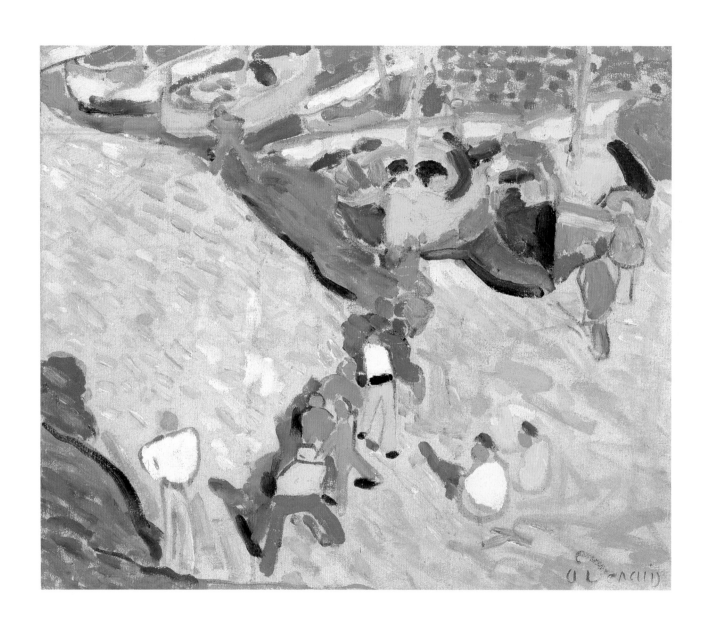

Surveying the Terrain

the fauves and the landscape

JUDI FREEMAN

The Fauve years—1904 to 1908—represented a brief moment when the concerns of the nineteenth century lingered into the twentieth. The turn of the century seemed to demand a new art for the new era. The Fauves fused this vision of modernity with the rich legacy left them by the preceding generation of artists. The Fauves did not promulgate manifestoes, as more radical groups would do in succeeding decades; nor did they necessarily see themselves as rebelling against anything. They certainly did not dismiss the imagery that had dominated the most avant-garde painting in France during the final three decades of the nineteenth century. Instead, they distilled the many currents in avant-garde art during the chaotic decade that began the twentieth century into their own concerted approach.

Critics and writers of the period perceived the Fauves—or "wild beasts," the appellation given them in 1905 by the critic Louis Vauxcelles—as a distinct group with an identifiable aesthetic.[1] The primary innovations that they identified as Fauve emerged gradually from 1904 to 1908. Within these years there was a shift from the use of intense primary and secondary colors applied in small patches with interstices of canvas left open to a darker, more nature-based range of colors and large, almost abstract masses of form. The Fauves considered themselves only a loose network connected more by friendship than by anything else.[2] Fauve activity principally revolved around Henri Matisse, André Derain, and Maurice de Vlaminck. Associated with them through friendship and exhibitions were Georges Braque, Raoul Dufy, Othon Friesz, Henri Manguin, Albert Marquet, and Jean Puy. On the periphery were the now shadowy figures of Charles Camoin, Louis Valtat, Kees van Dongen, and to a lesser extent, Béla Czobel, Pierre Girieud, and Georges Rouault, many of whom were linked to the Fauves by critics who identified various affinities among their works. A few others—Auguste Chabaud, André Lhote, Jean Metzinger, René Seyssaud—were intermittently associated with the Fauves, generally by critics, simply because of the high color in their paintings. The peripheral artists who were working in isolation from the principal Fauves often developed styles that were hybrids of pseudo-Impressionism and the color-saturated canvases of Matisse, Derain, and Vlaminck.

The Fauves formed clusters based on early acquaintances: a group consisting of Matisse, Camoin, Manguin, Marquet, and Puy, which had coalesced during their student days in Gustave Moreau's studio; the school of Chatou with its two residents, Derain and Vlaminck; and three artists from Le Havre—Braque, Dufy, and Friesz. Although these clusters stayed relatively separate, there were fre-

PLATE 1
André Derain
Les Pêcheurs à Collioure
(*The Fishermen at Collioure*),
summer 1905
Oil on canvas
18⅛ x 21¼ in. (46 x 54 cm)
Private collection

[13]

quent professional contacts among them. The spring Salon des Indépendants and the Salon d'Automne, both held annually in Paris, ensured that the artists saw one another at least twice a year. The fraternities formed among the Fauves helped them to reckon with the juries of the Salons and with the critics.

In tidily compartmentalized, often Francocentric histories of art, the Fauve period fits neatly between the end of "Post-Impressionism" and the emergence of Cubism, dominating the middle years of the first decade of the twentieth century—that is, from 1904 to 1908. "Fauvism" is considered to be a final immersion in color before the early twentieth-century fascination with form—manifested in Cubism—dominated all other interests of the avant-garde. The Fauves have traditionally been characterized as a group affected by waves of influence from the generations of artists preceding them.[3] Individual artists, their personalities, and their preferred sites have been identified. Rarely, however, has the body of work produced by the Fauve artists been looked at in cross section—that is, by distinguishing their intermittent interest in the portrait, figure, and still life from their ongoing preoccupation with the landscape.

If an inventory of Fauve motifs were made, landscape would clearly dominate. (Landscape in this case is defined broadly: seascape, riverscape, townscape, cityscape; sometimes populated, sometimes not.) The Fauves traveled together or in succession to far-flung corners of France and abroad; those who could afford it were members of the travel-and-leisure set that joined the Touring-Club de France. Indeed, an episodic history of the group can be organized around the artists' travels in search of landscapes to paint. The Fauves continually discussed these varied landscapes among themselves, and, most important, they seem to have initiated virtually every one of their stylistic experiments in landscape.

To Matisse and his colleagues, schooled in the traditional academies in which Impressionism and subsequent avant-garde efforts were rooted, painting nature was a central ambition. In some ways Impressionism and its successors had led artists to a dead end, especially those wanting to paint modern life. The Impressionists and the realist artists preceding them had already done so, outdoors, at diverse times and seasons and with figures from a variety of social classes. The emergence of the Fauves coincided with a quandary among artists and critics regarding the future of painting. Since the Fauves wanted to paint nature, they needed to find a way to distinguish that painting from what had come before.

In choosing to paint the landscape the Fauve painter would make certain basic decisions related to his site and, by implication, to his way of life. He determined a manner of painting outdoors (*en plein air*) or indoors or a combination of the two. He decided whether to paint the landscape he lived in or to travel in search of others. He decided whether to associate himself with the people living within the landscape he painted or to remain more distant. As he traveled from one site to another and as he grappled with the long-established tradition of landscape painting throughout the history of art, particularly in France, shifts occurred in his style. Inevitably, he assimilated certain attitudes that had been conveyed in earlier paintings: by their compositions, by their depictions of figures, by their rendering of climatic conditions and light.

Much of the recent writing on the Fauves has constructed a chronology of the years from 1904 to 1908 that is based on a sequence of discrete responses to their

immediate predecessors. Succinctly stated, this chronology posits that the Fauves first digested Impressionism; then the Pointillism of Georges Seurat and the Divisionist theory of Paul Signac and Henri-Edmond Cross; then the expressionist qualities in the work of Vincent van Gogh and the massing of brilliant tones and abrupt color shifts in the mature and late work of Paul Gauguin; and, finally, the strongly geometric, volumetric elements in the work of Paul Cézanne.[4] Each Fauve painter did absorb these precedents as he formulated his own style, but the mix of influences differed for each and no two absorbed them in the same way. Thus, the Fauves cannot be understood by superimposing the same series of identical influences on all of them. There are subtle but distinct differences in the work of the artists associated with Fauve painting, and these are as important to comprehending the group as the common bonds among them.

The Fauves would work in pairs or small groups, often positioning their easels side by side and engaging in extended discussions of style and subject while painting nearly identical motifs. Their ruminations and work habits during these periods closely involved the artists in each other's lives. The collaboration that this fostered, though not a collaboration in the most integrated sense, resulted in a body of landscape images from each of these pairs or small groups that demonstrated a concerted approach. The processes of selecting a site, responding to it, and collaborating within it were virtually inseparable.

Painting nature was a social practice, one that involved leaving the studio and encountering other people. Passersby might stop to watch the artist paint and judge the skill with which a motif had been put on canvas. The Fauves were not particularly gregarious individuals, and even Vlaminck, for all his reportedly outrageous behavior,[5] sought relatively secluded spots in which to paint. He was more eager to share his work with his fellow artists. Vlaminck described how he and Derain painted together (it is wise to note that he was prone to exaggeration):

> Each of us set up his easel, Derain facing Chatou, with the bridge and steeple in front of him, myself to one side, attracted by the poplars. Naturally I finished first. I walked over to Derain holding my canvas against my legs so that he couldn't see it. I looked at his picture. Solid, skillful, powerful, already a Derain. "What about yours?" he said. I spun my canvas around. Derain looked at it in silence for a minute, nodded his head and declared, "Very fine." That was the starting point of all Fauvism.[6]

A year later, in the summer of 1905, Derain related to Vlaminck what he and Matisse discussed while they were working together in Collioure:

> I am grinding away with Matisse and I believe that he does not believe that I possess a science of color, like that which was contained in the manuscript I read to you. ¶ He is undergoing a crisis over painting at the moment. But on the other hand, he is a more extraordinary type than I had believed, from the point of view of logic and psychological speculation.[7]

There was an eleven-year age difference between the two, and Derain seized the opportunity to learn from the "master." After one month in Collioure he listed for Vlaminck the ideas that had developed from his work with Matisse:

> 1. A new conception of light consisting in this: the negation of shadows. Light, here, is very strong, shadows very bright. Every shadow is a whole world of clarity and luminosity which contrasts with sunlight: what are known as reflections. ¶ Both of us, so far, had overlooked this, and in the future, where composition is concerned, it will make

for a renewal of expression.

2. Noted, when working with Matisse, that I must eradicate everything involved with the division of tones. He goes on, but I had my fill of it completely and hardly ever use it now. It's logical enough in a luminous, harmonious picture. But it injures things that owe their expression to deliberate disharmonies.[8]

Matisse often worked with other artists and freely shared his ideas. In Paris in 1904–5 he joined Marquet and Manguin at Manguin's studio—which was often the site of group activity—and shared a model. Indeed, though Matisse was often working independently and ruminating on his own, his 1908 "Notes of a Painter" can be interpreted as his response to all the ideas exchanged with his artist colleagues.

For the artists in the circle around Matisse, art was a serious career by which they earned their keep. Most had other sources of financial support but were able, in the years immediately following the Fauve period, to begin earning sufficient income from their art. Braque, Dufy, Friesz, and at times Marquet found painting a more difficult pursuit economically. As a result, they helped establish the Cercle de l'Art Moderne in Le Havre in order to have a regular exhibition outlet. Other opportunities for exhibition in Rouen as well as in Le Havre presented themselves to the Norman artists, and they also found dealers who would sell the work of other Fauves. For example, shortly after painting his Collioure landscapes, Matisse exhibited two of them in Le Havre.

Creative interaction characterized the friendships among the Norman artists and was essential to the evolution of their styles. Braque and Friesz traveled together to Antwerp, L'Estaque, and La Ciotat. Dufy and Marquet surveyed the northern coastline, painting together in Sainte-Adresse, Fécamp, Trouville, and Honfleur. The partnership later enjoyed by Braque and Pablo Picasso as Cubism evolved was no doubt rooted in the patterns of side-by-side painting practiced by the Norman Fauves.

The sites selected by the Fauves—the tourist meccas on the Norman coast, the towns along the Seine, the villages in the Midi, the resorts along the Côte d'Azur—were, more often than not, the same ones that had been celebrated by the Impressionists and the generation that succeeded them. When the Fauves went to these sites, they were inspired both by their predecessors and by their own deep desire to break new ground, thematically and stylistically.

It is clear that Vlaminck and Derain were fascinated with their home region—the northwestern suburbs of Paris dotting the banks of the Seine. As innovative artists painting in this region they had to confront and reinterpret characteristic Impressionist imagery. It was near Chatou that Claude Monet and Pierre-Auguste Renoir worked side by side, painting the bathers at La Grenouillère in 1869, and several of Renoir's later paintings were made there as well; the town was also recorded by Alfred Sisley on many occasions throughout the 1870s and 1880s. Vlaminck and Derain were keenly aware of the town's Impressionist legacy, and in their work of 1904–5 they remained faithful to the type of motif preferred by the Impressionists.

Venturing beyond Chatou along the Seine to paint the nearby villages, the artists continued to adopt Impressionist composition. Typically, when painting a village, the Impressionist artist would stand back from a road or winding path

PLATE 2
Alfred Sisley
(France, 1839–1899)
Boulevard Héloise in Argenteuil, 1872
Oil on canvas
15 ½ x 23 ½ in.
(39.4 x 59.7 cm)
National Gallery of Art, Washington, D.C., Ailsa Mellon Bruce Collection

PLATE 3
Maurice de Vlaminck
Restaurant de la Machine à Bougival
(*Restaurant de la Machine at Bougival*), c. 1905
Oil on canvas
23 ⅝ x 31 ⅞ in. (60 x 81 cm)
Musée d'Orsay, Paris

and paint the buildings that framed the road and receded with it (plate 2). Vlaminck continued this distancing, but he painted the buildings with intense col-

ors and thick impasto that reflect van Gogh's influence as well (plate 3). On rare occasions Derain and Vlaminck would depart from the traditional Impressionist vista and instead depict buildings at close range, positioning themselves directly on the street or in a nearby clearing (plates 4–5).

The Impressionists had made a firm commitment to plein-air painting, the recording of nature on site. Early in his career Cézanne wrote to Emile Zola: "But you know all pictures painted inside, in the studio, will never be as good as those done outside. When out-of-door scenes are represented, the contrasts between the figures and the ground are astonishing and the landscape is magnificent. I see some superb things and I shall have to make up my mind only to do things out-of-doors."[9] During Impressionism's early years an Impressionist artist would often perch above a scene, looking down on the villages or bridges or waterways immediately below (plate 6). Human activity (or the evidence of previous activity)—the houses that make up the villages, the bridges built and crossed by the inhabitants, the boats that deliver goods and people from one place to another—is key to virtually all of their paintings. Some of the Impressionists preferred to consider their subjects through veils of trees; others opted to look down at a road winding through a village and record the people coming and going along it.

The Impressionists' efforts—especially their manner of framing landscape views asymmetrically, establishing a 1:2 ratio between land and sky, and weighting their compositions either at the lower left or lower right—gradually became the basis for virtually all renderings of landscape in France. In the years after the

PLATE 2

PLATE 3

PLATE 4

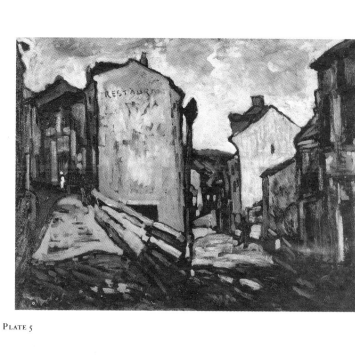

PLATE 5

PLATE 4
André Derain
Restaurant du Pecq
(*Restaurant at Le Pecq*), 1904–5
Oil on canvas
25 ⁹⁄₁₆ x 19 ¹¹⁄₁₆ in. (65 x 50 cm)
Private collection,
Switzerland

PLATE 5
Maurice de Vlaminck
Le Village
(*The Village*), c. 1904
Oil on canvas
35 x 45 ¹¹⁄₁₆ in. (89 x 116 cm)
Museum Folkwang, Essen,
West Germany

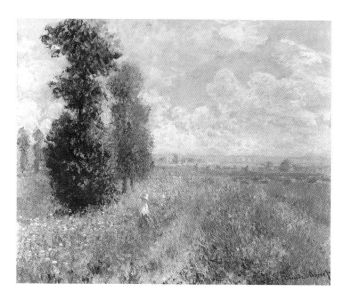

PLATE 6

final Impressionist exhibition of 1886 artists—both those exhibiting at the Salons and growing numbers of those functioning outside traditional artists' societies—experimented with various means of applying paint but followed the same compositional conventions. Painters who remained faithful to various areas in the northern half of France—suburban and rural towns from Paris to the Norman coast and Brittany, as well as the Barbizon-Fontainebleau axis—essentially retained the compositional formats favored by the Impressionists (plate 7). When the generation following the Impressionists moved south to the Midi (plate 8), their style changed to convey the intensity of light and color that characterized Provence, but the organization of their paintings remained within the Impressionist tradition.[10]

When painting along the Seine—their preferred activity—Derain and Vlaminck paraphrased the standard view pioneered by the Impressionists. They perched on the riverbank or on small jetties that projected slightly from the bank and painted the activity on the banks, on the river, and on the bridges crossing it. Monet had made such views famous in his classic Impressionist pictures of 1872–74, as in his depiction of a Sunday in Argenteuil (plate 9). His paintings, excellent exemplars of the picturesque tradition that grew out of the concept of the pastoral landscape, feature the same composition found in the work of Jean-Baptiste-Camille Corot and even John Constable, particularly in the latter's many views of the paths near Salisbury Cathedral. When they took up comparable views (plates 10–11), Derain and Vlaminck included people, too, though their figures tend to be not the elegant bourgeoisie of Monet's paintings but workers out for a Sunday stroll.[11] Derain's image minimizes the distinction between the figure and the landscape—indeed, his depiction of the shoreline at Le Pecq and the multiple activities around the barges prefigures his fascination with shipping and commerce on the Thames, as depicted in his 1906 London paintings.

When the Impressionists focused their attention on suburban or, especially, rural areas, they celebrated scenes where leisure activities could be enjoyed free from the intrusion of the industrial or the urban. Their rendering of such sites was considerably affected by ideas prevailing in the 1860s and 1870s about the essential role of leisure in the health and welfare of society. The clearest prescriptions appeared in popular journals as well as guidebooks published to aid Frenchmen—no doubt chiefly Parisians—in their travels.

By comparison, Vlaminck was a native of Chatou, and we need not scour guidebooks for clues to how he responded to his own town. He identified with the people he portrayed, whether it was the worker hunched over in the fields or the crewman on a barge; he held strongly left-wing convictions, was an avid reader of Karl Marx and the anarchist Pyotr Kropotkin, and contributed to the anarchist journal *Le Libertaire*. His writ-

PLATE 6
Claude Monet
(France, 1840–1926)
Meadow with Poplars, 1875
Oil on canvas
21 ½ x 25 ¾ in.
(54.6 x 65.4 cm)
Courtesy, Museum of Fine Arts, Boston, bequest of David P. Kimball in memory of his wife, Clara Bertram Kimball

PLATE 7
Georges Seurat
(France, 1859–1891)
The Large Basin
(*The Seine at Courbevoie*),
c. 1887
Oil on canvas
25 ⅝ x 32 ¼ in.
(65.1 x 81.9 cm)
Musées Royaux des Beaux-Arts, Brussels

PLATE 8
Vincent van Gogh
(The Netherlands, 1853–1890)
Entrance to the Public Garden, 1888
Oil on canvas
28 ½ x 35 ¾ in.
(72.5 x 90.8 cm)
The Phillips Collection, Washington, D.C.

PLATE 9
Claude Monet
(France, 1840–1926)
Basin at Argenteuil, 1872
Oil on canvas
23 ⅝ x 31 ¹¹/₁₆ in.
(60 x 80.5 cm)
Musée d'Orsay, Paris

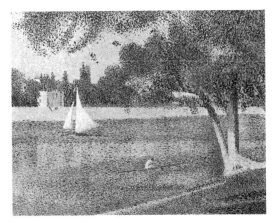

PLATE 7

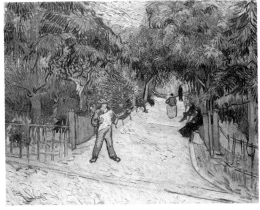

PLATE 8

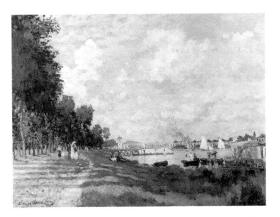

PLATE 9

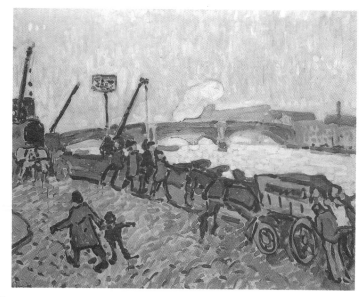

Plate 10

Plate 10
André Derain
Le Pecq, 1905
Oil on canvas
31 ⅞ x 39 ⅜ in. (81 x 100 cm)
Musée National d'Art
Moderne, Centre Georges
Pompidou, Paris

Plate 11
Maurice de Vlaminck
Les Canotiers à Chatou
(*The Boaters at Chatou*), c. 1904
Oil on canvas
23 ⅝ x 28 ⅞ in. (60 x 73.3 cm)
Perls Galleries, New York

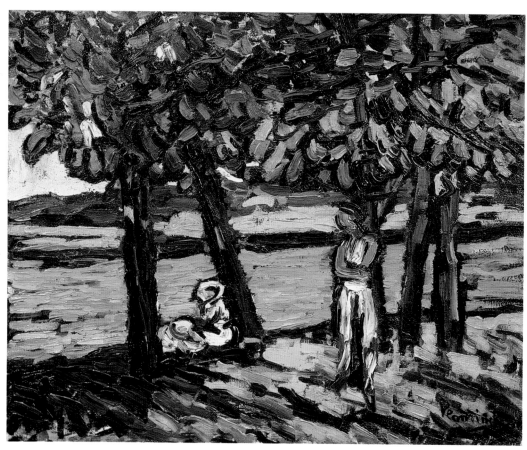

Plate 11

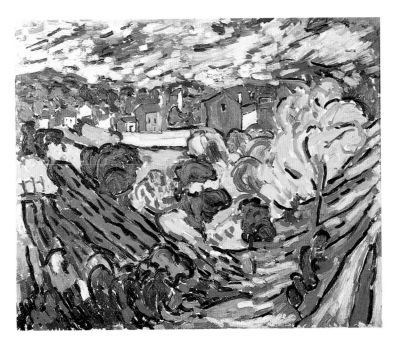

PLATE 12

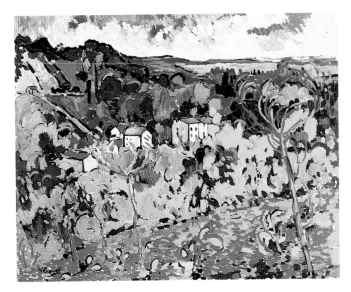

PLATE 13

PLATE 12
Maurice de Vlaminck
Paysage près de Chatou
(*Landscape near Chatou*), 1906
Oil on canvas
23 ¹³/₁₆ x 28 ¹⁵/₁₆ in.
(60.5 x 73.5 cm)
Stedelijk Museum,
Amsterdam

PLATE 13
Maurice de Vlaminck
Bougival, 1905
Oil on canvas
31 ½ x 39 in. (80 x 99 cm)
Dallas Museum of Art, the
Wendy and Emery Reves
Collection

ings underscore his radical posture: "I wanted to burn down the Ecole des Beaux-Arts with my cobalts and vermilions and I wanted to express my feelings with my brushes without troubling what painting was like before me.... Life and me, me and life."[12] His figures are van Goghesque peasants or workers in peaceful Impressionist settings. A keen admirer of van Gogh, Vlaminck wrote after seeing the van Gogh exhibition at Galeries Bernheim-Jeune in March 1901: "In him I found some of my own aspirations. Probably from similar Nordic affinities? And, as well as a revolutionary fervor an almost religious feeling for the interpretation of nature. I came out of this retrospective exhibition shaken to the core." On another occasion he said, "I loved van Gogh that day more than my own father."[13]

Even though they returned to sites made famous by the Impressionists and others, the Fauves surely knew that these towns and villages had changed economically and socially. Despite some attempts toward decentralization, France stubbornly revolved around Paris; at the same time suburbs were gradually sprawling around regional industrial cities, and clusters of tourist sites were developing to satisfy the needs of growing numbers of French workers. Often the Fauves responded to these changes by making their imagery nonspecific, almost universal or idyllic. Vlaminck, who rarely left the Seine suburbs in these years (and even when he did travel, as he did to Martigues, he appears not to have painted much), would stand alone on a hill overlooking a suburban town undergoing dramatic changes and generalize it in his painting, using an isolated motif such as a bridge or a church steeple to provide the clue required for identification (plates 12–13). The names of the towns are occasionally noted in his titles, but one village tends to be indistinguishable from another, as Vlaminck looked down on them from comparable vantage points.

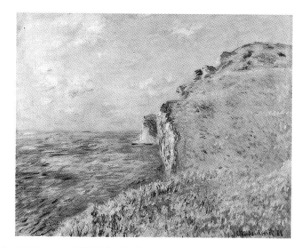

PLATE 14

Frequently the Fauves applied an Impressionist precedent to an altogether different geographical site. For example, while in Collioure during the summer of 1905 Matisse produced a series of pictures small enough to be painted in the top of his paint box. These views of *moulades* (plate 15)—the rocky outcroppings along the Mediterranean coast that Matisse could see when he wandered a short distance from the principal harbor in Collioure—recall the topography of Etretat and Fécamp (plate 14), the rocky coastal towns in Normandy where Monet had found starkly dramatic imagery to paint. The scale of Matisse's paintings is minute compared to the grandeur of Monet's canvases, but the motifs are clearly related.

The burning question for the Fauves was what to depict and how. "The artist," observed Matisse, "encumbered with all the techniques of the past and present, asked himself: 'What do I want?' This was the dominating anxiety of Fauvism."[14] Matisse was deeply troubled by his selection of what to paint and by his need to achieve a degree of originality that would satisfy him.[15] He wrote to Manguin during the difficult summer of 1904, when Matisse was staying in Saint-Tropez with Signac, "I believe that painting will make me crazy, and I am going to try to get out of it as soon as possible."[16] Four years later he transformed his doubts about painting into a concentrated statement of his goals:

> What I am after, above all, is expression. . . . The entire arrangement of my picture is expressive: the place occupied by the figures, the empty spaces around them, the proportions, everything has its share. . . . A work of art is harmonious in its entirety; any superfluous detail would replace some other essential detail in the mind of the specta-tor. . . . ¶ What I dream of is an art of balance, of purity and serenity, devoid of troubling or depressing subject matter, an art which could be for every mental worker, for the businessman as well as the man of letters, for example, a soothing, calming influence on the mind, something like a good armchair which provides relaxation from physical fatigue.[17]

Matisse distinguished his achievement and that of the Fauves from that of the Impressionists: "The word 'impressionism' perfectly characterizes their style, for they register fleeting impressions. It is not an appropriate designation for certain more recent painters who avoid the first impression, and consider it almost dis-

PLATE 14
Claude Monet
(France, 1840–1926)
The Cliff at Fécamp, 1881
Oil on canvas
25 x 31 ½ in. (63.5 x 80 cm)
Aberdeen Art Gallery
and Museums, Aberdeen,
Scotland

PLATE 15
Henri Matisse
La Côte, Collioure
(*The Coast of Collioure*),
c. 1905–6
Also known as *La Moulade*
Oil on panel
9½ x 13 in. (24.1 x 33 cm)
Private collection, courtesy
Barbara Divver Fine Art

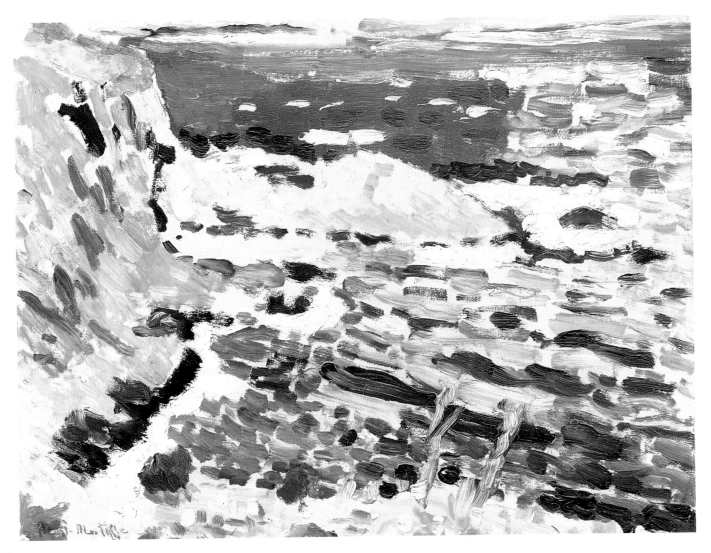

Plate 15

honest. A rapid rendering of a landscape represents only one moment of its existence. I prefer, by insisting upon its essential character, to risk losing charm in order to obtain greater stability."[18]

Derain also agonized over a specific role for his art. Even after spending the summer of 1905 with Matisse in Collioure, where together they resolved many of the stylistic issues plaguing them, Derain continued to question his goals and the directions he was taking. During the course of that summer both artists had produced major compositions that articulated their individual attitudes toward painting within the well-established tradition of a pastoral ideal.

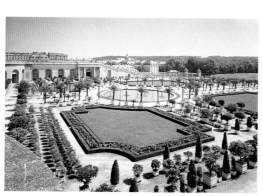

PLATE 16

PLATE 16
The Gardens at the Palace
of Versailles
Designed by André Le
Nôtre, 1669–85

The pastoral tradition was the French answer to the grand canvases and panoramic vistas of natural wonders that constituted the sublime approach to landscape elsewhere in Europe and America, especially during the first half of the nineteenth century. Paintings of the sublime—in which nature was depicted as an awe-inspiring universe in miniature, a domain given to man by God—were peripheral to the mainstream French landscape tradition.[19] To be sure, Roman Catholicism, the state religion in France, did not encourage the veneration of nature espoused by Protestant religions. Also, the royal and imperial taste in France for the grand formal garden, epitomized by the sweeping views from Louis XIV's Versailles (plate 16), may have made the French experience of the formal landscape sufficiently imposing that painting did not have to aspire to such grandeur. In any event, French geography was hardly rampant with natural spectacles; most easily celebrated was the beautiful coastline, which was far more accessible to most individuals than soaring mountain ranges or plummeting valleys.

French artists from the seventeenth through the nineteenth century cultivated a preference for Arcadian visions—mythological figures situated in lush landscapes—in which the human and the natural realms peacefully coexisted. Primary inspiration for such pastoral images came from poetic idylls (beginning with Virgil) rather than from historical, moral, or narrative subjects.[20] The seventeenth-century painters Nicolas Poussin and Claude Lorrain created landscapes (plates 17–18) that express a shared view of humankind—albeit represented by mythological or religious figures—at peace within tranquil nature. Later historians viewed Poussin and Claude as the heirs to the Venetian pastoral tradition established by Giorgione, Titian, Correggio, and Annibale Carracci in the fifteenth and sixteenth centuries. Indeed, all of these artists contributed to the emergence, during and after the Renaissance, of the pastoral landscape: one in which the figures are not doing much of anything, except perhaps making love or music or contemplating the landscape itself, within an intimate outdoor setting.[21]

These pastoral landscapes became a somewhat romanticized legacy for succeeding generations of French painters. Later writers on Claude, for example, encouraged an ideal view of the artist at work outdoors, when in fact Claude had rarely painted directly from nature.[22] In the poetic worlds created by the great eighteenth-century French artists François Boucher, Jean-Honoré Fragonard, Hubert Robert, and Jean-Antoine Watteau, mythological figures are replaced by contemporary French men or women, frolicking contentedly in landscapes of

PLATE 17
Nicolas Poussin
(France, 1594–1665)
Detail of *Landscape with a
Woman Washing Her Feet*, 1650
Oil on canvas
45 ⅞ x 68 ¼ in.
(116.5 x 174.6 cm)
National Gallery of Canada,
Ottawa, gift of H. S.
Southam, Ottawa, 1944

PLATE 18
Claude Lorrain
(France, 1600–1682)
Detail of *A Pastoral
Landscape*, c. 1650
Oil on copper
15 ⅞ x 21 ⅝ in.
(40.3 x 54.9 cm)
Yale University Art Gallery,
New Haven, Connecticut,
Leonard C. Hanna, Jr., B.A.
1913, Fund

PLATE 19
Jean-Antoine Watteau
(France, 1684–1721)
Detail of *Pilgrimage to the
Island of Cythera*, 1717
Oil on canvas
50 ¹³⁄₁₆ x 76 ⅛ in.
(129 x 194 cm)
Musée du Louvre, Paris

PLATE 20
Jean-Baptiste-Camille Corot
(France, 1796–1875)
Detail of *Forest of
Fontainebleau*, c. 1830
Oil on canvas
69 ⅛ x 95 ½ in.
(175.6 x 242.6 cm)
National Gallery of Art,
Washington, D.C.,
Chester Dale Collection

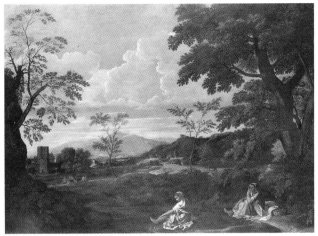

Plate 17

Plate 18

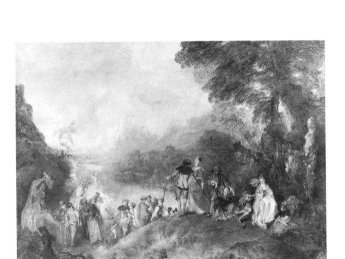

Plate 19

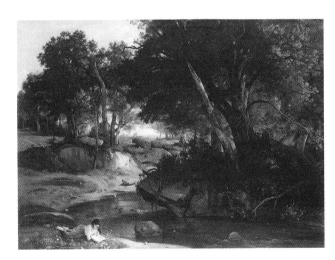

Plate 20

PLATE 21
Henri Matisse
Nu dans un paysage, Collioure
(*Nude in a Landscape,
Collioure*), 1905
Oil on panel
16 x 12½ in. (40.6 x 31.7 cm)
Nippon Autopolis Co., Ltd.

PLATE 22
Henri Matisse
Nu dans la forêt
(*Nude in the Wood*), 1905
Oil on panel
16 x 13 in. (40.6 x 33 cm)
The Brooklyn Museum,
gift of George F. Of

PLATE 23
Henri Matisse
La Pastorale
(*Pastoral*), 1905
Oil on canvas
18⅛ x 21⅝ in. (46 x 55 cm)
Musée d'Art Moderne de
la Ville de Paris

intense beauty and lushness (plate 19).

Corot, working in the mid-nineteenth century, created pastoral views of timeless nature populated with idealized contemporary figures (plate 20). In his landscapes—as in most of those created by artists working outdoors in the forest of Fontainebleau and in the town of Barbizon, about thirty-five miles from Paris—the artist (and hence the viewer) is situated slightly above the scene. This perspective creates the illusion that these landscapes are more accessible to the viewer. Since these pastoral landscapes were created at the same time as Jean-François Millet's dramatic *Man with a Hoe* (1860–62, private collection, U.S.A.) and Gustave Courbet's *Burial at Ornans* (1849–50, Musée d'Orsay, Paris), and on the heels of Eugène Delacroix's monumental tableaux, they were often exhibited and reproduced concurrently with such politically symbolic works. The larger audience—among them, members of the working classes—that was attracted to the politically charged canvases thus would encounter pastoral landscapes as well, both at the Salons and in the newspapers and journals where engravings of the works appeared.

Somewhere in the midst of Impressionism the pastoral gave way to the picturesque (the painting of charming, unpopulated scenes of nature); only Gauguin and Cézanne had portrayed figures—whether native women or bathers—seen in harmonious coexistence with their surroundings. Later the most sophisticated of the Fauve artists—Matisse and Derain—sought to merge the picturesque and the pastoral. In Matisse's group of nudes painted on small panels in the top of his paint box (plates 21–22),[23] a rapidly sketched figure reminiscent of the women in Manet's *Luncheon on the Grass* (1863, Musée d'Orsay, Paris) curls up comfortably in

PLATE 23

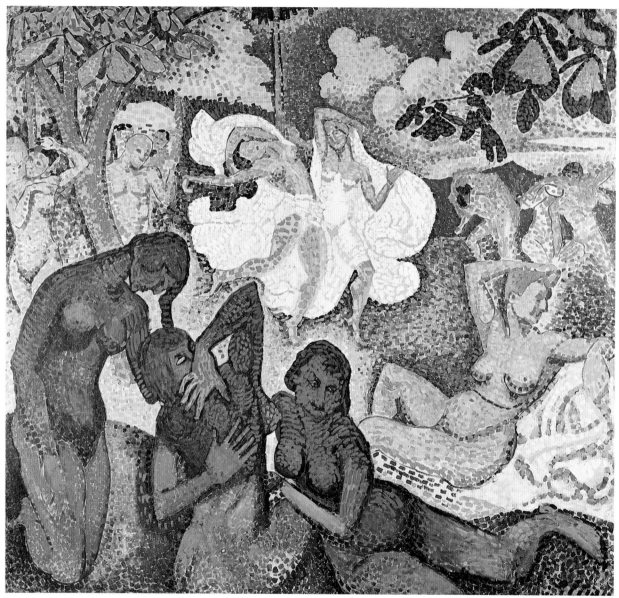

PLATE 24

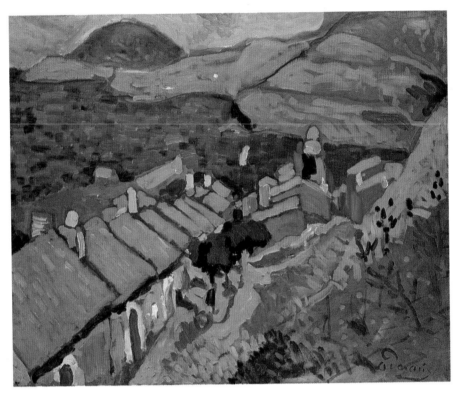

PLATE 25

the wooded landscape that Matisse had found on the outskirts of Collioure. These figures led to larger-scale compositions that clearly draw upon the tradition of the pastoral (plate 23), as do the artist's monumental *Le Bonheur de vivre* (*The Joy of Life*, plate 176) and the studies related to it.

Derain was passionate about the virtues of Collioure, praising in a letter to Vlaminck, "above all, the light. A blond light, a golden hue that suppresses the shadows."[24] His village views (plate 25) originated in part in Vlaminck's preference for peaceful towns nestled in a hillside. At the same time Derain painted mammoth compositions of large-scale bathers cavorting outdoors. His *L'Age d'or* (*The Golden Age*, plate 24) presents exotic, idealized figures in a composition that recalls in content and format the work of Claude and Pierre Puvis de Chavannes. Like Derain's other major figure composition of the Fauve years, *La Danse* (*The Dance*, plate 26), the painting belongs to the tradition of pastoral landscapes.

When Derain traveled to London in 1906, he spent considerable time visiting museums, both the ethnographic collections at the British Museum and the paintings at the National Gallery. He focused on the work of Claude and Joseph Mallord William Turner, discussing these artists at great length in letters to Matisse and Vlaminck. To Matisse, Derain wrote that Turner considered every detail to be important, no matter how seemingly inconsequential. His figures "do not need only to be figures. What gives them significance are the masses of color that, when combined, support the whole. One can then find in Claude Lorrain significant emotion resulting from the harmony of separate sensations."[25] Since Derain wrote to Matisse about Claude and Turner on two occasions that can be documented, it can logically be assumed that these artists had been a topic of

PLATE 26
André Derain
La Danse
(*The Dance*), 1906
Oil on canvas
72 ¹³/₁₆ x 89 ¾ in.
(185 x 228 cm)
Fridart Foundation

PLATE 26

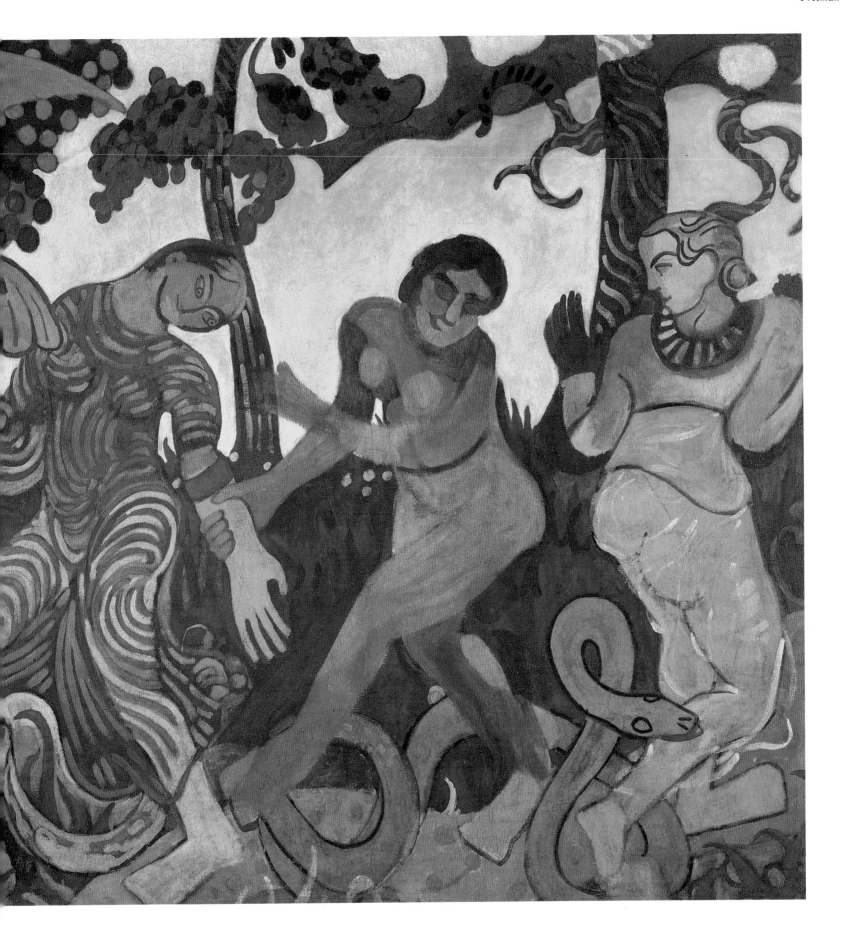

conversation between them before Derain's departure for London. It seems clear that the interests of both artists alternated between the pastoral and the picturesque, though the latter was less of a concern for them.

That Derain and Matisse eventually adopted the figure as central to all nature-based imagery is evident in Derain's bathers and Matisse's figurescapes of 1907–8 (plates 27–28). Figures are no longer the idealized types of *Luxe, calme, et volupté* (plate 175), *Le Bonheur de vivre* (plate 176), and *L'Age d'or* (plate 24). Instead, relatively exaggerated and distorted figures are prominent within landscapes, shifting from a balanced, harmonious scene toward a more dynamic contrast between figure and setting.

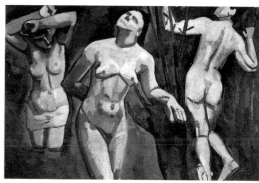

The pastoral landscape was of relatively less concern to the other Fauve artists, despite their ongoing contact with their colleagues in Collioure, particularly Matisse. The Fauve artists such as Camoin (plate 31) and Manguin, who were based in the Mediterranean corridor between Nice and Marseille in 1904–6, viewed their work as a pleasurable métier: to render figures situated in comfortable, attractive places, rather than classicized figures in idealized settings (plate 29). The artists—the "flock of migrating birds," as the critics termed them[26]—would pair up with one another for brief painting trips in small Mediterranean towns (plate 30). Their correspondence focused on the difficulties of painting and the details of daily life: the quality of light, the changing climatic conditions, the politics of exhibitions, the failings of their children. From Saint-Tropez, Marquet wrote to Camoin in 1905: "It is marvelous is your Midi sun!... When you come, try to bring with you some good weather. There are also some marvelous landscapes to paint."[27] Writing to Matisse in Saint-Tropez, Manguin complained that a prolonged bout of poor weather had interfered with the "small studies" with which he was trying to capture the beauty of the area around La Percaillerie.[28] Marquet's and Manguin's comments recall Monet's letters, in which he agonized to his family over the often adverse conditions under which he had to paint.[29] Their images reflect a desire to put the best face on nature, also a characteristic of Impressionist painting. In contrast, Matisse and Derain tended in their musings to worry about formal issues (composition, color, light) rather than the external conditions of the sites they were painting; Matisse's and Derain's formal decisions, especially those made while the two were together in Collioure, were reconciled with their content-related goals, which were inextricably tied to the tradition of the pastoral landscape.

The Impressionists had spent relatively little time in the Midi during the 1870s, preferring Norman coastal sites. Monet retraced the footsteps of Eugène Boudin, Courbet, Johan-Barthold Jongkind, and others when he painted the tourists who frequented Sainte-Adresse, Le Havre, and Trouville—ports turned vacation spots on the English Channel. Monet was born in Le Havre; as Robert Herbert has convincingly demonstrated, his paintings of Le Havre reflect his engagement with it both as a local boy coming home and as a painter recognizing the potential of the site.[30] Monet spent several summers in the 1860s at the region around Sainte-Adresse, an upper middle-class residential section of Le Havre, painting the seacoast residents from the promenade directly above the beach and

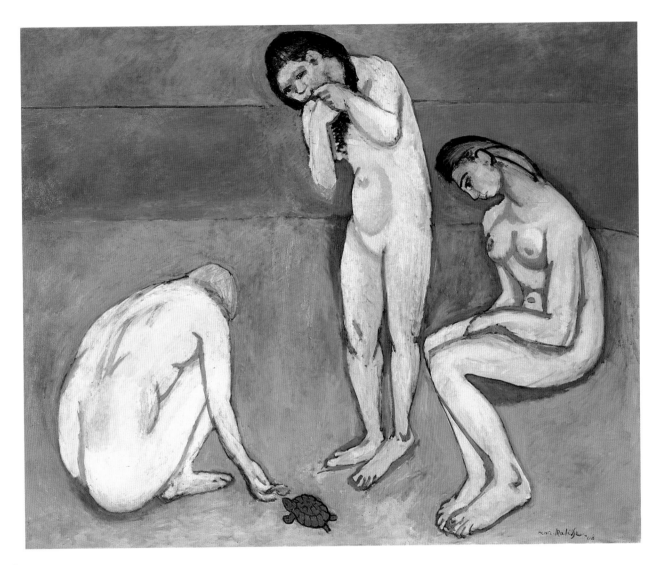

PLATE 28

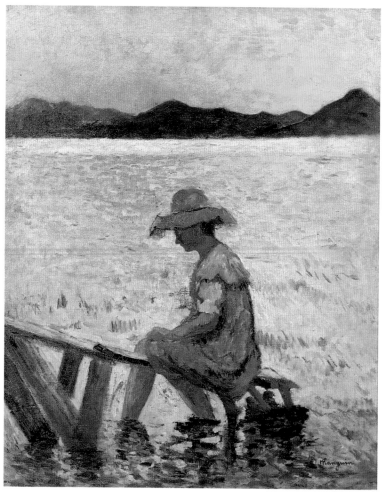

PLATE 29

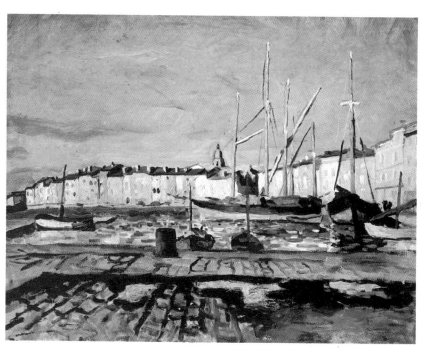

PLATE 30

PLATE 29
Henri Manguin
Saint-Tropez, le coucher de soleil
(*Saint-Tropez, Sunset*),
autumn 1904
Oil on canvas
31 ⁷/₈ x 25 ⁹/₁₆ in. (81 x 65 cm)
Mr. and Mrs. Jean-Pierre
Manguin, Avignon, France

PLATE 30
Albert Marquet
Port de Saint-Tropez
(*Port of Saint-Tropez*), 1905
Oil on canvas
25 ⁹/₁₆ x 31 ⁷/₈ in. (65 x 81 cm)
Musée de l'Annonciade,
Saint-Tropez, France

PLATE 31
Charles Camoin
*Le Pont des Arts vu du
Pont Neuf*
(*The Pont des Arts Seen from
the Pont Neuf*), 1904
Oil on canvas
13 x 16 ⅛ in. (33 x 41 cm)
Private collection

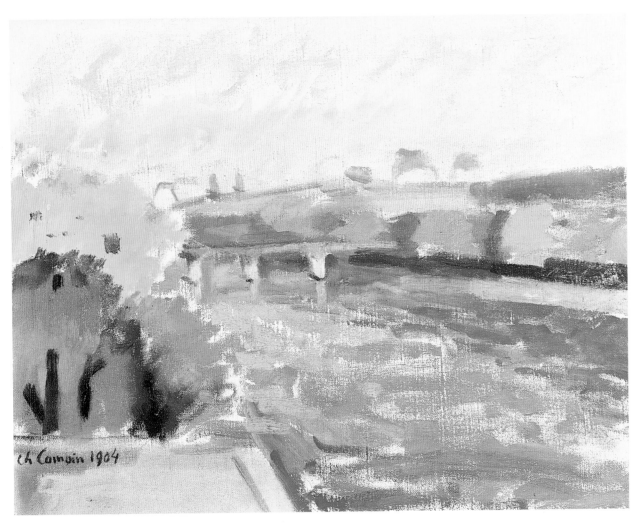

PLATE 31

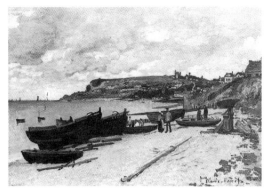

PLATE 32

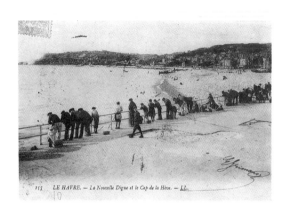

PLATE 33

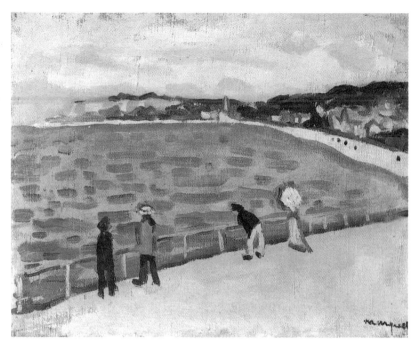

PLATE 34

from a point on the beach looking north toward the end of the accessible shoreline (plate 32).

Dufy, also a native of Sainte-Adresse and much closer to the Impressionists in style than Derain or Vlaminck, took up Monet's vantage point to paint an extensive series of fishermen and pedestrians along the same coast (plates 35–36). He was equally attracted to Monet's manner of titling paintings with references to time of day, weather conditions, and place.[31] In painting fishermen on the shores or on the jetty, he was joined by Marquet (plate 34), who painted alongside him during the summer of 1906 (while their fellow Havrais artists, Braque and Friesz, were in Antwerp). The views chosen by Dufy and Marquet were equally preferred by photographers in the town, who found an audience for images contrasting sea and shore in Sainte-Adresse (plate 33). Boudin had earlier placed his views of Le Havre, Honfleur, and Trouville in the towns' shop windows to attract the tourists' attention, and Dufy and Marquet similarly sought to capture popular images of the Norman coast.

PLATE 32
Claude Monet
(France, 1840–1926)
*Sainte-Adresse, Fishing Boats
on the Shore*, 1867
Oil on canvas
22 ⁷⁄₁₆ x 31 ½ in. (57 x 80 cm)
Private collection

PLATE 33
The Le Havre and Saint-
Adresse coastline

PLATE 34
Albert Marquet
*La Passerelle Sainte-Adresse
(The Boardwalk, Sainte-
Adresse)*, 1906
Oil on canvas
19 ¹¹⁄₁₆ x 24 in. (50 x 61 cm)
Private collection

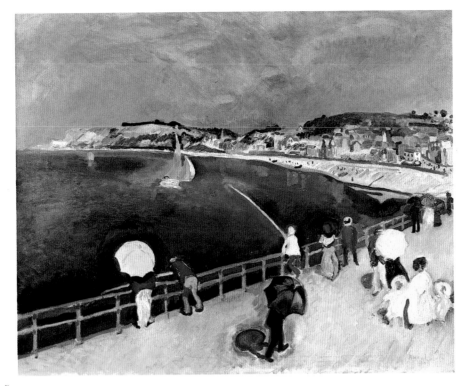

PLATE 35

PLATE 35
Raoul Dufy
*La Baie de Sainte-Adresse
(The Bay at Sainte-Adresse)*,
1906
Oil on canvas
25 ⁹⁄₁₆ x 31 ⅞ in. (65 x 81 cm)
Collection Alain Delon

PLATE 36
Raoul Dufy
*Les Pêcheurs à la ligne
(Fishermen Angling)*, 1907
Oil on canvas
23 ⅝ x 28 ¾ in. (60 x 73 cm)
Private collection

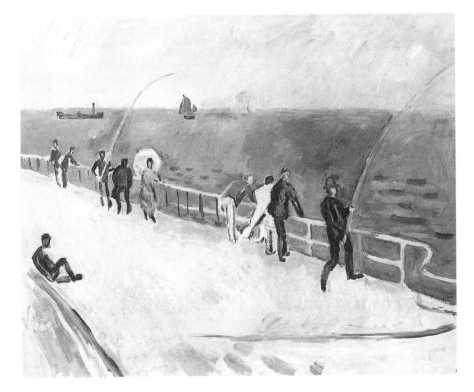

PLATE 36

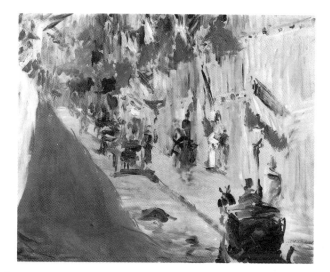

PLATE 37

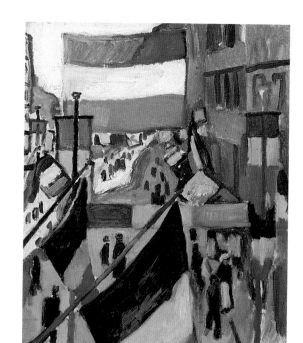

PLATE 38

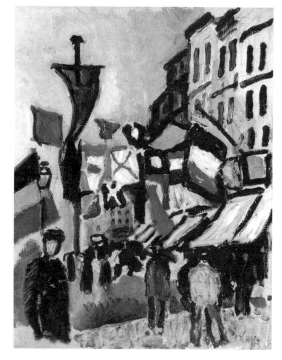

PLATE 39

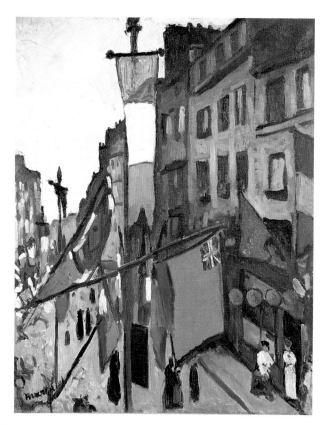

PLATE 40

Dufy and Marquet shared the Impressionist enthusiasm for the annual transformation of cities and towns for Bastille Day on July 14 and other flag-waving celebrations. Whereas Manet and Monet occasionally painted Parisian boulevards adorned with flags for patriotic holidays (plate 37), Dufy and Marquet regularly depicted the festivities (plates 38–40). For the Impressionists the flag-draped streets provided an opportunity to show a colorful festival of modern life, occasionally tinged with political overtones. For Dufy and Marquet the holiday provided motifs that could be situated within the Impressionist tradition but more loosely rendered, with the sketchier brushwork and scattered, almost random color typical of the quasi-Fauve style adopted by the Fauves Havrais.

In 1906–7 Derain, Braque, Friesz, and Dufy all frequented the site that Cézanne had favored throughout most of his later years: L'Estaque, which faced the port of Marseille and had its own slightly dilapidated harbor. L'Estaque was not off the beaten track by any means; virtually all travel to the south of France required passage via Marseille. Derain painted at L'Estaque in the summer of 1906, relying less on the precedent of Cézanne than on Gauguin, who had painted with van Gogh in nearby Arles in 1888. Derain's paintings from L'Estaque are monumental; he had fused the lessons from his summer with Matisse at Collioure in 1905 and from his two months in London in early 1906 into a radically new form of landscape painting with little semblance of naturalistic color. In a letter to Vlaminck written during this summer, Derain mused:

> I have the feeling that I am now orienting myself toward something better, where the picturesque mattered less than [it did] last year, [and I am] looking only at the question of painting. ¶ Really, we have a problem that has grown to such a degree that it becomes quite difficult. I am so lost that I ask myself with what words am I going to explain this to you.... If we are not looking for a decorative usage, we may just tend to purify, more and more, this transposition of nature. But, until now, we only did it, intentionally, in terms of colors.... We are still lacking many things, though, in the general view of our art.... ¶ I do not imagine the future agreeing with our [present] inclinations: On the one hand, we seek to free ourselves from the objective world but, on the other hand, we guard those elements of the objective world as the source and as the end [of what we are doing]. No, to tell the truth... I do not see at all what I should do to be logical.... ¶ Instead, I believe that the problem is to group forms in light and to harmonize them at the same time with the material that one has available.[32]

Though clearly Impressionist in composition, Derain's L'Estaque paintings (plates 41, 43–47) make clear that his color bore little resemblance to even an intensified reality—a liberation that Gauguin had accomplished a decade earlier in his Tahitian landscapes (plate 42).[33]

The end of the Fauve period has been identified as 1907 by many historians, but a date of 1908 seems far more accurate. When one considers that the notion of a Fauve movement originated in a term coined by a critic to characterize the work of artists exhibited in one room at the 1905 Salon d'Automne, it is not surprising that the end of such a vaguely defined phenomenon is difficult to pinpoint. Nevertheless, if a Fauve style, as it is loosely defined here, consists of painting that is simplified, nature-based, filled with high-keyed, saturated color that is liberated from reality, then Matisse and Derain seem to have shifted away from such a style beginning hesitantly around 1907 and more resolutely by mid-1908.

PLATE 37
Edouard Manet
(France, 1832–1883)
The Rue Mosnier Decked Out in Flags, 1878
Oil on canvas
25 9/16 x 31 7/8 in. (65 x 81 cm)
Private collection, Switzerland

PLATE 38
Raoul Dufy
14 Juillet au Havre
(*July 14 at Le Havre*), 1906
Oil on canvas
18 5/16 x 14 15/16 in.
(46.5 x 38 cm)
Fridart Foundation

PLATE 39
Raoul Dufy
Le 14 Juillet au Havre
(*July 14 at Le Havre*), 1906
Oil on canvas
16 1/8 x 13 in. (41 x 33 cm)
Sold, M. Guy Loudmer,
Paris, March 25, 1990

PLATE 40
Albert Marquet
Le 14 Juillet au Havre
(*July 14 at Le Havre*), 1906
Oil on canvas
31 7/8 x 25 9/16 in. (81 x 65 cm)
Musée de Bagnols-sur-Cèze,
Bagnols-sur-Cèze, France

Exhibited at the Salon
d'Automne, 1905

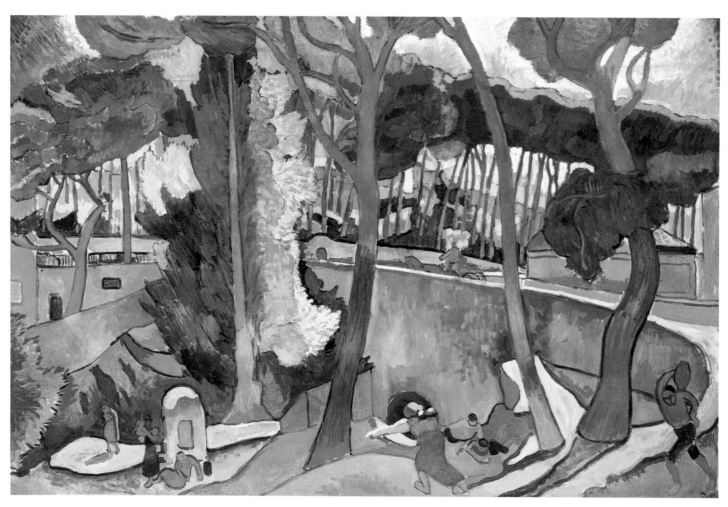

PLATE 41

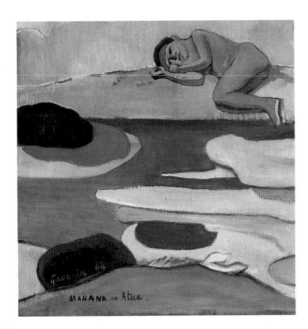

PLATE 42

PLATE 42
Paul Gauguin
(France, 1848–1903)
Detail of *Mahana no atua*
(*Day of the Gods*), 1894
Oil, possibly mixed with
wax, on canvas
26 ⅝ x 35 ⅝ in. (67.6 x 90.5 cm)
The Art Institute of Chicago,
Helen Birch Bartlett
Memorial Collection

PLATE 43
André Derain
Paysage à L'Estaque
(*Landscape at L'Estaque*), 1906
Oil on canvas
32 ⅜ x 40 in. (82.3 x 101.6 cm)
Private collection

PLATE 41
André Derain
L'Estaque, route tournante
(*Turning Road, L'Estaque*), 1906
Oil on canvas
51 x 76 ¾ in. (129.5 x 195 cm)
The Museum of Fine Arts,
Houston, the John A. and
Audrey Jones Beck Collec-
tion, 1974

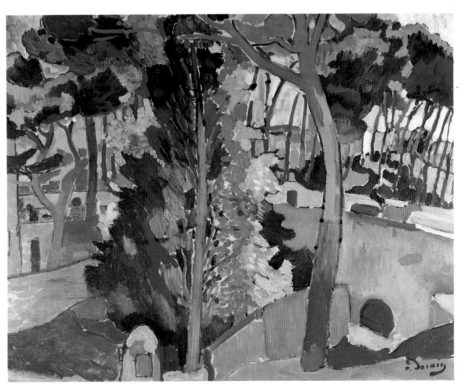

PLATE 43

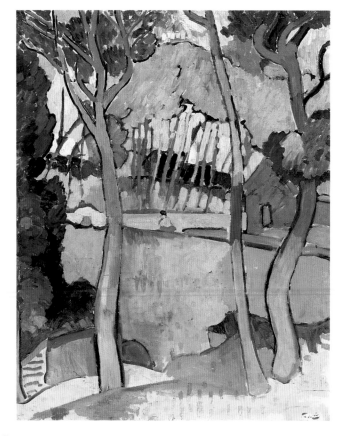

PLATE 44

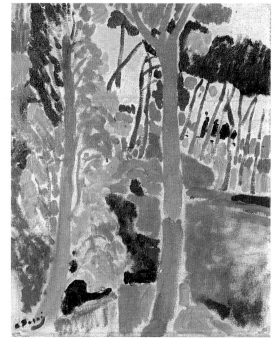

PLATE 45

PLATE 44
André Derain
Trois Arbres, L'Estaque
(*Three Trees, L'Estaque*), 1906
Oil on canvas
39 ½ x 31 ½ in. (100.3 x 80 cm)
Private collection

PLATE 45
André Derain
Arbres, L'Estaque
(*Trees, L'Estaque*), 1906
Oil on canvas
18 ⅛ x 14 ¹⁵⁄₁₆ in. (46 x 38 cm)
Gabriel Sabet, Geneva

PLATE 46
André Derain
L'Estaque, 1906
Oil on canvas
14 ¹⁵⁄₁₆ x 21 ⅝ in. (38 x 55 cm)
Musée des Beaux-Arts, La
Chaux-de-Fonds, Switzer-
land, René and Madeleine
Junod Collection

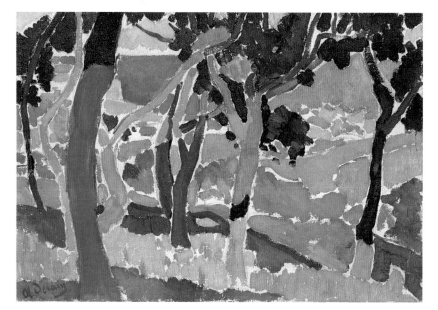

PLATE 46

PLATE 47
André Derain
L'Estaque, 1906
Oil on canvas
28 ¼ x 36 ¼ in. (73 x 92 cm)
Private collection,
Switzerland

PLATE 47

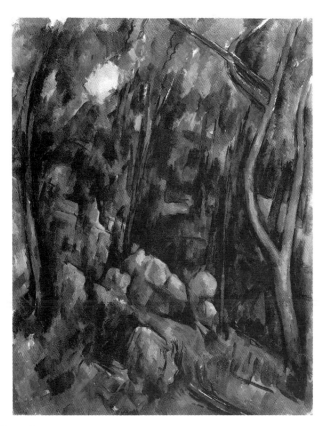

PLATE 48

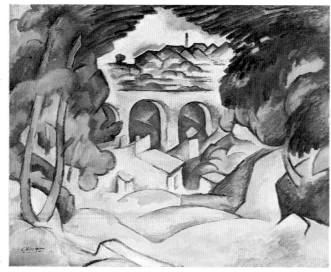

PLATE 49

The winding down of the Fauve period clearly relates to an increased interest in Cézanne by many of the Fauves. The blocky masses that are typical of Cézanne's late paintings (plate 48) gradually came to characterize the paintings of the Fauves working in the region around Marseille—La Ciotat, Cassis, and Martigues—and L'Estaque in 1906–8. The works made by the Fauves Havrais in L'Estaque reveal a shift from a concentration on strong color to a dominance of solid, volumetric form. Clearly their response to the site incorporated their responses to the work of Cézanne. (It is interesting that those artists working in the Midi, such as Derain, Manguin, and Matisse, assimilated Cézanne's work far more slowly than the geographically distant Fauves from Normandy.) In Braque's and Friesz's earliest paintings of L'Estaque, large patches of complementary colors alternate with the white priming on the canvas beneath, conveying a sense of glistening, shimmering nature. Initially, it was Braque's shift toward a more subdued palette and more geometric form that portended the dissolution of the Fauve efforts in favor of Cubism, although Dufy and Friesz were not far behind.[34] The volumes in their paintings solidified; massing became a determining factor in the selection of motifs. On several occasions Braque painted the prominent stone viaducts set within the greenery of the L'Estaque hills, and they grew increasingly angular each time he depicted them (plate 49). Braque and Friesz again painted the same views together, just as they had in Antwerp that summer. Side by side, they painted the same landing stage as it jutted into the harbor at L'Estaque (plates 50–55); their palettes and manners of execution differ considerably, but the motif is exactly the same. Braque, in particular, was persistent in painting it, executing several versions at the same scale until he had resolved nuances of the wood, water, and rock.

PLATE 48
Paul Cézanne
(France, 1839–1906)
In the Park of the Château Noir,
c. 1902
Oil on canvas
35 ⅝ x 28 ⅛ in.
(90.5 x 71.5 cm)
Trustees of the National
Gallery, London

PLATE 49
Georges Braque
Le Viaduc de L'Estaque
(*The Viaduct at L'Estaque*),
September 1907–early 1908
Oil on canvas
25 ⅝ x 31 ⅞ in. (65.1 x 81 cm)
The Minneapolis Institute of
Arts, the John R. Van Derlip
Fund, Fiduciary Fund,
and gift of funds from
Mr. and Mrs. Patrick Butler
and various donors

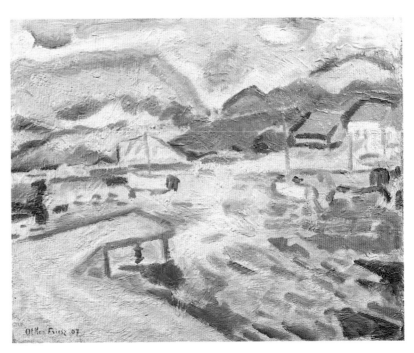

PLATE 51

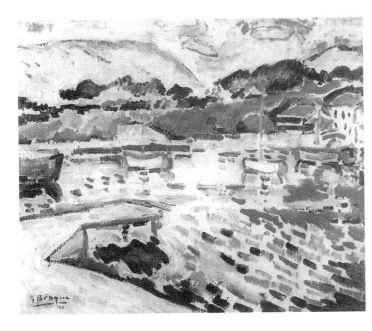

PLATE 50

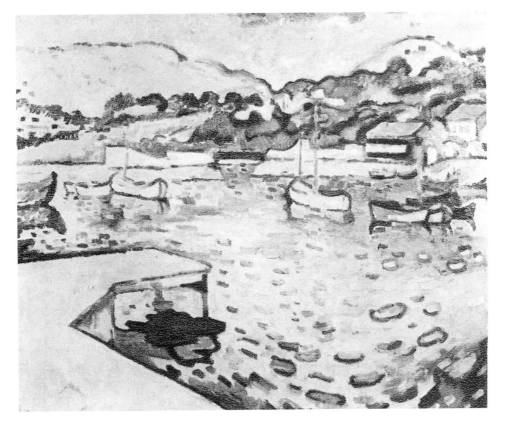

PLATE 50
Georges Braque
L'Embarcadère, L'Estaque
(*Landing Stage, L'Estaque*),
autumn 1906
Oil on canvas
15 ⅛ x 18 ⅛ in. (38.5 x 46 cm)
Musée National d'Art
Moderne, Centre Georges
Pompidou, Paris

PLATE 51
Othon Friesz
L'Estaque, 1907
Oil on canvas
18 ⅛ x 21 ⅝ in. (46 x 55 cm)
Hilde Gerst Gallery,
New York

PLATE 52
Georges Braque
Le Port de L'Estaque—
L'Embarcadère
(*The Port of L'Estaque,*
the Landing Stage),
autumn 1906
Oil on canvas
24 x 28 ¾ in. (61 x 73 cm)
Private collection

PLATE 52

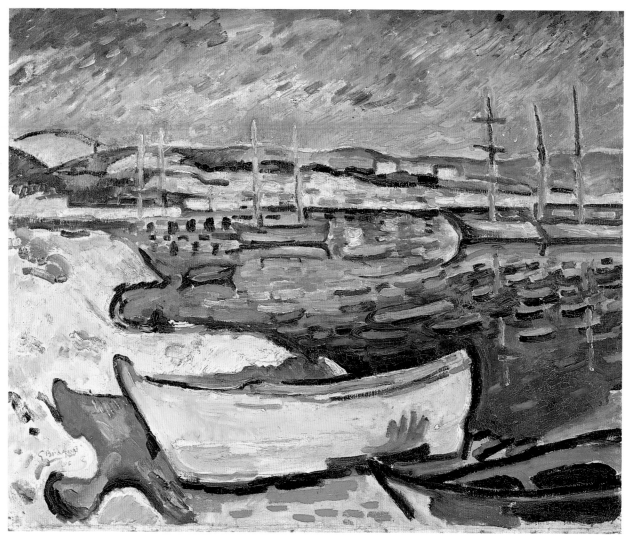

Plate 53

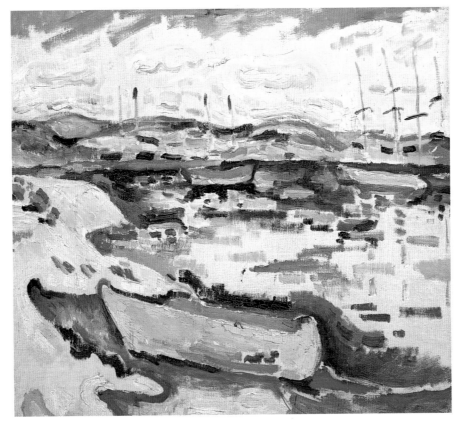

Plate 54

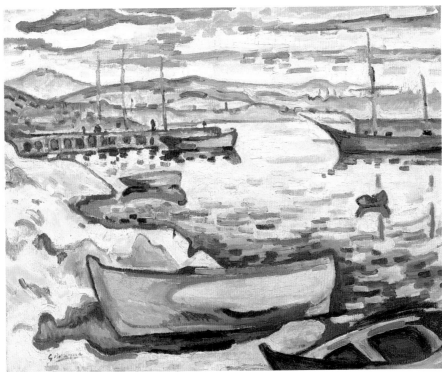

Plate 53
Georges Braque
Bateaux sur la plage, L'Estaque
(*Boats on the Beach, L'Estaque*),
autumn 1906
Oil on canvas
19 ½ x 23 ½ in.
(49.5 x 59.7 cm)
Los Angeles County Museum
of Art, gift of Anatole Litvak

Plate 55

Plate 54
Georges Braque
Paysage à L'Estaque
(*Landscape at L'Estaque*),
autumn 1906
Oil on canvas
19 ⅝ x 24 in. (49.9 x 61 cm)
Private collection

Plate 55
Georges Braque
Le Port de L'Estaque
(*The Port of L'Estaque*),
autumn 1906
Oil on canvas
19 ¹¹⁄₁₆ x 24 in. (50 x 61 cm)
Fridart Foundation

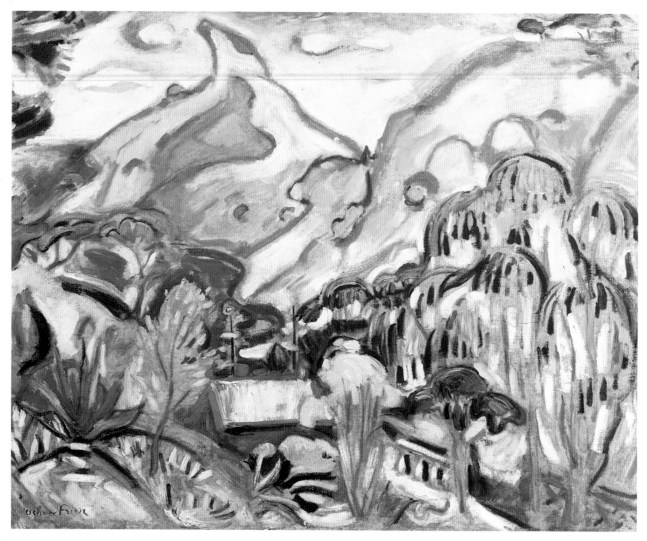

Plate 56

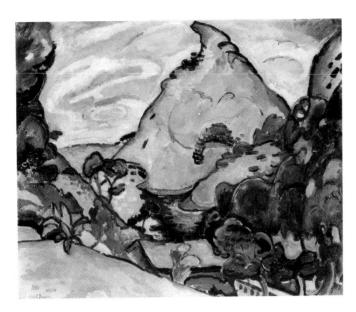

PLATE 57

PLATE 56
Othon Friesz
Le Bec de l'Aigle, La Ciotat
(*Eagle's Beak, La Ciotat*), 1907
Oil on canvas
25 ⅝ x 31 ¹⁵/₁₆ in. (65.1 x 81.2 cm)
Private collection, Switzerland

PLATE 57
Georges Braque
La Calanque—Temps gris
(*The Cove, Gray Weather*), 1907
Oil on canvas
23 ⅝ x 28 ¾ in. (60 x 73 cm)
Neue Staatsgemaldegalerie,
Munich

In the late spring and summer of 1907 Braque and Friesz traveled southeast along the Mediterranean coast from L'Estaque to La Ciotat, an industrial port to their liking. Although the two artists made several paintings of the port, what really piqued their interest were the cliffs and coves on the outskirts of town, particularly the Bec de l'Aigle (Eagle's Beak) (plates 56–57). To paint these rocky formations Braque and Friesz again altered their palettes, to pinks, oranges, and ochers; this further change in color, precipitated by the new surfaces that these two artists had chosen to depict, signaled a shift in attitude toward landscape painting.

Derain's summer of 1907 in Cassis, one town to the west of La Ciotat, marked a comparable transformation in his work (plates 58–59). His palette darkened considerably and became predominantly orange as he, too, faced a landscape that was browner and less lush than the Seine suburbs, Collioure, or L'Estaque. His forms hardened so that the typically Impressionist way of portraying a village that he had once favored was consumed by angular, geometric forms. There is a lack of luminosity, partially due to the absence of traces of primed canvas. At Cassis, Derain worked out where he would go next with his imagery; as the brilliant color of the Fauve inner circle gave way to a more restrained range of tones, Derain became more conservative and classical in his outlook. In the summer of 1908 he traveled northwest of L'Estaque to the town of Martigues. In each of the modest landscapes he painted there (plate 60), complementary tones of orange and blue are contained within strongly geometric boundaries. A similar tonal shift is evident in Dufy's predominantly orange-green-yellow views from the previous year of angular boats in the Martigues harbor (plates 61–62). The paintings that both did there were Fauve in organization but minimally Fauve in palette.

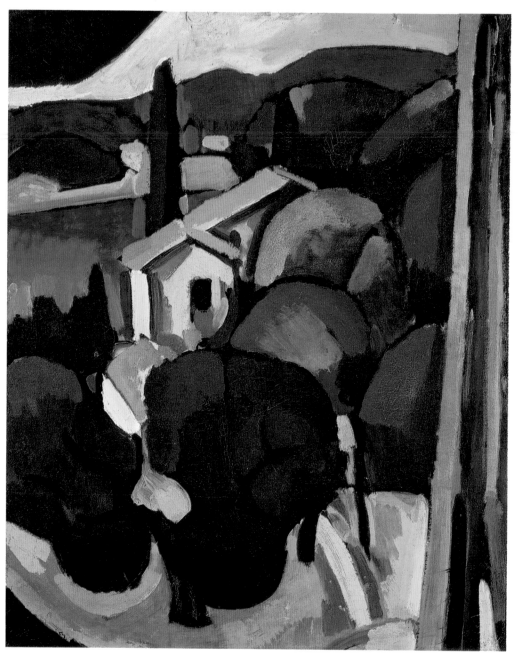

PLATE 58

PLATE 58
André Derain
Paysage à Cassis
(*Landscape at Cassis*), 1907
Oil on canvas
24 x 20 in. (61 x 50.8 cm)
New Orleans Museum of Art,
gift of William E. Campbell

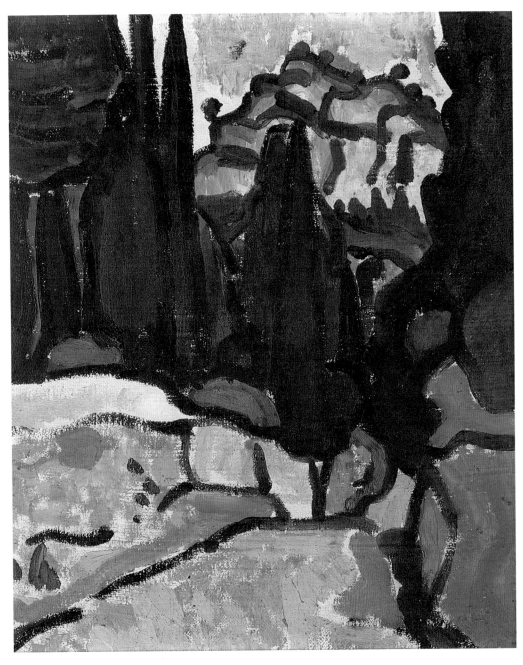

PLATE 59

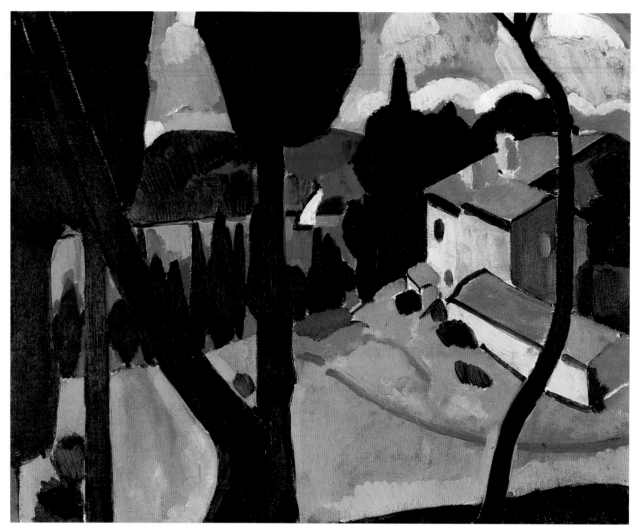

Plate 60

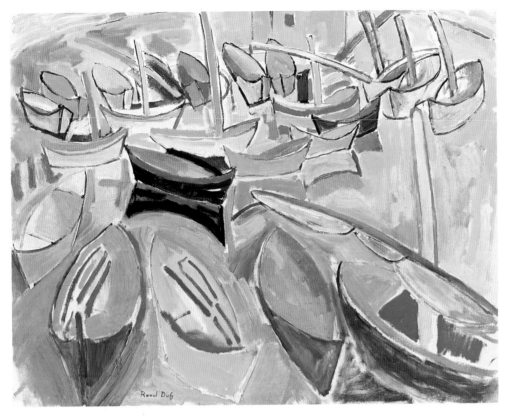

PLATE 61

PLATE 61
Raoul Dufy
Barques aux Martigues
(*Boats at Martigues*), 1907
Oil on canvas
25 ⅝ x 31 ⅞ in. (65.1 x 81 cm)
Arnold and Anne Gumowitz

PLATE 62
Raoul Dufy
Barques aux Martigues
(*Boats at Martigues*), 1907
Oil on canvas
21 ¾ x 25 ¼ in. (54 x 64.1 cm)
Fridart Foundation

PLATE 60
André Derain
La Baie de Martigues
(*The Bay of Martigues*), 1908
Oil on canvas
19 ¾ x 24 ¼ in.
(50.2 x 61.6 cm)
Private collection, courtesy
Barbara Divver Fine Art

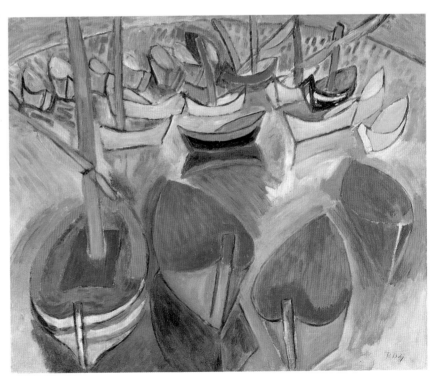

PLATE 62

Focusing on landscape painting within the Fauve period illuminates the inter-actions of the Fauve painters with both artistic tradition and with France itself. The French historian Fernand Braudel has perspicaciously written:

> What then, do we mean by the identity of France.... It is in sum a residue, an amalgam, a thing of additions and mixtures. It is a process, a self-inflicted conflict, destined to go on indefinitely.... A nation can have its *being* only at the price of being forever in search of itself, forever transforming itself in the direction of its logical development...it will recognize itself in a thousand touchstones, beliefs, ways of speech, excuses, in an unbounded subconscious, in the flowing together of many obscure currents, in a shared ideology, shared myths, shared fantasies.[35]

The Fauve artists sought a new way to approach nature—through their under-standing of traditional ways of depicting landscape, through their exploration of diverse terrains, and through their partnerships with one another. Theirs was a short-lived effort; after the first decade of the twentieth century, landscape was overshadowed by other artistic preoccupations.[36] Later generations of artists and critics have inexplicably segregated the Fauves' artistic techniques from their subjects, valuing the color that the Fauves used so adroitly rather than
the nature that had prompted its use. Now it is time to tip the
scales in the other direction, to see the *landscape*
in Fauve landscape painting as clearly
as we have seen the
painting.

*

PLATE 63
Maurice de Vlaminck
Les Baigneuses
(*The Bathers*), 1908
Oil on canvas
35 x 45 ⅝ in. (88.9 x 115.9 cm)
Mr. and Mrs. Robert A. Belfer

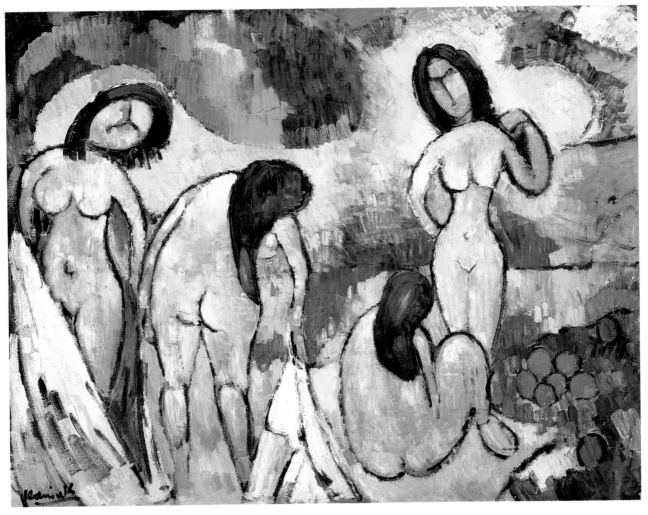

PLATE 63

Unless otherwise indicated, all translations are by the author and Catherine Cottet.

1. A cautionary note: the terms *Fauve* and *Fauvism* have multiple associations. Louis Vauxcelles's oft-quoted review, in which he referred to the work of the little-known sculptor Albert Marque—situated in a gallery dominated by the paintings of Matisse, Derain, and Vlaminck—as "Donatello among the wild beasts [*les fauves*]" and to Matisse as a Christian virgin before hostile audiences of "wild beasts [*fauves*]" (Louis Vauxcelles, "Le Salon d'Automne," *Gil Blas*, October 17, 1905), led, curiously, to adoption of the term by critics to refer to the artists loosely grouped together within the very large Salon d'Automne. The appellation stuck, and *Fauves* became the label of the group in the years immediately following the 1905 Salon. The artists accepted it—witness the use of "Les Fauves" as the title of an article by Michel Puy, Jean Puy's brother ("Les Fauves," *La Phalange*, November 15, 1907), and in 1929 by Matisse in an interview with E. Tériade ("Visite à Henri Matisse," *L'Intransigeant*, January 14 and 22, 1929).

The adjectives *Fauve* and *Fauvist* have evolved, through association with the noun, to describe paintings and artists using simplified, nature-based imagery and high-keyed, saturated color liberated from a fidelity to reality. The concept of "Fauvism" as a movement is symptomatic of the propensity of early twentieth-century writers on art to divide various artistic endeavors into neatly compartmentalized movements or "isms." My preference is to use the word *Fauve* as an adjective; to use *Fauves* when describing the group that was constituted by contemporary critics and to avoid the use of *Fauvism*, which implies a deliberately organized movement.

2. I disagree slightly with John Elderfield's rejection of friendship as a criterion used to establish the group. See John Elderfield, *The "Wild Beasts": Fauvism and Its Affinities*, exh. cat. (New York: Museum of Modern Art, 1976), p. 15. In a certain sense, Félix Vallotton could be considered just as much a Fauve as van Dongen, based on his personal association with members of the group.

3. See, for example, Ellen C. Oppler, *Fauvism Reexamined* (Ph.D. diss., Columbia University, 1969; New York: Garland Publishing, 1976), passim; and Elderfield, "*Wild Beasts*," especially p. 117.

4. The best examples of this occur in Oppler, *Fauvism Reexamined*; and in Elderfield, "*Wild Beasts*."

5. Vlaminck reportedly wore eccentric clothing, wooed women aggressively, and regularly made the rounds of the brothels in Paris.

6. Vlaminck, in Jean Leymarie, *Fauvism*, trans. James Eammons (Geneva: Skira, 1959), p. 41; for a related comment, see Maurice de Vlaminck, *Portraits avant décès* (Paris: Flammarion, 1943), pp. 12–13.

7. "J'ai turbiné avec Matisse et je crois qu'il ne me croyait pas en possession d'une science de la couleur, comme celle contenue dans le manuscrit que je t'ai lu.

"Il subit une crise, en ce moment, à propos de peinture. Mais, d'un autre côté c'est un type beaucoup plus extraordinaire que je ne l'aurais cru, au point de vue logique et spéculations psychologiques." Derain to Vlaminck, from Collioure, [summer 1905]; in André Derain, *Lettres à Vlaminck*, ed. Maurice de Vlaminck (Paris: Flammarion, 1955), p. 161.

8. "1. Une nouvelle conception de la lumière qui consiste en ceci: la négation de l'ombre. Ici, les lumières sont très fortes, les ombres très claires. L'ombre est tout un monde de clarté et de luminosité qui s'oppose à la lumière du soleil: ce qu'on appelle des reflets.

"Nous avions, jusqu'à présent, négligé cela tous les deux et, dans l'avenir, pour la composition, c'est un regain d'expression.

"2. Savoir, dans le voisinage de Matisse, extirper tout ce que la division du ton avait dans la peau. Il continua; mais moi, j'en suis complètement revenu et ne l'emploie presque plus. C'est logique dans un panneau lumineux et harmonieux. Mais cela nuit à ces choses qui tirent leur expression des inharmonies intentionnelles." Derain to Vlaminck, from Collioure, July 28, 1905; ibid., pp. 154–55.

9. Cézanne to Emile Zola, from Aix, c. October 19, 1866; in Paul Cézanne, *Letters*, ed. John Rewald, trans. Marguerite Kay (New York: Hacker Art Books, 1976), pp. 112–13.

10. There was a comparable change even in Monet's palette when he traveled to the Mediterranean coast to paint along the Côte d'Azur in 1883–84, and to Antibes in 1888.

11. I am grateful to John Klein, who discussed with me the patterns among Vlaminck's images. Klein also considers it noteworthy that, although both were regular customers, neither Vlaminck nor Derain ever painted the Restaurant Fournaise on the Ile de Chatou.

12. "Je voulais brûler avec mes cobalts et mes vermillons l'Ecole des Beaux-Arts et je voulais traduire mes sentiments sans songer à ce qui avait été peint.... la vie et moi, moi et la vie." Vlaminck, in Florent Fels, *Vlaminck* (Paris: Marcel Seheur, 1928), p. 39. On Vlaminck's anarchism and the politics of the other Fauves, see Oppler, *Fauvism Reexamined*, pp. 184–95.

For additional discussion of Vlaminck's background, see Maïthé Vallès-Bled, "Un Esprit libertaire," in *Vlaminck: Le Peintre et la critique*, exh. cat. (Chartres, France: Musée des Beaux-Arts, 1987), pp. 42–51; and John Klein, "New Lessons from the School of Chatou: Derain and Vlaminck in the Paris Suburbs," pp. 123–51 in this volume.

13. "Je retrouvais chez lui certaines de mes aspirations. Sans doute, de mêmes affinités nordiques? Et, en même temps qu'un sens révolutionnaire, un sentiment presque religieux de l'interprétation de la nature. Je sortis de cette rétrospective l'âme bouleversée." Vlaminck, *Portraits avant décès*, p. 31. "Ce jour-là, j'aimais mieux Van Gogh que mon père." Vlaminck, in *Les Cahiers d'aujourd'hui* (July–August 1922). For an important assessment of van Gogh's relation to Fauvism, see Niamh O'Laoghaire, "The Influence of van Gogh on Matisse, Derain, and Vlaminck, 1900–1910" (Ph.D. diss., University of Toronto, 1990). I am grateful to Ms. O'Laoghaire for generously sharing with me portions of her manuscript in advance of its completion.

14. Matisse, in E. Tériade, "Matisse Speaks," *Art News Annual* (New York), 1952, p. 43; in Jack D. Flam, ed., *Matisse on Art* (New York: E. P. Dutton, 1978), p. 132.

15. For a provocative discussion of this issue, see Richard Shiff, *Cézanne and the End of Impressionism: A Study of the Theory, Technique, and Critical Evaluation of Modern Art* (Chicago: University of Chicago Press, 1984), p. 57ff.

16. "Je crois que la peinture me rendra fou aussi je vais tâcher d'en sortir le plus tôt possible." Matisse to Manguin, from Saint-Tropez, [end of August–early September 1904], Jean-Pierre Manguin, Avignon, France.

17. Matisse, "Notes d'un peintre," *La Grande Revue*, December 25, 1908, pp. 733–34, 741–42; in Flam, *Matisse on Art*, pp. 35–36, 38.

18. Matisse, "Notes d'un peintre," pp. 735–36; in Flam, *Matisse on Art*, p. 36.

19. Landscape paintings that could be characterized as sublime *were* produced by minor artists in the Alpine areas of southeastern France and those working along the Pyrenees in the southwestern part of the country.

20. On Virgil and the origins of a pastoral Arcadia, see Paul Alpers, *The Singer of the Eclogues: A Study of the Virgilian Pastoral* (Berkeley and Los Angeles: University of California Press, 1979).

21. The best discussion of the pastoral landscape and its history is to be found in the exemplary catalog accompanying the exhibition *Places of Delight: The Pastoral Landscape*, Phillips Collection, Washington, D.C., 1988. I am indebted to Sir Lawrence Gowing, one of the organizers of this exhibition, for discussing this exhibition and its ramifications with me at length.

22. This myth was perpetuated by Joachim von Sandrart, a contemporary and biographer of Claude's; see Lawrence Gowing, "Nature and the Ideal in the Art of Claude [review of Marcel Röthlisberger's *Claude Lorrain: The Drawings*]," *Art Quarterly* 37 (Spring 1974): 91–97.

23. In Collioure, Matisse made numerous sketches *en plein air* on panels he placed in the top of his paint box; because of the intense heat and sun in Collioure, it was useful to adopt this small size, which enabled Matisse to make rapid sketches in situ. Only a few of these tiny panels survive. Pierre Matisse, interview with author, April 1989.

24. "Mais, surtout, c'est la lumière. Une lumière blonde, dorée qui supprime les ombres." Derain to Vlaminck, from Collioure, [summer 1905]; in Derain, *Lettres à Vlaminck*, p. 148.

25. "Ses [Turner's] figures n'ont nullement besoin d'être des figures. Elles ne prennent que l'importance d'une masse colorée qui soutient l'ensemble. On peut donc déduire dans Claude Lorrain une émotion majeure résultant de l'accord de sensations séparées." Derain to Matisse, from London, March 8, 1906, private collection.

26. "une bande d'oiseaux migrateurs." Louis Vauxcelles, "Le Salon d'Automne," *Gil Blas*, October 17, 1905.

27. "Il est chouette ton soleil du midi!... Lorsque tu viendras, tâche d'amener le beau temps. Il y a aussi de merveilleux paysages à faire." Marquet to Camoin, from Saint-Tropez, 1905; in Danièle Giraudy, *Camoin: Sa Vie, son oeuvre* (Marseille: "La Savoisienne," 1972), p. 98.

28. Manguin to Matisse, from La Percaillerie, August 17, 1904, Jean-Pierre Manguin, Avignon, France.

29. Monet to Paul Durand-Ruel, letter nos. 701 and 1280; in Daniel Wildenstein, *Monet, biographie et catalogue raisonné*, 4 vols. (Lausanne and Paris: La Bibliothèque des Arts, 1974), vol. 1, p. 27, and vol. 2, p. 283.

30. Robert L. Herbert, *Impressionism: Art, Leisure, and Parisian Society* (New Haven, Conn., and London: Yale University Press, 1988), pp. 286–99.

31. An excellent example is Dufy's *Effet de soleil sur l'eau à Sainte-Adresse (Effect of Sunlight on the Water at Sainte-Adresse)*, 1906 (Statens Museum for Kunst, Copenhagen).

32. "Cependant, je me sens m'orienter vers quelque chose de meilleur où le pittoresque compterait moins que l'année dernière pour ne soigner que la question peinture.
"Vraiment, nous sommes à un degré du problème qui est bien ardu. Je suis tellement perdu que je me demande par quels mots je vais te l'expliquer.... Si l'on ne fait des applications décoratives, la tendance que l'on peut, seule, avoir est de purifier de plus en plus cette transposition de la nature. Or, nous ne l'avons fait intentionnellement, jusqu'ici, que pour la couleur.... Il y a bien des choses qui nous manquent dans la conception générale de notre art....
"Je ne vois pas du tout l'avenir pour être en accord avec nos tendances: d'une part, nous cherchons à nous dégager de choses objectives et, d'autre part, nous les gardons comme cause et comme fin. Non, à vrai dire..., je ne vois pas du tout ce que je dois faire pour être logique....
"Je crois que le problème est plutôt de grouper des formes dans la lumière et de les harmoniser concurremment à la matière dont on dispose." Derain to Vlaminck, from L'Estaque, [summer 1906]; in Derain, *Lettres à Vlaminck*, pp. 146–47.

33. The organization of Gauguin's *Blue Trees*, autumn 1888 (Ordrupgaard Collection, Copenhagen), resembles that of Derain's L'Estaque paintings, although the radical innovations in color present in Gauguin's Tahitian work are not evident in this painting made at Arles.

34. See William Rubin, "Cézannisme and the Beginnings of Cubism," in New York, Museum of Modern Art, *Cézanne: The Late Work*, exh. cat., 1977, pp. 151–202; and New York, Museum of Modern Art, *Picasso and Braque: Pioneering Cubism*, exh. cat., 1989.

35. Fernand Braudel, *The Identity of France*, trans. Siân Reynolds (New York: Harper and Row, 1988), vol. 1, *History and Environment*, p. 23.

36. Sir Kenneth Clark observed: "The microscope and telescope have so greatly enlarged the range of our vision that the snug, sensible nature which we can see with our own eyes has ceased to satisfy our imaginations. We know that by our new standards of measurement the most extensive landscape is practically the same as the hole through which the burrowing ant escapes from our sight." Kenneth Clark, *Landscape into Painting* (New York: Harper and Row, 1950), p. 140.

Map of Paris, 1906

Documentary *chronology, 1904–1908*

JUDI FREEMAN

All events not associated with a particular day, month, or season are placed at the beginning of the year. Unless otherwise noted, all exhibitions took place in Paris, and all other events took place in France. Francs are converted by using the average exchange rate of the period: 4.9 francs equaled 1 dollar.

At the start of 1904 Henri Matisse is living in his fifth-floor studio at 19, quai Saint-Michel, Paris, where he has been living since 1899. Matisse later recalled: "I had two windows which looked straight down from the fifth floor on to the channels of the Seine. A fine view: on the right Notre-Dame, on the left the Louvre, the Préfecture [of Police] and the Palais de Justice opposite. On Sunday mornings there was always terrific activity on the *quai*; barges were moored there, fishermen came and planted their little rods, people browsed in the boxes on the bookstalls. It was the real heart of Paris." [1]

Maurice de Vlaminck is resident in his native Chatou, painting landscapes along the banks of the Seine. André Derain is doing his military service in eastern France. Prior to Derain's departure, they had leased a studio at 7, place de l'Hôtel de Ville, Chatou. Albert Marquet resides in Paris, although exactly where is unclear. He may have been living at 38, rue Monge or 25, quai de la Tournelle— both addresses appear in Ambroise Vollard's address book. By February he is living at 211 bis, avenue de Versailles. Henri Manguin and Jean Puy are also living in Paris (at 61, rue Boursault and 69, rue Lepic, respectively). Georges Braque is studying in the city, living at 48, rue d'Orsel. Raoul Dufy and Othon Friesz are dividing their time between Paris and Le Havre. When in Paris, Friesz is living at 86, rue de Sèvres (by early February he moves to 15, place Dauphine), and Dufy resides at 31, quai Bourbon. Charles Camoin is living at 3, rue des Pyramides, and Louis Valtat resides on the rue Girardon.

20-franc coin, 1907
Designed by J. C. Chaplain

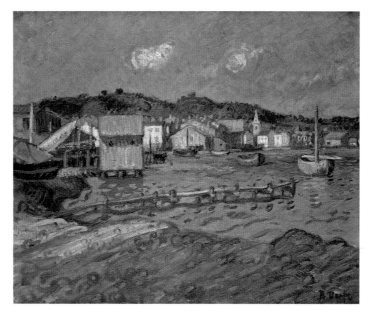

PLATE 64

PLATE 64
Raoul Dufy
Le Port de Martigues
(*The Port of Martigues*), 1904
Oil on canvas
18 ⅛ x 21 ⅝ in. (46 x 55 cm)
Musée Cantini, Marseille

Wilhelm Uhde, c. 1906

Ambroise Vollard

1904
Camoin and Marquet travel together to Marseille and Cassis.

Dufy is in Marseille and Martigues.

The German dealer Wilhelm Uhde settles in Paris.

1904 BEGINNING OF THE YEAR
Valtat visits the painter Paul Signac in Saint-Tropez.

1904 JANUARY 20–FEBRUARY 20
Paintings, pastels, and watercolors by Dufy (seven), P. Duparque, R. Juste, and Ev. Torent, Galerie Berthe Weill. Catalog text by Laurent Tailhade.

Weill had opened her gallery at 25, rue Victor-Massé on December 1, 1901.

1904 JANUARY 31
Puy writes to Manguin that he is hoping they will work together for a week, starting next Tuesday.[2]

1904 FEBRUARY
Fifty paintings and approximately the same number of drawings by Paul Gauguin, Galerie Vollard, 6, rue Laffitte.

Vollard had been a dealer since about 1893 and had had a gallery at 6, rue Laffitte since about 1895.

1904 FEBRUARY 17–27
Forty-six works by Emile Bernard, Bernheim-Jeune, 8, rue Laffitte, second floor (established 1863).

1904 FEBRUARY 21–MARCH 24
Twentieth Salon des Indépendants, Grandes Serres, Grand Palais. Among the 2,395 works in the exhibition are those by Camoin (six), Kees van Dongen (six), Dufy (six), Friesz (five), Pierre Girieud (six), Manguin (six), Marquet (five), Matisse (six), Jean Metzinger (six), Puy (six), Félix Vallotton (six), and Valtat (three). A special exhibition of Paul Cézanne's work includes thirty paintings, two drawings, and photographs of at least twenty-seven other works.

This Salon, organized by the Société des Artistes Indépendants, accepted all entries without restriction; the official policy stated, "The Society of Independent Artists, based on the suppression of admission juries, has as its goal to permit artists to freely represent their works for the judgment of the public."[3] Participants who paid a nominal entrance fee could exhibit at least two works of art. Matisse had been on the hanging committee since 1903; Manguin and Marquet joined the committee in 1904.

SOCIÉTÉ DES ARTISTES INDÉPENDANTS

CATALOGVE DE LA 20ME EXPOSITION 1904

Octave Maus

1904 FEBRUARY 25–MARCH 29
Peintres Impressionnistes, eleventh exhibition of La Libre Esthétique, Brussels, includes works by Valtat (three) and artists of the Impressionist and Post-Impressionist generations. Catalog by Octave Maus.

La Libre Esthétique had been established in 1893 by Maus, an amateur painter and attorney at the appeals court in Brussels, as the successor to the Belgian group of avant-garde artists, Les XX.

1904 MARCH 3–31
Jules Chéret, Paul Helleu, Félix Nadar, Théophile Steinlen, Henri de Toulouse-Lautrec, and others, Galerie Berthe Weill.

1904 MARCH 12–26
Two hundred drawings by Maximilien Luce, Galerie Druet. Catalog by Félix Fénéon.

Francis Jourdain

Eugène Druet, whose gallery at 114, Faubourg Saint-Honoré had opened earlier this year as an outgrowth of his work as a photographer of art, was to become a prominent dealer for the Fauves. The painter Francis Jourdain (son of Frantz Jourdain, a founder of the Salon des Indépendants and architect of the department store La Samaritaine) recalled: "The painters in charge of picture hanging [at the Salon des Indépendants] would stop off [at Druet's] for a beer after work, with the members of the committee. Thus it came about that the proprietor [Druet] became the customer of his own customers." [4]

1904 MARCH 15–25
Forty-three works by René Seyssaud, Bernheim-Jeune.

1904 APRIL
Accompanied by his friend Sebastián Junyer Vidal, Pablo Picasso moves to Paris, to a building nicknamed the Bateau-Lavoir (floating laundry) at 13, rue Ravignan, facing the place Emile-Goudeau. He takes the top-floor apartment vacated by Paco Durio, a Spanish sculptor, and lives there intermittently through 1909. Monthly rent averages about 450 francs ($91.84).

Bateau-Lavoir, photograph inscribed by Pablo Picasso "Windows of my studio, 13 rue Ravignan"

1904 APRIL 2–30
Camoin (seven), Manguin (eight), Marquet (six), Raoul de Mathan, Matisse (six), and Puy (eight), Galerie Berthe Weill. Catalog text by Roger Marx, in which he identifies them as a group in which most members had studied in Gustave Moreau's studio.

1904 APRIL 8–18
Pierre Bonnard, Maurice Denis, Aristide Maillol, Ker-Xavier Roussel, Vallotton, and Edouard Vuillard, Bernheim-Jeune.

1904 APRIL 13
Matisse begins copying Raphael's *Portrait de Balthazar Castiglione* at the Louvre.[5] Manguin had registered on March 15 to paint Titian's *Portrait of a Man*, and Marquet had registered on April 5 to copy Jean-Baptiste-Siméon Chardin's *House of Cards*.[6] The critic Louis Vauxcelles encounters the three of them at the Louvre and describes the encounter in an article in *Gil Blas* on May 4.

1904 APRIL 17–JUNE 30
Fourteenth Salon of the Société Nationale des Beaux-Arts, Grand Palais. Among the artists included are Léon Bakst, Emile-Antoine Bourdelle, Patrick Henry Bruce, Eugène Carrière, Jean Delville, Denis, Charles Despiau, George Desvallières, Raymond Duchamp-Villon, Pierre Laprade, Alfred Maurer, Constantin Meunier, Auguste Rodin, Georges Rouault, Jacques Villon, and James McNeill Whistler.

The Société was an organization of relatively conservative, academic painters founded by Pierre Puvis de Chavannes and Ernest Meissonier as a splinter group of the Société des Artistes Français.

1904 APRIL 20–MAY 15
Forty-six paintings by Friesz, Galerie des Collectionneurs (owned by L. Soullié), 338, rue Saint-Honoré.

1904 MAY 1
One hundred twenty-second Salon of the Société des Artistes Français opens,

PLATE 65

Henri Matisse in his studio with *The Serf*, c. 1904

PLATE 65
Henri Matisse
Balthazar Castiglione, 1904
Oil on canvas
32 5/16 x 26 3/8 in. (82 x 67 cm)
Musée de Bagnols-sur-Cèze,
Bagnols-sur-Cèze, France

Grand Palais.

The Société, founded in 1772, was a conservative organization of academic artists aligned with Adolphe-William Bouguereau.

1904 MAY 9–JUNE 4
Thirty-seven views of the Thames by Claude Monet, Galeries Durand-Ruel (founded in the mid-nineteenth century), 16, rue Laffitte and 11, rue Le Peletier. Catalog text by Octave Mirbeau.

1904 JUNE 1–10
Walter Sickert, Bernheim-Jeune. Catalog text by Jacques-Emile Blanche.

1904 JUNE 1–18
Forty-five paintings and one drawing by Matisse, Galerie Vollard. Catalog text by Roger Marx.

Matisse had known Vollard since 1899, when the artist had bought a painting of bathers by Cézanne and a sculpture by Rodin and traded one of his own paintings for a portrait by Gauguin. The exhibition, which is Ma-

tisse's first one-man show, is largely unsuccessful. Shortly afterward, however, Vollard purchases one of the exhibited works, *La Desserte* (*The Sideboard*, 1897, plate 67). Charles Morice writes: "M. Matisse's painting reveals a delight in color and tone and in the relationships between them, but these relationships are important only in themselves. This artist certainly has a taste, even a passion, for his medium; but perhaps not a complete sense of his art." [7]

1904 JUNE 10
Mathan writes to Manguin that he had seen the Matisse exhibition at Vollard's gallery and that it "made a very good impression on me." [8]

1904 BY JUNE 10–OCTOBER 13
Manguin and his family are in La Percaillerie, at the tip of Cotentin (Manche) in Normandy, where he and fellow artist Mathan had spent the summer of 1896.

1904 PROBABLY LATE SPRING–SUMMER
Marquet and Dufy paint together in Fécamp.

1904 LATE JUNE
Manguin writes to Matisse that he has heard from Marquet that Matisse was not very happy with his exhibition at Vollard's. [9]

1904 SUMMER
Braque leaves Paris and vacations in Brittany and Normandy. He spends a little time in Le Pouldu, near Pont-Aven, where Gauguin and his circle had painted.

Camoin visits Naples and Capri.

1904 ABOUT JULY
French Primitives, Pavillon Marsan, Palais du Louvre, Paris.

1904 EARLY JULY
Marquet, in Paris, does not paint landscapes, despite good weather. Instead, he works on illustrations for Charles-Louis Philippe's *Bubu de Montparnasse* so it can be published by October. [10]

PLATE 66
Henri Matisse
Notre Dame, c. 1904
Oil on board
11 ¾ x 12 ¹³⁄₁₆ in.
(29.9 x 32.5 cm)
Private collection, Paris

PLATE 67
Henri Matisse
La Desserte
(*The Sideboard*), 1897
Also known as *The Dinner Table*
Oil on canvas
39 ⅜ x 51 ⁹⁄₁₆ in. (100 x 131 cm)
Private collection

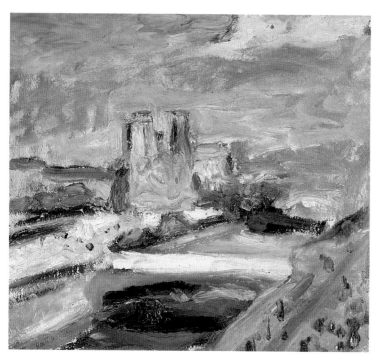

PLATE 66

Saint-Tropez

Paul Signac, c. 1907

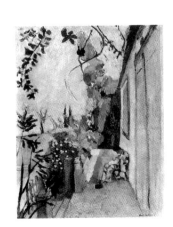

PLATE 68

1904 JULY 7
The Divisionist painter Henri-Edmond Cross writes to the painter Charles Angrand: "I went this morning to the show of French primitives.... What a marvelous and transporting art! The difficult problem of transposing the real on the imaginary is resolved here, and by such simple means...." [11]

1904 JULY 12–LATE SEPTEMBER
Matisse, his wife, Amélie, and his son Pierre spend the summer with the Signacs (at the Signacs' suggestion) at their villa in Saint-Tropez. [12] Matisse had met Signac earlier that year in Paris. Originally Marquet was to accompany the Matisses, but he did not have sufficient funds and he had begun to make the illustrations for *Bubu de Montparnasse.*

Matisse does not paint Pointillist works in Saint-Tropez, which displeases Signac, the leading practitioner and advocate of the Pointillist style. He especially dislikes Matisse's painting *La Terrasse, Saint-Tropez* (*The Terrace, Saint-Tropez*, plate 68), which depicts Signac's boathouse and Mme Matisse in a kimono. Matisse is reportedly so disturbed by Signac's criticism that he goes for a walk with his wife and son, during which he paints *Le Goûter* (*Golfe de Saint-Tropez*) (*Midday Snack* [*Gulf of Saint-Tropez*], plate 163), one of the first studies for *Luxe, calme, et volupté* (plate 175). [13]

Toward the end of his stay Matisse, extremely low on funds, is eager to sell the copy of *Balthazar Castiglione* (plate 65) that he had executed that spring. Cross, who sees Matisse and Signac toward the end of Matisse's visit, characterizes him as "Matisse the anxious one, the madly anxious one." [14]

1904 MID-JULY–EARLY SEPTEMBER
Weill vacations in Le Havre and Sainte-Adresse; Dufy takes her to visit Trouville.

1904 JULY 16
Marquet writes to Manguin that Manguin's painting (*La Baigneuse, Jeanne* [*The Bather, Jeanne*], 1904, private collection, France), exhibited at the 1904 Salon des Indépendants, has been accepted for ac-

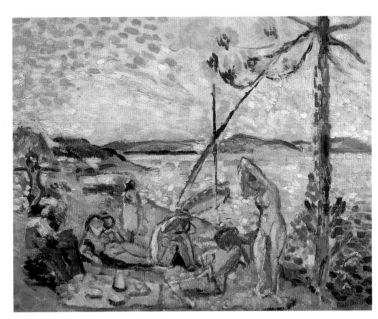

PLATE 69

quisition by the state. He mentions that the critic Roger Marx, representing the state, has not yet seen Matisse's painting (*Balthazar Castiglione*, plate 65). [15]

1904 AUGUST 8
Marquet writes to Manguin that he has received "distressing letters" from Matisse in Saint-Tropez. No doubt these letters refer to the often heated debates between Matisse and Signac. [16]

1904 AUGUST 17
Manguin writes a long letter to Matisse bemoaning the incessantly changeable weather in Normandy, which makes it difficult to paint landscape studies. He envies Matisse the sun that he is no doubt enjoying in Saint-Tropez. He also mentions that Marquet has reported that the Salon d'Automne promises to be splendid. [17]

1904 EARLY SEPTEMBER
Matisse writes to Manguin describing the intense heat and how difficult it has been to work. He has been able to complete only one painting, "done at sunset and that satisfies me somewhat and even then I cannot imagine that I created it, although I worked at it for a dozen sit-

PLATE 68
Henri Matisse
La Terrasse, Saint-Tropez
(*The Terrace, Saint-Tropez*),
1904
Oil on canvas
28 ¾ x 22 ¾ in. (73 x 57.8 cm)
Isabella Stewart Gardner
Museum, Boston, gift of
Thomas Whittemore

PLATE 69
Henri Matisse
Composition, Etude pour "Luxe, calme, et volupté"
(*Composition, Study for "Luxe, calme, et volupté"*),
summer 1904
Oil on canvas
12 ¾ x 16 in. (32.4 x 40.6 cm)
Mrs. John Hay Whitney

tings, it seems to me that it was by chance that I got [this] result." Matisse may be referring to *Le Goûter* (*Golfe de Saint-Tropez*, plate 163); he does not mention *La Terrasse, Saint-Tropez* (plate 68).

In the same letter Matisse worries that painting may drive him crazy and acknowledges that he is never happy with the results. He also mentions that he is sketching the owner of a café in Saint-Tropez.[18]

Matisse also writes to Marquet that he is running low on funds. He mentions visiting Agay and Menton. He says that he has made six paintings of "20 format" (21 ¼ by 28 ¾ inches [54 by 73 centimeters]). He compares the personalities of Cross and Signac; he wishes he had spent more time with Cross. He asks Marquet to purchase a copy of *L'Occident* from July 1904 because he has borrowed Signac's copy. The issue contains Bernard's article on Cézanne: "Cézanne's own words 'Organize one's sensations'—'Model' and 'Don't model.' You can cut this out to read it—It's very interesting."[19]

1904 SEPTEMBER 8
Marquet writes to Manguin that the summer weather in Paris has been marvelous. His illustrations for *Bubu de Montparnasse* had been rejected by the publisher, who chose another illustrator. In a postscript Marquet refers to "the captain of cuddling" (probably Puy), who has returned to Paris after wonderful summer travels through Brittany, during which he produced a substantial body of work.[20]

1904 EARLY AUTUMN
Matisse begins work on the final version of *Luxe, calme, et volupté* (plate 175), using a title inspired by Charles Baudelaire's poem "L'Invitation au voyage" ("Invitation to the Voyage"):

> There, all is nothing but order and beauty,
> Luxury [extravagance], calm, and voluptuousness.[21]

The painting is completed in the winter of 1905.

1904 AUTUMN
Amélie Matisse visits Collioure, con-

Henri and Amélie Matisse, after 1912

templating a future stay there with her family.[22]

1904 AFTER SEPTEMBER
Derain completes his three years of military service, chiefly stationed in Commercy, and returns to Chatou, where he and Vlaminck resume their work together. (Derain and Vlaminck had first met on a train from Paris in 1900.) Shortly after his return Derain takes up residence in his studio at 7, place de l'Hôtel de Ville, Chatou. According to Vlaminck, Derain is "full of energy and of hope." Derain decides to frequent the Académie Julian in Paris, despite Vlaminck's disdain for it.[23] Derain begins to make paintings, often in Vlaminck's company, in Chatou, Le Pecq, Montesson, and Marly-le-Roi, all northwestern suburbs of Paris along the Seine.

During the autumn Derain becomes friendly with the poet and critic Guillaume Apollinaire, who is living nearby at Le Vésinet. Derain also visits the Musée d'Ethnographie du Trocadéro (now the Musée de l'Homme) in Paris.

1904 OCTOBER
Friesz moves to 18, impasse du Maine.

Picasso and Fernande Olivier (whose accounts of this period are one of the essential sources for our knowledge of it) move in together. Picasso remains with Olivier intermittently for the next seven years.

1904 OCTOBER 1
Having received a letter dated September 22 from Roger Marx, declaring that the state wants to purchase *Balthazar Castiglione* (plate 65), Matisse writes to him and accepts the offer of 300 francs ($61.22).[24]

1904 OCTOBER 4
Manguin writes to Marquet from Saint-Tropez, after visiting Marseille. He has found the Villa Demière (in Malleribes, near Saint-Tropez) and is enthusiastic about staying there, presumably the next year. "It is ideal," he declares.[25]

The bridge at Chatou

PLATE 70
André Derain
Paysage, la pluie de Chatou
(*Landscape, Rain at Chatou*),
1904
Oil on canvas
16 ⅛ x 13 in. (41 x 33 cm)
Private collection

PLATE 71
Maurice de Vlaminck
L'Etang de Saint-Cucufa
(*The Pond at Saint-Cucufa*),
c. 1904
Oil on canvas
21 ¼ x 25 ⁹⁄₁₆ in. (54 x 65 cm)
Former collection of
Boris Fize

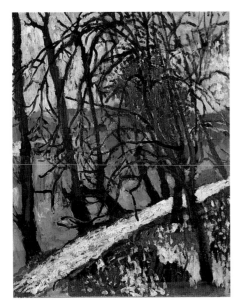

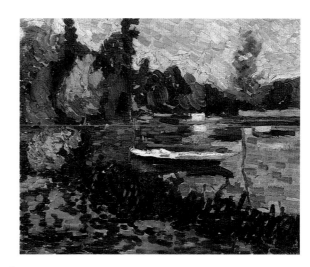

PLATE 70

PLATE 71

Gertrude Stein, c. 1906

Leo Stein, 1905

1904 ABOUT OCTOBER 13
The Manguins resume residency in Paris.

1904 OCTOBER 15–NOVEMBER 15
Second Salon d'Automne of the Société du Salon d'Automne, Petit Palais. Includes 1,317 paintings and sculptures by 324 artists. Individual galleries are devoted to Cézanne (forty-two), Puvis de Chavannes (forty-three paintings, drawings, pastels, cartoons, and caricatures), Odilon Redon, Pierre-Auguste Renoir, and Toulouse-Lautrec. Also represented are Camoin (seven), Robert Delaunay (one), van Dongen (two), Friesz (four), Girieud (two), Wassily Kandinsky (nine watercolors and nine prints), Marquet (ten), Matisse (thirteen paintings and two sculptures, all made before his summer in Saint-Tropez), Metzinger (three), Francis Picabia (three), Puy (five), Rouault (forty-four), Seyssaud (seven), Vallotton (three), Valtat (three), and others. The state purchases paintings by Camoin, Marquet, and Matisse. This is the first year that the Salon includes photography.

In the press coverage of the Salon considerable discussion is devoted to the rapidly ascending prices for art and the high prices paid by American collectors for "mediocre" paintings.[26]

At the Salon d'Automne, Matisse begins to hyphenate his name, Henri-Matisse, in order to distinguish himself from the painter Auguste Matisse.

1904 AFTER OCTOBER 15
Leo Stein, who had moved to Paris in 1902 and is living with his sister Gertrude at 27, rue de Fleurus, looks "again and again at every picture" at the Salon d'Automne and finds that Matisse's work makes a strong impression, "though not the most agreeable."[27]

1904 OCTOBER 17
Cross writes to Angrand that he has recently found "real pleasure in installing myself in front of nature and painting directly."[28]

1904 OCTOBER 24–NOVEMBER 20
Paintings, watercolors, and drawings by Dufy (eleven), Girieud (six), Picabia (three), Picasso (twelve works from 1901–4), and others, Galerie Berthe Weill. Catalog text by Maurice Le Sieutre.

1904 NOVEMBER 15–25
One hundred five paintings and twenty drawings by van Dongen, Galerie Vollard. Catalog text by Fénéon.

1904 NOVEMBER 22–DECEMBER 10
Eighty-five works by Denis, Galerie

Druet. Catalog text by André Gide.

1904 EARLY DECEMBER
Camoin writes to Cézanne from Martigues, requesting permission to visit him in Aix-en-Provence. Cézanne, responding on December 9, invites him to have lunch at his studio. Cézanne encourages Camoin to respond to influences that interest him.[29]

1904 DECEMBER 14
Manguin writes to the critic and historian Elie Faure, indicating that he will attend the banquet for the painter and teacher Eugène Carrière, as will Mme Matisse, Marquet, and the painter Albert Braut.[30]

1904 DECEMBER 17–31
Signac, Galerie Druet.

1904 DECEMBER 19
The *assemblée générale* (general assembly) meets to elect the members of the jury for the next Salon des Indépendants. In a letter of December 1 the painter René Piot had urged Manguin to bring all of his friends and colleagues so that all would be represented.[31] Piot is friendly with Manguin, Marquet, Matisse, and Puy.

1904–5 WINTER
Manguin, Marquet, Matisse, and Puy paint companion paintings in Manguin's Paris studio (plates 72–75).

1905
The German artist Hans Purrmann, who becomes one of Matisse's principal students in 1908, arrives in Paris.

Vollard purchases from Puy all the work he has available.

1905 JANUARY 16–FEBRUARY 15
Van Dongen (eight) and others, Galerie Berthe Weill. Catalog text signed by "Place aux 'Jeunes.'"

1905 BEFORE FEBRUARY
Derain invites Matisse (whom he has known since 1899 from their student days together in Carrière's class) to visit him and Vlaminck in Chatou. Matisse

visits the two artists and convinces them to exhibit at the Salon des Indépendants.

Derain had introduced Matisse to Vlaminck in March 1901, during the van Gogh retrospective at Bernheim-Jeune. Matisse visited the two soon afterward in their studio in the former Restaurant Levanneur alongside the Pont de Chatou, but he has not seen much of them since. Matisse described his visit: "I went to Chatou two or three times to see Derain and one day he took me to see his friend. Vlaminck insisted on absolutely pure colors, on a vermilion that was absolutely vermilion, which obliged him to intensify the other parts of the painting accordingly."[32] Matisse reacted strongly to Vlaminck's work: "I was unsettled, I was not able to sleep that night."[33]

1905 FEBRUARY
Matisse introduces Vollard to Derain; Vollard purchases the entire contents of Derain's Chatou studio and signs him to a contract.

1905 FEBRUARY 2–18
Paintings and drawings by Berthe Morisot, Galerie Druet.

1905 FEBRUARY 10–25
First exhibition of the Ensemble d'Intimistes (Peintres d'Intérieurs) (Group of Intimist Painters [Painters of Interiors]), Galeries Henry Graves, 18, rue de Caumartin, includes Bonnard, Laprade, Matisse, and Vuillard.

Picabia, Galerie Haussmann, 67, boulevard Haussmann. Catalog text by L. Roger-Milès.

1905 FEBRUARY 21–MARCH 24
Twelfth exhibition of La Libre Esthétique, Brussels, includes James Ensor, Henri Evenepoel, Georges Lemmen, Emil Nolde, Jan Toorop, and others. Catalog by Maus.

1905 FEBRUARY 25–MARCH 6
Auguste Gérardin, Picasso, and Albert Trachsel, Galeries Serrurier, 27, boulevard Haussmann. Catalog texts by Morice and Pierre-Paul Plan. Picasso ex-

Paul Cézanne near Aix-en-Provence, 1904

Hans Purrmann

PLATE 72

PLATE 73

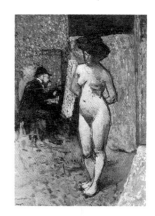

PLATE 74

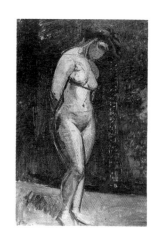

PLATE 75

PLATE 72
Henri Manguin
L'Atelier, le modèle nu
(*The Studio, the Nude Model*),
1904–5
Oil on canvas
25 9/16 x 21 1/4 in. (65 x 54 cm)
Private collection

PLATE 73
Henri Matisse
Nu dans l'atelier
(*Nude in the Studio*), 1904–5
Oil on canvas
35 13/16 x 28 3/8 in. (91 x 72 cm)
Musée National d'Art
Moderne, Centre Georges
Pompidou, Paris

PLATE 74
Albert Marquet
*Matisse peignant dans l'atelier
de Manguin*
(*Matisse Painting in Manguin's
Studio*), 1904–5
Oil on canvas
28 1/8 x 39 3/8 in. (71.5 x 100 cm)
Musée National d'Art
Moderne, Centre Georges
Pompidou, Paris

PLATE 75
Jean Puy
Grand Nu fauve
(*Large Fauve Nude*), 1904–5
Oil on paper mounted
on panel
40 3/4 x 28 5/16 in.
(103.5 x 72 cm)
Private collection, Roanne,
France

hibits thirty-three works plus prints; among these are eight harlequin and saltimbanque paintings and the earliest Rose period paintings.

1905 FEBRUARY 25–MARCH 25
Watercolors, drawings, and paintings by van Dongen (ten), Dufy (five), and others, Galerie Berthe Weill.

1905 MARCH
The first issue is published of *Vers et prose*, the Symbolist journal founded by the poet Paul Fort and launched at the café Closerie des Lilas, on boulevard Montparnasse. Matisse is among the subscribers. Evenings sponsored by the journal would be held on Tuesdays at the Closerie des Lilas.

Camoin is living at 13, carrefour de l'Odéon. Friesz is back at 15, place Dauphine. Marquet resides at 25, quai des Grands-Augustins, not far from Matisse; Puy is at 56, avenue de Clichy. Vlaminck is now at 21, boulevard des Ormes in Rueil.

1905 MARCH 7
Vollard writes to Marquet, offering him 1,000 francs ($204.08) for six canvases, without frames.[34]

1905 MARCH 10–25
Seyssaud, Bernheim-Jeune.

1905 MARCH 21–APRIL 8
Thirty paintings and thirty watercolors by Cross, Galerie Druet. Catalog text by Emile Verhaeren.

1905 BEFORE MARCH 24
As they are delivering their work to the Salon des Indépendants, Derain and Vlaminck meet Signac for the first time.

1905 MARCH 24–APRIL 30
Twenty-first Salon des Indépendants, Grandes Serres, Grand Palais. Among the 4,269 works by 669 artists are included retrospectives of work by Georges Seurat (serre B) and Vincent van Gogh (serre A). Matisse lends one of his van Gogh drawings (probably *Hayricks*, Faille no. 1427) to the retrospective, which includes forty-five paintings

and drawings. The Seurat retrospective, with forty-three paintings and drawings, includes *Sunday Afternoon on the Island of the Grande Jatte* (1884–86, Art Institute of Chicago) and *The Circus* (1890–91, Musée d'Orsay, Paris). Henri Rousseau exhibits three paintings, including a jungle picture and *The Wedding* (1904–5, Musée de l'Orangerie, Paris; Collection Jean Walter–Paul Guillaume). Cézanne is represented with ten paintings.

Among the Fauves and the artists associated with them the following artists participate: Camoin (seven), Delaunay (eight), Derain (eight), Desvallières (seven), van Dongen (seven), Dufy (eight), Friesz (eight), Girieud (one), Manguin (eight), Marquet (eight), Matisse (eight, including *Luxe, calme, et volupté* [plate 175]), Metzinger (eight), Puy (eight), Rouault (eight), Valtat (three), and Vlaminck (eight).

Matisse is *secrétaire adjoint* and Signac serves as one of the vice presidents of the Salon. Supported by Signac, Matisse is placed in charge of the hanging committee, assisted by Bonnard, Camoin, Laprade, Luce, Manguin, Marquet, Metzinger, Puy, and Vallotton. Purchases worth 81,000 francs ($16,530) are made by the state, the city, and individuals. Leo Stein buys a Vallotton and a Manguin (no. 2648). The state buys Matisse's *Vue de Saint-Tropez* (*View of Saint-Tropez*, 1904, plate 160) and Marquet's *Notre Dame* (*Soleil*) (*Notre Dame* [*Sun*], 1904, plate 258). Derain sells four of the eight paintings he exhibits. Three of them—no. 1199, *Le Vieil Arbre* (*The Old Tree*, 1904, Musée National d'Art Moderne, Centre Georges Pompidou, Paris); no. 1195, *Solitude* (Musée National d'Art Moderne, Centre Georges Pompidou, Paris); and no. 1197, *La Pluie* (*Rain*, location unknown)—are sold to the Russian Ivan Morosov, for 150 francs ($30.61) each. Vlaminck sells *Les Bords de la Seine à Nanterre* (*The Banks of the Seine at Nanterre*, 1905), for 100 francs ($20.41). According to Vlaminck, a man from Le Havre (Ernest Siegfried) who hated modern paintings bought paintings by Derain and Vlaminck, choosing only those that were "the most

At a café near the Salon des Indépendants (left to right): Claude Manguin, Francis Jourdain, Alcide Lebeau, Albert Marquet, Henri Manguin, c. 1905

eccentric and the most ugly in order to give them as gifts to his son-in-law (Olivier Senn)." [35] Camoin, van Dongen, and Manguin sell paintings for 150 francs ($30.61) each.

In his review Denis criticizes Matisse's work as "the demonstration of a theory." [36] Morice complains: "The group of Pointillists and Confettiists is not growing smaller. On the contrary, it is receiving new adherents, some of whom, like M. Henri Matisse, count.... M. Matisse is ill inspired in bringing his talent to a group which is already abundant in it." [37]

Dufy is awestruck by Matisse's *Luxe, calme, et volupté;* he later recalled that it was in front of this painting that he understood "all the new reasons for painting.... I understood instantly the new pictorial mechanics." [38]

1905 APRIL 6
Camoin, Marquet, and Matisse attend a dinner for Rodin held at the Closerie des Lilas. The painter Henri Lebasque invites Manguin, promising that the evening's discussion will concern the Salon des Indépendants. [39]

1905 APRIL 6–29
Camoin (one), Manguin (seven), Marquet (five), Matisse (six), and others, Galerie Berthe Weill.

Weill states, "It is Camoin who is leading at the moment in terms of sales, with Marquet in second place." [40]

1905 APRIL 15–JUNE 30
Fifteenth Salon of the Société Nationale des Beaux-Arts, Grand Palais. Bernard, Bourdelle, Carrière, Denis, Despiau, Meunier, Rodin, and others.

1905 MAY 1
Following Leo Stein's purchase of one of his paintings at the Salon des Indépendants, Manguin meets Leo and Gertrude Stein at their apartment. [41]

One hundred twenty-third Salon of the Société des Artistes Français opens, Grand Palais.

Stein apartment at 27, rue de Fleurus

1905 MAY 2–23
Henri Le Fauconnier and others, Galerie de l'Indépendance Artistique, 20, rue Le Peletier. Catalog text by Georges Bonnamour.

1905 MAY 12
Marquet leaves Paris for the Côte d'Azur, traveling via Marseille (to enjoy some bouillabaisse and to explore the women on the "rue Pavé d'Amour"). He hopes to be in Saint-Tropez by May 14. [42]

1905 MAY 12–JUNE 10
Paintings and pastels by Friesz (twelve), Paul Ranson, and others, Galerie Berthe Weill.

1905 MAY 15
Matisse, en route to Collioure, stops in Perpignan. He writes to Manguin, who is living with his family at the Villa Demière in Malleribes, near Saint-Tropez, that he is anxiously awaiting 150 francs ($30.61) from Weill and expresses annoyance at her delay. [43] In response, Manguin sends Matisse 100 francs ($20.41).

Villa Demière, near Saint-Tropez

1905 MID-MAY
The painter Francis Jourdain writes to Manguin from Nice, complaining about the bad weather there. He mentions that Matisse's close friend Simon Bussy has come to Nice. He alludes to political problems surrounding plans for the Salon d'Automne. [44]

1905 MAY 16–WEEK OF SEPTEMBER 4
Matisse arrives in Collioure. He secures a pension in an inexpensive boardinghouse not far from the train station in Collioure and plans to be at work in several days. Amélie Matisse had suggested that the family go to Collioure, as she is from nearby Toulouse and has family living in the region.

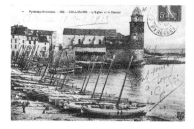

Collioure

1905 MAY 20
Matisse writes to Manguin, thanking him for the money; he remains extremely agitated about Weill and her failure to send funds. He says that he and his family find Collioure satisfactory and that he has rented a room on the quay with a view of the water,

where he can work easily.

Matisse also mentions that he has been seeing Etienne Terrus, a local painter who exhibits at the Salon des Indépendants and is a friend of the Pointillist painter Maximilien Luce. Terrus lives in Elne, twelve miles from Collioure, and paints the local landscape. Terrus becomes a constant companion of Matisse during this and subsequent trips to Collioure, and he later introduces Matisse to the sculptor Aristide Maillol. Maillol's biographer Marc Lafargue later writes:

> Proud, almost misanthropic, Terrus would have liked to remain rooted to his native soil like a gnarled olive-tree. He was not, however, a *naïf* artist, nor ignorant of recent painting. He thought highly of Matisse. . . . ¶ An afternoon spent with Maillol and Terrus in some forgotten valley of the Albères was a great pleasure. We would sit under a laurel bush; Maillol imagining his splendid torsos and goddesses; Terrus looking for the subject he wanted, an old farmhouse built by the Moors, its ancient walls baked in the sun. Beyond the valleys were

glimpses of the sea. Terrus would be painting it.[45]

Matisse encourages Manguin to visit him in Collioure, saying that Manguin would find "charming sights [to paint]." He notes in a postscript that he will write to Braut to ask whether Matisse will be paid by the state for the works purchased at the Salons.[46]

1905 MAY 25–JUNE 1
Camoin visits Marseille, staying at 1, rue du Théâtre Français. He is enthusiastic about the sun and the light there. He helps the Belgian Pointillist Théo van Rysselberghe to find a model.

1905 MAY 27
Francis Jourdain visits Manguin and his guest Marquet at the Villa Demière.

1905 JUNE 1
Marquet is staying at the Hôtel Sube near the port in Saint-Tropez, with a spectacular view that he can paint from his balcony. This is better for him than staying with the Manguins at the Villa

Henri Matisse's window at Collioure

Etienne Terrus, 1907

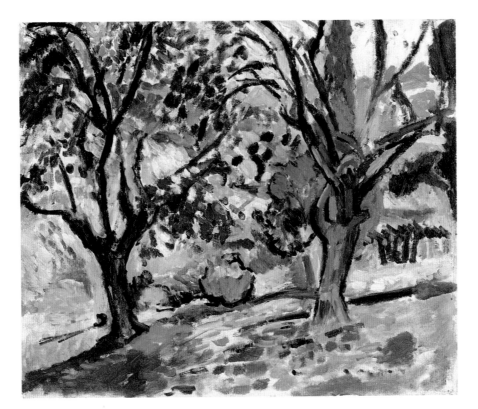

PLATE 76

PLATE 76
Henri Matisse
Paysage à Collioure
(*Landscape at Collioure*), 1905
Also known as *Promenade among the Olive Trees*
Oil on canvas
17 ½ x 21 ¾ in. (44.5 x 55.2 cm)
The Metropolitan Museum of Art, New York, Robert Lehman Collection, 1975.1.194

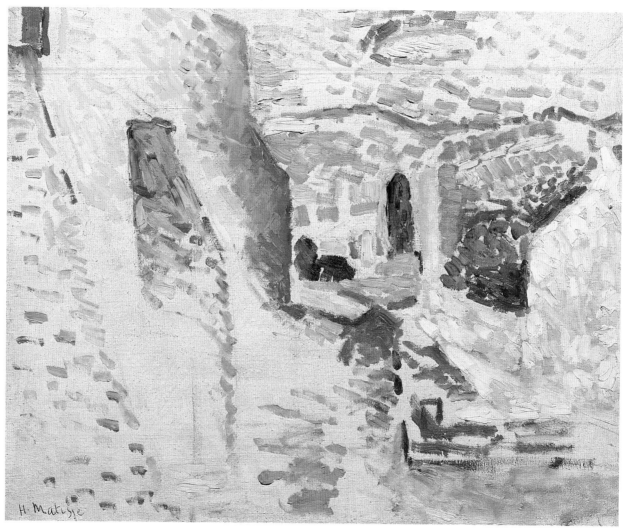

PLATE 77

PLATE 77
Henri Matisse
Rue à Collioure
(*Street in Collioure*), 1905
Oil on canvas
18 ⅛ x 21 ⅝ in. (46 x 55 cm)
Private collection

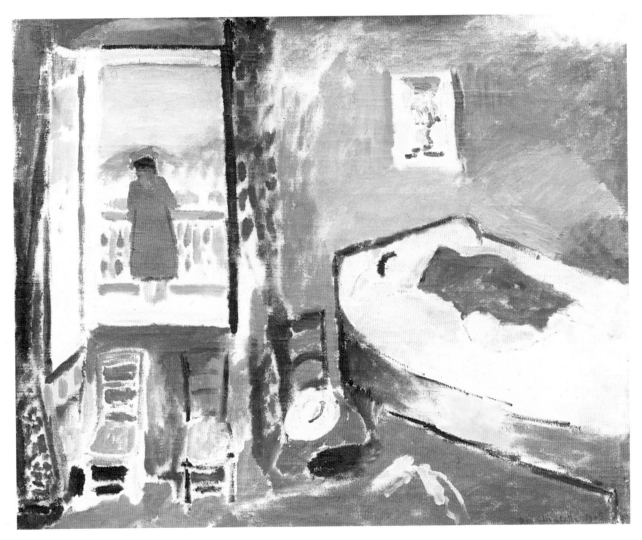

PLATE 78

PLATE 78
Henri Matisse
La Sieste
(*The Rest*), 1905
Also known as *Intérieur à Collioure* (*Interior at Collioure*)
Oil on canvas
23 ¼ x 28 ⅜ in. (59 x 72 cm)
Private collection, Switzerland

Demière, where he did not generally have easy access to a model or to women. Of Saint-Tropez and the Midi, Marquet writes to Camoin, "In these French tropics, we become tropical people." [47]

1905 JUNE 6

Matisse writes to Marquet, delighted to learn that he is staying at the Hôtel Sube. He encourages him to take advantage of the sun, because the weather is often gray in Saint-Tropez.

Matisse says that they are not at all bored in Collioure. He has made two small oil sketches, some watercolors, of which three are not bad, and some sketches. He finds the region stunning and encourages Marquet to visit. Thanks to Terrus, they have seen Maillol, whom Matisse helped with a sculpture he was making. Matisse notes of Maillol, "I got to know him well and he

Henri Matisse and Aristide Maillol

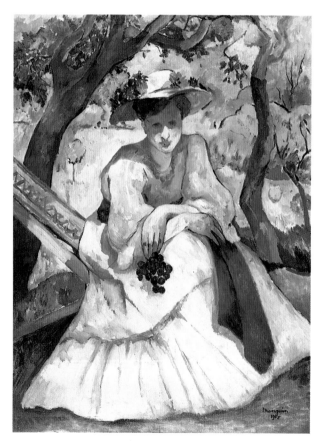

PLATE 79

is charming." [48]

1905 JUNE 8

Amélie Matisse writes to Jeanne Manguin, the artist's wife, expressing the hope that the Manguins have been able to take enjoyable walks. She remembers that the Midi sun can be a bit brutal, but she hopes that Manguin and Marquet have not lost their good humor over this. [49]

1905 JUNE 9

Manguin writes to Matisse that he has not had two consecutive days without clouds. He has, however, made quite a few rough sketches, followed by several canvases of "25 or 30 format" (23⅝ by 31 5/16 inches [60 by 81 centimeters] or 25⅝ by 36 3/16 inches [65 by 92 centimeters], respectively); this is not splendid progress, he says, but he has done the best he can do. He comments, "I am enthusiastic about this region and, above all, about the place where we are staying." The one inconvenience is that they are a bit far from the water and Saint-Tropez, which he considers quite beautiful.

Manguin also notes that he has recently seen Signac, who "continues to be very pleasant. I saw him in the evening [when I was out] for a bit of air." He also saw van Rysselberghe and Cross, who had been ill (he has severe arthritis) and unable to work. [50]

Jeanne Manguin, c. 1906

1905 SUMMER

Signac writes to Matisse:

"Our poor painters Marquet, Manguin, and van Rysselberghe groan over the impermanence of the weather. Really, I cannot understand the connection between the art and the barometer. In that case there would be no painters in a country where it rained or the wind blew all the time! To my mind, it is futile and dangerous to battle thus with nature. The quickest method of notation is still the best. It provides you with the most varied information and, at the same time, leaves you freer to *create* afterwards." [51]

Braque stays in Honfleur and Le Havre with the sculptor Manolo (Manuel Martínez Hugué) and the critic Maurice Raynal. Braque reportedly ac-

quires a mask from Gabon from a sailor.[52]

Friesz visits Antwerp.

1905 SUMMER–AUTUMN
Dufy visits Marseille and Martigues.

1905 JUNE 28
Camoin, in Saint-Tropez, writes to Matisse that he and Marquet have been working together, painting women. He remarks, "Marquet is thinking of exhibiting it [one of the works] next year at the Salon des Indépendants under the title *The New Olympia*." He says that he has gone to Saint-Tropez with "the good intention of making up for lost time and the weather here [allows me] to absorb the tropics while waiting for the sun." Camoin notes that it is rather expensive for him to stay in Saint-Tropez and that he hopes to finish some studies before moving along toward Agay. He also mentions that, like Matisse, he continues to wait for money owed him by Weill.[53]

1905 JULY
Matisse, writing to Signac, requests that he copy eight lines from an article on Cézanne by Bernard published in the July 1904 issue of *L'Occident*.[54]

Work by Friesz and others, Prath et Magnier.

1905 PROBABLY EARLY JULY
Camoin and Marquet depart Saint-Tropez for Cassis, where they stay at the Hôtel Cendrillon.

1905 ABOUT JULY 5
Marquet visits Saint-Raphaël.[55]

1905 JULY 8–SEPTEMBER
Derain is in Collioure to work with Matisse.[56]

1905 JULY 13–AT LEAST JULY 24
Marquet and Camoin stay at the Grand Hôtel, Agay. Marquet writes to Manguin that the surroundings are splendid and he is eager to begin working; if Manguin would visit Agay, he continues, Manguin would never return to Saint-Tropez.[57]

PLATE 80

PLATE 81

1905 JULY 14
Matisse writes to Signac concerning *Luxe, calme, et volupté* (plate 175): "Did you find in my painting *Baigneuses* [*Bathers*—subsequently exhibited at the Salon d'Automne as *Luxe, calme, et volupté*] a perfect harmony between the character of the drawing and the character of the painting? To me, they seem totally different from one another and even absolutely contradictory. One, the drawing, depends on linear or sculptural plasticity, and the other, the painting, depends on colored plasticity. Result: The painting, especially because it is Divisionist, destroys the drawing, which derives all of its eloquence from the outline.... It would have sufficed if I had filled in the compartments with flat tones such as Puvis [de Chavannes] uses."[58] He adds that he has been making mainly sketches and watercolors that would be useful to him later in Paris.

Marquet, in Saint-Tropez, writes to Camoin that he has celebrated the national holiday (July 14) by dancing the farandole (a Provençal dance) with Manguin, Signac, and Mme Signac. "It is marvelous, your Midi sun.... Near the port there is a small, stunning spot where you can find delicious and inexpensive models.... There also are marvelous landscapes to make."[59]

PLATE 79
Henri Manguin
La Femme à la grappe, Villa Demière
(*Woman with Grapes, Villa Demière*), 1905
Oil on canvas
45 11/16 x 31 7/8 in. (116 x 81 cm)
Fondation Pierre Gianadda, Martigny, Switzerland

PLATE 80
Albert Marquet
Camoin peignant à Cassis
(*Camoin Painting at Cassis*), 1905
Oil on canvas
10 5/8 x 13 3/4 in. (27 x 35 cm)
Private collection

PLATE 81
Georges Braque
Côte de Grâce, Honfleur, summer 1905
Oil on canvas
19 7/16 x 23 11/16 in. (49.3 x 60.2 cm)
Musée des Beaux-Arts André Malraux, Le Havre, France

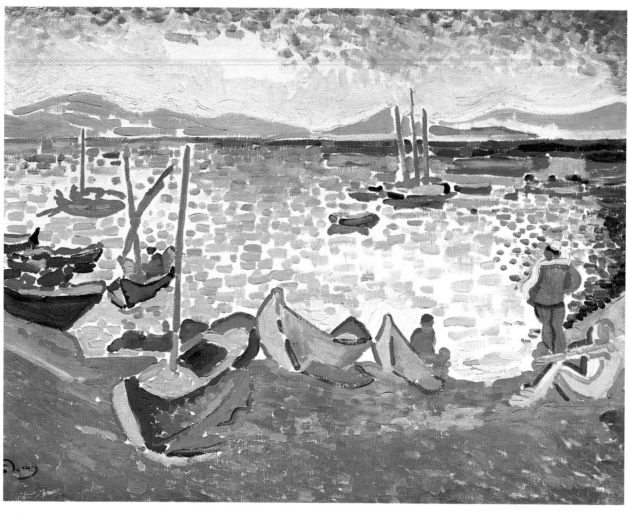

PLATE 82

PLATE 82
André Derain
Bateaux au port de Collioure
(*Boats in the Port of Collioure*),
summer 1905
Previously known as *Bateaux
dans le port* (*Boats in the Port*)
Oil on canvas
28 ⅛ x 37 ⅛ in. (72 x 95 cm)
Private collection, Switzerland

1905 July 15
Amélie Matisse writes to Jeanne Manguin, "My husband and Derain work steadily, despite the strong heat." Mme Matisse reports that they have come to enjoy Collioure and that they have made many trips, including an enchanting visit to Spain.[60]

Derain writes to Vlaminck that he is fascinated by the light, "a blond, golden light that suppresses the shadows." He also writes that Matisse is in a crisis over his painting.[61]

Matisse writes to his friend Bussy: "I am fairly satisfied with my work. I notice enormous and continual progress—more suppleness of execution than in the preceding studies and a return to softer harmonies and closer values. This will certainly be more acceptable to collectors—even the officials of the rue de Valois [Matisse is referring to the officials of the state ministry responsible for purchasing art from the Salons]—whom they've already pleased in the days when my painting wasn't understood nor [*sic*] supported by 'correct' drawings. I don't repudiate, however, my preceding studies because what I do is the logical consequence of my past efforts." [62]

1905 MID-JULY
Terrus and Joachim Gasquet (Cézanne's confidant and biographer) visit Manguin in Saint-Tropez.

PLATE 83
Henri Manguin
Le 14 Juillet à Saint-Tropez, côté gauche
(*July 14 in Saint-Tropez, Left Side*), summer 1905
Oil on canvas
24 x 19 11/16 in. (61 x 50 cm)
Private collection, Avignon, France

PLATE 84
Henri Manguin
Le 14 Juillet à Saint-Tropez, côté droit
(*July 14 in Saint-Tropez, Right Side*), summer 1905
Oil on canvas
24 x 19 11/16 in. (61 x 50 cm)
Private collection, Avignon, France

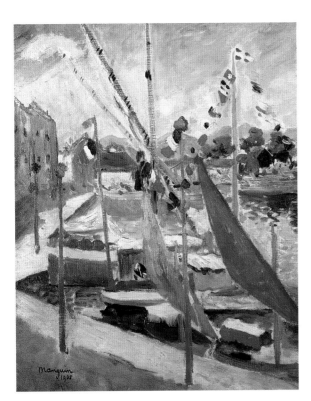

PLATE 83

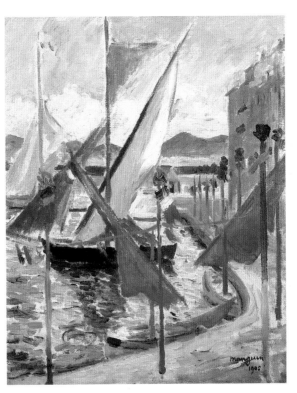

PLATE 84

Maurice Denis

1905 JULY 25–ABOUT AUGUST 15
Marquet and Camoin visit Anthéor, which Marquet describes as "more and more stunning."[63]

1905 BEFORE JULY 28
Maillol takes Matisse and Derain to visit Georges-Daniel de Monfried, who lived in Leucate (a village near Maillol's town of Banyuls-sur-Mer), so they can see his archives and collection of paintings by Gauguin.

1905 JULY 28
Derain writes to Vlaminck that a new concept of light is the negation of shadow and that he can experiment with the division of tones to obtain a harmonious and luminous image. He indicates that he is no longer strongly interested in anarchist politics. He also mentions that he has gone to Spain and visited various potteries via car.[64]

1905 JULY 31
Matisse writes to Manguin that they are doing well despite inertia resulting from the intense heat. He sends greetings from Derain and asks whether Manguin knows the date when submissions must be made to the Salon d'Automne.[65]

1905 LATE JULY–EARLY AUGUST
Following an extended trip to Italy, Francis Jourdain writes to Manguin from Paris about summer in the city, which is filled with English tourists armed with guidebooks. He offers to assist Camoin, Manguin, and Marquet with their submissions to the Salon d'Automne by handling their transportation, framing, registration, etc.[66]

1905 AUGUST
In Pont-Aven for the summer, Denis discusses Matisse's work with fellow artists Paul Sérusier and Pierre Hepp. Denis reported: "Apropos of Matisse, Sérusier quotes this saying of Gauguin's: 'When a kid writes *merde* on a wall, he is translating a state of mind. However, that does not make it a work of art.' "[67]

1905 AUGUST 5
Derain writes to Vlaminck that he

hopes to make thirty paintings, twenty drawings, and fifty sketches before returning to Paris; he plans to return about September 1.[68]

1905 MID-AUGUST
The Manguins and the Signacs bicycle east along the Côte d'Azur, visiting Anthéor, Agay, and Menton. The Manguins continue to Cannes, Antibes, Saint-Jean, Beaulieu-sur-Mer, and Nice, returning to Malleribes via the inland route through the valley of the Var. Manguin finds the inland gorges and the mountains stunning, although he writes to Matisse on August 22 that he still prefers the sea.[69]

Marquet travels alone along the Mediterranean coast, toward Menton, staying at the Hôtel des Négociants near the port.[70]

1905 AUGUST 22
Manguin writes to Matisse about his disappointment at not having completed more paintings this summer. Although short of funds, he plans to stay in Malleribes until late September or early October. He reports that he has seen Signac regularly and that he could not have been kinder; however, Signac does seem to be somewhat on the defensive regarding Matisse. According to Manguin, Signac plans to be in Paris in October, but he doubts that Cross will be well enough to go.[71]

1905 AUGUST 25
Marquet leaves Menton for Nice.[72]

1905 AUGUST 28 OR 29
Marquet returns to Saint-Tropez.[73]

1905 WEEK OF AUGUST 28
Storms in Collioure delay Matisse's completion of some of his paintings.[74]

1905 WEEK OF SEPTEMBER 4
Matisse and his family return to Paris; Derain probably returns by this date, traveling via L'Estaque, Agay, and Marseille.

1905 BY SEPTEMBER 8
Upon his return to Paris, Marquet im-

PLATE 85

PLATE 86

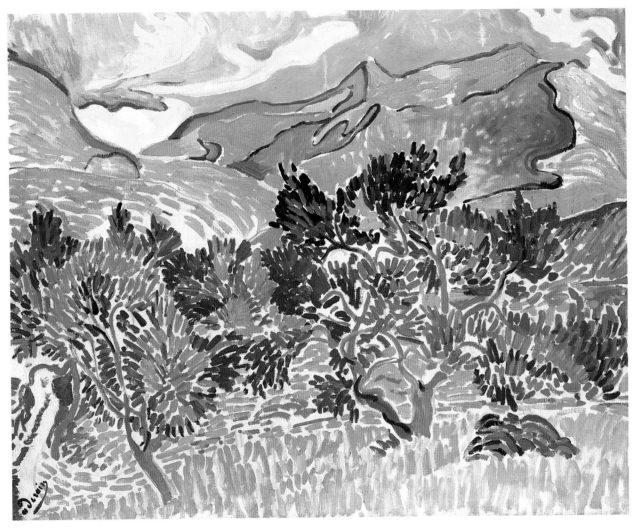

PLATE 87

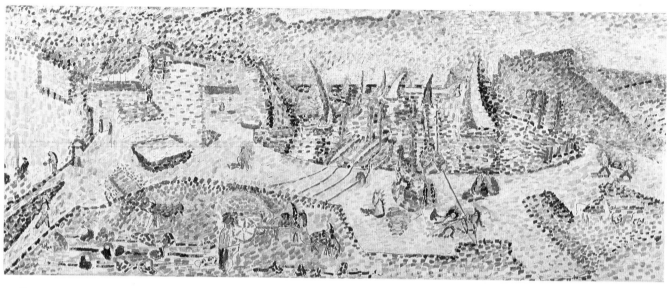

PLATE 88

PLATE 88
Henri Matisse
Le Port d'Avall
(*The Port of Avall*),
summer 1905
Previously known as *Le Port
d'Abaill*
Oil on canvas
23 ⅝ x 55 ⅛ in. (60 x 140 cm)
Private collection

Included in Matisse's 1906
exhibition at Galerie Druet,
Paris

PLATE 89
Henri Matisse
Vue de Collioure
(*View of Collioure*),
summer 1905
Oil on board
8 ⅝ x 19 in. (21.9 x 48.3 cm)
The Museum of Fine Arts,
Houston, gift of Oveta Culp
Hobby

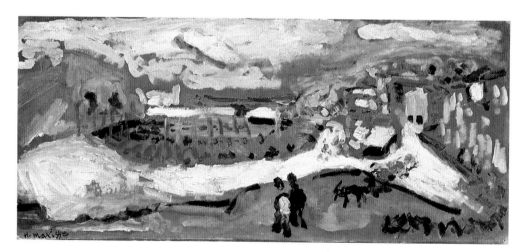

PLATE 89

mediately sells three paintings. He has seen the paintings that Matisse and Derain made in Collioure and writes to Manguin that they "have made stunning things." [75]

1905 SEPTEMBER 13

Fénéon visits Matisse and sees the artist's work from Collioure: fifteen oils, forty watercolors, and about one hundred drawings. [76]

1905 SEPTEMBER 14

Matisse writes to Signac that Marquet and Camoin (who rejoined in early September) have returned from the Côte d'Azur. En route they had stopped in Marseille and toured the red-light district on the rue Bonterie. Of the two artists' work Matisse observes, "I like their work, though to tell the truth it is rather the opposite of mine." He also notes that they have both made some significant sales. [77]

1905 SEPTEMBER 18

Matisse writes to Manguin that Signac has purchased *Luxe, calme, et volupté* (plate 175) for 1,200 francs ($244.90), and he sends Manguin 60 francs ($12.24) of the 100 francs ($20.41) he owes him. [78]

1905 SEPTEMBER 19

Marquet has been in Bordeaux for several days; his mother lives nearby. By this time he has sold seven paintings since his return to Paris.

Matisse writes to Bussy that he is painting a large canvas measuring 59 1/16 by 15 3/4 inches (150 by 40 centimeters), now generally agreed to be *Le Port d'Avall* (*The Port of Avall*, plate 88), which he intends to exhibit at the Salon d'Automne (in fact, the painting is not exhibited until March 1906, in Matisse's exhibition at Galerie Druet). He tells Bussy that he has received an extension from the Salon d'Automne to complete the painting (an indication of Matisse's standing within the Salon committee). "As I am painting in dots, it is rather a long process, especially since they don't always come out right the first time." Matisse assures Bussy that he can count on support from "our friends" Roger

Marx, Piot, Desvallières, and Rouault, as well as from Matisse. He adds an upbeat note: he has sold a rather important painting that he is baptizing "luxe, calme, et volupté." [79]

1905 SEPTEMBER 21

Manguin writes to Matisse that he is intrigued by his news but that he had already known about Signac's purchase of *Luxe, calme, et volupté* (plate 175). He mentions that Signac has also obtained from Cross one of his earlier paintings, predominantly yellow in tone and featuring women. The Cross and the Matisse paintings are to be installed in Signac's dining room in Saint-Tropez, and Manguin hopes to see them hanging before he leaves the Midi. Manguin adds, "The Midi has been, I think, a good lesson for me, and I return, if not content with myself, at least with a great impression of beauty and an understanding of many things which, until now, were unknown to me." [80]

1905 SEPTEMBER 23

Derain signs a receipt with Vollard for 3,300 francs ($673.46) for eighty-nine paintings and eighty drawings. [81]

1905 SEPTEMBER 25

The American painter Max Weber arrives in Paris for a three-year stay.

1905 SEPTEMBER 28

Matisse writes to Signac that works by Camoin, Manguin, and Marquet have been accepted at the Salon d'Automne and that Vauxcelles has already mentioned Manguin's paintings of Saint-Tropez in *Gil Blas*. Regarding his own works he notes, "If I had not been on the committee and strongly supported by friends, they would not have been accepted." [82]

1905 AUTUMN

Derain visits London for several days. [83]

1905 OCTOBER

Matisse rents a studio at the Couvent des Oiseaux, 56, rue de Sèvres (at the corner of boulevard de Montparnasse), which he retains through spring 1908.

PLATE 90
Maximilien Luce
(France, 1858–1941)
*Félix Fénéon Dressed in
His Long Coat*, 1902
Oil on canvas
29 1/2 x 23 1/2 in.
(74.9 x 59.7 cm)
Los Angeles County Museum
of Art, promised gift of Iris
and B. Gerald Cantor in
honor of the museum's
twenty-fifth anniversary

PLATE 91
Albert Marquet
*Camoin et son modèle aux
Bar des Roses*
(*Camoin and His Model at the
Bar des Roses*), 1905
Charcoal on paper
12 1/16 x 17 5/16 in. (27 x 44 cm)
Private collection

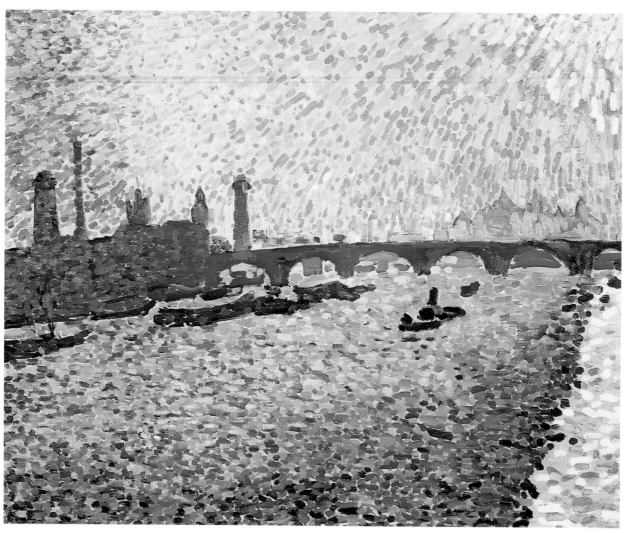

PLATE 92

There Matisse begins to paint *Le Bonheur de vivre* (*The Joy of Life*, plate 176).

1905 OCTOBER 1
The Manguins return to Paris, traveling via Marseille in order to view murals by Puvis de Chavannes in the Musée des Beaux-Arts at the Palais de Longchamps. Signac accompanies them to Marseille, where he stays to make some watercolors.

1905 OCTOBER 18–NOVEMBER 25
Third Salon d'Automne, Grand Palais. Among the 1,625 works by 397 artists are included retrospectives of work by Jean-Auguste-Dominique Ingres, Edouard Manet, and Renoir. Works by Camoin (five), Derain (nine, including views from Collioure), Manguin (five), Marquet (five), Matisse (ten), and Vlaminck (five) are featured in room 7. Puy's works (four) are in room 3 with those by the older Nabis and by Bonnard and Vuillard. Rouault (three) is represented in room 16; Valtat (five) is in room 15 with Alexei Jawlensky (six) and Kandinsky (twelve). Friesz exhibits four works. Dufy does not exhibit (although many later references erroneously indicate that he did). Rousseau exhibits *The Hungry Lion Throws Himself on the Antelope* (1905, private collection). Renoir is honorary president of the Salon.

Emile Loubet, president of the Republic, refuses to open the Salon because some of the paintings are considered radical compared with those at the more conservative Salon of the Société Nationale des Artistes Français.

From the press commentary prompted by this Salon emerges the term *les fauves;* Vauxcelles coins the phrase in his review for *Gil Blas.*[84] The critics had seemed to be aware of a change in contemporary painting by the preceding year, but they did not identify it as a movement or body of artists until this Salon. Generally, critics for *Gil Blas,* *L'Ermitage,* *Le Figaro,* and *Mercure de France* respond positively to the Salon, which is dominated by the Fauve artists. Gide writes: "I stayed quite a time in this gallery [the one dominated by the work of the Fauve artists]. I listened to the visitors and when I heard them exclaim in front of a Matisse: 'This is madness!' I felt like retorting, 'No sir, quite the contrary. It is the result of theories....' "[85] Denis describes Matisse's work as "an emotion from nature."[86] The critic for *Le Radical* writes: "There is much better than just hopes and promises [in this Salon]. And these youths' names, now unknown by the snobs who rush to society openings, will be celebrated tomorrow."[87]

L'Illustration, November 4, 1905

Vauxcelles comments: "M. Derain is going to alarm people; he alarms them at the Indépendants. I think he is more of a poster designer than an artist. The decided character of his virulent imagery, the facile juxtaposition of his complementaries will seem willfully puerile to some; let us recognize nevertheless that his *Boats* [plate 266] would happily decorate the wall of a child's room. M. Devlaminck [*sic*] makes naïve images: his painting, which really looks terrible, is really very good-natured."[88] M. Nicolle writes, "That which we are presented with does not have, aside from the materials used, any connection with painting; presenting some odd medleys of color; of blue, of red, of yellow, of green; touches of crude colorings juxtaposed haphazardly; barbaric and naïve games of a child who is playing with the 'box of colors.'..."[89]

Paintings to be installed in the Salon, c. 1900–1910

PLATE 92
André Derain
Le Pont de Waterloo
(*Waterloo Bridge*), autumn
1905
Oil on canvas
31 ½ x 39 ⅜ in. (80 x 100 cm)
Thyssen-Bornemisza Collection,
Lugano, Switzerland

1905 AFTER OCTOBER 18–BEFORE NOVEMBER 25

Braque is impressed by Matisse's and Derain's works at the Salon d'Automne. Friesz, his friend from Le Havre, exhibits at the Salon but not in room 7, designated the "Fauve" room by the critics.

Purrmann goes to Paris from Munich to see the Manet retrospective at the Salon. Overwhelmed by Matisse's work in the Salon, he goes to see more of it in Gertrude and Leo Stein's collection, a visit arranged by the American painter Maurice Sterne. Leo Stein introduces him to Matisse.[90]

Jawlensky sees the Salon and meets Matisse.[91]

Alexei Jawlensky

1905 OCTOBER 21–NOVEMBER 20

Paintings by Camoin (six), Derain (five), Dufy (fifteen), Manguin (seven), Marquet (seven), Matisse (six), and Vlaminck (five), Galerie Berthe Weill.

According to Weill's memoirs: "Dufy had expressed to me his wish to be made a part of this group [of artists exhibiting]; I agreed and notified Matisse, who was furious, [and] wrote to me: 'Ah! No! This young man who would like to find a way in among us, we would not like to have him. Put him in another room if you want.' Our dear spirit [Matisse] was not accommodating. Dufy was then in the group, without being in it; he had his small one-man exhibition in the other room [of the gallery]."[92]

1905 OCTOBER 23

Having attended the vernissage of the Salon, Gertrude Stein and Etta Cone (the latter lived in Paris from late October through the end of April 1906) return to the Salon. Claribel Cone, who visited the Salon separately, subsequently described her view of the Fauve room: "The walls were covered with canvases—presenting what seemed to me then a riot of color—sharp and startling, drawing crude and uneven, distortions and exaggerations—composition primitive and simple as though done by a child. We stood in front of a portrait— it was that of a man bearded, brooding, tense, fiercely elemental in color with

Etta and Claribel Cone, 1903

green eyes (if I remember correctly), blue beard, pink and yellow complexion. It seemed to me grotesque. We asked ourselves, are these things to be taken seriously."[93]

1905 OCTOBER 23–NOVEMBER 11

Nineteen works by van Dongen, Galerie Druet.

1905 OCTOBER 28–NOVEMBER 11

Fifty-six works by Seyssaud, Hôtel des Architectes, Marseille.

1905 LATE OCTOBER–EARLY NOVEMBER

Signac writes to Manguin from Marseille, mentioning that he is there waiting to pick up his new Peugeot. Several days later he writes again, ecstatic about his new car and delighted with the ease of traveling in it from Saint-Tropez to Marseille. In both letters he inquires about the Salon d'Automne.[94]

1905 NOVEMBER 18–DECEMBER 2

Paintings, drawings, and watercolors by van Rysselberghe, Galerie Druet.

1905 NOVEMBER 25

Camoin arrives in Martigues, where he will spend the winter.

1905 NOVEMBER 29

Leo Stein writes to a friend, Mabel Foote Weeks: "The Autumn salon is over and has left two pictures stranded in our atelier. All our recent accessions are unfortunately by people you never heard of, so theres [sic] no use trying to describe them, except that one of those out of the salon made everybody laugh except a few who got mad about it [he refers here to Matisse's *Femme au chapeau* (*Woman with a Hat*, 1905, private collection, San Francisco), for which Stein paid 500 francs ($102.04)], and two other pictures are by a young Spaniard named Picasso whom I consider a genius of very considerable magnitude and one of the most notable draughtsmen living."[95] Following the Salon, Leo takes his brother, Michael Stein, and his brother's wife, Sarah, who were living at 58, rue Madame, to visit Matisse in

Sarah and Michael Stein's apartment, Paris, early 1908

PLATE 93

his studio. A close friendship develops between the Matisses and the Michael Steins.

Sarah and Michael Stein, c. 1905

1905 DECEMBER 2
Camoin writes to Matisse from Martigues and refers to his recent mishaps in Marseille, about which he believes Marquet has told Matisse: Camoin had been painting outdoors when some youths threw his painting to the ground, stole his easel, and hit him on the head. In Martigues—which he calls "a marvelous region, the Provençal Venice—Camoin begins to explore the region. "I began to . . . become familiar somewhat with the character of the country. . . . I have benefited in this from visiting the region around the village and . . . while one looks at nature in trying to reason with it and to understand the manner in which to be able to remember it, one works equally with a paintbrush in hand. And that is the only way to see. Otherwise one does not see."

Camoin also reports seeing Cézanne, and he mentions that Cézanne was outside painting "before his subject." He also mentions that he hopes to see Matisse during March, at the time of the Salon des Indépendants.[96]

1905–6 WINTER
Picasso begins to paint Gertrude Stein's portrait (plate 98). He had met her and Leo Stein at Clovis Sagot's secondhand shop.

1905 END OF THE YEAR
Marquet signs a contract with Druet, who is also his chess partner.

Signac writes to Manguin, indicating that he has been following the intense debates in the press surrounding the Salon d'Automne. He also indicates that the paintings in his dining room, including Matisse's *Luxe, calme, et volupté* (plate 175), are in place.[97]

Upon his return from London, Derain's future wife, Alice Princet, leaves her husband, Maurice Princet (a mathematician and theorist on the fourth dimension who influenced the Cubists), to live with Derain. Derain and Picasso meet.[98]

Albert Marquet (left) and Eugène Druet, c. 1900–1910

1906
Derain mentions in a letter to Vlaminck that he has been reading and thinking about Friedrich Wilhelm Nietzsche, whose work he finds "astonishing."[99]

A Russian artist, Elizabeth Epstein, takes Jawlensky to visit Manguin, whose paintings Jawlensky admires.

Sergei Shchukin—a Russian collector who had built a massive collection of art and antiques and placed it on public display, first in his home and later in the Museum of Imperial History in Moscow—asks Vollard for Matisse's address.

Van Dongen moves to the Bateau-Lavoir (where the Spanish painter Juan Gris also lives from 1906 to 1922). Van Dongen lives there for one year with his wife, Guus, and his one-year-old daughter, Dolly. While there, van Dongen recalled, "I had the good fortune to meet Félix Fénéon, who, like myself, frequented the group of anarchists."[100]

Valtat visits Algeria.

Kees and Guus van Dongen with their daughter, Dolly, 1905

1906 JANUARY 3
Marquet writes to Faure that he is flattered by his invitation to exhibit (it is not clear to what exhibition he is referring); he says, "The pleasure with which I accept would be even greater if you could invite my friend Matisse, with whom I always exhibited and who would bring honor, certainly, to your exhibition."[101]

1906 JANUARY 12–FEBRUARY 10
Henri Dezire, Charles Guérin, Laprade, Piot, Rouault, Nicholas Tarkhoff, and others, Galerie Berthe Weill.

1906 JANUARY 13
Manguin and other Fauve artists attend one of the Saturday gatherings regularly held at Gertrude and Leo Stein's apartment.[102]

1906 JANUARY 14
Manguin, Matisse, and Leo Stein visit a large private collection of Cézanne paintings.

Signac writes to Angrand about *Le Bonheur de vivre* (plate 176): "Matisse, whose work I have liked until now,

PLATE 93
Kees van Dongen
Poster for "Exposition Kees van Dongen," 1905
Watercolor, black ink, colored crayon, and gouache on paper
23 7/16 x 11 1/8 in.
(59.5 x 28.2 cm)
Sold, Christie's, London,
June 27, 1989

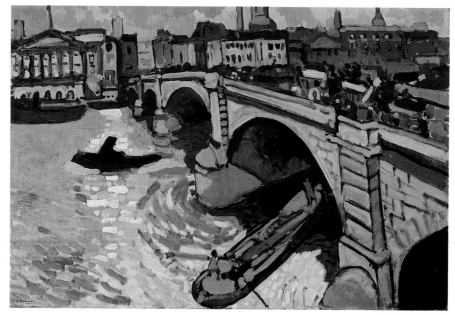

PLATE 94

PLATE 94
André Derain
Pont de Londres
(*London Bridge*), winter 1906
Oil on canvas
26 x 39 in. (66 x 99.1 cm)
Collection, The Museum of
Modern Art, New York, gift
of Mr. and Mrs. Charles
Zadok

seems to have gone to the dogs. Upon a canvas of two and a half meters he has surrounded some strange characters with a line as thick as your thumb. Then he has covered the whole thing with flat, smooth colors which, however pure, seem disgusting." [103]

1906 JANUARY 15
Sarah Stein takes Etta Cone to meet Matisse; Cone purchases two drawings.

1906 JANUARY 20
Vlaminck writes to Marquet, inquiring about the plans for the annual exhibition of La Libre Esthétique. [104]

1906 JANUARY 21
Maus, in Paris to select works for the Libre Esthétique exhibition, notifies Manguin that he has chosen three of his paintings from Galerie Druet: *La Sieste (Le Rocking-Chair, Jeanne)* (The Rest [*The Rocking Chair, Jeanne*], plate 264), *La Toilette (The Dressing Table)*, and a version of *Femme couchée (Reclining Woman)*. He invites Manguin to attend the festivities on February 24 in Brussels. [105]

Maus is encouraged to invite Matisse, Manguin, Camoin, and the other Fauves by his friend and fellow Belgian van Rysselberghe. [106]

1906 JANUARY 29–MID-MARCH
In London for his second trip, Derain resides at 65 Blenheim Crescent, in the middle-class Holland Park section of the city.

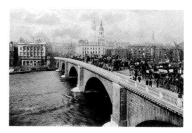

London Bridge

1906 JANUARY 30
Derain writes to Matisse about the works by Claude Lorrain, Joseph Mallord William Turner, Diego Velázquez, and Hans Holbein that he has seen in London museums. He writes to Matisse: "Naturally I am devouring the museums. And for the moment in my Soul Rembrandt is the chief." [107]

His letter to Matisse, which suggests the nature of the discussions that the two artists must have had the previous summer in Collioure, continues:

Faced with the multiplicity of my sensations [toward the old master works he saw in London], I got the idea that there are some highly talented painters whom we, as we ourselves are painters, must look at because [with their work] they bring painting to an end. Most of all I say this about the Primitives. And it is also true of Claude Lorrain and Turner. I would say the same about Velázquez and Holbein. ¶ Then the various

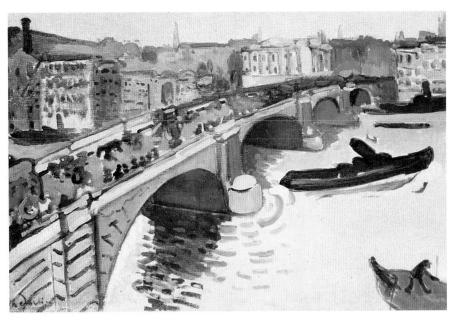

PLATE 95
André Derain
Pont de Londres
(*London Bridge*), winter 1906
Oil on canvas
24 ¹³/₁₆ x 37 ⅝ in.
(63 x 95.5 cm)
Private collection,
Switzerland

PLATE 96
Henri Matisse
Le Port de Collioure
(*The Harbor of Collioure*),
summer 1905
Watercolor on paper
14 ⁵/₁₆ x 12 ¼ in.
(36.3 x 31.1 cm)
The Baltimore Museum of Art,
the Cone Collection, formed
by Dr. Claribel Cone and
Miss Etta Cone of Baltimore,
Maryland, BMA 1950.226

and contradictory conceptions bury us more within the general idea and it is in the general idea that freedom is the greatest. This variety makes us forget the reasons, the forms, the origins of our sensations, so that we keep only the essence of it, which is the sense of our personality or the familiarity with ourselves. It is like a game to express oneself for those who know themselves. They sacrifice their failings to their [good] qualities. I sincerely believe that we ought to aim for calm, unlike the generations that preceded us. This calm is something of which we can be certain. Beauty, then, ought to be an aspiration toward this calm. Do you think that if we were completely disinterested we would be distressed? Such a real happiness exists I think in the perfect pleasure of oneself. This is an egoism, it's true, but not an overly disastrous one, since I am talking about a moral silence that would encourage us to help our neighbors psychically and would be, by its own existence, a precious moral help for them.

Derain mentions in the same letter that at this year's Salon des Indépendants there will be representation from a large group of what he brands "newcomer idiots" who were rejected from the Ecole des Beaux-Arts. It is not clear to whom he is referring.[108]

1906 FEBRUARY 10–17
Paintings and drawings by Ranson, Galerie Druet.

1906 FEBRUARY 14–MARCH 3
Second exhibition of the Intimistes, Galeries Henri Graves.

1906 FEBRUARY 18
Etta Cone purchases a watercolor (*Le Port de Collioure* [*The Harbor of Collioure*], 1905, plate 96) and a drawing from Matisse.[109]

1906 FEBRUARY 22–MARCH 25
Thirteenth exhibition of La Libre Esthétique, Brussels, includes Camoin (four), Manguin (three), Marquet (six), Matisse (seven), Puy (six), and others. Catalog by Maus.

1906 FEBRUARY 26–MARCH 3
Sixty works on paper by Francis Jourdain, Galerie Druet.

1906 FEBRUARY 28–MARCH 15
Fifty-three works by Redon, Galeries Durand-Ruel.

1906 MARCH
Vollard purchases 150 paintings from

Manguin.

1906 MARCH 7

Derain writes to Vlaminck that he has seen Turner's work in the National Gallery and has been to the British Museum. He also comments, "The Thames is immense and it is the opposite of Marseille." [110]

1906 MARCH 8

Derain writes to Matisse that he has been thinking a great deal about Turner's and Claude's work, particularly the relationship of tones in Turner and the massing of colors and the sense of construction—analogous to the Italian and French Primitives—in Turner and in Claude. He also writes about the strong emotions aroused in him by Velázquez's work and about the humanity of Rembrandt's paintings. It is evident from his letter that he has spent considerable time at the National Gallery, looking at works by these artists plus El Greco, Anthony van Dyck, Ferdinand Bol, Paolo Uccello (specifically his *Niccolò Mauruzi da Tolentino at the Battle of San Romano*, plate 97), and Bartolomé Esteban Murillo. He was also fascinated by native New Zealand statues at the British Museum.

Derain writes that he will return to Paris in time for the March 19 opening of Matisse's exhibition at Galerie Druet.[111]

1906 MARCH 9 AND 10

Submissions are due for the Salon des Indépendants.

1906 MARCH 19

Braque probably meets Matisse and Derain at the opening of the Salon.

1906 MARCH 19–APRIL 7

Fifty-five paintings, three sculptures, and several watercolors, lithographs, and woodcuts from 1897–1906 by Matisse, Galerie Druet. Not many works are sold.[112]

In a review of the exhibition Léon Rosenthal writes, "M. Henri-Matisse... is preoccupied with astonishing and disconcerting the public."[113]

PLATE 97

1906 BETWEEN MARCH 19 AND APRIL 7

Derain, back in Paris, sees Matisse's exhibition and writes to Vlaminck that it is "really not bad. He is very gifted. That is undeniable." Derain adds, "As for Claude Monet, in spite of everything I adore him."[114]

1906 MARCH 20–APRIL 30

Twenty-second Salon des Indépendants, Serres de la Ville, Grand Palais. There are 5,552 works by 842 artists. Cézanne is represented by ten paintings. Matisse shows only *Le Bonheur de vivre* (plate 176). Also included are Braque (seven, which he later destroys), Camoin (eight, many painted in Corsica), Béla Czobel (eight), Delaunay (eight), Derain (three), van Dongen (eight), Dufy (eight), Friesz (eight), Girieud (eight), Auguste Herbin (eight), Manguin (eight), Marquet (eight, all of which belong to Druet), Metzinger (eight), Valtat (eight), and Vlaminck (eight). The opening is dedicated to more than 1,200 victims of a catastrophe in the coal mines near Courrières (Pas-de-Calais). The hanging committee, elected at the Salon's general assembly, comprises Laprade, Lebasque, Luce, Manguin, Albert Marque, Marquet, Matisse, Metzinger, Signac, and others. Friesz is on the executive committee.

Concerning *Le Bonheur de vivre*, Morice comments: "The large canvas of M. Henri Matisse, the *Bonheur de vivre*, is the 'question' of the Salon. A good many people have made merry before this strange work. I have not shared their hilarity. Indeed, it is rather with disquiet, with sadness, that I see an admirably gifted artist squander his energies...."[115] Weill later called the painting "the biggest laughing stock of any time in his career."[116]

In the Salon catalog Dufy lists his address as Sous-les-Rochers-Falaise.

1906 SPRING

About the time of the Salon, Gertrude Stein introduces Matisse and Picasso.[117] Olivier described this meeting:

There was something very sympathetic about Matisse. With his regular features and

PLATE 97
Paolo Uccello
(Italy, c. 1397–1475)
Niccolò Mauruzi da Tolentino at the Battle of San Romano,
c. 1450s
Oil on panel
71 ½ x 126 in. (181.6 x 320 cm)
Trustees of the National Gallery, London

PLATE 98
Pablo Picasso (Spain, 1881–1973)
Portrait of Gertrude Stein, 1905–6
Oil on canvas
39 ¼ x 32 in. (99.7 x 81.3 cm)
The Metropolitan Museum of Art, New York, bequest of Gertrude Stein, 47.106

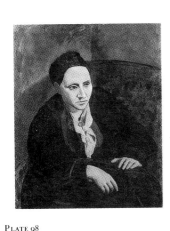

his thick, golden beard, he really looked like a grand old man of art. He seemed to be hiding, though, behind his thick spectacles, and his expression was opaque, gave nothing away, though he always talked for ages as soon as the conversation moved on to painting. ¶ He would argue, assert and endeavor to persuade. He had an astonishing lucidity of mind: precise, concise and intelligent. I think he was a good deal less simple than he liked to appear. ¶ He was already nearly forty-five [*sic*: Matisse was thirty-seven and Picasso was twenty-five] and very much master of himself. Unlike Picasso, who was usually rather sullen and inhibited at occasions like the Steins' Saturdays, Matisse shone and impressed people. ¶ They were the two painters of whom the most was expected.[118]

In his copy of the Indépendants catalog, Apollinaire noted by Matisse's name, "At the moment Stein speaks only of two painters, Matisse and Picasso."[119]

Picasso erases the head from his portrait of Gertrude Stein (plate 98), leaving it unfinished until he returns from Gósol, in the Spanish Pyrenees, later this summer. Stein later wrote: "One day Picasso painted out the whole head. 'I can't see you any more when I look,' he said irritably. And the portrait was put aside."[120]

According to Metzinger, Albert Gleizes and Metzinger meet when Gleizes admires Metzinger's paintings at the Salon des Indépendants.[121]

Archaic Iberian reliefs from Osuna, Spain (excavated in 1903 by a French expedition), Musée du Louvre.[122]

1906 MARCH 26–APRIL 4
Thirty-one works by Seyssaud, Bernheim-Jeune.

1906 MARCH 27
Eugène Carrière, who was known by many of the Fauves from their studies in his atelier, dies.

1906 APRIL
Luce, Galerie Druet.

1906 APRIL 5
While in Nice during a trip of several weeks along the Mediterranean coast, Puy and his wife, Jeanne, write to the Manguins (who are in Paris), after spending some time in Saint-Tropez, where the weather was cold and gray and the sea rough.[123]

1906 APRIL 15–JUNE 30
Sixteenth Salon, Société Nationale des Beaux-Arts, Grand Palais.

1906 APRIL 21
Vollard writes to Vlaminck, telling him that he cannot visit him tomorrow but will do so soon.[124]

1906 APRIL 23–MAY 7
Signac is in Rotterdam for "a change of scenery!!" as he puts it in a letter to Manguin, who is in Cavalière through mid-July.[125]

1906 LATE APRIL
Vollard goes to Rueil and purchases the entire contents of Vlaminck's studio for 6,000 francs ($1,224.49), also reserving the right of first refusal on all future paintings. This purchase enables Vlaminck to devote himself entirely to his painting, though he continues to give violin lessons to supplement his income.

1906 EARLY MAY
Friesz writes from Paris to Manguin in Cavalière, asking him which two of his paintings at Bernheim-Jeune and Druet he wants to send to the exhibition that Friesz is organizing for the newly established Cercle de l'Art Moderne in Le Havre. Friesz also asks Manguin to choose two drawings for an exhibition (location unknown) of drawings by Derain, Friesz, Manguin, Matisse, and Puy that he is organizing.[126]

1906 MAY
Vollard purchases at least twenty paintings from Picasso for 2,000 francs ($408.16).[127] Picasso will use the funds to travel to Spain that summer.

1906 MAY–MID-AUGUST
Picasso and Olivier go to Barcelona and then to Gósol, where Picasso studies Iberian masks.

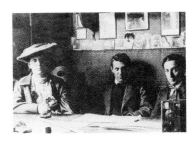

Fernande Olivier, Pablo Picasso, and Ramón Reventos, Barcelona, 1906, photographed by Juan Vidal y Ventosa

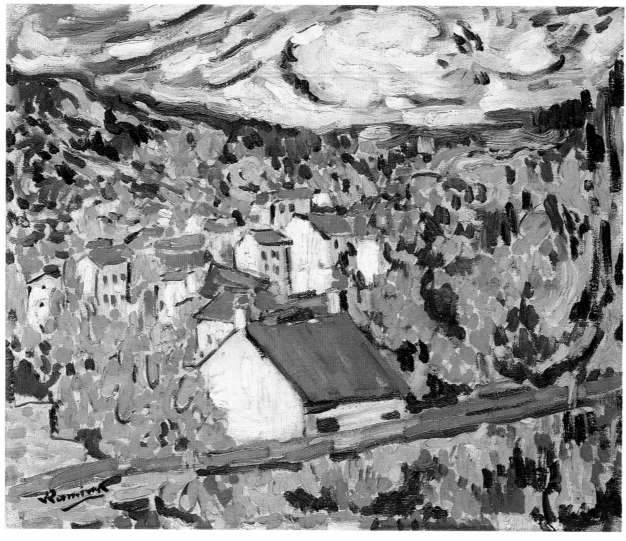

PLATE 99

PLATE 99
Maurice de Vlaminck
Vue de Chatou
(*View of Chatou*), 1906
Oil on canvas
18 5/16 x 21 5/8 in. (46.5 x 55 cm)
Tel Aviv Museum, bequest of
Harry and Lea Meklembourg,
New York, 1979

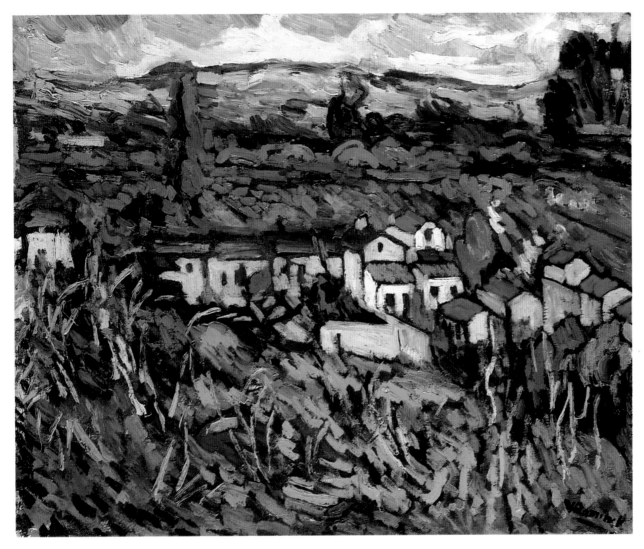

PLATE 100

PLATE 100
Maurice de Vlaminck
La Colline à Bougival
(*The Hill at Bougival*), 1906
Also known as *The Valley of
the Seine at Carrière-sur-Denis*
Oil on canvas
21 9/16 x 25 11/16 in. (54.1 x 65.2 cm)
Staatsgalerie, Stuttgart,
West Germany

Photographs of Collioure
owned by Henri Matisse

San Francisco after the earthquake, 1906

1906 MAY 1

Puy writes to Manguin from Paris, where he plans to stay through June 1. He describes his travels through Saint-Tropez, Le Lavandou, Cavalière, Agay, Cannes, Antibes, and Nice as difficult and disruptive; it is hard to work, he observes, when he is somewhere for only eight days. Matisse, reports Puy, has been selling his works for 2,000 francs ($408.16) each—to Druet, to Vollard, and to a private collector.[128] This is later confirmed by Matisse in a letter to Manguin, in which he indicates that he sold older paintings to Vollard for 2,200 francs ($448.98) and recent ones to Druet for 2,000 francs ($408.16).[129]

One hundred twenty-fourth annual Salon, Société des Artistes Français opens, Grand Palais.

1906 MAY 4–17

Vallotton, Bernheim-Jeune, 15, rue Richepanse.

1906 MAY 4–OCTOBER

Matisse spends the summer in Collioure, making various side trips. Mme Matisse and the children arrive slightly later and return to Paris on September 10; Matisse probably returned in early October.

1906 MAY 5–12

Paintings and engravings by Luce, Galerie Druet.

1906 MAY 8

Leo Stein writes to Manguin that Michael Stein's family has survived the San Francisco earthquake (April 18).[130] Although much of the city was destroyed by fire, the Stein family's properties in the city are still standing. Michael Stein leaves Paris for New York on May 12; after he arrives and sends word about the situation in San Francisco, Leo and Gertrude plan to go to Italy.

1906 MAY 10–26

Matisse, who has been in Perpignan since May 5, visits Algeria. He goes to Algiers, then travels to Biskra for a short stay, returning to Algiers and then pro-

PLATE 101

ceeding to Constantine and Biskra. His letters describe his fascination with the North African landscapes and, to a lesser extent, with the people.[131]

1906 MAY 12

Manguin writes from Cavalière to Matisse in Algeria. Of Cavalière, he says: "It is monotonous, nothing other than pines, no greenery, no vast panoramas, no houses, no boats, nothing. With the exception of a plain of a nice character, it is not really exciting. I don't even know if, when the heat is higher, I will be able to have someone pose since, despite the isolation of this damned village, there are always some guys fishing in the rocks.... I miss the Villa Demière and its nice shade. The area around Saint-Tropez was much more cheerful." [132]

Manguin mentions that Lebasque had settled in Saint-Tropez the previous week and is enchanted with it; Lebasque travels to Italy later in the year.

1906 MAY 13

Matisse writes to Manguin that his work is going well.[133]

1906 MAY 15

Marquet's father dies.

1906 MAY 18

Matisse is in Biskra, "feasting [his] eyes." [134]

PLATE 101
Jean Puy
Le Bateau à la voile bleue
(*The Boat with the Blue Sail*),
1904
Oil on panel
18 1/8 x 14 1/4 in. (46 x 37.5 cm)
Private collection, Roanne,
France

From Paris, Friesz writes to Manguin, telling him that he has taken two of Manguin's paintings from Vollard's gallery for the Cercle de l'Art Moderne exhibition (opening May 26), along with works by Bonnard, Puy, and Valtat. All of the artists that Friesz had invited to participate will be included, with the exception of van Rysselberghe and Vuillard.[135]

1906 MAY 19–JUNE 2
Vuillard, Bernheim-Jeune.

1906 MAY 22
Kandinsky and Gabriele Münter arrive in Paris, renting an apartment at 12, rue des Ursulines. One month later they move to 4, petite rue des Binelles, Sèvres, where they remain until June 7, 1907. Kandinsky had known Purrmann, a close friend of Matisse's, since their days as students in Franz von Stuck's atelier. It is possible that Kandinsky meets the Steins in Paris through Purrmann.[136]

1906 MAY 24–JUNE 17
Seventy-three paintings and drawings by van Dongen, Kunstkring, Rotterdam.

1906 MAY 25
Friesz writes to Marquet from Le Havre that the exhibition of the Cercle de l'Art Moderne features a "stunning group of work." He has various offers for Marquet's works.[137]

1906 MAY 26–JUNE 30
Paintings by Braque, Derain, Dufy, Friesz, Manguin, Marquet, Matisse, Puy, Vlaminck, and others, Hôtel de Ville, Le Havre. Organized by Friesz for the Cercle de l'Art Moderne. Catalog text by Le Sieutre.

Matisse's two paintings—*La Plage rouge* (*The Red Beach*, 1905, plate 102) and *La Marine de Collioure* (*Seascape of Collioure*, location unknown)—sell for a total of 550 francs ($112.24).

The Cercle de l'Art Moderne had been founded in the spring. Charles Braque, Georges Braque's father, was among the nine founders, as was Georges Jean-Aubry, a close friend and biographer of Eugène Boudin. Braque, Dufy, and Friesz served on the painting committee.

1906 LATE MAY
Camoin's paintings of negresses are in

Wassily Kandinsky and his cat in Sèvres, France, photographed by Gabriele Münter, 1906–7

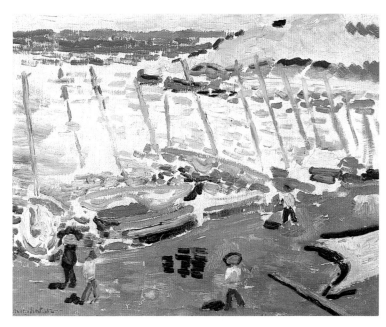

PLATE 102

the *Exposition Coloniale*, Marseille.

1906 LATE MAY–EARLY JUNE

Matisse writes to Manguin that *Le Bonheur de vivre* (plate 176) (he calls it his "grand tableau") is hanging on the left wall of Leo and Gertrude Stein's studio, at a height of twelve to fifteen feet. (Also installed in that room is Picasso's "le grand cheval" [large horse], according to Leo Stein, writing to Manguin at the end of May; this is Picasso's *Boy Leading a Horse*, 1905, private collection, New York.) The Steins have not yet purchased Matisse's painting, due to lingering questions about the effect of the San Francisco earthquake on their finances. According to Matisse, Gertrude Stein told him, "If our situation does not change, we will take the painting." The Steins seem to be pleased by how the painting looks in their studio, as are Terrus and Mme Matisse. Matisse encourages Manguin to go see it and give him his opinion.

Matisse also reports that he has sold to Shchukin a large still life, which he had found in the attic of his studio, plus a drawing and two lithographs.[138]

1906 MAY 31

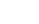

Friesz writes to Manguin from Le Havre that the exhibition there has been popular, with one hundred fifty people visiting the first day and twenty-five to thirty daily thereafter. The press has been critical. Friesz, Manguin, Marquet, and Matisse have sold works; offers have been made for Redon's and Vlaminck's paintings. Friesz writes that there are many interesting things to paint in Le Havre but that it is difficult to work and he is going to Antwerp soon.[139]

Le Havre

1906 JUNE

Signac urges Manguin to move to Saint-Tropez on a more permanent basis. He offers to sell Manguin his Peugeot—the celebrated model of the year in France—for 4,500 francs ($918.37).[140]

1906 JUNE 1

Sarah Stein writes to the Manguins from San Francisco that the family's af-fairs in the city are complicated; she and Michael will remain there for several months to settle them.[141]

1906 JUNE 12–SEPTEMBER 11

Braque and Friesz are in Antwerp. They stay at the Lusthof Frascati, Vlaamsch-Hoofd bij Antwerp (June 12–July 12), and the Pension Rosalie van der Auwera, Saint Anna Vlaamsch-Hoofd (August 11–September 11). It is not known where they stayed in Antwerp during July 13–August 10.[142]

Antwerp

1906 JUNE 17

Cross writes to van Rysselberghe: ". . . as soon as I could get a palette, I went to the nearest spot—the garden—in order to prove to myself that I still knew how to put a green next to a red, and especially to satisfy this feeling, this rutting that only painters know. This garden is all red—the flames of the geraniums which overstimulate the blue-green of the mimosas. It is in the midst of these ardors that I find calm."[143]

1906 June 18–EARLY July

Puy is in Doëlan (Finistère).

1906 SUMMER

Derain is in the Midi. He first visits the Auvergne, then Béziers, then Marseille, after which he discovers the port of L'Estaque, where he spends the rest of the summer. En route he loses all his baggage. In a letter to Vlaminck in Chatou, he calls the landscape stunning. He also writes, "I sense that I am orienting myself toward something better, where the picturesque would matter less than last year, in order to attend only to the question of painting."[144] L'Estaque at this time is a significant coastal tourist site, with at least six hotels.

L'Estaq

1906 LATE JUNE

Matisse writes to Manguin, urging him to visit Collioure. He has found a house for the Manguin family with a kitchen and a terrace that has a panoramic view of the boats, the sea, and the mountains. The rent is 200 francs ($40.82) for three months, which Matisse feels is reason-

able; he is paying 185 francs ($37.76) per month for himself, his wife, and their three children at a hotel in Collioure.

Matisse describes his routine in Collioure: he and his wife leave at six each morning to go to a forest near the mountain; there she poses peacefully and they have not been disturbed. He can work only until ten or eleven in the morning because of the intense heat. He reminds Manguin that Collioure "is just a village, whose only regular visitors are some lower-middle-class people from Perpignan; to go swimming, it is necessary to travel about one-half hour to a small pebble beach." [145]

1906 LATE JUNE–EARLY JULY

Manguin writes to Matisse that he will not go to Collioure right away as he is in the midst of making several paintings. He thinks that he and his wife might be able to leave Cavalière either sometime in July or spend the months of September and October with the Matisses. [146]

1906 EARLY JULY

Marquet is in Paris, caring for his mother, who has fallen ill following the death of his father. He is eager to go to Le Havre to paint. [147]

Signac, having driven his car from Saint-Tropez, visits with Camoin in Marseille. Later in the summer Camoin travels to Corsica.

1906 JULY 10

Mathan writes to Manguin from Paris that Rouault and Desvallières (both of whom had been in Moreau's studio in the 1890s with Marquet) have left Paris but that Girieud remains. Mathan has been drawing at the Palais de Justice and at executions and attending the debates about Alfred Dreyfus at the Cour de Cessation. Mathan observes that Camoin has decided to specialize in the study of boxing and that Cézanne told him that he was meant to do that. Mathan asks, "Old Cézanne, was he an ironist?"

According to Mathan, Matisse has written telling him that he is producing a significant number of paintings in Collioure. [148]

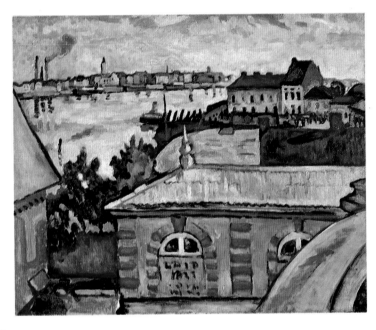

PLATE 103

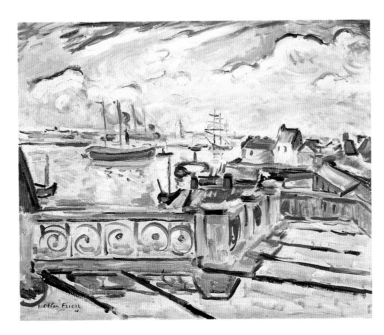

PLATE 104

PLATE 103
Georges Braque
Anvers
(*Antwerp*), summer 1906
Oil on canvas
23 ½ x 28 ¾ in. (59.7 x 73 cm)
Sara Lee Corporation,
Chicago

PLATE 104
Othon Friesz
Le Port d'Anvers
(*The Port of Antwerp*),
summer 1906
Oil on canvas
21 ¼ x 25 ⁹/₁₆ in. (54 x 65 cm)
Musée d'Art Moderne, Liège,
Belgium

PLATE 105
Henri Manguin
La Pinède à Cavalière
(*The Pine Forest at Cavalière*),
spring–summer 1906
Oil on canvas
25 ⁹/₁₆ x 31 ⁷/₈ in. (65 x 81 cm)
Private collection,
Avignon, France

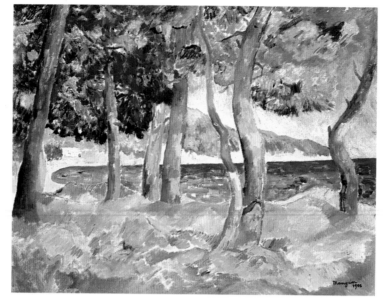

PLATE 105

Dufy painting in
Saint-Adresse, 1906

Marquet painting in
Saint-Adresse, 1906

1906 JULY 12

Matisse writes to Manguin, inquiring again whether he will come to Collioure. He has heard through Cross (who is spending the summer in Saint Clair [Var], near Le Lavandou) that Manguin had made some astonishing paintings. Matisse has been unable to paint for two weeks because of bronchitis.[149]

1906 JULY 12–AUGUST 14

Manguin and his family are in Collioure.

1906 JULY 13–17

Marquet joins Dufy in Le Havre and stays at the Hôtel du Ruban Bleu, place d'Arme. He finds the Norman coast very beautiful. Dufy's interest in the coast at Sainte-Adresse encourages both artists to paint there together; Dufy later recalled:

Toward 1905–6 I painted on the beach at Sainte-Adresse. Until then I had created beaches in the Impressionist style and I had reached the saturation point with them, understanding that in this manner of copying nature, I was moving toward infinity, in these meanderings and transient, minute details. I remained outside of the canvas. Having arrived before no matter which motif on the beach, I found a spot and began to exam-

ine my tubes of paint and brushes. With these how can I attain not only what I see but that which is, that which exists for me, *my reality?* Here was the entire problem.... I began to draw, to choose in nature that which suited me.... From this day forward it was impossible for me to return to my sterile battles with the elements which offered themselves to me. It was no longer a question of representing these elements within the exterior form.[150]

Sometime in July or early August, Dufy and Marquet travel together to Trouville, Honfleur, Dieppe, and Fécamp.[151]

1906 JULY 14

On a postcard reproduction of a work by Abel Grimmer in the Musée Royal d'Anvers, Friesz sends greetings to Matisse and Manguin from Antwerp.[152]

1906 JULY 16

Puy writes to Manguin from Bénodet (Finistère), saying that he suffers from extraordinary inertia. He had moved to Bénodet from Doëlan because he found Doëlan unsuitable for painting and an unpleasant place to stay. In Bénodet he has found some exceptional motifs to paint, particularly views to be

Postcard from Manguin
to Matisse, from Antwerp,
with reproduction of
Abel Grimmer's *Le Printemps*
(Musée Royal d'Anvers)

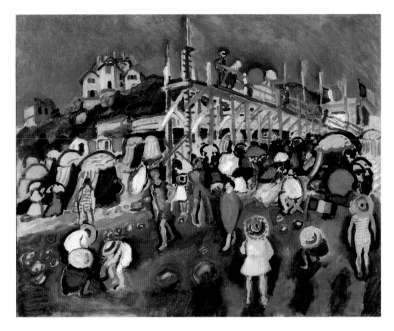

PLATE 106

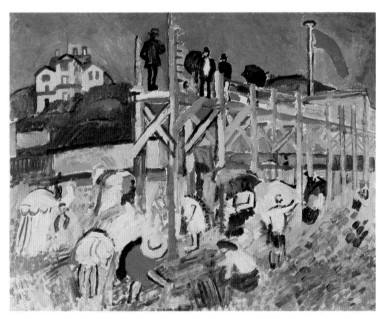

PLATE 107

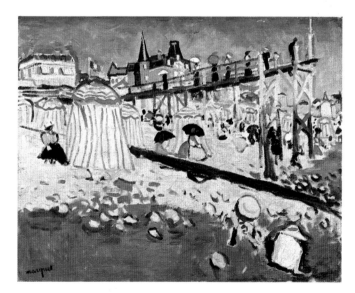

PLATE 108

PLATE 106
Raoul Dufy
La Plage à Sainte-Adresse
(*The Beach at Sainte-Adresse*),
1906
Oil on canvas
26 x 32 ¼ in. (66 x 81.9 cm)
Private collection,
Los Angeles

PLATE 107
Raoul Dufy
Sainte-Adresse, La Jetée
(*Sainte-Adresse, The Jetty*), 1906
Also known as *Boardwalk of
the Marie-Christine Casino
at Sainte-Adresse*
Oil on canvas
25 ⅝ x 31 ½ in. (65.1 x 80 cm)
Milwaukee Art Museum, gift
of Mrs. Harry Lynde Bradley

PLATE 108
Albert Marquet
La Plage à Sainte-Adresse
(*The Beach at Sainte-Adresse*),
1906
Oil on canvas
25 ⁹⁄₁₆ x 31 ⅞ in. (65 x 81 cm)
Former collection of Boris Fize

made on a boat in the Atlantic. Nonetheless, he has decided not to submit any works to the Salon d'Automne.[153]

1906 JULY 20
Derain signs a receipt for 1,800 francs ($367.34) for Vollard in exchange for twelve paintings of London.[154]

1906 AUGUST 10–LAST WEEK OF AUGUST
Marquet is in Fécamp, staying at 5, quai du Vicomte. He has gone there because he could not work easily in Le Havre, though he had found being there

fun. He wants to produce some paintings to show at the Salon d'Automne, but the bad weather is making that difficult.[155]

1906 AUGUST 26
Terrus writes to Manguin in Cavalière (where the Manguins remain until mid-September), regretting that he will not be able to visit Manguin in the Midi this summer and meet all of the painters who are working there. He mentions that Gustave Fayet, a collector with particularly strong holdings of work by Gauguin, and a M. Fabre (presumably another collector) have visited Collioure. Terrus plans to be in Paris in October.[156]

1906 POSSIBLY THE END OF SUMMER
Writing in 1929, Vlaminck recalled that he discovered *art nègre* at this time. He acquired two Dahomey statuettes and one from the Ivory Coast in exchange for buying drinks for customers in an Argenteuil café. Vlaminck also asserted that he received two masks and a statue from the Ivory Coast from a friend of his father; he sold the mask to Derain, after the latter had seen it over his bed, for 50 francs ($10.20).[157]

1906 BEFORE THE END OF AUGUST
Picasso returns from Gósol and replaces the face on Gertrude Stein's portrait with a mask (plate 98).

1906 LATE SUMMER–EARLY AUTUMN
After returning from the Midi, Derain leases a studio in Montmartre at the famed Villa les Fusains, 22, rue Tourlaque; this building had been a popular site for artists' studios since the late nineteenth century.[158]

1906 SEPTEMBER 10
Amélie Matisse and the Matisse children return to Paris.

1906 SEPTEMBER 15–21
Manguin learns from Marquet that Manguin is to serve, along with Lebasque and others, on the Salon d'Automne jury. Manguin plans to submit only six paintings to the Salon. Marquet urges Manguin to return to Paris as soon as possible, but neither Manguin nor Lebasque is able to get there in time to serve as jurors.[159]

1906 MID-SEPTEMBER–OCTOBER
Braque is in Paris, after staying with Friesz in nearby Durtal at the home of the painter Alexis Axilette.

1906 SEPTEMBER 20
Matisse writes to Manguin, concerned about getting Manguin elected a juror at the Salon d'Automne (since Matisse was in Collioure, he was unaware that this had already happened). Now that Matisse's family has left Collioure, he has been spending two nights a week with Terrus.[160]

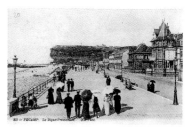

Fécamp

Matisse also writes to Marquet about Manguin's inability to return to Paris to be elected to the jury. Matisse feels that this is foolish. "It's modern to let them name you to the jury and not to go, that's the ultimate elegance. Doing this when one is in a period of battle as we are...." [161]

1906 SEPTEMBER 21

Marquet reports to Manguin about the submissions to the Salon d'Automne: Manguin's, Matisse's, and his own paintings met with great success, but Camoin had two paintings returned for retouching. Van Dongen, Dufy, and Friesz are also reworking most of their paintings, which Marquet found very attractive. Matisse had submitted five paintings. [162]

1906 SEPTEMBER 24–LATE OCTOBER

First Die Brücke exhibition of paintings, Lampen-Fabrik Seifert (a lamp factory), Dresden. The founders of Die Brücke were Fritz Bleyl, Erich Heckel, Ernst Ludwig Kirchner, and Karl Schmidt-Rottluff. In early 1906 Cuno Amiet, Nolde, and Max Pechstein joined the group.

1906 SEPTEMBER 28–OCTOBER 7

Manguin stops in Menton, en route to Paris.

1906 OCTOBER

Dufy moves to 15, quai Conti; Vlaminck resides at 20, avenue Victor-Hugo, Rueil.

Dufy, Galerie Berthe Weill.

1906 OCTOBER–FEBRUARY 1907

Braque stays in L'Estaque at the Hôtel Maurin.

1906 OCTOBER 6–NOVEMBER 15

Fourth Salon d'Automne, Grand Palais. There are 1,805 works by 532 artists. Includes retrospectives of Carrière, Gustave Courbet, and Gauguin as well as an exhibition of contemporary Russian art (the latter—organized by the emerging impresario Sergei Diaghilev—includes works from the eighteenth century through the Mir Iskusstva [World of Art] school of artists).

Among the Fauves and associated artists included are: Camoin (five), Czobel (six), Delaunay (two), Derain (eight, including one painting of London and five paintings of L'Estaque), Desvallières (eight), van Dongen (three), Dufy (seven), Friesz (four), Manguin (six), Marquet (eight), Matisse (five), Metzinger (two), Puy (ten), Valtat (ten), and Vlaminck (seven).

1906 AFTER OCTOBER 6

Derain carves two wooden bed panels (plate III) after seeing the Gauguin retrospective at the Salon d'Automne. He also begins carving "blocks of building stone" from the front steps of his family's house in Chatou. [163]

1906 OCTOBER 7

Cross writes to Manguin from Le Lavandou, where he has been without a model since October 2. He asks if the seventh volume of *Vers et prose* has appeared. [164]

1906 OCTOBER 22

Cézanne dies in Aix-en-Provence.

1906 OCTOBER 25–NOVEMBER 8

Roussel, Bernheim-Jeune.

1906 EARLY NOVEMBER–END OF THE YEAR

Derain, back in L'Estaque, writes to Vlaminck and asks him to purchase a copy of Alfred Jarry's 1896 play *Ubu roi* and send it to Derain. He also notes that Braque, Friesz, and Girieud are in L'Estaque and that most of the artists from the Salon des Indépendants are working in the region. Matisse spends eight days there en route to Collioure. Of Braque and Friesz, Derain observes: "Friesz, Braque are very happy. Their idea [about painting] is youthful and seems new to them." [165]

While in L'Estaque, Derain has considerable difficulty with his painting. Writing to Vlaminck, he comments: "I have reached a crisis.... Impossible to do something suitable." [166]

1906 NOVEMBER–SPRING 1907

Matisse returns to Collioure; Amélie

PLATE III

Collioure

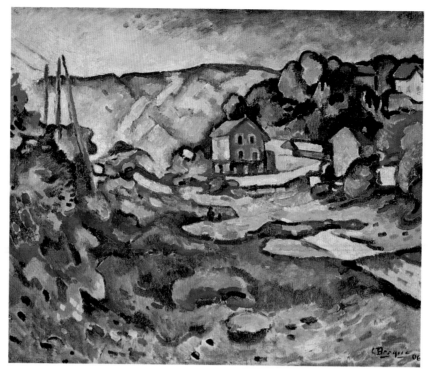

PLATE 112

PLATE 113

PLATE 112
Georges Braque
L'Estaque, autumn 1906
Oil on canvas
20 x 23 ¼ in. (50.8 x 60.3 cm)
New Orleans Museum of
Art, bequest of Victor K. Kiam

PLATE 113
Kees van Dongen
Blé et coquelicot
(*Corn and Poppy*), 1905
Oil on canvas
25 ⁹/₁₆ x 21 ⅛ in. (65 x 54.3 cm)
Galerie H. Odermatt–
Ph. Cazeau, Paris

and his daughter, Marguerite, join him in November. He frequently sees Maillol in neighboring Banyuls-sur-Mer. He paints *Nu bleu* (*Souvenir de Biskra*) (*Blue Nude* [*Souvenir of Biskra*], plate 221).[167]

1906 NOVEMBER 9–20
Forty-one works by Bonnard, Bernheim-Jeune.

1906 NOVEMBER 23
Fénéon, who serves as director of contemporary art at Bernheim-Jeune from November 1906 to 1924, buys a body of van Dongen's works.

1906 DECEMBER
Second Die Brücke exhibition, consisting of woodcuts, Lampen-Fabrik Seifert, Dresden.

1906 DECEMBER 4–30
Braut, Desvallières, Laprade, Rouault, and others, Galerie Berthe Weill.

1906 DECEMBER 14
Matisse writes from Collioure to Manguin, who is in Paris for the winter, offering his frank opinion of Manguin's recent work. Matisse evaluates the use of color and tone in Manguin's paintings and urges him to discuss his comments with Derain and Puy, who are well acquainted with his views.[168]

1906 DECEMBER 30
Manguin thanks Matisse for his evaluation. He discusses his goal of obtaining harmony and luminous expression in his paintings.

Manguin also mentions that Fénéon has associated himself with Bernheim-Jeune; his first project at the gallery will be to show the Neo-Impressionists. According to Manguin, Druet is disturbed by this, and he plans to show work by Manguin, Matisse, and their colleagues in a group exhibition the following March and to present an exhibition of work by Bonnard and his associates. Druet has also guaranteed Marquet 4,000 francs ($816.33) per year in order to have first choice of Marquet's works, which have sold very well through Weill and in Le Havre. Mar-

quet's paintings will be priced at 4,000 francs each for at least three years.[169]

1906 END OF THE YEAR
Marquet moves to 29, place Dauphine; his mother is living with him (through April).

1907
During the year Derain spends twenty-eight days in the army.

Friesz signs a contract with Druet.

Apollinaire moves to 9, rue Léonie, Montmartre, near the Bateau-Lavoir.

Valtat moves to a new studio in the place Constantin-Pecqueur.

1907 JANUARY 14–FEBRUARY 10
Delaunay (four), Metzinger (six), and others, Galerie Berthe Weill.

1907 JANUARY 19–31
Paintings and drawings by Lucie Cousturier, Galerie Druet.

1907 JANUARY 21–FEBRUARY 2
Eighty works by Signac, Bernheim-Jeune. Catalog text by Paul Adam.

1907 FEBRUARY–APRIL
Van Dongen, accompanied by Luce for a portion of his trip, visits Holland for two months.

1907 FEBRUARY 1–15
Seventy-six works by Picabia, Galerie Haussmann.

1907 FEBRUARY 2
Matisse and Terrus visit Prades (Pyrénées-Oriéntales).

1907 BY FEBRUARY 4
Vollard goes to Picasso's studio and purchases much of his Rose period work for 2,500 francs ($510.20).

1907 FEBRUARY 5–25
Fourth exhibition of the conservative Société des Peintres du Paris Moderne, Grand Palais.

1907 FEBRUARY 7
Matisse writes to Manguin from Narbonne about a frame for a nude he has

PLATE 114

PLATE 114
Axel Gallén-Kallela
(Finland, 1865–1931)
Maiden and Death in the Woods,
1895
Woodcut
6 1/2 x 4 5/8 in. (16.5 x 11.7 cm)
Los Angeles County Museum of Art
The Robert Gore Rifkind Center for German Expressionist Studies, purchased with funds provided by Anna Bing Arnold, Museum Acquisition Fund, and deaccession funds

Included in the portfolio accompanying the second Die Brücke exhibition, Dresden.

painted that is 54 5/16 by 35 5/8 inches (138 by 90 centimeters); no doubt this is *Nu bleu* (plate 221). He wants the frame to be three to four inches larger than that and a trefoil or Louis XVI frame. Manguin secures a Louis XV frame, and in a letter of about February 12 he promises that it will be ready about March 5 or perhaps slightly earlier.

Matisse plans to return to Paris in early March. (He may have returned to Collioure soon thereafter, as he is back in Collioure in mid-April.)[170]

1907 FEBRUARY 11–23
Thirty-nine works by Marquet, Galerie Druet.

Sales are very brisk. Many of the works are already in private collections and have been borrowed for the exhibition.

1907 FEBRUARY 12
Matisse, Amélie Matisse, and Terrus are in Vernet-les-Bains, where there is over eight feet of snow.[171]

1907 FEBRUARY 15–28
Luce, Bernheim-Jeune. Catalog text by Gustave Geffroy.

1907 FEBRUARY 16
Manguin reports to Matisse that Manet's *Olympia* is now on view next to Ingres's *Odalisque* in the Salle des Etats at the Louvre and that it looks stunning. He also mentions that Weill has sold one of Matisse's landscapes with red rocks.[172]

1907 AFTER MID-FEBRUARY
Gertrude and Leo Stein buy six paintings by Matisse from Druet, exchanging their Denis, Henri Fantin-Latour, and Adolphe Monticelli paintings as part of the transaction. Druet, Fénéon, and Vollard are arguing over who will show Matisse's work.

1907 FEBRUARY 22
Daniel-Henry Kahnweiler arrives in Paris from his native Mannheim, having spent several years working in London for his uncle, a financier with extensive South African investments. He intends to open an art gallery and begins meeting the Fauve artists.[173]

1907 EARLY MARCH
Picasso purchases two Iberian sculptures from Gery Pieret, Apollinaire's secretary. In August 1911 he learns that they had been stolen from the Louvre.

1907 MARCH
Paintings and ceramics by Vlaminck, Galerie Vollard.[174]

1907 MARCH–APRIL
Gauguin (seventy-two), Marquet (seven), Matisse (four), Puy (seven), Signac (four), Valtat (eight), and others, Galerie Miethke, Vienna. Catalog text by Rudolf Adalbert Meyer.

**1907 MARCH–LATE MAY
OR EARLY JUNE**
Matisse makes ceramics (plate 117) with André Méthey at his atelier in suburban

Louis XVI frame

PLATE 116

PLATE 117

PLATE 115
Henri Matisse
Nymph et satyre
(*Nymph and Satyr*), 1907
Triptych made for
Haus Hohenhof,
Hagen, West Germany
Glazed and painted tiles
Left panel: 23 1/16 x 15 9/16 in.
(58.5 x 39.5 cm)
Center panel: 22 1/4 x 26 1/8 in.
(56.5 x 67 cm)
Right panel: 22 7/16 x 14 15/16 in.
(57 x 38 cm)
Karl-Ernst Osthaus, Hagen

PLATE 115

Asnières; Derain and Vlaminck have been doing so since 1904. Some later accounts indicate that Vollard urged the artists to work with Méthey; others suggest that Méthey invited the artists himself. Matisse may have completed the ceramic triptych (plate 115) for Karl-Ernst Osthaus's Haus Hohenhof in Hagen, Germany, at this time.[175]

1907 MARCH 3–APRIL 3
Fourteenth exhibition of La Libre Esthétique, Brussels, includes Derain (four views of London that would subsequently be seen at the Toison d'Or, Moscow), Friesz (five), Girieud (six), Laprade (four), Vlaminck (five), and others. Catalog by Maus.

1907 MARCH 11
Redon sale, Hôtel Drouot.

1907 MARCH 20–APRIL 30
Twenty-third Salon des Indépendants, Serres du Cours de la Reine, Grand Palais. There are 5,406 works by more than 1,055 artists. Includes a memorial exhibition of the work of Cézanne. Matisse is on the hanging committee.

Matisse exhibits *Nu bleu* (plate 221), under the title *Tableau no. III*, along with five works on paper. Vauxcelles writes about *Nu bleu*: "I admit to not understanding. An ugly nude woman is stretched out upon grass of an opaque blue under the palm trees.... This is an artistic effect tending toward the abstract that escapes me completely." Derain exhibits his *Baigneuses I* (1907, plate 27), along with three paintings of L'Estaque and a portrait. Derain and Vlaminck (six) sell particularly well. Braque exhibits six paintings, five made at L'Estaque the previous autumn; five are purchased by Uhde, the sixth by Kahnweiler. Dufy exhibits six works, including four landscapes made in Normandy. Marquet shows three paintings, all of which belong to Druet. Delaunay is represented by a landscape study and five other works. Other artists included are Camoin (six), Auguste Chabaud (six), Czobel (six), Girieud (six), Herbin (six), Metzinger (six), Puy (six), and Valtat (six).

Vauxcelles describes the Fauve group within the Salon:

> A movement I consider dangerous (despite the great sympathy I have for its perpetrators) is taking shape among a small clan of youngsters. A chapel has been established, two haughty priests officiating, MM. Derain and Matisse; a few dozen innocent catechumens have received their baptism. Their dogma amounts to a wavering schematicism that proscribes modeling and volumes in the name of I-don't-know-what pictorial abstraction. This new religion hardly appeals to me. I don't believe in this Renaissance.... ¶ M. Matisse, fauve-in-chief; M. Derain, fauve deputy; MM. Othon Friesz and Dufy, fauves in attendance; M. Girieud, irresolute, eminent, Italianate fauve; M. Czobel, uncultivated, Hungarian or Polish fauve; M. Bérény, apprentice fauve; and M. Delaunay (a fourteen-year-old—pupil of M. Metzinger...), infantile fauvelet.[176]

In the Salon catalog Dufy lists his address as 73, rue de Normandie, Le Havre.

1907 SPRING
After possibly traveling to Le Havre to prepare for the Cercle de l'Art Moderne exhibition that is to open in early June, Braque and Friesz go to the south of France.

Derain convinces Picasso to visit the ethnographic museum at the Palais de Trocadéro.

1907 MARCH 25–APRIL 6
Ninety-five works by Seyssaud, Bernheim-Jeune.

1907 MARCH 30
Camoin, Cézanne, Derain, Dufy, Friesz, Manguin, Marquet, Matisse, and Puy, Galerie Berthe Weill.[177]

1907 APRIL
Vlaminck publishes his third novel, *Ames de Mannequins* (*Souls of Mannequins*), in collaboration with Fernand Sernada and a new editor, Pierre Douville, at the publisher Frères Offenbach, who accepted the manuscript but rejected Derain's illustrations. Vlaminck's two earlier novels, *D'un lit dans l'autre* (*From One Bed to Another*, 1902) and *Tout pour ça*

(*All for That*, 1903), were very successful. Both were illustrated by Derain.

Braque meets Kahnweiler; Kahnweiler had already met Picasso.[178]

1907 APRIL 2–MAY 10
Camoin, Friesz, and Marquet visit London; Marquet returns for another trip later that summer.[179]

Marquet writes to Manguin: "I am not liking much about the North. Sick with rheumatism and tired, I would return immediately if I still didn't have to see so many things. However, the weather is good, although cold, and life here is very amusing."[180]

1907 APRIL 8–20
Sixty-five works by Denis, Bernheim-Jeune.

Thirty-four works by Laprade, Galerie Druet.

1907 APRIL 14–JUNE 30
Seventeenth Salon, Société Nationale des Beaux-Arts, Grand Palais.

1907 APRIL 17
Derain writes to Kahnweiler, as he has heard that the dealer offered 100 francs ($20.41) for his painting *La Jetée de L'Estaque* (*The Jetty at L'Estaque*, location unknown); Derain says that 150 francs ($30.61) is his lowest price. Kahnweiler replies on the back of this letter, stating he would pay the 150 francs. Kahnweiler tells Derain that he saw at Puy's studio some of Derain's watercolors; he finds them "passionate" and says he would like to acquire one.[181]

1907 APRIL 22
Back in Collioure, Matisse writes to Kahnweiler that he agrees to sell him a drawing exhibited at the Salon (no. 1242) for the price listed; Kahnweiler may take the drawing at the close of the Salon.[182]

1907 APRIL 22–MAY 8
Eighty-five works by Cross, Bernheim-Jeune. Catalog text by Denis.

1907 APRIL 27
Picasso invites Gertrude and Leo Stein

to see his *Demoiselles d'Avignon* (1906–7, Museum of Modern Art, New York).[183]

1907 APRIL 30–MAY 19
Herbin, Tarkhoff, and others, Galerie Berthe Weill.

1907 MAY
Galerie Kahnweiler opens at 28, rue Vignon.

1907 MAY–EARLY SEPTEMBER
Braque and Friesz are in La Ciotat.

La Ciotat

1907 MAY 1
One hundred twenty-fifth exhibition, Société des Artistes Français, opens at the Grand Palais.

1907 MAY 14–ABOUT OCTOBER 20
The Manguins are in Saint-Tropez and at the Villa Demière in nearby Malleribes.

1907 MID-MAY–BEFORE SEPTEMBER 15
The Matisses are in Collioure. They are accompanied by a nineteen-year-old cousin of Matisse's who has been diagnosed as having a brain tumor and is paralyzed. Matisse paints *Les Aloès* (*The Aloes*, plate 121).

1907 MAY 23
Puy is in Bénodet.

1907 MAY 26
Matisse visits Amélie-les-Bains.

1907 EARLY JUNE
Second exhibition of the Cercle de l'Art Moderne opens, Le Havre. Included are Braque (two), Derain (two), Dufy (two), Friesz (two), Manguin (two), Marquet (two), Matisse (two), Vlaminck (two), and others. Catalog text by Ferdinand Fleuret.

1907 JUNE
Camoin travels to Seville and Grenada in Spain.

1907 JUNE 3–15
Bonnard, Denis, Maillol, Ranson, Roussel, Vallotton (twelve), Vuillard, and others, Bernheim-Jeune.

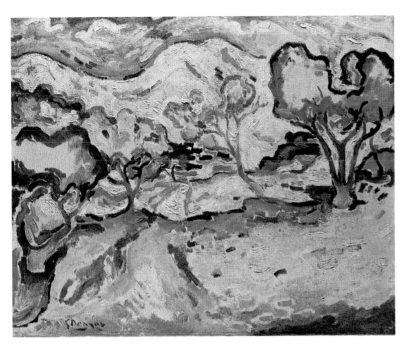

PLATE 118

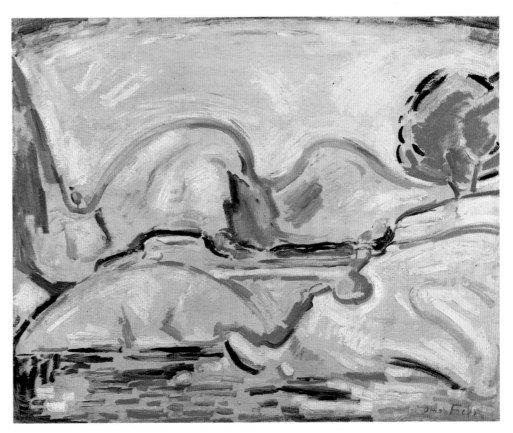

PLATE 118
Georges Braque
Paysage à La Ciotat
(*Landscape at La Ciotat*),
summer 1907
Oil on canvas
19 ⅝ x 23 ¾ in.
(49.9 x 60.3 cm)
The Wohl Family

PLATE 119
Othon Friesz
Paysage, La Ciotat
(*Landscape, La Ciotat*), 1907
Oil on canvas
25 ½ x 31 ½ in. (64.8 x 80 cm)
Fridart Foundation

PLATE 119

1907 JUNE 6

Marquet is in Fontainebleau, where he is disappointed by the weather. He hopes to leave by the end of the month.[184]

1907 JUNE 11

Manguin writes to Matisse that Fayet is selling many of the paintings that he had bought; the Steins have bought several through Fénéon. He also mentions that there is a new dealer, "a new German" (Kahnweiler), on the rue Vignon, who is paying the prices asked for paintings by Braque, Friesz, Marquet, and Puy.

Manguin adds that Cross's exhibition at Bernheim-Jeune sold well.[185]

1907 JUNE 13

Matisse writes to Fénéon from Collioure that he is sending him four canvases on which several small areas of red are not yet dry. He says that the weather has been bad in Collioure since his arrival from Paris.[186]

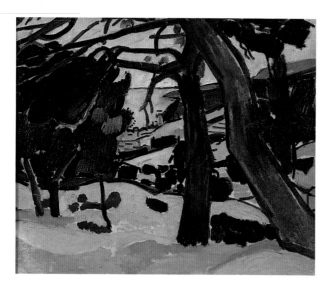

PLATE 120

1907 JUNE 17–29

Watercolors by Cézanne, Bernheim-Jeune.

1907 BY JUNE 17–END OF SUMMER

Derain stays at the Hôtel Cendrillon, Cassis. Periodically he goes to the bullfights in Marseille. He finds the landscapes there splendid, certainly more beautiful than those in Collioure. He writes to Vlaminck that he is content there. "There is a sweetness of tones, of smells, of an atmosphere of strangeness."[187]

During his stay he writes to Vollard to settle their account; a subsequent letter tallies the 6,100 francs ($1,244.90) owed Derain for twenty-six paintings of London, his work at the Salon d'Automne, the bed he carved for Vollard, and ceramics.[188]

1907 ABOUT JUNE 20

Matisse writes to Manguin that he is sending three or four paintings to Fénéon.[189]

1907 SUMMER

Kahnweiler buys several paintings from Vlaminck and Braque.

Derain signs a contract with Kahnweiler about this time.

Dufy paints his Pêcheurs à la ligne (Fishermen Angling) series during his summer stay in Sainte-Adresse.

Valtat travels to Normandy, Port-en-Bessin, and Arromanches.

Cassis

1907 SUMMER–LATE OCTOBER

Drawings by Rodin, Bernheim-Jeune.

1907 JULY–AUGUST

Van Dongen and others, Kunsthandel C. M. van Gogh, Amsterdam.

1907 JULY 9

Braque and Friesz are at the Hôtel Cendrillon, Cassis. They visit Derain during their stay.[190]

1907 JULY 12

Matisse signs receipt for Fénéon indicating that he has been paid 1,800 francs ($367.35) for four paintings.[191]

1907 JULY 13

Matisse writes to Fénéon that he is sending him several paintings. Included among these are *Les Aloès* (plate 121), a *Baigneuse* of the same price (which one is unclear), and *La Musique* (probably *Music [Sketch]*, 1907, Museum of Modern Art, New York) for 400 francs ($81.63) each.[192]

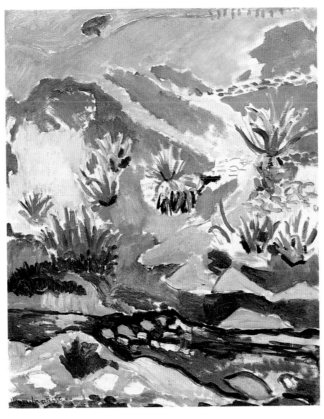

PLATE 121

The Matisse and
Michael Stein
families, probably
summer 1907

1907 JULY 14–ABOUT AUGUST 14
Matisse and Mme Matisse visit Italy, at
the urging of Leo Stein. En route to the
Steins in Fiesole, they visit Derain and
Girieud at Cassis, Braque and Friesz at
La Ciotat, Cross at Saint-Clair (Var),
and Manguin at Saint-Tropez. Derain
describes Matisse's visit to Vlaminck: "I
saw Matisse for the second time. He
came here with his wife, here, en route
to Italy. He showed me photos of his
canvases; they are completely stunning.
I believe that he is crossing the thresh-
old of the seventh garden, that of
happiness."[193]

While in Fiesole (about July 26–29)
the Matisses stay at the Hotel Italia.
They tour Florence, Siena (about Au-
gust 2), Arezzo, and Padua, then travel
up the Adriatic coast to Ravenna and
Venice (about August 6). Much later,
Matisse recalled: "Leo was at [my] heels
all the time except in front of great
works of art. He would then move a few
steps away and come back with the
question: 'What do you think of it?' 'I
could not reply,' Matisse continues.
'This manner of visiting museums para-
lysed me completely; so much so that I
couldn't see anything anymore, I looked
at things with the one idea that I'd have
to talk about them.'"[194] During his stay
with the Steins in Fiesole, Matisse meets
the aesthetician Walter Pach. At the
conclusion of this trip the Matisses re-
turn to Collioure.

1907 JULY 15–MID-AUGUST
Marquet is in London, staying at 44
Dean Street in Soho.

1907 AUGUST 8
Terrus is in Elne, awaiting Matisse's
return.[195]

1907 AUGUST 19–26
Marquet visits his ailing mother in Le
Teich (Gironde); she dies August 25 and
Marquet spends a short time in Saint-
Jean-de-Luz before returning to Paris.

1907 AUGUST 21
Matisse writes to Fénéon: "[I was] en-
chanted by my trip and my head is
stuffed with the many beautiful things I
saw in Italy."[196]

PLATE 120
André Derain
La Pinède à Cassis
(*The Pine Forest at Cassis*), 1907
Oil on canvas
21 ¼ x 25 ⁹/₁₆ in. (54 x 64 cm)
Musée Cantini, Marseille

PLATE 121
Henri Matisse
Les Aloès
(*The Aloes*), 1907
Also known as *The Brook
with Aloes, Collioure*
Oil on canvas
28 ⅞ x 23 ⅝ in. (73.4 x 50 cm)
The Menil Collection,
Houston

1907 AUGUST 29
Matisse writes to Vlaminck that "[I am] concentrating on my paintings." He plans to stay in Collioure until the end of October, though his wife will return in mid-September (in fact, Matisse returns with her). He urges Vlaminck to show good work at the Salon d'Automne.[197]

1907 LATE AUGUST
Kahnweiler receives recommendations from Derain (in Cassis), Friesz (in La Ciotat), and Braque (in L'Estaque) for their submissions to the Salon.[198]

1907 SEPTEMBER
Braque and Friesz return to Paris from the Midi. Braque may have seen Picasso's *Demoiselles d'Avignon* (1906–7, Museum of Modern Art, New York) at the Bateau-Lavoir shortly after returning to Paris, between September 23 and 25.[199] He is probably accompanied by Apollinaire.[200] According to Olivier, Braque tells Picasso, "You paint as if you wanted to force us to eat rope or drink paraffin."[201]

Van Dongen moves from the Bateau-Lavoir to the rue Lamarck.

Paintings and prints, Die Brücke, Richter Art Salon, Dresden.

1907 SEPTEMBER 1–OCTOBER 15
Salon des Peintres Divisionnistes Italiens, organized by Milan's Galerie d'Art, Serre de l'Alma, Cours de la Reine, Grand Palais. Catalog text by Achille Locatelli-Milesi.

1907 SEPTEMBER 3
Manguin writes to Vallotton from Saint-Tropez that he has sent four paintings to Fénéon for the Salon d'Automne and that he plans to spend the winter in Saint-Tropez.[202]

1907 SEPTEMBER 4
Puy writes to Manguin that Vollard has taken care of Manguin's submissions to the Salon d'Automne. Puy says that he has had difficulty painting all summer and has been relatively unproductive.[203]

1907 SEPTEMBER 8
Alice B. Toklas (who later becomes Gertrude Stein's companion) arrives in Paris.

1907 SEPTEMBER 11
Jeanne Manguin reports to Amélie Matisse that Manguin is sending four paintings to the Salon d'Automne and that Marquet has nothing to submit, as his mother has just died.[204]

1907 BY SEPTEMBER 15
The Matisses return to Paris, where they plan to stay until the end of December. While in Paris, Matisse makes faiences with Méthey.

1907 SEPTEMBER 15
Matisse writes to Manguin that Fénéon has bought two of Matisse's most recent paintings. He also mentions that he sold a large painting to the Steins, as well as a composition he calls *La Musique (Esquisse)* (*Music* [*Sketch*], 1907, Museum of Modern Art, New York), a still life, and a landscape.[205]

1907 SEPTEMBER 19
Marquet returns to Paris from the west coast of France following the burial of his mother.

1907 AUTUMN
Matisse paints the second version of *Le Luxe* (*Le Luxe II*, Statens Museum for Kunst, Copenhagen).

Matisse exchanges paintings with Picasso, giving him his *Marguerite* (1907, plate 122).

Dufy travels to Martigues and Marseille.

Mercure de France publishes Cézanne's correspondence with Bernard, which serves as the clearest statement published to date of Cézanne's ideas about composition and form.

1907 AUTUMN–SUMMER 1908
Max Pechstein, a member of Die Brücke in Dresden, lives in Paris and makes contact with Purrmann and van Dongen.

1907 BY SEPTEMBER 28–MID-NOVEMBER
Braque goes to L'Estaque, following the Cézanne retrospective at the Salon d'Automne.[206]

(from left to right) rear: Joseph Parayre (Amélie Matisse's father), Matisse, unknown, Amélie Matisse; center: Pierre, Jean, Marguerite Matisse; front: the painter Albert Huyot, 1907

PLATE 122
Henri Matisse
Marguerite, 1907
Oil on canvas
25 ⁹⁄₁₆ x 21 ¼ in. (65 x 54 cm)
Musée Picasso, Paris

PLATE 123
Georges Braque
Paysage à L'Estaque
(*Landscape at L'Estaque*), 1907
Oil on canvas
18 ⅛ x 14 ¹⁵⁄₁₆ in. (46 x 38 cm)
Private collection, Geneva

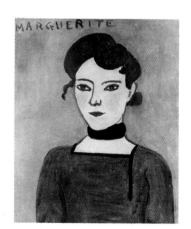

PLATE 122

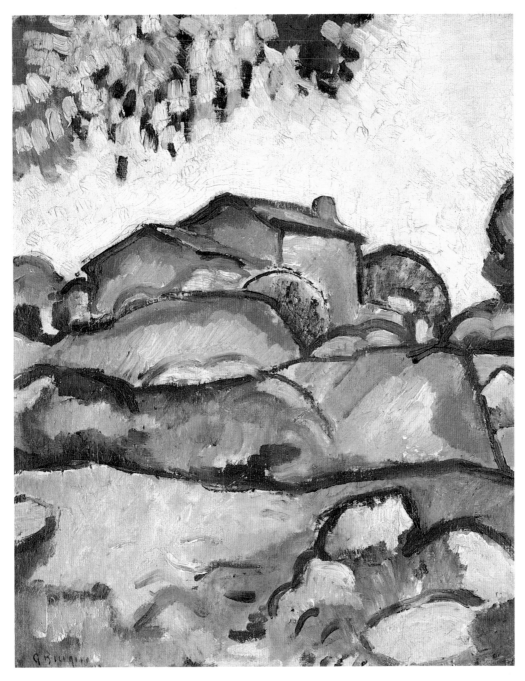

PLATE 123

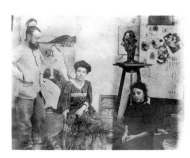

Henri, Amélie, and Marguerite
Matisse in front of *Le Luxe I*, 1907

1907 OCTOBER
Derain marries Alice Princet, and she moves to Villa les Fusains, 22, rue Tourlaque, in Montmartre, where Derain had already been living.

1907 OCTOBER–NOVEMBER
Marquet (two), Valtat (three), and others, Gallery Manes, Prague.

1907 OCTOBER 1–22
Fifth Salon d'Automne, Grand Palais. There are 1,748 works by more than 571 artists. Includes a retrospective of Cézanne's work, as well as a Belgian art exhibition and a group of Rodin's drawings. Matisse and Marquet serve as the Fauves on the jury. Many of the ceramics made at Méthey's by the Fauve painters are exhibited in a vitrine. Derain shows five paintings, among them three landscapes, including those painted at Cassis. Braque exhibits only one painting. Matisse exhibits *La Musique (Esquisse)* (*Music* [*Sketch*], 1907, Museum of Modern Art, New York); *Le Luxe I* (early 1907, Musée National d'Art Moderne, Centre Georges Pompidou, Paris); and *La Coiffure* (*The Hairstyle*, 1907, Staatsgalerie, Stuttgart, West Germany), all of which he labels as sketches, as well as four other paintings. Apollinaire refers to Matisse as the "fauve of fauves." [207] Dufy is represented by two paintings, Braque (one), Camoin (seven), Chabaud (five), Czobel (two), Delaunay (one), Friesz (five), Girieud (three), Herbin (two), Henri Le Fauconnier (two), André Lhote (three), Manguin (four), Marquet (two), Metzinger (two), Valtat (six), and Vlaminck (six). Works by Matisse and Derain are criticized for the ugliness of the models.

By this time the critic Michel Puy (brother of Jean Puy) considers the Fauve group to include Braque and Le Fauconnier. [208]

1907 OCTOBER 11
The Manguins plan to return to Paris around October 17 or 18 and stay there through mid-November. [209]

1907 OCTOBER 18
Vlaminck is invited to serve as *sociétaire*

at the Salon d'Automne, but the invitation is rescinded three days later, with considerable embarrassment on both sides. [210]

1907 OCTOBER 20
Dufy writes to Weill from Marseille:
> I have had more good weather in two days than during the entire summer in Le Havre. I have a room on the port, splendid view. I can work on the port. Life is not expensive.... You should be convinced that you have in Matisse, Vlaminck, Derain, Friesz, and others the types for tomorrow and for a long time; isn't this evident at the Salon? Compare the intensity of life, of thought that the paintings of these artists contain, to the quantity of boredom and uselessness contained in most other paintings. [211]

1907 OCTOBER 24–NOVEMBER 10
Camille Claudel, Manguin (eight), Marquet (ten), and Puy (fourteen), Galerie Eugène Blot, rue Richepanse. Catalog text by Vauxcelles. [212]

1907 NOVEMBER–DECEMBER
Matisse and Derain probably see *Demoiselles d'Avignon* (1906–7, Museum of Modern Art, New York) at Picasso's studio. [213]

1907 NOVEMBER 4–16
Thirty-nine works by Friesz (all painted in Normandy, Belgium, or near Marseille), Galerie Druet. Catalog text by Fernand Fleuret.

1907 NOVEMBER 14–30
Matisse (two) and others, group exhibition of flowers and still lifes, Bernheim-Jeune.

1907 NOVEMBER 15
La Phalange publishes the first full-length study of the Fauves, written by Michel Puy.

1907 DECEMBER
La Phalange publishes an interview with Matisse by Apollinaire.

Braque begins painting *Nu* (*Nude*, collection Alex Maguy, Paris), which he completes by June 1908.

Matisse (eight drawings) and others,

fourteenth Berliner Secession, Berlin.

1907 DECEMBER 8–15
Maillol, Galerie Druet.

1907 DECEMBER 8–SUMMER 1908
Manguin returns to Saint-Tropez, traveling via Lyon, Orange, and Arles. Bonnard stays at the Villa Demière during the summer.

1907 DECEMBER 28
Cross, writing to Angrand, mentions that he owns three Matisse oils, which he has had since 1906.[214]

1908
Matisse takes Shchukin to Picasso's studio.
 Shchukin acquires Matisse's *Panneau décoratif* (*La Desserte, harmonie rouge*) (*Decorative Panel* [*The Sideboard, Harmony in Red*], 1908, Hermitage Museum, Leningrad).

1908 JANUARY 6–18
One hundred paintings by van Gogh, Bernheim-Jeune.
 Thirty-five works by van Gogh, Galerie Druet.

1908 JANUARY 6–31
Marie Laurencin, Mathan, Metzinger, and others, Galerie Berthe Weill.

1908 JANUARY 10
Matisse opens his academy at the former Couvent des Oiseaux, where he has rented a studio since October 1905. The academy exists until the summer of 1911, although its activities diminish considerably after Matisse moves to the Paris suburb of Issy-les-Moulineaux in the autumn of 1909. Among his students are the American painters Patrick Henry Bruce and Max Weber, and Sarah Stein.[215]
 The photographer Edward Steichen writes to Alfred Stieglitz, owner of the Little Galleries of the Photo-Secession (known as 291) in New York:
 I have another cracker-jack exhibition for you that is going to be as fine in its way as the Rodins are. ¶ Drawings by Henri-Matisse—the most modern of the moderns—his drawings are the same to him & his painting as Rodin's are to his sculpture. Ask young [George] Of [a painter who acquired through Michael and Sarah Stein the first Matisse in America, *Nu dans la forêt* (*Nude in the Wood*), 1905, plate 22] about him. ¶ I don't know if you will remember any of his paintings at Bernheim's. Well they are to the figure what the Cézannes are to the landscape. Simply great.[216]

1908 JANUARY 27
Marquet moves into Matisse's former apartment on the fifth floor at 19, quai Saint-Michel, which Matisse had vacated because he needed larger quarters for his family.

1908 FEBRUARY 17–29
Thirty-six works by Vuillard, Bernheim-Jeune.

1908 FEBRUARY 18
Braque and Picasso make drawings of a deaf female model.
 Marquet urges Manguin to return to Paris from Saint-Tropez to serve as vice president at the Salon des Indépendants and to work on the placement of paintings. He wants this exhibition to be stunning, because it will be the last at the Grand Palais. The Serres, where the Salon has been held, is being torn down, and subsequent salons will be held at the Jardin des Tuileries.[217]

1908 MARCH
Camoin is living at 6, rue Mansart. Friesz moves back to 86, rue de Sèvres.
 Seascapes, landscapes, and still lifes by Vlaminck, Galerie Vollard.

1908 MARCH 1–APRIL 5
Fifteenth exhibition of La Libre Esthétique, Brussels, includes Valtat (three) and others. Catalog by Maus.

1908 MARCH 2–14
Fifty-one landscapes and still lifes by Seyssaud, Bernheim-Jeune.

1908 MARCH 2–28
Twenty-seven paintings by van Dongen, Galerie Kahnweiler. Catalog text by Saint-Georges de Bouhélier.

Sergei Shchukin

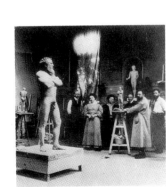

Henri Matisse's sculpture class in the Hôtel Biron (formerly the Couvent du Sacré Coeur), c. 1909 (left to right): Jean Heiberg, unknown woman, Sarah Stein, Hans Purrmann, Matisse, Patrick Henry Bruce

View from Henri Matisse's quai Saint-Michel studio

1908 MARCH 20–MAY 2

Twenty-fourth Salon des Indépendants, Serres du Cours de la Reine, Grand Palais. There are 6,701 works by more than 1,314 artists, including Braque (four plus one not shown in the catalog), Camoin (six), Chabaud (six), Derain (eight), van Dongen (six), Dufy (six), Friesz (six), Manguin (six), Marquet (six), Vlaminck (six), and others. Derain is a member of the executive committee. Matisse does not exhibit. In his review Apollinaire says that Braque's work is the most original effort of the Salon.[218] Even though Matisse does not exhibit, Vauxcelles refers to him and to Picasso, another nonexhibitor, as "barbarous 'schematizers.' The primary school Metaphysicians who want to create an 'abstract art.'... The two excellent painters that MM Matisse and Picasso were—and will be (for nothing has been lost)—have truly brought about ravages in the naïve brains of their young successors."[219]

Derain, in viewing the Salon, comments on the work of Henri Rousseau, "It seems hardly worthwhile searching and using technical training, when a person so simple, so pure, such a dope, in fact, can succeed in giving such an impression; his work is the triumph of the dopes."[220]

1908 AFTER MARCH 20

The American writer Gelett Burgess begins conducting interviews with the individual Fauve artists, others associated with them, and Picasso, as part of an article he publishes in *Architectural Record* in May 1910.

1908 SPRING

The state closes the Couvent des Oiseaux. Matisse and Rodin move to the Hôtel Biron at 33, boulevard des Invalides (which later became the Musée Rodin). The Hôtel was available to artists because the government had seized the property (formerly the Couvent du Sacré Coeur) in 1904.[221]

Hôtel Biron

1908 APRIL 6–18

Twenty-seven paintings and drawings by Camoin, Galerie Kahnweiler.

1908 APRIL 6–25

Drawings, lithographs, watercolors, and etchings by Matisse, Little Galleries of the Photo-Secession (known as 291), 291 Fifth Avenue, New York.

1908 APRIL 9

Valtat leaves Saint-Raphaël to go to Paris.

1908 APRIL 15–June 30

Eighteenth exhibition of the Société Nationale des Beaux-Arts, Grand Palais. Includes Constantin Brancusi, Duchamp-Villon, František Kupka, Amédée Ozenfant, Gino Severini, Seyssaud, and others.

1908 APRIL 18–May 24

Braque (five), Derain (six paintings, including four views of London), van Dongen (four), Friesz (three), Girieud (seven), Manguin (two), Marquet (three), Matisse (five), Metzinger (five), Puy (three), Valtat (two), and others, Salon de la Toison d'Or, Moscow.

1908 APRIL 27

Burgess and his companion, Inez Haynes Irwin, visit Braque's studio in Paris.[222]

1907 APRIL 27–MAY 16

Van Rysselberghe, Bernheim-Jeune.

1908 MAY–late NOVEMBER

Derain is in Martigues, staying at the Maison Chassaigne, rue Lamartine. He writes to Vlaminck in Chatou: "I am going to work seriously, and essentially become a painter again. In short, it is very difficult to make paintings in Paris. One loses any point of contact. And I believe that here is the only place where all one has are the sensations of a painter."[223] Derain does go to Paris at least once during the period, visiting Picasso in La Rue des Bois (a town approximately twenty-seven miles [forty-three kilometers] north of Paris) sometime between August and early September.[224]

Martigues

1908 AFTER MAY 2

Braque goes to Le Havre to help orga-

nize the Cercle de l'Art Moderne exhibition.[225]

1908 MID-MAY–BY SEPTEMBER 25
Braque makes his third trip to L'Estaque. He writes to Kahnweiler that he is "well begun with his work." According to Kahnweiler, Braque went south by bicycle, sending his belongings and painting supplies by mail. Braque writes to Kahnweiler, "I reached port safely after a rather good crossing and was able to set to work right away." He stays at the Hôtel Maurin.[226]

1908 MAY 20
Derain writes to Vollard, asking that he give 100 francs ($20.41) to Derain's friend (unidentified).[227]

1908 MAY 27
The Belgian architect Henry van de Velde, who is designing Osthaus's house in Hagen, Germany, writes to Osthaus that he will soon design the installation of Matisse's tile triptych (plate 115), which had already arrived in Hagen.[228]

1908 JUNE
Third exhibition of Cercle de l'Art Moderne, Hôtel de Ville, Le Havre. Includes works by Braque (two), Derain, van Dongen, Dufy, Friesz, Marquet, Matisse, and Vlaminck. Catalog text by Apollinaire.

A conference on musical poetry is held in conjunction with the exhibition.[229]

1908 JUNE 1–20
Girieud and others, Galerie Berthe Weill.

1908 JUNE 6
Matisse is in Dieppe.

Marquet and Manguin are visiting Gertrude and Leo Stein and Signac in Fiesole. They travel on to Naples and throughout Italy through mid-July.[230]

1908 MID-JUNE
Matisse makes an eight-day trip to Germany with Purrmann, now one of the students in Matisse's academy; they visit Speyer (Purrmann's native city), Munich, Nuremberg, and Heidelberg. Ma-

L'Estaque

tisse writes from Speyer (June 12) to Manguin in Naples that the beer and the cigars are good, but he has doubts about the wine; he sends a similar card on the same day to Leo and Gertrude Stein in Fiesole. From Munich (June 15) he adds that the women are round and pretty. Amélie is in Perpignan with her ailing mother.[231]

1908 ABOUT JUNE 15–EARLY DECEMBER
Cross and his wife travel to Italy.[232]

1908 SUMMER
Dufy joins Braque in L'Estaque.

Braque possibly visits Derain in Martigues.

1908 JULY
Druet is in Naples.

1908 JULY 3–20
Camoin (two), Friesz (three), Girieud (three), Francis Jourdain, Laprade, Manguin (three), Marquet (three), and others, Galerie Druet. According to the catalog, this exhibition was to be held at Druet's new gallery on 20, rue Royale, but the new space was not yet finished.

1908 JULY 17
Derain writes to Vollard, requesting that the dealer send him money.[233]

1908 JULY 18–27
Puy is in Brittany, then returns to Paris.

1908 JULY 27–LATE AUGUST
Matisse is in Paris and has been frequenting the Bal Tabarin, a popular café and dance hall. Amélie is back in Perpignan for her mother's burial.

1908 AUGUST–EARLY SEPTEMBER
Picasso and Olivier visit La Rue des Bois.

1908 AUGUST 12–13
Marquet is in Cassis, on his way back to Paris.[234]

1908 AUGUST 22
Vollard writes to Vlaminck, asking the artist to let Vollard know if he has paint-

ings ready and needs money. Vollard has arranged for Vlaminck's submissions to the Salon d'Automne to be framed about September 10, and he asks Vlaminck to give the framer the paintings' titles prior to the Salon.[235]

1908 AUGUST 24
Marquet and Matisse visit the Bal Tabarin together.

1908 FROM AUGUST 28
Marquet paints for several days in Poissy, staying at the Hôtel de Rouen.[236]

1908 SEPTEMBER
According to Gertrude Stein, Matisse takes Shchukin to Picasso's studio, where he sees *Demoiselles d'Avignon* (1906–7, Museum of Modern Art, New York).[237]

Paintings and prints, Die Brücke, Richter Art Salon, Dresden. Includes at least sixteen works by Fauve artists, including van Dongen, Friesz, Marquet, and Vlaminck.

1908 SEPTEMBER 1
Druet's new gallery on the rue Royale is nearly complete, scheduled to open September 28.

1908 SEPTEMBER 2–5
Matisse joins Marquet in Poissy to fish, go boating, and ride horses.

1908 SEPTEMBER 20
Marquet and Matisse, traveling to Madrid, visit Saint-Sébastian. En route they may first have stopped in Collioure.

1908 SEPTEMBER 23
Marquet and Matisse are in Bordeaux, en route to Dakar. Marquet writes, "We are going to attend the opening of the Salon d'Automne with negresses."[238]

1908 SEPTEMBER 24–BY OCTOBER 3
Marquet and Matisse are in Dakar.

1908 OCTOBER 1–NOVEMBER 8
Sixth Salon d'Automne, Grand Palais. There are 2,107 works by more than 644 artists. Special exhibitions at the Salon include several works by El

Greco, a group of works by Denis, a retrospective devoted to the work of Monticelli, and a number of frescoes by Piot. Matisse has his own section, exhibiting eleven paintings, six drawings, and thirteen sculptures that are not for sale. Matisse's section elicits a very positive response from the critics.[239] Also included are: Camoin (five), Chabaud (two), Derain (six), Friesz (six), Girieud (seven), Le Fauconnier (one), Manguin (one), Marquet (six), Puy (five), Valtat (six), and Vlaminck (six).

Matisse and Marquet (vice president) served as jury members, and the number of works that Matisse was permitted to show was unlimited. Among the works rejected were six by Braque, although Marquet, as the jury's vice president, chose to save one Braque from rejection. Matisse was among the jurors voting against them; he had seen many of Braque's most recent paintings of L'Estaque at Picasso's studio. Although two were subsequently admitted, Braque removed all of his entries from the Salon and showed them later that autumn at Kahnweiler's.

1908 OCTOBER 4
Marquet and Matisse are in Fontainebleau.

1908 OCTOBER 10
Marquet returns to Paris.

1908 OCTOBER 12–24
Twenty-three works by Toulouse-Lautrec, Bernheim-Jeune.

1908 OCTOBER 19
Apollinaire writes to Braque, telling him that Kahnweiler has asked him to write the preface to the catalog of Braque's forthcoming exhibition. He asks whether Braque agrees. Apollinaire declares, "I will be very happy to say the best that I think of an artist whose talent and character I admire."[240]

1908 OCTOBER 25–NOVEMBER 14
Paintings by Girieud and others, Galerie Kahnweiler. Catalog text by Morice.

PLATE 124
Maurice de Vlaminck
Guillaume Apollinaire, c. 1903
Oil on canvas
21 ¼ x 17 ½ in. (54 x 44.4 cm)
Marion and Nathan Smooke

Dakar

PLATE 124

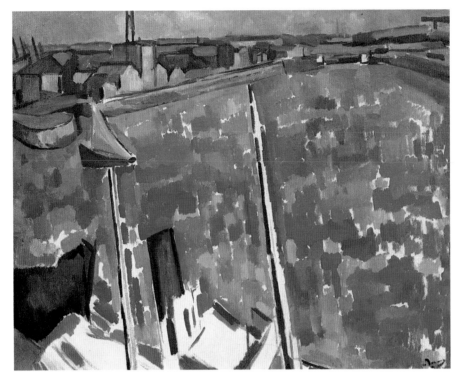

PLATE 125

PLATE 125
André Derain
Martigues, 1908
Previously known as *Le Havre*
Oil on canvas
28 ⅞ x 35 ⅞ in.
(73.4 x 91.1 cm)
Perls Galleries, New York

PLATE 126
Marie Laurencin
(France, 1885–1956)
Group of Artists, 1908
Detail of Henri Rousseau
Oil on canvas
25 ½ x 31 ⅞ in. (64.8 x 81 cm)
The Baltimore Museum of Art,
the Cone Collection, formed by
Dr. Claribel Cone and
Miss Etta Cone of Baltimore,
Maryland, BMA 1950.396

Galerie Kahnweiler
28, Rue Vignon, 28

Exposition
≋ Georges
Braque ≋

Du 9 au 28 Novembre 1908

1908 OCTOBER 26–NOVEMBER 8
Paintings, drawings, and watercolors by
Francis Jourdain, Galerie Druet.

1908 NOVEMBER 9–21
Paintings, pastels, drawings, and litho-
graphs by Redon, Galerie Druet.

1908 NOVEMBER 9–28
Twenty-seven works from 1906–8 by
Braque, Galerie Kahnweiler. Catalog
text by Apollinaire.
 Matisse's comment about Braque's
painting "cubes" appears in Vauxcelles's
review of the exhibition. Vauxcelles
calls Braque "a very daring man.... He
creates metallic and deformed figures
that are terribly simplified. He despises
form, reducing everything, site and fig-
ures and houses, to some geometric
schemes, to cubes." [241]

1908 NOVEMBER 11–24
Seventy-five works by Vuillard,
Bernheim-Jeune.

1908 NOVEMBER 12
The *Nation* publishes the art historian
Bernard Berenson's letter to the editor
concerning Matisse: "I have the convic-
tion that he [Matisse] has, after twenty
years of very earnest searching, at last
found the great highroad [*sic*] traveled by
all the best masters of the visual arts for
the last sixty centuries at least.... He is
a magnificent draughtsman and a great
designer." [242]

1908 NOVEMBER 21 OR 28
At Picasso's studio, Picasso and Olivier
host a banquet honoring Rousseau. Apol-
linaire, Braque, Friesz, Marie Lauren-
cin, André Salmon, Gertrude Stein,
and many others attend. Rousseau tells
Picasso, "You and I are the greatest
painters of our time, you in the Egyp-
tian style, I in the modern." [243]

**1908 BY NOVEMBER 22–LATE
NOVEMBER**
Braque is in Le Havre. [244]

1908 NOVEMBER 23–DECEMBER 5
Seventy-one works by Denis, Galerie
Druet.

PLATE 126

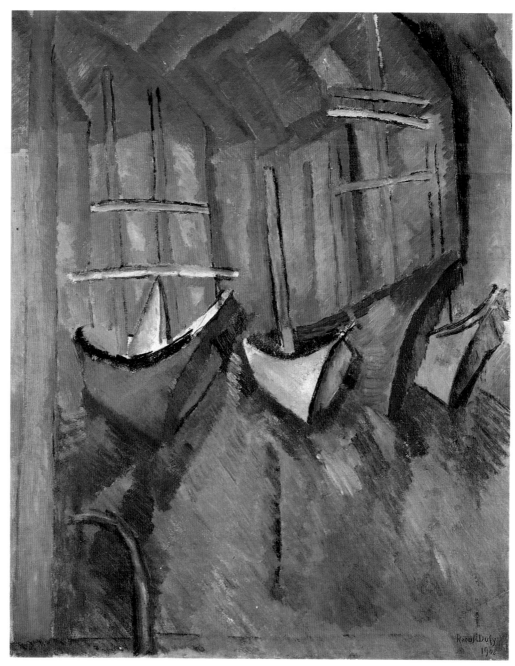

Plate 127

1908 NOVEMBER 25–DECEMBER 12
Eighty-nine works by van Dongen, Bernheim-Jeune. Catalog text by Marius and Ary Leblond.

1908 NOVEMBER 26
Matisse writes to Fénéon regarding a canvas of a bacchante and a faun. The price is 2,500 francs ($510.20). He is waiting for Fénéon to respond before he gives him prices on several other canvases.[245]

1908 LATE NOVEMBER–BEFORE DECEMBER 4
A farewell banquet given by Rousseau in honor of Max Weber is attended by Apollinaire, Picasso, and Olivier.[246]

1908 BY DECEMBER
Matisse discusses Henri Bergson's *Creative Evolution* with Matthew Stewart Prichard, an English student of philosophy who worked for the Museum of Fine Arts in Boston.

1908 DECEMBER 11–31
Manguin', Marquet, Matisse, and Puy, Galerie Berthe Weill.

1908 DECEMBER 14–JANUARY 9, 1909
One hundred seven works by Seurat, Bernheim-Jeune.

1908 DECEMBER 21–END OF THE MONTH
Matisse is in Berlin with Purrmann to install an exhibition at Paul Cassirer's gallery. Negative advance criticism in the press prompts Cassirer to refuse to hang some of Matisse's paintings; he puts the others in a vestibule. The Leipzig *Kunstchronik*'s critic comments, "I stand speechless in front of these extravaganzas and, I confess it openly, have only one feeling in response to them: a huge, irrepressible impulse to laugh!" The paintings are taken down as soon as Matisse and Purrmann leave Berlin. Before the removal of the paintings occurred, however, the German Expressionist painter Ernst Ludwig Kirchner, in Berlin in January 1909, sees Matisse's exhibition.

During this trip Matisse meets Henry van de Velde and the German painter Max Liebermann; Liebermann calls Matisse and Purrmann Don Quixote and Sancho Panza. En route back to Paris, Matisse and Purrmann stop in Hagen to see Osthaus, then spend Christmas with Oskar and Greta Moll. Shortly after his return to Paris, Matisse receives a laurel wreath with a card, "To Henri-Matisse, triumphant on the battlefield of Paris," from Thomas Whittemore, an American professor who subsequently would unearth the mosaics at the Hagia Sophia in Constantinople.[247]

1908 DECEMBER 21–JANUARY 15, 1909
Braque (six), Derain (three), Dufy (four), Herbin (four), Metzinger (two), Picasso (two), and others, Galerie Notre-Dame-des-Champs, 73, rue Notre-Dame-des-Champs.

1908 DECEMBER 21–JANUARY 16, 1909
Friesz, Manguin, Marquet, Mathan, and Puy, Galerie Druet.

1908 DECEMBER 25
Matisse publishes "Notes of a Painter" in *La Grande Revue*, partly motivated by Péladan's negative review of his work at the Salon d'Automne. Péladan wrote: "Each year it becomes more difficult to speak of these people who are called *les fauves* in the press. They are curious to see beside their canvases. Correct, rather elegant, they might be taken for department-store floorwalkers. Ignorant and lazy, they try to offer the public colorlessness and formlessness."[248]

Matisse's essay indicates that he sought expression in his work above all else. He discusses the organization of his compositions and especially the tonalities and modeling of his forms. He demonstrates the lessons he has applied from the art of the past to his own work.[249]

PLATE 127
Raoul Dufy
Bateaux à L'Estaque
(*Boats at L'Estaque*), 1908
Oil on canvas
21 ⅝ x 18 ⅛ in. (55 x 46 cm)
Musée des Beaux-Arts, Nice, France, gift of Mme Dufy, 1962

Much of the documentation used to compile this chronology comes from the families of the Fauve artists. As is evident from the notes that follow, I am indebted above all to Jean-Pierre Manguin and his family for their devotion to amassing the most complete collection of primary source material on this period and for sharing it with me.

Unless otherwise noted, all translations are by myself and Catherine Cottet.

1. Matisse, in Nigel Gosling, *Paris 1900–1914: The Miraculous Years* (London: Weidenfeld and Nicolson, 1978), p. 85. See also the comments on his studio recorded by Pierre Courthion and cited in Pierre Schneider, *Matisse* (New York: Rizzoli, 1984), p. 429.

2. Puy to Manguin, from Paris, January 31, 1904, Jean-Pierre Manguin, Avignon, France.

3. "La Société des Artistes Indépendants, basée sur la suppression des Jurys d'admission, a pour but de permettre aux artistes de présenter librement leurs oeuvres au jugement au public." Paris, Grand Palais, *20ème Salon des Indépendants*, exh. cat., 1904.

4. Francis Jourdain, *Sans remords ni rancune* (Paris: Correa, 1953), p. 267.

5. Roger Benjamin, "Une Copie par Matisse du *Balthazar Castiglione* de Raphaël," *La Revue du Louvre et des Musées de France* 35 (October 1985): 275–77.

6. *Registres des copistes*, Archives des Musées Nationaux, Palais du Louvre, Paris, LL31, pp. 123ff.

7. "La peinture de M. Matisse témoigne du plaisir qu'il trouve aux couleurs, aux tons, à leurs relations, mais ces relations ne sont significatives que d'elles-mêmes...." Charles Morice, "Art moderne," *Mercure de France* 51 (August 1904): 533.

8. "m'a fait très bonne impression." Mathan to Manguin, from Saint-Lô, June 10, 1904, Jean-Pierre Manguin, Avignon.

9. Manguin to Matisse, postcard from Barneville-sur-Mer (Manche), [late June 1904], Jean-Pierre Manguin, Avignon.

10. Marquet to Manguin, from Paris, [early July 1904]; Matisse to Manguin, from Paris, July 11, 1904; both Jean-Pierre Manguin, Avignon.

11. Cross to Angrand, July 7, 1904; in Catherine C. Bock, *Henri Matisse and Neo-Impressionism, 1898–1908* (Ann Arbor, Mich.: UMI Research Press, 1981), p. 67.

12. Matisse left Paris on July 11, according to Schneider, *Matisse*, p. 135 n. 36.

13. John Elderfield, *Matisse in the Collection of the Museum of Modern Art* (New York: Museum of Modern Art, 1978), p. 36. For an analysis of the Matisse and Signac relationship, see Bock, *Matisse and Neo-Impressionism*, p. 139 n. 9. See also Isabelle Monod-Fontaine, Anne Baldassari, Claude Laugier, *Matisse* (Paris: Musée National d'Art Moderne, Centre Georges Pompidou, 1989), p. 28.

14. "Matisse l'anxieux, le follement anxieux." Cross to Théo van Rysselberghe, September 7, 1904, van Rysselberghe archives, Paris; in Alfred H. Barr, Jr., *Matisse: His Art and His Public* (New York: Museum of Modern Art, 1951), p. 53.

15. Marquet to Manguin, from Paris, dated Saturday [July 16], postmarked July 17, 1904, Jean-Pierre Manguin, Avignon.

16. "des lettres désolées." Marquet to Manguin, from Paris, August 8, 1904, Jean-Pierre Manguin, Avignon.

17. Manguin to Matisse, from La Percaillerie, August 17, 1904, Jean-Pierre Manguin, Avignon.

18. "faite au coucher du soleil qui me satisfasse un peu et encore je ne me figure pas que c'est moi qui l'ai faite quoique je l'ai menée en une dizaine de séances, il me semble que c'est par hasard que j'ai eu le résultat." Matisse to Manguin, from Saint-Tropez, [early September 1904], Jean-Pierre Manguin, Avignon.

19. "les propres paroles de Cézanne 'Organiser ses sensations'—'Moduler' et non 'Moduler.' Tu pourras couper le no. pour le lire—C'est très intéressant." Matisse to Marquet, from Saint-Tropez, [early September 1904], Marquet archives, Fondation Wildenstein, Paris.

20. Marquet was informed about the rejection of his illustrations in a letter from Charles-Louis Philippe to Marquet, from Paris, September 7, 1904, Marquet archives, Fondation Wildenstein, Paris. "le capitaine peloteur." Marquet to Manguin, from Paris, September 8, 1904, Jean-Pierre Manguin, Avignon.

21. "Là, tout n'est qu'ordre et beauté, / Luxe, calme, et volupté."

22. According to Marguerite Duthuit, in Questionnaire III, April 1950, Alfred H. Barr, Jr., archives, Museum of Modern Art, New York. See also Barr, *Matisse*, p. 54.

23. "plein d'allant et d'espoir." Maurice de Vlaminck, *Portraits avant décès* (Paris: Flammarion, 1943), p. 67.

24. Matisse to Roger Marx, from Paris, October 1, 1904, private collection, Paris.

25. "C'est le rêve." Manguin to Marquet, postcard from Saint-Tropez, postmarked October 4, 1904, Marquet archives, Fondation Wildenstein, Paris.

26. *L'Illustration*, October 15, 1904, p. 254.

27. Leo Stein, *Appreciation: Painting, Poetry, and Prose* (New York: Crown Publishers, 1947), p. 157.

28. Cross to Angrand, October 17, 1904, Angrand archives, Paris; in Bock, *Matisse and Neo-Impressionism*, p. 59.

29. Cézanne to Camoin, from Aix-en-Provence, December 9, 1904; in Paul Cézanne, *Letters*, ed. John Rewald, trans. Marguerite Kay (New York: Hacker Art Books, 1976), pp. 308–9.

30. Manguin to Faure, from Paris, December 14, 1904, Jean-Pierre Manguin, Avignon.

31. Piot to Manguin, from Paris, December 1, 1904, Jean-Pierre Manguin, Avignon.

32. Matisse, in Georges Duthuit, *The Fauvist Painters*, trans. Ralph Mannheim (New York: Wittenborn, Schultz, 1950), p. 42.

33. "Je suis bouleversé, je n'ai pu dormir de la nuit." Matisse, in Jeanine Warnod, *Le Bateau-Lavoir, 1892–1914* (Paris: Les Presses de la Connaissance, 1975), p. 52. Vlaminck describes the visit in similar terms in *Portraits avant décès*, p. 73.

34. Vollard to Marquet, from Paris, March 7, 1905, Marquet archives, Fondation Wildenstein, Paris.

35. "les plus loufoque et le plus laid et il avait fait ce choix en vue d'un cadeau destiné à son gendre." Vlaminck, *Portraits avant décès*, p. 76.

36. "le schéma d'une théorie." Maurice Denis, "La Réaction nationaliste," *L'Ermitage*, May 15, 1905.

37. "Le groupe de pointillistes et de confettistes ne se réduit pas; bien au contraire il lui vient de nouvelles adhésions, certaines qui comptent, celle par exemple de M. Henri Matisse....M. Matisse a été mal inspiré d'apporter au groupe—qui déjà en abondait—son talent." Charles Morice, "Le XXIe Salon des Indépendants," *Mercure de France* 54 (April 15, 1905): 542–43.

38. "toutes les nouvelles raisons de peindre....[Il] compri[t] tout de suite la nouvelle mécanique picturale." Dufy, in 1925, in Dora Perez-Tibi, *Dufy* (Paris: Flammarion, 1989), p. 19.

39. Lebasque to Manguin, from Paris, postmarked April 6, 1905, Jean-Pierre Manguin, Avignon.

40. "Camoin est, pour l'instant, celui qui, pour la vente, vient en tête; en second, Marquet." Berthe Weill, *Pan! Dans l'oeil!* (Paris: Lipschutz, 1933), p. 115.

41. Gertrude and Leo Stein to Manguin, from Paris, April 28, 1905, Jean-Pierre Manguin, Avignon.

42. Marquet to Manguin, from Paris, May 11, 1905, Jean-Pierre Manguin, Avignon.

43. Matisse to Manguin, from Perpignan, May 15, 1905, Jean-Pierre Manguin, Avignon.

44. Francis Jourdain to Manguin, from Nice, mid-May 1905, Jean-Pierre Manguin, Avignon.

45. Marc Lafargue, in Raymond Escholier, *Matisse: A Portrait of the Artist and the Man*, trans. Geraldine and H. M. Colvile (New York: Frederick A. Praeger, 1960), p. 66.

46. "des choses charmantes." Matisse to Manguin, from Collioure, May 20, 1905, Jean-Pierre Manguin, Avignon.

47. Marquet to Camoin, from Saint-Tropez, n.d.; in Danièle Giraudy, *Camoin: Sa vie, son oeuvre* (Marseille: "La Savoisienne," 1972), p. 100.

48. "J'ai fait sa connaissance assez intime et il est charmant." Matisse to Marquet, from Collioure, June 6, 1905, Marquet archives, Fondation Wildenstein, Paris.

49. Amélie Matisse to Jeanne Manguin, from Collioure, June 8, 1905, Jean-Pierre Manguin, Avignon.

50. "Suis enthousiasmé du pays et surtout de l'endroit où nous sommes." "continue à être très aimable. Je le vois le soir à

la petite goutte d'oxygénée." Manguin to Matisse, from Malleribes, June 9, 1905, Jean-Pierre Manguin, Avignon.

51. Signac to Matisse, from Saint-Tropez, [summer 1905]; in Françoise Cachin, *Paul Signac* (Greenwich, Conn.: New York Graphic Society, 1971), pp. 97–99.

52. Paris, Grand Palais, *Georges Braque*, exh. cat., 1973, p. xv; G. Habasque, *Les Soirées de Paris*, exh. cat. (Paris, 1954), p. 37; Jean Laude, *La Peinture française (1905–1914) et l'art nègre* (Paris: Klincksieck, 1968), p. 322.

53. "Marquet pense l'exposer l'année prochaine aux Indépendants sous ce titre *La Nouvelle Olympia*." (The current location of Marquet's painting is unknown.) "Je suis venu à Saint-Tropez dans la bonne intention de me rattraper et le temps se passe ici à sucer des pailles en attendant le soleil." Camoin to Matisse, from Saint-Tropez, June 28, 1905; in Danièle Giraudy, "Correspondance Henri Matisse–Charles Camoin," *Revue de l'art* 12 (1971): 10–11.

54. Matisse to Signac, from Collioure, [July 1905], Signac-Cachin archives, Paris; in Schneider, *Matisse*, p. 44.

55. Marquet to Jeanne Manguin, postcard from Saint-Raphaël, postmarked July 5, 1905, Jean-Pierre Manguin, Avignon.

56. Amélie Matisse to Jeanne Manguin, from Collioure, July 8, 1905, Jean-Pierre Manguin, Avignon.

57. Marquet to Manguin, from Agay, July 13, 1905, Jean-Pierre Manguin, Avignon.

58. Matisse to Signac, July 14, 1905, Signac-Cachin archives, Paris; in Schneider, *Matisse*, p. 98.

59. Marquet to Camoin, postcard from Saint-Tropez, [July 14, 1906]; in Giraudy, *Camoin*, p. 98.

60. "avec mon mari ils travaillent ferme malgré la forte chaleur." Amélie Matisse to Jeanne Manguin, from Collioure, July 15, 1905, Jean-Pierre Manguin, Avignon.

61. "une lumière blonde, dorée, qui supprime les ombres." Derain to Vlaminck, from Collioure, [summer 1905]; in André Derain, *Lettres à Vlaminck*, ed. Maurice de Vlaminck (Paris: Flammarion, 1955), p. 148.

62. Matisse to Bussy, from Collioure, July 15, 1905; in Bock, *Matisse and Neo-Impressionism*, p. 37.

63. "de plus en plus épatant." Marquet to Manguin, from Anthéor, July 25, 1905, Jean-Pierre Manguin, Avignon.

64. Derain to Vlaminck, from Collioure, July 28, 1905; in Derain, *Lettres à Vlaminck*, pp. 148, 162–63.

65. Matisse to Manguin, from Collioure, July 31, 1905, Jean-Pierre Manguin, Avignon.

66. Francis Jourdain to Manguin, from Paris, [late July–early August 1905], Jean-Pierre Manguin, Avignon.

67. "A propos de Matisse, Sérusier rapporte ce mot de Gauguin: 'Lorsqu'un gamin écrit *merde* sur un mur, il traduit un état d'âme; cependant, ce n'est pas une oeuvre d'art." Maurice Denis, *Journal* (Paris: La Colombe, 1958), vol. 2, p. 22.

68. Derain to Vlaminck, from Collioure, August 5, 1905; in Derain, *Lettres à Vlaminck*, pp. 159–60

69. Marquet to Claude Manguin, from Saint-Raphaël, postmarked August 8, 1905; Manguin to Marquet, from Cannes, postmarked August 15, 1905; Manguin to Matisse, from Malleribes, August 22, 1905; all Jean-Pierre Manguin, Avignon.

70. Marquet to Manguin, postcard from Menton, postmarked August 16, 1905; ibid., postmarked August 20, 1905; both Jean-Pierre Manguin, Avignon.

71. Manguin to Matisse, from Malleribes, August 22, 1905, Jean-Pierre Manguin, Avignon.

72. Marquet to Manguin, postcard from Menton, postmarked August 25, 1905, Jean-Pierre Manguin, Avignon.

73. Marquet's postcard to Manguin, ibid., announces Marquet's planned return to Saint-Tropez.
 In Lausanne, Fondation de l'Hermitage, *Albert Marquet, 1875–1947*, exh. cat., 1988, p. 39, it is incorrectly asserted that Matisse and his family were in Saint-Tropez when Marquet arrived. Matisse to Manguin, from Collioure, August 27, 1905, Jean-Pierre Manguin, Avignon, proves that this was not the case.

74. Matisse to Manguin, postcard from Collioure, August 28, 1905, Jean-Pierre Manguin, Avignon.

75. "ont fait des choses épatantes." Marquet to Manguin, postcard from Paris, postmarked September 8, 1905, Jean-Pierre Manguin, Avignon.

76. Matisse to Signac, from Paris, September 14, 1905, Signac-Cachin archives, Paris; in Schneider, *Matisse*, p. 262.

77. Ibid.; in Schneider, *Matisse*, cited incorrectly on p. 132 and correctly on p. 188.

78. Matisse to Manguin, from Paris, postmarked September 18, 1905, Jean-Pierre Manguin, Avignon.

79. Matisse to Bussy, from Paris, September 19, 1905 (copies at the Courtauld Institute of Art, University of London, and at the National Gallery of Art, Washington, D.C.); in Schneider, *Matisse*, pp. 188 and 262, who asserts that this was clearly *Le Port d'Abaill* [sic].

80. "le midi m'a été je crois d'un bon enseignement et reviens sinon content de moi d'au moins avec une grande impression de beauté et la compréhension de beaucoup de choses jusqu'alors inconnues." Man-guin to Matisse, from Malleribes, postmarked September 21, 1905, Jean-Pierre Manguin, Avignon.

81. Receipt signed by Derain and dated September 23, 1905, Vollard archives, Musée d'Orsay, Paris.

82. Matisse to Signac, from Paris, September 28, 1905, Signac-Cachin archives, Paris; excerpted in Schneider, *Matisse*, p. 188.

83. There has been considerable dispute over the actual date of this trip. For further discussion see Judi Freeman, "Far from the Earth of France: The Fauves Abroad," in this volume, pp. 177–213.

84. Louis Vauxcelles, "Le Salon d'Automne," *Gil Blas*, October 17, 1905.

85. "Je suis resté longtemps dans cette salle. J'écoutais les gens qui passaient, et lorsque j'entendis crier devant Matisse: 'C'est de la folie!' J'avais envie de répliquer: 'Mais non, Monsieur, tout au contraire. C'est un produit de théories.'" André Gide, "Promenade au Salon d'Automne," *Gazette des beaux-arts*, 3d per., 34 (December 1, 1905): 483.

86. "une émotion de nature." Maurice Denis, "De Gauguin, de Whistler, et de l'excès des théories," *L'Ermitage*, November 15, 1905.

87. "Il y a là mieux que des espoirs et des promesses. Et ces noms de jeunes quasi inconnus des snob que se pressent aux vernissages mondians, seront célèbres demain." Quoted in Warnod, *Le Bateau-Lavoir*, p. 77.

88. "M. Derain effarouchera; il effarouche aux Indépendants. Je le crois plus affichiste que peintre. Le parti-pris de son imagerie virulente, la juxtaposition facile des complémentaires sembleront à certains d'un art volontiers puéril; reconnaissons, cependant, que ses *Bateaux* décoreraient heureusement le mur d'une chambre d'enfant. M. Devlaminck [sic] épinalise: sa peinture, que a l'air terrible, est, au fond, très bon enfant." Vauxcelles, "Le Salon d'Automne," October 17, 1905.

89. "Ce qui nous est présenté, n'ayant—à part les matériaux employés—aucun rapport avec la peinture; de bariolages informés; du bleu, du rouge, du jaune, du vert; des taches de colorations crues juxtaposés au petit bonheur; les jeux barbares et naïfs d'un enfant qui s'exerce avec la 'boîte à couleurs.' . . ." M. Nicolle, "Le Salon d'Automne," *Journal de Rouen*, November 20, 1905, n.p.

90. Purrmann to Barr, 1950–51, Barr archives, Museum of Modern Art, New York; see also Barr, *Matisse*, p. 59.

91. Munich, Städtische Galerie im Lenbachhaus, *Alexej Jawlensky, 1864–1941*, exh. cat., 1983, p. 18.

92. "Dufy m'ayant exprimé le désir de faire partie de ce groupe, je accepte et en fais part Matisse qui, furieux, s'écrie: 'Ah! Non! ce petit jeune homme qui veut se faufiler parmi nous, nous n'en voulons pas! Mettez-le dans l'autre salle si vous voulez!' Pas commode notre cher espoir. Dufy est donc du groupe, sans y être, tout en y tant; il a sa petite exposition particulière dans l'autre salle." Weill, *Pan! Dans l'oeil*, p. 119.

93. Claribel Cone, in Barbara Pollack, *The Collectors: Dr. Claribel and Miss Etta Cone* (Indianapolis and New York: Bobbs-Merrill Company, 1962), p. 70. Pollack states that this quote comes from the memoirs of Claribel Cone in the Cone archives at the Baltimore Museum of Art; however, Brenda Richardson asserts (Baltimore Museum of Art, *Dr. Claribel and Miss Etta: The Cone Collection of the Baltimore Museum of Art*, exh. cat., 1985, p. 158 n. 25) that this document is not in the Cone archives but may belong to Ellen B. Hirschland, a relative of the Cone sisters.

94. Signac to Manguin, from Marseille, [late October 1905]; ibid., from Saint-Tropez, [late October–early November 1905]; both Jean-Pierre Manguin, Avignon. Saint-Tropez had no train station; it was necessary to go to Saint-Raphaël to take a train to Marseille.

95. Leo Stein to Mabel Foote Weeks, from Paris, November 29, 1905, Beinecke Rare Book and Manuscript Library, Yale University; in New York, Museum of Modern Art, *Four Americans in Paris: The Collections of Gertrude Stein and Her Family*, exh. cat., 1970, p. 27.

96. "pays merveilleux, la Venise provençale." "Je commençais…à reconnaître un peu le caractère du pays.…J'en ai profité pour visiter les environs du village et…lorsqu'on regarde la nature en essayant de la raisonner et de la comprendre de façon à pouvoir s'en souvenir, on travaille tout autant qu'avec des pinceaux en main. Et c'est là la seule façon de regarder. Autrement on ne voit pas." "sur le motif." Camoin to Matisse, from Martigues, December 2, 1905; in Giraudy, "Correspondance Henri Matisse–Charles Camoin," p. 9.

97. Signac to Manguin, from Saint-Tropez, [end of 1905], Jean-Pierre Manguin, Avignon.

98. Pierre Daix, *Picasso: The Cubist Years, 1907–1916*, trans. Dorothy S. Blair (Boston: New York Graphic Society, 1979), p. 18. Judith Cousins, however, believes that Derain and Picasso did not meet until spring 1906; see her chronology in New York, Museum of Modern Art, *Picasso and Braque: Pioneering Cubism*, exh. cat., 1989, p. 341.

99. Derain to Vlaminck, [probably 1906]; in Derain, *Lettres à Vlaminck*, pp. 167–68.

100. Warnod, *Le Bateau-Lavoir*, p. 25; and van Dongen, in Jeanine Warnod, *Washboat Days*, trans. Janet Green (New York: Orion Press, 1972), p. 69.

101. "Le plaisir avec lequel j'accepte serait encore plus grand si vous pouviez inviter mon ami Matisse avec qui j'ai toujours exposé et qui ferait certainement honneur à votre exposition." Marquet to Faure, from Paris, January 3, 1906, Marquet archives, Fondation Wildenstein, Paris.

102. Leo Stein to Manguin, from Paris, January 11, 1906, Jean-Pierre Manguin, Avignon.

103. Signac to Angrand, January 14, 1906, Angrand archives, Paris; in Bock, *Matisse and Neo-Impressionism*, p. 124 n. 64, and in Jack Flam, ed., *Matisse: A Retrospective* (New York: Hugh Lauter Levin Associates, 1988), p. 51.

104. Vlaminck to Marquet, from Rueil, January 20, 1906, Marquet archives, Fondation Wildenstein, Paris.

105. Maus to Manguin, from Paris, January 21, 1906, Jean-Pierre Manguin, Avignon.

106. Robert L. Herbert, *Neo-Impressionism*, exh. cat. (New York: Solomon R. Guggenheim Museum, 1968), p. 247.

107. "Naturellement je dévore les musées. Et pour le moment dans mon Esprit Rembrandt est le coq." Derain to Matisse, from London, January 30, 1906, private collection, France.

108. "Devant la multiplicité de mes sensations il m'est venu cette idée c'est qu'il est des peintres de grand talent que nous, peintres nous-mêmes, nous ne devons faire que regarder parce qu'ils ferment la peinture avec eux. Je dis cela à propos des primitifs surtout. Et un peu aussi de Claude Lorrain et de Turner. Je le dirai même de Velázquez et de Holbein.
"Ensuite les conceptions variées et contradictoires nous enterrent davantage dans la généralité et c'est dans la généralité que la liberté est la plus grande. Cette variété nous fait oublier les causes, les formes,

les origines de nos sensations, pour n'en garder que l'essence qui est le sentiment de notre personnalité ou la connaissance de soi. C'est un jeu de s'exprimer pour celui qui se connaît. Il sacrifie ses défauts à ses qualités. Je pense sincèrement que pour nous nous devons tendre vers le calme par opposition aux générations qui nous précédèrent. Ce calme c'est la certitude. La beauté doit donc être une aspiration au calme. Croyez-vous que si nous étions complètement désintéressés nous serions angoissés. Ce bonheur réel existe je crois dans la parfaite jouissance de soi-même. C'est un égoïsme c'est vrai mais peu néfaste car je parle ici d'une quiétude morale qui nous inciterait à rendre des services psychiques à notre prochain et qui par son existence évidente serait une précieuse aide morale pour lui." Derain to Matisse, from London, January 30, 1906, private collection, France.

109. Etta Cone, entry in expense notebook, February 18, 1906, Cone Collection archives, Baltimore Museum of Art.

110. "La Tamise est immense et c'est le contraire de Marseille." Derain to Vlaminck, from London, March 7, 1906; in Derain, *Lettres à Vlaminck*, pp. 196–97.

111. Derain to Matisse, from London, March 8, 1906, private collection, France.

112. Bock, *Matisse and Neo-Impressionism*, p. 95.

113. "M. Henri-Matisse…est préoccupé d'étonner le public et de le dérouter." Léon Rosenthal, "Petites Expositions," *La Chronique des arts*, March 31, 1906, p. 100.

114. "vraiment pas mal. Il est très calé. C'est incontestable." "Quant à Claude Monet, en dépit de tout je l'adore." Derain to Vlaminck, n.d.; in Derain, *Lettres à Vlaminck*, p. 188.

115. "La grande toile de M. Henri Matisse, le *Bonheur de vivre*, est la 'question' du Salon. Bien des personnages se sont

égayées devant cette oeuvre étrange. Leur hilarité ne m'a pas gagné. C'est bien plutôt avec inquiétude, avec tristesse, que je vois un artiste admirablement doué gaspiller ses forces.…" Charles Morice, "Le XXIIe Salon des Indépendants," *Mercure de France* 61 (April 15, 1906): 535–36.

116. "le plus grand succès d'hilarité de toute sa carrière." Weill, *Pan! Dans l'oeil*, p. 124.

117. New York, Museum of Modern Art, *Pablo Picasso: A Retrospective*, exh. cat., 1980, p. 59; Flam, *Matisse: A Retrospective*, p. 16. The date of this meeting was assigned to autumn 1906 by Gertrude Stein, *The Autobiography of Alice B. Toklas* (1933; reprint, New York: Vintage Books, 1961), p. 63; and by Barr, *Matisse*, p. 84.

118. Fernande Olivier, *Picasso and His Friends*, trans. Jane Miller (New York: Appleton-Century, 1965), p. 88.

119. "Stein ne voit en ce moment que par deux peintres, Matisse et Picasso." Apollinaire, in Michel Décaudin, "Apollinaire et les peintres en 1906 d'après quelques notes inédites," *Gazette des beaux-arts*, 6th per., 75 (1970): 119.

120. Stein, *Autobiography of Alice B. Toklas*, p. 53.

121. Jean Metzinger, *Le Cubisme était né* (Chambéry, France: Editions Présence, 1982). This differs from Gleizes's recollections; see Joann Moser, *Jean Metzinger in Retrospect*, exh. cat. (Iowa City: University of Iowa Museum of Art, 1985), p. 12.

122. These excavations were first published by Arthur Engel and Pierre Paris, *Une Fortresse ibérique à Osuna* (Paris: Imprimerie National, 1906). Pierre Daix says that the works may have been placed on exhibition in late 1905; see Pierre Daix, *La Vie de peintre de Picasso* (Paris: Editions du Seuil, 1977), p. 72.

123. The Puys to the Manguins, postcard from Nice, April 5, 1906, Jean-Pierre Manguin, Avignon.

124. Vollard to Vlaminck, from Paris, April 21, 1906; in Vlaminck, *Portraits avant décès*, p. 83.

125. "changement de décor!!" Signac to Manguin, from Rotterdam, April 23, 1906, Jean-Pierre Manguin, Avignon.

126. Friesz to Manguin, from Paris, Tuesday, [May 1906], Jean-Pierre Manguin, Avignon.

127. Fernande Olivier, *Souvenirs intimes* (Paris: Calmann-Lévy, 1988), p. 212. Leo Stein reports (in a letter to Manguin, from Paris, May 8, 1906, Jean-Pierre Manguin, Avignon) that Vollard has purchased twenty-seven paintings by Picasso, who will leave shortly to spend the summer in Spain.

128. Puy to Manguin, from Paris, May 1, 1905, Jean-Pierre Manguin, Avignon.

129. Matisse to Manguin, from Collioure, [late May–early June 1906], Jean-Pierre Manguin, Avignon.

130. Leo Stein to Manguin, from Paris, May 8, 1906, Jean-Pierre Manguin, Avignon.

131. Matisse to Manguin, postcard from Algiers, postmarked May 13, 1906; ibid., postcard from Biskra, postmarked May 18, 1906; ibid., postcard from Algiers, May 23, 1906; ibid., from Collioure, [late May–early June 1906]; all Jean-Pierre Manguin, Avignon.

132. "C'est monotone, rien que des pins, pas de verdure, pas de grands horizons, pas de maisons ni bateaux rien. A part une plaine derrière chez nous d'un beau caractère ce n'est guère emballant. Je ne sais même si quand il va faire plus chaud je pourrai faire poser, car malgré l'isolement de ce sacré patelin, il y a toujours quelques mocauds à la pêche dans les rochers.…Je regrette la Villa Demière et ses beaux ombrages.

Le voisinage de Saint-Tropez c'était plus gai." Manguin to Matisse, from Cavalière, May 12, 1906, Jean-Pierre Manguin, Avignon.

133. Matisse to Manguin, from Algiers, May 13, 1906, Jean-Pierre Manguin, Avignon.

134. Matisse to Manguin, from Biskra, postmarked May 18, 1906, Jean-Pierre Manguin, Avignon.

135. Friesz to Manguin, from Paris, May 18, 1906, Jean-Pierre Manguin, Avignon.

136. For further discussion of Kandinsky's interaction with the Fauves, see Jonathan David Fineberg, *Kandinsky in Paris, 1906–07* (Ann Arbor, Mich.: UMI Research Press, 1984), pp. 49–50.

137. "un ensemble épatant." Friesz to Marquet, from Le Havre, postmarked May 25, 1906, Marquet archives, Fondation Wildenstein, Paris.

138. "Si notre situation ne se trouve pas changée, nous le prenons." Matisse to Manguin, from Collioure, [late May–early June 1906]; Leo Stein to Manguin, from Paris, [end of May 1906]; both Jean-Pierre Manguin, Avignon.

139. Friesz to Manguin, from Le Havre, May 31, 1906, Jean-Pierre Manguin, Avignon.

140. Signac to Manguin, from Saint-Tropez, June 1906, Jean-Pierre Manguin, Avignon.

141. Sarah Stein to the Manguins, from San Francisco, June 1, 1906, Jean-Pierre Manguin, Avignon.

142. For further discussion of this, see Judi Freeman, "Far from the Earth of France: The Fauves Abroad," in this volume, p. 213 n. 31.

143. Cross to van Rysselberghe, June 17, 1906, van Rysselberghe archives, Paris; in Herbert, *Neo-Impressionism*, p. 50.

144. "Je me sens m'orienter vers quelque chose de meilleur où le pittoresque compterait moins que l'année dernière pour ne soigner que la question peinture." Derain to Vlaminck, from L'Estaque, [summer 1906]; in Derain, *Lettres à Vlaminck*, p. 146.

145. "n'est qu'un village qui ne voit comme touristes habituels que des petits bourgeois de Perpignan et encore fort peu, il faut près d'une ½ heure pour aller se baigner sur une petite plage de galets." Matisse to Manguin, from Collioure, [late June 1906], Jean-Pierre Manguin, Avignon.

146. Manguin to Matisse, from Cavalière, [late June–early July 1906], Jean-Pierre Manguin, Avignon.

147. Marquet to Manguin, from Paris, [early July 1906], Jean-Pierre Manguin, Avignon.

148. "Le père Cézanne serait-il ironiste?" Mathan to Manguin, from Paris, July 10, 1906, Jean-Pierre Manguin, Avignon.

149. Matisse to Manguin, postcard from Collioure, postmarked July 12, 1906, Jean-Pierre Manguin, Avignon.

150. "Vers 1905–1906, je peignais sur la plage de Sainte-Adresse. Jusqu'alors, j'avais fait des plages à la manière des impressionnistes et j'en étais arrivé au point de saturation, comprenant que, dans cette façon de me calquer sur la nature, celle-ci me menait à l'infini, jusque dans ses méandres et ses détails les plus menus, les plus fugaces. Moi, je restais en dehors du tableau. Arrivé devant un motif quelconque de plage, je m'installai et me mis à regarder mes tubes de couleurs et mes pinceaux. Comment avec cela, parvenir à rendre, non pas ce que je vois, mais ce qu'est, ce qui existe pour moi, *ma réalité?* Voilà tout le problème. . . . Je mis alors à dessiner, à choisir dans la nature ce qui me convenait. . . . A partir de ce jour là, il me fut impossible de revenir à mes luttes stériles avec les éléments qui s'offraient à ma vue. Ces éléments, il n'était plus question de les représenter sous leur forme extérieure." Raoul Dufy, *Carnet*, no. 23, p. 13, Musée National d'Art Moderne, Centre Georges Pompidou, Paris, AM 366D; in Perez-Tibi, *Dufy*, p. 23, and in Pierre Courthion, *Dufy* (Geneva: Editions Pierre Cailler, 1951), p. 66.

151. Marquet to Manguin and Matisse, postcard from Le Havre, postmarked July 15, 1906, Jean-Pierre Manguin, Avignon.

152. Friesz to Matisse and Manguin, postcard from Antwerp, postmarked July 14, 1906, Jean-Pierre Manguin, Avignon.

153. Puy to Manguin, from Bénodet (Finistère), July 16, 1906, Jean-Pierre Manguin, Avignon.

154. Receipt signed by Derain, dated July 20, 1906, at top and July 6, 1906, next to signature, Vollard archives, Musée d'Orsay, Paris.

155. Marquet to Manguin, from Fécamp, August 12, 1906; ibid., postcard from Fécamp, August 13, 1906; ibid., August 24, 1906; all Jean-Pierre Manguin, Avignon.

156. Terrus to Manguin, from Collioure, August 26, 1906, Jean-Pierre Manguin, Avignon.

157. Maurice de Vlaminck, *Tournant dangereux: Souvenirs de ma vie* (Paris: Stock, 1929), p. 88, and Vlaminck, *Portraits avant décès*, pp. 105–6, 212. According to Robert Goldwater, who interviewed André Level and Daniel-Henry Kahnweiler on this subject, Vlaminck made his discovery in 1904, but it is questionable whether both men could have had firsthand knowledge of this event. Robert Goldwater, *Primitivism in Modern Art*, rev. ed. (New York: Vintage Books, 1967), p. 102 n. 4. See also Jean-Louis Paudrat, "From Africa," p. 139 (who dates the episodes to the end of March and first two weeks of April 1906), and Jack Flam, "Matisse and the Fauves," pp. 213–15, both in New York, Museum of Modern Art, *"Primitivism" in Twentieth-Century Art: Affinity of the Tribal and Modern*, ed. William Rubin, 2 vols., exh. cat., 1984. See also Laude, *La Peinture française*, p. 104, who cites a 1944 letter from Vlaminck to Marius-Ary Leblond. Both Paudrat and Flam correct Vlaminck's memoirs, which date these events to 1905, and assign a date of 1906. Flam, p. 215, argues convincingly that this date helps to reconcile some of the related circumstantial evidence.

A little-known, unsigned article—"Vers un musée d'art nègre," *Nouvelles*, September 22, 1912, in the Vlaminck archives, Rueil-la-Godelière, France—indicates that Vlaminck, Derain, and Matisse were acquiring works from a small dealer, "Au vieux Rouet." "Au vieux Rouet" was associated with an organization, "Société d'art nègre," of which the artists were no doubt aware. I am grateful to Maïthé Vallès-Bled for providing me with a copy of this article.

Vlaminck reportedly sold all of his *art nègre* to Jos Hessel; see Christian Zervos, interview with Jos Hessel, *Cahiers d'art* 2, nos. 4–5 (1927): 2.

158. Vlaminck confirms this; see Vlaminck, *Portraits avant décès*, p. 84.

159. Marquet to Manguin, September 15, 1906; ibid., September 21, 1906; both Jean-Pierre Manguin, Avignon.

160. Matisse to Manguin, from Collioure, September 20, 1906, Jean-Pierre Manguin, Avignon.

161. "C'est moderne ça de laisser nommer du jury et ne pas y aller, c'est la dernière élégance. Mettant quand on est dans une période de lutte comme nous y sommes." Matisse to Marquet, from Collioure, September 20, 1906, Marquet archives, Fondation Wildenstein, Paris.

162. Marquet to Manguin, from Paris, September 21, 1906, Jean-Pierre Manguin, Avignon.

163. Ron Johnson, unpublished essay on Derain's sculpture, 1969, cited in Flam, "Matisse and the Fauves," pp. 217–18; Edward Fry, "Cubism 1907–8: An Early Eyewitness Account," *Art Bulletin* 48 (March 1966): 73.

164. Cross to Manguin, from Le Lavandou, October 7, 1906, Jean-Pierre Manguin, Avignon.

165. "Les Friez [*sic*], les Braque sont très heureux. Leur idée est jeune et leur semble neuve." Derain to Vlaminck, from L'Estaque, [early November–end of 1906]; in Derain, *Lettres à Vlaminck*, pp. 152–53.

166. "Je traverse une crise. . . . Impossible de faire quelque chose de propre." Derain to Vlaminck, from L'Estaque, n.d.; in Derain, *Lettres à Vlaminck*, p. 152.

167. Pierre Courthion described Matisse's activities leading up to the painting of *Nu bleu* (plate 221); these are cited in Schneider, *Matisse*, p. 349.

168. Matisse to Manguin, from Collioure, December 14, 1906, Jean-Pierre Manguin, Avignon.

169. Manguin to Matisse, from Paris, December 30, 1906, Jean-Pierre Manguin, Avignon.

170. Matisse to Manguin, from Narbonne, February 7, 1907, Jean-Pierre Manguin, Avignon. Matisse clearly was endeavoring to show *Nu bleu* (plate 221) at the Salon des Indépendants. Manguin to Matisse, from Paris, February 12, 1907, Jean-Pierre Manguin, Avignon.

171. Terrus to Manguin, postcard from Vernet-les-Bains, February 12, 1907, Jean-Pierre Manguin, Avignon.

172. Manguin to Matisse, from Paris, February 16, 1907, Jean-Pierre Manguin, Avignon.

173. Daniel-Henry Kahnweiler with Francis Crémieux, *My Galleries and Painters*, trans. Helen Weaver (New York: Viking, 1971), pp. 28–34.

174. Maïthé Vallès-Bled, *Vlaminck: Le Peintre et la critique*, exh. cat. (Chartres, France: Musée des Beaux-Arts, 1987), p. 338.

175. For an excellent study of Matisse's ceramic work, see John H. Neff, "Matisse and Decoration, 1906–1914" (Ph.D. diss., Harvard University, 1974), pp. 33–51.

176. Louis Vauxcelles, "Le Salon des Indépendants," *Gil Blas*, March 20, 1907.

177. *La Chronique des arts et de la curiosité* 13 (March 30, 1907): 106.

178. Pierre Assouline, *L'Homme de l'art: D. H. Kahnweiler (1884–1979)* (Paris: Editions Balland, 1988), p. 51; Kahnweiler with Crémieux, *My Galleries and Painters*, p. 43.

179. Marcelle Marquet and François Daulte, *Marquet* (Lausanne: Editions Spes, 1953), p. ix.

180. "le Nord ne me vaut plus rien. Enrhumé plein de rhumatismes et fatigué je reviendrai de suite si je n'avais encore tant de choses à voir. Pourtant le temps est beau quoique frais et la vie ici est bien amusante." Marquet to Manguin, postcard from London, April 2, 1907, Jean-Pierre Manguin, Avignon.

181. Derain to Kahnweiler, from Chatou, April 17, 1907, Kahnweiler archives, Galerie Louise Leiris, Paris.

182. Matisse to Kahnweiler, from Collioure, April 22, 1907, Kahnweiler archives, Galerie Louise Leiris, Paris; in Paris, Musée National d'Art Moderne, Centre Georges Pompidou, *Daniel-Henry Kahnweiler*, exh. cat., 1984, p. 95.

183. Picasso to Gertrude and Leo Stein, postcard from Paris, April 27, 1907, Beinecke Rare Book and Manuscript Library, Yale University.

184. Marquet to Manguin, postcard from Fontainebleau, June 6, 1907, Jean-Pierre Manguin, Avignon.

185. Manguin to Matisse, from Paris, June 11, 1907, Jean-Pierre Manguin, Avignon.

186. Matisse to Fénéon, from Collioure, June 13, 1907, Bernheim-Jeune archives, Paris.

187. Derain to Druet, from Cassis, June 17, 1907, accompanied by drawings; this letter is reproduced in Paris, Ader, Picard, Tajan, *Catalogue de vente*, March 20, 1984. "C'est d'une douceur de tons, d'odeur, d'atmosphère d'une étrangeté." Derain to Vlaminck, from Cassis, n.d.; in Derain, *Lettres à Vlaminck*, pp. 165–66.

188. Derain to Vollard, from Cassis, [1907]; Derain to Vollard, [1907]; both Vollard archives, Musée d'Orsay, Paris.

189. Matisse to Manguin, from Collioure, [c. June 20, 1907], Jean-Pierre Manguin, Avignon. In this letter Matisse refers to Marquet's being in London with Derain and Friesz. It is known that Marquet was in London, but the reference to Derain's trip that year is a mystery.

190. Friesz to Druet, postcard with drawings from Cassis, July 9, 1907; in Paris, Ader, Picard, Tajan, *Catalogue de vente*, March 20, 1984.

191. Bernheim-Jeune receipt signed by Matisse, July 12, 1907, Bernheim-Jeune archives, Paris. I am grateful to Jack Flam for sharing this material with me.

192. Matisse to Fénéon, from Collioure, July 13, 1907, Bernheim-Jeune archives, Paris.

193. "J'ai vu Matisse une seconde fois. Il est passé avec sa femme, ici, se rendant en Italie. Il m'a montré les photos de ses toiles; c'est tout à fait épatant. Je crois qu'il franchit la porte du septième jardin, celui du bonheur." Derain to Vlaminck, from Cassis, n.d.; in Derain, *Lettres à Vlaminck*, p. 149.

194. Matisse to Pierre Courthion, 1941; in Schneider, *Matisse*, p. 135 n. 17.

195. Terrus to Manguin, from Elne, August 8, 1907, Jean-Pierre Manguin, Avignon.

196. "enchanté de mon voyage et la tête farcié par la multitude des belles choses que j'ai vu en Italie." Matisse to Fénéon, from Collioure, August 21, 1907, Bernheim-Jeune archives, Paris.

197. "étant trop le nez sur mes tableaux." Matisse to Vlaminck, from Collioure, August 29, 1907; in Vlaminck, *Portraits avant décès*, pp. 103–4.

198. Musée National d'Art Moderne, *Kahnweiler*, p. 97. See Derain to Kahnweiler, August 29, 1907; in Paris, Musée National d'Art Moderne, Centre Georges Pompidou, *Donation Louise et Michel Leiris: Collection Kahnweiler-Leiris*, exh. cat., 1984, p. 37.

199. Cousins says that they stayed in L'Estaque through late October or early November (after returning from La Ciotat in early September) and that there is a postcard to Kahnweiler from Friesz from L'Estaque dated September 28 that suggests they entrusted Kahnweiler to submit their entries to the Salon d'Automne. Cousins also suggests that the two probably returned to Paris for Friesz's exhibition at Galerie Druet. She contradicts herself when she states (p. 347) that Braque went to L'Estaque before early October *after* viewing the Cézanne retrospective; this is impossible, as the Salon did not open until October 1. See Museum of Modern Art, *Picasso and Braque*, pp. 346–47. Youngna Kim, "The Early Works of Georges Braque, Raoul Dufy, and Othon Friesz: The Le Havre Group of Fauvist Painters" (Ph.D. diss., Ohio State University, 1980), p. 178, states that they returned to Paris for the Salon d'Automne.

200. Braque, interview with André Verdet, *Entretiens: Notes et écrits sur la peinture* (Paris: Editions Galilée, 1978), p. 21. Museum of Modern Art, *Picasso and Braque*, p. 347, says that Apollinaire was possibly accompanied by Fénéon on his visit to see *Demoiselles d'Avignon* (1906–7, Museum of Modern Art, New York).

201. Olivier, *Picasso and His Friends*, p. 97. See also Kahnweiler with Crémieux, *My Galleries and Painters*, p. 39.

202. Manguin to Vallotton, from Saint-Tropez, September 3, 1907; in Félix Vallotton, *Documents pour une biographie et pour l'histoire d'une oeuvre*, vol. 2: *1900–1914*, ed. Gilbert Guisan and Doris Jakubec (Lausanne and Paris: La Bibliothèque des Arts, 1974), no. 205.

203. Puy to Manguin, from Paris, September 4, 1907, Jean-Pierre Manguin, Avignon.

204. Jeanne Manguin to Amélie Matisse, from Saint-Tropez, September 11, 1907, Jean-Pierre Manguin, Avignon.

205. Matisse to Manguin, from Paris, September 15, 1907, Jean-Pierre Manguin, Avignon.

206. Museum of Modern Art, *Picasso and Braque*, p. 347.

207. Guillaume Apollinaire, "Henri Matisse," *La Phalange* 2 (December 15–18, 1907): 481–85.

208. Michel Puy, "Les Fauves," *La Phalange* 2 (November 15, 1907): 450–59.

209. Manguin to Matisse, from Saint-Tropez, October 11, 1907, Jean-Pierre Manguin, Avignon.

210. See Guillaume Apollinaire, "Le Cas Maurice de Vlaminck," *Je dis tout*, October 26, 1907; in Guillaume Apollinaire, *Chroniques d'art, 1902–1918*, ed. Leroy C. Breunig (Paris: Gallimard, 1960), pp. 59–62.

211. "J'y ai plus de beau temps en deux jours que pendant tout l'été au Havre. J'ai une chambre sur le port, vue splendide. Je pourrai travailler sur le port. La vie n'est pas chère. . . . Soyez convaincue que vous avez en Matisse, Vlaminck, Derain, Friesz, et quelques autres les types de demain et de longtemps encore; est-ce assez visible au Salon, voyons? Comparez l'intensité de vie, de pensée que contiennent les toiles de ces gens-là, à celle de la quantité d'ennui et d'inutilité contenus dans la plupart des autres cadres." Dufy to Weill, from Marseille, October 20, 1907; in Weill, *Pan! Dans l'oeil!*, pp. 143–45.

212. Blot also hosted a one-man exhibition for Puy sometime in 1907, as did Vollard, chez Dru (on the rue Montaigne); see Geneva, Musée du Pétit Palais, *J. Puy*, exh. cat., 1977, p. 15.

213. Museum of Modern Art, *Picasso and Braque*, p. 348.

214. Cross to Angrand, December 28, 1907, Angrand archives, Paris. The three Matisse paintings have not been identified. Matisse owned at least one Cross, *La Ferme, matin: Les Bouilleurs de cru* (*The Farm, Morning: The Wine Distillers*, 1892–93, private collection). For further discussion of the possible exchange of paintings, see Herbert, *Neo-Impressionism*, p. 44.

215. Barr, *Matisse*, p. 116; an opening date of January 1 is given in Sandra E. Leonard, *Henri Rousseau and Max Weber*, exh. cat. (New York: Richard L. Feigen and Co., 1970), p. 24.

216. Steichen to Stieglitz, from Paris, n.d., Beinecke Rare Book and Manuscript Library, Yale University.

217. Marquet to Manguin, from Paris, February 18, 1908, Jean-Pierre Manguin, Avignon.

218. Guillaume Apollinaire, "Le Salon des Indépendants," *La Revue des lettres et des arts*, May 1, 1908; in Apollinaire, *Chroniques d'art*, pp. 63–74.

219. " 'Schématisants' barbares, les métaphysiciens de l'école primaire, ceux qui veulent créer un 'art abstrait.' . . . Vraiment les deux excellents peintres qui furent—et qui seront (car il n'y a rien de perdu)—MM. Matisse et Picasso auront occasionné des ravages dans les cervelles naïves de leurs petits successeurs." Louis Vauxcelles, "Le Salon des Indépendants," *Gil Blas*, March 20, 1908.

220. Derain, in Denys Sutton, *André Derain* (London: Phaidon, 1959), p. 27.

221. According to Patrick Henry Bruce's widow, this move did not take place until the fall, but all Matisse biographers agree that it occurred in the spring. See William C. Agee and Barbara Rose, *Patrick Henry Bruce*, exh. cat. (New York: Museum of Modern Art; Houston: Museum of Fine Arts, 1979), p. 137. The Bruces lived in an apartment above the Matisses at 33, boulevard des Invalides.

222. Irwin, typescript of diary, April 27, 1908, pp. 129–32; in Museum of Modern Art, *Picasso and Braque*, p. 350.

223. "Je vais travailler sérieusement et redevenir essentiellement peintre. En somme, il est très difficile de faire de la peinture à Paris. On manque de point de contact. Et je crois que c'est ici le seul pays où l'on ait que des sensations de peintre." Derain to Vlaminck, from Martigues, n.d.; in Derain, *Lettres à Vlaminck*, pp. 163–64.

224. Olivier, *Picasso and His Friends*, p. 145.

225. Braque to Picasso, postcard from Le Havre, postmarked May 12, 1908, Picasso archives, Musée Picasso, Paris; see Museum of Modern Art, *Picasso and Braque*, p. 352.

226. Braque to Kahnweiler, postcard received in Paris, June 1, 1908, Kahnweiler archives, Galerie Louise Leiris, Paris; in Museum of Modern Art, *Picasso and Braque*, p. 352.

See also William Rubin, *Cézanne: The Late Work*, exh. cat. (New York: Museum of Modern Art, 1977), pp. 172–73, for further discussion of this postcard and its importance.

227. Derain to Vollard, from Cassis [but address indicated on letter is 22, rue Tourlaque, Paris], May 20, 1908, Vollard archives, Musée d'Orsay, Paris.

228. Van de Velde to Osthaus, May 27, 1908, Karl-Ernst Osthaus Museum, Hagen, West Germany.

229. Maximilian Gauthier, *Othon Friesz* (Geneva: Editions Pierre Cailler, 1957), p. 51.

230. Signac from Saint-Tropez to Manguin in Naples, June 19, 1908, Jean-Pierre Manguin, Avignon.

231. Matisse to Manguin, from Speyer, June 12, 1908; ibid., from Munich, June 15, 1908; both Jean-Pierre Manguin, Avignon. Matisse to Gertrude and Leo Stein, from Speyer, June 12, 1908; Matisse and Purrmann to Gertrude and Leo Stein, from Munich, June 15, 1908; both Gertrude Stein archives, Beinecke Rare Book and Manuscript Library, Yale University.

232. Isabelle Compin, *H.-E. Cross* (Paris: Quatre Chemins, 1964), pp. 32, 73.

233. Derain to Vollard, from Martigues, July 17, 1908, Vollard archives, Musée d'Orsay, Paris.

234. Marquet to Manguin, from Cassis, [August 12–13, 1908], Jean-Pierre Manguin, Avignon.

235. Vollard to Vlaminck, from Bourbonne-les-Bains, August 22, 1908; in Vlaminck, *Portraits avant décès*, p. 105.

236. Foundation de l'Hermitage, *Marquet*, p. 39, says that he spent the summer in Poissy, with a room at the Hôtel de Rouen. This is contradicted by Marquet's letters to Manguin and others.

237. Gertrude Stein, *Picasso* (New York: Charles Scribner's Sons, 1939); in Museum of Modern Art, *Picasso and Braque*, pp. 354, 355, 441 n. 46.

238. "Allons faire le vernissage du Salon d'A[utomne] avec les négresses." Marquet to Manguin, postcard from Bordeaux, September 23, 1908, Jean-Pierre Manguin, Avignon.

239. Louis Vauxcelles, "Le Salon d'Automne," *Gil Blas*, September 30, 1908.

240. Apollinaire to Braque, October 19, 1908, Braque archives, Paris.

241. "un jeune homme fort audacieux. . . . Il construit des bonshommes métalliques et déformés et qui sont d'une simplification terrible. Il méprise la forme, réduit tout, site et figures et maisons, à des schémas géométriques, à des cubes." Louis Vauxcelles, "Exposition Braque chez Kahnweiler," *Gil Blas*, November 14, 1908.

242. Bernard Berenson, "Letter to the Editor," *Nation*, November 12, 1908; in Barr, *Matisse*, p. 114.

243. Rousseau, in Olivier, *Picasso and His Friends*, p. 92.

244. Braque to Kahnweiler, from Le Havre, November 22, 1908, Kahnweiler archives, Galerie Louise Leiris, Paris.

245. Matisse to Fénéon, from Paris, November 26, 1908, Bernheim-Jeune archives, Paris; I am grateful to Jack Flam for sharing the text of this letter with me.

246. Rousseau to Apollinaire, from Paris, December 15, 1908; in Guillaume Apollinaire, "Le Douanier," *Les Soirées de Paris* 3 (January 15, 1914): n.p.

247. Barr, *Matisse*, pp. 105 and 109.

248. "Chaque année il devient plus difficile de parler de ces gens qui se font appeler 'les fauves' dans les communiqués à la presse. Ils sont curieux à voir auprès de leur toile. Corrects, plutôt élégants, on les prendrait pour des chefs de rayon de grands magasins. Ignorants et paresseux, ils tentent d'offrir au public l'incolore et l'informe." Joséphin Péladan, "Le Salon d'Automne et ses rétrospectives, Greco et Monticelli," *La Revue hebdomadaire* 12 (October 17, 1908): 361.

249. Henri Matisse, "Notes d'un peintre," *La Grande Revue* 52 (December 25, 1908): 731–45.

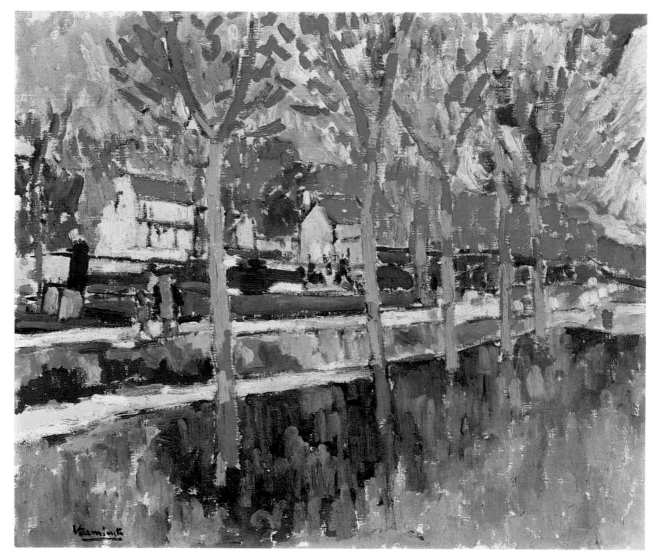

PLATE 128

New Lessons from the School of Chatou

derain and vlaminck in the paris suburbs

JOHN KLEIN

Fauvism, we are told, began by accident. On a June day in 1900 the chance meeting of two young men, André Derain and Maurice de Vlaminck, launched the first avant-garde art movement of the twentieth century. The story is well known and often recounted. When their outbound suburban train derailed shortly after leaving Paris, Derain and Vlaminck, who had taken notice of each other previously on this route, struck up a conversation while walking the rest of the way to Chatou, where they both lived. It turned out that they also both painted, and by the end of their walk they had agreed to meet the next day under the Pont de Chatou and to set out together with their canvases. So it was, as Vlaminck later said in his typically oracular manner, that "the School of Chatou was created."[1]

Following this miraculous conception (the story continues), Fauvism took on a life of its own. The two artists, each following his own dictates, worked side by side in a synergism that changed the course of modern art. Their ardent individualism was reflected in their unconventional and spirited interpretations of nature and the suburban towns that provided them with picturesque sites. The young suburbanites were bound together in splendid isolation from the pressures of life in the capital, from the influence of other artists, indeed from all that might taint a spontaneous vision of the world and its direct translation into paint. Fauvism was the ultimate embodiment of personal freedom in an artistic style.

This is the myth that for a long time passed for an explanation of Fauve painting at Chatou. It was largely engendered by Vlaminck, a practiced raconteur, who gave his own color to events. Much of the rhetoric has been tempered by more recent research, which has shown how sophisticated Vlaminck and especially Derain actually were, and how politics, literature, and other art decisively influenced the thinking of the two young men.[2]

What such revisions have left out of the story of the Fauves in the Paris suburbs are the distinctive character of the sites themselves, their meaning to the artists, and specifically what Derain and Vlaminck chose to depict there. They painted regularly in several towns in the Seine valley west of Paris—among them Nanterre, Marly-le-Roi, Carrières-sur-Seine, and especially Le Pecq and Chatou. Chatou and nearby Le Pecq were also amply recorded in the commercial photography of the period made for postcard views for tourists. The photographic-view postcard had first flourished in the 1890s and reached its zenith of popularity throughout Europe in the first decade of the new century, creating a burgeoning commerce in such images during the very time when Derain and Vla-

PLATE 128
Maurice de Vlaminck
Les Ecluses à Bougival
(*The Locks at Bougival*), 1906
Oil on canvas
21 ¼ x 25 ⁹/₁₆ in. (54 x 65 cm)
National Gallery of Canada,
Ottawa

[123]

minck painted in the suburbs.[3] So it is possible to compare these artists' painted representations with another system of representation of the same sites. The purpose in doing this is not to gauge the "accuracy" of the painters' depictions but to determine if they shared sites and compositions with images made for a growing popular market for views of the suburbs. Questions may then be considered about Derain's and Vlaminck's awareness of this body of photographic views; about their participation in conventions of viewing codified by these photographs; and about how these painters distinguished their products within the stream of images flowing from the western suburbs of Paris.

Soon after their fortuitous encounter on the train Vlaminck and Derain did in fact develop an intense partnership. They rented a large and inexpensive studio on the Ile de Chatou, very convenient to where they both lived. For fifteen months they often painted side by side. Few of Vlaminck's canvases from this period are known (he would not become a full-time painter for several years more), and those are confined to vigorously worked, even garish figure paintings. Derain, with years of thorough study in academies and museums behind him, was already painting brightly colored generalized rural landscapes and river views. In the autumn of 1901 Derain began his compulsory three years in the army. During this period the two friends saw each other infrequently but wrote many letters that testify to their continued intimacy.[4]

In early 1904 Derain returned to Chatou and civilian life. He had been changed by the odiousness of military service, but he and Vlaminck carried on as before, roaming up and down the Seine to paint, sometimes treating the same motif (plates 129, 130). Both chose a view from the right bank of the Seine, looking upriver toward the Pont de Chatou and a small group of buildings on the Ile de Chatou where the bridge crosses the island.[5] Both painters have shown in the foreground the *bateaux-lavoirs* that can be identified in numerous photographs of Chatou during this period (see plate 131, in which we look downriver at laundry boats in the same spot). Although a comparison of these two paintings does not encompass all the differences between the work of the two artists at this time, it does reveal significant variations in their approaches to composition and in their attitudes toward the integrity of their subject.

Vlaminck has composed these elements in scenic fashion, with a clearly defined viewpoint, making it easy to see what is depicted and where it was depicted from. Choosing a ground-level point of view, that of a resident or casual visitor, Vlaminck has given more or less equal prominence to the bank in the foreground, the laundry boats, the river, the bridge, and the sky, in an orderly succession into the background. Not that there is no art here—characteristically, he has aligned prominent vertical elements, bringing together the masts of the boats with the piers of the bridge, and another mast at right with the edges of the houses across the river. The strong horizontal of the bridge straps all of this down, giving stability to the oblique view. Although not all of his compositions are this neatly packaged, Vlaminck would generally set up a firm but unobtrusive structure that imposed further order on a landscape already highly mediated by suburban development. Such a solid and essentially conservative approach to composition enabled him to organize and make legible his arbitrary treatment of color and abrupt, summary brushwork.

PLATE 129
Maurice de Vlaminck
Le Pont de Chatou
(*The Bridge at Chatou*), 1905–6
Oil on canvas
21 ¼ x 28 ¾ in. (54 x 73 cm)
Musée de l'Annonciade,
Saint-Tropez, France

PLATE 130
André Derain
Le Pont de Chatou
(*The Bridge at Chatou*), 1905
Watercolor on paper
18 ½ x 22 ¹³⁄₁₆ in. (47 x 58 cm)
Private collection, Paris

PLATE 131
Chatou—The Laundry,
c. 1905–7

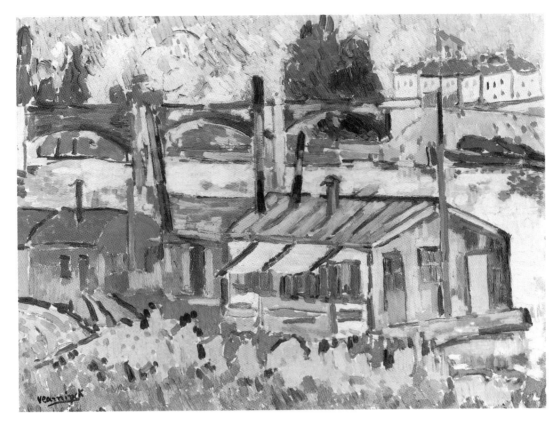

Plate 129

Chatou - Le Lavoir

Plate 131

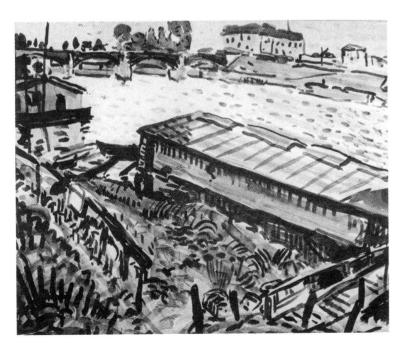

Plate 130

PLATE 132

PLATE 133

With the same components Derain has constructed a far more active composition, preferring to dramatize the oblique and unstable rather than the horizontal and vertical. The bridge is confined to a less prominent spot in the upper-left corner, and its piers are not made to rhyme with other vertical elements. Towpath and footbridge cut in diagonally from left and right to converge at the bottom. The tipped-up bank dominates the foreground, creating the impression that the viewer has an elevated position. Derain has correspondingly reduced the area of the sky, pressing the edge of the frame down on the houses and trees. Vlaminck's cleverness in arrangement notwithstanding, Derain's composition is more willful than his companion's, and it is certainly less ingratiating.

Comparison of Derain's painting with postcard views of the same site (plates 132–133) shows how much he selected and composed his view of bridge, houses, and laundry boats. Vlaminck, too, has brought the same elements found in the photographic views into a more compact and unified arrangement. But his painting shares with the postcards the ease of comprehension and identification essential to the souvenir. What might be called the scenic values of this suburban site have been carefully preserved by Vlaminck and determinedly subverted by Derain.

By 1905 some of the intensity had left the painters' friendship. They slowly drifted apart after Derain began to visit Paris more frequently that spring and took up with the crowd around Pablo Picasso. That summer he went to the Midi to work near Henri Matisse. Such excursions into new territory were necessary to Derain; he would not be confined to the riverbanks and their familiar motifs. When he returned to Chatou after several months in the south, he and Vlaminck continued to paint together, but any sense that they were working in similar ways

and with similar aims was gone. Thus two intense but short periods, in 1900–1901 and 1904–5, constitute the two sessions of the School of Chatou.

Although in terms of color and touch their art indeed made an abrupt break with convention, Vlaminck and Derain were working within an established modern practice of painting in the Paris suburbs, and in Chatou particularly.[6] Pierre-Auguste Renoir was most closely associated with Chatou. In *Luncheon of the Boating Party* (plate 134), and in many other paintings of boaters, strollers, and diners on the Ile de Chatou, Renoir celebrated a suburban world of social pleasures. His locus, and the subject of this painting, was the Restaurant Fournaise. About a mile downriver at Croissy, Renoir and Claude Monet had painted another pleasure spot, La Grenouillère, and Bougival, across the river from there, also provided them with many motifs.[7]

Monet immortalized the suburb of Argenteuil (plate 135), where he lived in the 1870s. He largely ignored the industry there in his paintings, but elsewhere it was taken up with relish by the Neo-Impressionists, especially Paul Signac and Georges Seurat in such places as Clichy and Asnières. Although industry had been implicit in the sites of the Impressionist painters, they rarely emphasized it. The Neo-Impressionists made explicit the concentrations of manufacturing and capital that had brought into being the world of pleasure lauded by the Impressionists. The Fauves, in turn, did not celebrate industry as the Neo-Impressionists had done, but they did frankly acknowledge this aspect of modernity. In their choices of subjects, and sometimes in what they chose not to paint, both Derain and Vlaminck showed some ambivalence toward the effects of industrial progress in the Seine valley.

Chatou is located on the right bank of the Seine at the beginning of the third bend in the river as it flows out of Paris. As at many other points in the reaches between the big bends, the Seine at Chatou is divided into two arms by a series of long, slender islands. Such topography facilitated bridgebuilding, and for over 350 years a bridge has traversed the Ile de Chatou and connected the town with Rueil across the river and Paris beyond.[8] Over the centuries the Pont de Chatou contributed to making the town an important market center for the surrounding agricultural communities, and it has always been vital to Chatou's economic life.

Events arising from France's twin revolutions—the political and the industrial—brought the most significant changes to Chatou. Until the 1790s it had been part of one of the vast seigneurial landholdings that dominated the Seine valley west of Paris. The power of the seigneurs ended with the Terror, and their lands were divided among independent communities, eventually to be sold to private individuals in parcels of diminishing size. Another milestone in the history of private enterprise in France was the first railway line in the country, which opened between Paris and Le Pecq in 1837; it was soon extended to Saint-Germain-en-Laye. Chatou was one of the earliest stations on the line, and suddenly the life of the town was reoriented toward the railroad. This development required a railroad bridge downriver from the Pont de Chatou, which carried road traffic and pedestrians. The trains brought Parisians to Chatou in large numbers, some as residents, some as visitors seeking relief from the city. This pattern of development was typical of other western suburbs of Paris served by the railroad, but change came slowly to some, more rapidly to others.[9]

PLATE 132
Chatou—A Corner of the Island, c. 1905
Postcard
Collection Mr. Marceau Hautrive, Chatou, France

PLATE 133
The Seine at the Chatou Bridge—The Laundry, c. 1905
Postcard
Collection Mr. Marceau Hautrive, Chatou, France

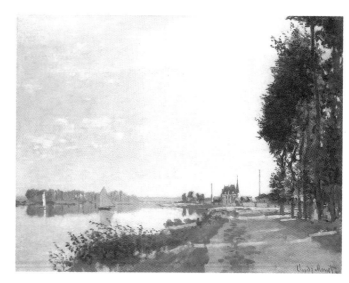

PLATE 135

PLATE 135
Claude Monet
(France, 1840–1926)
Argenteuil, c. 1872
Oil on canvas
19 ⅞ x 25 ⅝ in.
(50.4 x 65.2 cm)
National Gallery of Art,
Washington, D.C., Ailsa
Mellon Bruce Collection

PLATE 134

PLATE 134
Pierre-Auguste Renoir
(France, 1841–1919)
Luncheon of the Boating Party,
1881
Oil on canvas
51 x 67 ⅞ in.
(129.5 x 172.4 cm)
The Phillips Collection,
Washington, D.C.

From "a kind of 'Barbizon' at the gates of Paris" in the final decade of the century, Chatou became the Fauves' "Jungle" (both characterizations are by Derain).[10] In fact, it was a prosperous and growing middle-class town, well between the poles of the rural idyll and the exotic wild suggested by Derain's tongue-in-cheek remark. Chatou had neither the fame nor the historical significance of Saint-Germain-en-Laye around the next bend, and it was neither as progressive nor as important commercially as Argenteuil just upriver. But in the guidebooks of the period Chatou usually rated at least a brief mention, being notable for its thirteenth-century church and a grotto by Soufflot.

In 1900 the town had a population of just under 4,500. This represented an increase of one third over the number of residents in 1881, denoting significant but not explosive growth at the end of the century.[11] Already in 1881 one guidebook had commented on the boom in new construction in Chatou, mainly of summer houses for well-to-do Parisians, which had begun with the opening of the railroad.[12] Chatou was steadily becoming an extension of Paris, and by 1899 the construction of private villas was identified as the most important industry in the town.[13] But in 1908 it was still noted for the natural beauty of its riverside site, "deliciously embedded... in flowers and foliage."[14]

The manufacturing and shipping industries that had profoundly transformed many other Seine towns were not to be seen along the river at Chatou. Argenteuil

was marked by cement and iron works; Le Pecq, downriver, had a commercial port and a large natural-gas plant; Rueil and Nanterre, directly across the river from Chatou, were cluttered with factories and warehouses. By contrast, Chatou's banks showed little evidence that the industrial revolution had occurred. Between the water's edge and the property lines were a towpath and a watering place for livestock, and the only apparent "industry" was hand laundry. In fact, Chatou's railroad bridge was the sole prominent sign of modernity, and it had been there for over sixty years (the railroad was no more a novelty to the local villager of 1900 than the jet airplane is to the resident of an American suburb today).[15] Tugboats churned up and down the river with their barges, as earlier boats had done, but they never stopped at Chatou because there was no place for them. The commercial ports were elsewhere.

The town was attractive, but the Ile de Chatou far surpassed it for simple rustic pleasures. Trees still grew to the water's edge along most of its length. Groups of buildings only occasionally interrupted the wooded expanses. The island's original name had been the Ile du Chiard, the "kid's island," suggesting a great wooded playground. That is just what it remained, even after receiving a more formal name, but now the playground was for adults. Most of the buildings on the island were related to the tourist industry—hotels, restaurants, pavilions. The Restaurant Fournaise, the Impressionist watering hole, was still operating in 1900. Photographs from the turn of the century show many pleasure boats on the branch of the river between the Fournaise's piers and the banks at Rueil. If not Chatou's main industry, tourism was certainly its liveliest.

Even so, several signs indicated that its peak was past. Canoeing and sailing were giving way to cycling as the recreation of choice, a development that dispersed tourism away from the river.[16] A popular steamer, *Le Touriste*, used to stop at Chatou on its daily run between Paris and Le Pecq, but by 1903 it had dropped that port of call on this "monotonous part of the trip."[17] The studio that Derain and Vlaminck rented so cheaply had until recently been a thriving tourist spot, the Restaurant Levanneur, but by 1900 it had gone out of business and was partially demolished. Ironically, the two artists benefited from a slip in the cogs of entrepreneurial capitalism.[18]

This is not only the milieu in which Vlaminck and Derain worked in 1900, it is also where they had both come of age. Derain was born to a baker in Chatou in 1880, and he spent his childhood in the town. Vlaminck, whose parents were part-time musicians, grew up in nearby Le Vésinet. When Vlaminck was a boy his family lived with his grandmother, who sold vegetables at Les Halles, taking the train every day to the Gare Saint-Lazare. Since Vlaminck's parents also relied on employment in Paris, commuting to the city was a way of life for this suburban family. In 1892 the sixteen-year-old boy moved with his parents to Chatou. Two years later he married there and soon fathered his first two children. He became a musician like his parents, and he, too, found work in Paris, giving lessons and playing the violin in the music halls of Montmartre. Seeking less expensive quarters, the young family moved in 1901 to Rueil, at the other end of the Pont de Chatou. Derain strayed even less—although he had attended school in Paris and frequented the Louvre, during his first twenty years he never lived outside Chatou.[19]

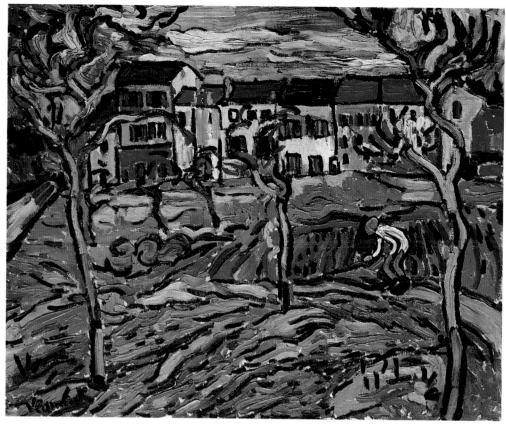

PLATE 136

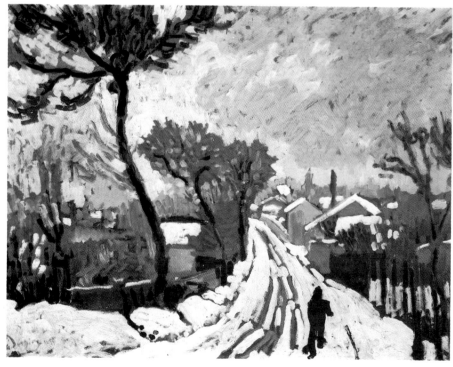

PLATE 137

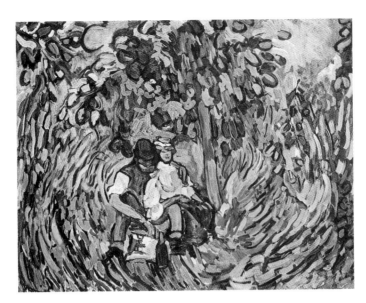

PLATE 138

PLATE 136
Maurice de Vlaminck
Maisons à Chatou
(*Houses at Chatou*), 1905–6
Oil on canvas
32 ½ x 39 ⅜ in. (82.5 x 100 cm)
The Art Institute of Chicago

PLATE 137
André Derain
Paysage de neige à Chatou
(*Snowy Landscape at Chatou*),
1904–5
Oil on canvas
24 x 31 ⅞ in. (61 x 81 cm)
Private collection

Because Derain and Vlaminck were longtime residents of the region, the motifs that they painted in Chatou and the surrounding area were deeply familiar to them. The sense of being *of* the place gives their paintings a profoundly different character, at once more intimate and more poignant, than the canvases of Bougival, Chatou, or La Grenouillère by Renoir and Monet, who had been tourists like all the others. While Renoir's work in particular stresses conviviality and the enjoyment of nature in the company of one's fellows, Derain's and Vlaminck's vision of life in the suburbs was generally unsocial.[20] Sailboats, skiffs, and other pleasure-craft do appear frequently, but they are always at some distance, as one part of the general scene. They share the river unemphatically with tugs and barges. Work and play both are taken for granted.

There are no celebrations in this art, no holidays at this school. Painting goes on in season and out, after the tourists have stopped coming. The cheerfulness of an uncharacteristic picnic in Vlaminck's work (plate 138) or a lively scene by Derain at Le Pecq (plate 145) only occasionally offsets the loneliness that pervades so many of their suburban landscape paintings.[21] In Derain's *Paysage de neige à Chatou* (*Snowy Landscape at Chatou*, plate 137), a solitary trudger pushes up a dirty white road under an oppressive sky. Vlaminck's *Maisons à Chatou* (*Houses at Chatou*, plate 136) is less bleak, but a single bent figure and stark twisting trees à la van Gogh emphasize the evacuated quality of this view from the Ile de Chatou across the river to the *maisons rouges* (called "red houses" because of the color of their roofs) in the town. This is a painting by locals, of local sites, activities, and moods.

Does familiarity breed contempt? Certainly not in Vlaminck, not for the sites he painted over and over with such engagement. Despite the melancholy that underlies his suburban canvases, he obviously loved the places he painted, with the love of someone who can be pleased to see the same things under old as well as new lights. Whenever he recalled the motifs of the suburbs, he did so affectionately, and he reserved his most nostalgic expressions for Chatou and its familiar sights, sounds, and routines: "The laundry boat below the Chatou bridge with the washerwomen and the sound of the clothes beaters, the towpath, the barge maids and the deckhands running on the planks."[22] Their work and his were entirely harmonious.

PLATE 138
Maurice de Vlaminck
Partie de Campagne
(*Party in the Country*), 1905
Oil on canvas
33 ⅞ x 45 ¹¹/₁₆ in. (86 x 116 cm)
Private collection

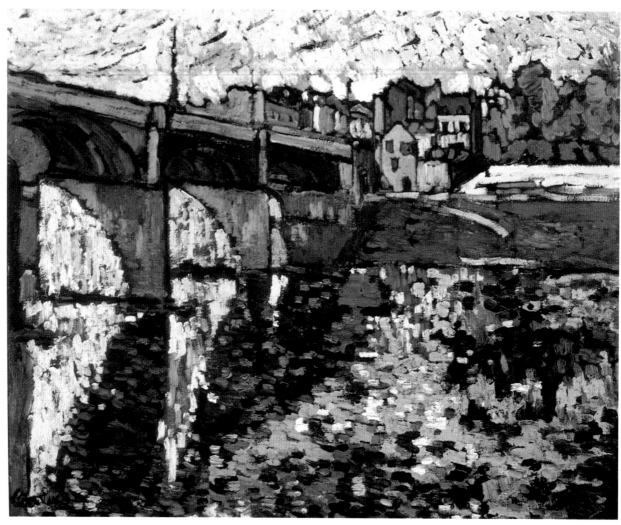

PLATE 139

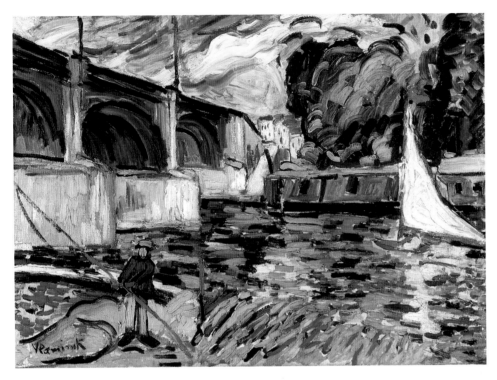

PLATE 140

PLATE 139
Maurice de Vlaminck
Le Pont de Chatou
(*The Bridge at Chatou*), 1905
Oil on canvas
25 ¾ x 32 in. (65.4 x 81.3 cm)
Private collection, California

PLATE 140
Maurice de Vlaminck
Le Pont de Chatou
(*The Bridge at Chatou*), 1907
Oil on canvas
26 ¾ x 37 ¹³⁄₁₆ in. (68 x 96 cm)
Staatliche Museen
Preussischer Kulturbesitz,
Nationalgalerie, Berlin

Vlaminck was extraordinarily faithful to certain motifs and viewpoints. A particular favorite was the view of Chatou seen in *Maisons à Chatou* (plate 136), but he more often depicted the town in a state of verdant splendor, through a screen of trees and foliage, as if he were looking out from a leafy sanctuary (Monet and Renoir, too, had favored such a device). But Vlaminck's greatest predilection by far was for the Pont de Chatou. He painted it in all seasons and from all angles. In *Le Pont de Chatou* (*The Bridge at Chatou*, plate 139), he has made the river, the bridge, and the town shimmer vividly under mercurial skies. His point of view was from the island, just upriver from the bridge, looking across to several houses and La Boule d'Or, a prominently located restaurant. He placed himself close enough to the base of the bridge so that the structure presses in forcefully at the left, emphasizing its passage into the center of town. In a slightly later canvas (plate 140) Vlaminck has shown the other segment of the Pont de Chatou, on the other side of the island, looking from a point on the bank next to the Restaurant Fournaise. A lone fisherman at the edge of the water offsets a scooting sailboat. The massive piers of the bridge march into Rueil, where Vlaminck had lived since 1901. In these two paintings he was looking outward from the center of his world.

In art and in life this bridge had very particular associations for Vlaminck. It was not just a point from which he could reconnoiter his painting territory. The bridge was as vital to him as it was to Chatou itself. He later recalled his early tutelage by the naïve painter "Monsieur Henri Rigal of Chatou," whom Vlaminck visited every day at "his favorite haunt under the bridge," looking at the town.[23] The two segments of the Pont de Chatou linked all the places that were important to Vlaminck. Over it he had passed from his dwellings in Chatou to the island and his studio, sanctuary within sanctuary. When he moved to Rueil on the left bank, the bridge continued to carry him from home to studio, and also now to Derain's home in Chatou. The bridge gave Vlaminck a sense of connectedness with the elements of his limited world. Only this allowed him to revel in his suburban isolation.

PLATE 141

A contemporary critic, evidently recognizing the bridge's importance to Vlaminck, went so far as to call it "his atelier."[24] This figure of speech was not far wrong. Only a few steps from where the Pont de Chatou crossed the narrow island was the former Restaurant Levanneur. Its partial demolition had left only a large ground-floor room, which Derain and Vlaminck rented as their studio. This studio appears in several postcard views of the period (plate 141). So when Vlaminck and Derain painted such scenes as plates 129 and 130, they also referred to themselves and their place in their environment.[25]

Whereas the road bridge was a frequent feature in Vlaminck's work, he rarely painted the railroad bridge, and when he did he kept it at a distance. The view in *La Seine à Chatou* (*The Seine at Chatou*, plate 143) is from a point near the studio at the base of the Pont de Chatou, looking downriver, with the railroad bridge on the horizon and some of the grander riverside houses of Chatou at the right. A comparison of the painting with a postcard from the time confirms this point of view (plate 142).[26] Why Vlaminck paid such scant attention to Chatou's other bridge is worth a moment's speculation.

PLATE 142

When Monet lived in Argenteuil in the 1870s, he was grateful for the railroad as his means of staying in contact with affairs in Paris. Vlaminck hated it: "For a little village, a railway is what a wound is for a human being—a gaping sore which admits infection."[27] In Vlaminck's view the trains brought an urban disease. The railroad had been essential to the livelihood of his family, and he himself had relied on it to get to Paris and his music-hall jobs. But when the main theater in Paris in which he played the violin went out of business, he was glad to be rid of the need to go to the capital.[28] "I have never considered Paris," he said, "as anything other than a permanent show, a fair, a place for pleasure, but also with possibilities for boredom and sorrow. Paris has always exasperated me."[29]

Vlaminck's association of the railroad with the artificiality of Paris, and his preference for what he considered the greater simplicity and integrity of suburban life, may account for the minimal presence of the railroad in his painting. His compass was limited, and the bridge that accommodated the horse carriage, the

PLATE 141
Chatou—From the Top of the Bridge, c. 1900–1905

PLATE 142
Detail of Chatou—A Corner of the Island, c. 1905
Postcard
Collection Mr. Marceau Hautrive, Chatou, France

PLATE 143
Maurice de Vlaminck
La Seine à Chatou
(*The Seine at Chatou*), 1906
Oil on canvas
32 ½ x 40 ⅛ in. (82.5 x 102 cm)
The Jacques and Natasha Gelman Collection

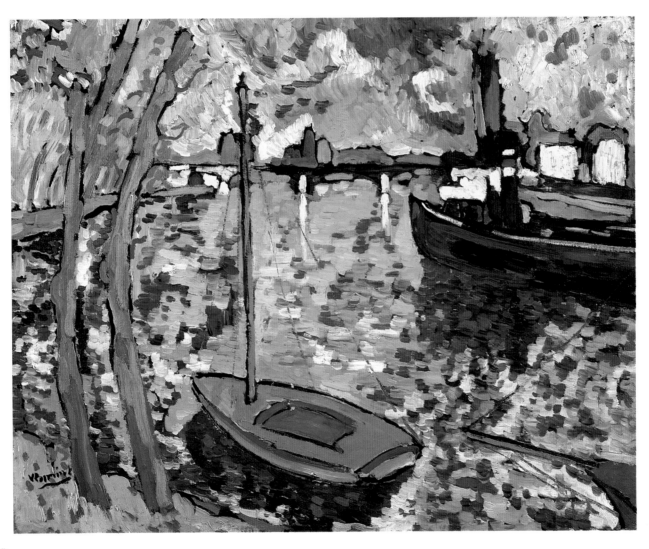

PLATE 143

bicyclist, and the pedestrian was enough for him.

Vlaminck's resistance to progress can be placed in a wider context. Like many young Frenchmen, he and Derain had been sympathetic to the anarchist tendencies of the 1890s. Vlaminck especially identified with the working classes, but he had also spent much of his childhood in the sheltered and privileged environment of Le Vésinet. Still, Vlaminck was more politically engaged than Derain, and he pursued his convictions more actively than his friend by writing articles for several radical journals and novels with subthemes of social criticism.[30] Within a few years Derain had renounced his anarchist sympathies, perhaps due to the influence of the studiously apolitical Matisse.[31] Vlaminck continued to fulminate against whatever he disliked about the government, the military, the middle class, and those in power generally.

The recent consensus among scholars is that Derain's and Vlaminck's early political inclinations, however sincere, were not reflected in their Fauve paintings.[32] Their convictions, no—but ambivalence, certainly. Vlaminck's feelings about progress were contradictory. While despising the railroad, he loved the speed made possible by other machines, such as the bicycles he raced as a teenager and the fast cars he collected later in life.[33] Money also had two edges. In the hands of others it corrupted; yet he relished the middle-class trappings that the sale of his work brought him. It would not be surprising, therefore, if Vlaminck were deeply ambivalent about his surroundings at Chatou. He loved the place but may have felt estranged from its growing middle-class constituency, made possible by the railroad—hence his strangely conservative concentration on older buildings, monuments, and traditions.

Derain manifested nothing like Vlaminck's attachment to what was stable and comfortable in their surroundings. Whereas Vlaminck's incendiary color and furious brush strokes were draped on orderly compositions of familiar subjects,

PLATE 144

Derain, allegedly more conservative in his politics than his friend, went to much greater lengths to generate instability and uncertainty in his art. When he painted Vlaminck's beloved Pont de Chatou, which he did infrequently, he treated the bridge less as a solid and substantial monument than as an element in a design. In *Barques à Chatou* (*Boats at Chatou*, plate 144) an unstable and seemingly casual grouping of skiffs dominates the image field, which is tipped up in the same manner as in *Le Pont de Chatou* (plate 129). These two paintings are, in fact, different framings of the same view; at the top edge of *Barques à Chatou*, obscure and severely cropped, are the bridge's truncated piers, which here renounce their function by looking even less firmly moored than the boats. The precariousness of the bridge's status, the unstable composition, and the absence of a clear focus urge the viewer into a dynamic relationship with this scene and thus with the artist's unique point of view.

Because Derain consistently sought unusual viewpoints or framed his subjects in unexpected ways, many of the landscapes he painted while living in Chatou in 1904–5 are difficult to link with specific sites. Such identification is usually easier in the work of Vlaminck. To the degree that many of the sites *can* be pinpointed in the paintings of both artists, their depictions can be called accurate. But even when they are accurate, Derain's landscape paintings are less explicit than Vlaminck's and provide less information, demanding greater local knowledge or compelling the viewer to work harder to make sense of them. Vlaminck's paintings are more often accurate *and* explicit, which is why they usually require less effort to recognize what they depict. They share with traditions of topographical illustration, as well as with the contemporary photographic-view postcard, the scenic values of legibility and comprehensibility that many of Derain's canvases lack.

Le Pont du Pecq (*The Bridge at Le Pecq*, plate 145) is one of Derain's most spectacular and imaginative compositions. This site can be identified without any trouble: it is the view downriver from the left bank of the town, whose two sections straddle the Seine. Like Chatou, Le Pecq had a long and distinguished history, but under different circumstances. In the seventeenth century, under Louis XIII, Le Pecq had been designated a free port, the only place on the Seine for the transshipment of goods between Paris and the western provinces. So for centuries Le Pecq had been one of the most active river ports in the Ile-de-France, a distinction it still held early in the twentieth century. It was an important depot for raw materials such as wood, coal, and natural gas, and for foodstuffs such as grain, salt, and wine, and it was central to the economy of the entire region.[34] Only a few miles downriver from Chatou, Le Pecq showed a completely different face of the modern world.

The activity of this busy port is the focus of Derain's painting. Horse-drawn carts wait to unload the barges' cargo. Figures moving in all directions dot the foreground and middle distance. In the rear at left other figures stroll down the double alley of trees that marks the beginning of the town's central area. Beyond this Derain has aligned the bridge of Le Pecq, which connected the two parts of the town, more or less with the horizon. He has rendered all of this with lively and variable brushwork and a full palette of vivid color. As in his paintings of Chatou, Derain has raised the horizon in order to get in a larger foreground, a

PLATE 144
André Derain
Barques à Chatou (*Boats at Chatou*), 1904
Oil on canvas
15 x 21 ⅝ in. (38 x 55 cm)
Private collection, France

Plate 145

decision that has the effect of tilting the ground plane and bringing the viewer into the picture more precipitously. Problems of scale further confound any easy reading of the space, as it is difficult to reconcile the relative sizes of the two figures closest to the viewer—a boy moving away, a man with a cane looking out. With the direct gaze of this man Derain has acknowledged not only the viewer's presence but, by implication, that of the artist as well, suggesting his role in fashioning the view depicted. The artist is not an anonymous, neutral observer but someone with a distinct point of view.

A similarly placed figure in Derain's *La Seine au Pecq* (*The Seine at Le Pecq*, plate 146) performs the same function of calling attention to the creative role of the artist-observer. Here the nearly square format, unusual in Fauve landscape painting, combines with an empty foreground and high horizon to create an especially vertiginous effect. The dramatically receding line of trees, the same alley seen in the background of *Le Pont du Pecq* (plate 145), further emphasizes the plunge of perspective and thus the unique and controlling point of view of the observer.

PLATE 145
André Derain
Le Pont du Pecq
(*The Bridge at Le Pecq*), 1904–5
Oil on canvas
38 ⅝ x 45 ¾ in. (98.1 x 116.2 cm)
Theodore J. Forstmann

PLATE 146
André Derain
La Seine au Pecq
(*The Seine at Le Pecq*), 1904–5
Oil on canvas
33 ⁷/₁₆ x 37 ⅜ in. (85 x 95 cm)
Musée National d'Art
Moderne, Centre Georges
Pompidou, Paris

PLATE 146

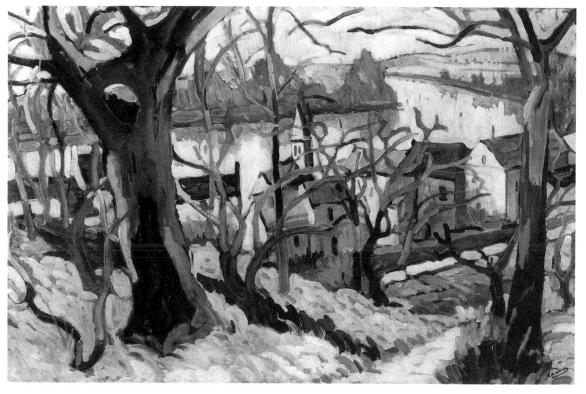

PLATE 147

PLATE 148

PLATE 149

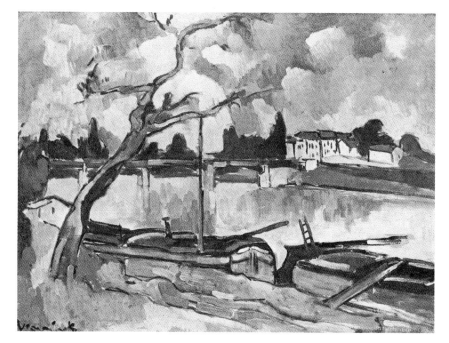

PLATE 150

From a high viewpoint the viewer also seems to survey and control the landscape, as in Derain's *La Seine à Carrières-sur-Seine* (*The Seine at Carrières-sur-Seine*, plate 147), until now mistakenly called *La Seine à Chatou* (*The Seine at Chatou*). Carrières-sur-Seine's distinctive church, with its squat, square, simply formed bell tower (plate 148), can be identified in the painting as the building at the center.[35] Vlaminck later spoke of this town, Chatou's upriver neighbor, as a favorite place for the two friends to paint: "Our hunting ground [for motifs] was often the hillsides of Carrières-Saint-Denis [as the town was called early in the century], which were still planted in vines and from where you could get a view of the whole Seine valley."[36] The high horizon in Derain's painting contributes to the impression that this deep landscape view is flattened and tipped up close to the viewer's space. Derain has framed the view between two large trees, a means of presentation that heightens the pictorial effect but also focuses the vista; and the solid trunk at the left anchors a web of smaller trees that screens this view and qualifies the spectator's sense of access and control. Such tensions and equivocations—between the surface and the deep view, between obstruction and control, between a landscape painting and a scene in nature—are far more marked in Derain's Fauve painting than in Vlaminck's.

A slightly later painting by Vlaminck of the port at Le Pecq demonstrates how much less he called attention to the point of view of the artist-observer in his work. Like Derain's *Le Pont du Pecq* (plate 145), Vlaminck's *La Seine au Pecq* (*The Seine at Le Pecq*, plate 150) shows the barges of the port, the bridge, and the large, distinctive Hôtel du Pont in the distance. Vlaminck's position was slightly upriver from Derain's (that is, farther from the bridge). He has given the sky greater prominence and has cast against it the bare branches of a tree that acts as both a *repoussoir* to set off the deep vista and a diagonal to oppose and balance the oblique transit of the river. As in *Le Pont de Chatou* (plate 129), Vlaminck's point of view implies that the observer is at ground level, taking everything in without bestowing significant emphasis or imposing imaginative distortion.

The scenic values of Vlaminck's depiction of Le Pecq are broadly reflected in an earlier postcard of the port (plate 149).[37] Vlaminck set up his easel a few steps downriver from and to the left of the photographer's position, but the same tree is recognizable, and the relationships among the other elements of the scene have been defined similarly by the makers of both images. Yet there are also substantial differences between the two representations. As in *Le Pont de Chatou* (plate 129) Vlaminck has unified the scene effectively by tightening the foreground and giving all the principal elements the same degree of prominence. In the painting the tree spreads across the center of the space, and Vlaminck has linked it visually to the mast of the boat. Both devices tend to emphasize the surface in contrast to the steady progression into space in the photograph. Finally, Vlaminck has omitted any sign of human activity in the painting; in the photograph half a dozen people are engaged in various activities.

I am not suggesting that Vlaminck used this particular photograph as a "source," but the affinity between these two images may imply a broader relationship. Despite all the myths of Vlaminck's singularity and despite his vividly personal handling of paint, the relationship between viewer and landscape that he proposes is analogous to that found in the contemporaneous, and anonymous,

PLATE 147
André Derain
La Seine à Carrières-sur-Seine
(*The Seine at Carrières-sur-Seine*), 1905
Previously known as *La Seine à Chatou (The Seine at Chatou)*
Oil on canvas
27 ⅞ x 43 ⅝ in.
(70.7 x 110.7 cm)
Kimbell Art Museum,
Fort Worth

PLATE 148
Carrières-sur-Seine—Church and Main Street, c. 1912
Postcard
Mr. and Mrs. Gilles Outin,
Chatou, France

PLATE 149
Le Pecq—The Port, 1904

PLATE 150
Maurice de Vlaminck
La Seine au Pecq
(*The Seine at Le Pecq*), 1907
Oil on canvas
27 3/16 x 37 ⅜ in. (69 x 95 cm)
Location unknown

photograph. The photographer's image was intended for a postcard meant to identify and summarize the salient qualities of this place, to be sent by someone who had observed this landscape to someone else for whom it provided a guiding representation, a way of seeing the landscape that rendered it comprehensible and familiar. For a different audience, Vlaminck did the same thing.

Not all of Vlaminck's depictions of suburban sites place the observer in a neutral or seemingly passive position in relation to the landscape. He was capable of compositions nearly as bold as any of Derain's, as in *Sous le Pont de Bezons* (*Under the Bridge at Bezons*, plate 153), until now known as *Sous le Pont de Chatou* (*Under the Bridge at Chatou*). This small, strongly designed painting presents a view from the riverbank under one of the iron spans of the bridge at Bezons, on the right bank of the Seine between Chatou and Argenteuil (plate 151).[38] Within his emphatic framing device Vlaminck did practice some moderation in another subtle balance of elements, giving nearly equal prominence to the foreground bank, the river and the far shore in the middle distance, and the sky above.

This practice of framing the landscape with a bridge was common by the time Vlaminck made his painting. The severe cropping of the buttress and span of the bridge and the resulting lateral asymmetry recall the compositional devices that the Impressionists had assimilated from Japanese prints. In fact, the iron bridges of the Seine valley and Paris had given Monet and Gustave Caillebotte the premises for some of their own daring compositions, which Vlaminck's way of framing his view closely resembles.[39] A postcard of the bridge at Le Pecq from the first years of the century also offers a partial view of a bridge span and the sweep of the riverbank (plate 152).[40] Some differences between Vlaminck's painting and the photograph again deserve comment. Vlaminck's choices about how to frame his view give a more focused result, a tighter crop, than the postcard. As in *La Seine au Pecq* (plate 150), he has used a strong vertical element, centrally placed, to pull together the middle distance, the background, and the sky. Vlaminck has composed his view more explicitly than did the photographer of the postcard, but he was still following an established modern convention of framing a view of nature within an imposing man-made structure that dominates the foreground of the image. As the bridge itself controlled the land and shaped its use, so does the representation of the bridge as a framing device shape the viewer's comprehension of its meaning, and that of the landscape it encompasses. In understanding this, Vlaminck proved to be more than the merely instinctive painter he has often been made out to be.[41]

Once again, the people who used the land are absent from Vlaminck's painting. Eliminating people from so many of his paintings of places that were actually filled with human activity may have been a way for the artist to gain some distance from the deep associations he had with his subjects. Possibly he also felt estranged from many of the middle-class inhabitants of these places and the supporting labor that served them. But it must be remembered that Vlaminck

PLATE 151

PLATE 152

PLATE 151
Bezons—The Towpath, under the Bridge, c. 1905–10

PLATE 152
View under the bridge at Le Pecq, c. 1900–1905

PLATE 153
Maurice de Vlaminck
Sous le Pont de Bezons
(*Under the Bridge at Bezons*),
1906
Previously known as *Sous le Pont de Chatou* (*Under the Bridge at Chatou*)
Oil on canvas
21 ¼ x 25 ½ in. (54 x 64.8 cm)
The Evelyn Sharp Collection

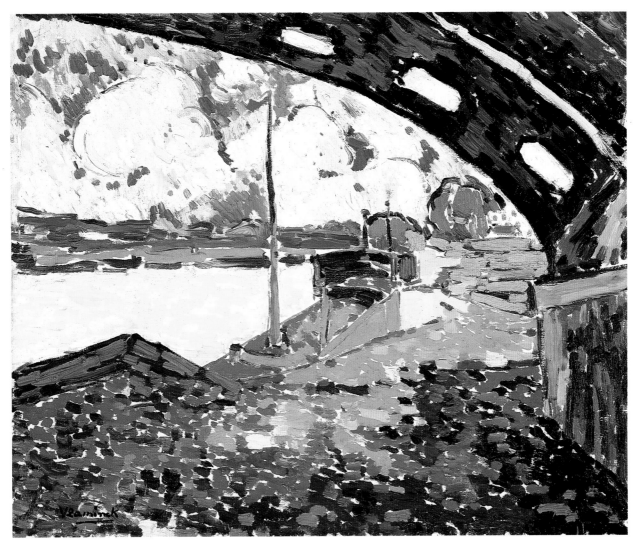

PLATE 153

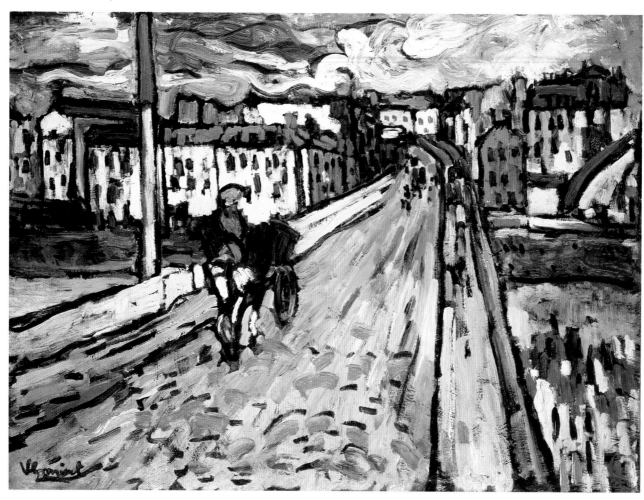

PLATE 154

CHATOU. - Le Pont et Rue de Seine

PLATE 155

PLATE 156

PLATE 154
Maurice de Vlaminck
Le Pont de Chatou
(*The Bridge at Chatou*), 1905–6
Oil on canvas
28 ¾ x 39 9/16 in. (73 x 100.5 cm)
Private collection

PLATE 155
Chatou—The Bridge and the
Route along the Seine, c. 1905

PLATE 156
Gustave Caillebotte
(France, 1848–1894)
The Pont de l'Europe, 1876
Oil on canvas
51 9/16 x 71 ¼ in. (131 x 181 cm)
Musée du Petit Palais, Geneva

PLATE 157
Chatou, the Bridge, c. 1905–6
Postcard
Mr. and Mrs. Gilles Outin,
Chatou, France

was a terrible painter of the human figure, and so perhaps an empty landscape was a convenient landscape.

One of Vlaminck's most dramatic Fauve paintings, charged by the vivid brushwork and exquisite color harmonies that characterize his strongest work, is *Le Pont de Chatou* (*The Bridge at Chatou*, plate 154), 1905–6. He painted it right in the heart of "his atelier," atop the bridge, at the point where it crossed the island. A horse-drawn cart and driver coming from the town advance toward the viewer. The riverbank, the *maisons rouges* at the left, and several buildings to the right of the bridge form a solid horizontal block under a roiling sky. The hefty pole to the left of the cart provides an opposing vertical. The bridge itself is the main focus, seen in acute perspective and spreading into most of the foreground.

A contemporaneous postcard presents virtually the same view of the bridge in a larger commerce of images (plate 155).[42] Like Vlaminck's painting, this postcard emphasizes the foreshortened, accelerated passage of the bridge into the town, and it too supplies some human incident to suggest a measure of the distance traversed. That this was evidently thought to be a picturesque way to represent the Pont de Chatou illustrates how thoroughly a radical composition such as Caillebotte's *Pont de l'Europe* (1876, plate 156) had been assimilated into the realm of popular imagery. By 1905 such rushing perspective had become an established convention for representing a suburban bridge, forming common ground for Vlaminck and the postcard photographer.

46 — CHATOU (Seine-et-Oise). Le Pont. ND Phot.

PLATE 157

Another postcard (plate 157) suggests a different relationship between Vlaminck's painting and touristic photography of his day. This postcard is not merely similar to Vlaminck's *Le Pont de Chatou* (plate 154); it shows precisely the same view. Vlaminck has copied the composition of this particular photograph, even to the extent of framing the view identically at all edges but the top. He did make

several changes: he eliminated the women at lower left and lower right; he re-moved the tramway rails on the bridge; and he exaggerated the curve of the street at the upper right leading from the bank up the hill into the town. Finally, he adjusted the edge of the pedestrian sidewalk at the right to create a vertical line in the bridge where there is none in the photograph—a vertical element in the lower right to correspond to the pole at the upper left, making another careful and solid composition. These alterations did not disguise Vlaminck's dependence on this photographic representation, but they did yield a simpler and stronger design that also bears his personal mark in active and summary brushwork, particularly where he has translated the reflections of the buildings on the far bank into a cascade of blue, white, and red.

The changes may not have been entirely for compositional reasons. Vlaminck has suppressed all signs of modernity in this scene. Thick strokes of blue paint are the only vestiges of the rails of the new steam tramway. Insulators for the tele-graph lines have been stripped from their poles. The women that Vlaminck excised were dressed in the plain, high-waisted fashion of the early years of the century. Prominent advertising signs have been removed from the buildings along the river. In contrast to the topographic specificity of Vlaminck's painting, no temporal reference remains to counter the timeless image of a horse-drawn cart. Vlaminck's composition, at once boldly modern and narrowly nostalgic, exempli-fies his ambivalence toward the forces of change in his limited world.[43]

Landscape is a mental conception, not a positivist fact. Whether a picture or a view in nature, a landscape conveys a relationship between the perceiving subject and the objects perceived. An idea of landscape is contained in a culture's atti-tudes toward the relationship between people and their environment; the product of that idea, whether an image (such as a painting or a photograph) or the comprehension of a view, reflects those larger attitudes.[44] Landscapes offer vari-ous possibilities of metaphorical control over the environment through processes of selection, framing, and possession. A painter alters nature by the way he chooses and composes its parts; the viewer of a landscape painting has a private window onto another world; the recipient of a postcard view imagines being there herself. Truly new and magnificent experiences are rare; images are plentiful. For some people the only way to come to terms with the uniqueness and the sub-limity of a place such as the Grand Canyon is to photograph it.

In Chatou and its environs Derain and Vlaminck had different ways of taking possession of the landscapes they knew so well, although both often relied on steep perspective as an agent of control. Derain's solution was often to make the familiar look strange, an approach frequently taken by Monet late in his career, as in his disorienting, scaleless paintings of his own water-lily pond. Vlaminck, by contrast, sought confirmation of his deeply held attitudes and preferred to reit-erate, not rupture, the familiar. Despite the want of conviviality in his painting, Vlaminck thus seems allied with Renoir, who lamented many of the changes that shaped the modern world. The reliance of an allegedly instinctive artist such as Vlaminck on a photographic source may seem surprising. His postcard (plate 157) may have given him a degree of distance that enabled him to make a landscape out of a place he knew so well that he could no longer see it as an object of art. It may also have been a means for him to make a major painting in winter without leaving

the studio. But whether a matter of theory or practice, both Vlaminck and Derain, despite their normal plein-air approach to the landscape, probably needed some means to disengage themselves at times from their motifs.

The photographic-view postcard exemplified a modern system of representation of the Paris suburbs, but it may not be the only one that mediated Vlaminck's landscape idea. He recounted his early passion for collecting several genres of popular imagery, including "the chromo-lithographs which were in the packets of chicory my grandmother bought at the grocer's. They were pictures of the banks of the Seine at Charenton or Bougival." His description of one of them makes it sound not at all like his own paintings of the Seine—in fact, it sounds more like a scene from an Impressionist painting: "In the distance one could see an inn lit with lamps, where several people were dancing, while in the foreground was a boat, with a man in a blue striped jersey and straw hat holding the oars. Behind him, a woman, dressed in a mulberry-red dress, reclined nonchalantly, in the shade of a rose parasol."[45] Further research may disclose more about what these popular images were like and whether any generalizations can be made about them in the context of other representations of the Paris suburbs.

What the chromolithographs, the postcard views, and Vlaminck's paintings have in common is that each represented the Paris suburbs to an audience elsewhere—to consumers of chicory, to urban tourists in the suburbs, and to the visitors to large public exhibitions in Paris.[46] Furthermore, the postcards and Vlaminck's paintings were produced locally for these wider markets.[47] These affinities—of representation and of intended audience—between the postcard views and Vlaminck's landscape paintings should alert us to the potential benefit of cutting across the usual boundaries between apparently unrelated systems of representation.

Derain's views of the Paris suburbs seem less related than Vlaminck's to contemporary postcards. Derain himself retrospectively cited photography as a different kind of source for the Fauves: "Fauvism was our ordeal by fire.... It was the era of photography. This may have influenced us, and played a part in our reaction against anything resembling a snapshot of life."[48] With regard to his own work, Derain was probably right. He was more candid about the influences on his art, and his imagination was more active than Vlaminck's. This combination made him restless and seeking. Not content to stay in Chatou in partnership with Vlaminck, he joined Matisse in the Midi with great anticipation of new perspectives.

There, however, he gave full vent to his doubts (Derain's doubt is as notorious as Paul Cézanne's). In one of his first letters to Vlaminck after arriving in the south, Derain.tells his friend how impressed he is with this new place and its people, and that "it is stupid to want to express in a street scene the whole range of emotions that a place produces in you." No longer were everyday subjects adequate to his purposes. In the next letter he tells Vlaminck that eventually he wants to live either in Paris or the Midi, because "the perspective of Chatou doesn't tempt me at all."[49] When he did return to Chatou that autumn, he took the light of the Mediterranean back with him in his head and projected its liberating purity onto the familiar motifs.[50]

Vlaminck professed no doubt about anything, ever, and his unbridled confi-

dence slipped easily into complacency. More comfortable with what was familiar and reassuring, he disliked traveling or moving. When Derain rented a studio in Paris in 1906, Vlaminck was content to stay in the suburbs: "I had no wish for a change of scene. All these places that I knew so well, the Seine with its strings of barges, the tugs with their plumes of smoke, the taverns in the suburbs, the color of the atmosphere, the sky with its great clouds and its patches of sun, these were what I wanted to paint...."[51] In 1911 Ambroise Vollard talked him into going to London to paint, as he had convinced Derain to do five years earlier. Whereas Derain had been enthralled with the city, dense with history and artistic tradition, Vlaminck was unimpressed. Following in Derain's footsteps again two years later, Vlaminck visited him in Martigues on the Mediterranean coast. After Vlaminck's departure Derain scolded him for seeing this brilliant land through northern glasses: "To paint the Midi, you wait until it looks like Chatou."[52] Vlaminck's response to landscape had long since devolved into formula. Derain continued to seek new forms, often from old masters. But at a critical juncture in their mutual development, they had reinforced each other's courage and inventiveness. In this small school of two, each of these young artists had been at once both pupil and teacher. Even if ultimately their individual visions led them apart, while together they made some of the most audacious paintings of the twentieth century.

★

PLATE 158
Maurice de Vlaminck
Maisons et arbres
(*Houses and Trees*), 1906
Oil on canvas
21 ⅜ x 25 ¾ in. (54.3 x 65.4 cm)
The Metropolitan Museum
of Art, New York, gift of
Raymonde Paul, in memory
of her brother, C. Michael
Paul, 1982.179.13

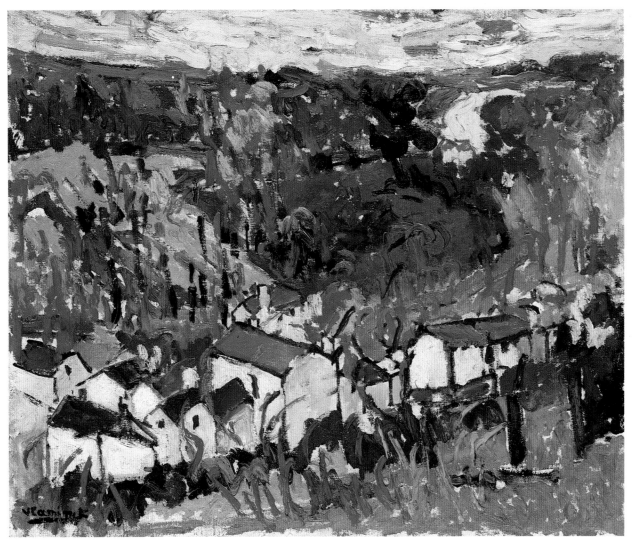

PLATE 158

I would like to thank Judi Freeman and Sasha Newman for their collegiality and for stimulating discussions about landscape painting, and Mollie McNickle and Liz Childs for their perceptive comments. In Chatou I was helped in significant ways by Paulette Blampin, Mme Jacques Catinat, Marie-Christine Davy, Michel Deroin-Thévenin, Marceau Hautrive, Isabelle and Gilles Outin, and Pierre Rannaud.

Unless otherwise indicated, all translations are my own.

1. "Pour nous, c'est toujours le lieu où fut fondée l'Ecole de Chatou." Maurice de Vlaminck, *Portraits avant décès* (Paris: Flammarion, 1943), p. 37. Also: "It was due to my chance encounter with André Derain that the school of Fauvism was born." Vlaminck, *Dangerous Corner*, trans. Michael Ross (London: Elek, 1961; originally published as *Tournant dangereux*, 1929), p. 74.

2. Ellen C. Oppler, *Fauvism Reexamined* (Ph.D. diss., Columbia University, 1969; New York: Garland Publishing, 1976); John Elderfield, *The "Wild Beasts": Fauvism and Its Affinities*, exh. cat. (New York: Museum of Modern Art, 1976); Marcel Giry, *Le Fauvisme: Ses Origines, son évolution* (Neuchâtel, Switzerland: Ides et Calendes, 1981). Early mythic versions of the story of Fauvism were sometimes propagated by Vlaminck's friends, such as Francis Carco (*Vlaminck* [Paris: Nouvelle Revue Française, 1920]), but they took purest form in *Tournant dangereux* and later books by Vlaminck himself.

3. See Georges Guyonnet, *La Carte postale illustrée* (Paris: Chambre Syndicale Française de la Carte Postale Illustrée, 1947); and Frank Staff, *The Picture Postcard and Its Origins* (London: Lutterworth Press, 1966). The first postcard of any kind was introduced in Austria in 1869 as an inexpensive alternative to the full-postage letter. The potential business in photographic views as souvenirs was rapidly realized throughout Europe. The Exposition Universelle of 1900 was a great stimulus to this commerce in France.

A trivial-sounding but significant change in the postal regulations in many European countries contributed to the development of the souvenir postcard we know today; in France this change was made in 1904 (Staff, *Picture Postcard*, p. 66). Before then only the address and the stamp were permitted on the recto; the message had to be placed on the verso, alongside or written over the image printed there. For this reason photographic views were generally vignetted to allow room for the message. The new regulation permitted the address and the message to share the recto, allowing a photograph to be bled to the edges of the verso. Since the other countries of Europe adopted this change at different times (France was neither first nor last), different cautions to the sender about the limitations on his or her use of the postcard were required to be printed on the recto. By June 1906 all member countries of the Universal Postal Union had agreed to the new regulation, so these cautions were no longer necessary (see Union Postale Universelle, *Documents du Congrès Postal de Rome*, 1906 [Bern: Imprimerie Lierow, 1906], 1:154–55; 2:215, 722). In the absence of internal evidence, I have been able to use these changes in postal regulations to date some of the postcards illustrated in this essay. Others carry legible postmarks or were dated by the sender; these provide a *terminus ante quem* for both the making of the photograph and the manufacture of the postcard.

4. André Derain, *Lettres à Vlaminck*, ed. Maurice de Vlaminck (Paris: Flammarion, 1955). Vlaminck's letters to Derain have not survived.

5. Vlaminck's painting has also been dated 1906. Dating the Fauve work of both artists can be a vexing problem, and even on the basis of style it is difficult to come to firm conclusions. In any case, I do not mean to imply that these two paintings of the Pont de Chatou and the laundry boats were done at the same moment, only that Derain and Vlaminck sometimes reiterated each other's choice of motifs.

6. For a brief account of Chatou in art, see Hélène Adhémar, "Un Moment de l'histoire à la fin du XIXe siècle: Renoir, Maupassant et l'école de Chatou," in Chatou, Hôtel de Ville, *Regard sur Chatou*, exh. cat., 1980, pp. 7–16.

7. For an excellent recent discussion of Impressionist painting in the Paris suburbs, see Robert L. Herbert, *Impressionism: Art, Leisure, and Parisian Society* (New Haven, Conn., and London: Yale University Press, 1988), pp. 195–263. See also Paul Hayes Tucker, *Monet at Argenteuil* (New Haven, Conn., and London: Yale University Press, 1982); and T. J. Clark, *The Painting of Modern Life: Paris in the Art of Manet and His Followers* (New York: Alfred A. Knopf, 1985), chap. 3, "The Environs of Paris."

8. Suzanne Bertauld, *Promenade dans Chatou* (Chatou: Syndicat d'Initiative, [1960s]), p. 12. Over time many different bridges have been built successively in the same location. In 1966 the present Pont de Chatou was constructed at a new spot about two hundred yards downstream in order to consolidate traffic along a major artery; the final bridge at the old site was demolished. This change must be borne in mind when identifying views in Chatou today.

9. The history of Chatou can be more completely studied in Jacques Catinat, *XII Grandes Heures de Chatou et la naissance du Vésinet* (Paris: Editions S.O.S.P., 1967); and Paul Bisson de Barthélemy, *Histoire de Chatou et de ses environs* (Chatou: Académie Palatine, [1950s]). For the history of the Paris suburbs generally in this period, see *Le Peuplement intensif de la banlieue parisienne* (Lagny, France: Emile Colin, [1900]); and Jean Bastié, *La Croissance de la banlieue parisienne* (Paris: Presses Universitaires de France, 1964).

10. "une sorte de 'Barbizon' aux portes de Paris"; "Chatou, c'était bien notre Jungle." Paris, Galerie Bing, *Chatou*, exh. cat., with statements by Derain and Vlaminck, 1947, [pp. 2, 4]. My thanks to Eric Carlson for showing me his copy of this publication.

11. Michel Deroin-Thévenin, *Chatou 1980: Nos Rues et leur histoire* (Chatou: privately printed, 1980), p. 3. Chatou's population in 1881: 3,382; in 1901: 4,514. Population figures may be unreliable, as different sources give different numbers for the same year; the Joanne guide to the Paris suburbs for 1881, for example, states that Chatou's population was 2,284. The discrepancies probably result from different definitions of a "resident." I am assuming at least an internal consistency in Deroin-Thévenin's book, which gives population figures for a period of over one hundred fifty years.

12. Adolphe Joanne, *Les Environs de Paris illustrés* (Paris: Librairie Hachette et Cie, 1881), pp. 145–46.

13. Deroin-Thévenin, *Chatou 1980*, p. 2.

14. "délicieusement noyé... dans les fleurs et la verdure." Marius Tranchant, *L'Habitation du parisien en banlieue* (Paris: Administration, [1908]), p. 94.

15. Chatou did have manufacturing concerns at the turn of the century—a glass-painting studio and a hosiery factory, for example—but they were not heavily industrial, and they did not employ the river (Catinat, *XII Grandes Heures*, p. 135). In 1897 Phonographes Pathé was founded in Chatou, and by 1900 it was the world leader in the production of recorded music on cylinders (Hôtel de Ville, *Regard sur Chatou*, pp. 56–57). Chatou was also one of the sites of the nascent electrical industry, another "clean" and highly modern enterprise. Today Chatou is still a key center of the music and electronics industries in France.

16. Adhémar, "Un Moment de l'histoire," p. 13.

17. Compare Paul Joanne, *Environs de Paris* (Paris: Librairie Hachette et Cie, 1889), p. 242, with the same author's *Paris, Sèvres, Saint-Cloud, Versailles, Saint-Germain, Fontainebleau, Saint-Denis, Chantilly* (Paris: Librairie Hachette et Cie, 1903), p. 24, where the passage I've quoted in the text is found. Baedeker's *Paris and Environs* of 1900 does not mention a stop by *Le Touriste* in Chatou either.

18. The studio is now gone. The Restaurant Fournaise is being restored by an association of friends. But for now this part of the island has been returned to the "chiards," with a playground and a miniature railroad being the principal attractions.

19. On the early years of Derain's life, see Denys Sutton, *André Derain* (London: Phaidon, 1959); and Georges Hilaire, *Derain* (Geneva: Editions Pierre Cailler, 1959). For Vlaminck in these years, see his *Dangerous Corner*; and Maïthé Vallès-Bled, *Vlaminck: Le Peintre et la critique*, exh. cat. (Chartres, France: Musée des Beaux-Arts, 1987).

20. The common misapprehension that Fauve painting in the suburbs of Paris was concerned mainly with pleasure was stated most recently by Robert Herbert, who found this art to be "stimulated by the impressionists and founded also on themes of leisure and hedonism (Derain and Vlaminck painted at Chatou)" (Herbert, *Impressionism*, p. 219); and again: Derain and Vlaminck are noted for painting "riverbank leisure" (p. 306).

21. As observed by John Golding, "Fauvism and the School of Chatou: Post-Impressionism in Crisis," *Proceedings of the British Academy* 66 (1980): 91. Derain and Vlaminck sometimes emphasized the specter of loneliness in the suburbs in their titles: among the paintings that Vlaminck exhibited at the Salon des Indépendants of 1905 was no. 4151, "*Blanche tristesse*" (*Banlieue suburbaine de Paris*) ("*White Sadness*" [*Suburb of Paris*]), reproduced in Golding's article, plate IVa. In the same exhibition Derain showed a canvas entitled *Solitude* (no. 1196).

22. "Le bateau-lavoir au bas du pont de Chatou avec des laveuses et le bruit des battoirs, le chemin de halage, les filles de péniches et les débardeurs courant sur les planches." Vlaminck, in Florent Fels, *Vlaminck* (Paris: Seheur, 1928), p. 34. For similarly rosy sentiments for Chatou, see also Vlaminck's introduction to Derain, *Lettres à Vlaminck*, p. 10; and his statement in Galerie Bing, *Chatou*, [pp. 6–8].

23. Vlaminck, *Dangerous Corner*, pp. 71–72.

24. An anonymous critic in *La Liberté*, April 1, 1907; in Vallès-Bled, *Vlaminck: Le Peintre et la critique*, p. 60.

25. Monet's contrasting aversion to local banalities was vividly expressed by Clark, *Painting of Modern Life*, p. 194. I would like to thank Isabelle and Gilles Outin for their help in identifying the precise site of Derain's and Vlaminck's studio.

Although the studio is now gone, the house that backed it alongside the Pont de Chatou remains.

26. From where the photographer set up his camera "du haut du Pont"—that is, the Pont de Chatou—the building containing Derain's and Vlaminck's studio was to the immediate left. In the foreground of both the postcard and Vlaminck's painting are paired trees, and it seems likely that they are the same trees, as they would have been only steps from the studio door.

27. Vlaminck, *Dangerous Corner*, p. 124.

28. Ibid., p. 73.

29. Vlaminck, quoted by Denys Sutton in his introduction to ibid., p. 18.

30. Sutton, ibid., p. 10; Oppler, *Fauvism Reexamined*, p. 186.

31. Derain to Vlaminck, July 28, 1905; in Derain, *Lettres à Vlaminck*, p. 156.

32. Oppler, *Fauvism Reexamined*, pp. 194–95; Elderfield, "*Wild Beasts*," p. 40.

33. Vallès-Bled, *Vlaminck: Le Peintre et la critique*, p. 14.

34. *Le Pecq: Annuaire municipal, 1988–1989* (Le Pecq, France: Service Information et Relations Publiques, 1989), p. 7; Pierre Rannaud, *Le Pecq en cartes postales anciennes* (Zaltbommel, The Netherlands: Bibliothèque Européenne, 1974), pp. 5–6.

35. Although Derain could wildly distort natural color in a landscape, I believe he was faithful enough to the topography of a site that Chatou can be ruled out as the subject of plate 147. First, no place in Chatou affords the view offered by the painting, from a high vantage close to the river. Second, the Seine downriver from Chatou curves to the right, not to the left as in Derain's painting. Third, at Chatou the

railroad bridge crosses the Seine only a few hundred yards downstream from the church; there is no bridge in the painting. Finally, as noted in my text, Derain has painted a church that closely resembles the basilica plan and simple tower and belfry of the church at Carrières-sur-Seine, not the more ornate and multiform church of Chatou. The topography of Carrières-sur-Seine (until 1905 called Carrières-Saint-Denis) matches Derain's depiction closely. Vlaminck painted a similar view of Carrières-sur-Seine several years later, but without Derain's screen of trees; it is reproduced as *Paysage près de Chatou* (*Landscape near Chatou*) in Diane Kelder, *Masters of the Modern Tradition: Selections from the Collection of Samuel J. and Ethel LeFrak* (New York: LeFrak Organization, 1988), pp. 68–69.

36. "Notre habituel terrain de chasse, c'était les côteaux de Carrières-Saint-Denis qui étaient encore couverts de vignes et d'où l'on apercevait toute la vallée de la Seine." Vlaminck, *Portraits avant décès*, p. 64.

37. The postcard is reproduced in Rannaud, *Le Pecq en cartes postales anciennes*, no. 4, where it is dated 1904.

38. Neither of Chatou's bridges was constructed with the distinctive pierced metal arches found in the bridge at Bezons (see plate 132). Furthermore, the towpath at Chatou led through a stone arch within the main buttress of the Pont de Chatou, not under the first iron span. It is also possible that Vlaminck's painting depicts the bridge at Argenteuil, which had similar pierced spans, but Bezons is more likely.

39. See, for example, Monet's *La Gare Saint-Lazare, vue extérieure: Esquisse* (*The Saint-Lazare Station, Seen from the Outside: Sketch*), c. 1877 (Wildenstein I, no. 447); and Caillebotte's *Le Pont d'Argenteuil et la Seine* (*The Argenteuil Bridge and the Seine*), c. 1882 (Berhaut, no. 310).

40. The postcard is reproduced in Rannaud, *Le Pecq en cartes postales anciennes*, no. 13. Several postcards in the Hautrive and Outin collections, Chatou, present views framed by the arch in the stone buttress of the Pont de Chatou. See also *Chatou à la Belle Epoque* (Brussels: SODIM, [1977]), no. 57.

41. The idea that Vlaminck painted from his first impressions is common even in the most advanced scholarship on Fauvism; see Oppler, *Fauvism Reexamined*, pp. 349–50; and Elderfield, "*Wild Beasts*," p. 71.

42. This postcard is reproduced in *Chatou à la Belle Epoque*, no. 32. Other postcards show similar perspectives of both the Pont de Chatou and the Pont du Pecq.

43. A few years after Vlaminck made this painting, signs warning of "tournants dangereux" (dangerous corners) were erected on the Pont de Chatou before its intersection with the streets of the town, evidently in response to increased traffic (photograph in the Chatou town archives). Could this signal of progress in Chatou have suggested to Vlaminck an ironic title for his first book of reminiscences?

44. For extended consideration of the "landscape idea" as a cultural product, see Denis Cosgrove, *Social Formation and Symbolic Landscape* (London: Croom Helm, 1984); and Denis Cosgrove and Stephen Daniels, eds., *The Iconography of Landscape: Essays on the Symbolic Representation, Design and Use of Past Environments* (Cambridge: Cambridge University Press, 1988), especially the introduction by the editors. My thanks to Maria Gough for the latter reference.

45. Vlaminck, *Dangerous Corner*, p. 70.

46. Vlaminck began exhibiting his work only in 1905, when he showed six scenes of Paris suburbs (out of eight submissions) at the Salon des Indépendants. Thereafter he consistently emphasized his production in this area when he showed his work in Paris. In addition, Ambroise Vollard, who bought the contents of Vlaminck's studio in April 1906, showed these kinds of paintings to a more select urban audience.

47. Most of the postcards were made by firms in or near the towns represented—Fichard, My, Bigard, and many others in Chatou; Morel and Carré in Le Pecq; Nardot in Montesson; l'Abeille in Asnières; others in Rueil, Nanterre, and Le Vésinet.

48. Derain, in Sutton, *Derain*, p. 20. Sutton gave no date for Derain's statement.

49. "il est stupide de vouloir exprimer dans un coin de rue toute la synthèse des émotions qu'un pays vous fait éprouver"; "la perspective de Chatou ne me tente pas du tout." Derain to Vlaminck [July or August 1905]; in Derain, *Lettres à Vlaminck*, pp. 147, 150.

50. The impact of Mediterranean light on Derain's painting in the north was noted by John Golding, "Fauvism and the School of Chatou," p. 92.

51. Vlaminck, in Gaston Diehl, *The Fauves* (New York: Harry N. Abrams, 1975), p. 104.

52. Léon Werth, *Vlaminck: Vingt et une reproductions* (Paris: Bernheim-Jeune, 1925), p. 6.

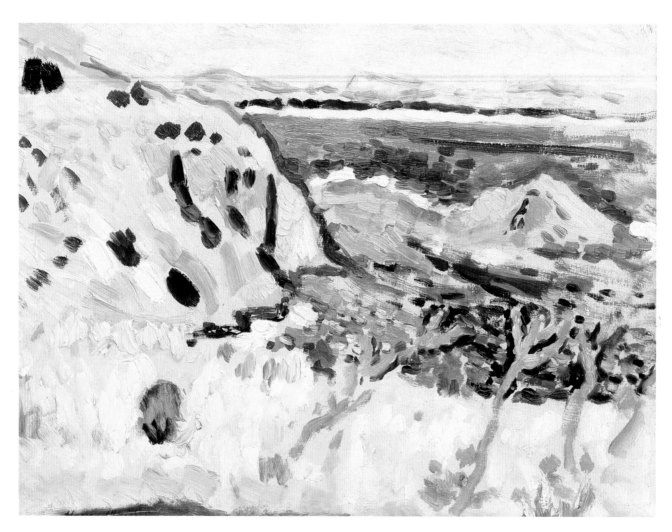

PLATE 159

Painters and Tourists

matisse and derain on the mediterranean shore

JAMES D. HERBERT

The sunny Mediterranean beckoned, and virtually all the Fauves heeded its call. Around mid-decade they began to abandon the sites in the north of France that had been favored by many French artists of the preceding generations and traveled south to paint instead. Henri Matisse summered at Saint-Tropez on the Riviera in 1904 and in Collioure, near the Spanish border, in 1905. His younger colleague André Derain joined him at Collioure in 1905. As they depicted these sites Matisse and Derain developed many of the distinctive painting techniques and treatments of theme that were to become hallmarks of the Fauve movement.

The towns portrayed by Matisse and Derain were still sleepy fishing ports rather than the chic international resort or the French vacation center that Saint-Tropez and Collioure, respectively, have become today. In ever-increasing numbers, however, tourists were beginning to "discover" such quaint Mediterranean locales during the same years that Matisse and Derain frequented them. These travelers adopted attitudes toward the sites they visited that differed markedly from those of the previous generation of French tourists, who had favored bathing establishments along the English Channel. The new breed of tourists discarded the habits of urbanity that visitors to the Channel had taken with them from Paris and instead attempted to integrate themselves into seemingly untouched fishing ports and the surrounding countryside. The simultaneous development of new manners of painting and touring in the south of France was hardly happenstance. The taste—artistic and "touristic"—for such sites as Saint-Tropez and Collioure had to be invented, and the activities of these painters and tourists in tandem produced a new standard by which to assess the landscape.

Almost without exception, Matisse's and Derain's paintings from the south present a vision of town and landscape harmoniously intertwined. In Matisse's *Vue de Saint-Tropez* (*View of Saint-Tropez*, plate 160), the town occupies the comfortable middle ground of the picture. Topography limits the expanse of human habitation, for these buildings are surrounded by rolling hills and nestled on a moderate promontory extending into the calm waters of the bay. Yet nature here never overwhelms Saint-Tropez nor renders human presence superfluous. Since the near and far shores are all but bisected by the bay, their integrity as a single coastline within the picture relies heavily on the visual bridge provided by the man-made tower of the village church. Fishing port and landscape commingle, neither complete without the other.

Often color as well as composition blend town and setting. In both Matisse's *Vue de Collioure* (*View of Collioure*, plate 161) and Derain's *Petit Port méditerranéen*,

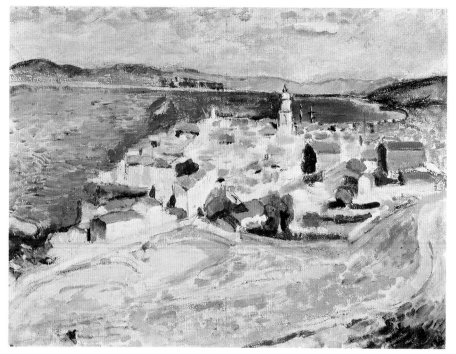

PLATE 160

PLATE 160
Henri Matisse
Vue de Saint-Tropez
(*View of Saint-Tropez*), 1904
Oil on canvas
13 ¾ x 18 ⅞ in. (35 x 48 cm)
Musée de Bagnols-sur-Cèze,
Bagnols-sur-Cèze, France

Exhibited in the Salon des
Indépendants, 1905

PLATE 161
Henri Matisse
Vue de Collioure
(*View of Collioure*),
summer 1905
Oil on canvas
23 ⅞₆ x 28 ¼ in. (59.5 x 73 cm)
The State Hermitage
Museum, Leningrad

Collioure (*Small Mediterranean Port, Collioure*, plate 162) the bright colors—orange, pink, blue—that define the walls and roofs of the village recur in the foreground land and the distant waters and hills. It is difficult in Derain's canvas to determine where the foreground terrain ends and buildings begin, or even where man-made structures give way to the bay. All intermixes, a collection of highly saturated brush strokes depicting a cozy fishing port basking beneath the hot southern sun.

Fauve paintings of the south not only unite buildings and settings, they also stake out claims for Matisse and Derain over the harmonious townscapes portrayed. Matisse's *Le Goûter (Golfe de Saint-Tropez)* (*Midday Snack* [*Gulf of Saint-Tropez*], plate 163) appropriates the site for the artist indirectly, through an act of substitution. In this picture a woman—her clothes and her leisure mark her as a tourist—assumes within the same setting a place quite similar to that of the town in *Vue de Saint-Tropez* (plate 160). And, like the town, she is posed so that the contours of her body echo the line of the coast: she too appears at one with nature. A second figure, a boy—barely discernible, sitting in front of the woman—is even more integrated into his surroundings, for he all but dissolves into the outcroppings of rock around him. Absorbed into the setting, equated with Saint-Tropez by serving as its replacement, this woman and child mingle with the site as harmoniously as town and landscape intertwine in *Vue de Saint-Tropez*.

A mother, a child... and a father. The artist himself—likewise a tourist, likewise having taken up a place along the beach of Saint-Tropez—implicitly joins the happy family circle. The woman posing for *Le Goûter (Golfe de Saint-Tropez)* was, in fact, Matisse's wife, Amélie, and the boy, his son Pierre. This family, the artist's own, provided Matisse with his link to Saint-Tropez. In *Le Goûter (Golfe de Saint-Tropez)* the politics of domesticity extend beyond the woman and child to encompass nature and town, with which they are, respectively,

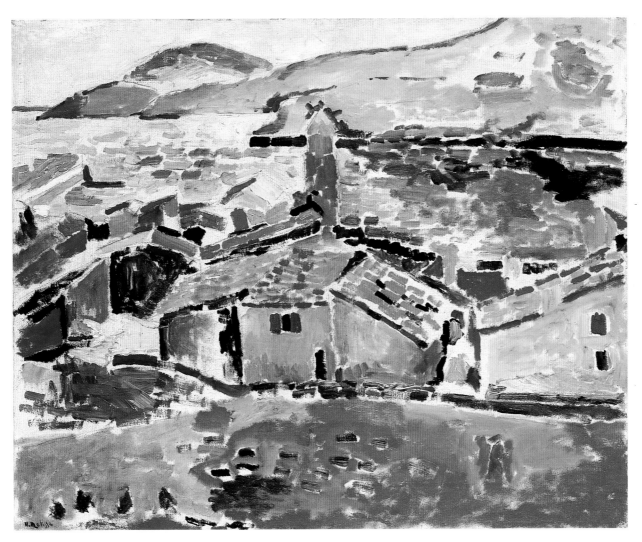

PLATE 161

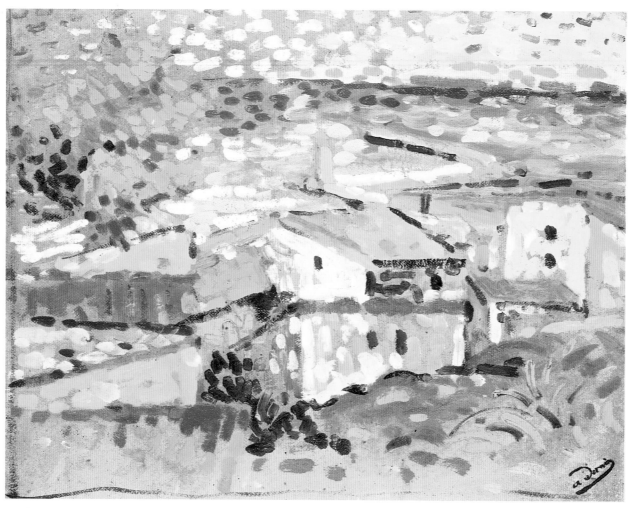

PLATE 162

PLATE 162
André Derain
Petit Port méditerranéen,
Collioure
(*Small Mediterranean Port,*
Collioure), summer 1905
Oil on board
14 ⅛ x 18 ⅛ in. (35.9 x 46 cm)
Private collection

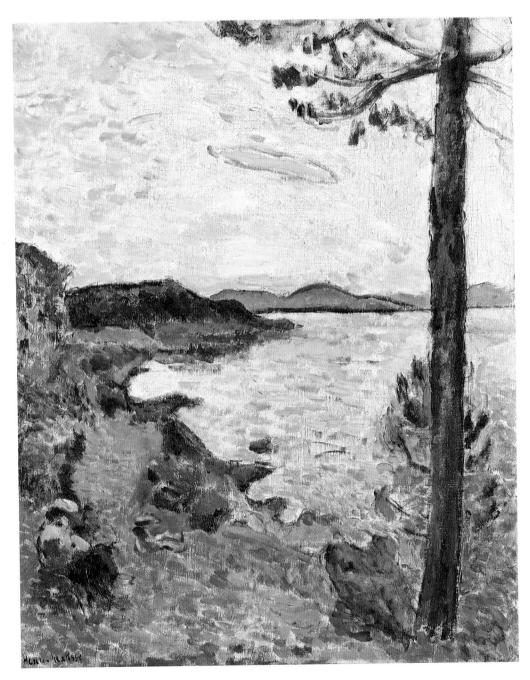

PLATE 163

PLATE 163
Henri Matisse
Le Goûter (*Golfe de Saint-Tropez*)
(*Midday Snack* [*Gulf of Saint-Tropez*]), summer 1904
Also known as *By the Sea*
Oil on canvas
25 ⁹/₁₆ x 19 ⅞ in. (65 x 50.5 cm)
Kunstsammlung Nordrhein-
Westfalen, Düsseldorf,
West Germany

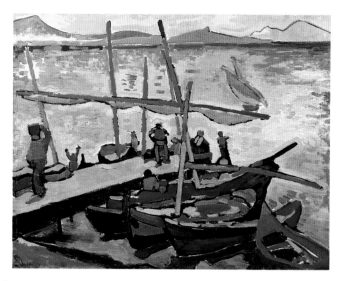

PLATE 164

integrated and equated. The painting credits the artist with the same relationship to the site of Saint-Tropez that a bourgeois male at the turn of the century presumably enjoyed within his own family: intimacy coupled with paternal authority.

Derain's *Rentrée de la pêche (Les Barques)* (*Return of the Fishing Boats* [*The Boats*], plate 164) makes Collioure appear the artist's home by positioning him on native soil. To paint this work Derain must have stood on one of Collioure's two sandy beaches where the local fishermen moored their craft. Adopting the perspective of the men he portrayed, Derain surveyed those things—shore and dock, boats and water—that undoubtedly made up many of the daily concerns of these fishing types. To scan the picture repeatedly from side to side is to shift one's footing from land on the left to shipboard on the right and back again, replicating the action of the depicted fishermen, who pass back and forth along the pier between the beach and their boats. Derain's painting claims for the artist full access to the world of these locals. These fishermen, moreover, would have appeared to most of Derain's viewers as "naturally" part of Collioure. The aesthetician Frédéric Paulhan voiced a truism of the day when he declared in 1913: "Villagers and peasants, those who do not come to the countryside as tourists but who live their lives there, working the soil, are in some sense part of nature."[1] Derain's proximity to these locals ostensibly placed him in similarly close contact with Collioure itself.

Matisse and Derain appeared to belong, then, in these small fishing ports seemingly unsullied by civilization—and, conversely, these sites belonged to them. It was a rustic theme for high art, and in accordance the Fauves painted their southern scenes in a style that declared itself: simple. The predominant color in Derain's *Port de Collioure, le cheval blanc* (*Port of Collioure, the White Horse,* plate 165) is white, but what we are seeing is untouched primed canvas. Against this surface lie Derain's large and unctuous brush strokes and swatches of color, for the most part isolated one from another. The treatment of the horse that gives the work its subtitle is exemplary; the animal is carved out of the priming only by the handful of lines that define its harness and the shadowed edges of its belly and legs. The passage is so abbreviated, in fact, that we cannot be sure that Derain has not reversed the beast and put the cart before the horse.

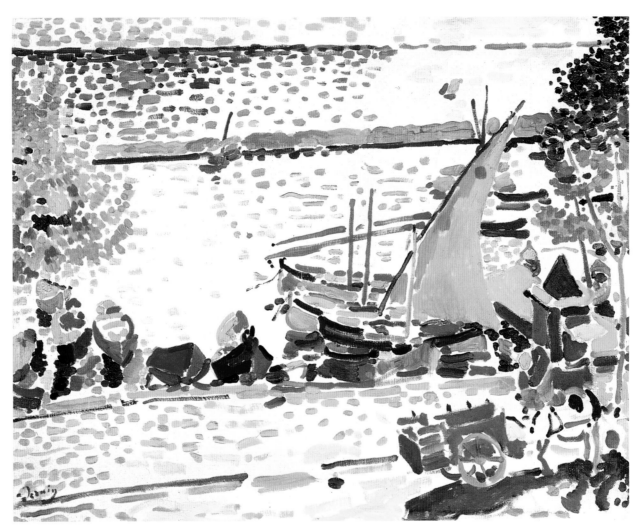

PLATE 165

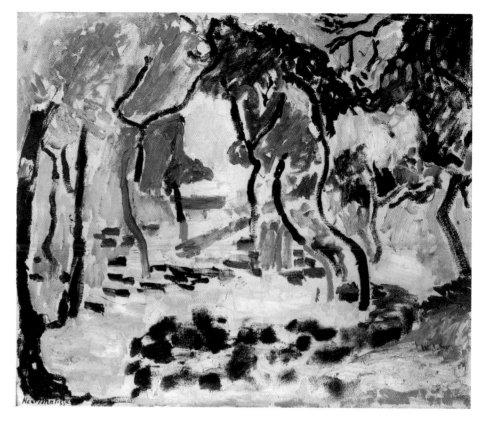

PLATE 166

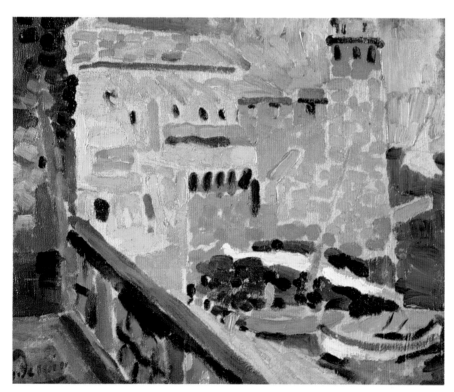

PLATE 167

Matisse's *Paysage de Collioure* (*Landscape at Collioure*, plate 166) and Derain's *Le Phare de Collioure* (*The Lighthouse at Collioure*, plate 167), both depicting the small church at Collioure, are more rudimentary still. The academically trained Matisse did not even bother to prime his coarse burlap canvas before smearing on the handful of strokes that must suffice to define the tower. Likewise, the dark tan of Derain's rough unprimed support peeks out between the isolated orange brush strokes depicting the rough-hewn stones of the church. All here seems patently obvious: no underpainting, little layering; nothing hidden from view, nothing to suggest artistic finesse. Indeed, if we define technique as that special erudition or set of skills that only artists possess, the handling of paint in these two works seems so commonplace as to constitute no technique at all. The artists of these paintings went out of their way—we might even say "skillfully" so—not to represent the esoteric skills of the painter trained in academic or Impressionist technique. The views of rustic Collioure provided by the Fauves appear unmediated by art—where art means the practices of painters trained and based in Paris.

Of course, in a different sense these pictures are replete with the representation of artistic intervention. Bright, nonmimetic colors and loose brushwork signaled to most viewers in 1905 personal "expression," especially in the wake of the recent and notorious Vincent van Gogh. Since van Gogh's hallucinatory colors, geometric distortions, and great swirls of pigment seem unaccountable in terms of the scene portrayed, writers—then as now—have tended to attribute these pictorial discrepancies to the artist's unique individuality. The artist's idiosyncratic personality, as the source of his art, has been given a variety of names: "vision," "insanity," "genius." To some degree, such notions of enigmatic personal style transcending visual transcription inevitably carried over to Fauve pictures. Nevertheless, for the most part Fauve paintings cut against the grain of letting style represent inexplicable individuality at the expense of the depicted object. Signs of expression in canvases by Matisse and Derain appear not as the attributes of unadulterated personality but rather as the product of the very rustic sites and people they are used to portray.

The palette of the Fauves, it is true, often seems arbitrary, but it is simple as well: little mixing and no modeling in this collection of paints straight from the tube. Primary hues abound. The small sailboat in the upper-right corner of Derain's *Port de Collioure* (plate 165) is archetypical: an elementary color wheel of the three most basic hues—yellow, red, blue. At the time such highly saturated color evoked the unrefined tastes of "primitive" races and classes. "If the savage, if the peasant prefer vivid colors," argued the writer Paul Adam in 1905, "it is because their optic is not sufficiently refined. At a village ball, green and red attire, ruthlessly blue hats, and white lace collars are in abundance."[2] Purged of the nuances of color that Adam and others associated with the fine art of painting, canvases by Matisse and Derain evoked instead the chromatic forthrightness of ostensibly plain, natural folk.

Similarly, the seemingly crude application of paint made the artists appear as unsophisticated as the locals before them. Factoring the residents out of the equation altogether, Derain's *Le Phare de Collioure* (plate 167) goes so far as to assert that the vision of Collioure it provides is indistinguishable from the site itself. The sail of a fishing boat at the right edge of the picture consists entirely of

exposed canvas, a clever matching of the rugged fabric of the painting's support to the coarse sailcloth of the fishing craft. The object portrayed by the painting appears as tangibly physical and as immediately present to the viewer as the unpainted surface itself. In like fashion Derain's brush strokes often emulate the physical characteristics of that which they depict: one well-laden stroke for each massive building block of the church; one long, continuous streak for the railing in the left foreground. In these passages the site is evoked less by visual resemblance than by direct tactile correspondence: Derain's "bricks" of pigment are set into place like so many rough-hewn stones at Collioure. Pictures by both Derain and Matisse are filled with such visual puns that turn on the shared substantiality of paint and depicted object. Iconic representation, with the gulf it always implies between image and reality, collapses into material similitude: to examine the physical object that is the painting seems tantamount to beholding the actual portrayed scene.

Even here, the practice of painting always and inevitably mediates the view. The conflation of picture and seascape is a fiction manufactured by the artist's effacement of skilled technique. Because the interventions of style in Matisse's and Derain's pictures are hidden by their mimicking of rustic scenes, the resulting views onto the Mediterranean shore appear direct, unencumbered by the artifices of art or by the idiosyncrasies of expressive personality. Pictorial means seem as guileless as pictorial theme. The practice proved effective among Parisian critics, for it earned these artists the label *les fauves*, "wild beasts" presumably as much at home in nature as were the fishermen of Collioure.

This direct rendition of the harmonious Mediterranean landscape corresponded to a new manner of touring, likewise developed in the south of France beginning in the first decade of the twentieth century. (Allow me for the moment to leave the nature of that correspondence vague.) Although their numbers were not yet legion, a new breed of tourist was beginning to search out the charms of nature in small Mediterranean villages and ports. These travelers, like Matisse and Derain, claimed to submerge themselves in their surroundings and to associate with the local residents. Albert Dauzat, author of a book meant to improve its readers' skills as travelers entitled *Pour qu'on voyage: Essai sur l'art de bien voyager* (*How to Travel: Essay on the Art of Traveling Well*), advised in 1911: "To know a country and its inhabitants, it is necessary to make contact with the natives and penetrate as much as possible the local settings."[3] Such sojourns were seen to have their rewards. Again, Dauzat: "For a time, one recovers for oneself a primitive mentality that, by contrast, demonstrates that the needs created by refined civilization are, in the end, artificial and relative. One learns better to appreciate those things that appear completely natural and upon which we have never taken the trouble to reflect."[4]

Small unspoilt ports along the Mediterranean such as Saint-Tropez and Collioure were perfect places for the new generation of tourists to attempt to escape the artificiality of civilization and rediscover the virtues of things natural. A postcard of Saint-Tropez from the first decade of the twentieth century (plate 168) conveys this new manner of viewing and appreciating a "primitive"

PLATE 168

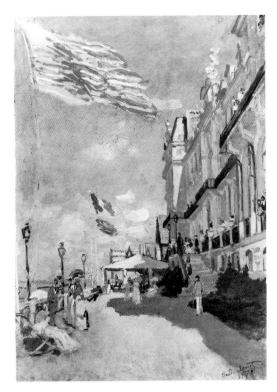

PLATE 169

PLATE 170

PLATE 168
Saint-Tropez, c. 1902

PLATE 169
Claude Monet
(France, 1840–1926)
*Hôtel des Roches Noires,
Trouville*, 1870
Oil on canvas
31 ½ x 21 ¹¹/₁₆ in. (80 x 55 cm)
Musée d'Orsay, Paris

PLATE 170
Trouville, c. 1904

town and its surrounding landscape. The photograph composes the scene in a fashion virtually identical to Matisse's *Vue de Saint-Tropez* (plate 160).

This informal, ostensibly natural manner of visiting the seaside emerged as a common practice only at the beginning of the twentieth century. In the preceding years touring—and, for that matter, painting—had been quite a different affair. In 1870 Claude Monet visited the posh resort of Trouville on the coast in the north of France. For his *Hôtel des Roches Noires, Trouville* (plate 169), Monet set up his easel on the terrace of the liberally ornamented hotel, which was then the jewel of the luxurious establishments along the Channel. The painting invites its viewers to partake in the swirl of activities at this pinnacle of holiday society at Trouville. Before our eyes opens the expansive terrace, almost exactly as wide as the canvas itself. To enter the pictorial space of the painting, to follow the path laid out by the commanding orthogonals commencing in the lower two corners of the canvas, is to join in the pleasantries of the well-dressed and urbane crowd situated on Monet's social stage. Above, an assortment of flags proclaims the international character of the clientele. And what of nature? Here it seems all but beside the point. The ocean may lie beyond the railing at the left of the picture and a sea breeze may flutter the flags, but these people—and Monet—seem oblivious to the natural attractions of the place. Reenacting cosmopolitan rituals with fellow tourists is occupation enough at Trouville. The *Guide Diamant* declared of Trouville in 1873: "It is Paris, transported for two or three months to the seaboard, with its qualities, its frivolities and its vices."[5]

Three and a half decades later little had changed in the north. A hand-tinted postcard from about 1904 (plate 170) features the same urban crowds, ornate façades, international flags—and indifference to nature—as Monet's painting. This stretch of sand, proclaimed the Baedeker's guide to the northwest of France

in 1908, "is the summer boulevard of Paris."[6]

But Monet, of course, did paint nature along the Channel. Forsaking cosmopolitan Trouville after 1870, he ventured several times in subsequent decades to the dramatic rock formations of Etretat and other sites along the Normandy coast. His *Cliffs of the Petites Dalles* (plate 171) belittles humanity: an expanse of violent sea and the soaring heights of distant cliffs dwarf several small figures in the middle distance. This is nature not encompassed by civilized life but opposing it, contrary to human society.

In a word, this is the sublime. French audiences at the turn of the century would undoubtedly have conceived of the sublime in terms derived from Edmund Burke and Immanuel Kant. The aesthetic theories of these two eighteenth-century philosophers had percolated through virtually all nineteenth-century writings on landscape, including those penned in France. It could be said that Monet formulated a Burkean conception of the sublime in *Cliffs of the Petites Dalles*. Burke claimed that the sublime consisted of those things "vast in dimension," "terrible," and evocative of "pain and danger." And when Burke wrote, "The passion caused by the great and sublime in *nature . . .* is Astonishment" and "Whatever excites this delight, I call *sublime*," it is clear that he situated the sublime in nature, independent of human cognition.[7] Monet's juxtaposition of minute humans with the soaring cliffs at Petites Dalles reiterates this same Burkean principle: the terrible sublime exists in nature, beyond the human realm.

This contrast between humans and cliffs, far from contradicting an appreciation of the refined life at the luxurious resorts, stood as its complement. Nature's surpassing the measure of society reinforced the sense that humanity existed only within the framework of civilized life. Monet's representations of the Petites Dalles, like his pictures of Trouville, placed civilization on one side of a conceptual divide and nature on the other.

Yet where mere mortals could not go, the artist dared to tread. In *The Manneporte, Etretat II* (plate 172) and many other like canvases, Monet pitted himself alone—there are no *staffage*, or incidental figures—against the soaring rock face. The artist claimed special powers in relation to the sublime: he could interpret it. Viewers of Monet's canvases could discover ample pictorial evidence of such artistic mediation; Monet, in other words, offered a representation of his privileged status as the interpreter of sublime nature. In *The Manneporte, Etretat II*, the heavily worked surface—layer upon layer of stippling, troweling, and broad brush strokes—catalogs many of the intricate technical devices that Monet had developed over two decades as a painter. Complexity mystifies technique—it is exceedingly difficult to discern exactly how Monet put this picture together—and thus late Impressionist style conveniently becomes the sign for the artist's special vision. Such elaborate procedures offered proof to contemporary critics who labeled Monet a pantheistic priest, able to grasp the spiritual essence in nature and render it on canvas.[8] Unlike the rest of us, the argument ran, the artist comprehends sublime nature *because* he possesses his seemingly magical artistic skills, and vice versa.

This affinity between the artist and terrible nature reiterated, in place of Burke's ideas, the account of the sublime provided by Kant. Kant argued that aesthetic categories were purely mental constructs: "We express ourselves incor-

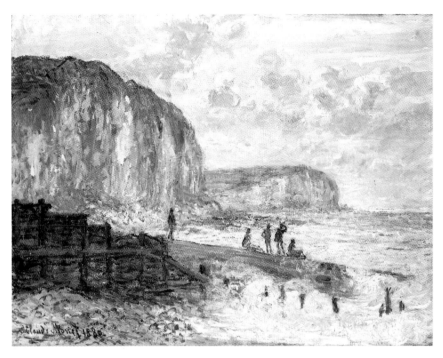

PLATE 171

PLATE 171
Claude Monet
(France, 1840–1926)
Cliffs of the Petites Dalles, 1880
Oil on canvas
23 7/8 x 31 5/8 in.
(60.6 x 80.3 cm)
Denman Waldo Ross Collection, courtesy, Museum of
Fine Arts, Boston

PLATE 172
Claude Monet
(France, 1840–1926)
The Manneporte, Etretat II,
1886
Oil on canvas
32 x 25 3/4 in. (81.3 x 65.4 cm)
The Metropolitan Museum of
Art, New York, bequest of
Lizzie P. Bliss, 1931, 31.67.11

PLATE 172

rectly if we call any *object of nature* sublime.... [T]rue sublimity must be sought only in the mind of the subject judging, not in the natural object the judgment upon which occasions this state."[9] Kantian aesthetics, by treating the sublime as a cognitive rather than an ontological category, granted fantastic powers to those who could perceive nature using the mental construct of the sublime. If nature seemed threatening, if humans feared for their safety before its mightiness, humanity could use the concept of the sublime to tame dangerous nature, to bring it down to human scale. "In our mind," Kant argued, "we find a superiority to nature even in its immensity."[10]

From a Kantian perspective the category of the sublime, far from marking inhuman nature off-limits to human experience, functioned as the very device by which such nature could be brought under control once again, contained within an aesthetic created by human minds. The sublime allowed society, through the offices of the artist, to have nature both ways: both infinitely powerful *and* bounded by human sensibilities. The literary theoretician Terry Eagleton has recently commented on this seeming paradox:

> There is... that about the particular ideology of the bourgeois class—its restless, dynamic self-distancing from Nature—which enters into potentially tragic conflict with one of the requirements of ruling orders in general: the need to see themselves consolingly reflected in a world of their own creation. The aesthetic accordingly steps in to unify, for a precious, precarious moment, a subject and object ripped rudely apart by common social practice.... Lest we grow complacent in contemplating the image of our own powers in the mirror of reality, there is always the shattering, destabilizing inruption of the sublime to remind the bourgeoisie that its forces are infinitely expandible, that its true home is eternity.[11]

In France at the turn of the century, the sublime served as an "aesthetic" in Eagleton's sense of the word, for it "step[ped] in to unify" a certain bourgeois class, Monet's audience, with awe-inspiring and eternal nature, Monet's theme. The privileged, mystical artist Monet facilitated the claim by a finite social class to have control over the infinity of the natural.

In their paintings from the south Matisse and Derain systematically rejected this vision of nature formulated in the north. Certainly nature in the Fauve canvases from Saint-Tropez and Collioure is not sublime: rather it is calm and harmoniously intertwined with human society. And Matisse and Derain disavowed the privileged status of the skilled artist: none of Monet's layered and recondite reworkings show up here. Yet the Fauves did contain the landscape within an alternative aesthetic category. In Kantian and Burkean vocabularies that category would go by the name of the beautiful, describing a "limited and measured... order and harmony" that stood in antithesis to the infinitude and chaos of the sublime.[12] However, an alternative term, one in active use in France at the turn of the century, better captures the aesthetic character of Matisse's and Derain's paintings of the south: the *pittoresque*, or picturesque.[13] A "picture-esque" landscape is quite literally a view of a section of countryside that conforms to the compositional standards set by previous landscape paintings. As the Littré *Dictionnaire de la langue française* defined the term in 1876: "It is said of all that lends itself to the making of a characteristic painting."[14] In the most obvious sense the picturesque treats territory as a purely aesthetic entity.

PLATE 173
Claude Lorrain
(France, 1600–1682)
Ariadne and Bacchus on Naxos,
1656
Also known as *Ulysses Discovering Himself to Nausicaa*
Oil on canvas
30 1/2 x 40 5/8 in.
(80.1 x 103.2 cm)
Collection of the Arnot Art Museum, Elmira, New York

PLATE 174
Nicolas Poussin
(France, 1594–1665)
Detail of *Bacchanal with a Guitar Player:
The Andrians*, c. early 1630s
Oil on canvas
47 5/8 x 68 7/8 in. (121 x 175 cm)
Musée du Louvre, Paris

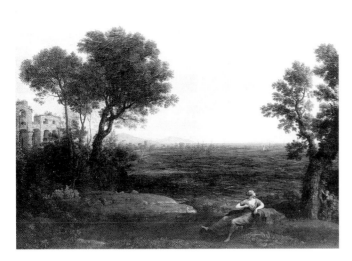

At the beginning of this century in France the compositional standard that defined the picturesque was set above all by artists of the French *grande tradition*, that seemingly unbroken chain of great Latinate and French artists extending from antiquity to modern times. Beyond a doubt, in 1905 the works of art most widely considered to exemplify the *grande tradition* were the landscapes by the seventeenth-century masters Nicolas Poussin and Claude Lorrain.

Over and again as they shunned sublime elements in their paintings of the Mediterranean coast, Matisse and Derain produced canvases that conformed to the contemporary standards of the picturesque as embodied in the *grande tradition*. Except for its vertical format, Matisse's *Le Goûter* (*Golfe de Saint-Tropez*, plate 163) echoes the pictorial organization of Claude's *Ariadne and Bacchus on Naxos* (plate 173): a tree as *repoussoir* along the right edge, secondary massing on the left, gradual spatial recession articulated by the diagonal of the shore line, and even *staffage* figures in the foreground. Moreover, Matisse's colors, despite their saturation, actually set up a rudimentary atmospheric perspective similar to Claude's: warm tones in the foreground, cool blues in the distance.

In his two largest and most famous paintings from the period Matisse introduced nymphs and baccants into his depictions of the southern landscape: *Luxe, calme, et volupté* (plate 175) obviously reiterates the topography of Saint-Tropez, while *Le Bonheur de vivre* (*The Joy of Life*, plate 176) is based on landscape studies executed near Collioure. Such mythical figures further articulate the connection between the Fauves' Mediterranean works and classical bacchanals along the lines of Poussin's *Bacchanal with a Guitar Player: The Andrians* (plate 174) in the Louvre. We have entered the idyll, a realm already delimited by the artists of the *grande tradition*.

This is not to suggest a direct "influence": Matisse did not systematically copy Claude or Poussin.[15] Such obvious and self-conscious borrowing was, for the most part, unnecessary: even the most elementary artistic training in France at the turn of the century would have instilled in painters a way of thinking about landscape that would have made picturesque devices immediately available for use. No need for reflection, no need for specific classical prototypes. Likewise,

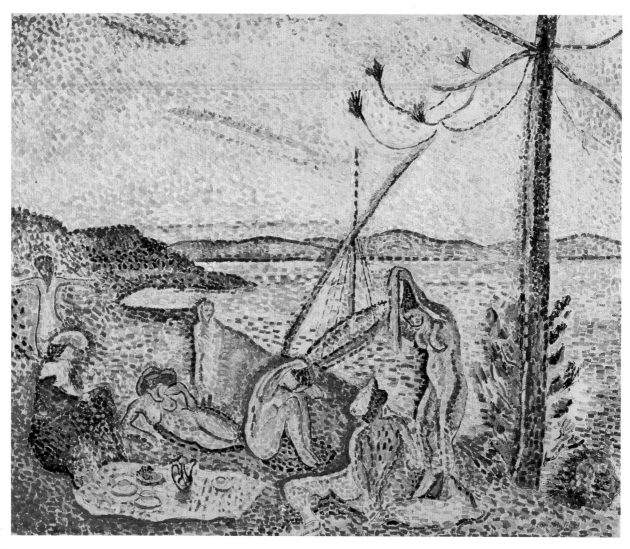

PLATE 175

PLATE 175
Henri Matisse
Luxe, calme, et volupté, 1904–5
Oil on canvas
33 7/8 x 45 11/16 in. (86 x 116 cm)
Musée d'Orsay, Paris

Referred to by Matisse as
Baigneuses (*Bathers*) prior to its
exhibition at the Salon des
Indépendants, 1905

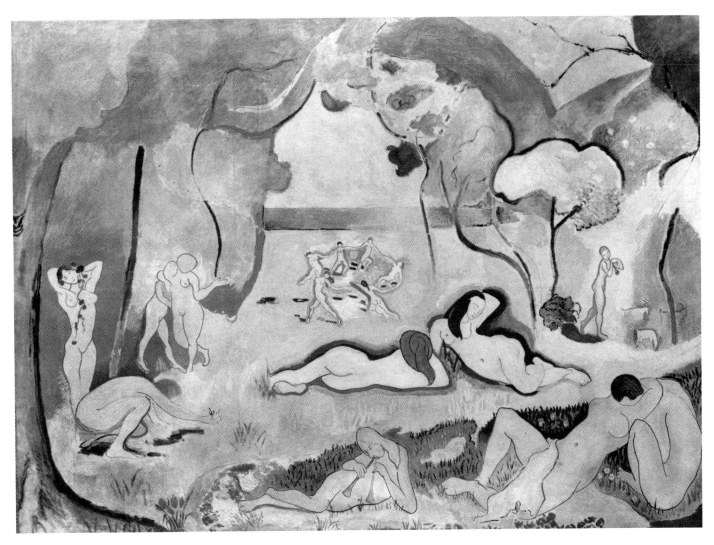

PLATE 176

viewers at the turn of the century—as today—may well not have consciously recognized a filiation between the Fauves and the artists of the *grande tradition*. Nevertheless, conditioned by exposure to countless picturesque canvases from the past, that audience would have marshaled the artistic category of the picturesque to the task of viewing these Fauve landscapes with such rapidity and ease that the classification would have felt like an unconscious act of intuition.

Once nymphs and satyrs materialize within Matisse's world, his paintings enter mythic time. These pictures are far from the snapshot of contemporary civilities in Monet's *Hôtel des Roches Noires* (plate 169). Rather, the presence of bacchants and bathers takes *Luxe, calme, et volupté* (plate 175) and *Le Bonheur de vivre* (plate 176) back in time, through the Roman *campagna*, through ancient Greece, to the age of myth at the dawn of civilization. In *Luxe, calme, et volupté*, Amélie Matisse at Saint-Tropez joins a circle of eternal nudes, while the idyllic gathering in *Le Bonheur de vivre* appears to sprout spontaneously out of the landscape at Collioure. In Matisse's pictures the modern Mediterranean assumes the timeless quality of the classical pastoral.

The Mediterranean locations of Saint-Tropez and Collioure greatly facilitated the Fauves' evocation of classical eternity. Geographically, France shared the Mediterranean with Italy and Greece, and thus conceptually its southern shore could be directly linked to the nation's illustrious cultural predecessors. For example, the geographer Onésime Reclus, in describing his descent from the mountains to the sea near Collioure in 1903, extolled "the great cerulean waters of the Hellenes and the Latins" that stretched before him.[16] The nymphs and fauns in Matisse's pastorals were not, in fact, needed to transport these southern locales into classical eternity. Simply by treating such sites as picturesque, Matisse and Derain engaged that Latin cultural heritage.

Made part of the *grande tradition* and the picturesque, the settings of Saint-Tropez and Collioure in Matisse's and Derain's paintings appear as eternal as myth—and as timeless as art. Thus in their Mediterranean landscapes Matisse and Derain—without first positing nature as a monster to be tamed, as had Monet with the sublime—likewise suggested that nature was infinite, now along the temporal axis of eternity rather than the spatial axis of unlimited expanse. Simultaneously the picturesque, like the Kantian sublime, contained the portrayed landscape within the bounds of human aesthetics.

Much more was at stake, with both the sublime and the picturesque, than simply the manner of painting a picture. As we have seen, the two aesthetic principles corresponded to two different modes of touring. Yet the two manners of painting did not follow meekly in the wake of tourism, recording the sensibilities of tourists in a servile fashion. If anything, the opposite was true. To make sense of the natural scenery around them, tourists turned to the visual precedents furnished by landscape painters. The Comte d'Ussel, yet another writer counseling readers on how to travel correctly, stated in 1907: "To understand the landscape well, and as preparation for a voyage in a country of landscapes, it would be good to have drawn or painted oneself, or—failing that—to have carefully studied many paintings: the lessons of painting are better than those of nature itself contemplated directly."[17] Tourists self-consciously viewed the landscape, analyzed it, and registered it in memory, utilizing categories al-

ready provided by painting. It is far from coincidental that painters and writers pioneered the tourist sites of Saint-Tropez and Collioure—and, in an earlier age, of Etretat and even Trouville—for in doing so they brought a set of aesthetic principles to bear on the site that subsequently served as models for other tourists following in their paths.

Fine art provided more than a set of epistemological categories with which to view the countryside. Just as artists used the sublime and the picturesque to colonize nature for human contemplation, so tourists could use their travels to assert a similar control over the land. As the novelist Henry Bordeaux, in a remarkably forthright passage, declared in 1906: "To travel is to conquer new lands with one's eyes, to annex emotions and images onto one's sensibility like a vanquisher adds territories to his nation."[18] Tourists, at least initially, did not claim actual ownership of the regions they visited; rather, they asserted that the landscape that fell beneath their gaze belonged within the purview of their cultural experience. In a conceptual sense, the landscape belonged to them.

Bordeaux's formulation has an additional resonance: tourists don't just stake a claim, they build a nation. To perform this patriotic task—"adding territories to a nation" were Bordeaux's words—the picturesque proved particularly efficacious, for the *grande tradition* upon which it was founded was considered, in the first decade of the twentieth century, fundamentally French. In 1905 Jean Tarbel (probably a pseudonym for the novelist Mme J. Delorme-Jules-Simon) proclaimed Poussin "the most characteristic painter of our race...our great national painter"[19]; there were many who echoed her words. Indeed, a conservative nationalist movement that based its definition of the French nation on the cultural heritage of the Latin world was emerging during these very years; Charles Maurras of the journal *L'Action française* was perhaps its most vocal proponent. In 1905 the *grande tradition* in painting carried a strong political charge.

Inevitably, many of these nationalist connotations surface in Fauve canvases that evoke the *grande tradition*, most explicitly in such works as Matisse's *Luxe, calme, et volupté* (plate 175) and *Le Bonheur de vivre* (plate 176) but implicitly in all Fauve picturesque paintings of the south. Thus, French tourists viewing the southern landscape through the lens of the picturesque provided by artists such as Matisse and Derain treated such sites as theirs not only because the landscape was contained within an aesthetic but also because it became part of the Latinate French nation. In the years to come the Mediterranean shore was indeed to be made over in France's own image, for the rapid growth of tourism in towns such as Saint-Tropez and Collioure was to integrate these previously isolated and semi-autonomous sections of the Mediterranean coast into the mainstream of French cultural and political life.

The appropriation of the south by contemporary Frenchmen, no matter how thorough, was rarely declared openly. Even as French artists and tourists asserted their interests in the Mediterranean landscape, even as they colonized these sites using the category of the picturesque, more often than not they dissimulated their claims on the land behind another Kantian principle, that of aesthetic disinterestedness. In a particularly Kantian formation, the essayist Paul Gaultier in a commentary of 1909 entitled "Le Sentiment de la nature dans les beaux-arts" ("The Feeling for Nature in the Fine Arts") described the attitude that he felt

artists should take as they stood within nature: "It is crucial to be, as much as possible, free from the prejudices, biases, interests, concerns and conventions that in ordinary life interpose themselves between nature and ourselves to such a degree as to mask the view.... It is necessary to have a fundamentally disinterested sensibility."[20]

In viewing the landscape using the aesthetic categories provided by artists, tourists adopted this apparently disinterested attitude as their own. The fact that their claim consisted of a conceptual appropriation of the site rather than actual ownership of the land only reinforced the pretense of disinterestedness. In 1905 there was little question as to which class possessed the legitimating powers of this Kantian aesthetic, and did so absolutely: the educated bourgeoisie on vacation, not the practical peasantry. In *Pour qu'on voyage*, Dauzat invented the following typical exchange between tourist and local inhabitant to make the point; it is an anecdote told from a position of such unequivocal class self-assurance that nothing restrained the author from indulging in caricature of those he considered beneath him.

> Has it never happened, during a journey when before a view of the sea, forest or mountains, that you have expressed your admiration to a passerby—fisherman, laborer or woodcutter—exclaiming before him: "What beautiful country!" ¶ But the man does not understand you, and invariably you elicit one of the following responses: "Yes, it's good land; crops grows well, [or] the fishing is good [or] the oak wood sells at a profit." ¶ Or more frequently: "Oh, no! It's bad country; nothing grows well, [or] you can't catch fish, [or] you work to death to earn a miserable living." ¶ But if, to your companion, you try to extol the beauty of the lines of the mountain, the coloring of the ocean, or of the forest or of the clouds at sunset, the worthy fellow will shrug his shoulders with a smile of disdain, not understanding how one can loiter over such nonsense. It is useless to insist; you will waste your time and your eloquence: *he does not feel it....* ¶ [The feeling for nature] does not exist among simple and primitive souls, among children, among peasants who, the one like the other, only appreciate the sensible world to the degree to which it is capable of satisfying their pleasures, their needs, their interests. The feeling for nature supposes, on the contrary, a disinterested contemplation; it is a form of artistic enjoyment.[21]

The argument behind the story is uncompromising: only those endowed with the gift of aesthetic contemplation, and not those burdened with mere practical concerns, truly understand the landscape. This "beautiful country" must belong to the aesthetically inclined, for no one else can even see it. The appropriation of the land disguises itself, legitimates itself, as art.

In a much more sophisticated way—certainly without having to resort to the overt disparagement of the lower classes—the Fauves performed much the same dissimulating function. The Mediterranean south, depicted in paint, received the sanction of disinterested aesthetics. In the hands of Matisse, Saint-Tropez becomes a picturesque landscape; Collioure is transformed into a classical pastoral. And, to be precise, Derain in *Rentrée de la pêche* (plate 164), though he rubs elbows with the local residents, is not fishing (and thus personally concerned with the success of the catch). He is painting.

Yet the Fauves—and here lies the special power of their version of the picturesque and of aesthetic disinterest—masked the overt presence of art in their

paintings. Matisse's and Derain's adherence to the pictorial standards of the picturesque was oblique enough—and the material from the *grande tradition* upon which they relied so elementary—that the reference did not call attention to itself. Certainly critics hardly commented on the connection. And the Fauves pretended to an intimacy with their Mediterranean sites and the local residents that seemed to cast aside the sophistication—social and artistic—of Paris.

Most important, Fauve canvases are stripped clean of any signs of the skilled artist's mediation. Highly noticeable in these paintings are all the technical devices that declare this manner of painting to be so simple as to not constitute recondite art—visible priming, crude brushwork—and to be derived directly from the object portrayed—the bright colors favored by the locals, the conflation of sailcloth and canvas. This was a double dissimulation: politics posed as art, which in turn posed as the direct rendition of nature. Such an aesthetic paved the way for the new generation of tourists just beginning to discover the south and for the cultural expansion of the French nation. The artifice of art, the practices of tourism, and the fiction of national character all passed themselves off as natural.

The political operation performed by such images is perhaps difficult for us to recognize precisely because it continues unabated to this day. When we travel to tourist sites we still, more often than not, organize our expectations, sensations, and recollections according to the aesthetic principles of the harmonious picturesque. Consider, for example, how often today's travelers taking souvenir snapshots or professional photographers of postcards compose—consciously or unconsciously—their views of the scenic tourist site along picturesque lines. And the photograph, the medium popularly regarded as free of the taint of mediation, prescribes and records those perceptions in an ostensibly direct and natural way.

Touring, like all human activity, is an interested affair: we benefit from our travels, we lay claim to the sites we visit. We Americans who today pose for the camera before Saint-Tropez or buy postcards of Collioure can regard ourselves as "worldly," and in a cultural sense we assert Europe to be our own. These are political propositions, for they lay out positions of authority and power over those Americans who have not traveled, and over Europeans whose land and culture we claim. Yet for the most part we, like the French tourists along the Mediterranean at the turn of the century, consider touring to be disinterested, a comforting idea that legitimates our peregrinations. That belief is an ideological construct, produced by artists such as Matisse and Derain, who grafted the aesthetic values invested in painting onto the sites that came to be visited by tourists.

And with the aid of that particular version of the aesthetic formulated by the Fauves in Saint-Tropez and Collioure,

touring could—and still can—be made to appear

not just as high-minded as art

but also as unaffected as

nature itself.

*

All translations from the French are my own.

1. "Les villageois, les paysans, ceux qui ne viennent pas aux champs en villégiature, mais qui y vivent leur vie, travaillent le sol, font en quelque sorte partie de la nature." Fr[édéric] Paulhan, *L'Esthétique du paysage* (Paris: Félix Alcan, 1913), p. 8.

2. "Si le sauvage, si le paysan préfèrent les couleurs vives, c'est que leur optique ne s'affine pas suffisamment. Dans un bal villageois les toilettes vertes, rouges, les chapeaux cruellement bleus, les cols de guipure blanche abondent." Paul Adam, *La Morale des sports* (Paris: Librairie Mondiale, 1907), pp. 273–74.

3. "Pour connaître le pays et les habitants, il faut prendre contact avec l'indigène et pénétrer le plus possible dans les milieux locaux." Albert Dauzat, *Pour qu'on voyage: Essai sur l'art de bien voyager* (Toulouse, France: Edouard Privat; Paris: Henri Didier, 1911), p. 330.

4. "On se refait ainsi, pour quelque temps, une mentalité primitive, qui, par contraste, nous montre que les besoins créés par la civilisation raffinée sont, somme toute, artificiels et relatifs; on apprend à mieux apprécier des choses qui nous semblent toutes naturelles et auxquelles nous n'avons jamais pris la peine de réfléchir." Ibid., p. 121.

5. "C'est Paris transportée pendant deux ou trois mois aux bords de l'océan avec ses qualités, ses ridicules et ses vices." Adolphe Joanne, *Guide Diamant: Normandie* (Paris: Librairie Hachette et Cie, 1873), p. 166.

6. "C'est le boulevard d'été de Paris." *Le Nord-Ouest de la France* (Leipzig, Germany: Karl Baedeker, 1908), p. 218.

7. Edmund Burke, *A Philosophical Enquiry into the Origin of Our Ideas of the Sublime and Beautiful*, ed. J. T. Boulton (London: Routledge and Kegan Paul,

1958), pp. 57, 51. Other passages leave open the possibility that Burke also positioned the sublime in the mind of the perceiver. For example: "Whatever is fitted in any sort to excite the ideas of pain, and danger, that is to say, whatever is in any sort terrible, or is conversant about terrible objects, or operates in a manner analogous to terror, is a source of the *sublime*; that is, it is productive of the strongest emotion which the mind is capable of feeling" (p. 39). A comment by Burke on the beautiful may clarify the location of the sublime in Burke's aesthetics: "Whatever produces pleasure, positive and original pleasure, is fit to have beauty engrafted on it" (p. 131). Although beauty, and by extension the sublime, may not exist without humans to perceive it, once that perception occurs these properties become "engrafted" onto external nature.

8. Explicitly or implicitly, the idea that late Monet was a pantheist crops up with relative frequency in the critical literature. Perhaps the strongest case for Monet's pantheism was made by Léon Bazalgette in response to Monet's series depicting Rouen Cathedral, exhibited in 1895. Léon Bazalgette, "Les Deux Cathédrales," in *L'Esprit nouveau dans la vie artistique, sociale, et religieuse* (Paris: Société d'Editions Littéraires, 1898).

9. Immanuel Kant, *Critique of Judgment* (selections), in *Critical Theory since Plato*, ed. by Hazard Adams (New York: Harcourt Brace Jovanovich, 1971), pp. 391, 394.

10. Ibid., p. 396.

11. Terry Eagleton, "The Ideology of the Aesthetic," *Times Literary Supplement*, January 22–28, 1988, p. 94.

12. "Le beau est toujours défini, limité, mesuré; c'est l'ordre et l'harmonie. Le *sublime*, c'est

l'infini, l'indéterminé, l'incommensurable, le desordre et souvent l'imprévu." Pierre Larousse, *Grand Dictionnaire universel du XIXe siècle*, 17 vols. (Paris: Administration du Grand Dictionnaire Universel, [1817–75]), vol. 14, p. 1170.

13. My conflation of the beautiful and the picturesque here may come as a surprise to Anglo-American readers familiar with the aesthetic theories of William Gilpin (*Three Essays on Picturesque Beauty; Picturesque Travel; and on Sketching Landscapes...*, 1792) and Uvedale Price (*An Essay on the Picturesque...*, 1796). Gilpin and Price, to simplify, describe the picturesque as an intermediate category between the beautiful and the sublime whose characteristics of roughness and variation, while not evoking the expanse and force of the sublime, contrast with the smoothness and regularity of the beautiful. This account of the picturesque, however, held little currency across the Channel. Although in France about 1900 the term *pittoresque* was used in a variety of often contradictory ways, most often it served as a near synonym for the beautiful (with the added resonance of pertaining to pictures) or as a global label encompassing both sublime and beautiful landscapes. I will be relying on the first of these two prevalent definitions.

14. "Il se dit de tout ce qui se prête à faire une peinture bien caractérisée." E. Littré, *Dictionnaire de la langue française*, 4 vols. (Paris: Librairie Hachette et Cie, 1876), vol. 3, p. 1137.

15. Although, as Jack Flam has pointed out, Matisse might well have lifted the pose of his foremost nude in *Luxe, calme, et volupté*, seen from behind, from the similarly positioned male figure in *Bacchanal with a Guitar Player: The Andrians*. Jack Flam, *Matisse: The Man and His Art, 1869–1918* (Ithaca, N.Y.: Cornell University Press, 1986), p. 118.

16. "la grande eau céruléenne des Hellènes et des Latins." Onésime Reclus, *Pyrénées Orientales*, vol. 18 of *A la France: Sites et monuments* (Paris: Touring-Club de France, 1903), p. 8.

17. "Pour bien comprendre le paysage, et comme préparation à un voyage dans une contrée à paysages, il serait bon d'en avoir soi-même dessiné ou peint et à défaut, d'avoir regardé avec attention beaucoup de tableaux: les enseignements de la peinture sont meilleurs que ceux de la nature elle-même directement contemplée." Le Comte d'Ussel, "Des Voyages à l'époque actuelle," *Le Correspondant* 228 (September 10, 1907): 969. Dauzat offered similar advice: many pages of *Pour qu'on voyage* are devoted to training readers to evaluate the vistas they would encounter as tourists according to the aesthetic categories of landscape painting. The author of this tourist manual, in fact, also wrote a book entitled *Le Sentiment de la nature et son expression artistique* (Paris: Félix Alcan, 1914).

18. "Voyager, c'est conquérir par les yeux des pays nouveaux, annexer à sa sensibilité des émotions et des images comme un vainqueur ajoute des territoires à sa patrie." Henry Bordeaux, *Paysages Romanesques* (Paris: Librairie Plon, 1906), p. 229.

19. "le peintre le plus caractéristique de notre race...notre grand peintre national." Jean Tarbel [Mme J. Delorme-Jules-Simon], "Le Grand Peintre français: Nicolas Poussin," *Le Correspondant* 228 (August 10, 1907): 544.

20. "Il importe de s'être débarrassé, autant que faire se peut, des préjugés, partis pris, intérêts, soucis et conventions qui, dans l'ordinaire de la vie s'interposent entre la nature et

nous, au point d'en masquer la vue....il faut avoir...une sensibilité foncièrement désintéressée." Paul Gaultier, "Le Sentiment de la nature dans les beaux-arts," in *Reflets d'histoire* (Paris: Librairie Hachette et Cie, 1909), p. 125.

21. "Ne vous est-il jamais arrivé, au cours d'un voyage, en face d'un paysage marin, forestier ou montagnard, de communiquer votre admiration à un passant de rencontre, pêcheur, laboureur ou bûcheron, et de vous écrier devant lui:

"'Quel beau pays!'

"Mais l'homme ne vous a pas compris, et invariablement vous vous attirez une des réponses suivantes:

"'Oui, c'est un beau pays, le blé vient bien, [ou] la pêche est bonne, [ou] le bois de chêne se rend très cher.'

"Ou plus souvent:

"'Oh! non, c'est un mauvais pays, rien ne vient, [ou] on ne prend plus de poisson, [ou] on s'échine à gagner misérablement sa vie.'

"Mais se vous essayez de vanter à votre interlocuteur la beauté des lignes de la montagne, le coloris de la mer, de la futaie ou des nuages au soleil couchant, le brave homme haussera les épaules avec un sourire de dédain, ne comprenant pas qu'on puisse s'attarder à pareilles balivernes. Inutile d'insister, vous perdriez votre temps et votre éloquence: *il ne sent pas....*

"Il n'existe pas chez les âmes simples et primitives, chez l'enfant, chez le paysan, qui, l'on et l'autre, apprécient uniquement le monde sensible dans la mesure où il est susceptible de satisfaire leurs plaisirs, leurs besoins, leurs intérêts; le sentiment de la nature suppose, au contraire, une contemplation désintéressée; il est une forme de la jouissance artistique." Dauzat, *Pour qu'on voyage*, pp. 137–38, 139–40.

PLATE 177

PLATE 177
Henri Matisse
La Japonaise au bord de l'eau
(*The Japanese Woman at the
Seashore*), summer 1905
Also known as *La Japonaise*,
Mme Matisse, and *Woman
beside the Water*
Oil on canvas
13 7/8 x 11 1/8 in. (35.2 x 28.2 cm)
Collection, The Museum of
Modern Art, New York,
purchase and partial
anonymous gift

Included in Matisse's 1906
exhibition at Galerie Druet,
Paris

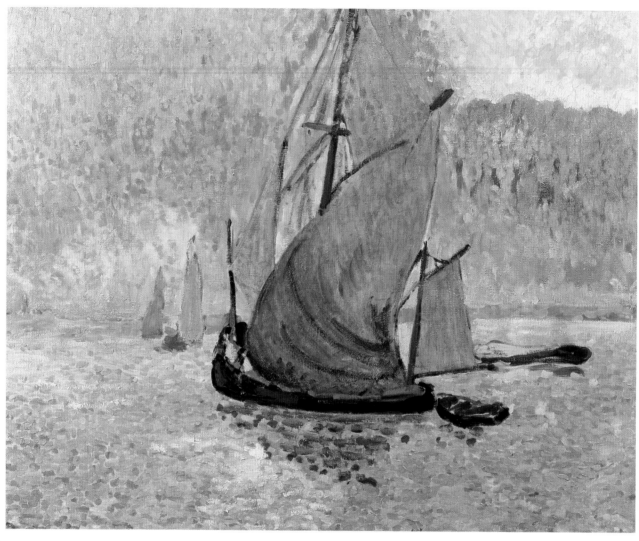

PLATE 178

Far from the Earth of France

the fauves abroad

JUDI FREEMAN

To paint French landscapes as a French artist working in France was to depict imagery that had immediately identifiable associations for the local viewing public. To paint abroad implied something quite different. It involved travel outside the country, which in turn-of-the-century France required passage via boat or steamer—if one was crossing the English Channel, the Mediterranean, or indeed traveling virtually anywhere beyond continental Europe—or via train within the Continent. Crossing a border was a significant act, even if the journey was between friendly nations. Travel for pleasure was a rapidly growing industry in the France of 1900. As standards of living improved and leisure time increased for much of the population, greater numbers of people traveled farther and farther away from Paris for their annual (usually August) holidays. The accelerated development of resort areas along the Mediterranean evidenced this. Many French tourists consequently sought the undiscovered, untouristed site; Henri Matisse was among them and was attracted to Collioure for this reason. He and many others also sought to escape France entirely, preferring relatively untrammeled foreign locales.

Artists who partook of this passion for the foreign journey continued a tradition of artists traveling outside France to paint abroad and then returning with their canvases to exhibit in Paris. The most vivid exemplar, of course, is Paul Gauguin, who sought what was considered to be untamed civilization, first in the Caribbean and later in the South Seas. To Gauguin the tropics represented an idyllic place, an earthly paradise of sorts, theoretically untainted by "the European diseases." To the painter and playwright August Strindberg he wrote, "Everything is bare and primordial in the languages of Oceania, which contain the essential elements, preserved in their rugged forms, whether isolated or united, without regard for politeness."[1]

Gauguin's travels recalled those of earlier artists who had trekked to non-Western sites in search of the exotic, often Oriental motif: Horace Vernet, Pierre-Auguste Renoir, and Eugène Delacroix, among others.[2] Indeed, Gauguin's admiration for the Oceanic peoples echoes Delacroix's sentiments during his 1832 trip to North Africa:

> Beautiful country, very blue mountains, violet to the right; the mountains are violet in the morning and evening, blue during the day. Carpet of yellow flowers, violet before reaching the river.... ¶ We notice a thousand things which are lacking with these people. Their ignorance produces their calm and their happiness; but we ourselves, are we at the summit of what a more advanced civilization can produce? ¶ They are closer

PLATE 178
André Derain
Les Voiles rouges
(*The Red Sails*), winter 1906
Oil on canvas
30 x 39 in. (76.2 x 99.1 cm)
Private collection

to nature in a thousand ways: their dress, the form of their shoes. And so beauty has a share in everything that they make. As for us, in our corsets, our tight shoes, our ridiculous pinching clothes, we are pitiful. The graces exact vengeance for our science.[3] As in the case of Gauguin, whose personal links to exotic regions have become inseparable from his work, the impressions of Morocco that recur in Delacroix's journals and letters until his death resonate in our comprehension of his work. The prominence of their travels in later commentaries on these and other artists— after all, the same could be said for Nicolas Poussin and Claude Lorrain in Italy— underscores the influential role played by foreign forays in the artists' oeuvres.

The Fauve artists traveling abroad in the early twentieth century generally were not as romantic in their responses to foreign locales or populations as Delacroix and Gauguin had been. In fact, they were largely attracted to established European cities instead of more exotic destinations. Looking through eyes that were very much those of the foreign tourist, these artists—who made their catalytic journeys in 1906—often recorded impressions of life in those urban centers, documenting commerce and daily activity within expansive, sometimes panoramic views. This was certainly true of André Derain's images of London and Georges Braque's and Othon Friesz's views of Antwerp. Figures appear infrequently in these paintings, yet their presence is implied in every one of them. People set in motion the shipping activity on the Thames and guided the comings and goings of the boats in Antwerp's harbor. Matisse, on the other hand, eschewed the thoroughly Westernized urban center, preferring less "modern" sites that had been colonized by France. In search of exotic elements to inject into his idealized, nature-based work, Matisse in the Fauve years voyaged to Algeria. Although the travels of Derain, Braque, and Friesz differed from Matisse's trip in character, the foreign subjects of all four artists capture aspects of modern life in Western or Western-influenced societies. These views are twentieth-century equivalents of their predecessors' romantic views of exotic locales and peoples in the nineteenth century.

Derain made two visits to London during the Fauve years.[4] The first was a brief preliminary one sometime in 1905; the second, three months in duration, was in the spring of 1906. He is known to have painted thirty views of London, all of which have been identified.[5] Considerable confusion surrounds their dates of execution, which is linked to uncertainty about exactly when Derain made his first visit to England. It has been argued that this took place in the spring of 1905, following the Salon des Indépendants at which Matisse's *Luxe, calme, et volupté* was presented (plate 175). According to this view, the paintings that Derain executed during his first trip are those that are the most Divisionist in style (see plate 186), having been heavily influenced by Matisse's painting. It is also often said that the dealer Ambroise Vollard's purchase of the contents of Derain's studio provided the artist with the funds necessary for the trip.[6]

Several facts contradict this contention. First, Vollard's memoirs recount his purchase of the entire contents of Maurice de Vlaminck's studio and his visit to Derain's studio, where he bought virtually everything except a copy that Derain had made of a Domenico Ghirlandaio painting. Vollard then commented, "Afterwards I asked Vlaminck and Derain to go and make me some views of London."[7] Vollard's purchase of Derain's studio occurred in February 1905, before the Salon

des Indépendants; his purchase of Vlaminck's studio followed a year later. Consequently, Vollard's reference to his request sometime later that the two artists go to London to paint strongly suggests that he was referring to the spring 1906 trip rather than the first trip, whenever it occurred in 1905.[8] Second, although Vollard obviously was positive about Derain's work, he did not grant the artist a one-man exhibition. Furthermore, Derain's work was publicly received without much enthusiasm in the spring of 1905. The three of his paintings (plate 179) that were purchased from the 1905 Salon des Indépendants were acquired, along with one of Vlaminck's paintings, by a collector who sought to buy the worst of contemporary art to make a point to his son-in-law.[9] In spite of Vollard's encouragement, it seems unlikely, given Derain's pressing aesthetic concerns and financial constraints, that he would have traveled to London on the heels of this lukewarm reception of his Salon submissions and in advance of his impending trip to Collioure at Matisse's invitation.

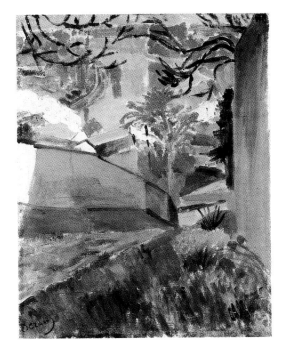

PLATE 179

It is also difficult to imagine that the pronounced transition from Derain's paintings of the region around his native Chatou in 1904 and early 1905 to any of the Divisionist or broadly painted London pictures could have been made before the work that he did alongside Matisse in Collioure.[10] The paintings that Derain created in the Seine suburbs (plate 180) are predominantly naturalistic landscapes, richly painted with broad areas of color. In format these paintings echo earlier landscapes made in the region by Charles-François Daubigny and, early in his career, by Camille Pissarro. Stylistically, the paintings, highlighted by touches of strong color and frequently enlivened by thick impasto, reflect Derain's close association with Vlaminck. Derain's selective use of an increasingly vibrant palette in 1904 was succeeded by a more abstract use of boldly applied color in 1905 (plate 181). The application of complementary tones side by side, first in measured strokes and subsequently in masses of color, appeared in Derain's work only after he began to paint with Matisse in Collioure. There Derain shifted from using distinct tones to articulate buildings, beaches, water, and sky to creating open webs of complementary color on primed but otherwise unpainted canvas, which convey, above all, an intense luminosity (plate 182). This shift in style paralleled a change in Matisse's work (plate 183), as his brushwork became more broken and animated.

Matisse's influence on Derain's London paintings seems likely to have resulted from extended discussion and firsthand experience during the summer in Collioure, where Derain witnessed the creation of paintings like *La Fenêtre ouverte, Collioure* (*Open Window, Collioure*, plate 265) and *Paysage à Collioure* (*Landscape at Collioure*, plate 183) at the same time that he produced his own canvases using divided tones.

Derain returned to Paris from Collioure in late August 1905, traveling via L'Estaque, Marseille, and Agay. A painting done during this trip (plate 184) exemplifies Derain's newly developed signature style, which combines broad areas and short strokes of color applied to primed canvas. The style that Derain had developed in Collioure, evident in this painting, was essential to the kind of

PLATE 179
André Derain
Bord de la Seine à Bougival
(*Bank of the Seine at Bougival*),
c. 1904
Oil on canvas
16 ⅛ x 13 in. (41 x 33 cm)
Private collection

Exhibited at the Salon des
Indépendants, 1905, and
bought by Ernest Siegfried
for Olivier Senn

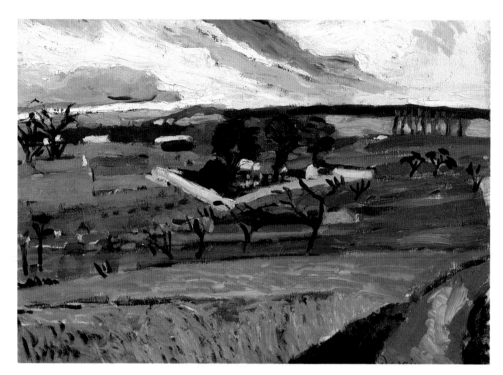

PLATE 180
André Derain
Paysage de l'Ile-de-France
(*Landscape in the Ile-de-France*),
1904–5
Oil on canvas
15 ⅜ x 20 ⅞ in. (39 x 53 cm)
Fridart Foundation

PLATE 181
André Derain
*Arbre, paysage au bord d'une
rivière*
(*Tree, Landscape at a River
Bank*), 1904–5
Oil on canvas
23 ⅝ x 31 ¹¹⁄₁₆ in. (60 x 80.5 cm)
Private collection, Switzerland

PLATE 180

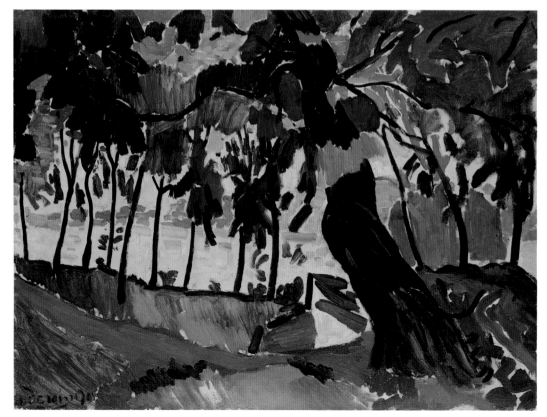

PLATE 182
André Derain
Bateaux à Collioure
(*Boats at Collioure*),
summer 1905
Oil on canvas
23 ⅝ x 28 ¼ in. (60 x 73 cm)
Kunstsammlung Nordrhein-
Westfalen, Düsseldorf, West
Germany

PLATE 181

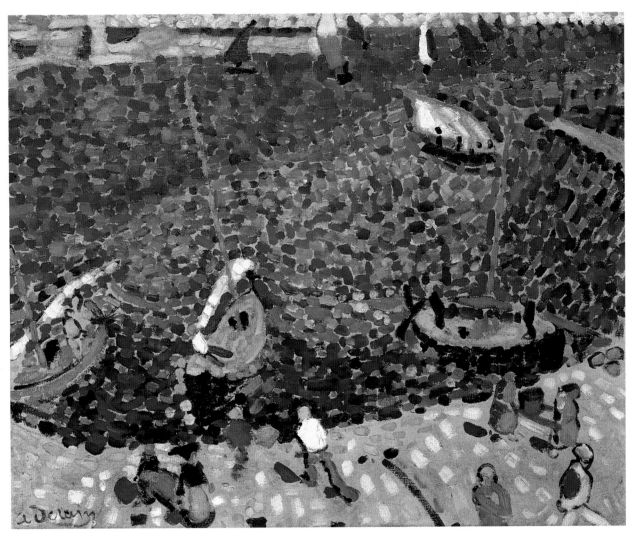

Plate 182

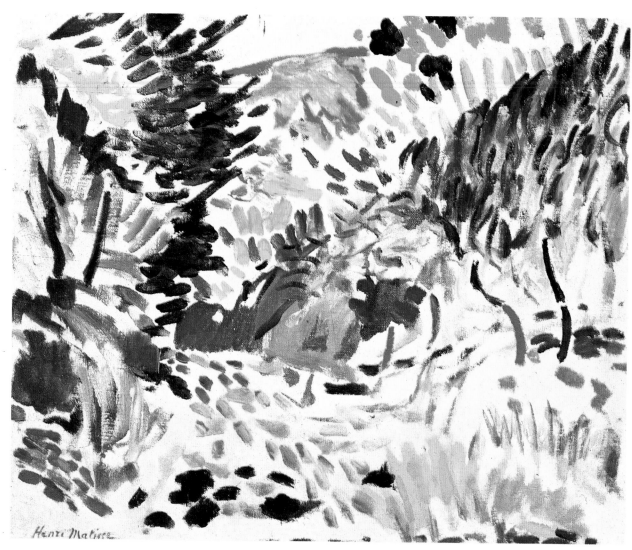

PLATE 183

PLATE 183
Henri Matisse
Paysage à Collioure
(*Landscape at Collioure*), 1905
Oil on canvas
15 ⅜ x 18 ⅜ in. (39 x 46.7 cm)
Private collection, New York

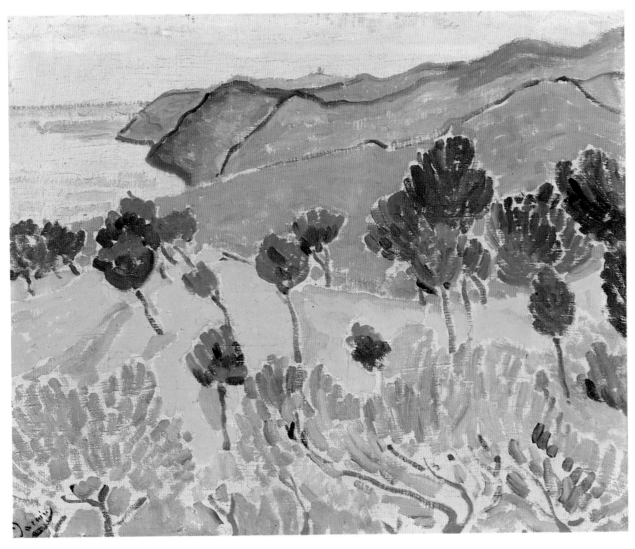

PLATE 184

PLATE 184
André Derain
Paysage au bord de la mer:
La Côte d'Azur près d'Agay
(*Landscape by the Sea: The Côte*
d'Azur near Agay), 1905
Oil on canvas
21 ½ x 25 ⁹/₁₆ in. (54.6 x 65 cm)
National Gallery of Canada,
Ottawa

PLATE 185

painting he produced in London. Therefore, his first trip to that city must have occurred in the autumn of 1905.

The first trip to London was brief, with Derain planning a more extended stay in 1906. The sites he was to paint were established in advance, as Derain later acknowledged: "M. Vollard...had sent me to London at that time so that I could make some paintings for him. After a stay in London he was very enthusiastic and wanted paintings inspired by the London atmosphere. He sent me in the hope of renewing completely at that date the expression which Claude Monet had so strikingly achieved which had made a very strong impression on Paris in the preceding years."[11] It was Vollard's insistence that Derain emulate Monet's London paintings—thirty-seven of which had been exhibited at Galeries Durand-Ruel from May 9 to June 4, 1904—that helped to predetermine Derain's imagery. In addition, the reception of Monet's paintings had been positive, and Derain was hardly immune to the glowing reviews that Monet had received from the same critics evaluating the work of the Fauves in their earliest Salon exhibitions. The sequence that has been suggested for Derain's London paintings has been based on stylistic analysis.[12] It seems likely that in the initial canvases he reiterated motifs that Monet had painted but subsequently allowed himself a more open-ended exploration of London's riverside landscape.

Monet was certainly not the only French artist to have painted in London.[13] Gustave Courbet had visited several times in the early 1850s; Pissarro went in 1870, when Daubigny and François Bonvin were already there; Renoir and Gauguin each visited in the 1880s. Pissarro painted views around Upper Norwood, in south London, as well as nearby Dulwich and the Crystal Palace during his stay in 1870–71; when he returned in 1892, he painted Pointillist views of Kew Gardens and surrounding areas. Alfred Sisley was in London as a teenager (both of his parents retained British citizenship), and he returned in 1874, painting Hampton Court and Molesey, with many views of regattas on the Thames. Matisse went to London on his honeymoon in January 1898, encouraged by Pissarro, but no paintings have been identified from that trip.

Monet's interest in the city was the most sustained and his views the most varied. He went to the city several times: initially in 1870–71, with his first wife, Camille, and their three-year-old son, Jean; then annually from 1898 to 1901; and finally in 1904. During his first visit, when he went to avoid military service during the Franco-Prussian War, Monet depicted several London parks. He also produced the first of his paintings of the Thames by perching on a wharf or on a viewing point along the embankments on the north bank. His series of Thames views began in 1899, after an initial scouting trip in 1898 to arrange for a prolonged stay. In 1899 he lived in the Savoy Hotel, which overlooks the Victoria Embankment and the Thames between Waterloo Bridge and Hungerford Bridge (popularly known as Charing Cross Bridge, after the train station erected on the site of the Hungerford market; this was the second bridge on the site). There he painted forty-one views of Waterloo Bridge, thirty-four views of Charing Cross Bridge, and nineteen views of the Houses of Parliament.[14] All were painted from the windows or sheltered terraces of the Savoy Hotel or from Saint Thomas's Hospital, which is on the south bank of the Thames and to the east of Westminster Bridge, just opposite the Houses of Parliament. None was painted entirely *en*

PLATE 185
The Thames between
Nine Elms and
Barking, 1905

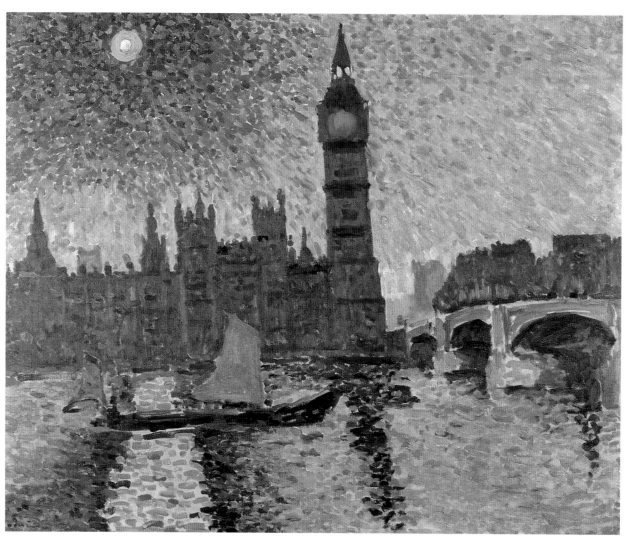

PLATE 186

plein air. Monet's imagery was devoid of figures; his extended painting sessions that produced this series were conducted in isolation.

The dominance of the Thames bridges in Monet's paintings is mirrored in Derain's pictures. Of the thirty known paintings of London by Derain, eight feature the Houses of Parliament and Westminster Bridge; six depict the Pool of London and Tower Bridge; six document the expanse between and including Charing Cross and Waterloo bridges; two illustrate London Bridge; two feature Southwark Bridge; and two present sunsets over the river (one with boats, one without), seen somewhere downriver from London, near Greenwich. Single images exist of each of the following: Regent Street, Hyde Park, Saint Paul's, and boats in the Thames seen from above. Sixteen of the paintings measure approximately 32 by 39 inches (81 by 100 centimeters); another four are in the range of 32 by 36 inches (73 by 92 centimeters); nine are in the range of 26 by 39 inches (66 by 99 centimeters); one is smaller, 21 5/16 by 25 5/8 inches (54 by 65 centimeters). Only one of the thirty paintings is vertical. In short, Derain painted most of these works on a scale suitable for exhibition (ironically, the complete group has never been exhibited together), no doubt in response to his dealer's request that he go to London and paint.[15]

PLATE 187

Unlike Monet, Derain constantly shifted his views of the river. He celebrated the commercial traffic on the river as well as the diverse businesses on its banks, from Westminster Bridge eastward to Tower Bridge and the Pool of London (plate 185). When he painted an early view of the Houses of Parliament (plate 186), he stood on the Albert Embankment, slightly to the east of Saint Thomas's Hospital (where Monet had painted), between Westminster and Lambeth bridges, a perspective that afforded a broad view of Westminster Bridge as well as a clear view of the Parliament buildings (plate 187). From the same embankment, with its distinctive iron gaslights, he also looked eastward (plates 188 and 189), glimpsing two pedestrian tourists gazing, along with the painter, at the Houses of Parliament (though only the corner of Big Ben is visible) and, most prominently, at the expansive Westminster Bridge beyond. His angle of vision was also directed northward (plate 293), curtailing the view of the bridge while introducing boats sailing in front of the Houses of Parliament. One unusual early view (plate 191), which remains unfinished, was painted from just beyond the bridge itself (plate 190). The bridge is so sketchily rendered that it looks like a flimsy pedestrian walkway rather than the mammoth structure that had been hailed as a feat of engineering since its completion in 1862.

Derain's other depictions of Parliament reduced the compositional importance of the bridge, focusing instead on the buildings and skyline in diverse weather conditions (plate 294). This was, of course, the most popular postcard view. The Houses of Parliament were a major tourist attraction, and Derain's images, like Monet's, reinforced their importance. Monet's paintings capture the Houses of Parliament head on, seen from the hospital windows. He depicted the scene in a variety of atmospheric and temporal conditions: in the mist of dawn (plate 192), in the fog, in the setting sun (plate 193). Indifferent to such changing effects, Derain concentrated instead on capturing the surfaces of the buildings and the brilliant

PLATE 186
André Derain
Big Ben, 1905
Oil on canvas
31 1/8 x 38 5/8 in. (79 x 98 cm)
Musée d'Art Moderne,
Troyes, France

PLATE 187
Westminster Bridge and the
Houses of Parliament, c. 1905

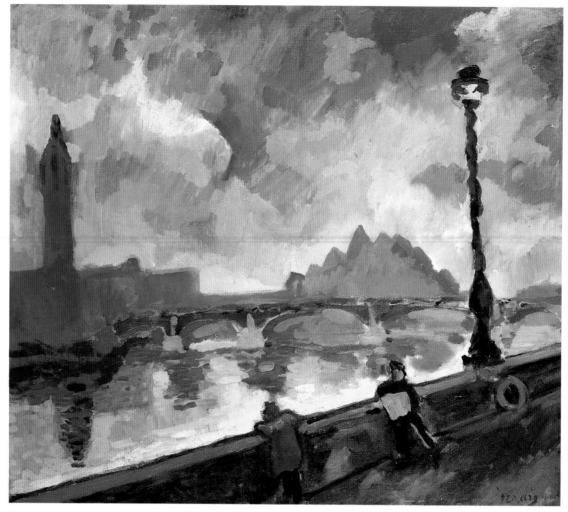

PLATE 188

PLATE 189

PLATE 188
André Derain
La Tamise, Pont de Westminster
(*The Thames, Westminster
Bridge*), winter 1906
Oil on canvas
25 9/16 x 29 1/2 in. (65 x 75 cm)
Private collection

PLATE 189
The Albert Embankment and
the Westminster Bridge,
c. 1890

PLATE 190
Westminster Bridge and the
Houses of Parliament, c. 1920

PLATE 191
André Derain
*Le Parlement et le Pont de
Westminster*
(*The Houses of Parliament and
Westminster Bridge*),
winter 1906
Oil on canvas
29 x 36¼ in. (73.7 x 92.1 cm)
Cleveland Museum of Art,
Leonard C. Hanna, Jr., Fund

PLATE 190

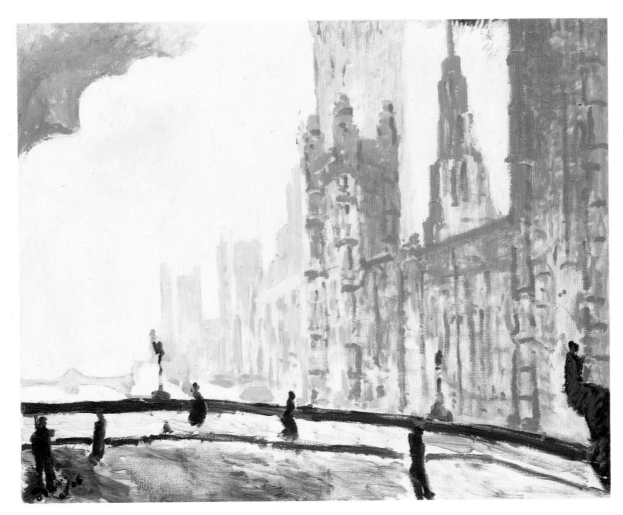

PLATE 191

PLATE 192

PLATE 193

PLATE 194

PLATE 192
Claude Monet
(France, 1840–1926)
*Houses of Parliament,
Westminster,* 1903
Oil on canvas
31 ⅞ x 36 ½ in. (81 x 92.7 cm)
The Art Institute of Chicago,
Mr. and Mrs. Martin A.
Ryerson Collection

PLATE 193
Claude Monet
(France, 1840–1926)
Parliament, The Setting Sun,
1901
Oil on canvas
31 ⅞ x 35 ¼ in. (81 x 92 cm)
Musée Marmottan, Paris

PLATE 194
Wharves on the Thames
between Westminster and
Blackfriars bridges, 1905

reflections in the water, all within the confines of the formats established by Monet.

Derain's depictions of Charing Cross Bridge (plate 195) properly belong, on stylistic grounds, to the latter part of his second stay in London. Once again, he followed Monet's precedent, in this case looking west from the walkway on Waterloo Bridge toward Charing Cross Bridge. Monet's window at the Savoy Hotel had afforded him a similarly westward view onto the bridge (plate 196), with Westminster Bridge and the Houses of Parliament visible to varying degrees, depending on the time of day and the amount of mist. Derain made some sketches from the same elevated point of view as Monet,[16] but unlike Monet he generally painted outdoors, actually setting his easel on the embankments and bridges.

Derain occasionally ventured along the south bank in search of a suitable angle of vision. The south bank downriver from Westminster Bridge consisted of hundreds of wharves, each dotted with numerous businesses (plate 194). To paint a view of Charing Cross Bridge (plate 198), Derain stood on one of these wharves near the heart of the shipping activity along the Thames. Immediately in front of him was the Lion's Brewery, one of the oldest brewers in the area and among the most noted buildings on the south-bank skyline (plate 197). The building sat directly on the Belvedere Road embankment. By situating himself directly east of it, Derain had a view of the bridge topped by the smoke of a train heading into the station and of the river with the towers of the Houses of Parliament in the distance, as well as a foreground view that featured boats, obviously in frequent use, scattered along the irregular shoreline.

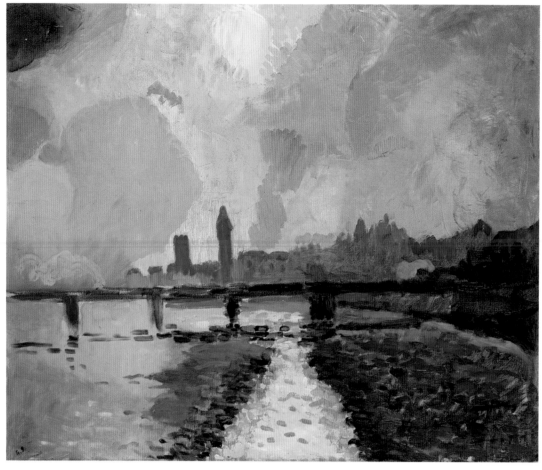

PLATE 195

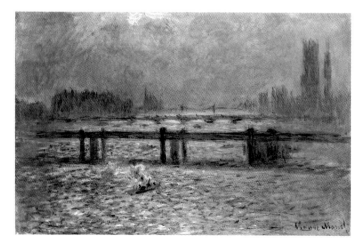

PLATE 196

PLATE 197

PLATE 195
André Derain
Le Pont de Charing-Cross
(*Charing Cross Bridge*), 1906
Oil on canvas
31 ⅞ x 39 ⅜ in. (81 x 100 cm)
Private collection

PLATE 196
Claude Monet
(France, 1840–1926)
Reflections on the Thames, c. 1900
Also known as *Charing Cross Bridge*
Oil on canvas
24 ½ x 39 ½ in. (62.2 x 100.3 cm)
The Baltimore Museum of
Art, gift of Mrs. Abram
Eisenberg in memory of her
husband, BMA 1945.94

PLATE 197
Hungerford Bridge seen from
Westminster, 1930

The Lion's Brewery is
circled.

PLATE 198
André Derain
*Le Pont de Charing-Cross,
Londres* (*Charing Cross Bridge,
London*), 1906
Oil on canvas
32 x 39 ½ in. (81.3 x 100.3 cm)
National Gallery of Art,
Washington, D.C., the John
Hay Whitney Collection

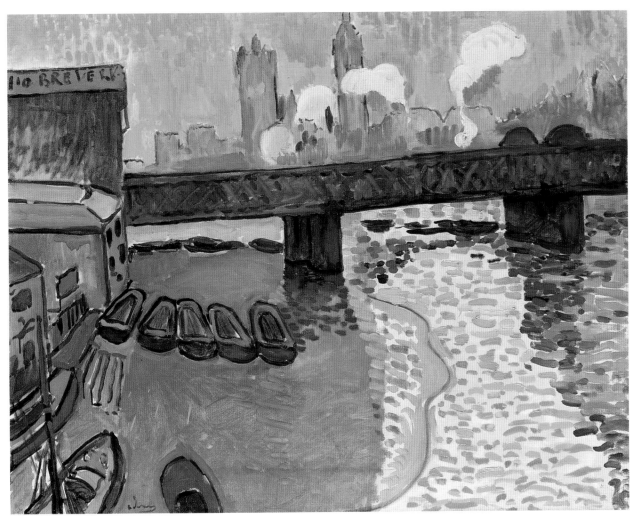

PLATE 198

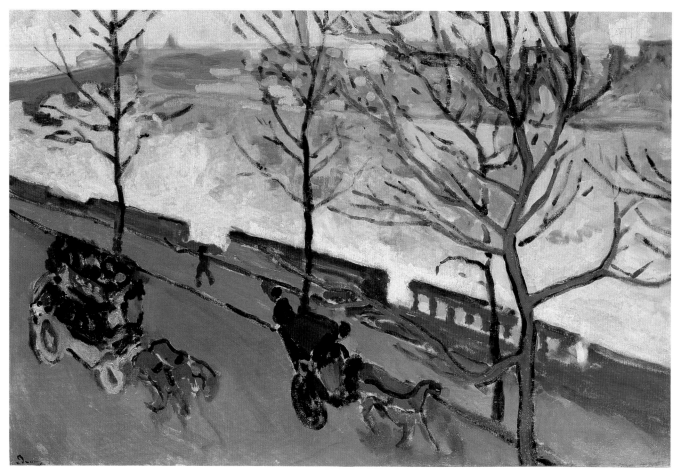

PLATE 199

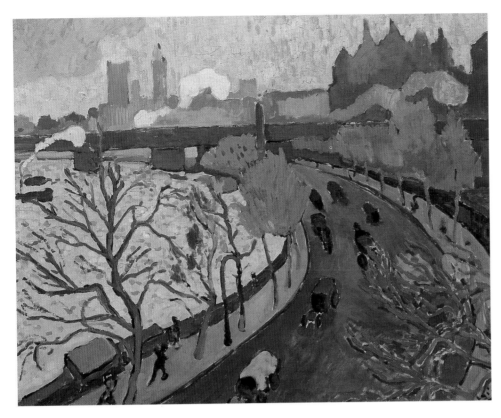

PLATE 200

PLATE 201

PLATE 199
André Derain
Le Quai de la Tamise
(*The Thames Embankment*),
winter 1906
Oil on canvas
26 x 39 in. (66 x 99.1 cm)
Private collection,
Monte Carlo

PLATE 200
André Derain
Pont de Charing-Cross
(*Charing Cross Bridge*),
winter 1906
Oil on canvas
31⅞ x 39⅜ in. (81 x 100 cm)
Musée d'Orsay, Paris, gift of
Max and Rosy Kaganovitch

PLATE 201
Thames looking upstream
from the Savoy Hotel, c. 1930

As Derain moved east along the south bank, passing the approaches to Waterloo and Blackfriars bridges, the density of the businesses on the wharves increased, as did the activity on the river. When he looked directly across the river, the dome of Saint Paul's Cathedral dominated the city as prominently as the Houses of Parliament had upriver in Westminster. To paint Saint Paul's straight on meant depicting the commercial buildings that lay between it and the river as well as the stream of boats moored along the banks. Once again, the industry of the city was at the heart of Derain's motif.

Derain's preference for views of commerce and urban activity extended to his depictions of the embankments themselves.[17] Facing northeast from the walkway on Westminster Bridge, he looked down on the embankment toward Charing Cross Bridge (plate 199) and captured the spectacle of the horse-drawn carriages heading in the direction of Parliament. He also positioned himself on Waterloo Bridge and looked over the traffic, both pedestrian and horse-drawn, along the Victoria Embankment (plate 200)—approximating what Monet would have seen from his window at the Savoy (plate 201). These oblique views from slightly above enabled Derain to observe local activity close up, as in his view of the barges on the river (plate 292). In all of these views he used vibrant color to enliven the relatively gray streets and river water as well as the white marble.

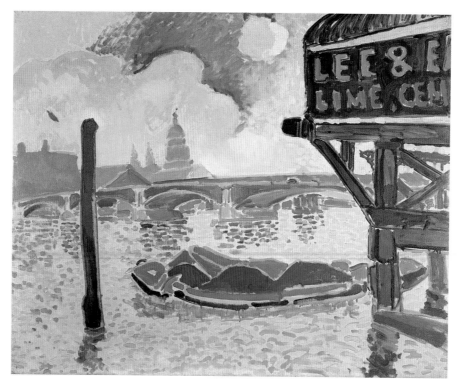

PLATE 202

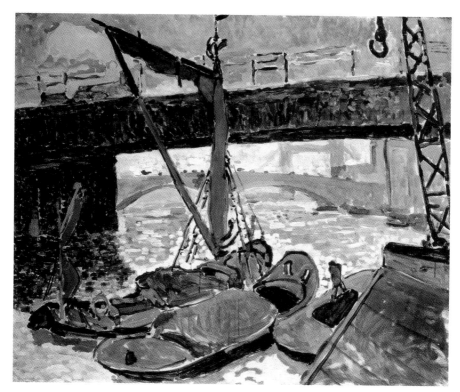

PLATE 203

The commercial activity on the Thames picked up along the portion of the river adjacent to the City of London itself, where greater numbers of barges arrived to load and unload cargo. To paint *Le Pont de Blackfriars, Londres* (*Blackfriars Bridge, London*, plate 202), Derain stood on the south bank, at the edge of Jamaica wharf, amid the rice mills, the offices of mechanical engineers, and the cement firms; the sign for one of the businesses on the wharf, Wm. Lee Son & Co., Ltd. (lime burners), is visible to the immediate right.[18] The view he saw was dominated by Blackfriars Bridge and the adjacent railroad bridge (both of which had been on the site for forty years) as well as by the buildings and warehouses on the north bank, in front of Saint Paul's (plate 204). Closer to him, a nearly empty barge is anchored by the wharf.

Derain's paintings document all the bridges over the Thames from Westminster east through Tower Bridge, with the exception of Southwark Bridge, an iron structure that was one of the earliest bridges to be erected over the Thames, in 1814–19. Derain did, however, paint the railroad bridge immediately downriver from it. Standing to the west of the bridge and looking between its piers gave him a view of the London and Tower bridges (plate 203). That position was one of the few points on the river where the three bridges and the commerce between them could be viewed simultaneously. This portion of the river—the Pool—seems to have fascinated Derain the most, given the frequency with which he depicted it; perhaps the increased commercial activity along this section of the river appealed to him. To paint London Bridge, one bridge east, he moved slightly farther downriver and stood in the shadow of Southwark Cathedral, alongside Saint Saviour's Dock (plate 94). Beyond the massive piers of London Bridge was a view of the Monument, a column erected in 1677 to commemorate the great fire of London; Billingsgate Market; and the Customs House; as well as the buildings of the financial hub of the City. Shifting his position downriver, Derain depicted a view back toward London Bridge that was equally animated with traffic (plate 95).

The vantage that afforded the most impressive view of the Thames and the activity along it was the Tower of London and the Upper and Lower Pools adjacent to it (plate 205). Derain could stand at King's Stairs Gardens in Bermondsey and get a sweeping view of the barges and steamers heading upriver toward the docks.[19] Tower Bridge, which had replaced an earlier, lower bridge in 1894, was designed to accommodate tall-masted ships that needed to get to the Upper Pool's quaysides between the Tower and London bridges. Cranes on these quaysides lifted freight off the arriving boats. The increased vehicular traffic along the old bridge and the need for this particular crossing on the Thames had made imperative the construction of a new bridge on the site

of Tower Bridge. The new Tower Bridge opened and closed an average of seventeen times per day. It had a pedestrian walkway, 140 feet above the Thames, that was accessible to the public via gaslit towers.

The new bridge was a tremendous tourist attraction, with calendars, china, bookmarks, and postcards issued to commemorate its opening. "There is perhaps

no journey in the world," remarked one writer, "in which the past and what now is and the links between them stand out more clearly stratified than a journey up the Thames upon the tide from the Sea-reach to the Pool."[20] People would go to watch the traffic, spending hours looking down at the Pool from either Tower or London Bridge:

> ...at any time of day and all the year round, except in days of rain and snow, you may find a long line of people, men and women, boys and girls—people well dressed and people in rags, people who are halting here on their errands or their business, and people who have no work to do. They stand here side by side, leaning over the low wall, and they gaze earnestly and intently upon the river below. They do not converse with each other; there is no exchange of reflections; they stand in silence. The place is London Bridge; they lean against the wall and they look down upon the Pool—that is to say, upon the reach of the river that lies below London Bridge. I have never crossed that bridge without finding that long line of interested spectators. They are not in a hurry; they seem to have nothing to do but look on; they are not, apparently, country visitors; they have the unmistakable stamp of London upon them, yet they never tire of the prospect before them; they tear themselves away unwillingly; they move on slowly; when one goes another takes his place. What are they thinking about? Why are they all silent? Why do they gaze so intently? What is it that attracts them?... Perhaps their imagination is vaguely stimulated by the mere prospect of the full flood of a river and by the sight of the ships. As they stand there in silence, their thoughts go forth; on wings they are wafted beyond the river, beyond the ocean, to far-off lands and purple islands.[21]

The lure of the site was no doubt why Monet had painted a single view of the Pool (plate 206) on his initial trip to London in 1870–71, even though the impressively engineered Tower Bridge had not yet been erected. Derain's six paintings celebrate the tourist view with great vigor (plate 207; see also plate 297); all were given to Vollard, as Derain considered them among the most successful works from his stay in London.[22] Figures populate the ships in the Pool to varying degrees; Derain—who had not painted large numbers of people while he was in

London (or elsewhere)—rendered them hastily, depicting them lifting, moving, rowing, hoisting. The large patches of color that figure in his other views of the Thames appear consistently in these views, supporting a date for them toward the end of Derain's 1906 trip, as his next body of work—the paintings he made in L'Estaque in the summer of 1906—is dominated by the same stylistic devices.[23]

The broad color areas dominant in most of Derain's views of the London downriver bridges achieve their greatest resolution in a painting that Derain made of the Thames near Greenwich (plate 208). The painting paraphrases the mist and tonality in Monet's famed landscape *Impression, Sunrise* (1872, Musée Marmottan, Paris), a painting that helped to inspire the label "Impressionist." Yet Derain's color is not temporally or meteorologically specific; it is abstracted, the product of the artist's intense interest in the effects that could be achieved by setting brilliant tones close to one another. The view depicted is of the lowest crossing point on the Thames, which would have been seen by someone moving downriver from London toward

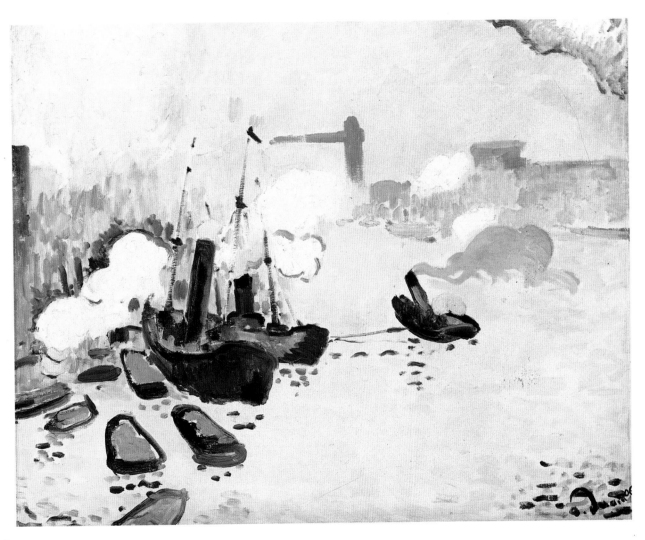

PLATE 207

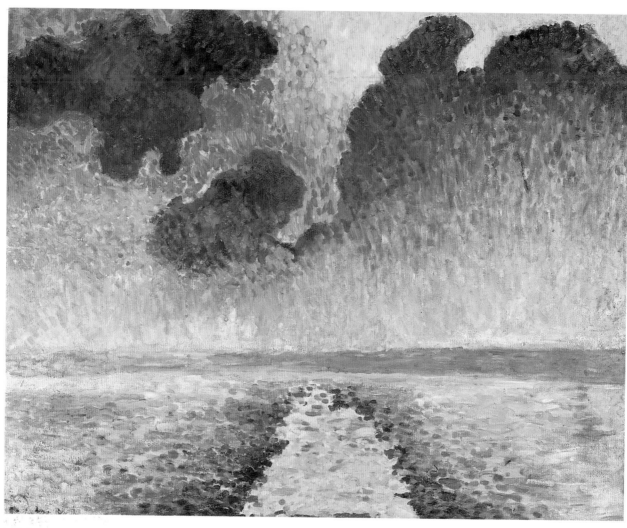

PLATE 208

the Channel; it was known as one of the most breathtaking views along the river.

Derain had begun his second sojourn in London on January 29, 1906, taking up residence at 65 Blenheim Crescent in Holland Park. Initially, he had planned to stay only a dozen days, but he ultimately remained nearly two months. His goal was simple: he needed, as he wrote to Matisse, a change of setting and a concentrated period in which to work. Both he and Matisse felt an ongoing need to arrive at a form of painting that somehow advanced art beyond anything that had been achieved by their predecessors. Derain wrote: "I sincerely believe that we ought to aim for calm, unlike the generations that preceded us. This calm is something of which we can be certain. Beauty, then, ought to be an aspiration toward this calm."[24] Derain thought he would find this calm in London, and indeed he did—briefly. His paintings, though depictions of active commercial places, convey a sense of arrested time. As he wrote to Vlaminck, "England really has a certain charm, for a very short time."[25] Increasingly, though, the charm wore thin, and Derain found the city's atmosphere less inviting. Despite its busy rivers and ports, the whole city seemed silent and rather gloomy to him:

> I detest the sad, hypocritical, bantering British spirit. Everything is dead here. In a restaurant full of people, one cannot hear anything. I have seen a port with boats that arrived, a group of workers that finished their work, and I thought I was dreaming—in all this, not a sound. ¶ This first unpleasant sensation is over, and hereafter, it is this form that interests me. ¶ The [British] women . . . the majority are admirably beautiful. In the streets, I have seen young very blond women whose hair is slovenly twisted, with their tight braids wound around a face of matte ivory lightly tinted rose on the lips and cheeks, rendering their skin green, obviously blue eyes, and fragile forms that made me think that everything has its place. These faces are made in order to appear in the haze of the streets or in the cold tranquility of the British interiors. . . . ¶ On the contrary, the woman from the south of France, with her impressively noble and voluptuous face, as we saw last year, made to move in bright light, affirms a precise, ample line that is infinitely more grand than the blurred forms that emerge from the fog [here in London].[26]

From his visit to London, Derain learned two principal lessons. One was the virtue of depicting scenes packed with activity that nevertheless convey a sense of overriding calm. The Impressionists who had preceded Derain in London had captured its calm as well, particularly in paintings of the Thames, which was less crammed with activity than its counterpart the Seine. Both for the Impressionists and for Derain, London was of interest because of its marked differences from Paris, just as the English were worthy of observation because of their differences from the French. In Monet's work the distinctive character of London and the Thames was evident in the particular atmospheric qualities he captured. In Derain's paintings the contrast with France is visible in his interpretation of the imagery; unlike Derain's and Vlaminck's views of individuals at leisure on the suburban banks of the Seine, his images of London demonstrate a more generalized sense of commerce being conducted smoothly and seemingly without effort. To express this sense of calm and to portray a city quietly engrossed in its own activities, Derain concentrated—and this became the second lesson that he learned—on massing forms in his paintings and gradually eliminating the interstices of white canvas visible through the touches of paint that he had previously

PLATE 208
André Derain
Effets de soleil sur la Tamise
(*Effects of Sunlight on the Thames*), winter 1906
Oil on canvas
31 ½ x 39 in. (80 x 99 cm)
Musée de l'Annonciade,
Saint-Tropez, France

preferred to use in his work.[27]

Derain returned to Paris in time for the opening of the Salon des Indépendants on March 20, 1906, where he exhibited three paintings, one a landscape from the previous summer at Collioure and one an early autumn scene in the suburbs of Paris.[28] Soon after, he left for L'Estaque, where the lessons he had learned in London were to be realized in large-scale landscapes of the town (plates 41, 43–47).

PLATE 209

PLATE 209
The Place Gambetta and
the Bassin du Commerce,
Le Havre, c. 1922

PLATE 210
Antwerp, c. 1870

PLATE 211
Antwerp, c. 1910

Derain's observations of British life enabled him to see the French environment and its inhabitants more clearly and, by extension, to find a form of landscape painting with which he could be comfortable. This is evident in the paintings he created in L'Estaque during the summer of 1906. When Braque and Friesz headed north to Antwerp from their native Le Havre, their intentions were altogether different from Derain's, although the results were not dissimilar. By 1906 Braque and Friesz had been painting for several years and had studied together at Léon Bonnat's studio in Paris. Friesz had been exhibiting in the Salons since 1900, whereas Braque did not publicly exhibit his work until the spring of 1906, at the Salon des Indépendants. Following the Indépendants, in May he and Friesz returned to Le Havre with their fellow Havrais artist Raoul Dufy and helped found the Cercle de l'Art Moderne du Havre, an organization that made it possible for these artists to show their work on a regular basis in their native town.[29] Dufy and Albert Marquet stayed in Le Havre for the summer, but Braque and Friesz soon left for Antwerp, arriving in mid-June. During the summer the two artists shifted from a form of second-generation Impressionist landscape painting to a style gradually infused by the liberated color of the Fauve painting of Matisse, Derain, and Vlaminck.

PLATE 210

Traveling to Flemish-speaking Antwerp constituted travel abroad, even though the Belgian coast and ports were not radically different from their counterparts in France. Friesz had made the journey once before, during the summer of 1905, when he made drawings of the port, which was among the busiest in western Europe. The river Scheldt (in French, the Escaut) is a major outlet into the North Sea. Braque and Friesz were accustomed to the smaller but fairly active port in Le Havre, which revolved around its principal docks; boats there were moored directly opposite the commercial center of town (plate 209). Braque, Dufy, and Friesz, whose families all had links to Le Havre's shipping industry, often painted along the docks, with Dufy, in particular, painting the colorful flag-draped boats that arrived in port.

PLATE 211

The Antwerp of 1906 had just undergone tremendous change, thanks to an ambitious improvement campaign inaugurated nearly a century earlier. When Napoleon went to Antwerp in the early nineteenth century, he found a port with great potential that had inadequate docks, streams filled with silt, neglected quays, and as a result, limited trade. He ordered the digging of new docks, which revitalized the city's harbor (plate 210), but the

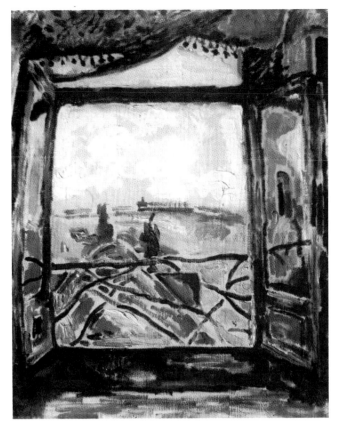

PLATE 212

ensuing increase in shipping taxed the old wooden quays. A major renovation of the Antwerp shoreline began during the Franco-Prussian War of 1870–71, while Belgium was neutral and could focus its energies on internal affairs; the quays were straightened and streams filled (plate 211). A significant number of buildings along the docks were demolished to make way for the straightened shoreline. New crane parks were built to ease the unloading of massive cargoes, many from large ships arriving from Belgian colonies, particularly the Congo.[30] Onlookers strolled along quays directly in front of the docks. In the center of the quays was the ninth-century fortress the Steen, which had recently been converted into a museum celebrating the boating activity along the Scheldt; it was a historic building on a shoreline otherwise filled with late nineteenth-century structures.

Braque and Friesz found lodging in two residential sections of Antwerp along the less expensive left bank of the Scheldt, first at the pension Lusthof Frascati and then at the nearby Pension Rosalie van der Auwera. The bills that remained in Braque's possession indicate that they stayed from June 12 through July 12 and August 11 through September 11, but letters indicate that they spent the entire period from June to September in Antwerp.[31] From one of their pension windows they could observe the shipping activity on the Scheldt (plate 212), but they needed to work outdoors to get a view of the busiest part of the harbor. From the area adjacent to their hotel Braque painted two views of the masts on the boats (plates 213–14) as well as the more desolate dunes (plates 281–82) that faced the less-developed parts of the right bank.

PLATE 212
Georges Braque
La Fenêtre
(*The Window*), summer 1906
Also known as *Window Overlooking the Scheldt, Antwerp*
Oil on canvas
18 ⅛ x 15 in. (46 x 38 cm)
Location unknown

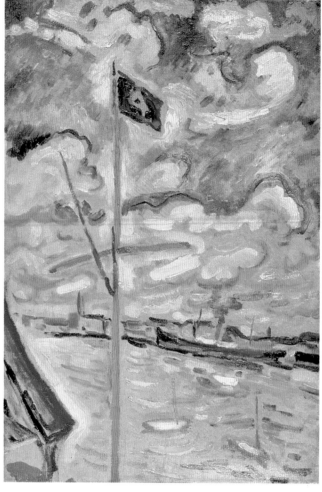

PLATE 213

PLATE 213
Georges Braque
Le Port d'Anvers
(*The Port of Antwerp*),
summer 1906
Oil on canvas
18 ⅛ x 14 in. (45 x 35.6 cm)
Nippon Autopolis Co., Ltd.

PLATE 214
Georges Braque
Le Mat—Le Port d'Anvers
(*The Mast, the Port of
Antwerp*), summer 1906
Oil on canvas
18 ⅛ x 15 ⅛ in. (46 x 38.4 cm)
Marion and Nathan Smooke

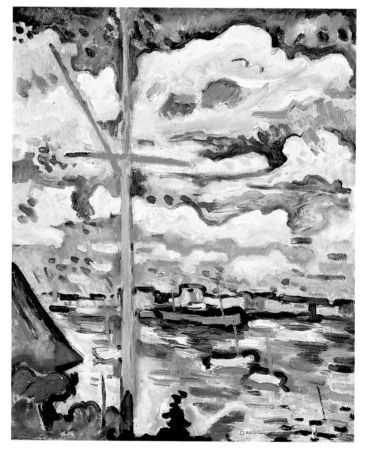

PLATE 214

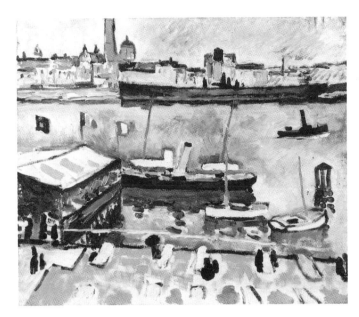

PLATE 216

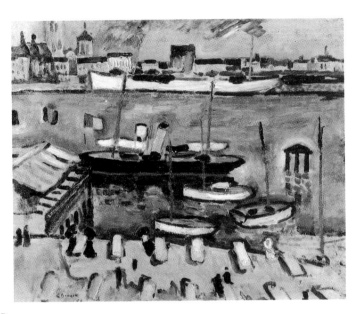

PLATE 215

PLATE 215
Georges Braque
Le Bateau blanc
(*The White Boat*),
summer 1906
Oil on canvas
15 ⅛ x 18 ⅛ in. (38.4 x 46 cm)
Mr. Christopher Wright

PLATE 216
Georges Braque
Le Port d'Anvers
(*The Port of Antwerp*),
summer 1906
Oil on canvas
14 ¹⁵/₁₆ x 18 ⅛ in. (38 x 46 cm)
Von der Heydt Museum,
Wuppertal, West Germany

Braque and Friesz painted alongside one another during most of the trip, producing both horizontal and vertical canvases, often of identical views. Preferring more populated sites, they would set up their easels on the landscaped paths of the left bank that faced the busy docks on the right. This area was a popular tourist haunt, and visitors would stop at one of the waterside cafés to dine on mussels while watching the ships. Perched on a terrace outside one of these cafés above the grassy bank, both Braque (plates 215–16) and Friesz painted the small dock on the left bank in the foreground, with the skyline of Antwerp's right bank in the distance. The skyline—dominated by the spire of the cathedral, the grand towers of the Hôtel de Ville, and the medieval Steen—was visible from virtually all points on the left bank that directly faced the left-bank quays. When the two artists moved down to the terrace immediately overlooking the Scheldt, they had a closer view of the skyline and of the flag-draped boats that were as characteristic of Antwerp as they were of Le Havre (plates 217–19). It was only on the rarest of occasions that the artists painted the right bank's buildings in any detail (plate 103).

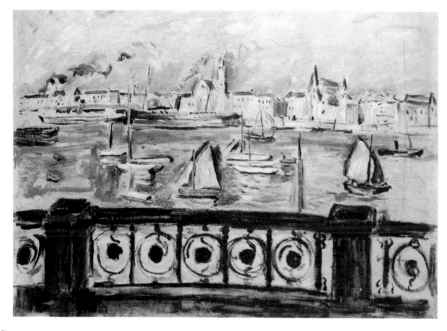

PLATE 217

PLATE 218

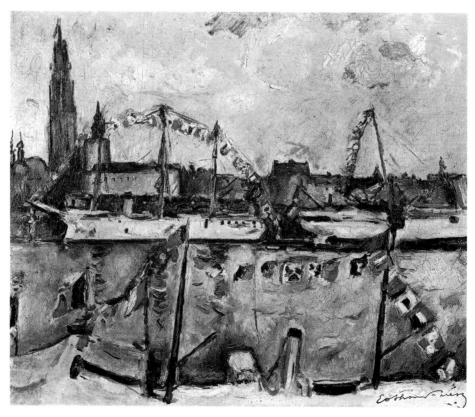

PLATE 219

Braque's and Friesz's depictions of Antwerp indicate that they gravitated to the same type of activity that had attracted them to the area around Le Havre. But unlike their views of Norman towns, these images maintained a distance from Antwerp itself and from the daily life of its inhabitants.[32] By painting from across the river and depicting relatively few figures in any of their paintings, the French artists preserved a sense of separateness from a city and a country that were not their own, as Derain had done in London. At the same time they celebrated the distinctive flavor of the city. They portrayed the city's skyline as dazzling, applying their most brilliant touches of color to accentuate the tall buildings on the opposite side of the Scheldt. Friesz's technique remained rooted in Impressionism; avoiding abrupt contrasts, he blended tones throughout—in the water and sky, on buildings and quaysides. Braque gravitated toward the juxtaposition of intensely colored brush strokes, moving beyond the harmonious contrasts present in much Impressionist painting. The intensity of his palette gradually increased during his three-month stay, becoming divorced from naturalistic depictions of objects and surfaces.

Shortly after leaving Antwerp, Braque and Friesz traveled briefly to Paris and then on to La Ciotat and L'Estaque in the Midi, where the two painted moderately industrial ports. The urban grayness of Antwerp, which Braque especially had energized through an assertive use of color, was supplanted by Mediterranean light. During their stay in these two towns, and especially in L'Estaque, it became evident that Friesz was increasingly learning more from Braque's discoveries than vice versa.

Matisse, too, found an opportunity in mid-1906 to leave France, albeit briefly, in search of his own change of scenery: he took a two-week trip to Algeria that May. Jack Flam has suggested that Matisse may have been inspired to go by reading André Gide's *Immoralist* (1902); he has also noted that Gide's description of the lushness of North Africa is mirrored in the one landscape made by Matisse during this trip, *Rue à Biskra* (*Street in Biskra*, plate 220).[33] Two other sources of inspiration for the trip were no doubt Delacroix's account of his crucial visit to North Africa in 1832 and Renoir's visit in 1881. Most of the literature about Matisse's trip to Algeria has focused on his budding interest in the primitive and exotic, and he certainly had developed a strong interest in non-Western art; he had been frequenting exhibitions of this material since 1903.[34] His decision to go to Algeria was motivated by this interest in the exotic, by his awareness of his artistic forebears and their passion for the region, and by the need to advance his study of the figure within nature.

Matisse left Paris for Collioure on May 4, 1906, in preparation for a summer-long stay in the village where he had spent the previous summer. Instead of going directly to Collioure, he stopped in Perpignan. Writing to Henri Manguin from Perpignan on May 9, he mentioned that he was leaving for Algeria the following day at 3 A.M. From this letter it is clear that he had been planning to make this voyage but had not had sufficient time to plan precisely how long or where he would stay.[35]

Only a handful of works have been identified from Matisse's stay in Algeria, and most are drawings. Matisse bought a considerable number of ceramics and other locally made objects during his trip, many of which he took to Collioure

PLATE 217
Othon Friesz
Le Port d'Anvers
(*The Port of Antwerp*),
summer 1906
Oil on canvas
23 ⅝ x 28 ¾ in. (60 x 73 cm)
Private collection, Paris

PLATE 218
The Yacht Basin at Saint
Anne, Antwerp, c. 1900

PLATE 219
Othon Friesz
Le Port d'Anvers
(*The Port of Antwerp*),
summer 1906
Oil on canvas
19 ¾ x 24 in. (50.2 x 61 cm)
Private collection

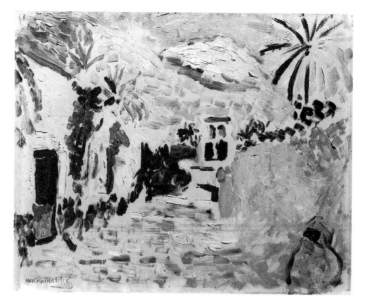

PLATE 220

PLATE 220
Henri Matisse
Rue à Biskra
(*Street in Biskra*), May 1906
Oil on canvas
13 ⅜ x 16 ⅛ in. (34 x 41 cm)
Statens Museum for Kunst,
Copenhagen, J. Rump
Collection

PLATE 221
Henri Matisse
Nu bleu (Souvenir de Biskra)
(*Blue Nude [Souvenir of Biskra]*),
1907
Oil on canvas
36 ¼ x 56 1/16 in.
(92.1 x 142.5 cm)
The Baltimore Museum of Art,
the Cone Collection, formed by
Dr. Claribel Cone and
Miss Etta Cone of Baltimore,
Maryland, BMA 1950.228

and incorporated into later paintings. The trip had a lasting spiritual impact on the artist, and it is this effect that altered the way he painted once he was back in Collioure. In a postcard to Manguin postmarked Algiers, Matisse mentioned that he "feasted his eyes." "The picturesque is abundant here," he wrote, "but to see very much of it, it would be necessary to live here for several months."[36]

Matisse's stay lasted fifteen days, with eight days spent moving from one place to another. Matisse traveled by boat from Perpignan to Algiers (on the Mediterranean coast) and then took trains to Biskra (located approximately 219 miles southwest, across the Sahara) and Constantine (just upriver from Biskra). Though unimpressed by Constantine, except for the Rhumel ravine nearby, Matisse was awed by virtually everything else: "I was continually surprised, unable to determine whether my astonishment came from the customs of the people or the new types of people I saw there or from purely pictorial emotions."[37] Above all, he wrote:

> The desert surprised me. Imagine an immense beach... of sand and pebbles. I was always searching for the sea at the horizon. Because of the sun, and it's almost always like this, the light is blinding. As a painter I saw many interesting subjects but of course my stay was too short. The Biskra oasis is very beautiful, but I know that one must spend many years in these countries in order to extract something new and that one cannot take just one's palette and one's system and apply it [to what one sees].[38]

Although entranced by its beauty, Matisse embraced Algeria cautiously, with an awareness of "the inhuman side of [its] nature that is startling and prevents us from loving this place." In his view—which he conceded might be affected by his unwillingness to accept something new at his age (he was thirty-six)—the Algerian towns were like a Paris that was "infected, not cleaned for a long time." The fascination he had with the Arab residents of Algeria, which had been a French colony since 1830, also diminished: "The Arabs who were nice to me at first disgusted me in the end—I find them too downtrodden." Ultimately he "returned to the earth of France with pleasure."[39]

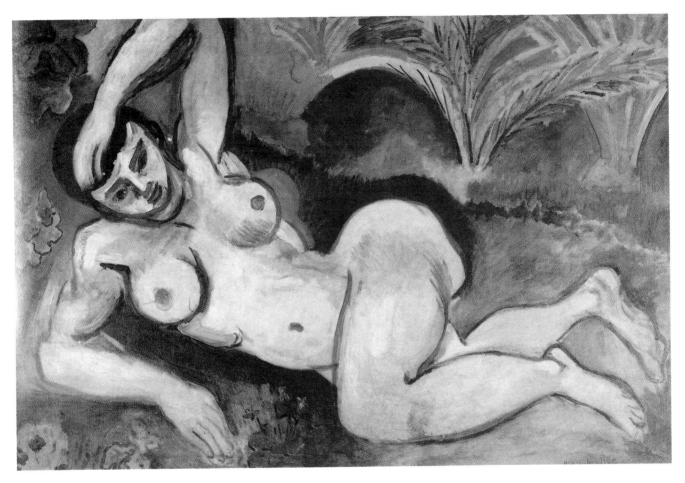

PLATE 221

Back in Collioure a reinvigorated Matisse explained to Manguin:

Before leaving for Algeria, I found [Collioure] a bit dull, but upon returning, it gave me a sudden urge to paint. I find myself back home again. . . . I am obsessed by painting, by trying to see a bit farther and, above all, by reuniting and organizing my sensations. I think continually about work that I have done for the past ten years and I tell myself that the most important thing is to be true to oneself.[40]

The paintings that Matisse made on his return from this fifteen-day immersion in relatively exotic African terrain were not principally landscapes. Indeed, during the summer of 1906 he painted still lifes and portraits and created a group of sculpted figures in a variety of poses. It was not until after he had created a major sculpture, *Nu couché 1* (*Reclining Nude 1*), 1907, that he returned to the theme of landscape with his *Nu bleu (Souvenir de Biskra)* (*Blue Nude* [*Souvenir of Biskra*], plate 221). Landscape was now inextricably linked to figure painting for Matisse; thereafter, unpopulated landscapes would be essentially absent from his oeuvre. As he wrote in "Notes of a Painter," the 1908 statement assessing his role in the Fauve years: "What interests me most is neither still life nor landscape, but the human figure. It is that which best permits me to express my almost religious awe towards life."[41] He returned to North Africa again in 1912 for the first of two trips to Morocco, and those visits, like the one to Algeria five years earlier, were to have a catalytic effect on his style and subject matter.[42]

The year 1906 marked a period in which several of the Fauve artists, fueled by the animated reaction to their imagery in the 1905 Salons, departed for points beyond the confines of France. Their goal was ostensibly to find ways of expanding their visual and thematic vocabularies. The outcome of these voyages was manifested in Derain's case in a powerful body of work; in the case of Matisse, Braque, and Friesz it resulted in ideas or stylistic innovations that would be applied to future painting. To go abroad enabled the Fauve artist to return—if not with pleasure then, at the very least, with a clarified sense of direction and deeply felt convictions— to the earth of France.

★

PLATE 222
Othon Friesz
Le Croiseur pavoisé, Anvers
(*The Flag-Draped Cruiser,
Antwerp*), summer 1906
Oil on canvas
25 9/16 x 31 7/8 in. (65 x 81 cm)
Private collection, Switzerland

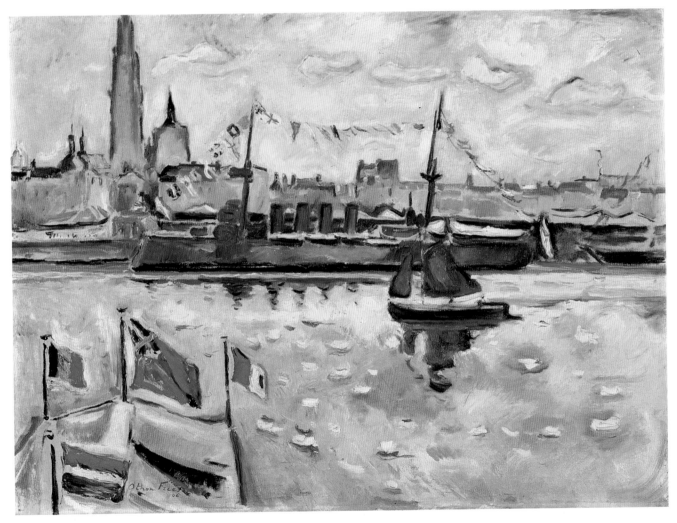

PLATE 222

Unless otherwise noted, all translations are by the author and Catherine Cottet.

1. For "the European diseases," see Paul Gauguin, *Intimate Journals*, trans. Van Wyck Brooks (New York: Liveright, 1949), entry of 1903, p. 207. Gauguin to Strindberg, February 5, 1895; in *Vente de tableaux et dessins par Paul Gauguin, artiste peintre*, February 18, 1895, pp. 3–6; reprinted in Paul Gauguin, *Letters to His Wife and Friends*, ed. Maurice Malingue, trans. H. J. Stenning (Cleveland and New York: World Publishing Company, 1949), pp. 197–98; and in Linda Nochlin, ed., *Impressionism and Post-Impressionism, 1874–1904: Sources and Documents* (Englewood Cliffs, N.J.: Prentice-Hall, 1966), p. 173.

2. On the persistence of Orientalism as a concern of nineteenth-century artists, see MaryAnne Stevens, ed., *The Orientalists, Delacroix to Matisse: European Painters in North Africa*, exh. cat. (London: Royal Academy of Arts, 1984).

3. Eugène Delacroix, entries of April 10 and April 28, 1832, in *The Journal of Eugène Delacroix*, trans. Walter Pach (New York: Covici, Friede Publishers, 1937), pp. 119–20, 122. These comments were written during Delacroix's trip to Morocco as part of the entourage of the count de Mornay. France had conquered Algeria in 1830 and was faced with a hostile Morocco on Algeria's western border. In 1831 the French government negotiated a treaty with the Sultan of Morocco, and Count de Mornay was its envoy to those negotiations.

4. Derain made a third trip in 1910, but no paintings have been identified from that visit.

5. Derain lists twenty-six paintings of London (which he sold to Vollard for 150 francs), and elsewhere in the same letter he mentions another four paintings of London (for 150 francs).

In the same letter he also mentions the wooden bed he sculpted for Vollard and the paintings from the Salon d'Automne, encouraging a date for this letter of late autumn 1906. Derain to Vollard, n.d., Vollard archives, Musée d'Orsay, Paris. A receipt in Derain's hand reads "Received from M. Vollard a check for 1800 francs . . . [for] a collection of paintings 'views of London' . . . at the price of 150 francs each." ("Reçu de M. Vollard un chèque de dix-huit cents francs . . . [pour] une collection de tableaux 'vus de Londres' . . . au prix de cent cinquante francs chacun.") Receipt signed by Derain, dated July 6, 1906, Vollard archives, Musée d'Orsay. Whether this indicates another ten paintings of London (in addition to the thirty already known) is unclear. I am grateful to Louis and Hélène Sébastian for sharing a copy of this letter with me, as the Vollard archives will not be available to scholars for several years at the Musée d'Orsay.

6. Ellen Oppler (*Fauvism Reexamined* [Ph.D. diss., Columbia University, 1969; New York: Garland Publishing, 1976], pp. 104, 104 n. 2, 125) and John Elderfield (*The "Wild Beasts": Fauvism and Its Affinities*, exh. cat. [New York: Museum of Modern Art, 1976], pp. 35–36, 152 n. 84) have suggested that Derain's first trip took place on the heels of the Salon des Indépendants—that is, in late spring 1905. Though positing the influence of Matisse's painting on Derain, Oppler and Elderfield have acknowledged the various points of view on this issue, and Elderfield (p. 152 n. 84) conceded that no definitive date has been established.

7. "Plus tard, je devais demander à Vlaminck et à Derain d'aller me faire des vues de Londres." Ambroise Vollard, *Souvenirs d'un marchand de tableaux* (Paris: Albin Michel, 1937), p. 225.

8. Based on Vollard's remark, various writers have assumed that Vlaminck, too, traveled to London. See, for example, London, Barbican Art Gallery, *The Image of London: Views by Travellers and Emigrés, 1550–1920*, exh. cat., 1987, p. 188. No work by Vlaminck from London has ever surfaced, which makes it unlikely that he accompanied Derain on his painting trip. However, it is true that no letters from Derain to Vlaminck during Derain's first trip to London in 1905 are included in Vlaminck's edition of Derain's letters. Since Derain and Vlaminck corresponded with marked frequency during these years, this absence of letters does add some circumstantial (but not compelling) evidence in support of Vlaminck's presence.

9. Marcel Giry, *Le Fauvisme: Ses Origines, son évolution* (Neuchâtel, Switzerland: Ides et calendes, 1981), p. 126.

10. In assuming that Derain's work in London was impossible without the intervening summer of 1905 in Collioure, I am in agreement with the Derain scholar Michael Parke-Taylor; see his "André Derain's 'Fauve' Era Sketchbook c. 1903–1906" (Master's thesis, Courtauld Institute of Art, University of London, 1979), p. 45 n. 8. See also London, Hayward Gallery, *The Impressionists in London*, exh. cat., 1973, p. 71. Various other authors have also assigned a date of autumn 1905 to Derain's first London trip. See, for example, Denys Sutton, *André Derain* (London: Phaidon, 1959), pp. 19–20; and Paris, Grand Palais, *André Derain*, exh. cat., 1977, p. 146. Denys Sutton's opinion on this subject warrants particular attention. In Mr. Sutton's personal collection is a sketchbook from Derain's London trip, which presumably could illuminate the dating of the London pictures, both in determining which works relate to which trip and in establishing the sequence of motifs within each visit. Regrettably, this sketch-

book has not been made available to me or to other scholars, but I have seen photographs of several of its leaves. These images indicate that Derain made detailed drawings of his London sites, noting selection and blocking of colors. Thorough sketches made *en plein air* clearly preceded final paintings of identical motifs. To the best of my knowledge, the sketchbook has been exhibited only once, in a 1961 exhibition at the Museum of Fine Arts, Houston, *Derain before 1915*. I am grateful to Michael Parke-Taylor for alerting me to its existence and to Kathleen Hartt for combing the Houston Museum of Fine Arts' archives to locate uncatalogued negatives made of three pages of the sketchbook.

11. Derain to the president of the Royal Academy, London, May 15, 1953; in Ronald Alley, *Tate Gallery Catalogues: The Foreign Paintings, Drawings, and Sculptures* (London: Tate Gallery, 1959), pp. 64–65.

12. Oppler, *Fauvism Reexamined*, p. 125; and Hayward Gallery, *Impressionists in London*, p. 71.

13. For a complete account of this subject, see Hayward Gallery, *Impressionists in London*; and John House, "London in the Art of Monet and Pissarro," in Barbican Art Gallery, *Image of London*, pp. 73–98.

14. See Joel Isaacson, "Monet's Views of the Thames," *Art Association of Indianapolis Bulletin*, 1965, pp. 50ff; John House, *Monet: Nature into Art* (London: Yale University Press, 1986), pp. 59–61, 102–6; and House, "London in the Art of Monet and Pissarro." For the most detailed account of Monet's paintings of London, see Grace Seiberling, *Monet in London*, exh. cat. (Atlanta: High Museum of Art, 1988).

15. Derain reported in his letter to the president of the Royal Academy, May 15, 1953 (see Alley, *Tate Gallery Catalogues*, pp. 64–65). "The majority of these pictures were among the canvases which he [Vollard] kept by him. He sold a few but many remained and were dispersed in the sales made by his heirs." Indeed, two of the canvases remain in the collection of one of Vollard's heirs. An attempt to gather a significant portion of the series, aided by Vollard, was made by the Lefevre Gallery, London, in the exhibition *The Thames 1907* [*sic*] of December 1937.

Vollard was clearly sensitive to, and proud of, the idea that he might have manipulated to some degree Derain's choice of motifs. As he commented, "At that time one criticized me for having 'displaced' these artists by having them depart from their usual themes. Now that time has passed and [Derain's] oeuvre is established, one can be convinced, in putting the canvases painted in France alongside those that they brought back from England, that if a painter has 'something to say,' he is always true to himself, even when he changes his environment." ("On m'a reproché alors d'avoir 'dépaysé' ces artistes en les détournant de leurs thèmes habituels. Maintenant que le temps a fait son oeuvre, on peut se convaincre, en mettant les toiles peintes en France à côté de celles qu'ils ont rapportées d'Angleterre, que s'il a 'quelque chose à dire,' un peintre, même en changeant d'atmosphère, est toujours égal à lui-même.") Vollard, *Souvenirs*, p. 225.

16. Drawings in Derain's London sketchbook (see note 10 above) were made from the Savoy or a neighboring building.

17. Derain's views of Regent Street and Hyde Park also emphasize the activity of people, around whom the landscape or cityscape aspects of the site are constructed.

18. All these buildings and wharves were destroyed for the Festival of Britain and the consequent redevelopment of the south bank in 1959.

19. Today much of this traffic has been shifted slightly downriver to the recently developed Docklands area east of the City of London.

20. Hilaire Belloc, *The River of London* (London and Edinburgh: T. N. Foulis, 1912), p. 17.

21. Walter Besant, *East London* (London: Chatto and Windus, 1901), p. 42.

22. All the paintings were completed in London, with one (plate 296) requiring retouching back in Paris to correct some damage incurred during its voyage. Derain to the president of the Royal Academy, January 25, 1952, archives of the Royal Academy of Arts, London. Several were exhibited at the Salon d'Automne of 1906, and then four were exhibited at the 1907 exhibition of La Libre Esthétique, Brussels (March 3–April 3) and the 1908 Toison d'Or exhibition, Moscow (April 18–May 24).

23. This is confirmed by Derain, who dates the Tate's painting to April 1906 in his letter to the president of the Royal Academy, January 25, 1952.

24. "Je pense sincèrement que pour nous nous devons tendre vers le calme par opposition aux générations qui nous précèderent. Ce calme, c'est la certitude. La beauté doit donc être une aspiration au calme." Derain to Matisse, from London, January 30, 1906, private collection.

25. "L'Angleterre a vraiment un certain charme pour un temps très court." Derain to Vlaminck, from London, March 1906; in André Derain, *Lettres à Vlaminck*, ed. Maurice de Vlaminck (Paris: Flammarion, 1955), p. 194.

26. "Je déteste l'esprit anglais triste, hypocrite et gouailleur, tout est mort ici. Dans un restaurant plein de monde on n'entend rien. J'ai vu un port avec des bateaux qui arrivaient, une bande d'ouvriers qui finissaient leur travail, et je croyais rêver: dans tout cela pas un bruit.
"Cette première sensation désagréable est finie et désormais cette forme m'intéresse.
"Les femmes... la plupart admirables de beauté. J'ai vu dans les rues des jeunes filles très blondes de cheveux entortillés comme en désordre avec des nattes serrées autour d'une tête à ton mat d'ivoire légèrement teinté de rose aux lèvres et aux joues ce qui rendait la peau verte avec des yeux évidemment bleus et des formes frêles qui m'ont fait penser que tout est dans son milieu. Ces visages là sont faits pour apparaître dans la brume des rues ou dans la froide tranquillité des intérieurs anglais....
"Contrairement à la femme du midi au visage formidable de noblesse et de volupté comme nous le voyions l'année dernière, faite pour se mouvoir dans la pleine lumière affirme une ligne ample précise qui a infiniment plus de grandeur que ces formes indécises qui émergent du brouillard."
Derain to Matisse, from London, March 8, 1906, private collection.

27. This desire to portray calm is also expressed in Derain's letter to Vlaminck written about the same time. See Derain to Vlaminck, from London, March 8, 1906; in Derain, *Lettres à Vlaminck*, pp. 195–96.

28. It was not until the 1906 Salon d'Automne that Derain exhibited one of his London paintings.

29. The first exhibition, organized by Othon Friesz, opened May 26 and included work by Braque, Derain, Dufy, Friesz, Manguin, Marquet, Matisse, Puy, and Vlaminck.

30. The Congo remained a Belgian colony until 1908.

31. This information comes from Braque's receipts (collection of Mr. and Mrs. Claude Laurens, Paris). For further discussion of this stay, see Judith Cousins, "Documentary Chronology," in New York, Museum of Modern Art, *Picasso and Braque: Pioneering Cubism*, exh. cat., 1989, pp. 341, 434 n. 3. Cousins corrects the dates for the stay that had been identified as August 14–September 11 by Nadine Pouillon and Isabelle Monod-Fontaine, *Braque: Oeuvres de Georges Braque (1882–1963)* (Paris: Musée National d'Art Moderne, Centre Georges Pompidou, 1982), p. 18. See also Alvin Martin, "Georges Braque: Stylistic Formation and Transition, 1900–1909" (Ph.D. diss., Harvard University, 1980), p. 50.

32. Braque and Friesz did visit the royal museum and saw its exceptional collection of Netherlandish painting. Their visit is documented in a postcard that Friesz sent from Antwerp to Manguin, who was staying with Matisse in Collioure. Friesz to Manguin, from Antwerp, postmarked July 14, 1906, Jean-Paul Manguin, Avignon, France. The postcard depicts a painting by Abel Grimmer, *Le Printemps*, in the collection of the Musée Royal d'Anvers.

33. Jack Flam, *Matisse: The Man and His Art, 1869–1918* (Ithaca, N.Y.: Cornell University Press, 1986), p. 167.

34. Ibid., pp. 173–74; Jack Flam, "Matisse and the Fauves," in New York, Museum of Modern Art, *"Primitivism" in Twentieth-Century Art*, ed. William Rubin, 2 vols., exh. cat., 1984, vol. 1, p. 221. Flam (p. 490 n. 18) notes that a visit to the large 1903 exhibition of Islamic art at the Pavillon Marsan and the French primitives' exhibition at the Musée des Arts Décoratifs of 1904 was confirmed by Marguerite Duthuit, Matisse's daughter, in conversation with Pierre Schneider.

35. In Matisse's letter to Manguin, dated May 9, 1906 (collection of Jean-Pierre Manguin, Avignon, France), he asked Manguin to send him a list of hotels in Algeria recommended by the Touring-Club of France. Matisse had been a member of the club but his membership had evidently lapsed. A letter from Manguin to Matisse, from Cavalière, May 12, 1906 (copy in collection of Jean-Pierre Manguin, Avignon, France), indicates that Manguin could not help, as he was no longer a member of the Touring-Club.

36. "Le pittoresque y abonde, mais pour voir plus loin il faudrait y vivre quelque mois." Matisse to Manguin, from Algeria, postmarked May 23, 1906, Jean-Pierre Manguin, Avignon, France.

37. "J'ai été de surprises en surprises. Sans pouvoir distinguer si mon étonnement venait des moeurs ou des types nouveaux que je voyais ou d'émotions purement picturales." Matisse to Manguin, from Collioure, late May or early June 1906, Jean-Pierre Manguin, Avignon, France.

38. "Le désert m'a surpris, figure-toi une plage immense... de sable et de galets, je cherchais toujours la mer à l'horizon. Par le soleil et c'est presque toujours ainsi, la lumière est aveuglante. Comme peintre j'ai vu des choses intéressantes mais évidemment, j'y suis resté trop peu. L'Oasis de Biskra est très beau, mais on a bien conscience qu'il faudrait passer plusieurs années dans ces pays pour en tirer quelque chose de neuf et qu'on ne peut prendre sa palette et son système et l'appliquer." Ibid.

39. "le côté inhumain de la nature qui effarouche et empêche d'aimer ce pays"; "infecté, mal nettoyé pendant longtemps"; "les arabes qui m'étaient d'abord sympathiques ont fini par me dégoûter, je les trouve trop avachis"; "j'ai retrouvé la terre de France avec plaisir." Ibid.

40. "Avant de partir en Algérie je l'avais trouvé un peu fade, mais en revenant, il m'a donné une envie de peindre à tout déchirer. Je me suis retrouvé dans mes pantoufles.... Je suis exclusivement pris par la peinture, en arguant de voir un peu plus loin et surtout de réunir et organiser mes sensations. Je pense continuellement au travail que j'ai fait depuis dix ans et je me dis que le principal est d'être bien soi." Ibid.

41. Henri Matisse, "Notes d'un peintre," *La Grande Revue* 52 (December 25, 1908): 741; in Jack D. Flam, ed., *Matisse on Art* (New York: E. P. Dutton, 1978), p. 38.

42. In the interim Matisse also traveled within Europe. A month-long trip to Italy in 1907 allowed the artist to immerse himself in Renaissance painting. He studied the work of Giotto, Duccio, and Piero della Francesca: "Giotto is for me the summit of my desires." ("Giotto est pour moi le sommet de mes désirs.") Matisse to Pierre Bonnard, May 7, 1946; in Jean Clair, "Correspondance Matisse-Bonnard," *La Nouvelle Revue française* 187 (August 1970): 70. He traveled to Germany twice in 1908 and to Spain in 1910–11. An important exhibition devoted to Matisse's visits to Morocco was presented in the spring of 1990; see Washington, D.C., National Gallery of Art, *Matisse in Morocco: Paintings and Drawings, 1912–13*, exh. cat., 1990.

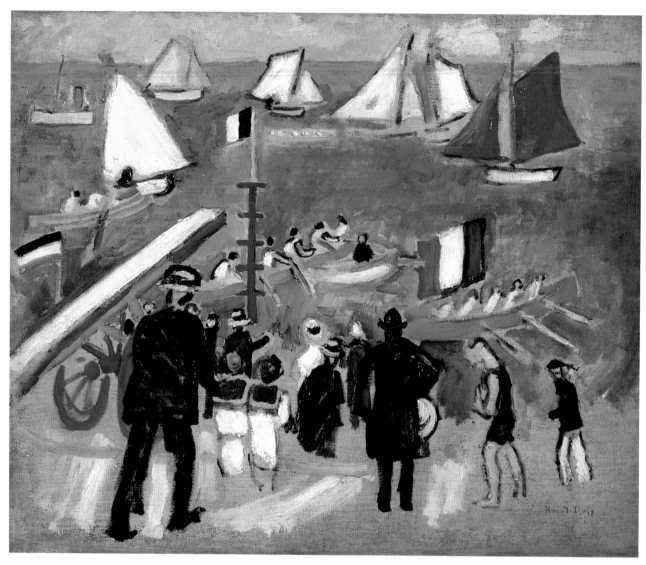

PLATE 223

The Distant Cousins in Normandy

braque, dufy, and friesz

ALVIN MARTIN AND JUDI FREEMAN

The branches of the Fauve family tree might at first glance appear to stem from Henri Matisse—that is, his friends and intimates Charles Camoin, Henri Manguin, Albert Marquet, and Jean Puy—and from the school of Chatou, consisting of André Derain and Maurice de Vlaminck. Those were the artists who dominated "la cage aux Fauves" at the 1905 Salon d'Automne; when *L'Illustration* devoted a double-page spread to the Salon, it reproduced works by Derain, Manguin, Matisse, Puy, Georges Rouault, and Louis Valtat.[1] However, a kind of Fauve spirit stirred elsewhere in that Salon as well. Several rooms away hung canvases by Othon Friesz, an artist from Normandy whose work, although clearly Impressionist inspired, featured brushwork with a textural physicality and an aspiration toward vivid color. When Georges Braque, a younger Norman artist who had been studying in Paris intermittently for several years, saw this work by Friesz, he quickly identified qualities in it that appealed to him.

Although subsequent events enabled Braque, Dufy, and Friesz to become more integrated into the extended Fauve family, something about their work is always distinctly separate. Exactly what is different, and why, is worth considering. It could be said that had these three artists never produced work identifiable as Fauve, the Fauve contribution to the history of art would have remained essentially unchanged. Yet they did exist, they did become an offshoot of the coterie of Fauve artists, and the distinct character of their work raises fascinating questions about the origins of the Fauve efforts and the position of Fauve painting within a deliberately modern art.

In a sense, the Norman Fauves were more directly the heirs to the Impressionist fascination with the changing urban and suburban landscape than were their Fauve colleagues. Matisse and Derain painted the tourist port (e.g., Saint-Tropez, Collioure); Derain and Vlaminck painted the populated but relatively tranquil suburban town (e.g., Chatou, Le Pecq, L'Estaque); Marquet and Matisse painted the core of Paris in its quieter moments. The Fauves from Normandy painted the working port. Their hometown, Le Havre, was centered on a busy industrial harbor. The other towns where they set up their easels—Trouville, Antwerp, L'Estaque, La Ciotat—had harbors and docks filled with shipping activity. They traveled elsewhere as well, but these industrialized settings and the life surrounding them were what they chiefly painted.

Braque, Dufy, and Friesz, like many of the other Fauves, were born in the northern half of France and identified with the north.[2] All three hailed from Le Havre, a port city located along the southern end of the English Channel (plate 224).

PLATE 223
Raoul Dufy
Les Régates
(*The Regattas*), 1907–8
Oil on canvas
21 ¼ x 25 ⁹⁄₁₆ in. (54 x 65 cm)
Musée d'Art Moderne de
la Ville de Paris

[215]

Plate 224

Whereas their fellow northern-born Fauves (with the exception of Vlaminck) often traveled south and only infrequently returned to the towns of their birth, Braque, Dufy, and Friesz alternated between Le Havre and the other places they decided to paint. If it is true, as many historians and sociologists have argued, that France is a divided nation, with an *"esprit nordique"* and an *"esprit méditerrané,"*[3] then the Fauves Havrais remained more faithful to that northern spirit than their fellow Fauves.

Le Havre was (and is) a modern provincial city, a rival to Rouen, the capital of Normandy located fifty-four miles to the east along the Seine. Le Havre had two advantages over more northern ports such as Calais and Deauville: it was strategically located at the mouth of the Seine and, conveniently, to its east were the traditional ship-building towns of Harfleur and Honfleur. Le Havre prospered in part because it served as the embarkation point for ships heading across the English Channel and the Atlantic. From the mid-nineteenth century through the outbreak of World War II most Americans traveling to France and most continental Europeans heading to America passed through the harbor at Le Havre.

When Braque, Dufy, and Friesz came of age in Le Havre, it was a densely populated city, with more than 129,000 inhabitants by 1906. By the turn of the century Le Havre had absorbed the towns contiguous with it: Harfleur to the east and Sainte-Adresse to the north. Sainte-Adresse, located on the bluff that rose along the northern edge of the city's coastline, encompassed the villas and mansions of the city's wealthier citizens.

The geographical and commercial center of Le Havre was the harbor, with its ten basins. No doubt Braque, Dufy, and Friesz frequented the cafés and restaurants set up to serve the passengers and personnel who passed through the basins. Their immersion in the life of the town gave Braque, Dufy, and Friesz a knowledge of cranes, winches, docks, quays, jetties, and ships that they translated into elements in their paintings.[4] Braque's earliest landscapes depict the boats in the harbor (plate 225). He used a palette of blue, gray, and brown to render the gritty surfaces of the sailing vessels and the docks. Dufy's early views of the port (plate 226) are more pastel in hue and feature a heavier impasto, but they still convey the strongly industrial quality of the imagery.

All three artists had long been familiar with the world of shipping and industry. The eldest, Dufy, had a father who worked as an accountant at a metalworking factory; Dufy himself worked for a firm that imported coffee.[5] Friesz's father was captain of his own ship and came from a long line of seafarers. Friesz often worked aboard his father's ship or in his uncle's shipyard in Marseille. Braque's association with the sea came from his residence near it rather than from any professional association with it. His father, who made his living as a commercial painter (and was an amateur artist who was among the nine founders of the Cercle de l'Art Moderne in 1906), moved his family to Le Havre precisely because he wanted to benefit from the opportunities afforded by the region's rapid growth. He taught his son the commercial paint and plastering business, endowing him with practical skills that were clearly marketable in Le Havre's growing economy.

The Fauves Havrais shared the encouragement of the leading local art teacher, Charles Lhuillier.[6] A close friend of Johan-Barthold Jongkind, Lhuillier taught at

PLATE 224
Normandy, Department of
the Seine-Inférieure, 1904

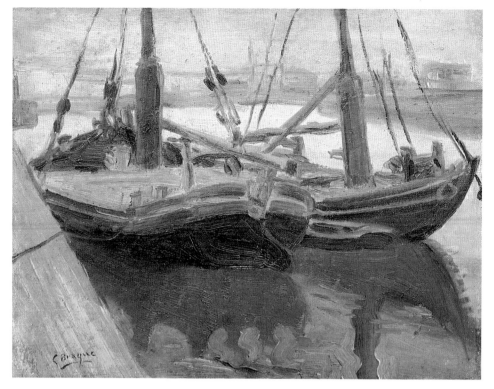

PLATE 225

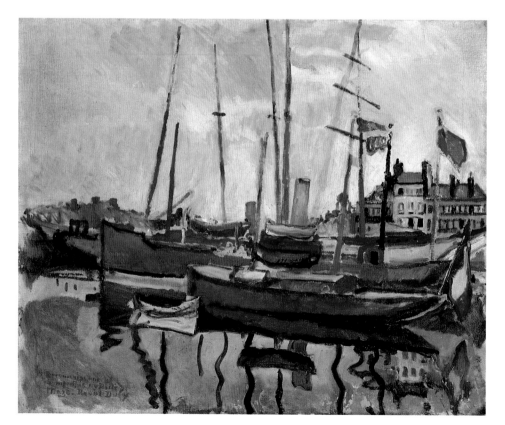

PLATE 226

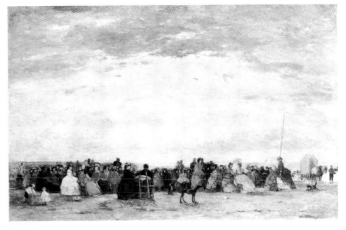

PLATE 228

PLATE 227

Le Havre's École des Beaux-Arts, in which Braque, Dufy, and Friesz enrolled at various times. Dufy joined in 1892, Friesz in 1893 (and full time in 1894), and Braque arrived in 1897 (after Lhuillier's death), studying with one of Lhuillier's successors, M. Courchet.[7] Lhuillier promoted technical experimentation and the study of landscape. He also encouraged an atmospheric, inviting, but relatively conservative version of Impressionism, influenced heavily by his friend Jongkind (plate 227) and by Eugène Boudin (plate 228), who also painted extensively in the region. By 1894 Dufy and Friesz had met at the school, and they soon began to travel together, visiting the Musée des Beaux-Arts in Rouen, hiking throughout Normandy, and painting.[8] Braque knew Dufy already; Dufy's brother Gaston had given him flute lessons.

Between 1898 and 1905 Braque, Dufy, and Friesz went individually to Paris, receiving civic grants to do so. At different times each entered the studio of Léon Bonnat at the École des Beaux-Arts, and each returned repeatedly to Le Havre to paint. Friesz arrived in Paris in 1898 but left a year later to serve in the armed forces; Dufy, released from his military service in 1899, went to Paris the follow-ing year, thanks to a scholarship of 200 francs a month from the city of Le Havre. He and Friesz, who were now close friends, shared a studio at 12, rue Cortot.[9] Braque initially studied art at night and served as an apprentice to a house painter, Laberthe, by day. Following his military stint in 1901–late 1902, he enrolled at the Académie Humbert in Paris, where he studied alongside Marie Laurencin and Francis Picabia. In October 1903 the three artists overlapped at Bonnat's studio for a brief period. Their work had matured into a pseudo-Impressionist style, with a muted palette, often pastel in tonality, and with Impressionist-inspired compositions.[10] Almost all of these paintings have a predominantly gray char-acter, lacking the climatic diversity characteristic of work by the principal Impressionists.

Friesz embraced Impressionism wholeheartedly. He had been a long-time admirer of Boudin, Jongkind, and Monet (all Havrais painters from an earlier generation), and about 1901 he became friendly with Armand Guillaumin and Camille Pissarro. Friesz worked with both of these artists in Normandy, painting in Crozent with Guillaumin in 1901 and with Pissarro in Le Havre and Honfleur in 1903. Dufy, too, had links to Impressionist subjects. He remained devoted to Boudin's work, as evident in his *Les Bains du Casino Marie-Christine à Sainte-Adresse* (*The Baths of the Marie-Christine Casino at Sainte-Adresse,* plate 229), in which the broad handling, feathery touch, light-filled atmosphere, and broken color recall Boudin's beach and harbor scenes. Braque, because of his relative youth, remained a student further into the Fauve period than his fellow Normans, but his paintings from about 1904–5 indicate that he was also moving along a vaguely Impressionist path.

Their encounter with the Fauve work in the 1905 Salon d'Automne stimulated the three Norman artists. To be sure, these artists did not simply stumble on the Fauves in room 7, with no previous knowledge of their existence. Friesz (who was two years younger than Dufy and three years older than Braque) had a head start on the rest of the Norman artists: he had exhibited at Berthe Weill's gallery along with other nascent members of the Fauve group in 1904 and had already had a solo exhibition in Paris, at the Galerie des Collectionneurs. His connections with the other Fauves were established earlier and consequently more firmly; Friesz is the only Fauve from Le Havre who is known to have corresponded with the principal Fauves. Dufy and Braque did not interact with the Fauves to the same degree, but they clearly had a strong response to what they saw in the 1905 Salon d'Automne.

PLATE 229
Raoul Dufy
Les Bains du Casino Marie-Christine à Sainte-Adresse
(*The Baths of the Marie-Christine Casino at Sainte-Adresse*), 1904
Oil on canvas
23 ⅝ x 28 ¾ in. (60 x 73 cm)
Musée National d'Art Moderne, Centre Georges Pompidou, Paris

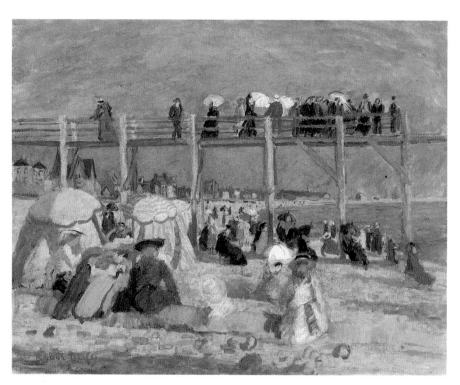

PLATE 229

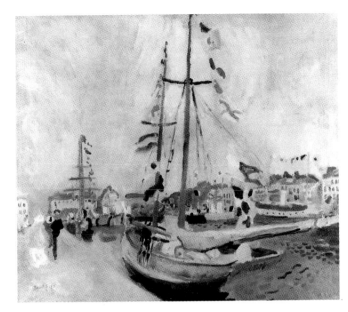

PLATE 231

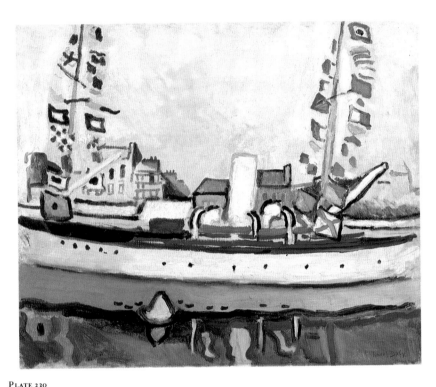

PLATE 230

PLATE 230
Raoul Dufy
Bateau pavoisé
(*Flag-Draped Boat*), 1905
Oil on canvas
21 ¼ x 25 ⁹/₁₆ in. (54 x 65 cm)
Musée des Beaux-Arts,
Lyon, France

PLATE 231
Raoul Dufy
Le Yacht pavoisé
(*The Flag-Draped Ship*), 1904
Oil on canvas
27 ⁹/₁₆ x 31 ⁷/₈ in. (69 x 81 cm)
Musée des Beaux-Arts, Le
Havre, France, gift of Mme
Dufy, 1962

What distinguished the work of the Fauves from Le Havre from that of Matisse and company was the treatment of surface and color. Whereas the Norman artists had been steadfastly loyal to the Impressionist approach to painting, Matisse, Derain, Vlaminck, and the others borrowed extensively from the far more audacious generation that succeeded the Impressionists. The Norman Fauves found irresistible the full-blown Fauve manner of painting, characterized by highly saturated color and the laying in of brilliant tones side by side, and they inevitably responded to it in their own work, produced back in their native Normandy.

Dufy championed the Fauve cause most assiduously of the three artists, while continuing to paint his familiar motifs. His paintings of 1905–6 seem to be invigorated with color, no doubt the product of his having experienced the sensational Fauve salon. A comparison of his 1905 *Bateau pavoisé* (*Flag-Draped Boat*, plate 230) with his 1904 *Le Yacht pavoisé* (*The Flag-Draped Ship*, plate 231)—both depictions of the docksides of his home city—reveals that out of the allover softness of hue and blended surface grew a bolder use of pronounced primary

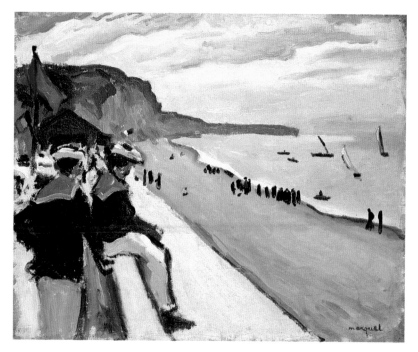

PLATE 233

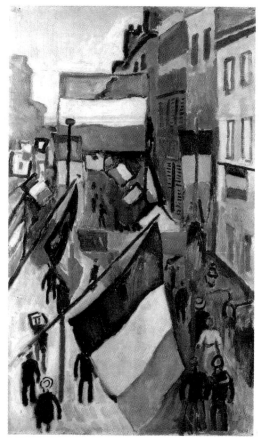

PLATE 232

PLATE 232
Raoul Dufy
Le 14 Juillet au Havre
(*July 14 at Le Havre*),
summer 1906
Oil on canvas
31 ⅞ x 19 ¹¹⁄₁₆ in. (81 x 50 cm)
Private collection

PLATE 233
Albert Marquet
La Plage de Fécamp
(*The Beach at Fécamp*),
summer 1906
Oil on canvas
19 ¹¹⁄₁₆ x 24 in. (50 x 61 cm)
Musée National d'Art
Moderne, Centre Georges
Pompidou, Paris

PLATE 234
Raoul Dufy
*Vieilles Maisons sur le Bassin
d'Honfleur*
(*Old Houses along the Honfleur
Basin*), 1905–6
Oil on canvas
23 ⅝ x 28 ¾ in. (60 x 73 cm)
Fridart Foundation

tones, more differentiated, more arbitrary color, and marked contrasts in surface texture. Dufy had not shed his preferences for unified tonalities between water and sky and for flat patterning, also characteristic of the work of Marquet, who began to paint with Dufy in Fécamp in 1904 (plate 233) and continued to paint with him around Le Havre in 1906. Dufy's festive views of local flag-draped streets, festooned for patriotic holidays, provided an especially good opportunity to use saturated color (plate 232). Painting Honfleur and Trouville, just across the estuary, gave Dufy and Marquet a chance to reinterpret, not reinvent, the sites so favored by Monet, Boudin, and others. In the small village of Honfleur, Dufy headed to the harbor and painted the uniform buildings at water's edge with heightened color and jewellike surfaces (plate 234). In their views of Trouville both artists seized the occasion to animate their canvases with the tourist signs that dominated this casino-centered town (plates 235–36).

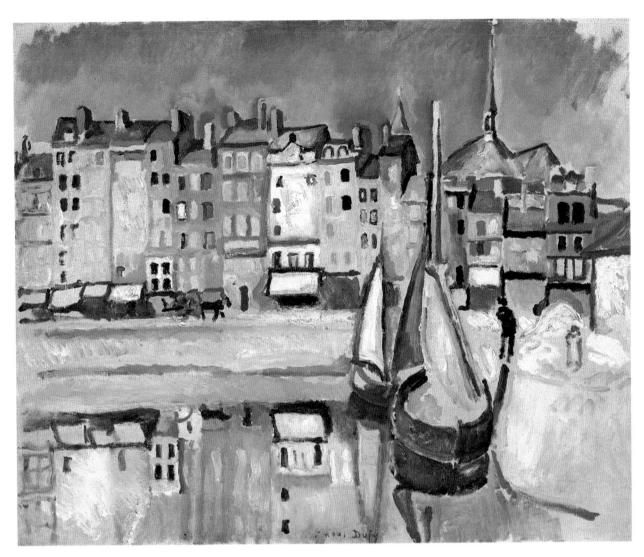

PLATE 234

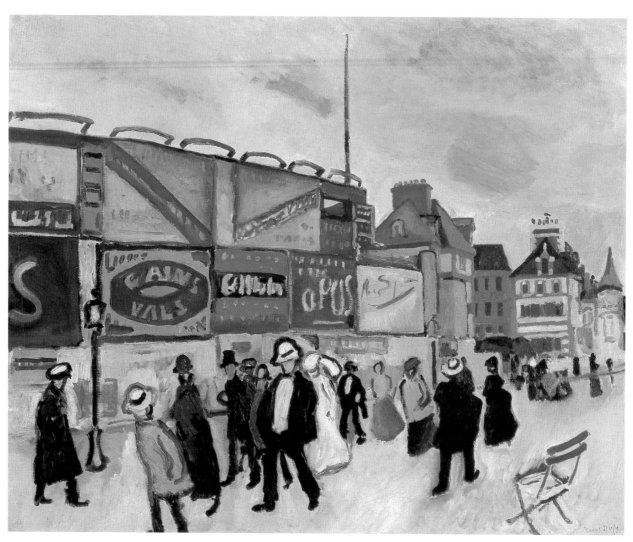

PLATE 235

PLATE 235
Raoul Dufy
Les Affiches à Trouville
(*Posters at Trouville*), 1906
Oil on canvas
25 9/16 x 31 7/8 in. (65 x 81 cm)
Musée National d'Art
Moderne, Centre Georges
Pompidou, Paris

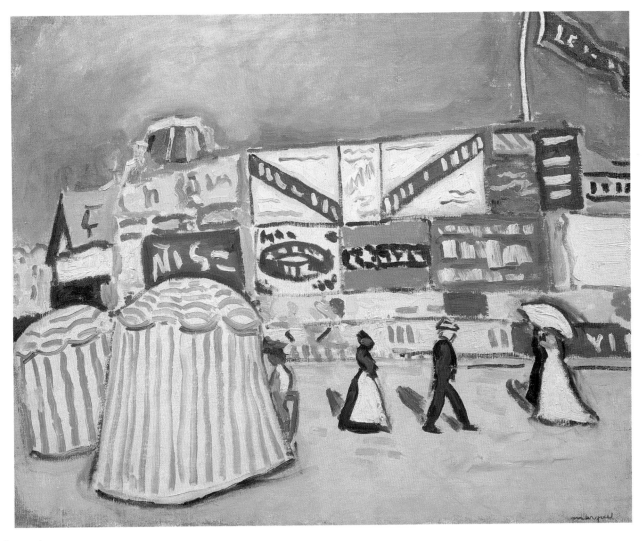

PLATE 236

PLATE 236
Albert Marquet
Les Affiches à Trouville
(*Posters at Trouville*), 1906
Oil on canvas
25 x 31½ in. (63.5 x 80 cm)
Mrs. John Hay Whitney

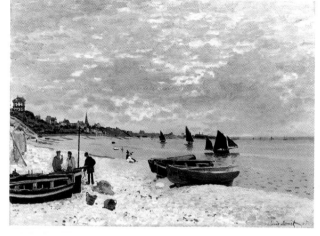

PLATE 237

Sainte-Adresse was also a preferred place to paint and photograph. Monet, a native son of Le Havre, had returned to the region to paint annually from 1865 to 1868.[11] He most often positioned himself at the southern end of the Sainte-Adresse coastline and looked northwest toward the Cap de la Hève or painted the same view from near the Cap de la Hève (plate 237). His predecessors in Le Havre had captured the same vista; countless examples can be identified in the work of Eugène Isabey, Jongkind, and the photographer Gustave LeGray. In addition, many postcard photographers (plate 239) capitalized on the popularity of this site with French and English tourists.

When Dufy and Marquet elected to paint in Sainte-Adresse in the summer of 1906, they were consciously choosing to address the Impressionist image on its own turf. Their paintings are pleasant, with tones balanced harmoniously, and in that they resemble Monet's work, but the subjects are Impressionist with a difference. There are always people, not necessarily the stylishly dressed strollers in Monet's elegant beach and bathing scenes, but the people who lived and worked along this coastline. Dufy and Marquet chose to paint what was familiar: the working man, the family on holiday, the fisherman. Marquet's carnival scenes along the beach or the port (plate 238) convey a sense of the crowds surging to participate in this popular form of entertainment. Dufy's more peaceful views of the beach at Sainte-Adresse and the regattas gliding along the coast (plate 240) feature intensified color that is comparatively more Fauve but still clearly related to the pastel hues of Impressionism.

The large number of paintings produced by Braque, Dufy, and Friesz depicting life in and around Le Havre demonstrates a particular loyalty to Normandy that is underscored by the involvement of all three artists in the local Cercle de l'Art Moderne. In 1906 Friesz and Georges Jean-Aubry, a local historian and biographer of Boudin, were among the founders of the organization. From 1906 to 1909 it produced annual festivals of contemporary art, music, and literature in Le Havre. As members of the painting committee, Braque, Dufy, and Friesz endeavored to share with their fellow Havrais what they had seen in Paris. Consequently, works by nearly all the leading Fauve artists were included in the Cercle's exhibitions, which were usually held at the Hôtel de Ville in Le Havre.

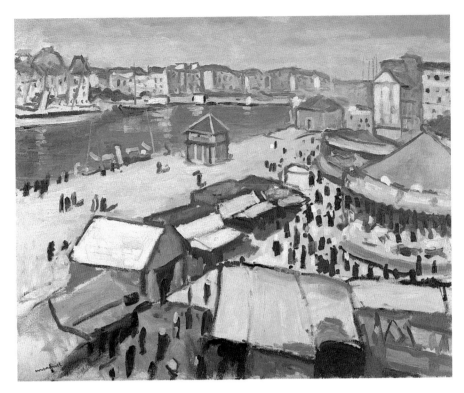

Plate 238

Plate 239

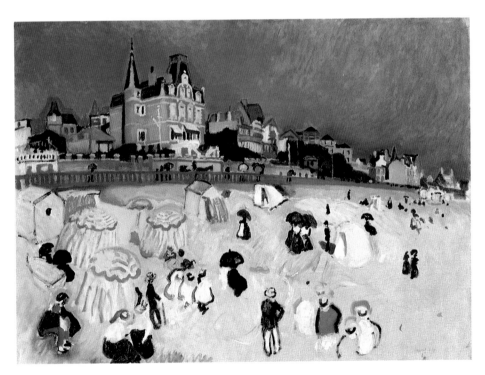

Plate 240

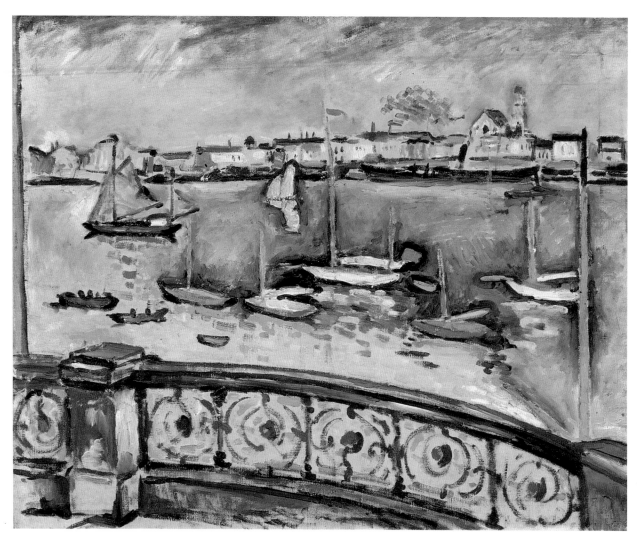

PLATE 241

PLATE 241
Georges Braque
Le Port d'Anvers
(The Port of Antwerp),
summer 1906
Oil on canvas
19 ⅝ x 24 1/16 in.
(49.8 x 61.2 cm)
National Gallery of Canada,
Ottawa

PLATE 242
Othon Friesz
Le Port d'Anvers
(The Port of Antwerp),
summer 1906
Oil on canvas
31 ⅞ x 25 ⅝ in. (81 x 65 cm)
Private collection

Local reaction to the first exhibition was predictably mixed. There were so many antagonistic responses that Jean-Paul Laurens—a local citizen, commander of the Legion of Honor, member of the Institut de France, and successful academic painter—founded an opposing organization, the Société Havrais des Beaux-Arts. This group held a rival exhibition showing more conventional art in 1907.[12] Although controversial, the exhibitions of the Cercle de l'Art Moderne were nevertheless extremely influential. By showing artists flushed with success direct from the Salon des Indépendants and the Salon d'Automne, they enabled Norman citizens to see the most important contemporary art produced in Paris. Braque and Friesz, in particular, juggled their administrative responsibilities within the Cercle de l'Art Moderne so that they could continue to travel to sites worth painting. They followed the coast up to Belgium and identified the busy port of Antwerp as a suitable place to paint (see Judi Freeman, "Far from the Earth of France: The Fauves Abroad," pages 177–213). Though Friesz's color brightened in Antwerp, his overall facture remained firmly rooted in Impressionism (plate 242). At the same time Braque began to experiment with using patches of bold and complementary colors (plate 241), closer to the Fauve style than to the fused Impressionist-Fauve technique that Friesz had developed. By the end of their summer in Antwerp, Braque had surpassed Friesz in the use of expressive—rather than descriptive—color and brushwork. The Antwerp trip facilitated Braque's transformation into a full-fledged painter of color-saturated canvases, though he continued to concentrate on images of industrial and maritime activity. The experience encouraged him to shift his attention to different regions of France, as the other Fauves had, and to experiment with their newly developed style.

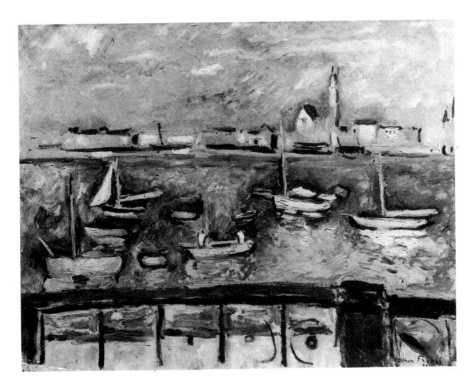

PLATE 242

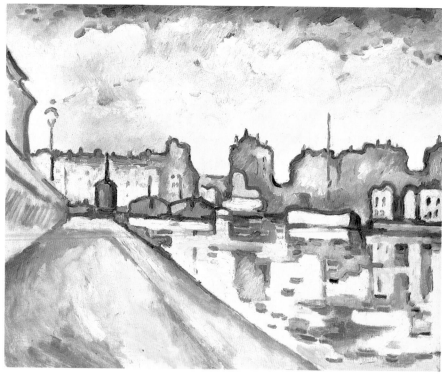

PLATE 244
L'Estaque

PLATE 245
Marseille to Sainte-
Maxime, 1896

PLATE 243

PLATE 243
Georges Braque
Le Canal Saint-Martin
(*The Saint-Martin Canal*),
autumn 1906
Oil on canvas
20 x 24 ¼ in. (50 x 62 cm)
Collection Alain Delon

During the eighteen months after his stay in Antwerp, Braque executed more than eighty paintings.[13] Returning to Paris, he painted two views of the Canal Saint-Martin. His attraction to maritime activity again governed his choice of subject; one painting (plate 243) represents the dockside of the canal, where barges traversing the Seine from Paris to Le Havre were unloaded. Having completed the two paintings of the canal, Braque shifted his attention to the Midi, particularly L'Estaque, again traveling with Friesz. In fact, the admission of Braque, Dufy, and Friesz into Fauve circles would not have been possible without their work in the Midi.

Derain, too, had devoted himself in 1906 to the depiction of L'Estaque, although he preferred to represent the heavily wooded areas and paths, whereas Braque and Friesz were attracted to the town's fully functioning port. L'Estaque was an industrial suburb of Marseille, located where the bay of Marseille curves to face the grand harbor of Marseille (plates 244–45). Sited beneath chalky cliffs punctuated by railway viaducts, L'Estaque had a skyline dominated by the factories and smokestacks of the Rio Tinto company. During their initial months there Braque and Friesz painted numerous views of the harbor and beach (views, incidentally, that Derain had avoided), imbuing these with saturated colors radically different from the grays, whites, and browns that constitute the real L'Estaque (plates 246–47). Later in the autumn and winter Braque moved inland, away from the port, and executed several landscapes with spatially compressed views and intensified color relationships (plate 248). He was, however, soon drawn back to maritime views in the region, which became the hallmark of his Fauve imagery.

L'ESTAQUE (Plage) — Un coin du Port

PLATE 244

PLATE 245

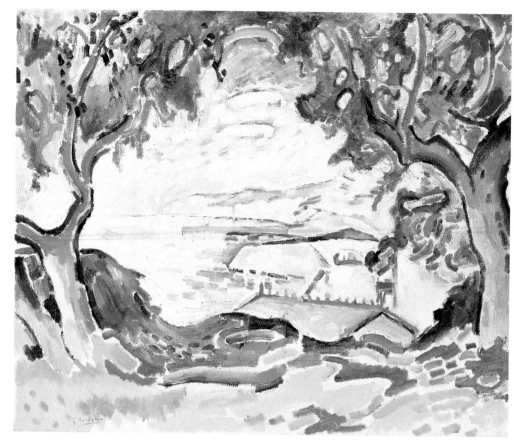

PLATE 246

PLATE 246
Georges Braque
Paysage à L'Estaque
(*Landscape at L'Estaque*),
autumn 1906
Oil on canvas
23 ⅝ x 28 ¾ in. (60 x 73 cm)
Private collection, Dallas

PLATE 247
Othon Friesz
L'Estaque, 1907
Oil on canvas
25 ⅝ x 31 ¼ in.
(65.1 x 80.6 cm)
Private collection

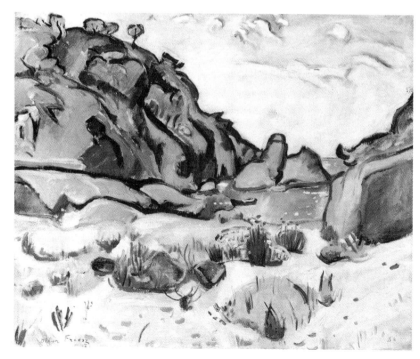

PLATE 247

PLATE 248
Georges Braque
L'Estaque, autumn 1906
Oil on canvas
18 ⅛ x 21 ⅝ in. (46 x 55 cm)
Private collection,
Switzerland

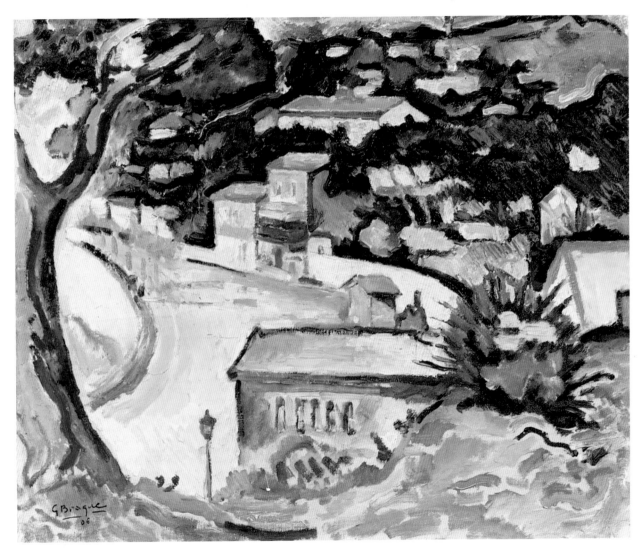

PLATE 248

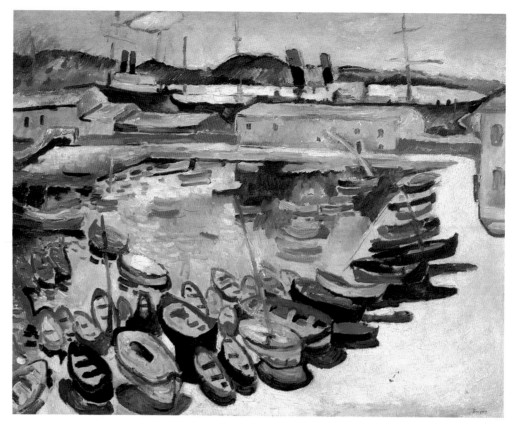

PLATE 249

PLATE 250

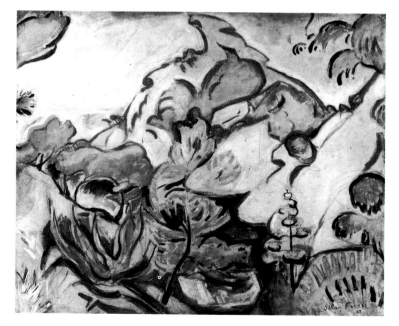

PLATE 251

Henceforth, Braque and Friesz (and, to a lesser extent, Dufy) would find time to paint only in the periods between their trips to Paris to participate in the Salons and their trips to Le Havre to work with the Cercle de l'Art Moderne. Both artists were receiving increasing recognition at the Salons, and both were approached by powerful dealers—Daniel-Henry Kahnweiler and Eugène Druet, respectively—who arranged to show their work. Braque and Friesz continued to paint side by side. In the late spring of 1907 they traveled to La Ciotat (plate 250), another working-class town renowned for ship building and outfitting; its small harbor was dominated by a massive dry-dock facility. Like L'Estaque, the town is situated in the shadow of Marseille.

As in L'Estaque, Braque and Friesz gravitated to the harbor. Their earliest works produced in La Ciotat bear a striking similarity in palette and in composition to the paintings the two artists did in the harbor at L'Estaque. *Le Port de La Ciotat* (*The Port of La Ciotat*, plate 249) features a crescent of small boats in the foreground and steamers in dry dock across the harbor—all painted in a relatively traditional manner. The hues of the boats and dinghies may resemble actuality, but the blue hills beyond the dry docks are, in fact, massive brown volcanic rocks, characteristic of the region. Their color and facture are pure invention.

Friesz was especially attracted to the coves (*calanques*) just beyond the town of La Ciotat, and he painted at least five views of the Bec de l'Aigle (Eagle's Beak), one of the landmarks among the coves (plate 251). In these paintings Friesz's liberation of color was thorough. Using a vivid palette dominated by orange and an ocher-infused green, he abandoned all sense of naturalism in favor of an expressive gestural style characterized by sweeping curvilinear brushwork and layers of pigment. Braque painted these coves too, but his images were much more nature-bound than Friesz's strongly abstract motifs.

By the 1907 Salon d'Automne the individual Fauves Havrais were changing. Braque showed only one work; Friesz had six on view. Both were affected by the same dominant figure of the 1907 Salon—Cézanne—and responded by painting figures in landscapes, subjects that Matisse and Derain were also pursuing. Along with Derain, Braque and Friesz were coming to terms in 1907 with Cézanne, whose solidified forms and figures provided a powerful counterforce to the Fauve palette; all three were profoundly affected by Cézanne's posthumous retrospective at the Salon. Looking back, it seems that Cézanne's impact made it impossible for the three artists to sustain a Fauve style (plates 252–53): his influence seemed to lead inevitably either to Cubism or to a darker, more brooding realism. Braque was especially affected by the structural implications of Cézanne's work. Returning to L'Estaque with Friesz in October 1907, Braque began a series of landscapes that he completed during the winter of 1907–8.[14] Derain's and Friesz's subsequent work reflects Cézanne's fascination with volume, which is generally lacking in Fauve

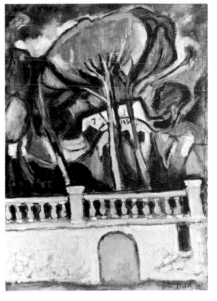

PLATE 252

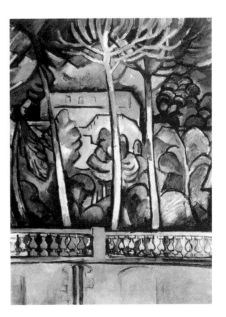

PLATE 253

painting. Dufy more or less followed the same course. Painting in Martigues in 1907 and L'Estaque in 1908, he gradually began to impart a sense of volume and angularity to his heretofore relatively flat imagery.

Braque, by the winter of 1907–8, had shifted his attention to his growing friendship with Picasso (whose *Demoiselles d'Avignon* and unfinished *Three Women* he saw in Picasso's studio in late November or early December).[15] During that autumn and winter his Fauve hues gave way to more earthy tonalities, and by the spring of 1908 his fascination with Cézanne's structure became the central issue in his painting. Braque's submissions to the 1908 Salon des Indépendants indicate an entirely different direction in his work, the first examples of his nascent Cubist style. Guillaume Apollinaire wrote about this Salon: "[Braque's work is] the most original effort of this Salon. Certainly, the evolution of this artist . . . is considerable. . . . It must be recognized that Mr. Braque has unfalteringly realized his will to construct."[16] Having experimented with these structurally centered landscapes, Braque returned to L'Estaque with Dufy for the summer of 1908. There Dufy flirted with a developing Cubism (plate 254), but he abandoned it several years later to return to a flattened, joyous view of nature. Braque painted blocky houses in predominantly olive-hued landscapes—the same paintings that would be rejected by Matisse and his fellow jurors at the 1908 Salon d'Automne, to be shown instead at Kahnweiler's newly opened gallery later that autumn.

The Fauves Havrais addressed a wide spectrum of concerns, making it difficult to define a single Fauve style or subject. They contributed to the Fauve circle the notion that a working port—not only tourist sites or relatively suburban towns but bona-fide industrial scenes—could provide worthy subjects for painting. By reinvestigating the traditional Impressionist images of their native Normandy, they also provided clearer examples, perhaps, than did most of the other Fauves of how late nineteenth-century landscape painting evolved into another kind of landscape painting at the beginning of the twentieth century. To be Fauve in spirit was not just to paint in bright colors. Their work thus reminded critics and other artists that the intense Fauve palette developed only as each Fauve made a gradual and painstaking progression from a pseudo-Impressionism. Friesz essentially led the trio of distant cousins into the Fauve orbit; Braque led them out. Their association with the Fauves, coupled with their deep-seated belief in Norman—and by extension, northern—values and their attitudes toward subjects to paint, transformed their careers.

★

PLATE 254
Raoul Dufy
La Tuilerie Saint-Henri
(*The Saint-Henri Tileworks*),
1908
Also known as *L'Usine*
(*The Factory*)
Oil on canvas
12 5/8 x 15 3/4 in. (32 x 40 cm)
Musée Cantini, Marseille

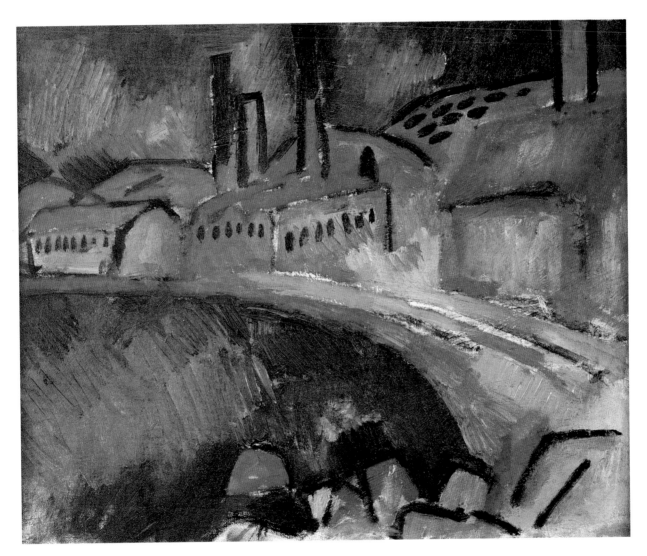

PLATE 254

All translations are by the authors.

1. *L'Illustration*, November 4, 1905, pp. 294–95.

2. Braque, in fact, was born in Argenteuil, a suburb of Paris along the Seine, which was one of Claude Monet's preferred sites to paint; he moved to Le Havre when he was six years old. Derain was born in Chatou; Manguin was born and raised in Paris; Matisse's hometown was Le Cateau-Cambrésis, in the Nord; Valtat was from Dieppe; Vlaminck was born in Paris but was raised in Le Vésinet and Chatou. The Fauves were not, however, without their southern adherents: Camoin was from Marseille; Marquet was from Bordeaux; Puy was from Roanne.

3. See Fernand Braudel, *The Identity of France*, trans. Siân Reynolds (New York: Harper and Row, 1988), vol. 1, *History and Environment*, pp. 250–51 and passim. In the 1920s artists and their patrons—Fernand Léger, Paul Dermée, and Katherine Dreier—began to articulate issues of an *esprit nordique* versus an *esprit méditerrané*, and there are ethnocentric, even fascist, overtones evident in these discussions. For a brief discussion of this issue see Judi Freeman, "L'Evénement d'objectivité plastique: Léger's Shift from the Mechanical to the Figurative, 1926–1933," in London, Whitechapel Art Gallery, *Fernand Léger: The Later Years*, exh. cat., 1987, p. 30.

4. The best sources on the Fauves Havrais are Youngna Kim, "The Early Works of Georges Braque, Raoul Dufy, and Othon Friesz: The Le Havre Group of Fauvist Painters" (Ph.D. diss., Ohio State University, 1980); Alvin Martin, "Georges Braque: Stylistic Formation and Transition, 1900–1909" (Ph.D. diss., Harvard University, 1980); and Dora Perez-Tibi, *Dufy* (Paris: Flammarion, 1989). A recent valuable addition to this is Judith Cousins's very detailed chronology for the years 1905–14 in New York, Museum of Modern Art, *Picasso and Braque: Pioneering Cubism*, exh. cat., 1989, especially pp. 340–59.

5. Perez-Tibi, *Dufy*, pp. 12–14. Dufy worked as an accountant for a Swiss firm, Compagnie Luthy et Hauser, that imported coffee from Brazil.

6. Bernard Esdras-Gosse, "De Raoul Dufy à Jean Dubuffet: Ou la descendance du 'Père Lhuillier,'" *Etudes Normandes* 59 [c. 1955]: 33; Maximilian Gauthier, *Othon Friesz* (Geneva: Editions Pierre Cailler, 1957), pp. 7–27.

7. This may be Félix Courché, an obscure figure and landscape painter born in Paris in 1863, who was a student of Léon Bonnat at the Ecole des Beaux-Arts in Paris.

8. Gauthier, *Friesz*, pp. 12–30.

9. Perez-Tibi, *Dufy*, pp. 18–19. To Friesz, Dufy wrote, "You are the only friend toward whom I feel these types of emotions." ("Tu es le seul ami envers qui j'éprouve ces sortes d'émotion.") Perez-Tibi, *Dufy*, p. 310 n. 15.

10. On this subject see, for example, Georges Duthuit, *The Fauvist Painters* (New York: Wittenborn, Schulz, 1950), pp. 51–53.

11. As Robert Herbert so aptly characterizes it, "[For Monet] to paint the Norman coastline was to return to the landscape of his youth, to construct images that could accommodate his memory, his well-tutored awareness of the constantly shifting, moist skies, of the winds that swept across the harbors, the beaches, and the chalk cliffs." Robert L. Herbert, *Impressionism: Art, Leisure, and Parisian Society* (New Haven, Conn., and London: Yale University Press, 1988), p. 284.

12. Gauthier, *Friesz*, pp. 49–53.

13. For many years Braque's Fauve work was virtually unknown, and no catalogue raisonné for the period exists. Indeed, the current catalogue raisonné for Braque begins in 1907. According to Nicole Worms de Romilly, Braque was dismissive of his Fauve work and generally did not want it to be shown in retrospectives of his work; Nicole Worms de Romilly, interview with Judi Freeman, Paris, November 17, 1989. Mme Worms de Romilly and Mme Claude Laurens have each compiled extensive documentation related to the paintings of this period.

14. For further discussion of Braque's transition from Fauve to Cubist work, see William Rubin, "Cézannisme and the Beginnings of Cubism," *Cézanne: The Late Work*, exh. cat. (New York: Museum of Modern Art, 1977), pp. 151–202; Martin, "Braque: Stylistic Formation and Transition," passim; Alvin Martin, "The Moment of Change: A Braque Landscape in the Minneapolis Institute of Arts," *Minneapolis Institute of Arts Bulletin* 65 (1981–82): 83–93; Museum of Modern Art, *Picasso and Braque*, pp. 340–58.

15. Paris, Musée Picasso, *Les Demoiselles d'Avignon*, exh. cat., 1988, p. 558, and Museum of Modern Art, *Picasso and Braque*, pp. 348–49.

16. "[La grand composition] de M. Georges Braque me paraît être l'effort le plus nouveau de ce Salon. Certes, le chemin parcouru par l'artist [depuis *Le Vallon* plein de tendresse jusqu'à sa nouvelle composition] est considérable. . . . On doit reconnaître que M. Braque a réalisé sans une défaillance sa volonté de construire." Guillaume Apollinaire, "Le Salon des Indépendants," *La Revue des lettres et des arts*, May 1, 1908; in Guillaume Apollinaire, *Chroniques d'art, 1902–1918*, ed. Leroy C. Breunig (Paris: Gallimard, 1960), p. 65.

PLATE 255
Georges Braque
Paysage à La Ciotat
(*Landscape at La Ciotat*),
summer 1907
Oil on canvas
21 ¼ x 25 ¾ in. (54 x 65.4 cm)
Nippon Autopolis Co., Ltd.

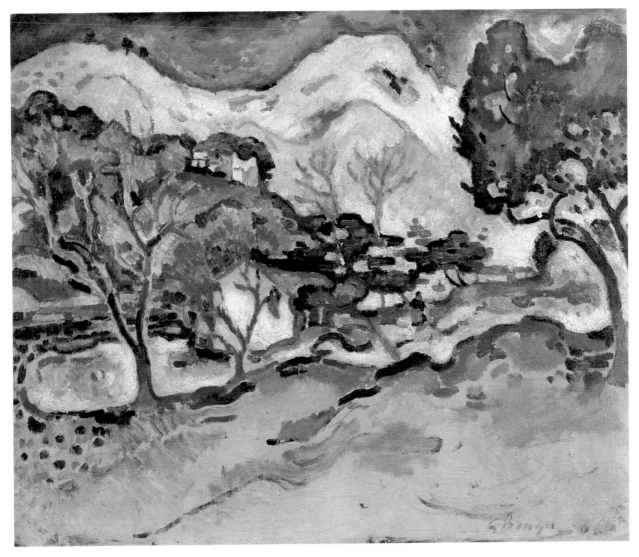

PLATE 255

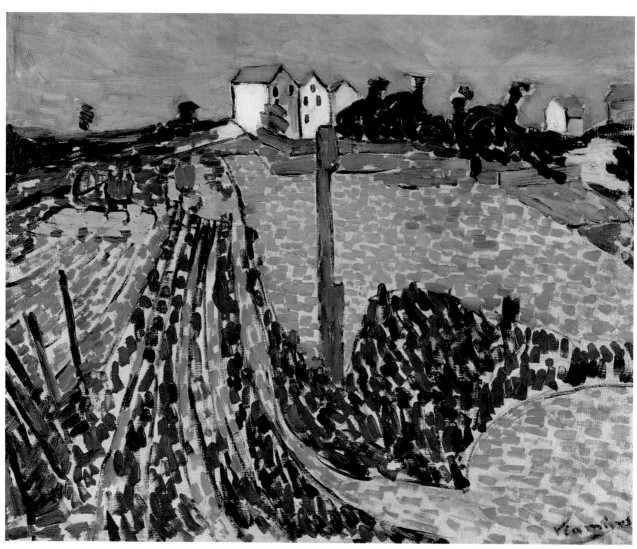

PLATE 256

Fauves in the Landscape of Criticism

metaphor and scandal at the salon

ROGER BENJAMIN

His submission (and, what's more, he knows it) will have the fate of a Christian virgin cast before the wild beasts [fauves] *of the Circus.*—Louis Vauxcelles on Matisse at the 1905 Salon d'Automne

Throughout the twentieth century ideas about Fauve art have been affected by the image of artists as wild beasts, an image that confirms our romanticized view of a combative avant-garde. Understanding the term *Fauve* demands a recitation of the story in which the critic Louis Vauxcelles, in a moment of metaphorical enterprise, so christened a group of artists exhibiting at the Salon d'Automne of 1905.[1] In the little-known version of his simile quoted above, Vauxcelles likened the exhibition to a Roman circus, and the artist to the hapless victim in the stadium. The public, in its seeming incomprehension, played the wild beast in the arena of art.[2] Vauxcelles's image portrays the Salon, where easel paintings were viewed and bought, where status and allegiance were decided, as a theater in which the French bourgeois public played out its crises about conformity. In this theater it was the role of the avant-garde artist to challenge whatever had become conventional in art—including his or her own earlier work. From Vauxcelles we learn that the artist Matisse anticipated brutal rejection as the result of revising his earlier, more accepted style.[3] So the critic's role was to be the chorus in the Salon drama, commenting, narrating, and thus recording the key ideas generated in the debates about art.

The writing of art critics is a conventionalized discourse, in which various figures of speech are used to articulate the critics' responses to the works on display.[4] The "wild beast" of Vauxcelles is one such figure, or trope. In analyzing the scandal that Fauvism caused at the Salons, I have paid particular attention to the tropes that helped situate the new art in aesthetic discourse.[5] To compile an iconography of the motifs of scandal, to decode the catalog of insults is to begin determining what values within French culture the aesthetic sphere articulated.[6]

Art criticism works within specific material constraints.[7] In Paris about 1905 there were two chief genres of criticism. The first comprised reviews for the numerous daily newspapers, both in short columns and in extended reports on the four annual Salons. The necessity of mentioning many dozens of artists to provide an effective opening-day guide to the exhibition left the newspaper critic little space for historical or theoretical analysis. Yet it was within the reviewing genre that a writer like Vauxcelles proposed the imagery (of Fauves and of Cubists) that popular parlance has endorsed. The second genre of criticism appeared

PLATE 256
Maurice de Vlaminck
*Route maraichère
(Road to the Garden Market)*,
1907
Oil on canvas
23 5/8 x 28 3/4 in. (60 x 73 cm)
Kunstmuseum, Winterthur,
Switzerland, Volkart Stiftung

[241]

in the monthly journals of art, literature, and current affairs. Here longer, more polemical articles investigated the state of contemporary art. Most of the theoretically challenging writings on Fauvism—by authors like Maurice Denis, Camille Mauclair, and Michel Puy—appeared in this second milieu.

In both kinds of writing the critics developed rhetorical strategies for handling the art of the Fauves, manipulating the various tropes in order to reject, to suspend judgment on, or finally to legitimate Fauve art. So one can reconstruct the critical career of Fauvism: the opposition to Matisse and his followers first appeared in the writings of Denis on the 1905 Salon des Indépendants, and it rapidly expanded, coming to include the notable conservatives Mauclair and Joséphin Péladan. The defense of Fauve art, begun by the equivocal, left-leaning Vauxcelles, was not bolstered until the wholehearted endorsements by the avant-gardists Michel Puy and Guillaume Apollinaire in late 1907; it was continued in 1908 by the painter and critic George Desvallières and by Henri Matisse himself.

The reception of the Fauve landscape needs to be placed within this context. Landscape had become established as the most typical subject for easel painting in the mid-nineteenth century, and it remained the preponderant genre in the advanced Salons of the new century. As one commentator on the 1906 Salon des Indépendants put it: "Naturally it is through landscape that the majority of artists struggle to fix their impressions. The landscape, that model which is immediately available to us with every step we take, and which permits us to extract the poetry of things much more readily than any other subject, is found here transposed across a thousand different temperaments."[8] Landscape was important as the field of experimentation in which the great "temperaments" of the previous generation—Claude Monet, Vincent van Gogh, Paul Cézanne—were made manifest to the avant-garde after 1900. Furthermore, landscape was the repository of ideas that the French had about their country and its various regions, of sentiments about the relationship of humankind to nature. The aura of the natural seemed to protect the Fauve landscape from the more extreme public judgments passed on other types of Fauve painting. I would argue that about 1905 the fiercest battles of the avant-garde and the public were fought less over landscape than figure painting (traditionally the more prestigious of the two genres): the distortions of line and color characteristic of Fauve painting were most disturbingly apparent in the representation of the human form.[9] And in the Fauves' hybrid Cézannesque subjects of the nude in the landscape (plates 175–76, 260, 269), the style and conception of the figures proved more accessible to commentary than the landscape.

French critics in the first decade of the twentieth century wrote less on the thematic or literary element in paintings than on the style and allegiances of the artists who produced them. The importance of the subject in advanced painting was diminishing: the subject came to be seen as merely the frame over which the cloak of the artist's distinctive style or personality would be drawn. The concept of the "decorative landscape" (*paysage décoratif*) that painters and theorists often associated with Fauve art developed against this background. Such a landscape was abstracted from its site in order to speak to self-contained considerations of a formal order as much as to the specificity of the geographical locale. Nevertheless, even the decorative landscape was tied to feelings about the beneficent spectacle of nature, and considering it was often a welcome relief for critics

exasperated by Fauve figure painting.

Rubrics like "the Fauves" were devised to differentiate elements within the morass of paintings at each of the four annual Salons, where up to five thousand works might be shown. The need for such distinctions was fundamental to the operation of the art market and, indeed, the entire cultural field.[10] The usual basis for differentiation was by author: a group of works was discussed in terms of the singular personality who had produced it and whose "style" set it off from the other works on display. However, before a young artist could accede to style in this sense, he or she was usually defined within a system of patrilineal affiliations, as the student or follower of an older painter (so the guild mentality survived into the twentieth century).

This is the way the future Fauves were first isolated on the cultural horizon. Charles Camoin, Henri Manguin, Albert Marquet, and Matisse, all four of whom had studied with the controversial Gustave Moreau at the Ecole des Beaux-Arts in the 1890s, were grouped by the press as "students of Gustave Moreau" right up to the Salon d'Automne of 1905.[11] Yet from 1904 on the critics increasingly recognized Matisse as the leader of the clique, and his name replaced Moreau's as an organizing principle. Within two years the critics were defining numerous other artists in terms of their affiliation to Matisse: his name, as much as the Fauve rubric, was used to delimit a stylistic field.

This system was not without its contradictions. Since the Impressionist exhibitions of the 1870s had broken the monopoly of the official Salon, the "group" had become established in the public eye as a viable unit of avant-garde research. The "students of Gustave Moreau" clearly recognized this, but they did not seek a group identity to the extent of surrendering their stylistic differences for a common aesthetic stance (as the Pointillists had done). The difficulty this created for critics is evident in Roger Marx's catalog preface for a group show in April 1904 at the Galerie Berthe Weill, in which he attempted to define the ground shared by the group: "The quality of their light, the richness of tone, the savorous working of the material, the virile straightforwardness of their technique constitute the virtues common to works whose subject and execution differ... according to the variety of the artists' temperaments."[12]

In 1904 the painters began to achieve significant critical profiles as individuals. Matisse was the first of them to be accorded a solo exhibition, by Cézanne's dealer, Ambroise Vollard. Charles Saunier's comment typifies the respect that leading critics professed for Matisse's technical prowess: "Among the artists of the extreme avant-garde, M. Henri Matisse is distinguished by a solid métier and a steadiness of eye which insure that his boldest choice of tones is always turned to good effect."[13] The simplified perspectival landscapes by Marquet won him praise as "a highly gifted artist in full possession of his talents," while Camoin was considered "a beautiful landscapist... whose souvenirs of Naples and the corners of Paris are bound to be appreciated."[14] These three and Manguin exhibited in the same room at the 1904 Salon d'Automne, from which the state purchased Camoin's *Le Vésuve* (*Vesuvius*, plate 257), Marquet's *Arbres à Billancourt* (*Trees at Billancourt*, plate 259), and Matisse's *Nature morte* (*Still Life*, Musée Fabre, Montpellier, France). This adventurous patronage of the group continued the following spring with the purchase of three more landscapes: Matisse's *Vue de Saint-Tropez* (*View*

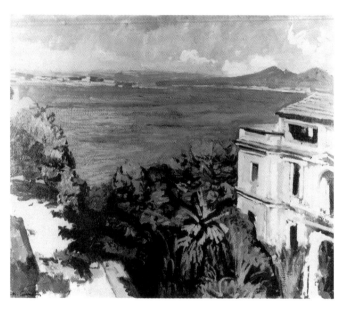

PLATE 257

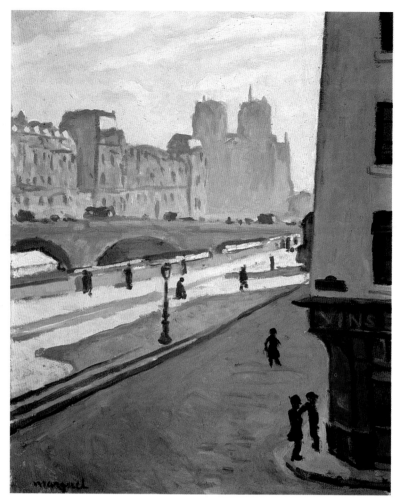

PLATE 258

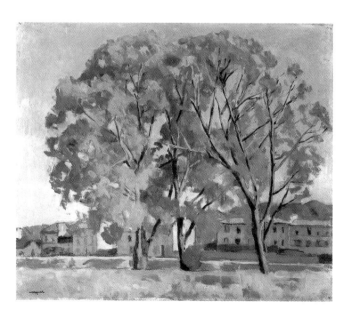

PLATE 259

PLATE 260

of Saint-Tropez, plate 160), Marquet's *Notre Dame (Soleil)* (*Notre Dame* [*Sun*], plate 258), and Camoin's *Coin du port, Martigues* (*Corner of the Port, Martigues*, location unknown).[15]

Groups of artists competing for a place in the public eye usually sought specific institutional domains: academic artists were identified with the Société des Artistes Français (at which they exhibited), and middle-of-the-road painters influenced by Impressionism were identified with the Société Nationale des Beaux-Arts. The juryless (and therefore somewhat anarchic) Salon des Indépendants was considered the fiefdom of Paul Signac and the Pointillists. The juried Salon d'Automne, founded in 1903, took some time to establish a distinctive critical profile: this became the privilege of Matisse's group in 1905. Michel Puy judged the importance of the Fauves to the new Salon thus: "Without them the Salon d'Automne would not have existed: it would have collapsed by itself. In it they represented life, curiosity, the new element that attracted the cultivated public."[16]

At the Salon des Indépendants of 1905 Matisse was already actively promoting the artists he would associate with his own developing aesthetic: he encouraged his young friends André Derain and Maurice de Vlaminck to have their first exhibitions there. However, the members of Matisse's group (including his friends from Moreau's studio) were scattered throughout the Salon: Matisse's own landscapes of Saint-Tropez (plates 160, 163) were displayed in a room with the Pointillist works of Charles Angrand and Henri-Edmond Cross.[17] On the basis of his ambitious *Luxe, calme, et volupté* (plates 175, 260), the critics abruptly labeled Matisse a convert to the Pointillism that dominated the Salon. In the *Mercure de France*, Charles Morice commenced an attack on the "Pointillists and Confettiists" by bitterly remarking that they were "receiving new adherents, some of whom count, like M. Henri Matisse."[18]

The widespread critical displeasure at Matisse's Neo-Impressionist exploit seems to have stemmed from the well-entrenched dislike of the style by critics with a Symbolist orientation. They were put off less by the anarchist politics of many Pointillist painters than by the positivist, scientistic basis of Neo-Impressionist theory, which was felt to result in monotonously uniform paintings. This was the view of the former Symbolist poet and theoretician Morice, of the younger Vauxcelles, and (with some qualifications) of the painter and essayist Denis. It was Matisse's Neo-Impressionism that provoked the first sustained critical discussion of his art in the intellectual journals.

As it became more controversial, Matisse's work was drawn into wider debates about cultural politics, like those activating the nationalist and Catholic review *L'Occident*, for which Denis wrote. This is the spirit that infused Denis's famous caution in response to Matisse's pictures at the 1905 Salon des Indépendants: "This first experiment . . . will alert him to the dangers of abstraction. *Luxe, calme et volupté* is the schema of a theory. It is through realism that he will best develop his very special gifts as a painter. He will rediscover in the French tradition the feeling for what is possible."[19] Here Denis opposed the "dangers" of abstraction to the study of nature and the French tradition, from which the inference that Matissean abstraction transgressed the boundaries of Frenchness was soon to be drawn. By calling Matisse's picture the "schema of a theory"—which is presumably even more incomplete than the much-criticized "sketches" of the Impressionists—Denis dismissed it as a theoretical construct rather than an organic, intuitive expression. This argument, initially developed for a Neo-Impressionist Matisse, became the basis of Denis's influential condemnations of the artist long after he had abandoned that particular style.

With the rhetorical consistency of the alert critic, Denis at the 1905 Salon d'Automne spoke of the celebrated room 7 as "fully within the domain of abstraction."[20] Accordingly, he found Matisse's work to be "painting outside of every contingency, painting in itself, the pure act of painting. All the qualities of the picture other than the contrast of lines and colors, everything not determined by the painter's reason, everything that comes from our instinct and from nature, finally all the qualities of representation and sensibility are excluded from the work of art. . . . Recourse to tradition is our best safeguard against the intoxications of reason, against an excess of theory."[21] In this and other passages, what Denis had devised for the condemnation of Matisse was the persona of the theoretician: one who can analyze, explicate, even speculate, but who is impotent in the task of spontaneous creation. His work, arrived at only by ratiocination, was calculated in its effect—from which it followed that Matisse's sincerity as an artist might be questioned. It was this argument, more than the authority of Denis's "neo-traditionalist" position, that secured the endorsement of the persona of the theoretician by critics of diverse persuasions (including Vauxcelles and Morice). It became the rhetorical figure preferred by art professionals and intellectuals (such as Denis's friend André Gide, who reviewed the same Salon for the *Gazette des beaux-arts*) who wished to condemn Matisse without resorting to the vulgar critical strategies of the popular press.[22]

In criticizing the schematic character of Matisse's work, Denis isolated a factor that disturbed many critics both in Fauve painting and in art generally at the

Salon d'Automne. There were elements inherent to the organization of the Salon d'Automne that encouraged the exhibition of paintings with the look and the subject matter of what came to be called Fauvism. The autumn Salon had been planned in 1902 to fill the void in Parisian cultural consumption that followed the annual return of the bourgeoisie from summer holidays spent in the country or on the coast. Such a salon was both a social occasion and a spectacle for a public hungry for new sensations (plate 261). A certain type of painting was dictated by this autumnal rhythm: not the large-scale picture, or *tableau*, that traditionally was worked up over the winter months in preparation for the three spring Salons, but a smaller work, made before the motif during the summer, impregnated with sunshine and painted as a study, or *étude*.[23] Landscape was the principal constituent of such works. Informed critics were quick to isolate the characteristics of what one called "Salon d'Automne painting," whether to lament the loss of technical skills and the ethic of conscientious work in a kind of "antivirtuosity," or to praise the intimacy of the spontaneous result, with its flavor of experimentation.[24]

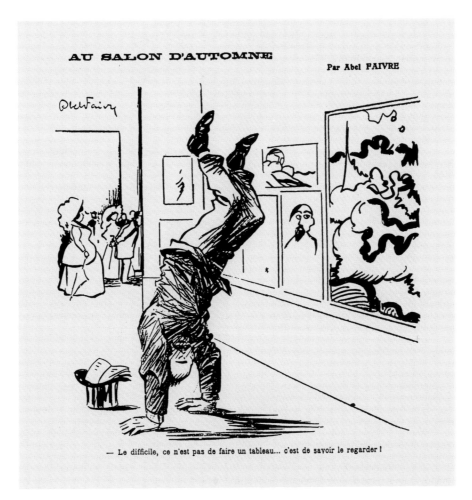

AU SALON D'AUTOMNE

Par Abel FAIVRE

— Le difficile, ce n'est pas de faire un tableau… c'est de savoir le regarder !

PLATE 261

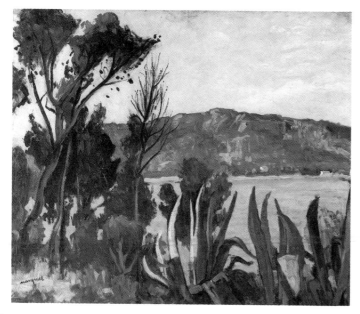

PLATE 262

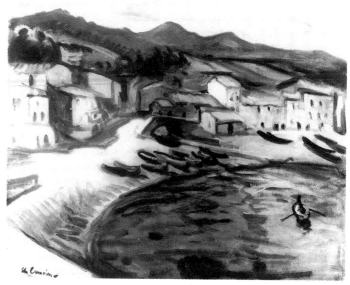

PLATE 263

PLATE 262
Albert Marquet
Vue d'Agay
(*View of Agay*), 1905
Oil on canvas
25 ⅝ x 31 ½ in. (65 x 80 cm)
Musée National d'Art
Moderne, Centre Georges
Pompidou, Paris

Exhibited at the Salon
d'Automne, 1905

PLATE 263
Charles Camoin
Village au bord de la mer
(*Village on the Edge of the
Water*), 1905
Oil on canvas
21 ¼ x 25 ⁹/₁₆ in. (54 x 65 cm)
Musée du Petit Palais, Geneva

Probably exhibited at the
Salon d'Automne, 1905

PLATE 264
Henri Manguin
La Sieste (*Le Rocking-Chair,
Jeanne*)
(*The Rest* [*The Rocking Chair,
Jeanne*]), 1905
Oil on canvas
35 ¹/₁₆ x 46 ¹/₁₆ in. (89 x 117 cm)
Private collection,
Winterthur, Switzerland

Exhibited at the Salon
d'Automne, 1905

The play between dislike of what was perceived as excessive informality and the positive response to the summer landscape subjects conditioned how the Fauve works were received at the 1905 Salon d'Automne. Both the Salon jury and a small number of critics were genuinely enthusiastic about landscapes from the south of France by Marquet and his colleagues.[25] Vauxcelles in his famous review in fact devoted far more space to the trio of Camoin, Manguin, and Marquet (plates 262–64) than to that of Derain, Matisse, and Vlaminck (plates 265–67). His consciousness of the Midi as an idyllic, trouble-free site, in contrast to the northern mists of Paris and its environs, is evident when he likens those painters who had gathered at Saint-Tropez to "a flock of migratory birds...a valiant little colony of artists painting and conversing in this enchanted land: Signac, Cross, Manguin, Camoin, and Marquet."[26] Vauxcelles's approval of Marquet led to his employing a descriptive mode in discussing his work: the critic found pleasure in the artist's style, so there was no obstacle to his immersion in the subject, to his armchair traveler's delectation of that southern landscape whose features he detailed: "No one will reproach M. Marquet with repeating himself: his joyous series from Agay [plate 262], from Saint-Tropez, and from Anthéor, in no way recalls the desolate riverbanks one admired at the Salon des Indépendants. Here are the red rocks of Agay and Le Trayas, soaring up from the glaucous blue of the sea...the sailboats of Saint-Tropez, the pink houses. The facture is broad, rich, and original."[27]

PLATE 264

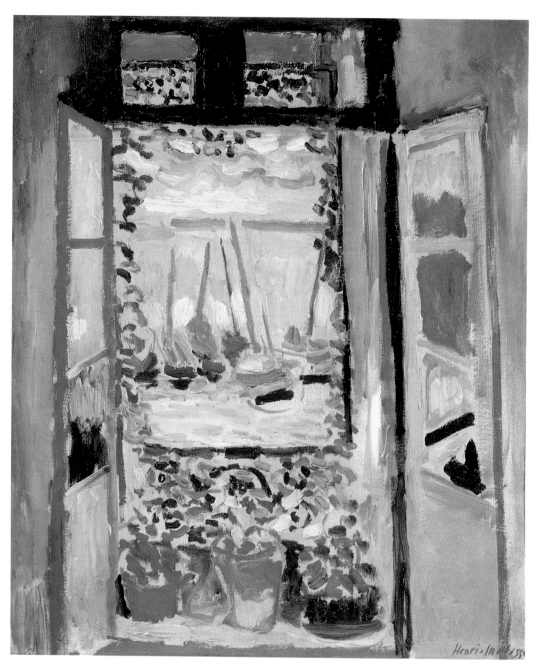

PLATE 265

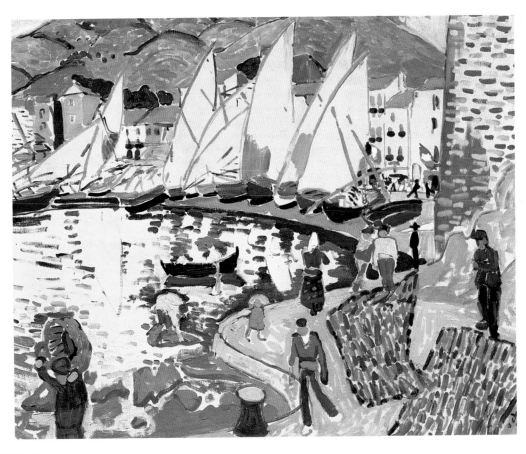

PLATE 266

PLATE 266
André Derain
Le Séchage des voiles
(*Drying the Sails*),
summer 1905
Oil on canvas
32 ⁵/₁₆ x 39 ¾ in. (82 x 101 cm)
State Pushkin Museum,
Moscow

Exhibited at the Salon
d'Automne, 1905

PLATE 267
Maurice de Vlaminck
Dans le jardin de mon père
(*In the Garden of My Father*),
1904–5
Oil on canvas
19 ¹¹/₁₆ x 25 ⁹/₁₆ in. (50 x 65 cm)
National Museum,
Belgrade, Yugoslavia

Exhibited at the Salon
d'Automne, 1905

PLATE 265
Henri Matisse
La Fenêtre
(*The Window*), 1905
Also known as *La Fenêtre
ouverte, Collioure* (*Open
Window, Collioure*)
Oil on canvas
21 ¾ x 18 ⅛ in. (55.2 x 46 cm)
Mrs. John Hay Whitney

Exhibited at the Salon d'Au-
tomne, 1905, and included in
Matisse's 1906 exhibition at
Galerie Druet, Paris

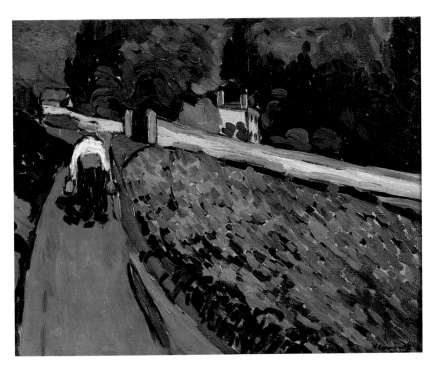

PLATE 267

In Vauxcelles's better-known comments on Derain, Matisse, and Vlaminck, however, the descriptive mode vanishes, and no mention is made of landscape as such. The problem of style has intervened, and the critic registered his anxiety about the response of the public before venturing his own cautiously tolerant estimates. Vauxcelles's review of Matisse apparently reflects the rough treatment that the artist had received at the hands of an unsympathetic Salon jury, where only the vote of sure friends had secured the acceptance of his works.[28] The gaze of the public was likely to be more hostile still: "M. Matisse . . . is a brave man, for his submission (and, what's more, he knows it) will have the fate of a Christian virgin cast before the wild beasts [*fauves*] of the Circus. M. Matisse is one of the most robustly gifted of today's painters—he could easily have won praises. Instead he prefers to plunge headlong into passionate research, to demand more vibration, more luminosity of Pointillism. But the concern for form suffers."[29] Side by side with the language of style comes Vauxcelles's first mention of *fauves*: they embody the fate that awaits a hapless Christian virgin. This image is less familiar in the history of art than the passage that closes the review of room 7: "In the center of the room, the torso of a child, and a little marble bust by Albert Marque. . . . The candor of these busts is surprising, amid the orgy of pure tones: Donatello among the wild beasts."[30] In this latter case it is the *painters* who are the wild beasts, but in the former, importantly, Matisse is the Christian virgin and the ravening beasts are none other than the public.

The source of this startling image, which so affected the art public of the day, was very likely a painting seen by Vauxcelles at the Salon des Artistes Français the previous April. Suzanne Bethemont's *Martyre* (*Martyr*, plate 268) pictures the condition of a Christian virgin who had been turned over to the wild beasts of the Roman Circus.[31] It was not a work sufficiently distinguished among the two thousand on display to have rated a mention in Vauxcelles's review, but he would certainly have seen it.[32] The work's anecdotal character was just the sort of thing the critic deplored about the Salon des Artistes Français. Its subject was construed by a hack writer of *Le Panorama: Salon 1905*:

PLATE 268

PLATE 268
Suzanne Bethemont
(France, dates unknown)
Martyre (*Martyr*), 1905
Oil on canvas
Dimensions unknown
Location unknown

Exhibited at the Salon des
Artistes Français, 1905

Here is the basement of the amphitheater and the barred ditches where ferocious animals are roaring. A well-paid gladiator's servant has agreed to allow a weeping woman . . . to enter the enclosure where the victims of the previous day lie: it is a mother searching for her daughter, a young Christian cast to the beasts on the recent holiday Caesar Imperator gave for the people. She sees the corpse of the child she loved so tenderly, this body of an adolescent virgin. . . . Her delicate flesh has been raked by the claws of the big cats [*grands fauves*].[33]

It is not surprising to find as the probable source for Vauxcelles's celebrated metaphor for wildness in art a slightly scabrous Salon melodrama suitable for reproduction in a popular album of painted nudes. Such were the resources of the hard-pressed newspaper critic who, with but a few hours to produce an enormous volume of copy, had previously reused both his own writings and those of his peers in constructing his Salon articles.[34] In this case the remembered heretical virgin's body provided a suitably dramatic metaphor for the fate of a dissenting artist at the hands of his public.

We must nevertheless ask what discourses are activated by this double-edged trope of the Fauve, in which the naming of a group of artists as wild animals quickly became the dominant usage: critics were soon speaking of the "cage of the wild beasts" (*cage des fauves*) at the Salon. Although issued as tongue-in-cheek hyperbole, Vauxcelles's terminology connotes a sexualized release of uncontrolled instinct into the urbane milieu of the art exhibition. In other words, he had named a social transgression, but one that was ritualized by 1905: the process of being outraged had become an almost expected part of the bourgeoisie's consumption of advanced art. The term *fauve* identified a twinned aggression in the ritual of the reception of new art: both exposing a captive public to the spectacle of "unintelligible" works and exposing experimenting artists to the howls of public outrage.

There were many alternatives to describing these artists as wild beasts, some of which utilized long-standing conventions for the discussion of new art. Symptomatic examples appeared in Vauxcelles's comments on Derain (plate 266) and Vlaminck (plate 267) at the Salon d'Automne: "M. Derain is going to frighten people, just as he frightens them at the Indépendants. I think he is more a poster designer than a painter. The petulant character of his virulent imagery, the facile juxtapositions of his complementaries will seem willfully puerile to some. Nevertheless, let us recognize that his *Boats* [also known as *Le Séchage des voiles* (*Drying the Sails*)] would happily decorate the walls of a child's room. M. Devlaminck [*sic*] makes naïve images: his painting, which has a fearsome air about it, is in fact very good-natured."[35] Puerility, naïveté, decorativeness—all ways of describing an inadequacy to the task of representation in conventional terms, ways of positioning the artist outside both the professional fraternity of painters (Derain is a poster designer) and correct society (he and Vlaminck would entertain children but frighten adults).

Many of the critical tropes used in the discussion of Fauve painting revolve around the mastery of language and work by analogy with the visual realm. The figure of the child is still learning to manipulate speech, not yet having mastered the knowledge that secures expression.[36] "Wild beasts," of course, have no coherent language; they utter inarticulate roars, threatening cries (as the critics were

pleased to point out). The same is true of the oft-employed figure of the savage, or the primitive man: the savage cannot use language to make sense to us. By extension, the savage cannot make art that performs the task of representing its model; it lacks the "science" of representation. As late as 1909 Vauxcelles could encapsulate all of these issues in commenting on Matisse: "From regression to regression, Matisse goes back to the art of the caverns, to the babble of the infant who with a pointed flint traces the silhouette of a reindeer's head onto the wall.... He schematizes, he synthesizes. And the Kanaka cubes of M. Braque are the direct result."[37]

If the critics agreed on the infantile or primitive character of Fauve art, they disagreed as to its motivation. The moral category of "sincerity" was constantly at play in the reception of Fauvism. The Fauves' supporters insisted on it: the ethic of work and the dignity of professionalism were used to claim the painters' unexampled productions for art. The other side of this ethic is present in the figure of the charlatan or the clown. The art historian Léon Rosenthal employed it to condemn Matisse's second solo exhibition at the Galerie Druet in spring 1906: "M. Henri-Matisse... is preoccupied with astonishing and disconcerting the public. He relies on the fear some people have of appearing to be behind the times if they fail to swoon before the most outrageous ventures. No doubt every innovator deserves respect... but only provided his sincerity is above suspicion. Here, whether conscious or not, there is sham acting."[38]

The charlatan represents the concept of bad faith: he masters language in order to deceive; he lives by manipulating the credulity of the public. The charlatan-artist offers the public trumped-up wares under the veil of sincere effort. Similarly, the clown turns the august realm of art into a sideshow, a diversion for the unwashed. Both figures were used effectively by Joséphin Péladan, the novelist and former impresario of Symbolist art, in his attacks on the Fauves. Péladan's imagery of the Salon as a sideshow of manners inadvertently implicated his own work: the publication of his articles became the occasion for merriment among the vanguard, and Matisse himself was moved to repudiate Péladan's charge of clowning in his "Notes of a Painter."[39]

These overblown but revealing elements of critical rhetoric should not cloud certain substantive issues that emerged in relation to Fauve landscape. In the Salon des Indépendants of 1906, at which Matisse's *Le Bonheur de vivre* (*The Joy of Life*, plates 176, 269) was the "question" of the Salon,[40] the matter of the decorative landscape was debated with new acuity. This category appears to have been a modernist addition to the traditional academic division between the historic landscape (*paysage historique*). with its figures in heroic action, and the rural landscape (*paysage champêtre*), with its more intimate country setting (early Impressionist landscape had developed from the latter). Critics had spoken of the decorative landscape for some time, and by 1900 they were distinguishing its "Expressionist" [*sic*] tendencies (plate 270) from the Impressionist landscapist's concern for direct observation.[41] In 1906 François Crucy wrote: "Among the 'Independents' who are plein-air painters one must distinguish those who demand of the spectacle of nature pretexts to realize decorative compositions from those who try to directly fix that spectacle or, more exactly, the impressions that the spectacle will cause them to experience."[42]

PLATE 269
Henri Matisse
Detail of *Le Bonheur de vivre*
(*The Joy of Life*), 1905–6
Oil on canvas
68 ½ x 93 ¾ in.
(174 x 238.1 cm)
The Barnes Foundation,
Merion, Pennsylvania

PLATE 269

PLATE 270
Francis Jourdain
(France, 1876–1958)
Le Cheminau
(*The Vagabond*), 1906
Oil on canvas
22 ⁷/₁₆ x 30 ⁵/₁₆ in. (57 x 77 cm)
Musée de Bagnols-sur-Cèze,
Bagnols-sur-Cèze, France

PLATE 270

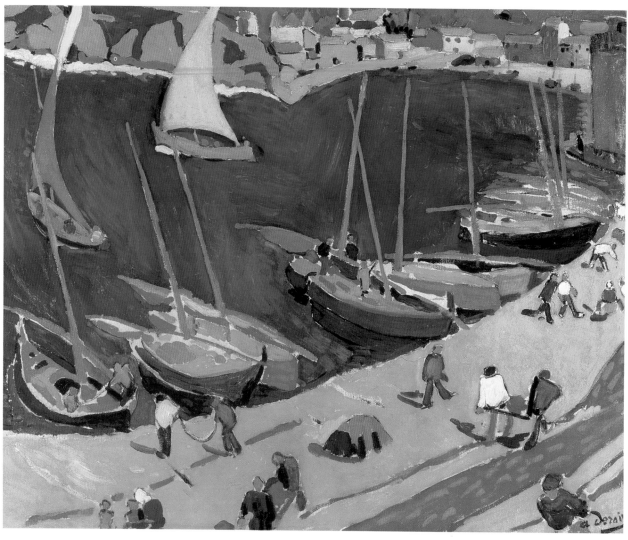

PLATE 271

The contemporary movement, in particular the wing aligned with the work of Cézanne, had come to reject key elements of the Impressionist aesthetic. The Fauves expressed dissatisfaction with attempting to fix the transient aspect of nature in a picture, seeking instead a synthesis of nature in its more permanent forms.[43] The abstracting, schematized landscapes that resulted stress the authority of the artist over the model in nature; this willful disposition of formal elements in the act of composing was considered to constitute a "decorative" procedure in painting.

For conservative critics the decorative landscape was compromised by a distressing lack of definition, by arbitrariness and exaggeration. So Etienne Charles in reviewing the 1906 Salon des Indépendants rebuked Derain for his "*Port de pêche, Collioure* [*Fishing Port, Collioure*, plate 271], in which it is difficult to discern a form"—the result of an "excessive taste for synthesis, which leads the artist to content himself with simple notations."[44] For critics like Vauxcelles, on the other hand: "Our young landscapists see truthfully 'because they see decoratively.' The site is for them a pretext, a décor in which the figures should be enclosed by arabesques. They all seem to be preoccupied with balancing volumes and masses. And this pursuit of the decorative is apparent even among those whose errors are most disconcerting."[45] Vauxcelles alludes here to the kind of use Matisse made of the landscape in his *Le Bonheur de vivre* (plates 176, 269), that utopian, decorative reworking of the historical landscape that mingles figures and observed site in an overall arabesque. Charles Morice, sensitive to Matisse's efforts to achieve a decorative harmony in this picture, nevertheless considered it a grandiose failure: "The canvas seems empty and it gives the general impression of the most irritating frigidity."[46] Vauxcelles partly attributed the problems he himself saw in *Le Bonheur de vivre* to the "perilous" influence of Derain, an artist whom "form leaves almost completely indifferent. He dreams of 'pure decoration.' . . . He plunges into the abstract and turns his back on nature."[47] Yet it was not in landscapes that Derain's abstraction troubled Vauxcelles: the following year, recoiling before the "Cézannesque mottling" of Derain's *Baigneuses* (*Bathers*, plate 27), the critic wrote: "I console myself in front of the little landscapes and the fluid marines, full of air and light, very bold, but not at all garish."[48]

The Fauves' baptism by fire was largely completed by the close of the 1906 Salon des Indépendants. From that time on, their presence was an acknowledged drawing card at the two advanced Salons (plate 272) even if it continued to generate copious negative criticism. Criticism is one good indicator of the reception given to Fauve art; the sale of paintings is quite another. The dyspepsia of the critics seemed to help generate a vigorous appetite in the patrons of contemporary art. From 1906 on, the major Fauve artists secured contracts with the dealers Ambroise Vollard, Eugène Druet, Daniel-Henry Kahnweiler, and the Bernheim brothers.[49] This guaranteed them a decent livelihood, and in the case of Matisse (the last to sign a contract, with Bernheim-Jeune in 1909), the income he derived from sales to private patrons rapidly became very considerable.[50]

The success of such artists in the art market generated two kinds of cynical commentary from the critics. The first was a debate about the role of dealers as behind-the-scenes manipulators of the Salons for the promotion of their stables of artists.[51] The second concerned the private patrons of Fauve art. The Steins

PLATE 271
André Derain
Port de pêche, Collioure
(*Fishing Port, Collioure*),
summer 1905
Oil on canvas
32 1/16 x 39 3/8 in. (81.5 x 100 cm)
Private collection, Switzerland

Exhibited at the Salon
d'Automne, 1905

LES NOUVEAUTÉS DE LA SAISON

Par ABEL FAIVRE

— Oh, je fais de la peinture pour m'amuser.
— Mais... ça nous amuse aussi.

PLATE 272

and Marcel Sembats, the Sergei Shchukins and Ivan Morosovs—who today are lauded as perceptive and dedicated underwriters of the avant-garde—were in their own time the butt of xenophobic and racist remarks.[52] The extreme view was that the patrons of Fauve art were either foreigners (the Russians Shchukin and Morosov, or German curators like Karl-Ernst Osthaus), political radicals (Sembat, the socialist deputy for Montmartre), or Jews (the Stein family).[53] Given such controversy, it is not surprising that the state now shunned the more radical Fauves. Significantly, however, works by the moderates Jean Puy and Marquet were purchased from the 1906 Salon d'Automne: *Paysage noble* (*Noble Landscape*, plate 273) and *Le Port de Fécamp* (*The Port of Fécamp*, plate 274) confirm that a gentler Fauve version of the French countryside could still find favor with official figures like Roger Marx (who was on the state selection committee).

Although the Fauves still remained well beyond the ken of the bourgeois French collector, their success within a more specialized sector of the art market suggests that the process by which society neutralizes the cultural irritant of avant-garde art had been set in motion. Such institutionalization takes place on a variety of fronts, usually beginning within the professional community of artists themselves. Critics of the day provided lists of the ever-increasing number of adherents to the newly identified "style" of the Fauves: Othon Friesz, Pierre Girieud (plate 275), Raoul Dufy, Georges Braque, Béla Czobel (plate 276), Jean Metzinger (plate 277), Robert Bérény, and so on. Non-French names among the new Fauves fueled the arguments of those who claimed that the abstraction and distortion of Matisse and his followers lay outside the French tradition in art (arguments that were similarly applied to Cubist painting in the next decade). So in 1907 a critic called for Fauve artists to be classified as "foreigners" because they

PLATE 273

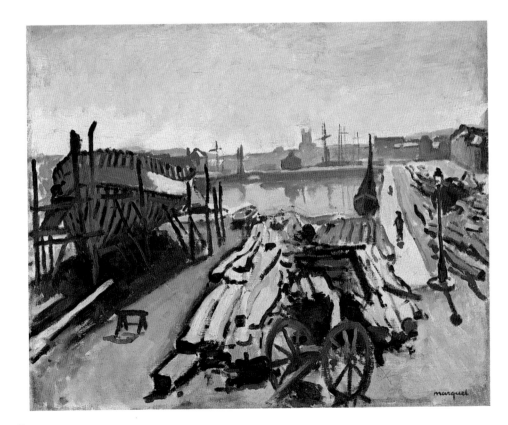

PLATE 274

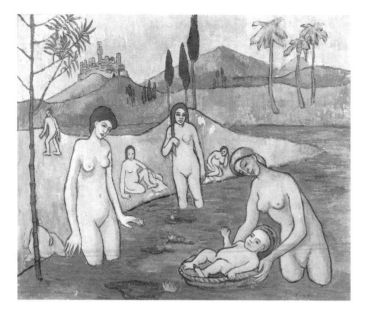

Plate 275

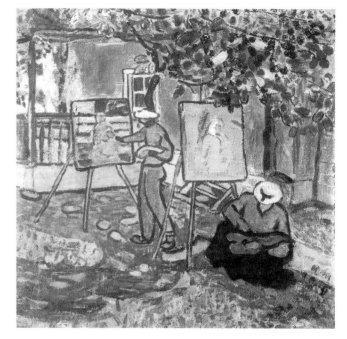

Plate 276

Plate 277

were "incoherents in revolt against the Latin soul," with its supposed attributes of order and clarity.[54]

The foundation of Matisse's studio school in late 1907 at the behest of admiring young artists was another signal moment in the radical movement's institutional-ization. But the Fauves' struggle for dominance within their own professional milieu was by no means won. There are tantalizing glimpses of the ructions that went on behind closed doors in the juries of the Salons d'Automne. Matisse's letters to colleagues in 1905 and 1906 indicate how actively he was counting votes in the jury,[55] and the ongoing conflict is evident in several accounts published during the autumn of 1907. Charles Malpel, the acute Toulousian critic, claimed that the 1907 hanging committee had deliberately intermixed paintings by the various Fauves, to their disadvantage. He also denounced the "brutality" of the "incompetent jury" that had rejected all of Kees van Dongen's works and re-stricted the displays of Braque, Derain, Dufy, and Metzinger.[56] Apollinaire in his own burlesque (but apparently well-founded) review corroborated this, indicting Frantz Jourdain (founding president of the Salon) for various irregularities in the face of opposition from the vice president George Desvallières.[57] He claimed that Jourdain was acting to appease the financial backer of the Salon, the tapestry manufacturer M. Jansen, who was opposed to the art of the Fauves.[58]

In the Société du Salon d'Automne's power struggle the Fauves were thus pitted against patrons and office-holding artists whose tastes did not extend beyond Impressionism (the tenets of which Matisse's generation wished to revise fundamentally).[59] Yet the Fauves by no means lost the battles of 1907. Georges Lopisgich, one of the founders of the Salon and its secretary general since 1903, resigned his position in 1907 to protest the artists' "preponderant influence" on what he called the "Salon des Fauves." At its outset, he recalled, the Salon d'Automne was to have welcomed all schools:

> However, little by little it has become the Salon of one school, if the word *school* is appropriate in speaking of artists hostile to all mental discipline, artists strangely drunk with color.... In the committee, we have seen a considerable party which on principle wanted to place the Fauves before all others.... Under their influence, the rules have been bent in favor of certain people. An irregularity having been committed in the reception of incoming works, I felt obliged to protest; but my claims were not recog-nized: the Fauves won out. I offered my resignation.[60]

The organizing committee for the 1908 Salon d'Automne does seem to have been particularly partisan toward Matisse, permitting him an inordinately large exhibi-tion of works that amounted to a mini-retrospective. The reviews of this display were filled with more praise than any since Matisse's 1904 Vollard exhibition. Such a welcome by the critics reflected not only a gradual familiarization with the extremities of Matisse's painting but perhaps also the success of a recent campaign in the press in favor of the Fauves.

Critical writings that attempted to legitimate Fauve art had been surprisingly slow to appear.[61] Although Vauxcelles and Morice were important in acquainting the public with Fauve work after 1905, they remained equivocal in their judg-ments of it. The first article to present a wholeheartedly favorable view of the movement was Michel Puy's "Les Fauves,"[62] published in late 1907 in the neo-Symbolist journal *La Phalange*. Puy was the brother of the Fauve painter Jean Puy

and thus wrote from a position of informed sympathy with the group; indeed, he explicitly intended to answer the "unjust" criticism of distinguished writers like Mauclair and Péladan.

In effect, Puy's article is the first history of the Fauves: it recounts the stages in their developing aesthetic, beginning by relating their work to that of Cézanne and Gauguin. This strategy of exegesis legitimated Fauve painting by giving it a pedigree of artists whose mastery was increasingly accepted. But Puy went beyond this, stating the ways in which Matisse, and to a lesser extent Derain, pushed past these masters in the innovative use of color and decorative form.

Just as Denis's early critique of Matisse had become vulgarized by the broad wing of writers opposed to the Fauves, so Puy's view of the Fauves' importance was echoed in subsequent writings. Its influence is apparent in the well-known "Wild Men of Paris," written by the American Gelett Burgess.[63] *La Phalange* itself went on to publish Apollinaire's interview with Matisse, which seems to have been designed to counter the public conception of Matisse's work as that of an unruly revolutionary. The poet stressed instead the painter's learning and his knowledge of traditional art, both Western and non-Western. He admired Matisse's long-standing scrutiny of his own work as symptomatic of the artist's "methodical mind": "We are not in the presence of some extremist venture; the distinctive feature of Matisse's art is its reasonableness."[64] In sum, Apollinaire

Au Salon d'automne

— Alors, il n'y a plus de « Salle des Fauves »?
— Non, monsieur le ministre... Nous les avons lâchés un peu partout, pour obliger le public à voir aussi ce qu'il y a de bien..

PLATE 278
Albert Guillaume
(France, 1873–1942)
Au Salon d'Automne
(*At the Salon d'Automne*)
Ink drawing
Published in *Le Figaro*,
October 10, 1908

[Dujardin-Beaumetz, Minister of Public Instruction]:
"Then there is no longer a 'Room of the Wild Beasts'?"

[Frantz Jourdain, President of the Salon d'Automne]: "No, Minister... We've let them disperse, to make the public look at the good things we have as well."

PLATE 278

argued that the new in painting, as in poetry, would have a claim to validity if it were tied to an intellectual program of measured experimentation.

Not all the champions of Fauve art were young writers from the avant-garde. The painter Desvallières, whose campaigning on behalf of Matisse and his colleagues at the Salon d'Automne was continuous and effective, was an establishment figure in his forties. As the art editor of the prestigious monthly *La Grande Revue*, Desvallières not only penned articles that were supportive of the younger generation and painters like Matisse, but he also encouraged the publication of their own points of view. This is the context within which Matisse's well-known "Notes of a Painter" went to press in December 1908, with a sympathetic introduction by Desvallières.[65] The article sets out to justify Matisse's practice by a detailed and eloquent exposition of the painter's conception of his own art. It thus constituted Matisse's answer to his critics: the "theory" that Denis had accused him of favoring over intuition is revealed as a sophisticated proposal for an instinctual, expressionistic model of art; the jibes that Péladan had directed against the Fauves in 1906 and 1908 are answered by an equally calculated set of insults.

So the campaign for the Fauves in the landscape of criticism had come full circle. The importance of their work had been forcefully claimed by the younger critics, and their published theories had merits that even opponents like Mauclair had to acknowledge.[66] Yet a certain ambiguity pervaded the Fauves' standing within the art establishment. They were a force within the art market, but only a specialized and largely non-French segment of it. At the Salon d'Automne the Fauves were an undeniably powerful presence, but a hostile leadership had taken steps in 1908 to counteract that presence, as a contemporary cartoon shows: the artists were dispersed as individualities, rather than being grouped as a united front (plate 278).[67] This fragmenting of the group also reflects a collapse in the Fauves' consensus about style: the previous year had seen the effective dissolution of the Fauve avant-garde.[68] Alert critics noted this in late 1908, speaking of Friesz, Vlaminck, Matisse, and others as *"former* Fauves" whose style had quieted down.[69] Paradoxically, at the same time the progressive Salons were witness to the wholesale vulgarization of the earlier Fauve style, which was fast becoming what Mauclair called a "new cliché." On the one hand, the distinctiveness of Fauve painting had begun generating a mass of youthful imitators. On the other, that very distinctiveness seemed to invite opposition by an elite of avant-gardists, who felt the resources of Fauve art were limited. By late 1908 a new model for artistic emulation had begun to claim the allegiance of all the former Fauves except Matisse: the sober "Kanaka cubes" from which Braque and Pablo Picasso formulated the Cubist style.

★

I should particularly like to thank Maria Gough, Jim Herbert, and Chris McAuliffe for their comments on an earlier draft of this paper; the students in my 1988 honors seminar in the Department of Fine Arts at the University of Melbourne for their stimulating discussion; and the University of Melbourne itself for materially facilitating my research. All translations are my own.

Epigraph: "Son envoi—il le sait, de reste—aura le sort d'une vierge chrétienne livrée aux fauves du Cirque." Louis Vauxcelles, "Le Salon d'Automne," *Gil Blas*, October 7, 1905.

1. For earlier discussions of the criticism of Fauvism see Marcel Giry, "Le Salon d'Automne de 1905," *L'Information de l'histoire de l'art* 13 (January–February 1968): 16–25; Ellen C. Oppler, *Fauvism Reexamined* (Ph.D. diss., Columbia University, 1969; New York: Garland Publishing, 1976), pp. 21–28; Ian Dunlop, *The Shock of the New* (London: Weidenfeld and Nicolson, 1972), chap. 3; John Elderfield, *The "Wild Beasts": Fauvism and Its Affinities*, exh. cat. (New York: Museum of Modern Art, 1976), pp. 13, 43–44; and Jean-Claude Lebensztejn, "Ground: 1" [1971], *Oxford Literary Review* 3 (1979): 38–44.

2. See Elderfield, *"Wild Beasts,"* p. 44. I discuss the more familiar version of the term's employment below.

3. On the reputation of the pre-Fauve Matisse see Catherine C. Bock, "A Question of Quality: A Note on Matisse's 'Dark Years,'" *Gazette des beaux-arts*, 6th per., 103 (April 1984): 169–74.

4. For a detailed account of the critical fortunes of Matisse, as well as discussions of the perspectives of major critics mentioned in this essay, see my *Matisse's "Notes of a Painter": Criticism, Theory, and Context, 1891–1908* (Ann Arbor, Mich.: UMI Research Press, 1987),

chaps. 3–5; numerous reviews first discussed there are now also available in Jack Flam, ed., *Matisse: A Retrospective* (New York: Hugh Lauter Levin Associates, 1988).

5. In this essay I use the term *discourse*, broadly following Michel Foucault, to indicate the sum total of ideas written and said about a particular topic, and beyond that, the interaction of people and things considered in relation to that topic. Thus an "aesthetic discourse" might include works of art and their treatment by institutions as well as things written and spoken about art or the beautiful. See Michel Foucault, "The Order of Discourse," in *Untying the Text*, ed. Robert Young (London: Routledge and Kegan Paul, 1981), pp. 51–77.

6. See the approach to this question formulated by T. J. Clark in *The Painting of Modern Life: Paris in the Art of Manet and His Followers* (London: Thames and Hudson, 1985), pp. 79–146.

7. I would like to acknowledge the ideas of Chris McAuliffe and Terry Smith in the following discussion of criticism; see Chris McAuliffe, "'Is "new-art" non-art?': Critical Responses to Conceptual Art in Australia," and Terry Smith, "Critical Possibility, Here and Now: The Practicalities of Art Writing Today," in *Practices of Criticism in Australia*, ed. Roger Benjamin, Papers of the Art Association of Australia (1986), vol. 1, pp. 1–12, 28–38.

8. "Naturellement c'est par le paysage que la plupart s'efforceront de fixer ces impressions. Le paysage, ce modèle immédiat dont à chaque pas nous disposons autour de nous, et qui nous permis de dégager la poésie des choses beaucoup plus aisément que tout autre objectif, nous le trouvons transposé à travers mille tempéraments bien divers." Alcanter de Brahm, "Le Salon des Indépendants," *La Critique* 12 (March 5–20, 1906): 23.

9. For an incisive discussion of the problematic relationship of color and line in Matisse's work, see Yve-Alain Bois, "Matisse and 'arche-drawing,'" in Bois, *Painting as Model* (Cambridge, Mass.: MIT Press, 1990).

10. See Pierre Bourdieu, *Distinction: A Social Critique of the Judgement of Taste* (London: Routledge and Kegan Paul, 1984).

11. This was largely the doing of Roger Marx, the Beaux-Arts administrator whose copious critical writing was followed closely by the younger critics; see Benjamin, *Matisse's "Notes of a Painter,"* pp. 49–65, 79–87.

12. "La qualité de la lumière, la richesse du ton, la trituration savoureuse de la matière, les mâles franchises de la pratique, constituent les vertus communes à des ouvrages dont le sujet et l'exécution se différencient... selon la variété des tempéraments." Roger Marx, "Préface," in Paris, Galerie Berthe Weill, *Exposition... par MM. Camoin, Manguin, Marquet, de Mathan, Matisse, Puy*, exh. cat., 1904, p. 2.

13. "Parmi les artistes d'extrême avant-garde, M. Henri Matisse se distingue par un métier solide et une sûreté d'oeil qui fait que ses plus audacieux échantillonnages de tonalités se présentent toujours en valeur." Charles Saunier, "Les Petites Expositions," *La Revue universelle* 4 (1904): 537; see also Flam, *Matisse: A Retrospective*, pp. 44–45, on this show.

14. "un artiste des mieux doués et en pleine possession de son art." Etienne Charles, "Les Indépendants," *La Liberté*, February 29, 1904. "un beau paysagiste... dont les souvenirs de Naples et les coins de Paris seront goûtés." François Thiébault-Sisson, "Le Salon d'Automne au Grand Palais," *Le Petit Temps*, October 14, 1904.

15. See Michel Hoog, "La Direction des Beaux-Arts et les fauves, 1903–05," *Art de France* 3 (1963): 363–66. The state also bought copies by the group in 1904; see my "Une Copie par Matisse du *Balthazar Castiglione* de Raphaël," *La Revue du Louvre et des Musées de France* 35 (October 1985): 275–77; and "Recovering Authors: The Modern Copy, Copy Exhibitions and Matisse," *Art History* 12 (June 1989): 176–201.

16. "Sans eux, le Salon d'Automne n'aurait pas existé: il serait tombé de lui-même. Ils y ont représenté la vie, la curiosité, l'élément nouveau qui attirait le public cultivé." Michel Puy, "Les Fauves," *La Phalange* 2 (November 15, 1907): 456.

17. The placement of artists according to groups was less a feature of the libertarian Salon des Indépendants than of the highly organized Salon d'Automne, where in 1904 Matisse's friend George Desvallières led the hanging committee.

18. "Il lui vient de nouvelles adhésions, certaines qui comptent, celle par exemple de M. Henri Matisse." Charles Morice, "Le XXIᵉ Salon des Indépendants," *Mercure de France* 54 (April 15, 1905): 542.

19. "Cette première expérience... l'avertira des dangers de l'abstraction. *Luxe, calme et volupté* est le schéma d'une théorie. C'est dans la réalité qu'il développera le mieux ses dons, très rares, de peintre. Il retrouvera, dans la tradition française, le sentiment du possible." Maurice Denis, "La Réaction nationaliste," *L'Ermitage*, May 15, 1905; in Maurice Denis, *Théories 1890–1910* (Paris: Rouart et Watelin, 1920), pp. 196–97.

20. "en plein dans le domaine de l'abstraction." Maurice Denis, "De Gauguin, de Whistler et de l'excès des théories," *L'Ermitage*, November 15, 1905; in Denis, *Théories*, p. 207.

21. "la peinture hors de toute contingence, la peinture en soi, l'acte pur de peindre. Toutes les qualités du tableau autres que celles du contraste des tons et des lignes, tout ce que la raison du peintre n'a pas déterminé, tout ce qui vient de notre instinct et de la nature, enfin toutes les qualités de représentation et de sensibilité sont exclues de l'oeuvre d'art.... Le recours à la tradition est notre meilleure sauvegarde contre les vertiges du raisonnement, contre l'excès des théories." Ibid., p. 208.

22. Some of the more resourceful examples of such reviewing were excited by the less-established Vlaminck: "Fénelon denied that by the chance mixing of letters one could obtain a verse of the Iliad. M. Vlaminck is not of that opinion. So it is that having prepared some little balls of color, he throws them against a canvas and calls the result *The House of My Father* [plate 267]. What is actually represented by these little red cobblestones? Where is the house? Mystery!" ("Fénelon niait qu'en mélangeant des lettres, au hasard, on puisse obtenir un vers de l'Iliade. M. Vlaminck n'est pas de cet avis. C'est ainsi qu'ayant préparé des petites boules de couleur, il les jette sur une toile et cela s'appelle: 'La Maison de mon père!' Que représentant, au juste, ces petits pavés rouges? Où est la maison? Mystère!") *La Correspondance Havas*, October 22, 1905; cited in Maurice de Vlaminck, *Portraits avant décès* (Paris: Flammarion, 1943), p. 80 (note that in some of the reviews reprinted here, Vlaminck altered the texts slightly and advanced the dates from 1906 to 1905).

23. See H. Ayraud-Degeorge, "Chronique: Le Salon d'Automne," *Le Rappel*, October 6, 1906: "Summer is the season of hard work for both plein-air and studio painters; it is the period of nature's full flourishing, it is the triumphal moment of brilliant light. One hopes that the artists will hurry back to the October Salon, bringing the vibrant and fresh impressions they have just experienced." ("L'été est la saison du grand travail pour les peintres de plein air aussi bien que pour les peintres d'atelier; c'est la période de plein épanouissement de la nature; c'est aussi le moment triomphal de l'éclatante lumière. On pourrait espérer que les artistes s'empresseraient d'apporter au Salon d'Octobre, toutes vives et toutes fraîches, les impressions qu'ils venaient de ressentir.")

24. Camille Mauclair mentioned the "antivirtuosity" of "Salon d'Automne painting" in his important critique of the informality of art at the 1905 Salon d'Automne, "La Crise de la laideur en peinture," in *Les Trois Crises de l'art actuel* (Paris: Fasquelle, 1906), p. 309. Roger Marx elucidated the distinctive small format and spontaneity of the paintings in his "Le Salon d'Automne," *La Chronique des arts*, November 2, 1903, p. 283.

25. See Benjamin, *Matisse's "Notes of a Painter,"* p. 106.

26. "une bande d'oiseaux migrateurs...une vaillante petite colonie de peintres peignant et devisant en ce pays enchanté: Signac, Cross, Manguin, Camoin, Marquet." Louis Vauxcelles, "Le Salon d'Automne," *Gil Blas*, October 17, 1905.

27. "Nul ne décochera à M. Marquet le reproche de se répéter: sa série joyeuse d'Agay, de Saint-Tropez, d'Anthéor, ne rapelle en rien les berges désolées qu'il fit admirer au Salon des Indépendants. Voici les rochers rouges d'Agay et du Trayas, pointant dans le bleu glauque de la mer...les voiliers du port de Saint-Tropez, les maisons roses. La facture est large, grasse, d'une coupe originale." Ibid.

28. Benjamin, *Matisse's "Notes of a Painter,"* p. 106.

29. "M. Matisse...a du courage, car son envoi—il le sait, de reste—aura le sort d'une vierge chrétienne livrée aux fauves du Cirque. M. Matisse est l'un des plus robustement doués des peintres d'aujourd'hui, il aurait pu obtenir de faciles bravos: il préfère s'enfoncer, errer en des recherches passionnées, demander au pointillisme plus de vibration, de luminosité. Mais le souci de la forme souffre." Vauxcelles, "Le Salon d'Automne," October 17, 1905.

30. "Au centre de la salle, un torse d'enfant, et un petit buste en marbre, d'Albert Marque.... La candeur de ces bustes surprend, au milieu de l'orgie de tons purs: Donatello chez les fauves." Ibid.

31. No. 162 in the catalog *Société des Artistes Français, Salon de 1905*. Mlle Suzanne Bethemont was listed as a student of the academician Jean-Paul Laurens; she had won a medal of honor in 1904.

32. Louis Vauxcelles, "Le Salon de la Société des Artistes Français," *Gil Blas*, April 29, 1905.

33. "Voici les soubassements de l'amphithéâtre et les fosses grillées où rugissent les animaux féroces. Un valet de bestiaire, bien payé, a consenti à laisser une femme en pleurs...pénétrer dans l'enceinte où sont étendues les victimes de la veille: c'est une mère qui cherche sa fille, une jeune chrétienne, livrée aux bêtes dans la récente fête que Caesar Imperator a donnée au peuple. Elle aperçoit le cadavre de l'enfant si tendrement aimée, ce corps de vierge adolescente!...Les chairs délicates ont étés labourées par les griffes des grands fauves." *Le Panorama: Salon 1905* (Paris: Jules Tallandier, 1905), n.p. (Many thanks to Chris McAuliffe for presenting me with this volume.)

34. See Benjamin, *Matisse's "Notes of a Painter,"* pp. 101–2.

35. "M. Derain effarouchera; il effarouche aux Indépendants. Je le crois plus affichiste que peintre. Le parti-pris de son imagerie virulente, la juxtaposition facile des complémentaires sembleront à certains d'un art volontiers puéril; reconnaissons, cependant, que ses *Bateaux* décoreraient heureusement le mur d'une chambre d'enfant. M. Devlaminck [*sic*] épinalise; sa peinture, qui a l'air terrible, est, au fond, très bon enfant." Vauxcelles, "Le Salon d'Automne," October 17, 1905.

36. Concepts of naïveté, sincerity, the primitive, and the childlike had an important place in the older discourses on Cézanne and Gauguin (with whom the Fauves were affiliated); for detailed discussion of such concepts see Richard Shiff, *Cézanne and the End of Impressionism: A Study of the Theory, Technique, and Critical Evaluation of Modern Art* (Chicago: University of Chicago Press, 1984), passim.

37. "De régression en régression, Matisse remonte à l'art des cavernes, au balbutiement du petit enfant qui crayonne d'une pointe de silex le tracé de l'ombre d'une tête de renne, sur le mur.... Il schématise, il synthétise. Résultat direct: les cubes canaques de M. Braque." [Charles] Estienne, "Des Tendances de la peinture moderne: Entretien avec M. L. Vauxcelles," *Les Nouvelles*, July 20, 1909, p. 4. Vauxcelles's designation for Braque's Cubism comes from a combination of terms he had used in March and November 1908; the word *Kanaka* derives from the Polynesian for *man* and is still current as a French term for Pacific islanders.

38. "M. Henri-Matisse...est préoccupé d'étonner le public et de le dérouter. Il spécule sur la peur qu'ont certains de paraître retardataires s'ils ne se pâment pas devant les tentatives les plus outrancières. Et, sans doute, tout novateur mérite le respect...mais c'est à la condition expresse qu'on ne puisse suspecter sa conviction. Ici, inconscient ou non, il y a cabotinage." Léon Rosenthal, "Petites Expositions," *La Chronique des arts*, March 31, 1906, p. 100.

39. On Péladan see Benjamin, *Matisse's "Notes of a Painter,"* pp. 153–57; for Matisse's response, see pp. 169–71.

40. Charles Morice, "Le XXIIᵉ Salon des Indépendants," *Mercure de France* 61 (April 15, 1906): 535.

41. In 1901 Raymond Bouyer associated the "decorative landscape" of Francis Jourdain (plate 270) and others with the concept of Expressionism (as opposed to Impressionism). See Benjamin, *Matisse's "Notes of a Painter,"* p. 211.

42. "Entre les 'Indépendants,' peintres de plein air, il faut distinguer ceux qui demandent aux spectacles de la nature prétextes à réaliser des compositions décoratives et ceux qui s'efforcent de fixer directement ces spectacles mêmes ou, plus exactement, les impressions que ces spectacles leur ont fait éprouver." François Crucy, "Le Salon des Indépendants," *L'Aurore*, March 22, 1906.

43. See Oppler, *Fauvism Reexamined*, pp. 71–82; and Benjamin, *Matisse's "Notes of a Painter,"* pp. 171–84.

44. "*Port de pêche*, où l'on ne parvient que difficilement à discerner une forme"; "le goût de la synthèse, poussé à l'excès, conduit l'artiste à se contenter de simples notations." Etienne Charles, "Le Salon des Indépendants," *La Liberté*, March 21, 1906.

45. "Nos jeunes paysagistes voient vrai 'parce qu'ils voient décoratif.' Le site est pour eux un prétexte, un décor où doivent s'enclore en arabesques les figures. On sent chez tous une préoccupation d'équilibrer les volumes et les masses. Et cette poursuite du décoratif se manifeste même chez eux dont l'erreur déconcerte." Louis Vauxcelles, "Le Salon des Indépendants," *Gil Blas*, March 20, 1906.

46. "La toile paraît vide et l'impression générale qu'elle dégage est celle de la plus fâcheuse froideur." Charles Morice, *Mercure de France* 61 (April 15, 1906): 537.

47. "La forme l'indiffère presque complètement. Il rêve de 'décoration pure.'....Il s'enfonce dans l'abstrait et s'élance hors de la nature." Vauxcelles, "Le Salon des Indépendants," March 20, 1906.

48. "marbrures cézanniennes"; "Je me console devant les petits paysages et les marines fluides, emplis d'air et de lumière, très hardis, mais point criards." Louis Vauxcelles, "Le Salon des Indépendants," *Gil Blas*, March 20, 1907.

49. For details see Oppler, *Fauvism Reexamined*, pp. 28–33.

50. Leo and Gertrude Stein paid five hundred francs in late 1905 for *La Femme au chapeau* (*Woman in a Hat*); in 1909 Sergei Shchukin commissioned *La Musique* (*Music*) and *La Danse* (*Dance*) for twelve and fifteen thousand francs, respectively—an indicator of the increase in price for Matisse's works. See Alfred H. Barr, Jr., *Matisse: His Art and His Public* (New York: Museum of Modern Art, 1951), pp. 57, 555.

51. See Mauclair's discussion of dealers (and critics under their sway) in "La Crise de la laideur," especially p. 320: "Those who are well informed . . . know the extent to which everything in an official or libertarian Salon—the internal regulations, management, exhibitions of masters, the launching of such and such a group, the ousting of another—all is secretly influenced by the diplomacy of a few dealers." ("Ceux qui sont au courant . . . savent à quel point, en un Salon officiel ou libertaire, tout, règlement intérieur, gérance, expositions de maîtres, lancement de tel ou tel groupe, éviction de tel autre, tout est occultement influencé par la diplomatie de quelques marchands.") See also Vauxcelles's reply in defense of the avant-garde and their Salons in "La Vie artistique: La Crise de l'art actuel," *Gil Blas*, September 12, 1906.

52. Of these collectors Shchukin was the major figure: by 1914 he owned thirty-seven Matisses, sixteen Derains, nine Marquets, and a few paintings each by Friesz, Manguin, Puy, Rouault, van Dongen, and Vlaminck; see Beverly Whitney Kean, *All the Empty Palaces: The Merchant Patrons of Modern Art in Pre-Revolutionary Russia* (New York: Universe Books, 1983), passim; on the Stein family see New York, Museum of Modern Art, *Four Americans in Paris: The Collections of Gertrude Stein and Her Family*, exh. cat., 1970.

53. See the symptomatic examples by Louis Rouart and Roland Dorgelès quoted in Flam, *Matisse: A Retrospective*, pp. 68–69 and 124–26.

54. "incohérents, en révolte contre l'âme latine." André Pérate, "Les Salons de 1907," *Gazette des beaux-arts* 37 (May 1, 1907): 356.

55. See Pierre Schneider, *Matisse* (London: Thames and Hudson, 1984), p. 729.

56. Charles Malpel, "Le Salon d'Automne à Paris," in *Notes sur l'art d'aujourd'hui et peut-être de demain* (Paris and Toulouse: Grasset, 1910), vol. 2, pp. 144, 152–53.

57. In one case Jourdain vetoed the jury's decision to accept Matisse's *La Coiffure* (*The Hairstyle*, Staatsgalerie, Stuttgart, West Germany); in another he apparently contrived to have Vlaminck's election to the committee annulled. See Guillaume Apollinaire, "Le Salon d'Automne," and "Le Cas Maurice de Vlaminck," *Je dis tout*, October 1907; translated in *Apollinaire on Art*, ed. Leroy C. Breunig (New York: Da Capo, 1972), pp. 18–36.

58. Jansen's position as backer is confirmed in Meredith L. Clausen, *Frantz Jourdain and the Samaritaine* (Leiden: E. J. Brill, 1987), p. 148 (see pp. 130–55 on Jourdain's activity as founder and longtime president of the Salon).

59. Vauxcelles detected in the deliberations of the jury "the *right*, those who prefer a watered-down Impressionism, and the *left*, who take pleasure in the aggressive polychromy of the 'fauves.'" ("la *droite*, ceux qui préférent l'impressionnisme édulcoré; et la *gauche*, qui se plaît aux truculences polychromes des 'fauves.'") Louis Vauxcelles, "Le Boulevard: Le jury de peinture," *Gil Blas*, September 17, 1908. See also Puy, "Les Fauves," p. 456; and Apollinaire, *Je dis tout*, passim.

60. "Or, il est devenu insensiblement le Salon d'une école, si ce mot d'école peut être employé quand il s'agit d'artistes hostiles à toute discipline d'esprit, d'artistes étrangement ivres de couleur. . . . Dans le comité, nous avons vu tout un parti vouloir, par principe, élever les Fauves au pinacle. . . . Sous leur influence, le règlement a fléchi en faveur de certains. Une irrégularité ayant été commise dans la réception des envois, j'ai cru devoir protester; mes réclamations n'ont pas été admises: les Fauves l'emportaient. J'ai donné ma démission." Lopisgich, in Etienne Charles, "Le Salon des 'Fauves'—Dissensions intérieures," *La Liberté*, November 28, 1907.

61. This may be linked to the fact that the Fauves were not intimate with a circle of writers as the early Impressionists had been.

62. For detailed accounts of the following four articles see Benjamin, *Matisse's "Notes of a Painter,"* chaps. 5, 6.

63. Gelett Burgess, "The Wild Men of Paris," *Architectural Record* 27 (May 1910): 401–14. On the dating of this article see Benjamin, *Matisse's "Notes of a Painter,"* pp. 126–28.

64. "Nous ne sommes pas en présence d'une tentative outrancière: le propre de l'art de Matisse est d'être raisonnable." Guillaume Apollinaire, "Henri Matisse," *La Phalange* 2 (December 15–18, 1907): 485.

65. Matisse's "Notes" are translated in Jack D. Flam, *Matisse on Art* (New York: E. P. Dutton, 1978), pp. 35–40.

66. See Mauclair in Benjamin, *Matisse's "Notes of a Painter,"* pp. 213–14.

67. Vauxcelles's room-by-room review ("Le Salon d'Automne," *Gil Blas*, September 30, 1908) confirms that works by Derain, Friesz, Manguin, Matisse, and Vlaminck were exhibited in separate rooms, alongside stylistically dissimilar works (those by Félix Vallotton and Walter Sickert in Matisse's case).

68. For an early statement of this argument see Alfred H. Barr, Jr., "Matisse, Picasso and the Crisis of 1907," *Magazine of Art* 44 (May 1951): 163–70.

69. Etienne Charles wrote ("Le Salon d'Automne, II," *La Liberté*, October 1, 1908) of "certain 'fauves' or former 'fauves' such as MM. Othon Friesz, de Vlaminck, Valtat, Lebasque, Puy, . . ." and of "M. Henri Matisse, who was a 'wild beast' among the 'wild beasts' and who now seems to us to be subdued." ("quelques 'fauves' ou anciens 'fauves,' tels que MM. Othon Friesz, de Vlaminck, Valtat, Lebasque, Puy, . . ."; "M. Henri Matisse, qui fut un 'fauve' entre les 'fauves,' et qui maintenant nous apparaît assagi.") Vauxcelles also called Friesz a former Fauve, seeing his work as exemplifying the move away from the sketchlike in the search for a more constructed picture ("Le Salon d'Automne," September 30, 1908).

PLATE 279
André Derain
Les Arbres
(*The Trees*), 1906
Oil on canvas
23 ⅜ x 28 ½ in.
(59.4 x 72.4 cm)
Albright-Knox Art Gallery,
Buffalo, gift of Seymour H.
Knox in memory of Helen
Northrup Knox, 1971

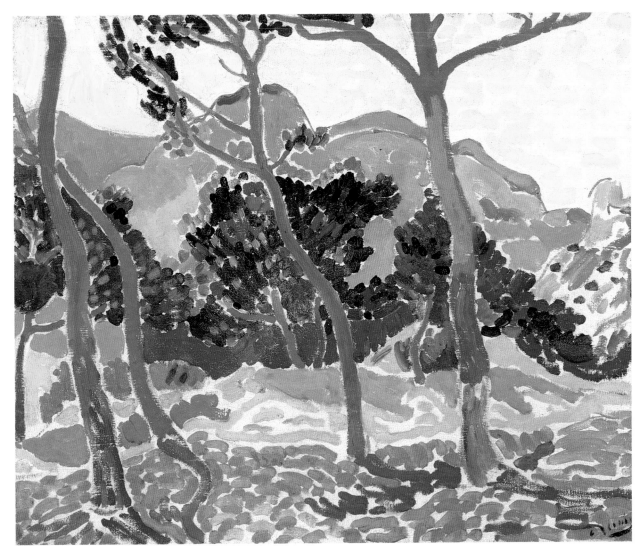

PLATE 279

Biographies and Exhibition Checklist

G Braque

Ch Camoin

a. Derain

van Dongen

Raoul Dufy

Friesz

Manguin

Marquet

Henri-Matisse

J Puy

L. Valtat

Vlaminck

Georges Braque

Argenteuil, May 13, 1882–

Paris, 1963

Georges Braque, c. 1908

At the age of eight Braque moved to Le Havre from the Paris suburb of Argenteuil, where his family had lived for three generations. About three years later he began to study flute with Gaston Dufy, brother of Raoul. In 1897 he started attending night classes at Le Havre's Ecole Municipal des Beaux-Arts. His father was a housepainter and amateur artist, and in 1899 Braque joined the family business as an apprentice to a painter-decorator.

After moving to Paris in 1900 Braque studied at the Académie Julian, along with Othon Friesz, whom he had met earlier in Le Havre. While in Paris, Braque supported himself by working for a housepainter, M. Laberthe. From October 1901 to October 1902 Braque served with a military regiment stationed in Le Havre; after receiving his diploma as a decorative painter he was able to start work rather than serving his full three years of military duty. He exhibited publicly for the first time (with a portrait) at the Société des Arts du Havre exhibition in August–October 1902 (he later destroyed much of his work executed prior to 1906).

Braque decided to become a full-time painter after returning to Paris in the autumn of 1902, where he often saw Friesz and Dufy. He studied at the Académie Humbert and, for two months of 1903, in Léon Bonnat's studio at the Ecole des Beaux-Arts. In the autumn of 1904 he left the Académie Humbert and took a studio at 48, rue d'Orsel. During the Fauve years Braque spent the summer of 1905 in Honfleur and Le Havre with the sculptor Manolo (Manuel Martínez Hugué) and the critic Maurice Raynal. The next summer he traveled to Antwerp with Friesz. He worked in L'Estaque in 1906–7 (the first of several trips) and in La Ciotat in 1907.

After his encounter with Pablo Picasso in 1907 and his viewing of the Paul Cézanne memorial exhibition at the 1907 Salon d'Automne, Braque began to render forms in his paintings as solid, geometricized volumes, blazing the way for the full-fledged Cubism that he and Picasso were to develop in the succeeding seven years. Following a stay in L'Estaque in the summer of 1908 (where he was joined by Dufy), Braque had his first one-man exhibition at Galerie Kahnweiler in November. During his summer 1909 trip to La Roche-Guyon, his summer 1910 stay in L'Estaque, and his summer 1911 visit to Céret with Picasso, he made Analytic Cubist landscape paintings. That September he made his first papier collé and introduced sand and sawdust into his paintings.

With the outbreak of World War I, Braque was drafted and sent to the front. He received a severe head wound at Carency in 1915 and was released from service one year later. In 1917 he began to paint again, and his work from the 1920s and 1930s depicts objects in relatively more decipherable form, with increasing use of black grounds and mixed media. In 1922 Braque moved from Montmartre to Montparnasse. Commissioned by Etienne de Beaumont's Soirées de Paris, he created the decors for the ballets Salade (1924) and Zéphyr et Flore (1925). Braque remained in Paris during World War II. Following the war he produced a series of paintings called Ateliers (Studios), notable for their dark grounds, reductive imagery, and large scale. In 1954 he created stained-glass windows for a church in Varengeville and for the Mas Bernard in Saint-Paul-de-Vence.

Côte de Grâce, Honfleur,
summer 1905
Oil on canvas
19 7/16 x 23 11/16 in. (49.3 x 60.2 cm)
Musée des Beaux-Arts André Malraux, Le Havre, France
Page 73, plate 81

Marine
(Seascape), c. 1905
Oil on canvas
13 13/16 x 25 9/16 in. (35 x 65 cm)
Private collection, Switzerland
Page 218, plate 225

Anvers
(Antwerp), summer 1906
Oil on canvas
23 1/2 x 28 3/4 in. (59.7 x 73 cm)
Sara Lee Corporation, Chicago
Page 93, plate 103

La Baie d'Anvers
(The Bay of Antwerp),
summer 1906
Oil on canvas
19 11/16 x 24 in. (50 x 61 cm)
Private collection, Liechtenstein
Page 271, plate 281

Bateaux sur la plage, L'Estaque
(Boats on the Beach, L'Estaque),
autumn 1906
Oil on canvas
19 1/2 x 23 1/2 in. (49.5 x 59.7 cm)
Los Angeles County Museum of Art, gift of Anatole Litvak
Page 46, plate 53

Le Canal Saint-Martin
(The Saint-Martin Canal),
autumn 1906
Oil on canvas
19 3/4 x 24 in. (50.2 x 61 cm)
The John A. and Audrey Jones Beck Collection, on extended loan to the Museum of Fine Arts, Houston
Page 96, plate 109

Le Canal Saint-Martin
(The Saint-Martin Canal),
autumn 1906
Oil on canvas
20 x 24 1/4 in. (50 x 62 cm)
Collection Alain Delon
Page 230, plate 243

L'Estaque, autumn 1906
Oil on canvas
18 ⅛ x 21 ⅝ in. (46 x 55 cm)
Private collection, Switzerland
Page 233, plate 248

L'Estaque, autumn 1906
Oil on canvas
20 x 23 ¾ in. (50.8 x 60.3 cm)
New Orleans Museum of Art,
bequest of Victor K. Kiam
Page 98, plate 112

Le Golfe, Les Lecques
(*The Gulf, Les Lecques*),
autumn 1906
Oil on canvas
14 ¹⁵⁄₁₆ x 18 ⅛ in. (38 x 46 cm)
Musée National d'Art Moderne,
Centre Georges Pompidou, Paris
Page 6

Le Mat—Le Port d'Anvers
(*The Mast—The Port of Antwerp*),
summer 1906
Oil on canvas
18 ⅛ x 15 ⅛ in. (46 x 38.4 cm)
Marion and Nathan Smooke
Page 204, plate 214

Paysage à L'Estaque
(*Landscape at L'Estaque*),
autumn 1906
Oil on canvas
19 ⅝ x 24 in. (49.9 x 61 cm)
Private collection
Page 47, plate 54

Paysage près d'Anvers
(*Landscape near Antwerp*),
summer 1906
Oil on canvas
23 ⅝ x 31 ⅞ in. (60 x 81 cm)
Solomon R Guggenheim
Museum, New York, gift,
Justin K. Thannhauser
Page 271, plate 282

Le Port d'Anvers
(*The Port of Antwerp*),
summer 1906
Oil on canvas
18 ⅛ x 14 in. (45 x 35.6 cm)
Nippon Autopolis Co., Ltd.
Page 204, plate 213

Le Port d'Anvers
(*The Port of Antwerp*),
summer 1906
Oil on canvas
19 ⅝ x 24 ¹⁄₁₆ in. (49.8 x 61.2 cm)
National Gallery of Canada,
Ottawa
Page 228, plate 241

Le Port de L'Estaque
(*The Port of L'Estaque*),
autumn 1906
Oil on canvas
19 ¹¹⁄₁₆ x 24 in. (50 x 61 cm)
Fridart Foundation
Page 47, plate 55

Le Port de L'Estaque
(*The Port of L'Estaque*),
autumn 1906
Oil on canvas
23 ¹³⁄₁₆ x 28 ¾ in. (60.5 x 73 cm)
Statens Museum for Kunst,
Copenhagen
Page 274, plate 285

La Maison derrière les arbres
(*The House behind the Trees*),
1906–7
Oil on canvas
14 ¾ x 18 ⅛ in. (37.5 x 46 cm)
The Metropolitan Museum of
Art, New York, Robert Lehman
Collection, 1975.1.159
Page 272, plate 283

La Ciotat, summer 1907
Oil on canvas
18 ½ x 22 ½ in. (47 x 57.1 cm)
Private collection
Page 274, plate 286

Les Oliviers, La Ciotat
(*Olive Trees, La Ciotat*),
summer 1907
Oil on canvas
15 x 18 ³⁄₁₆ in. (38.1 x 46.2 cm)
Worcester Art Museum,
Worcester, Massachusetts,
gift from the estate of
Mrs. Aldus Chapin Higgins
Page 273, plate 284

Paysage à La Ciotat
(*Landscape at La Ciotat*),
summer 1907
Oil on canvas
19 ⅝ x 23 ¾ in. (49.9 x 60.3 cm)
The Wohl Family
Page 103, plate 118

Paysage à La Ciotat
(*Landscape at La Ciotat*),
summer 1907
Oil on canvas
21 ¼ x 25 ¾ in. (54 x 65.4 cm)
Nippon Autopolis Co., Ltd.
Page 239, plate 255

Paysage à L'Estaque
(*Landscape at L'Estaque*), 1907
Oil on canvas
18 ⅛ x 14 ¹⁵⁄₁₆ in. (46 x 38 cm)
Private collection, Geneva
Page 107, plate 123

PLATE 280
Georges Braque
L'Estaque, autumn 1906
Oil on canvas
23 ⅝ x 28 ¾ in. (60 x 73 cm)
Musée de l'Annonciade,
Saint-Tropez, France

Not in exhibition

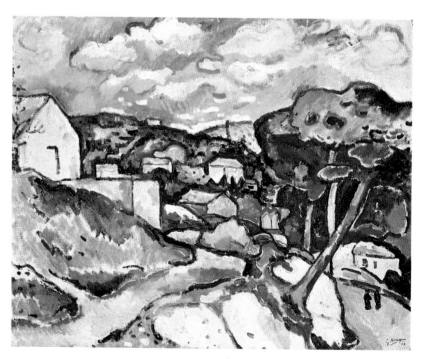

PLATE 280

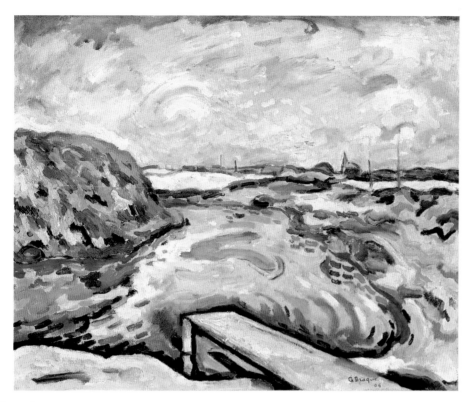

Plate 281

Plate 281
Georges Braque
La Baie d'Anvers
(*The Bay of Antwerp*),
summer 1906
Oil on canvas
19 ¹¹⁄₁₆ x 24 in. (50 x 61 cm)
Private collection,
Liechtenstein

Plate 282
Georges Braque
Paysage près d'Anvers
(*Landscape near Antwerp*),
summer 1906
Oil on canvas
23 ⅝ x 31 ⅞ in. (60 x 81 cm)
Solomon R. Guggenheim
Museum, New York, gift,
Justin K. Thannhauser

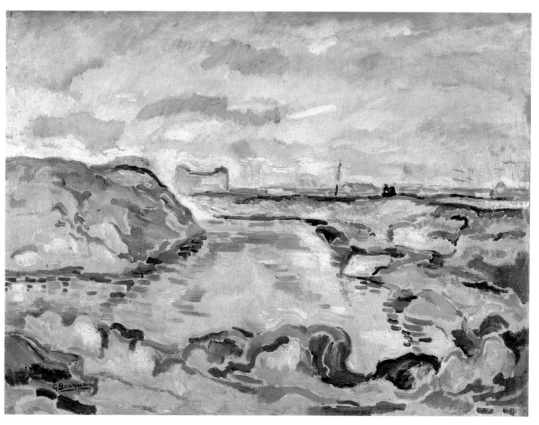

Plate 282

PLATE 283

PLATE 283
Georges Braque
La Maison derrière les arbres
(*The House behind the Trees*),
1906–7
Oil on canvas
14 ¾ x 18 ⅛ in. (37.5 x 45.7 cm)
The Metropolitan Museum of
Art, New York, Robert Lehman
Collection, 1975.1.159

PLATE 284

PLATE 284
Georges Braque
Les Oliviers, La Ciotat
(*Olive Trees, La Ciotat*),
summer 1907
Oil on canvas
15 x 18 ³/₁₆ in. (38.1 x 46.2 cm)
Worcester Art Museum,
Worcester, Massachusetts,
gift from the estate of
Mrs. Aldus Chapin Higgins

PLATE 285

PLATE 285
Georges Braque
Le Port de L'Estaque
(*The Port of L'Estaque*),
autumn 1906
Oil on canvas
23 ¹³/₁₆ x 28 ¾ in. (60.5 x 73 cm)
Statens Museum for Kunst,
Copenhagen

PLATE 286
Georges Braque
La Ciotat, summer 1907
Oil on canvas
18 ½ x 22 ½ in. (47 x 57.1 cm)
Private collection

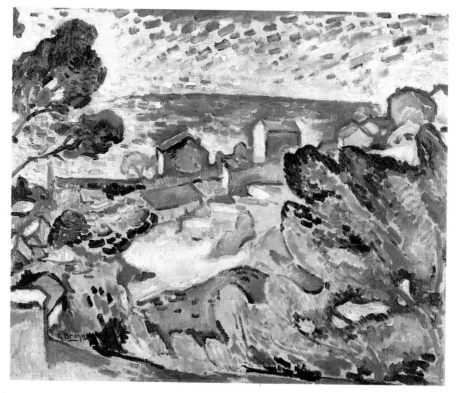

PLATE 286

Charles Camoin

Marseille, September 23, 1879–

Paris, 1965

Charles Camoin, c. 1905

Camoin came from a family of housepainters. From age seven he spent his mornings studying at the Ecole des Beaux-Arts in Marseille. At age nineteen he entered Gustave Moreau's studio in Paris, where he met Henri Manguin, Albert Marquet, Henri Matisse, and Jean Puy. In 1900 Camoin served his military duty in Arles and painted some of the motifs he had observed in Vincent van Gogh's paintings. He periodically visited Paul Cézanne in Aix-en-Provence until the latter died in 1906. During the Fauve years Camoin traveled extensively, most often with Marquet and chiefly in the south of France, although he also visited Italy and Spain. He favored a vivid palette but his motifs were typical of paintings of the French provinces, despite the intellectual influence of Cézanne.

Camoin had his first one-man exhibition with Daniel-Henry Kahnweiler in 1908. During the winter of 1912–13 he visited Morocco at the same time that Matisse made his second trip to Morocco. Camoin's subsequent paintings, shown at the Galerie Druet in 1914, clearly reflected Matisse's influence. During World War 1, Camoin specialized in camouflage. In 1918 he and Matisse visited Pierre-Auguste Renoir in Cagnes-sur-Mer, and his style thereafter shifted toward Impressionism. Camoin traveled extensively between the wars, notably to Spain in 1930 with Marquet. His work of the 1930s was especially influenced by Renoir and Pierre Bonnard. He married Charlotte Prost in 1940, and they divided their time between Saint-Tropez and Montmartre.

Le Pont des Arts vu du Pont Neuf (The Pont des Arts Seen from the Pont Neuf), 1904
Oil on canvas
13 x 16⅛ in. (33 x 41 cm)
Private collection
Page 35, plate 31

André Derain

Chatou, June 10, 1880–

Garches, 1954

André Derain, c. 1920s

Derain was the son of a successful baker in Chatou. His family wanted him to become an engineer, and he trained locally for this career. At age fifteen Derain began to paint, studying with a Father Jacomin and later with the artist Georges Linaret. In 1898 he began studying at the Académie Camillo under Eugène Carrière; during his time in Carrière's studio he met Henri Matisse.

Shortly after Derain and Maurice de Vlaminck met on a train from Paris, on June 18, 1900, they took up residence in the abandoned hotel-restaurant Levanneur on the Ile-de-Chatou. From September 1901 to September 1904 Derain fulfilled his three-year military service at Commercy. During this time he illustrated two books for Vlaminck: D'un lit dans l'autre (From One Bed to Another, 1902) and Tout pour ça (All for That, 1903).

Demobilized at the start of the Fauve years, Derain resumed painting landscapes with Vlaminck at Chatou, Le Pecq, and neighboring towns; he also intermittently attended sessions at the Académie Julian. The dealer Ambroise Vollard bought the entire contents of his studio in February 1905. Derain spent that summer with Matisse in Collioure. His succeeding years were marked by periods of travel, generally in the summer—in L'Estaque (1906), Cassis (1907), and Martigues (1908). He took his first trip to London in autumn 1905 and made a second, longer visit in early spring 1906. His style gradually shifted from a use of intensified, contrasting colors to a more restrained blue-brown palette and tighter, more geometricized forms.

Derain's paintings became increasingly brown toned and Cubist influenced in the summer of 1909, when he painted in Montreuil and, along with Georges Braque, in Carrières-sur-Seine; in 1910 he worked in Villeneuve-Loubet and Cagnes-sur-Mer, then at Cadaqués, Spain, with Pablo Picasso. In 1910 he moved from Montmartre to the Left Bank (13, rue Bonaparte).

Many of his images from the teens are devoted to tabletop still lifes. About 1912 his style was infused with archaizing tendencies inspired by Siennese painting. At the end of 1912, after a stay in Vers (near Cahors in the French department of Lot), he returned to Paris and increasingly concentrated on depicting the figure. In 1913 he and Vlaminck went to Marseille and Martigues.

At the outbreak of World War I, Derain was in Montfavet, near Avignon, with Braque and Picasso. He was mobilized and sent to the front at the Somme, Verdun, and the Vosges, where he made drawings, pastels, sculptures, and an occasional painting whenever he had the opportunity. In 1919 Derain designed the costumes and decor for Sergei Diaghilev's La Boutique fantasque (The Fantastic Boutique); he went to London for the performance. During the 1920s Derain painted mainly landscapes, traveling in Lot, Sanary, Bandol, La Ciotat, Cahors, and Italy. In 1930 Derain produced an important series of paintings in the Var, at Olières and Saint-Maximin; these were shown at the Paris gallery of Paul Guillaume (his dealer from 1923 to 1934) and were well received by critics. This was only his second solo exhibition in France. In 1935 Derain bought a home at Chambourcy, near Saint-Germain-en-Laye. In 1939 he returned to making sculpture. During World War II he remained mostly in Paris, although he made a trip to Berlin with other French artists in 1941 to attend the opening of an exhibition of work by the Nazi sculptor Arno Brecker. From the mid-1940s on, his paintings featured dark grounds with light, sketchily rendered figures. In 1954 Derain was struck by a car in Chambourcy and died several weeks later.

Paysage, la pluie de Chatou
(Landscape, Rain at Chatou), 1904
Oil on canvas
16 ⅛ x 13 in. (41 x 33 cm)
Private collection
Page 65, plate 70

Arbre, paysage au bord d'une rivière
(Tree, Landscape at a River Bank),
1904–5
Oil on canvas
23 ⅝ x 31 ¹¹⁄₁₆ in. (60 x 80.5 cm)
Private collection, Switzerland
Page 180, plate 181

Paysage de l'Ile-de-France
(Landscape in the Ile-de-France),
1904–5
Oil on canvas
15 ⅜ x 20 ⅞ in. (39 x 53 cm)
Fridart Foundation
Page 180, plate 180

Le Pont du Pecq
(The Bridge at Le Pecq), 1904–5
Oil on canvas
38 ⅝ x 45 ¾ in. (98.1 x 116.2 cm)
Theodore J. Forstmann
Page 138, plate 145

Restaurant du Pecq
(Restaurant at Le Pecq), 1904–5
Oil on canvas
25 ⁹⁄₁₆ x 19 ¹¹⁄₁₆ in. (65 x 50 cm)
Private collection, Switzerland
Page 18, plate 4

La Seine au Pecq
(The Seine at Le Pecq), 1904–5
Oil on canvas
33 ⁷⁄₁₆ x 37 ⅜ in. (85 x 95 cm)
Musée National d'Art Moderne,
Centre Georges Pompidou, Paris
Page 139, plate 146

Bateaux au port de Collioure
(Boats in the Port of Collioure),
summer 1905
Previously known as Bateaux
dans le port (Boats in the Port)
Oil on canvas
28 ⅜ x 37 ⅜ in. (72 x 95 cm)
Private collection, Switzerland
Page 74, plate 82

Bateaux pêcheurs, Collioure
(Fishing Boats, Collioure),
summer 1905
Oil on canvas
15 x 18 ¼ in. (38.1 x 46.3 cm)
Collection, The Museum of
Modern Art, New York, the
Philip L. Goodwin Collection
Page 280, plate 290

Bateaux pêcheurs, Collioure
(*Fishing Boats, Collioure*),
summer 1905
Oil on canvas
31 7/8 x 39 1/2 in. (81 x 100.3 cm)
The Metropolitan Museum of
Art, New York, gift of Ray-
monde Paul in memory of her
brother, C. Michael Paul,
1982.179.29
Page 279, plate 288

Collioure, summer 1905
Oil on canvas
14 1/2 x 18 1/2 in. (36.8 x 47 cm)
Private collection
Page 280, plate 291

Collioure, le village et la mer
(*Collioure, the Village and
the Ocean*), summer 1905
Oil on canvas
23 7/8 x 30 in. (60.7 x 76.2 cm)
Scottish National Gallery of
Modern Art, Edinburgh
Page 29, plate 25

Paysage de Collioure
(*Landscape at Collioure*),
summer 1905
Oil on canvas
14 1/4 x 17 1/2 in. (36.2 x 44.4 cm)
Joanne and Ira Kirshbaum,
Los Angeles
Page 10

Paysage de Collioure
(*Landscape at Collioure*),
summer 1905
Also known as *Mountains at
Collioure*
Oil on canvas
31 7/8 x 39 3/8 in. (81 x 100 cm)
National Gallery of Art,
Washington, D.C., the John
Hay Whitney Collection
Page 77, plate 87

Les Pêcheurs à Collioure
(*The Fishermen at Collioure*),
summer 1905
Oil on canvas
18 1/8 x 21 1/4 in. (46 x 54 cm)
Private collection
Page 12, plate 1

Le Pont de Waterloo
(*Waterloo Bridge*), autumn 1905
Oil on canvas
31 1/2 x 39 3/8 in. (80 x 100 cm)
Thyssen-Bornemisza Collection,
Lugano, Switzerland
Page 80, plate 92

Le Port de Collioure
(*The Port of Collioure*),
summer 1905
Oil on canvas
18 1/8 x 14 15/16 in. (46 x 38 cm)
Private collection, Liechtenstein
Page 278, plate 287

Port de Collioure, le cheval blanc
(*Port of Collioure, the White
Horse*), summer 1905
Oil on canvas
28 5/16 x 35 13/16 in. (72 x 91 cm)
Musée d'Art Moderne, Troyes,
France
Page 159, plate 165

Port de pêche, Collioure
(*Fishing Port, Collioure*),
summer 1905
Oil on canvas
32 1/16 x 39 3/8 in. (81.5 x 100 cm)
Private collection, Switzerland
Page 256, plate 271

Le Séchage des voiles
(*Drying the Sails*), summer 1905
Oil on canvas
32 5/16 x 39 3/4 in. (82 x 101 cm)
State Pushkin Museum,
Moscow
Page 251, plate 266

Les Voiliers à Collioure
(*Sailboats at Collioure*),
summer 1905
Oil on board
15 3/8 x 19 7/8 in. (39 x 50.5 cm)
National Museum, Belgrade,
Yugoslavia
Page 279, plate 289

L'Abbaye de Westminster
(*Westminster Abbey*), autumn 1905
Oil on canvas
29 3/4 x 36 1/4 in. (75.5 x 92 cm)
Musée de l'Annonciade,
Saint-Tropez, France
Page 283, plate 295

Les Arbres
(*The Trees*), 1906
Oil on canvas
23 3/8 x 28 1/2 in. (59.4 x 72.4 cm)
Albright-Knox Art Gallery,
Buffalo, gift of Seymour H.
Knox in memory of Helen
Northrup Knox, 1971
Page 267, plate 279

Arbres, L'Estaque
(*Trees, L'Estaque*), 1906
Oil on canvas
18 1/8 x 14 15/16 in. (46 x 38 cm)
Gabriel Sabet, Geneva
Page 42, plate 45

La Danse
(*The Dance*), 1906
Oil on canvas
72 13/16 x 89 3/4 in. (185 x 228 cm)
Fridart Foundation
Pages 30–31, plate 26

D'après Gauguin
(*After Gauguin*), 1906
Oil on canvas
11 x 18 1/8 in. (28 x 42 cm)
Private collection
Page 288, plate 302

Les Deux Péniches
(*The Two Barges*), winter 1906
Oil on canvas
31 1/2 x 38 3/8 in. (80 x 97.5 cm)
Musée National d'Art Moderne,
Centre Georges Pompidou, Paris
Page 281, plate 292

Effets de soleil sur la Tamise
(*Effects of Sunlight on the Thames*),
winter 1906
Oil on canvas
31 1/2 x 39 in. (80 x 99 cm)
Musée de l'Annonciade,
Saint-Tropez, France
Page 200, plate 208

L'Estaque, 1906
Oil on canvas
14 15/16 x 21 5/8 in. (38 x 55 cm)
Musée des Beaux-Arts, La
Chaux-de-Fonds, Switzerland,
René and Madeleine Junod
Collection
Page 42, plate 46

L'Estaque, route tournante
(*Turning Road, L'Estaque*), 1906
Oil on canvas
51 x 76 1/4 in. (129.5 x 195 cm)
The Museum of Fine Arts,
Houston, the John A. and Audrey
Jones Beck Collection, 1974
Cover (detail) and page 40,
plate 41

L'Étang de Londres
(*The Pool of London*), winter 1906
Oil on canvas
25 7/8 x 39 in. (65.7 x 99.1 cm)
The Trustees of the
Tate Gallery, London
Page 284, plate 296

Hyde Park, winter 1906
Oil on canvas
26 x 39 in. (66 x 99 cm)
Musée d'Art Moderne,
Troyes, France
Page 286, plate 298

Le Parlement de Londres de nuit
(*Houses of Parliament at Night,
London*), winter 1906
Oil on canvas
31 x 39 in. (78.7 x 99.1 cm)
The Metropolitan Museum of
Art, New York, Robert Lehman
Collection, 1975.1.168
Page 282, plate 293

*Le Parlement et le Pont de
Westminster*
(*The Houses of Parliament and
Westminster Bridge*), winter 1906
Oil on canvas
29 x 36 1/4 in. (73.7 x 92.1 cm)
Cleveland Museum of Art,
Leonard C. Hanna, Jr., Fund
Page 189, plate 191

Le Pont de Blackfriars, Londres
(*Blackfriars Bridge, London*),
winter 1906
Oil on canvas
31 9/16 x 39 1/16 in. (80.2 x 99.3 cm)
Glasgow Art Gallery and
Museum
Page 196, plate 202

*Le Pont de Charing-Cross,
Londres* (*Charing Cross Bridge,
London*), 1906
Oil on canvas
32 x 39 1/2 in. (81.3 x 100.3 cm)
National Gallery of Art,
Washington, D.C., the John
Hay Whitney Collection
Page 193, plate 198

Pont de Charing-Cross
(*Charing Cross Bridge*),
winter 1906
Oil on canvas
31 7/8 x 39 3/8 in. (81 x 100 cm)
Musée d'Orsay, Paris, gift of
Max and Rosy Kaganovitch
Page 195, plate 200

Pont de Londres
(*London Bridge*), winter 1906
Oil on canvas
24 13/16 x 37 5/8 in. (63 x 95.5 cm)
Private collection, Switzerland
Page 85, plate 95

Pont de Londres
(*London Bridge*), winter 1906
Oil on canvas
26 x 39 in. (66 x 99.1 cm)
Collection, The Museum of
Modern Art, New York, gift of
Mr. and Mrs. Charles Zadok
Page 84, plate 94

Le Pont de Westminster: Bleu et gris
(*Westminster Bridge: Blue and
Gray*), winter 1906
Oil on canvas
28 3/8 x 35 13/16 in. (72 x 91 cm)
Private collection
Page 283, plate 294

La Promenade
(*The Promenade*), 1906
Oil on canvas
18 1/8 x 21 5/8 in. (46 x 55 cm)
Private collection, Switzerland
Page 288, plate 301

Le Quai de la Tamise
(*The Thames Embankment*),
winter 1906
Oil on canvas
26 x 39 in. (66 x 99.1 cm)
Private collection, Monte Carlo
Page 194, plate 199

Regent Street, Londres
(*Regent Street, London*),
winter 1906
Oil on canvas
26 x 39 in. (66 x 99 cm)
The Jacques and Natasha
Gelman Collection
Page 287, plate 299

Sur la Tamise
(*On the Thames*), winter 1906
Oil on canvas
28 ⅞ x 36 ⅚ in. (73.3 x 92.2 cm)
National Gallery of Art,
Washington, D.C., Collection
of Mr. and Mrs. Paul Mellon
Page 199, plate 207

La Tamise, Londres
(*The Thames, London*),
winter 1906
Oil on canvas
26 ³/₁₆ in. (66.5 x 99 cm)
Fridart Foundation
Page 285, plate 297

La Tamise, Pont de Westminster
(*The Thames, Westminster Bridge*),
winter 1906
Oil on canvas
25 ⁹/₁₆ x 29 ½ in. (65 x 75 cm)
Private collection
Page 188, plate 188

Les Voiles rouges
(*The Red Sails*), winter 1906
Oil on canvas
30 x 39 in. (76.2 x 99.1 cm)
Private collection
Page 176, plate 178

Les Cyprès
(*The Cypresses*), 1907
Oil on board
9 ⁷/₁₆ x 13 in. (24 x 33 cm)
Private collection, Switzerland
Page 290, plate 304

Les Cyprès à Cassis
(*The Cypresses at Cassis*), 1907
Oil on canvas
18 ⅛ x 14 ¹⁵/₁₆ in. (46 x 38 cm)
Musée de Grenoble,
Grenoble, France,
Agutte-Sembat Bequest
Page 51, plate 59

Paysage à Cassis
(*Landscape at Cassis*), 1907
Oil on canvas
24 x 20 in. (61 x 50.8 cm)
New Orleans Museum of Art,
gift of William E. Campbell
Page 50, plate 58

La Pinède à Cassis
(*The Pine Forest at Cassis*), 1907
Oil on canvas
21 ¼ x 25 ³/₁₆ in. (54 x 64 cm)
Musée Cantini, Marseille
Page 104, plate 120

La Route dans la montagne
(*The Mountain Road*), 1907
Oil on canvas
31 ¹¹/₁₆ x 39 in. (80.5 x 99 cm)
The State Hermitage
Museum, Leningrad
Page 289, plate 303

La Baie de Martigues
(*The Bay of Martigues*), 1908
Oil on canvas
19 ¾ x 24 ¼ in. (50.2 x 61.6 cm)
Private collection, courtesy
Barbara Divver Fine Art
Page 52, plate 60

Martigues, 1908
Previously known as *Le Havre*
Oil on canvas
28 ⅞ x 35 ⅞ in. (73.4 x 91.1 cm)
Perls Galleries, New York
Page 113, plate 125

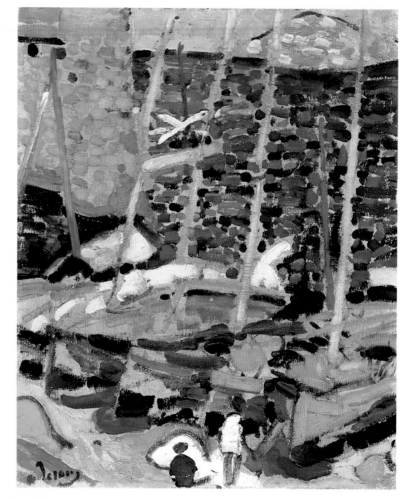

PLATE 287

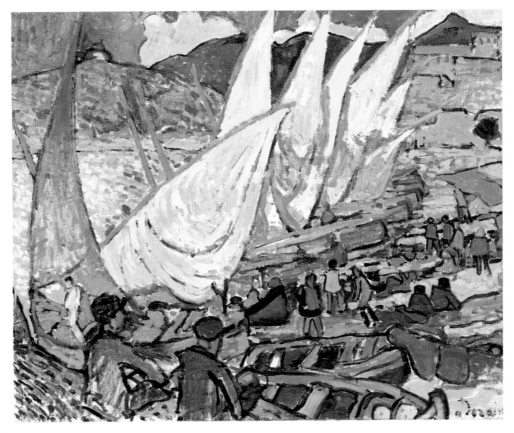

PLATE 287
André Derain
Le Port de Collioure
(*The Port of Collioure*),
summer 1905
Oil on canvas
18 ⅛ x 14 ¹⁵⁄₁₆ in. (46 x 38 cm)
Private collection,
Liechtenstein

PLATE 288

PLATE 289

PLATE 288
André Derain
Bateaux pêcheurs, Collioure
(*Fishing Boats, Collioure*),
summer 1905
Oil on canvas
31 ⅞ x 39 ½ in. (81 x 100.3 cm)
The Metropolitan Museum
of Art, New York, gift of
Raymonde Paul, in memory
of her brother, C. Michael
Paul, 1982.179.29

PLATE 289
André Derain
Les Voiliers à Collioure
(*Sailboats at Collioure*),
summer 1905
Oil on board
15 ⅜ x 19 ⅞ in. (39 x 50.5 cm)
National Museum,
Belgrade, Yugoslavia

PLATE 290

PLATE 290
André Derain
Bateaux pêcheurs, Collioure
(*Fishing Boats, Collioure*),
summer 1905
Oil on canvas
15 x 18 ¼ in. (38.1 x 46.3 cm)
Collection, The Museum of
Modern Art, New York, the
Philip L. Goodwin Collection

PLATE 291
André Derain
Collioure, summer 1905
Oil on canvas
14 ½ x 18 ½ in. (36.8 x 47 cm)
Private collection

PLATE 292
André Derain
Les Deux Péniches
(*The Two Barges*), winter 1906
Oil on canvas
31 ½ x 38 ⅜ in. (80 x 97.5 cm)
Musée National d'Art
Moderne, Centre Georges
Pompidou, Paris

PLATE 291

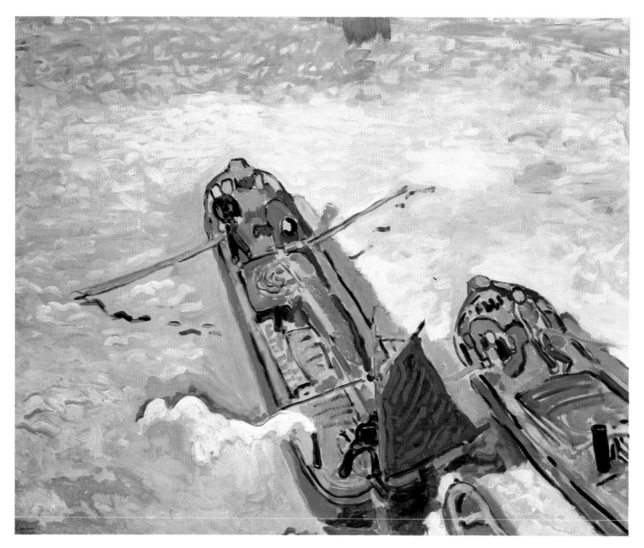

PLATE 292

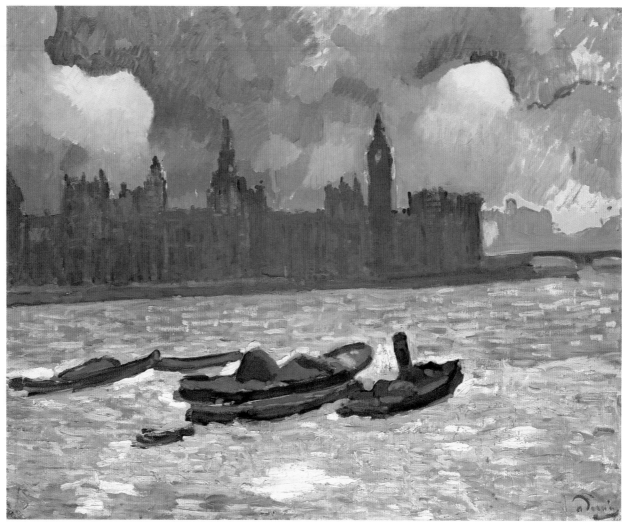

PLATE 293

PLATE 294

PLATE 294
André Derain
Le Pont de Westminster:
Bleu et gris
(*Westminster Bridge: Blue and*
Gray), winter 1906
Oil on canvas
28 ⅜ x 35 ¹¹⁄₁₆ in. (72 x 91 cm)
Private collection

PLATE 295
André Derain
L'Abbaye de Westminster
(*Westminster Abbey*),
autumn 1905
Oil on canvas
29 ¾ x 36 ¼ in. (75.5 x 92 cm)
Musée de l'Annonciade,
Saint-Tropez, France

PLATE 293
André Derain
Le Parlement de Londres de nuit
(*Houses of Parliament at Night,*
London), winter 1906
Oil on canvas
31 x 39 in. (78.7 x 99.1 cm)
The Metropolitan Museum of
Art, New York, Robert Leh-
man Collection, 1975.1.168

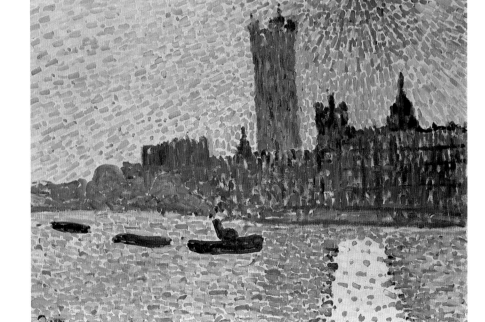

PLATE 295

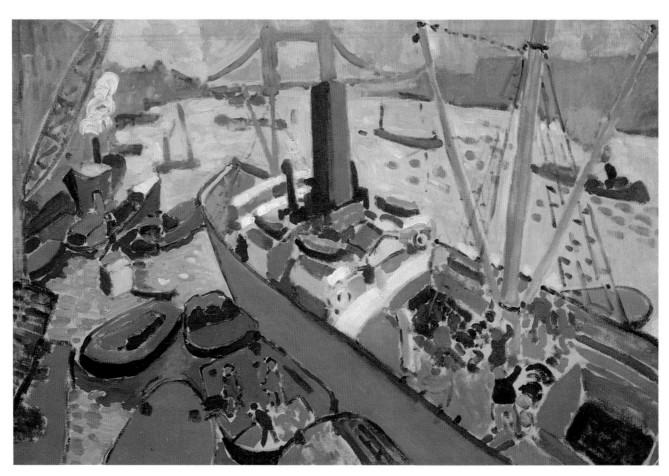

Plate 296

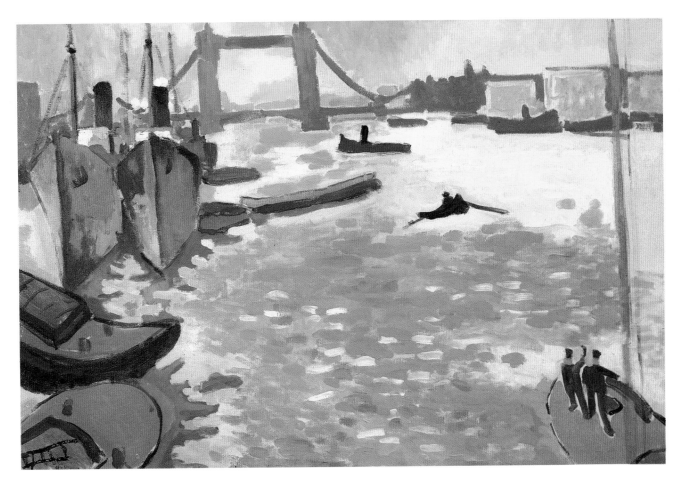

PLATE 297

PLATE 298

PLATE 298
André Derain
Hyde Park, winter 1906
Oil on canvas
26 x 39 in. (66 x 99 cm)
Musée d'Art Moderne,
Troyes, France

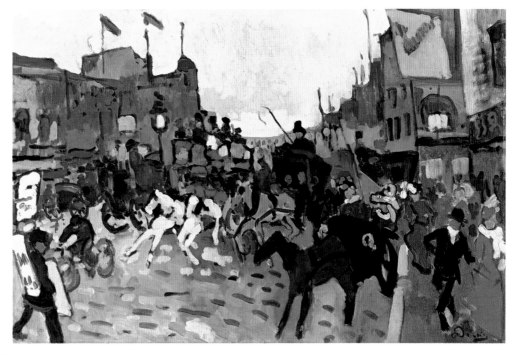

PLATE 299

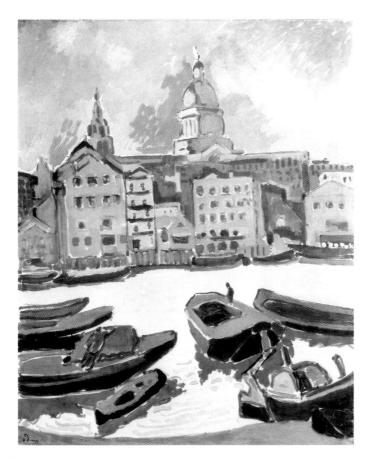

PLATE 299
André Derain
Regent Street, Londres
(*Regent Street, London*),
winter 1906
Oil on canvas
26 x 39 in. (66 x 99 cm)
The Jacques and Natasha
Gelman Collection

PLATE 300
André Derain
La Cathédrale de Saint-Paul,
vue de la Tamise
(*Saint Paul's Cathedral from the*
Thames), winter 1906
Oil on canvas
39 ¼ x 32 ¼ in. (99.7 x 81.9 cm)
The Minneapolis Institute of Arts,
bequest of Putnam Dana
McMillan

Not in exhibition

PLATE 300

PLATE 301
André Derain
La Promenade
(*The Promenade*), 1906
Oil on canvas
18 1/8 x 21 5/8 in. (46 x 55 cm)
Private collection,
Switzerland

PLATE 302
André Derain
D'après Gauguin
(*After Gauguin*), 1906
Oil on canvas
11 x 18 1/8 in. (28 x 42 cm)
Private collection

PLATE 301

PLATE 303
André Derain
La Route dans la montagne
(*The Mountain Road*), 1907
Oil on canvas
31 11/16 x 39 in. (80.5 x 99 cm)
The State Hermitage
Museum, Leningrad

PLATE 302

Plate 303

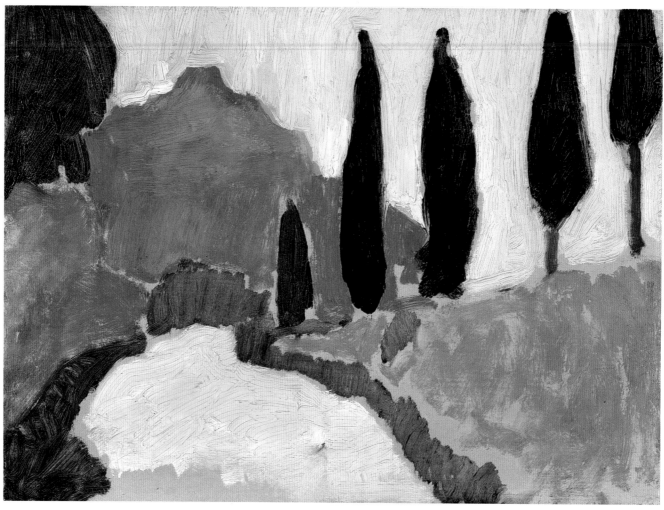

PLATE 304

PLATE 304
André Derain
Les Cyprès
(*The Cypresses*), 1907
Oil on board
9 7/16 x 13 in. (24 x 33 cm)
Private collection,
Switzerland

Kees van Dongen

Voorhaven at Delfshaven,

near Rotterdam,

January 26, 1877–Monaco, 1968

Kees van Dongen, c. 1900–1910

Van Dongen studied at the Academy of Fine Arts in Rotterdam from 1892 to 1897. Concurrently, he began making satirical illustrations for popular journals. After a brief trip to Paris in July 1897, he moved there in 1900. Almost immediately, he became close to the critic and theorist Félix Fénéon and the artist Maximilien Luce. His illustrations appeared in the popular French press during the first years of the twentieth century.

In 1904 van Dongen began to exhibit at the Salon des Indépendants, where he soon got to know André Derain and Maurice de Vlaminck. His two paintings at the 1905 Salon d'Automne were included in room 7, the "salle des Fauves." In 1906 he moved to the Bateau-Lavoir, where Pablo Picasso was also living. Most of van Dongen's work during this period consisted of portraiture; however, he also made some landscapes. In 1907 he signed a contract with Daniel-Henry Kahnweiler and in 1908, with Bernheim-Jeune. A work he showed in the 1913 Salon d'Automne was judged obscene by the police and removed from the Salon, with considerable ink spilled in the press on the subject. After World War 1, van Dongen began to make numerous portraits of high society figures in France. In 1921 he traveled to Venice. The next year he moved to an elegant apartment in Paris, where he became his own dealer. He traveled regularly between Paris, Deauville, and the Midi.

Blé et coquelicot
(*Corn and Poppy*), 1905
Oil on canvas
25 9/16 x 21 3/8 in. (65 x 54.3 cm)
Galerie H. Odermatt–
Ph. Cazeau, Paris
Page 98, plate 113

Raoul Dufy

Le Havre, June 3, 1877–
Forcalquier, 1953

Raoul Dufy, c. 1908–10

PLATE 305
Raoul Dufy
Le Marché aux pommes
(The Apple Market), 1904
Oil on canvas
21 ¼ x 25 9/16 in. (54 x 64.9 cm)
Collection of Samuel J.
and Ethel LeFrak

PLATE 306
Raoul Dufy
Trouville, 1907
Oil on canvas
21 ⅜ x 25 ¾ in. (54.3 x 65.4 cm)
Fridart Foundation

Raoul-Ernest-Joseph Dufy, the eldest of nine children, was raised in a house just outside Le Havre, on the rue de l'Espérance. His father ran a metal-producing firm and was also involved with local musical activities. At age fourteen Raoul began working in the office of Luthy and Hauser, a Swiss company that imported and exported coffee. In 1893 he met Othon Friesz at Le Havre's Ecole Municipal des Beaux-Arts (where Dufy had been studying since 1892 with Charles Lhuillier). Dufy began painting conservative, naturalistic watercolors around Le Havre, Honfleur, and Falaise, as well as family portraits. In 1898 he served in the military in Le Havre but was released after one year thanks to his brother Gaston's service as a flutist in the regimental band.

Dufy went to Paris in 1900 with a municipal scholarship and enrolled, along with Friesz, in Léon Bonnat's studio at the Ecole des Beaux-Arts. Living with Friesz on the rue Cortot in Montmartre, Dufy attracted the attention of the police because a painter-friend, Maurice Delcourt, held anarchist meetings in the apartment, one of which was raided. Dufy exhibited at the Société des Artistes Français in 1901 and switched to the Salon des Indépendants in 1903; he first participated in a group exhibition at Berthe Weill's gallery in 1903 and had his first one-man show there in 1906. During these years he often returned to Le Havre to paint in and around the city, in a style strongly influenced by the Impressionists.

By 1904 Dufy was familiar with the Fauves and friendly with Albert Marquet and Kees van Dongen. With Marquet he traveled to Fécamp in 1904, to Normandy and the Mediterranean coast in 1905, and to Le Havre and Sainte-Adresse in 1906. Powerfully affected by his viewing of Henri Matisse's Luxe, calme, et volupté (plate 175) at the 1905 Salon des Indépendants, Dufy moved away from Impressionism toward a more color-dominated painting. In the summer of 1907 he began a series of paintings called Pêcheurs à la ligne (Fishermen Angling), created in Sainte-Adresse. He spent the summer of 1908 with Georges Braque at L'Estaque, where they both explored a style and palette influenced by Paul Cézanne.

Dufy began to frequent the building known as the Bateau-Lavoir, where Pablo Picasso was living. In 1909 Friesz and Dufy traveled together to Munich. In the early teens he made woodcuts for Guillaume Apollinaire's Bestiaire. Dufy lived with André Lhote and Jean Marchand in Orgeville (Eure) at the Villa Médicis Libre, a subsidized artists' colony. Beginning in 1911 he created designs for fabrics for Paul Poiret and subsequently for the silk manufacturer Bianchini-Ferrier. He acquired a studio at 5, impasse de Guelma, Montmartre, which he maintained until his death.

During World War I, Dufy drove a van for the military postal service. In the summer of 1919 he traveled to Vence, where he began painting the brightly colored images of leisure and sport that became his signature style for the rest of his career. In the 1920s Dufy executed increasing numbers of commissioned works in situ, including murals at the 1925 Exposition Internationale des Arts Décoratifs et Industriels Modernes and the 1937 Pavillon de l'Electricité at the Exposition Internationale, Paris. He also began to make decors for the theater, notably for Jean Cocteau's 1920 production, Le Boeuf sur le toit (which Dufy executed with Henri Le Fauconnier). In 1925 Dufy accompanied Poiret to Morocco. Dufy spent more and more of his time in resort towns along the coast of France—Cannes, Nice, Deauville, and Trouville. During World War II he remained first in Nice, then moved to Perpignan; he moved to Forcalquier in 1952.

Les Bains du Casino Marie-
Christine à Sainte-Adresse
(The Baths of the Marie-Christine
Casino at Sainte-Adresse), 1904
Oil on canvas
23 ⅝ x 28 ¾ in. (60 x 73 cm)
Musée National d'Art Moderne,
Centre Georges Pompidou, Paris
Page 220, plate 229

Le Marché aux pommes
(The Apple Market), 1904
Oil on canvas
21 ¼ x 25 9/16 in. (54 x 64.9 cm)
Collection of Samuel J. and
Ethel LeFrak
Page 293, plate 305

Le Port de Martigues
(The Port of Martigues), 1904
Oil on canvas
18 ⅛ x 21 ⅝ in. (46 x 55 cm)
Musée Cantini, Marseille
Page 60, plate 64

Le Port du Havre
(The Port of Le Havre), 1905–6
Oil on canvas
23 ⅝ x 28 ¾ in. (60·x 73 cm)
Art Gallery of Ontario,
Toronto, gift from the Women's
Committee Fund to commemorate the Golden Jubilee of the
Art Gallery of Toronto, 1953
Page 218, plate 226

Vieilles Maisons sur le Bassin
d'Honfleur
(Old Houses along the Honfleur
Basin), 1905–6
Oil on canvas
23 ⅝ x 28 ¾ in. (60 x 73 cm)
Fridart Foundation
Page 223, plate 234

Les Affiches à Trouville
(Posters at Trouville), 1906
Oil on canvas
25 9/16 x 31 ⅞ in. (65 x 81 cm)
Musée National d'Art Moderne,
Centre Georges Pompidou, Paris
Page 224, plate 235

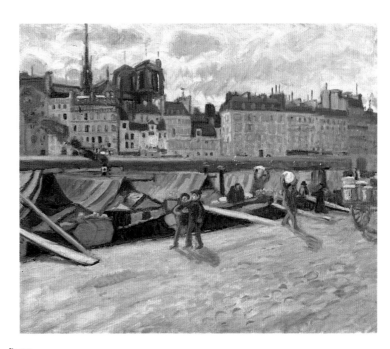

PLATE 305

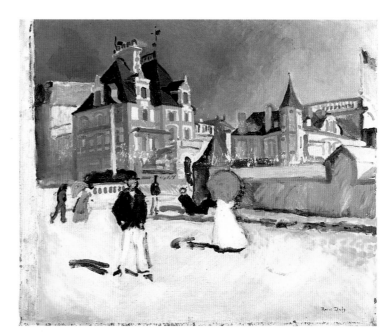

PLATE 306

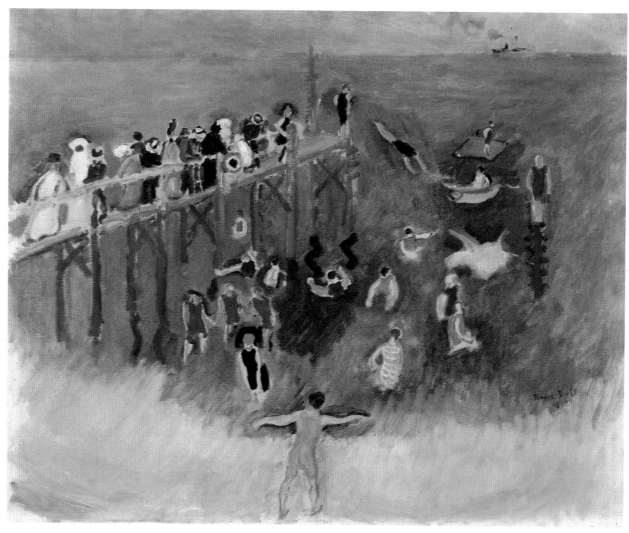

PLATE 307

PLATE 307
Raoul Dufy
La Baignade
(*The Bathing Place*), 1906
Oil on canvas
25 9/16 x 31 7/8 in. (65 x 81 cm)
Galerie Jean-Claude Bellier,
Paris

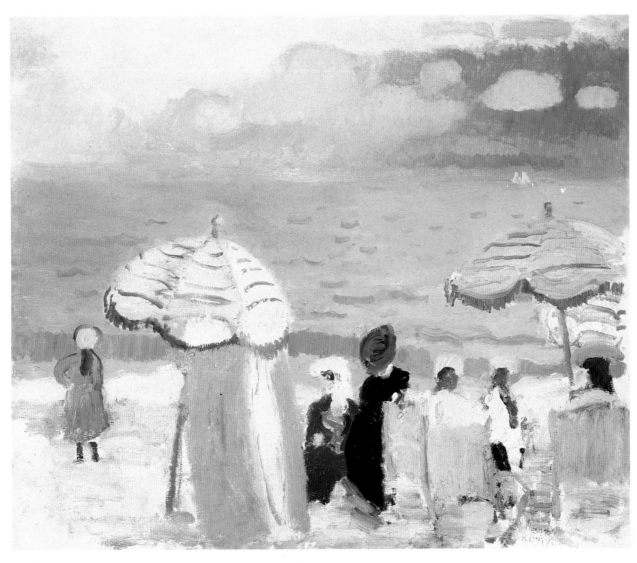

PLATE 308

PLATE 308
Raoul Dufy
Les Parasols
(*The Parasols*), 1906
Oil on canvas
18 x 21 ¾ in. (45.7 x 55.2 cm)
M. Schecter

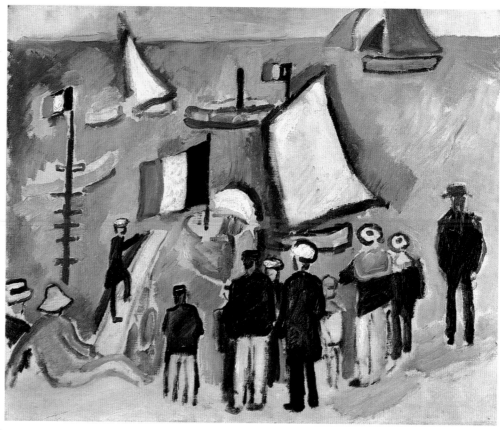

PLATE 309
Raoul Dufy
Les Régates
(*The Regattas*), 1907–8
Oil on canvas
21 ⅜ x 25 ¹¹⁄₁₆ in. (54.3 x 65.3 cm)
Josefowitz Collection

PLATE 309

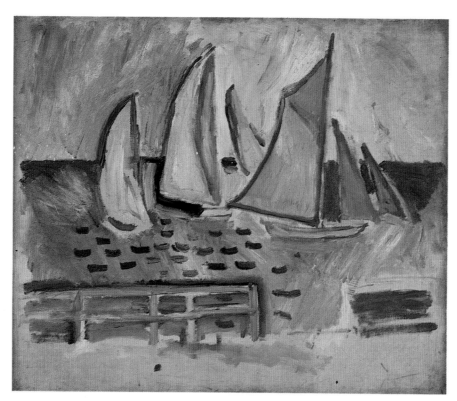

PLATE 310
Raoul Dufy
Sortie des régates au Havre
(*Departure of the Regattas at
Le Havre*), 1906
Oil on canvas
21 ¹⁄₁₆ x 25 ⅜ in. (53.5 x 64.5 cm)
Musée des Beaux-Arts André
Malraux, Le Havre, France

PLATE 311
Raoul Dufy
Barques aux Martigues
(*Boats at Martigues*), 1907
Oil on canvas
18 x 21 ½ in. (45.7 x 54.6 cm)
Private collection, New York

PLATE 310

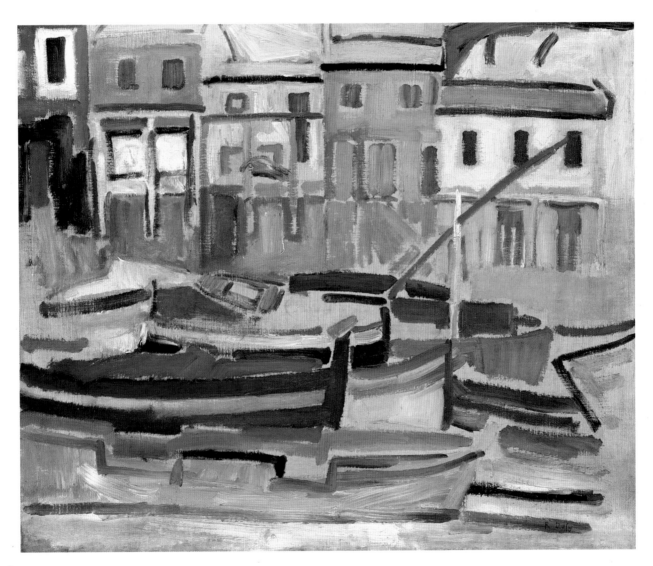

PLATE 311

Othon Friesz

Le Havre, February 6, 1879–

Paris, 1949

Othon Friesz, c. 1908

·Henri-Achille-Emile-Othon Friesz *was the son of a prosperous ship-owner, part of a longtime maritime family. After studying at the Ecole Municipale des Beaux-Arts under Charles Lhuillier, he arrived in Paris in October 1898, supported by a municipal scholarship of 1,200 francs ($244.90) per year to study at the Ecole des Beaux-Arts. Friesz studied with Léon Bonnat until 1903 and made copies in the Louvre.*

In 1900 Friesz joined the military, fulfilling his duty while stationed in Paris. He and Raoul Dufy, who arrived that year, lived together on the rue Cortot in Montmartre. Friesz was commissioned to paint a mural for the Salle de Fête at the 1900 Exposition Universelle. In the same year he took a trip to Brussels and Antwerp, visiting the museums. During his early years in Paris, Friesz often traveled back and forth to Le Havre and painted in Normandy. He exhibited at the Société des Artistes Français in 1901 and 1902 and then switched, along with Dufy, to the Salon des Indépendants in 1903.

Friesz's Fauve work essentially began during his second trip to Antwerp, in the summer of 1906, when he was accompanied by Georges Braque; it was preceded by a stay in Honfleur and a sojourn in Falaise with Dufy. Friesz's work coalesced into brightly colored, relatively linear imagery depicting motifs that are very close to those in Braque's works. With Braque he traveled to L'Estaque (1906–7) and La Ciotat (1907). As the Fauve years reached their end, Friesz increasingly favored a Cubist vocabulary.

In 1909 he and Dufy traveled to Munich, where they painted snow-scapes. In succeeding years Friesz traveled to Italy and Portugal to paint, as well as to far-flung corners of France. He served in the military during World War 1. His postwar paintings became more linear, with a more subdued palette applied to sketchily rendered images. In the 1920s he taught with Fernand Léger at the latter's Académie Moderne. In 1937 Friesz made decors for the Palais de Chaillot, one of the central buildings of that year's World's Fair.

*La Fête foraine à Rouen
(The Traveling Fair at Rouen)*,
1905
Oil on canvas
25 ⁹⁄₁₆ x 21 ¼ in. (65 x 54 cm)
Musée Fabre, Montpellier,
France
Page 299, plate 312

*Le Croiseur pavoisé, Anvers
(The Flag-Draped Cruiser,
Antwerp)*, summer 1906
Oil on canvas
25 ⁹⁄₁₆ x 31 ⅞ in. (65 x 81 cm)
Private collection, Switzerland
Page 211, plate 222

*L'Entrée d'une corvette dans le
port d'Anvers
(The Entry of a Sloop into the Port
of Antwerp)*, summer 1906
Oil on canvas
23 ⅝ x 29 ⅛ in. (60 x 74 cm)
Musée du Petit Palais, Geneva
Page 301, plate 316

*Etude—Anvers
(Study, Antwerp)*, summer 1906
Oil on canvas
11 ⁷⁄₁₆ x 17 ⁵⁄₁₆ in. (29 x 44 cm)
Private collection, Switzerland
Page 300, plate 314

*Le Port d'Anvers
(The Port of Antwerp)*,
summer 1906
Oil on canvas
11 ⁷⁄₁₆ x 17 ⁵⁄₁₆ in. (29 x 44 cm)
Gabriel Sabet, Geneva
Page 300, plate 313

*Le Port d'Anvers
(The Port of Antwerp)*,
summer 1906
Oil on canvas
11 ¹³⁄₁₆ x 17 ¾ in. (30 x 45 cm)
Musée de Grenoble,
Grenoble, France,
Agutte-Sembat Bequest
Page 301, plate 317

*Le Port d'Anvers
(The Port of Antwerp)*,
summer 1906
Oil on canvas
21 ¼ x 25 ⁹⁄₁₆ in. (54 x 65 cm)
Musée d'Art Moderne,
Liège, Belgium
Page 93, plate 104

*Le Port d'Anvers
(The Port of Antwerp)*,
summer 1906
Oil on canvas
31 ½ x 39 ⅜ in. (80 x 100 cm)
Private collection
Page 300, plate 315

*Le Bec de l'Aigle, La Ciotat
(Eagle's Beak, La Ciotat)*, 1907
Oil on canvas
25 ⅝ x 31 ¹⁵⁄₁₆ in. (65.1 x 81.2 cm)
Private collection, Switzerland
Page 48, plate 56

La Ciotat, 1907
Oil on board
10 ¼ x 13 ¾ in. (26 x 35 cm)
Kunstmuseum, Bern, Hermann
and Margrit Rupf Collection
Page 302, plate 318

*Un Dimanche à Honfleur
(A Sunday at Honfleur)*, 1907
Oil on canvas
18 ⅛ x 14 ¹⁵⁄₁₆ in. (46 x 38 cm)
Musée Toulouse-Lautrec,
Albi, France
Not illustrated

L'Estaque, 1907
Oil on canvas
18 ⅛ x 21 ⅝ in. (46 x 55 cm)
Hilde Gerst Gallery, New York
Page 45, plate 51

*Paysage, La Ciotat
(Landscape, La Ciotat)*, 1907
Oil on canvas
25 ½ x 31 ½ in. (64.8 x 80 cm)
Fridart Foundation
Page 103, plate 119

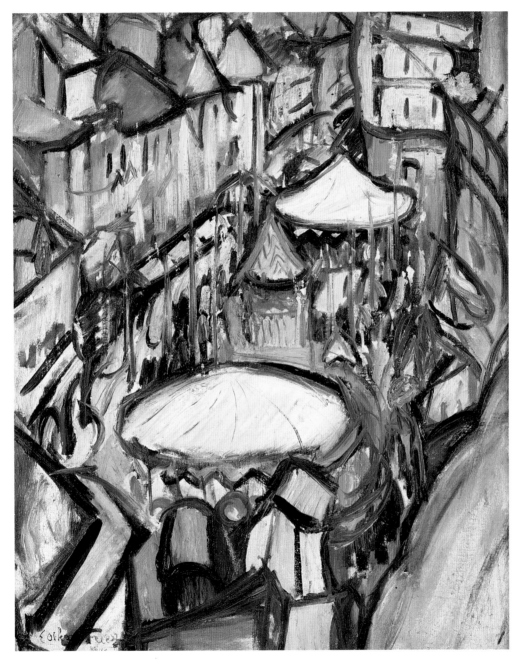

Plate 312

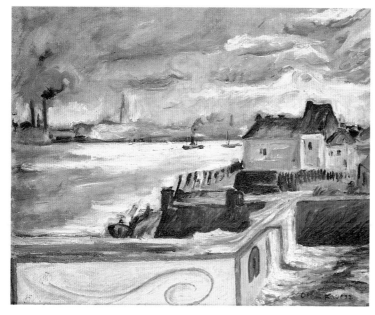

PLATE 313

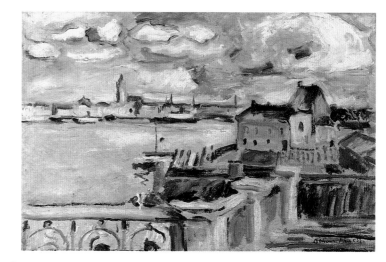

PLATE 314

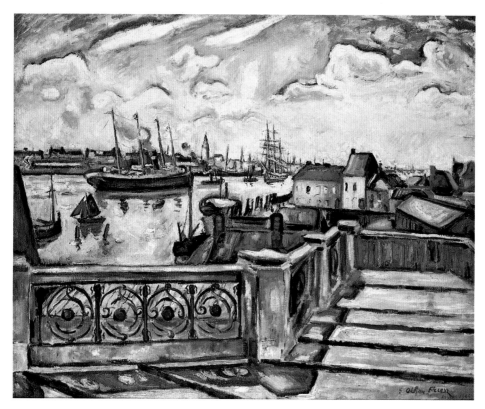

PLATE 315

PLATE 313
Othon Friesz
Le Port d'Anvers
(*The Port of Antwerp*),
summer 1906
Oil on canvas
11 7/16 x 17 5/16 in. (29 x 44 cm)
Gabriel Sabet, Geneva

PLATE 314
Othon Friesz
Etude—Anvers
(*Study, Antwerp*),
summer 1906
Oil on canvas
11 7/16 x 17 5/16 in. (29 x 44 cm)
Private collection,
Switzerland

PLATE 315
Othon Friesz
Le Port d'Anvers
(*The Port of Antwerp*),
summer 1906
Oil on canvas
31 ½ x 39 ⅛ in. (80 x 100 cm)
Private collection

PLATE 316
Othon Friesz
*L'Entrée d'une corvette dans le
port d'Anvers*
(*The Entry of a Sloop into
the Port of Antwerp*),
summer 1906
Oil on canvas
23 ⅝ x 29 ⅛ in. (60 x 74 cm)
Musée du Petit Palais,
Geneva

Exhibited at the Salon
d'Automne, 1906

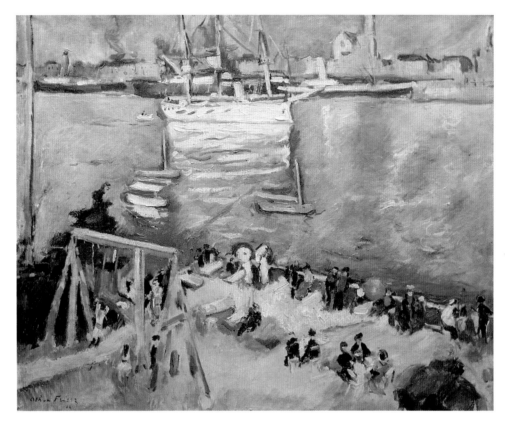

PLATE 316

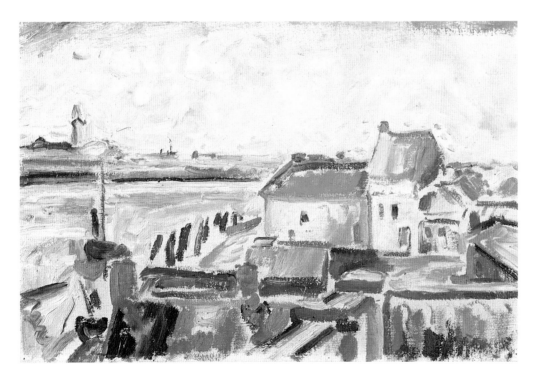

PLATE 317

PLATE 317
Othon Friesz
Le Port d'Anvers
(*The Port of Antwerp*),
summer 1906
Oil on canvas
11 ¹³/₁₆ x 17 ¾ in. (30 x 45 cm)
Musée de Grenoble,
Grenoble, France,
Agutte-Sembat Bequest

PLATE 318

PLATE 318
Othon Friesz
La Ciotat, 1907
Oil on board
10 ¼ x 13 ¼ in. (26 x 35 cm)
Kunstmuseum, Bern,
Hermann and Margrit
Rupf Collection

Henri Manguin

Paris, March 23, 1874–

Saint-Tropez, 1949

Henri Manguin, c. 1904–5

Manguin became a student in Gustave Moreau's atelier in 1894, along with Charles Camoin, Albert Marquet, Henri Matisse, and Jean Puy. After exhibiting for the first time at the Salon des Indépendants in 1902, Manguin became a sociétaire later that autumn at the Salon d'Automne. Manguin's style reached maturity during the Fauve years, with his best work created while he was living along the Mediterranean coast. He used a highly colored palette to depict the light-filled landscapes of the Midi and made numerous paintings of his wife and family.

In 1908 Manguin returned to the Académie Ranson (where he had studied as a young artist) and worked with Marquet and Francis Jourdain. In 1908 he traveled to Naples with Marquet. In 1909 he began a series of annual travels to Italy, Normandy, the Midi, and southwestern France, during which he painted numerous images of the local landscapes, applying his Fauve palette to naturalistic compositions. In 1940 he was in Avignon, where he remained throughout World War II. In 1949 he left Paris to live in Saint-Tropez.

Saint-Tropez, le coucher de soleil
(*Saint-Tropez, Sunset*),
autumn 1904
Oil on canvas
31 ⅞ x 25 ⁹/₁₆ in. (81 x 65 cm)
Mr. and Mrs. Jean-Pierre
Manguin, Avignon, France
Page 34, plate 29

*La Femme à la grappe,
Villa Demière*
(*Woman with Grapes,
Villa Demière*), 1905
Oil on canvas
45 ¹¹/₁₆ x 31 ⅞ in. (116 x 81 cm)
Fondation Pierre Gianadda,
Martigny, Switzerland
Page 72, plate 79

Nu sous les arbres, Villa Demière
(*Nude under the Trees,
Villa Demière*), summer 1905
Oil on canvas
21 ¼ x 25 ⁹/₁₆ in. (54 x 65 cm)
Dr. and Mrs. Steven G.
Cooperman
Page 304, plate 319

*Le 14 Juillet à Saint-Tropez,
côté droit*
(*July 14 in Saint-Tropez,
Right Side*), summer 1905
Oil on canvas
24 x 19 ¹¹/₁₆ in. (61 x 50 cm)
Private collection,
Avignon, France
Page 75, plate 84

*Le 14 Juillet à Saint-Tropez,
côté gauche*
(*July 14 in Saint-Tropez,
Left Side*), summer 1905
Oil on canvas
24 x 19 ¹¹/₁₆ in. (61 x 50 cm)
Private collection,
Avignon, France
Page 75, plate 83

Jeanne à l'ombrelle, Cavalière
(*Jeanne with an Umbrella, Cavalière*), spring–summer 1906
Oil on canvas
24 x 19 ¹¹/₁₆ in. (61 x 50 cm)
Kunsthalle, Bielefeld,
West Germany
Page 305, plate 322

Le Matin à Cavalière
(*Morning at Cavalière*),
summer 1906
Oil on canvas
32 ⅛ x 25 ⅜ in. (81.5 x 64.5 cm)
The State Hermitage
Museum, Leningrad
Page 305, plate 321

La Pinède à Cavalière
(*The Pine Forest at Cavalière*),
spring–summer 1906
Oil on canvas
25 ⁹/₁₆ x 31 ⅞ in. (65 x 81 cm)
Private collection,
Avignon, France
Page 94, plate 105

*Saint-Tropez vu de la Villa
Demière*
(*Saint-Tropez Seen from the Villa
Demière*), spring–summer 1906
Oil on canvas
31 ⅞ x 25 ⁹/₁₆ in. (81 x 65 cm)
Private collection,
Avignon, France
Page 304, plate 320

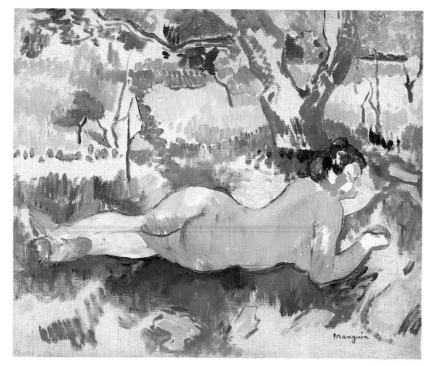

PLATE 319

PLATE 319

PLATE 319
Henri Manguin
Nu sous les arbres, Villa Demière
(*Nude under the Trees,*
Villa Demière), summer 1905
Oil on canvas
21 ¼ x 25 ⁹⁄₁₆ in. (54 x 65 cm)
Dr. and Mrs. Steven G.
Cooperman

PLATE 320
Henri Manguin
Saint-Tropez vu de la Villa
Demière
(*Saint-Tropez Seen from*
the Villa Demière),
spring–summer 1906
Oil on canvas
31 ⅞ x 25 ⁹⁄₁₆ in. (81 x 65 cm)
Private collection,
Avignon, France

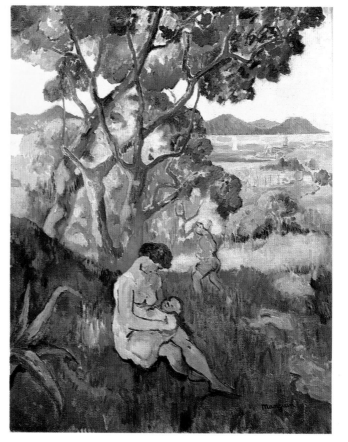

PLATE 320

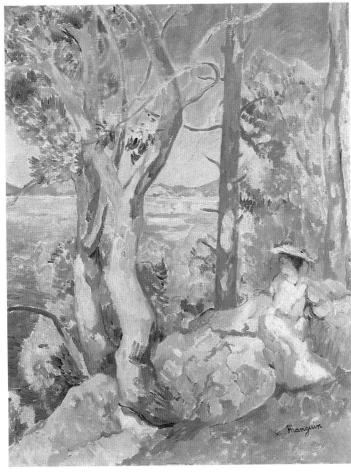

PLATE 321

PLATE 321
Henri Manguin
Le Matin à Cavalière
(*Morning at Cavalière*),
summer 1906
Oil on canvas
32 ⅛ x 25 ⅜ in. (81.5 x 64.5 cm)
The State Hermitage
Museum, Leningrad

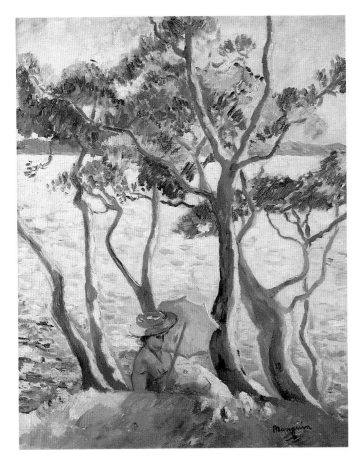

PLATE 322

PLATE 322
Henri Manguin
Jeanne à l'ombrelle, Cavalière
(*Jeanne with an Umbrella,
Cavalière*),
spring–summer 1906
Oil on canvas
24 x 19 ¹¹⁄₁₆ in. (61 x 50 cm)
Kunsthalle, Bielefeld,
West Germany

Albert Marquet

Bordeaux, March 26, 1875–

Paris, 1947

Albert Marquet, c. 1905

PLATE 323
Albert Marquet
Porte de Saint-Cloud
(Gate of Saint-Cloud), 1904
Oil on canvas
18 ⅛ x 25 ⁹/₁₆ in. (46 x 65 cm)
Musée des Beaux-Arts,
Bordeaux, France

Marquet was raised in Bordeaux and spent his summers with his mother's family in Teich, along the Bassin d'Arcachon. He went to Paris in 1890 and studied at the Ecole des Beaux-Arts, first with Aimé Morot and then with Gustave Moreau; there he met Charles Camoin, Henri Manguin, Henri Matisse, and Jean Puy. Subsequently he enrolled at the studio of Fernand Cormon. Marquet began exhibiting at the Salon des Indépendants in 1901. In 1903 he spent the summer with Manguin at La Percaillerie and Falaise. With Raoul Dufy he traveled to Fécamp in 1904, to Normandy and the Mediterranean coast in 1905, and to Le Havre and Sainte-Adresse in 1906. With Camoin and Othon Friesz he went to London in 1907. Marquet's paintings during the Fauve years were often subdued—this was particularly true of the dozens of views he made of the bridges over the Seine and of Notre Dame; only occasionally did flecks of brilliant color invade his loosely painted canvases.

In 1908 Marquet moved to a studio vacated by Matisse at 19, quai Saint-Michel, where he remained until 1931. He was an avid traveler: he visited Hamburg in the winter of 1909 and Naples that summer, and he had previously traveled to Naples in 1908 with Manguin. Marquet often depicted ports, visiting important or easily accessible harbors. He was also interested in painting nudes and portraits, which he rendered with the same smooth brushwork and evenly applied colors that he preferred in the years after his Fauve period. In 1911 and 1913 Marquet traveled to Morocco.

At the outbreak of World War I, Marquet was in Rotterdam. He traveled to Collioure and then to Marseille, continuing to paint. After the war he returned to Paris and resumed painting views of the Seine. He spent much of his time traveling along the Mediterranean coast, as well as to Tunisia, Morocco, and Algeria; he also visited Norway, Romania, Sweden, Holland, Italy, and the Soviet Union. During World War II he remained in Algeria, where his wife's family was living.

Notre Dame (Soleil)
(Notre Dame [Sun]), 1904
Oil on canvas
28 ¼ x 23 ⅝ in. (73 x 60 cm)
Musée des Beaux-Arts,
Pau, France
Page 244, plate 258

Porte de Saint-Cloud
(Gate of Saint-Cloud), 1904
Oil on canvas
18 ⅛ x 25 ⁹/₁₆ in. (46 x 65 cm)
Musée des Beaux-Arts,
Bordeaux, France
Page 307, plate 323

La Plage à Sainte-Adresse
(The Beach at Sainte-Adresse),
1906
Oil on canvas
25 ⁹/₁₆ x 31 ⅞ in. (65 x 81 cm)
Former collection of Boris Fize
Page 95, plate 108

Notre Dame sous la neige
(Notre Dame under Snow), 1905
Oil on canvas
25 ⁹/₁₆ x 32 ¼ in. (65 x 82 cm)
Musée Cantonal des
Beaux-Arts, Lausanne
Page 308, plate 326

Quai du Louvre
(The Louvre Embankment), 1905
Oil on canvas
25 ⁹/₁₆ x 31 ½ in. (65 x 80 cm)
Fridart Foundation
Page 308, plate 324

Le Soleil à travers les arbres
(The Sun across the Trees), 1905
Oil on canvas
25 ⁹/₁₆ x 32 ¼ in. (65 x 82 cm)
State Pushkin Museum,
Moscow
Page 9

Les Affiches à Trouville
(Posters at Trouville), 1906
Oil on canvas
25 x 31 ½ in. (63.5 x 80 cm)
Mrs. John Hay Whitney
Page 225, plate 236

Carnaval au Havre
(Carnival at Le Havre), 1906
Oil on canvas
25 ⁹/₁₆ x 31 ⅞ in. (65 x 81 cm)
Musée des Beaux-Arts,
Bordeaux, France
Page 227, plate 239

Carnaval sur la plage
(Carnival on the Beach), 1906

Also known as *Carnival at Fécamp*
Oil on canvas
19 ¹¹/₁₆ x 24 in. (50 x 61 cm)
David Bonderman
Page 310, plate 330

La Plage de Fécamp
(The Beach at Fécamp),
summer 1906
Oil on canvas
19 ¹¹/₁₆ x 24 in. (50 x 61 cm)
Musée National d'Art Moderne,
Centre Georges Pompidou, Paris
Page 222, plate 233

Le Pont-Neuf au soleil
(Pont-Neuf in the Sun), 1906
Oil on canvas
28 ¾ x 36 ¼ in. (73 x 92 cm)
Museum Boymans-van
Beuningen, Rotterdam,
The Netherlands
Page 309, plate 329

Le Port de Fécamp
(The Port of Fécamp), 1906
Oil on canvas
25 ¹³/₁₆ x 31 ⅞ in. (65.5 x 81 cm)
Musée des Beaux-Arts,
Quimper, France
Page 259, plate 274

Quai du Louvre et le Pont-Neuf à Paris
(The Louvre Embankment and the Pont-Neuf in Paris), 1906
Oil on canvas
23 ⅝ x 27 ¹⁵/₁₆ in. (60 x 71 cm)
The State Hermitage
Museum, Leningrad
Page 309, plate 327

La Seine au Pont-Neuf,
effet de brouillard
(The Seine at Pont-Neuf,
Fog Effect), 1907
Oil on canvas
25 ⁹/₁₆ x 31 ⅞ in. (65 x 81 cm)
Musée des Beaux-Arts, Nancy,
France, Galilée Bequest
Page 9

Le Pont Saint-Michel, 1908
Oil on canvas
25 ⁹/₁₆ x 31 ⅞ in. (65 x 81 cm)
Musée de Grenoble,
Grenoble, France,
Agutte-Sembat Bequest
Page 308, plate 325

Quai Bourbon, 1908
Oil on canvas
36 ¼ x 28 ¾ in. (92 x 73 cm)
Musée des Beaux-Arts,
Bordeaux, France
Page 309, plate 328

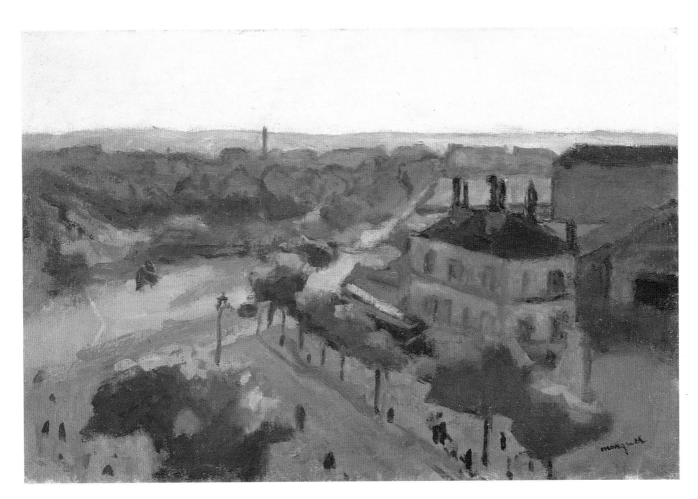

PLATE 323

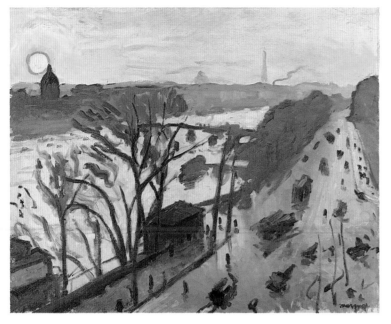

PLATE 324

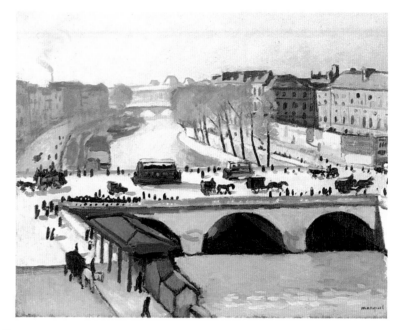

PLATE 325

PLATE 324
Albert Marquet
Quai du Louvre
(*The Louvre Embankment*),
1905
Oil on canvas
25 ⁹⁄₁₆ x 31 ½ in. (65 x 80 cm)
Fridart Foundation

PLATE 325
Albert Marquet
Le Pont Saint-Michel, 1908
Oil on canvas
25 ⁹⁄₁₆ x 31 ⅞ in. (65 x 81 cm)
Musée de Grenoble,
Grenoble, France,
Agutte-Sembat Bequest

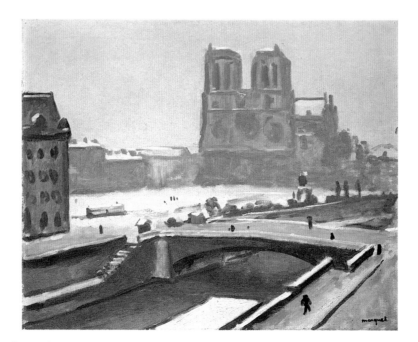

PLATE 326
Albert Marquet
Notre Dame sous la neige
(*Notre Dame under Snow*), 1905
Oil on canvas
25 ⁹⁄₁₆ x 32 ¼ in. (65 x 82 cm)
Musée Cantonal des
Beaux-Arts, Lausanne

PLATE 326

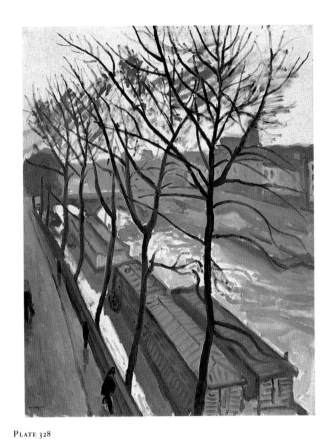

PLATE 328

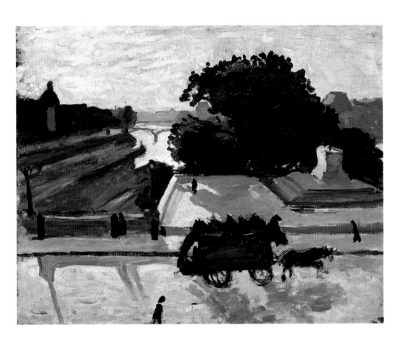

PLATE 327

PLATE 328
Albert Marquet
Quai Bourbon, 1908
Oil on canvas
36 ¼ x 28 ¾ in. (92 x 73 cm)
Musée des Beaux-Arts,
Bordeaux, France

PLATE 329
Albert Marquet
Le Pont-Neuf au soleil
(*Pont-Neuf in the Sun*), 1906
Oil on canvas
28 ¾ x 36 ¼ in. (73 x 92 cm)
Museum Boymans-van
Beuningen, Rotterdam,
The Netherlands

PLATE 327
Albert Marquet
*Quai du Louvre et le Pont-Neuf
à Paris*
(*The Louvre Embankment and
the Pont-Neuf in Paris*), 1906
Oil on canvas
23 ⅝ x 27 ¹⁵/₁₆ in. (60 x 71 cm)
The State Hermitage
Museum, Leningrad

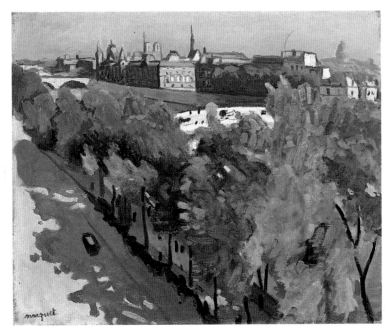

PLATE 329

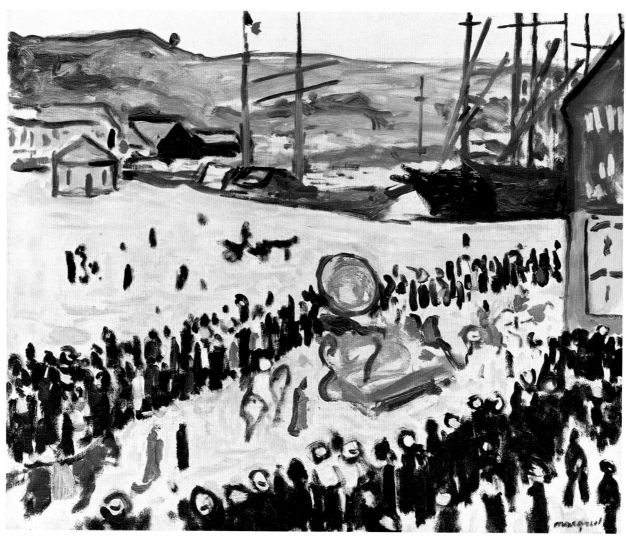

PLATE 330

PLATE 330
Albert Marquet
Carnaval sur la plage
(*Carnival on the Beach*), 1906
Also known as *Carnival at
Fécamp*
Oil on canvas
19 11/16 x 24 in. (50 x 61 cm)
David Bonderman

Henri Matisse

Cateau-Cambrésis,

December 31, 1869–1954, Nice

Henri Matisse, 1909

Matisse moved to Paris to study law in 1892, but he soon enrolled at the Ecole des Beaux-Arts in the studio of Adolphe-William Bouguereau. Subsequently, Matisse joined Gustave Moreau's atelier, where he met Charles Camoin, Henri Manguin, Albert Marquet, and Jean Puy. In 1896 he began to exhibit, first at the Salon of the Société Nationale des Beaux-Arts, and he became a sociétaire soon thereafter. In Corsica in 1898 Matisse began to paint highly colored small canvases—now identified as his "proto-Fauve" oeuvre—which were followed by more subdued views of Paris, relatively larger in scale. In 1899 he married Amélie Parayre and they honeymooned in London, where Matisse studied Joseph Mallord William Turner's work.

During the Fauve years Matisse was the focus for many of the artists associated with the group. In 1904 he summered with Paul Signac in Saint-Tropez, met Henri-Edmond Cross, and experimented with a Divisionist style. His first summer in Collioure was in 1905, where he was joined by André Derain; he would return there frequently in subsequent years. During those summers he began to make sculpture in clay and in bronze as well as decorative ceramics. From 1908 to 1911 he ran an art academy, where he taught mostly American, German, and Scandinavian students. At the end of 1908 he published his most important statement as an artist, "Notes d'un peintre."

In 1909 Matisse signed his first contract with Bernheim-Jeune. In 1909–10 he painted several decorative panels for the house of the Russian collector Sergei Shchukin. He traveled to Munich in 1910 to see an exhibition of Islamic art. The next year he went to Moscow, at the invitation of Shchukin, and studied Russian icons. In 1912–13 he made trips to Morocco.

Matisse remained in Paris during World War I. In 1917 he met Pierre-Auguste Renoir for the first time, in Cagnes-sur-Mer, and one year later Matisse began his series of Odalisques. He rented rooms in the Hôtel de la Méditerranée on the Promenade des Anglais in Nice, and his Nice period began. Increasingly, Matisse returned to painting views out of his windows or to painting models in his room. In 1920 he created decors for the Ballets Russes's production of Le Chant de rossignol. In 1930–31 he traveled extensively, to Italy, Spain, Germany, England, the Soviet Union, and Oceania, spending three months in Tahiti. On his way back to France he stopped in the United States, where he painted a mural for Dr. Albert Barnes in Merion, Pennsylvania. During World War II he remained in France, mostly in Nice; in failing health, he made a series of papiers découpés (cutouts). In 1948 he began work on designs for the Dominican Chapel in Vence, which was consecrated in 1951.

Le Goûter (Golfe de Saint-Tropez)
(Midday Snack [Gulf of Saint-Tropez]), summer 1904
Also known as *By the Sea*
Oil on canvas
25 9/16 x 19 7/8 in. (65 x 50.5 cm)
Kunstsammlung Nordrhein-Westfalen, Düsseldorf, West Germany
Page 157, plate 163

Notre Dame, c. 1904
Oil on board
11 3/4 x 12 13/16 in.
(29.9 x 32.5 cm)
Private collection, Paris
Page 62, plate 66

La Japonaise au bord de l'eau
(The Japanese Woman at the Seashore), summer 1905
Also known as *La Japonaise, Mme Matisse,* and *Woman beside the Water*
Oil on canvas
13 7/8 x 11 1/8 in. (35.2 x 28.2 cm)
Collection, The Museum of Modern Art, New York, purchase and partial anonymous gift
Page 175, plate 177

Nu dans un paysage, Collioure
(Nude in a Landscape, Collioure),
1905
Oil on panel
16 x 12 1/2 in. (40.6 x 31.7 cm)
Nippon Autopolis Co., Ltd.
Page 26, plate 21

La Pastorale
(Pastoral), 1905
Oil on canvas
18 1/8 x 21 5/8 in. (46 x 55 cm)
Musée d'Art Moderne de la Ville de Paris
Page 27, plate 23

Paysage à Collioure
(*Landscape at Collioure*), 1905
Oil on canvas
15 ⅜ x 18 ⅜ in. (39 x 46.7 cm)
Private collection, New York
Page 182, plate 183

Paysage à Collioure
(*Landscape at Collioure*), 1905
Oil on canvas
18 ⅜ x 15 ⅜ in. (46.7 x 39.1 cm)
Private collection
Page 314, plate 333

Paysage à Collioure
(*Landscape at Collioure*), 1905
Also known as *Promenade among
the Olive Trees*
Oil on canvas
17 ½ x 21 ¼ in. (44.5 x 55.2 cm)
The Metropolitan Museum of
Art, New York, Robert Lehman
Collection, 1975.1.194
Page 69, plate 76

Le Port d'Avall
(*The Port of Avall*),
summer 1905
Previously known as *Le Port
d'Abaill*
Oil on canvas
23 ⅝ x 55 ⅛ in. (60 x 140 cm)
Private collection
Page 78, plate 88

Rue à Collioure
(*Street in Collioure*), 1905
Oil on canvas
18 ⅛ x 21 ⅝ in. (46 x 55 cm)
Private collection
Page 70, plate 77

La Sieste
(*The Rest*), 1905
Also known as *Intérieur à
Collioure (Interior at Collioure)*
Oil on canvas
23 ¼ x 28 ⅜ in. (59 x 72 cm)
Private collection, Switzerland
Page 71, plate 78

Vue de Collioure
(*View of Collioure*),
summer 1905
Oil on board
8 ⅝ x 19 in. (21.9 x 48.3 cm)
The Museum of Fine Arts,
Houston, gift of Oveta Culp
Hobby
Page 78, plate 89

Vue de Collioure
(*View of Collioure*),
summer 1905
Oil on canvas
23 ⁷⁄₁₆ x 28 ¾ in. (59.5 x 73 cm)
The State Hermitage
Museum, Leningrad
Page 155, plate 161

La Côte, Collioure
(*The Coast of Collioure*),
c. 1905–6
Also known as *La Moulade*
Oil on panel
9 ½ x 13 in. (24.1 x 33 cm)
Private collection, courtesy
Barbara Divver Fine Art
Page 23, plate 15

Marine (Bord de mer)
(*Seascape [Seashore]*), c. 1905–6
Oil on board mounted on panel
9 ⅝ x 12 ¾ in. (24.5 x 32.4 cm)
San Francisco Museum of
Modern Art, bequest of
Mildred B. Bliss
Page 313, plate 331

Marine (La Moulade)
(*Seascape [La Moulade]*),
c. 1905–6
Oil on board mounted on panel
10 ¼ x 13 ¼ in. (26 x 33.7 cm)
San Francisco Museum of
Modern Art, bequest of
Mildred B. Bliss
Page 152, plate 159

La Moulade, Collioure, c. 1905–6
Oil on canvas
12 ½ x 10 in. (31.8 x 25.4 cm)
Private collection
Page 314, plate 332

Paysage à Collioure
(*Landscape at Collioure*), 1907
Oil on canvas
28 ¹⁵⁄₁₆ x 23 ¹³⁄₁₆ in.
(73.5 x 60.5 cm)
Private collection
Page 314, plate 334

Trois Baigneuses
(*Three Bathers*), 1907
Oil on canvas
24 x 29 in. (61 x 73.7 cm)
The Minneapolis Institute of
Arts, bequest of Putnam Dana
McMillan
Page 315, plate 335

Baigneuses à la tortue
(*Bathers with a Turtle*), 1908
Oil on canvas
70 ½ x 86 ¾ in.
(179.1 x 220.3 cm)
Saint Louis Art Museum, gift of
Mr. and Mrs. Joseph Pulitzer, Jr.
Page 33, plate 28

Petit Nu, assis
(*Small Seated Nude*), c. 1909
Oil on canvas
13 x 16 ⅛ in. (33 x 41 cm)
Musée de Grenoble,
Grenoble, France,
Agutte-Sembat Bequest
Page 316, plate 336

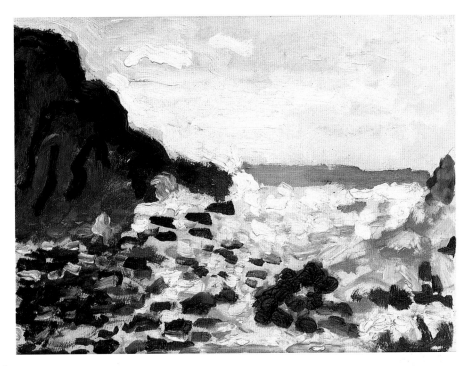

PLATE 331

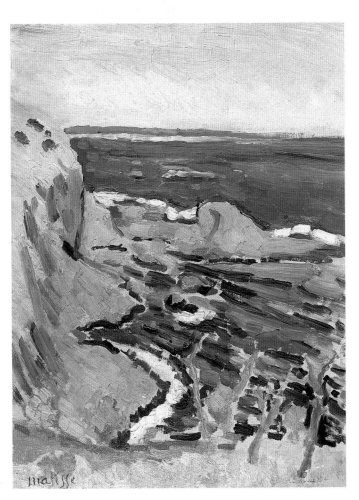

PLATE 332

PLATE 331
Henri Matisse
Marine (Bord de mer)
(*Seascape [Seashore]*), c. 1905–6
Oil on board mounted on
panel
9 ⅝ x 12 ¾ in. (24.5 x 32.4 cm)
San Francisco Museum of
Modern Art, bequest of
Mildred B. Bliss

Included in Matisse's 1906
exhibition at Galerie Druet, Paris

PLATE 332
Henri Matisse
La Moulade, Collioure,
c. 1905–6
Oil on canvas
12 ½ x 10 in. (31.8 x 25.4 cm)
Private collection

PLATE 333
Henri Matisse
Paysage à Collioure
(*Landscape at Collioure*), 1905
Oil on canvas
18 ⅜ x 15 ⅜ in. (46.7 x 39.1 cm)
Private collection

PLATE 334
Henri Matisse
Paysage à Collioure
(*Landscape at Collioure*), 1907
Oil on canvas
28 ¹⁵⁄₁₆ x 23 ¹³⁄₁₆ in. (73.5 x 60.5 cm)
Private collection

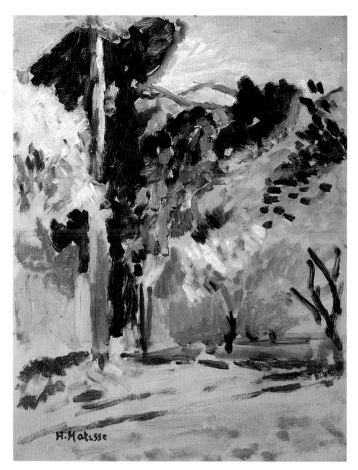

PLATE 333

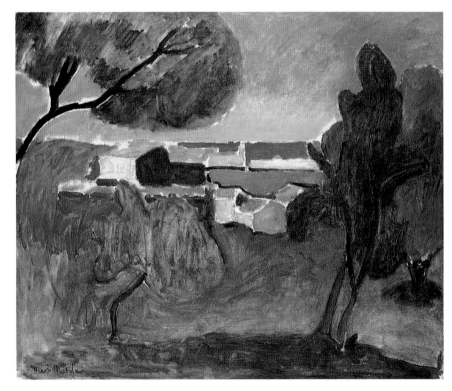

PLATE 335
Henri Matisse
Trois Baigneuses
(*Three Bathers*), 1907
Oil on canvas
24 x 29 in. (61 x 73.7 cm)
The Minneapolis Institute of
Arts, bequest of Putnam
Dana McMillan

PLATE 334

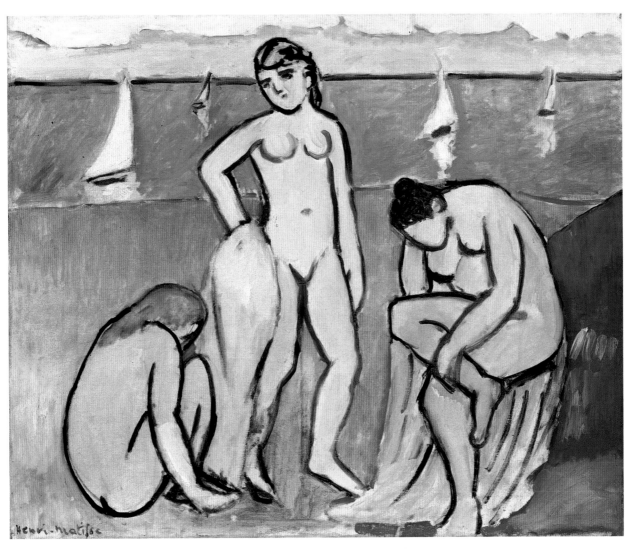

PLATE 335

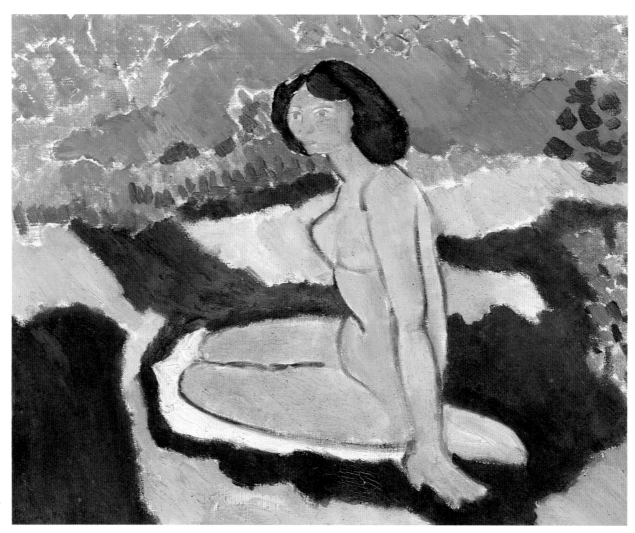

PLATE 336

PLATE 336
Henri Matisse
Petit Nu, assis
(*Small Seated Nude*), c. 1909
Oil on canvas
13 x 16 ⅛ in. (33 x 41 cm)
Musée de Grenoble,
Grenoble, France,
Agutte-Sembat Bequest

Jean Puy

Roanne, November 8, 1876–

Roanne, 1960

Jean Puy, c. 1920

Puy studied with the painter Tony Tollet at the Ecole des Beaux-Arts in Lyon beginning in 1895. He arrived in Paris three years later and studied with Jean-Paul Laurens and Benjamin Constant at the Académie Julian, then at Eugène Carrière's studio, where he met many of the students from Gustave Moreau's studio, including Henri Matisse and André Derain. His friendship with the Fauve artists who were his fellow students led to his exhibiting with them at the Salons and in gallery exhibitions. He exhibited in the 1904 Salon d'Automne and became a sociétaire the following year. Through his association with the Fauves and the dealer Ambroise Vollard, he began to make ceramics at André Méthey's studio. Although his style remained conservative compared to those of Derain, Matisse, and Maurice de Vlaminck, Puy shared their interest in landscape painting.

Puy remained in France during World War I and served at the front. In 1916 he joined the camouflage section of the French forces, along with Charles Camoin, Jacques Villon, and Dunoyer de Segonzac. Throughout the 1920s Puy traveled between Paris, Brittany, and the Côte d'Azur; gradually he migrated to the region around Lyon, where he stayed for much of the remainder of his life.

Louis Valtat

Dieppe, August 8, 1869–

Paris, 1952

Louis Valtat, c. 1900

Valtat began his artistic studies in Paris in 1887 and was soon admitted to the Ecole des Beaux-Arts. He frequented the studio of Henri Harpignies and perhaps that of Gustave Moreau. In 1889 he exhibited for the first time at the Salon des Indépendants. In 1891, following his military service, he enrolled at the Académie Julian; while there he met Pierre Bonnard and Maximilien Luce. He also worked with Aristide Maillol on some of his earliest sculptures. Between 1894 and 1896 Valtat traveled frequently to Arcachon; in 1897 he first visited Agay, where he built a house two years later. Thereafter he spent most of each year in the Midi. During these years he visited Pierre-Auguste Renoir in Cagnes and also met with Paul Signac. In 1900 he married Suzanne Noël, and they visited Florence and Venice. Valtat exhibited in the 1905 Salon d'Automne, although not in room 7, the "cage des fauves." Nonetheless, his work was illustrated in the famous article in L'Illustration, alongside that of the other Fauve artists. In 1906 he traveled to Algeria.

From 1908 to 1920 Valtat regularly visited Normandy and Brittany. After 1913 he stopped visiting the Midi and sold his house in Agay. From 1915 to 1924 he traveled principally in Normandy, while exhibiting regularly in Paris. In 1924 Valtat settled in Choisel, in the valley of the Chevreuse. He spent considerable time there throughout the rest of his life. After 1948 Valtat was blinded by glaucoma.

La Hutte dans la forêt
(*Hut in the Wood*), 1906
Oil on canvas
26 x 37 1/16 in. (66 x 83 cm)
State Pushkin Museum,
Moscow
Page 318, plate 338

Le Golfe d'Anthéor
(*The Gulf of Anthéor*), 1907
Oil on canvas
29 1/8 x 36 5/8 in. (74 x 93 cm)
The State Hermitage
Museum, Leningrad
Page 318, plate 337

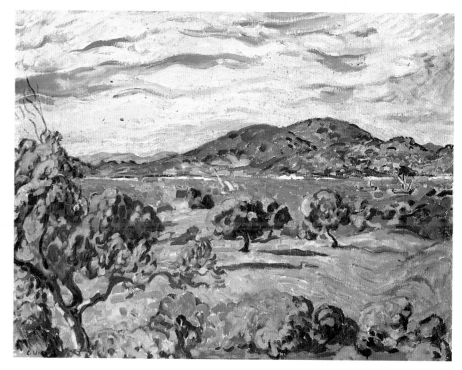

PLATE 337

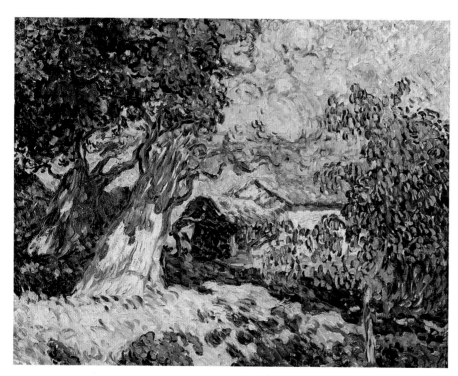

PLATE 338

PLATE 337
Louis Valtat
Le Golfe d'Anthéor
(*The Gulf of Anthéor*), 1907
Oil on canvas
29 ⅛ x 36 ⅝ in. (74 x 93 cm)
The State Hermitage
Museum, Leningrad

PLATE 338
Louis Valtat
La Hutte dans la forêt
(*Hut in the Wood*), 1906
Oil on canvas
26 x 37 1/16 in. (66 x 83 cm)
State Pushkin Museum,
Moscow

Maurice de Vlaminck

Paris, April 4, 1876–

La Tourillière, 1958

Maurice de Vlaminck, c. 1906

Born on the rue Pierre Lescot, near Les Halles, Vlaminck was raised by his Flemish-Catholic father and Protestant mother from Lorraine; both parents were musicians. At age three Vlaminck and his family moved to Le Vésinet to live with his maternal grandmother. In 1892 Vlaminck acquired his first racing cycle, which replaced his aging bicycle; eventually he planned to make a living as a professional cyclist. In 1893 he took drawing lessons from a M. Robichon and also painted on the Ile de Chatou with a naive painter, Henri Rigal. Vlaminck married Suzanne Berly in 1894. To support his family he gave violin lessons and raced professionally; after contracting typhoid fever in 1896 he was forced to end his cycling career. In November of the same year he began his military service at Vitré in Brittany, where he served as a musician in the 70th Regiment. On June 18, 1900, during one of his fifteen-day leaves, Vlaminck met André Derain. Demobilized in September, Vlaminck rented a studio with Derain in the abandoned hotel-restaurant Levanneur on the Ile-de-Chatou. His books D'un lit dans l'autre (From One Bed to Another, 1902) and Tout pour ça (All for That, 1903), thinly veiled pornographic novels, were published with illustrations by Derain.

During the Fauve years Vlaminck remained mostly in and around Chatou, exhibiting his work alongside that of the other Fauve artists at the Salons des Indépendants and d'Automne. About 1908 his palette grew increasingly blue and brown and his forms became distinctly Cézannesque.

In 1911, at the suggestion of the dealer Ambroise Vollard, Vlaminck made his first trip to London and painted along the Thames. In 1913 he joined Derain in Marseille and Martigues. During World War I he served in the reserve of the 74th Regiment in Rouen and was posted at various factories around Paris. He began to write poetry. After the war he resided in various towns in the northwestern suburbs of Paris, eventually settling in La Tourillière, in Rueil-la-Gadelière. With his second wife, Berthe Combes, he had two daughters, Edwige (born 1920) and Godelieve (born 1927). In 1925 he began to travel throughout France, a practice he continued each year, although the vast majority of his work was done in the suburbs of Paris along the Seine. His work made before and after World War II consists principally of landscapes and still lifes, characterized by a dark palette and thick strokes of paint enlivened by touches of white. During World War II he traveled to Berlin with other French artists, including Derain, to attend the opening of an exhibition of work by the Nazi sculptor Arno Brecker. He published dozens of autobiographical books, containing considerable exaggerations about his life and his relations with other artists.

Les Canotiers à Chatou
(*The Boaters at Chatou*), c. 1904
Oil on canvas
23 5/8 x 28 7/8 in. (60 x 73.3 cm)
Perls Galleries, New York
Page 20, plate 11

L'Etang de Saint-Cucufa
(*The Pond at Saint-Cucufa*),
c. 1904
Oil on canvas
21 1/4 x 25 9/16 in. (54 x 65 cm)
Former collection of Boris Fize
Page 65, plate 71

Paysage
(*Landscape*), c. 1904
Oil on canvas
28 9/16 x 39 in. (72.5 x 99 cm)
Private collection
Page 320, plate 339

Dans le jardin de mon père
(*In the Garden of My Father*),
1904–5
Oil on canvas
19 11/16 x 25 9/16 in. (50 x 65 cm)
National Museum, Belgrade,
Yugoslavia
Page 251, plate 267

*La Ferme de blé avec
la maison rouge*
(*The Wheat Farm with
the Red House*), 1905
Oil on canvas
23 5/8 x 28 3/4 in. (60 x 73 cm)
Shizuoka Prefectural Museum of
Art, Shizuoka, Japan
Page 320, plate 340

Le Pont de Chatou
(*The Bridge at Chatou*), 1905
Oil on canvas
25 3/4 x 32 in. (65.4 x 81.3 cm)
Private collection, California
Page 132, plate 139

Canot
(*Canal Boat*), 1905–6
Oil on canvas
23 11/16 x 28 3/4 in.
(60.2 x 73.1 cm)
Bridgestone Museum of Art,
Ishibashi Foundation, Tokyo
Page 321, plate 342

Le Pont de Chatou
(*The Bridge at Chatou*), 1905–6
Also known as *Les Bateaux-lavoirs*
(*The Laundry Boats*)
Oil on canvas
21 1/4 x 28 3/4 in. (54 x 73 cm)
Musée de l'Annonciade, Saint-
Tropez, France
Page 125, plate 129

Le Pont de Chatou
(*The Bridge at Chatou*), 1905–6
Oil on canvas
28 ¾ x 39 9/16 in. (73 x 100.5 cm)
Private collection
Page 144, plate 154

La Colline à Bougival
(*The Hill at Bougival*), 1906
Also known as *The Valley of the
Seine at Carrières-Saint-Denis*
Oil on canvas
21 5/16 x 25 11/16 in.
(54.1 x 65.2 cm)
Staatsgalerie, Stuttgart,
West Germany
Page 89, plate 100

Les Ecluses à Bougival
(*The Locks at Bougival*), 1906
Oil on canvas
21 ¼ x 25 9/16 in. (54 x 65 cm)
National Gallery of Canada,
Ottawa
Page 122, plate 128

Maisons et arbres
(*Houses and Trees*), 1906
Oil on canvas
21 ⅛ x 25 ¾ in. (54.3 x 65.4 cm)
The Metropolitan Museum
of Art, New York, gift of
Raymonde Paul in memory
of her brother, C. Michael
Paul, 1982.179.13
Page 149, plate 158

Paysage près de Chatou
(*Landscape near Chatou*), 1906
Oil on canvas
23 13/16 x 28 15/16 in.
(60.5 x 73.5 cm)
Stedelijk Museum, Amsterdam
Page 21, plate 12

Le Pont du Pecq
(*The Bridge at Le Pecq*), 1906
Oil on canvas
33 7/16 x 46 7/16 in. (85 x 118 cm)
Private collection
Page 323, plate 345

Le Remorqueur
(*The Tugboat*), c. 1906
Oil on canvas
23 ¼ x 31 ½ in. (59 x 80 cm)
Private collection, Switzerland
Page 321, plate 341

La Seine à Chatou
(*The Seine at Chatou*), 1906
Oil on canvas
29 ⅛ x 36 ½ in. (74 x 92.7 cm)
Collection Alain Delon
Page 322, plate 344

La Seine à Chatou
(*The Seine at Chatou*), 1906
Oil on canvas
32 ½ x 40 ⅛ in. (82.5 x 102 cm)
The Jacques and Natasha
Gelman Collection
Page 135, plate 143

La Seine et Le Pecq
(*The Seine and Le Pecq*), 1906
Oil on canvas
13 ¾ x 16 ⅛ in. (35 x 41 cm)
Kunsthaus, Zurich, Collection
of Johanna and Walter L. Wolf
Page 322, plate 343

Sous le Pont de Bezons
(*Under the Bridge at Bezons*), 1906
Previously known as
Sous le Pont de Chatou
(*Under the Bridge at Chatou*)
Oil on canvas
21 ¼ x 25 ½ in. (54 x 64.8 cm)
The Evelyn Sharp Collection
Page 143, plate 153

Vue de Chatou
(*View of Chatou*), 1906
Oil on canvas
18 5/16 x 21 ⅝ in. (46.5 x 55 cm)
Tel Aviv Museum, bequest of
Harry and Lea Meklembourg,
New York, 1979
Page 88, plate 99

Le Pont de Chatou
(*The Bridge at Chatou*), 1907
Oil on canvas
26 ¾ x 37 13/16 in. (68 x 96 cm)
Staatliche Museen
Preussischer Kulturbesitz,
Nationalgalerie, Berlin
Page 133, plate 140

Route maraichère
(*Road to the Garden Market*), 1907
Oil on canvas
23 ⅝ x 28 ¾ in. (60 x 73 cm)
Kunstmuseum, Winterthur,
Switzerland, Volkart Stiftung
Page 240, plate 256

Les Baigneuses
(*The Bathers*), 1908
Oil on canvas
35 x 45 ⅝ in. (88.9 x 115.9 cm)
Mr. and Mrs. Robert A. Belfer
Page 55, plate 63

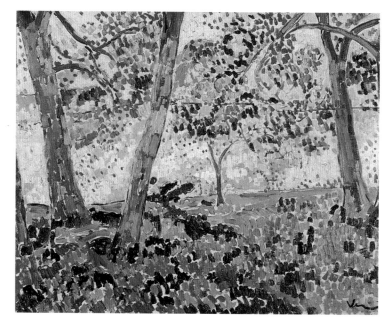

PLATE 339

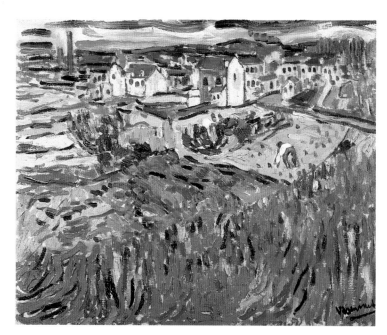

PLATE 340

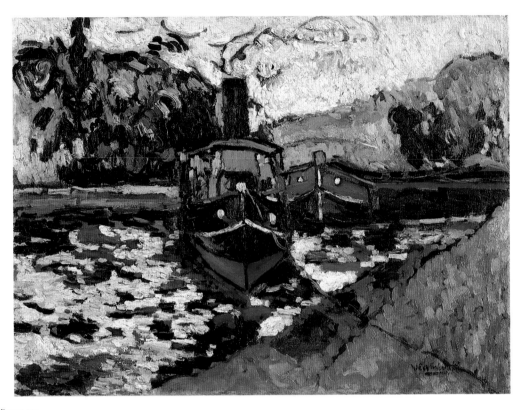

PLATE 341

PLATE 341
Maurice de Vlaminck
Le Remorqueur
(*The Tugboat*), c. 1906
Oil on canvas
23 ¼ x 31 ½ in. (59 x 80 cm)
Private collection,
Switzerland

PLATE 342
Maurice de Vlaminck
Canot (*Canal Boat*), 1905–6
Oil on canvas
23 ¹¹⁄₁₆ x 28 ¾ in. (60.2 x 73.1 cm)
Bridgestone Museum of Art,
Ishibashi Foundation, Tokyo

PLATE 339
Maurice de Vlaminck
Paysage
(*Landscape*), c. 1904
Oil on canvas
28 ⁹⁄₁₆ x 39 in. (72.5 x 99 cm)
Private collection

PLATE 340
Maurice de Vlaminck
*La Ferme de blé avec
la maison rouge*
(*The Wheat Farm
with the Red House*), 1905
Oil on canvas
23 ⅝ x 28 ¾ in. (60 x 73 cm)
Shizuoka Prefectural Museum
of Art, Shizuoka, Japan

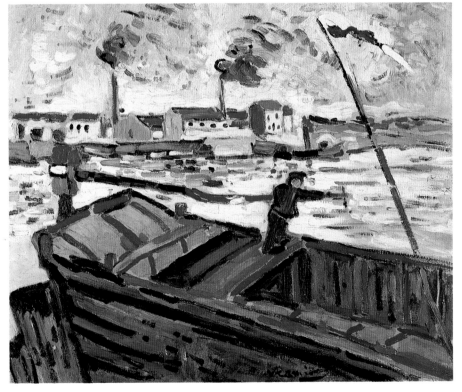

PLATE 342

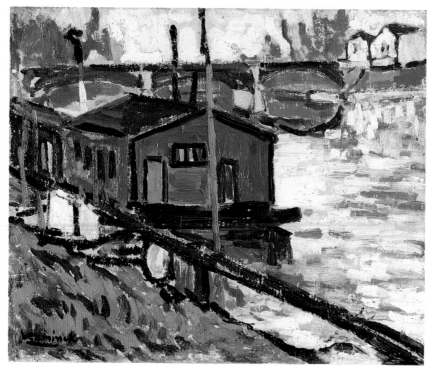

PLATE 343

PLATE 345
Maurice de Vlaminck
Le Pont du Pecq
(*The Bridge at Le Pecq*), 1906
Oil on canvas
33 ⁷⁄₁₆ x 46 ⁷⁄₁₆ in. (85 x 118 cm)
Private collection

PLATE 343
Maurice de Vlaminck
La Seine et Le Pecq
(*The Seine and Le Pecq*), 1906
Oil on canvas
13 ¾ x 16 ⅛ in. (35 x 41 cm)
Kunsthaus, Zurich,
Collection of Johanna
and Walter L. Wolf

PLATE 344
Maurice de Vlaminck
La Seine à Chatou
(*The Seine at Chatou*), 1906
Oil on canvas
29 ⅛ x 36 ½ in. (74 x 92.7 cm)
Collection Alain Delon

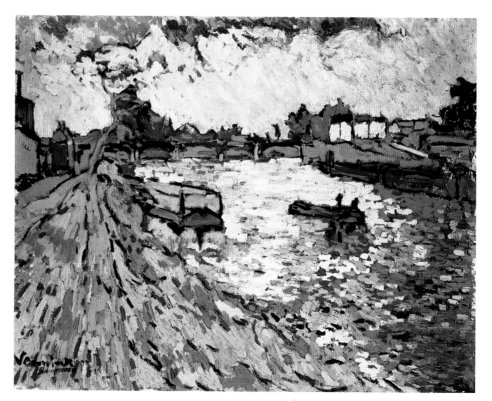

PLATE 344

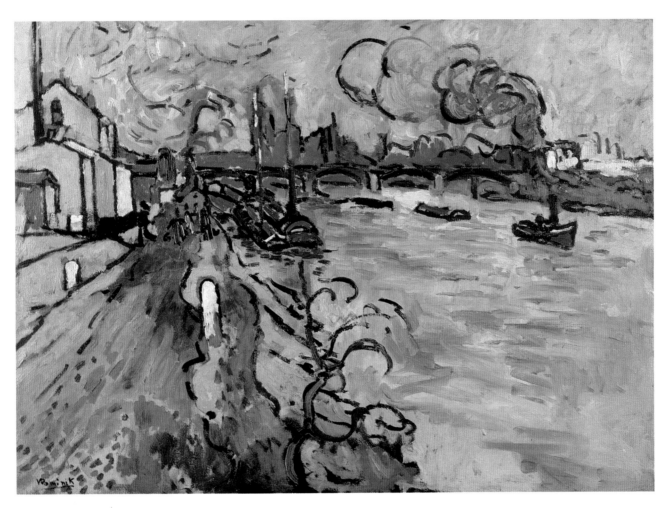

PLATE 345

Selected Bibliography

This bibliography complements two principal bibliographies on the Fauve period. The first is Georges Duthuit, *Les Fauves* (Geneva: Trois Collines, 1949), which was subsequently published in English as *The Fauvist Painters*, translated by Ralph Mannheim (New York: Wittenborn, Schultz, 1950). The second is John Elderfield, *The "Wild Beasts": Fauvism and Its Affinities*, an exhibition catalog published by the Museum of Modern Art, New York, in 1976. Duthuit and Elderfield are by no means comprehensive, but they do document the literature in a generally thorough fashion. An excellent bibliography also appears in Marcel Giry's *Le Fauvisme: Ses Origines, son évolution* (Neuchâtel, Switzerland: Ides et Calendes, 1981), which was published in English as *Fauvism: Origins and Development*, translated by Helga Harrison (New York: Alpine Fine Arts Collection, 1981).

The sources published here either have appeared since 1975 or were omitted from Duthuit's and Elderfield's bibliographies. This bibliography uses the same categories as the Elderfield catalog: general references on the Fauves are followed by specific references on individual artists, arranged in alphabetical order. Exhibition catalogs with more than one author are listed alphabetically by the name of the city of the organizing institution. Multiple publications by the same author are arranged chronologically.

GENERAL REFERENCES ON THE FAUVE PERIOD

Amarillo, Texas, Amarillo Art Center. *Early French Moderns: The Genesis of the Modern Era*. Exh. cat. 1982.

Association Collège-Quàrtier, Collège L'Estaque, L'Estaque, France. *L'Estaque au temps des peintres, 1870–1914*. Marseille: Imprimerie A. Robert, 1985.

Attenborough, David. *The Tribal Eye*. London: BBC Publications, 1976.

Baldwin, Carl R. "The Fauves: Reflections on an Exhibition, a Catalogue, and a History." *Arts Magazine* 50 (June 1976): 99–102.

Berhaut, Marie. "Le Legs Caillebotte: Vérités et contre-vérités." *Bulletin de la Société de l'Histoire de l'Art Français* (1983): 209–39.

Bernier, Georges. *Paris Cafés: Their Role in the Birth of Modern Art*. New York: Wildenstein, 1985.

Brussels, Gemeentekrediet. *De Brabantse fauvisten*. Exh. cat. 1979.

Clair, Jean. "Bacco e Arianna." In *Da van Gogh a Schiele: L'Europe espressionista, 1880–1918*, pp. 34–42. Verona, Italy: Palazzo Forti; Milan: Mazzotta, 1989.

Crochet, Bernard. "Histoire de la galerie Druet et de ses archives photographiques: Catalogue sommaire de quelques clichés pris par Druet et ses assistants, identifiés et répertoriés." Paris: Mémoire de l'Ecole du Louvre, 1971.

Daix, Pierre. "Picasso's Time of Decisive Encounters." *Artnews* 86 (April 1987): 136–41.

Deauville, France, Association Deauville-Culture. *Le Fauvisme en Normandie*. Exh. cat. 1976.

Décaudin, Michel. "Apollinaire et les peintres en 1906 d'après quelques notes inédites." *Gazette des beaux-arts*, 6th per., 75 (1970): 117–22.

Denvir, Bernard. *Fauvism and Expressionism*. London: Thames and Hudson, 1975.

Dorra, Henri. "*The 'Wild Beasts': Fauvism and Its Affinities* at the Museum of Modern Art." *Art Journal* 36 (Fall 1976): 50–54.

Düsseldorf, West Germany, Städtische Kunsthalle. *Vom Licht zur Farbe: Nachimpressionistische Malerei zwischen 1886 und 1912*. Exh. cat. 1977.

Elderfield, John. *The "Wild Beasts": Fauvism and Its Affinities*. Exh. cat. New York: Museum of Modern Art, 1976.

——— . "The Garden and the City: Allegorical Painting and Early Modernism." *Museum of Fine Arts, Houston, Bulletin* 7, no. 1 (1979–80): 3–20.

Etaples-sur-Mer, France, Musée de la Marine. *Peintures des côtes du Pas-de-Calais de Turner à Dubuffet*. Exh. cat. 1987.

Fineberg, Jonathan David. *Kandinsky in Paris, 1906–07*. Ann Arbor, Mich.: UMI Research Press, 1984.

Flagg, Peter J. "The Neo-Impressionist Landscape." Ph.D. diss., Princeton University, 1988.

Flam, Jack D. "The Spell of the Primitive: In Africa and Oceania Artists Found a New Vocabulary." *Connoisseur* 214 (September 1984): 124–31.

Gamwell, Lynn W. *Cubist Criticism*. Ann Arbor, Mich.: UMI Research Press, 1980.

Giry, Marcel. "Le Style géometrique dans la peinture vers 1907: Contribution au problème du fauvisme comme source du cubisme." In *Le Cubisme*. Saint-

Etienne, France: Université de Saint-Etienne, 1973.

———. "Ingres et le fauvisme." *Bulletin du Musée Ingres* 47–48 (1980): 55–60.

———. *Le Fauvisme: Ses Origines, son évolution.* Neuchâtel, Switzerland: Ides et Calendes, 1981. Published in English as *Fauvism: Origins and Development.* Translated by Helga Harrison. New York: Alpine Fine Arts Collection, 1981.

———. "La Période fauve de Braque." *L'Oeil* 323 (June 1982): 32–39.

Goldin, Amy. "Forever Wild: A Pride of Fauves." *Art in America* 64 (May–June 1976): 90–95.

Golding, John. "Fauvism and the School of Chatou: Post-Impressionism in Crisis." *Proceedings of the British Academy* 66 (1980): 85–102.

Gosling, Nigel. *Paris 1900–1914: The Miraculous Years.* London: Weidenfeld and Nicolson, 1978.

Herbert, James Daniel. "Fauvism and After: The Politics of French Cultural Unity." Ph.D. diss., Yale University, 1989.

Heusinger von Waldegg, Joachim. "Primitivismus und Expressionismus: Die Brücke-Maler." *Die Kunst* 2 (February 1987): 136–45.

Hobhouse, Janet. "The Fauve Years: A Case of Derailments." *Artnews* 75 (Summer 1976): 47–50.

Hoog, Michel. "*Les Demoiselles d'Avignon* et la peinture à Paris 1907–1908." *Gazette des beaux-arts* 82, no. 3 (October 1973): 209–16.

Jedlicka, Gotthard. *Der Fauvismus.* Zurich: Büchergilde Gutenberg, 1961.

Jerusalem, Israel Museum. *Peindre dans la lumière de la Méditerranée.* Exh. cat. 1987.

Kean, Beverly Whitney. *All the Empty Palaces: The Merchant Patrons of Modern Art in Pre-Revolutionary Russia.* New York: Universe Books, 1983.

Lampert, Catherine. "The Wild Beasts." *Studio International* 192 (July–August 1976): 78–79.

Lausanne, Fondation de l'Hermitage. *De Cézanne à Picasso dans les collections romandes.* Exh. cat. 1985.

Lehuard, R. "Charles Ratton et l'aventure de l'art nègre." *Art africaine noire* 60 (Winter 1986): 18 and 62 (Summer 1987): 50–52.

Lévy, Pierre. *Des artistes et un collectionneur.* Paris: Flammarion, 1976.

Leymarie, Jean. *Fauves and Fauvism.* New York: Skira, 1987.

Linnebach, Gabrielle. "La Brücke et le Fauvisme." In *Paris-Berlin, 1900–1933,* pp. 70–72. Exh. cat. Paris: Musée National d'Art Moderne, Centre Georges Pompidou, 1978.

London, Lefevre Gallery. *Les Fauves.* Exh. cat. 1978.

Milner, John. *The Studios of Paris.* New Haven, Conn.: Yale University Press, 1988.

Nakayama, K. "The Dawn of Modern Painting: Fauvism and Its Affinities" (in Japanese). *Mizue* 855 (July 1976): 21–29.

New York, Metropolitan Museum of Art. *Twentieth-Century Modern Masters: The Jacques and Natasha Gelman Collection.* Exh. cat. 1990.

New York, Museum of Modern Art. *Four Americans in Paris: The Collections of Gertrude Stein and Her Family.* Exh. cat. 1970.

———. *"Primitivism" in Twentieth-Century Art: Affinity of the Tribal and the Modern.* Edited by William Rubin. 2 vols. Exh. cat. 1984.

O'Laoghaire, Niamh. "The Influence of van Gogh on Matisse, Derain, and Vlaminck, 1900–1910." Ph.D. diss., University of Toronto, 1990.

Oppler, Ellen C. *Fauvism Reexamined.* Ph.D. diss., Columbia University, 1969; New York: Garland Publishing, 1976.

Paradise, JoAnne Culler. "Gustave Geffroy and the Criticism of Painting." Ph.D. diss., Stanford University, 1982.

Paris, Grand Palais, Salon d'Automne. *Les Fauves.* Exh. cat. 1979.

Paris, Musée Galliera. *"La Fête" chez les peintres.* Exh. cat. 1977.

Paris, Musée National d'Art Moderne, Centre Georges Pompidou. *Daniel-Henry Kahnweiler.* Exh. cat. 1984.

———. *Donation Louise et Michel Leiris: Collection Kahnweiler-Leiris.* Exh. cat. 1984.

Review of *The "Wild Beasts": Fauvism and Its Affinities,* at the Museum of Modern Art, New York (in Japanese). *Mizue* 855 (June 1976): 5–20.

Rewald, John. "An Introduction to the Fauve Movement." In *Studies in Post-Impressionism.* Edited by Irene Gordon and Frances Weitzenhoffer. New York: Harry N. Abrams, 1966.

Richardson, Brenda. *Dr. Claribel and Miss Etta: The Cone Collection of the Baltimore Museum of Art.* Exh. cat. 1985.

Rötzler, Willy. "Apollinaire und seine Freunde." *Du* 3 (March 1982): 26–67.

Rubin, William. "Cézannisme and the Beginnings of Cubism." In *Cézanne: The Late Work,* pp. 151–202. Exh. cat. New York: Museum of Modern Art, 1977.

Russell, John. "The Birth of a Wild Beast." *Horizon* 18 (Summer 1976): 4–17.

Saint-Tropez, France, Musée de l'Annonciade. *Le Fauvisme des provençaux.* Exh. cat. 1984.

Schiebler, Ralf. "Kunst ohne Illusion." Review of *Le Fauvisme: Ses Origines, son évolution,* by Marcel Giry. *Weltkunst* 53 (January 1983): 46–47.

Shiff, Richard. "The End of Impressionism: A Study in Theories of Artistic Expression." *Art Quarterly* 1 (Autumn 1978): 338–78.

———. *Cézanne and the End of Impressionism: A Study of the Theory, Technique, and Critical Evaluation of Modern Art.* Chicago: University of Chicago Press, 1984.

Spalding, Frances. "The 'Wild Beasts': Fauvism and Its Affinities." Review of the exhibition at the Museum of Modern Art, New York. *Connoisseur* 192 (July 1976): 241.

Stuttgart, West Germany, Kunsthaus Buhler. *Französische Postimpressionisten.* Exh. cat. 1978.

Thierry, G. "La Donation Pierre Lévy." *L'Oeil* 272 (March 1978): 26–33.

Vaisse, Pierre. "Salons, expositions et sociétés d'artistes en France, 1871–1914." In *Saloni, gallerie, musei e loro influenza sullo sviluppo dell'arte dei secoli XIX e XX.* Edited by Francis Haskell. Bologna, Italy: XXIV Congrès Internationale d'Histoire de l'Art, 1979.

Warnod, Jeanine. *Washboat Days.* Translated by Janet Green. New York: Orion Press, 1972.

——— . *Le Bateau-Lavoir, 1892–1914.* Paris: Les Presses de la Connaissance, 1975.

Washington, D.C., National Gallery of Art. *The Orientalists: Delacroix to Matisse. The Allure of North Africa and the Near East.* Exh. cat. 1984.

Washington, D.C., Phillips Collection. *Places of Delight: The Pastoral Landscape.* Exh. cat. 1988.

Werenskiold, Marit. *The Concept of Expressionism: Origin and Metamorphosis.* Oslo: Universitetsforlaget, 1984.

Whitfield, Sarah. *Fauvism.* London: Thames and Hudson, 1990.

"Wild Men of Paris." Review of *The "Wild Beasts": Fauvism and Its Affinities,* at the Museum of Modern Art, New York. *Apollo* 104 (July 1976): 64–65.

Individual Artists

Georges Braque

Bordeaux, France, Galerie des Beaux-Arts. *Georges Braque en Europe: Centenaire de la naissance de Georges Braque (1882–1963).* Exh. cat. 1982.

Füglister, Robert L. "Les Premiers Bateaux de Braque: Schiffmotive im ersten Jahrzehnt seines Schaffens." Ms., 1989.

Kim, Youngna. "The Early Works of Georges Braque, Raoul Dufy, and Othon Friesz: The Le Havre Group of Fauvist Painters." Ph.D. diss., Ohio State University, 1980.

Leroy, Claude. "Braque pseudonyme." *Cahiers du Musée National d'Art Moderne* 11 (1983): 144–59.

Martin, Alvin. "Georges Braque: Stylistic Formation and Transition, 1900–1909." Ph.D. diss., Harvard University, 1980.

——— "The Moment of Change: A Braque Landscape in the Minneapolis Institute of Arts." *Minneapolis Institute of Arts Bulletin* 65 (1981–82): 83–93.

McMullen, R. "'Something More Difficult than Painting': The Work of Georges Braque." *Réalités,* no. 281 (April 1974): 24–33.

Moselle, Franz. "Die kubistische Bildsprache von Georges Braque, Pablo Picasso, und Juan Gris unter besonderer Berücksichtigung der Entwicklung der Farbe." Ph.D. diss., Universität Zürich, 1973.

New York, Museum of Modern Art. *Picasso and Braque: Pioneering Cubism.* Exh. cat. 1989.

New York, Solomon R. Guggenheim Museum. *Georges Braque.* Exh. cat. 1988.

Pouillon, Nadine, and Isabelle Monod-Fontaine. *Braque: Oeuvres de Georges Braque (1882–1963).* Paris: Musée National d'Art Moderne, Centre Georges Pompidou, 1982.

Raphael, Max. *Raumgestaltungen: Der Beginn der modernen Kunst im Kubismus und im Werk von Georges Braque.* Edited by Hans-Jürgen Heinrichs. Frankfurt am Main and New York: Edition Qumran im Campus-Verlag, 1986.

Rubin, William. "Pablo and Georges and Leo and Bill." *Art in America* 67 (March–April 1979): 128–47.

Saint-Paul de Vence, France, Fondation Maeght. *Georges Braque.* Exh. cat. 1980.

Schunck, V. "Das provozierte Sehen: Ironie und Reflexion im Kubismus von Picasso, Braque, und Juan Gris (1907–1914)." Ph.D. diss., Universität Zürich, 1984.

Steinberg, Leo. "Resisting Cézanne: Picasso's *Three Women.*" *Art in America* 66 (November–December 1978): 114–33.

——— . "The Polemical Part." *Art in America* 67 (March–April 1979): 114–27.

Verdet, André. *Entretiens: Notes et écrits sur la peinture: Braque, Léger, Matisse, Picasso.* Paris: Editions Galilée, 1978.

Zurcher, Bernard. *Georges Braque: Life and Work.* New York: Rizzoli, 1988.

Charles Camoin

Giraudy, Danièle, ed. "Correspondance Henri Matisse–Charles Camoin." *Revue de l'art* 12 (1971): 7–14.

André Derain

Ball, Susan L. "The Early Figural Paintings of André Derain, 1905–1910." *Zeitschrift für Kunstgeschichte* 43, no. 1 (1980): 79–96.

Dagen, Philippe. "L'Age d'or: Derain, Matisse et le bain turc." *Bulletin du Musée Ingres* 53–54 (1984): 43–54.

——— . "'L'Exemple égyptien': Matisse, Derain et Picasso entre fauvisme et cubisme (1905–1908)." *Bulletin de la Société de l'Histoire de l'Art Français* (1984): 289–302.

Derain, André. "André Derain: Excerpts from the Notes." Translated and selected by Rosanna Warren. *Georgia Review* 32 (Spring 1978): 121–49.

———. "Notes d'André Derain." *Cahiers du Musée National d'Art Moderne* 5 (1980): 348–62.

Frigerio, Simone. "Lettre de Paris, 1: Derain réhabilité." *Colóquio artes* 2 (April 1977): 68–69.

Gilbert E. "L'Oeuvre gravé d'André Derain." Thesis, Université de Paris IV, 1985.

Giry, Marcel. "Le Curieux Achat fait à Derain et à Vlaminck au Salon des Indépendants de 1905 ou deux tableaux retrouvés." *L'Oeil* 254 (September 1976): 26–31.

———. "Une Composition de Derain dite *La Danse*." *Archives de l'art français* 25 (1978): 443–47.

Kalitina, N. *André Derain*. Leningrad: Aurora Art Publishers, 1976.

Lee, Jane H. "The Work of Derain between 1907 and 1914." Master's thesis, Courtauld Institute of Art, University of London, 1979.

———. "Painting as Divination: A Still Life by André Derain." *Stanford Museum Bulletin* 14–15 (1984–85): 3–8.

London, Barbican Art Gallery. *The Image of London: Views by Travellers and Emigrés, 1550–1920*. Exh. cat. 1987.

Nantes, France, Galerie des Beaux-Arts. *André Derain*. Exh. cat. 1987.

Paris, Galerie Schmit. *Derain*. Exh. cat. 1976.

Paris, Grand Palais. *André Derain*. Exh. cat. 1977.

Paris, Musée d'Art Moderne de la Ville de Paris. *Hommage à André Derain, 1880–1954*. Exh. cat. 1980.

Parke-Taylor, Michael. "André Derain's 'Fauve' Era Sketchbook c. 1903–1906." Master's thesis, Courtauld Institute of Art, University of London, 1979.

———. "Copies de l'album fauve." *Cahiers du Musée National d'Art Moderne* 5 (1980): 363–77.

———. *André Derain in North American Collections*. Exh. cat. Regina, Canada: Norman Mackenzie Art Gallery, 1982.

Rome, Villa Medici. *André Derain*. Exh. cat. 1976.

Salomon, G. "André Derain: Notes sur la peinture." *Cahiers du Musée National d'Art Moderne* 5 (1980): 342–48.

Sauré, Wolfgang. "Hohe Tradition und das Klassische: Das Werk von André Derain (1880–1954)." *Kunst* 7 (July 1987): 580–86.

Shimada, N. "André Derain's Testimony against the Time" (in Japanese). *Mizue* 914 (May 1981): 56–75.

Sutton, Denys. "*Self-Portrait with a Cap* by André Derain." *Apollo* 116 (July 1982): 44–45.

Warren, Rosanna. "A Metaphysic of Painting: The Notes of André Derain." *Georgia Review* 32 (Spring 1978): 94–112.

Kees van Dongen

Geneva, Musée de l'Athenée. *Van Dongen: 1877–1968*. Exh. cat. 1976.

Rotterdam, Museum Boymans-van Beuningen. *Kees van Dongen*. Exh. cat. 1989.

Saint-Tropez, France, Musée de l'Annonciade. *Kees van Dongen, 1877–1968*. Exh. cat. [1988].

Raoul Dufy

Engen, J. "Pinning the Butterfly." *Art Book Review* 1, no. 2 (1982): 93–94.

Guillon-Laffaille, Fanny. *Raoul Dufy: Catalogue raisonné des aquarelles, gouaches, et pastels*. 2 vols. Paris: Louis Carré, 1982.

Kim, Youngna. "The Early Works of Georges Braque, Raoul Dufy, and Othon Friesz: The Le Havre Group of Fauvist Painters." Ph.D. diss., Ohio State University, 1980.

Kostenevich, Albert. *Raoul Dufy*. Leningrad: Iskusstvo, 1977.

Laffaille, Maurice. *Raoul Dufy: Catalogue raisonné de l'oeuvre peint*. 3 vols. Geneva: Editions Motte, 1972–77.

———, and Fanny Guillon-Laffaille. *Raoul Dufy: Catalogue raisonné de l'oeuvre peint. Supplément*. Paris: Louis Carré et Cie, 1985.

Le Havre, France, Musée des Beaux-Arts André Malraux. *Raoul Dufy*. Exh. cat. 1977.

Léveque, Jean-Jacques. "Le Centenaire de Dufy: Va-t-il le réhabiliter?" *Galerie-Jardin des Arts* 161 (September 1976): 19–21.

London, Hayward Gallery. *Raoul Dufy, 1877–1953*. Exh. cat. 1983.

Paris, Musée National d'Art Moderne. *Raoul Dufy au Musée National d'Art Moderne*. 1977.

Perez-Tibi, Dora. *Dufy*. Paris: Flammarion; New York: Harry N. Abrams, 1989.

Perl, Jed. "Dufy among the Pattern Painters." *New Criterion* 3 (February 1985): 25–33.

Rézé-Huré, Antoinette. "Raoul Dufy, le signe." *Cahiers du Musée National d'Art Moderne* 5 (1980): 410–22.

Rousseau, F. O. "Raoul Dufy." *Beaux-arts*, no. 8 (1983): 32–41.

Rushton, R. "Raoul Dufy, 1877–1953: The Hayward Gallery." *Royal Society of the Arts Journal* 132, no. 5330 (1984): 133–34.

Wood, Jeremy. Review of *Raoul Dufy, 1877–1953*, at the Hayward Gallery, London. *Pantheon* 42 (April–June 1984): 180–81.

Zaragoza, Spain, Centro de Exposiciones y Congresos. *Raoul Dufy, 1877–1953*. Exh. cat. 1989.

Othon Friesz

Giry, Marcel. "A Propos d'un tableau d'Othon Friesz au Musée National d'Art Moderne." *La Revue du Louvre et des Musées de France* 20, no. 3 (1970): 168–70.

Kim, Youngna. "The Early Works of Georges Braque, Raoul Dufy, and Othon Friesz: The Le Havre Group of Fauvist Painters." Ph.D. diss., Ohio State University, 1980.

La Roche-sur-Yonne, France, Musée Municipal de La Roche-sur-Yonne. *Exposition rétrospective: Othon Friesz (1879–1949)*. Exh. cat. 1979.

Le Havre, France, Musée des Beaux-Arts André Malraux. *E. Othon Friesz*. Exh. cat. 1979.

Henri Manguin

Daulte, François. "Manguin parmi les fauves." *L'Oeil*, nos. 335–36 (June–July 1983): 68–69.

Diehl, Gaston. "Manguin, le fauve du bonheur." *L'Oeil*, no. 399 (October 1988): 32–39.

Gleiny, C. "Manguin, triomphe de la couleur." *Galerie-Jardin des Arts*, no. 156 (March 1976): 39–41.

Lausanne, Galerie Paul Vallotton. *Hommage à Henri Manguin (1879–1943): Exposition*. Exh. cat. 1980.

Martigny, Switzerland, Fondation Pierre Gianadda. *Manguin parmi les fauves*. Exh. cat. 1983.

Paris, Musée Marmottan. *Henri Manguin, 1874–1949*. Exh. cat. 1988.

Sainsaulieu, Marie-Christine, Jacques Lassaigne, Pierre Cabanne, and Alain Mousseigne. *Henri Manguin: Catalogue raisonné de l'oeuvre peint*. Neuchâtel, Switzerland: Editions Ides et Calendes, 1980.

Saint-Tropez, France, Chapelle de la Miséricorde. *Henri Manguin, 1874–1949*. Exh. cat. 1976.

Tokyo, Galerie Yoshii. *Exposition Henri Manguin*. Exh. cat. 1988.

Tokyo, Yamaguchi and Fukushima. *Exposition Henri Manguin*. Exh. cat. 1980.

Albert Marquet

Bordeaux, France, Galerie des Beaux-Arts. *Albert Marquet, 1875–1947*. Exh. cat. 1975.

Charleroi, France, Palais des Beaux-Arts. *Albert Marquet: Rétrospective*. Exh. cat. 1981.

Glasgow, Glasgow Art Gallery and Museums. *Albert Marquet, 1875–1947*. Exh. cat. 1977.

Lausanne, Fondation de l'Hermitage. *Albert Marquet, 1875–1947*. Exh. cat. 1988.

Le Targat, François. "Les Paysages d'Albert Marquet." *Beaux-Arts Magazine* 24 (May 1985): 94–95.

Léveque, Jean-Jacques. "Corot, Marquet, et la dégradation du paysage." *Galerie-Jardin des Arts* 148 (June 1975): 43–46.

———. "Marquet fut un admirable voyage." *Galerie-Jardin des Arts* 151 (October 1975): 41–43.

London, Wildenstein. *Albert Marquet, 1875–1947: A Tribute to the Late Jean-Claude Martinet, Author of the Forthcoming Catalogue Raisonné of the Artist's Works*. Exh. cat. 1985.

Munich, Städtisches Galerie im Lenbachhaus. *Marquet*. Exh. cat. 1975.

Pancera, M. "Indimenticabile Parigi di Marquet." *Arte* 15 (December 1985): 52–59.

Paris, Galerie de la Présidence. *Albert Marquet: Peintures, aquarelles, pastels, dessins*. Exh. cat. 1985.

Henri Matisse

Arnold, Matthias. "Das Fruhwerk von Henri Matisse." *Weltkunst* 50 (November 15, 1980): 3358–61.

Barcelona, Museo Picasso. *Henri Matisse: Pituras y dibujos de los Museos Pushkin de Moscú y el Ermitage de Leningrad*. Exh. cat. 1988.

Benjamin, Roger. "Une Copie par Matisse du *Balthazar Castiglione* de Raphael." *La Revue du Louvre et des Musées de France* 35 (October 1985): 275–77.

———. *Matisse's "Notes of a Painter": Criticism, Theory, and Context, 1891–1908*. Ann Arbor, Mich.: UMI Research Press, 1987.

———. "Recovering Authors: The Modern Copy, Copy Exhibitions, and Matisse." *Art History* 12 (June 1989): 176–201.

Bielefeld, West Germany, Kunsthalle. *Henri Matisse: Das goldene Zeitalter*. Exh. cat. 1981.

Bock, Catherine C. *Henri Matisse and Neo-Impressionism, 1898–1908*. Ann Arbor, Mich.: UMI Research Press, 1981.

———. "A Question of Quality: A Note on Matisse's 'Dark Years.'" *Gazette des beaux-arts*, 6th per., 103 (April 1984): 169–74.

Boime, Albert. "The Teaching of Fine Arts and the Avant-Garde in France during the Second Half of the Nineteenth Century." *Arts Magazine* 60 (December 1985): 46–57.

Bois, Yve-Alain. "Henri Matisse: Dessins." *Art Press* 19 (July–August 1975): 18–20.

———. "Matisse Redrawn." *Art in America* 73 (September 1985): 126–31.

———. "Matisse and 'Arche-drawing.'" In Yve-Alain Bois. *Painting as Model*. Cambridge, Mass.: MIT Press, 1990.

Bussy, Jane Simone. "A Great Man." *Burlington Magazine* 128 (February 1986): 80–84.

Carra, Massimo. *Tout l'oeuvre peint de Matisse, 1904–1928*. Paris: Flammarion, 1982.

Cuno, James B. "Matisse and Agostino Carracci: A Source for the *Bonheur de vivre.*" *Burlington Magazine* 122 (July 1980): 503–5.

Daftari, Feveshteh. "Influence of Persian Art on Gauguin, Matisse, and Kandinsky." Ph.D. diss., Columbia University, 1988.

Dagen, Philippe. "L'Age d'or: Derain, Matisse et le bain turc." *Bulletin du Musée Ingres* 53–54 (1984): 43–54.

———. "'L'Exemple égyptien': Matisse, Derain et Picasso entre fauvisme et cubisme (1905–1908)." *Bulletin de la Société de l'Histoire de l'Art Français* (1984): 289–302.

De Baranano, K. M. "Matisse e Iturrino." *Goya* 205–6 (July–October 1988): 94–98.

De Zarate, V.M.G. "Matisse y Rouault frente al mito histórico de la 'Belle Epoque.'" *Revista de ideas estéticas* 31 (July–September 1973): 177–99.

Edinburgh, Royal Scottish Academy. *Colour since Matisse: French Painting in the Twentieth Century*. Exh. cat. 1985.

Elderfield, John. *Matisse in the Collection of the Museum of Modern Art*. New York: Museum of Modern Art, 1978.

———. *The Drawings of Henri Matisse*. London: Thames and Hudson, 1984.

———. "Matisse: Myth vs. Man." Review of *Matisse*, by Pierre Schneider, and *Matisse: The Man and His Art, 1869–1918*, by Jack Flam. *Art in America* 75 (April 1987): 13–21.

Fauchereau, Serge. "Henri Matisse dans les collections russes." *Beaux-Arts Magazine* 40 (November 1986): 44–51.

Flam, Jack D., ed. *Matisse on Art*. New York: E. P. Dutton, 1978.

———. *Matisse: The Man and His Art, 1869–1918*. Ithaca, N.Y.: Cornell University Press, 1986.

———, ed. *Matisse: A Retrospective*. New York: Hugh Lauter Levin Associates, 1988.

———. "La Sculpture de Matisse." *Les Cahiers du Musée National d'Art Moderne* 30 (Winter 1989).

Fourcade, Dominique. "Autres propos de Henri Matisse." *Macula* 1 (1976): 92–115.

Giraudy, Danièle, ed. "Correspondance Henri Matisse–Charles Camoin." *Revue de l'art* 12 (1971): 7–14.

Golding, John. *Matisse and Cubism*. W. A. Cargill Memorial Lectures in Fine Art, no. 6. Glasgow: University of Glasgow, 1978.

Guichard-Melli, Jean. *Matisse*. Paris: Somogy, 1986.

Guillaud, Jacqueline, and Maurice Guillaud. *Matisse: Le Rythme et la ligne*. Paris: Gallimard, 1987. Published in English as *Matisse: Rhythm and Line*. Translated by Jack Flam, Timothy Bent, and Eleanor Levieux. New York: Clarkson N. Potter; Paris: Guillaud Editions, 1987.

Herbert, James D. "Matisse without History." Review of *Matisse*, by Pierre Schneider, and *Henri Matisse: The Man and His Art*, by Jack Flam. *Art History* 11 (June 1988): 297–302.

Hori, H. "*Luxury* and *Dance*" (in Japanese). *Mizue* 913 (April 1981): 58–61.

Izerghina, A., A. Barskaya, T. Borovaya, et al. *Henri Matisse: Paintings and Sculptures in Soviet Museums*. Leningrad: Aurora Art Publishers, 1978.

Kaiserslauten, Pfalzgalerie. *Matisse und seine deutscher Schüler*. Exh. cat. 1988.

Kerber, O. *Henri Matisse: Ausbau des perspektiven Raumes*. Giessen, West Germany: Schmitz, 1982.

Klein, John. Review of *Matisse*, by Pierre Schneider. *Art Journal* 45, no. 4 (Winter 1985): 359–67.

———. "The Portraits and Self-Portraits of Henri Matisse." Ph.D. diss., Columbia University, 1990.

Lebensztejn, Jean-Claude. "Eight Statements." *Art in America* 63 (July–August 1975): 62–66.

———. "Ground: 1" [1971]. *Oxford Literary Review* 3 (1979): 38–44.

———. "Les Textes du peintre" [1974]. In *Zig Zag*. Paris: Flammarion, 1981.

Le Cateau-Cambrésis, France, Musée Matisse. *Henri Matisse—Autoportraits*. Exh. cat. 1988.

Leinz, Gottlieb. "Henri Matisse (1869–1954): Das Gesetz der Arabeske." *Die Kunst und das schöne Heim* 94 (October 1982): 670–74.

Léveque, Jean-Jacques. "Henry [sic] Matisse." *Le Arti* 25 (July–August 1975): 3–14.

Linker, Kate. "Matisse and the Language of Signs." *Arts Magazine* 49 (May 1975): 76–78.

Matisse, Henri. *Ecrits et propos sur l'art*. Edited by Dominique Fourcade. Paris: Hermann, 1972.

Monod-Fontaine, Isabelle. *Matisse: Oeuvres de Henri Matisse (1869–1954)*. Paris: Musée National d'Art Moderne, Centre Georges Pompidou, 1979.

———. *The Sculpture of Henri Matisse*. London: Arts Council of Great Britain, 1984.

———, Anne Baldassari, and Claude Laugier. *Matisse*. Paris: Musée National d'Art Moderne, Centre Georges Pompidou, 1989.

Nakahara, Y. "Approaching Walls, Retreating Paintings" (in Japanese). *Mizue* 913 (April 1981): 51–58.

Nantes, France, Musée des Beaux-Arts. *Henri Matisse: Dessins, Collection du Musée Matisse*. Exh. cat. 1988.

Neff, John H. "Matisse and Decoration: An Introduction." *Arts Magazine* 49 (May 1975): 59–61.

——— . "Matisse and Decoration." *Arts Magazine* 49 (June 1975): 85.

——— . "Matisse and Decoration: The Shchukin Panels." *Art in America* 63 (July–August 1975): 38–48.

Nicholson, D. "Notes on Matisse." *Artscribe* 40 (April 1983): 20–26.

Paris, Bibliothèque Nationale. *Henri Matisse: Donation Jean Matisse.* Exh. cat. 1981.

Pleynet, Marcelle. "Matisse et Picasso." *Tel quel* 87 (1981): 37–49.

Puttfarken, Ted. "Mutual Love and Golden Age: Matisse and 'gli Amori de' Carracci." *Burlington Magazine* 124 (April 1982): 203–8.

Ratcliff, Carter. "In Detail: Matisse's *Dance.*" *Portfolio* 3 (July–August 1981): 38–45.

Rau, Bernd. "Henri Matisse and Auguste Renoir—eine schöpferische Begegnung." In *Studien zur Kunst: Gunter Thiem zum 60 Geburtstag.* Stuttgart, Germany: Edition Cantz, 1977.

Reiff, R. "Matisse and Torii Kiyonaga." *Arts Magazine* 55 (February 1981): 164–67.

Rome, Villa Medici. *Henri Matisse.* Exh. cat. 1978.

Schneider, Pierre. *Matisse.* New York: Rizzoli, 1984.

Seckel, Hélène. "L'Académie Matisse." In *Paris–New York.* Edited by Pontus Hulten. Exh. cat. Paris: Musée National d'Art Moderne, Centre Georges Pompidou, 1977.

Shearman, John. "Le Portrait de *Baldessar Castiglione* par Raphaël." *La Revue du Louvre et des Musées de France* 29, no. 4 (1979): 261–70.

Shiff, Richard. "Matisse and Symbolist Theory: The Conflict between Technical Procedure and Self-Expression." *Southeastern College Art Conference Review* 10, no. 2 (1982): 109–10.

Sproccati, S. "Henri Matisse 'Expressione e Decorazione.'" *Rivista di estetica* 3 (1979): 77–97.

Takamatsu, J., and T. Minemura. "Henri Matisse: The Pioneer of Modern Art" (in Japanese). *Mizue* 855 (June 1976): 30–37.

Tokyo, National Museum of Modern Art. *Henri Matisse (1869–1954).* Exh. cat. 1981.

Toulouse, France, Musée Paul Dupuy. *Matisse: Ajaccio-Toulouse, 1898–1899.* Exh. cat. 1986.

Vallier, Dora. Review of *Matisse,* by Pierre Schneider. *Critique* 457–58 (1985): 677–85.

Washington, D.C., National Gallery of Art. *Henri Matisse: The Early Years in Nice, 1916–1930.* Exh. cat. 1986.

——— . *Matisse in Morocco: The Paintings and Drawings, 1911–1913.* Exh. cat. 1990.

Watkins, Nicholas. *Matisse.* Oxford: Phaidon, 1977.

——— . "Matisse, A Sort of Spiritualist." Review of *Matisse,* by Pierre Schneider. *Art History* 9, no. 1 (1986): 115–19.

Werenskiold, Marit. *De Norske Matisse-Elevene: Laeretid og Gjennombrudd, 1908–1914.* Oslo: Gyldendal Norsk Forlag, 1972.

Zurich, Kunsthaus. *Henri Matisse.* Exh. cat. 1982.

Jean Puy

Geneva, Musée du Pétit Palais. *J. Puy.* Exh. cat. 1977.

Roanne, France, Musée Déchelette. *Rétrospective Jean Puy.* Exh. cat. 1988.

Wagner, A. "Jean Puy, 1876–1960, zum hundertsen Geburtstag." *Kunst und das schöne Heim* 88 (November 1976): 663–66.

Louis Valtat

Besançon, Musée des Beaux-Arts. *Valtat et ses amis: Albert André, Camoin, Manguin, Puy.* Exh. cat. 1964.

Cogniat, Raymond. *Louis Valtat.* Neuchâtel, Switzerland: Ides et Calendes, 1963.

Saint-Tropez, Musée de l'Annonciade. *Louis Valtat: Paysages de L'Estérel.* Exh. cat. 1989.

Valtat, Dr. Jean. *Louis Valtat: Catalogue de l'oeuvre peint, 1869–1952.* Vol. 1. Neuchâtel, Switzerland: Editions Ides et Calendes, 1977.

Maurice de Vlaminck

"Les Bois gravés de Vlaminck." *Nouvelles de l'estampe,* no. 31 (January–February 1977): 11–18.

Bouillot, Roger. "Hommage à Vlaminck." *L'Oeil,* no. 383 (June 1987): 42–47.

Giry, Marcel. "Le Curieux Achat fait à Derain et à Vlaminck au Salon des Indépendants de 1905 ou deux tableaux retrouvés." *L'Oeil* 254 (September 1976): 26–31.

Lesieur-Toupet, H., and K. von Walterskirchen. *Maurice de Vlaminck: Verzeichnis des graphischen Werkes: Holzschnitte, Radierungen, Lithographien.* West Berlin: Benteli Verlag, 1974.

Pétrides, Paul. "Pétrides: Vlaminck tel quel." *Galerie-Jardin des Arts* 147 (May 1975): 73.

Vallès-Bled, Maïthé. *Vlaminck: Le Peintre et la critique.* Exh. cat. Chartres, France: Musée des Beaux-Arts, 1987.

Acknowledgments

Organizing an exhibition is the most joyous of ordeals, often likened to prolonged labor before the birth of a child or to exhausting rehearsals before opening night at the theater. Happily, the memory of all the victories and defeats disappears once the final product debuts. No truer statement may be made about this exhibition and catalog. They are the outcome of nearly four years of intense work by many people, who consulted many more people, all of whose tireless efforts deserve to be saluted here.

In an era when Fauve paintings routinely fetch staggering sums at auction, this exhibition may well be among the last ever devoted to the Fauves. Indeed, this ascending market has cast a shadow on all of us involved with French art of the late nineteenth and early twentieth century. Consequently, I am indebted above all to Director Earl A. Powell III, who immediately endorsed the concept of a Fauve landscape exhibition. In every way he has gone that "extra mile"—cajoling his colleagues, calling in favors—to ensure that this exhibition included the necessary loans. His enthusiasm, shared by the museum's board of trustees and its president, Daniel N. Belin, has been heartening and warmly appreciated.

In support of this project Ford Motor Company provided a munificent grant, which kept the enormous costs involved in an exhibition of this kind from being prohibitive. It has been a personal pleasure to work with James E. N. Huntley and Mabel Brandon at Ford's national offices, Bill Selovar at Ford in Los Angeles, and Fred Schroeder of Ruder and Finn; they have transformed a museum-corporate partnership into a genuinely creative collaboration. In the exhibition's formative stages generous financial support was awarded by the special exhibitions program of the National Endowment for the Arts. This exhibition would have been impossible without the indemnities it received from the Federal Council on the Arts and the Humanities and from the British government. A National Endowment for the Arts fellowship for museum professionals funded my stay of several months in France, during which much of the research for this exhibition and catalog was conducted; I would like to gratefully acknowledge the essential role that the NEA has played in the genesis of this exhibition and so many others in the United States during its distinguished first twenty-five years.

Museum colleagues around the world leapt at the idea of hosting an exhibition on the Fauves. Indeed, many of the institutional lenders to this exhibition asked at one stage or another if they could participate in the exhibition's tour. It is with particular pride that I thank the Metropolitan Museum of Art (my museological alma mater) and the Royal Academy of Arts for presenting this exhibition. At the Metropolitan, Philippe de Montebello, William S. Lieberman, and Anne Strauss have graciously offered all manner of assistance, as has Kay Bearman, and they all have been indefatigable in their efforts on the project's behalf. Mr. de Montebello and Mr. Lieberman personally negotiated certain loans; their powers of persuasion have added immeasurably to the richness of this exhibition. Also at the Metropolitan, Lowery Sims and Sabine Rewald have contributed valued advice and information as well. On the other side of the Atlantic, Norman Rosenthal and MaryAnne Stevens have provided assistance at every turn, and I am grateful for their involvement, as well as that of Annette Bradshaw and Jane Martineau.

The seeds for the emphasis on landscape in this exhibition were sown in Robert L. Herbert's

1980 graduate seminar on Impressionist landscape at Yale University. Professor Herbert's scholarship and methodology inspired the site-specific framework for the exhibition and catalog. I sought out a number of young scholars working on the Fauve period who could bring fresh thinking to bear on the various questions raised by landscape painting. Each had previously published research on individual Fauve artists; in this catalog the high quality of the contributions by Roger Benjamin, James D. Herbert, John Klein, and Alvin Martin speak for themselves. I valued their ideas and input, and I hope that many new investigations into general issues of Fauve painting are spurred by this exhibition.

Few museum exhibitions of recent years have left such powerful memories as the Museum of Modern Art's remarkable exhibition *The "Wild Beasts": Fauvism and Its Affinities*, of 1976. Its curator, John Elderfield, made accessible to me his files and his thoughts, offering countless bits of information as well as good counsel. The great advantage of mounting a Fauve exhibition at this time is that many of the international scholars who have written extensively or continue to work on this subject are eager for a reexamination of this period and consequently have contributed freely and generously. I am grateful for the hours spent talking or corresponding with Marcel Giry, John Golding, Eric Hild, Michel Hoog, John House, Pavel Machotka, Niamh O'Laoghaire, JoAnne Paradise, Theodore Reff, John Rewald, William Rubin, Richard Shiff, Bogomila Welsh-Ovcharov, and Marit Werenskiold.

No group exhibition can fail to benefit from the ongoing scholarship on the individual artists, both by their families and heirs who preserve their legacy and by researchers who interpret and record it. Foremost among these are the legions devoted to Henri Matisse. I have been privileged to consult with Claude Duthuit—grandson of the artist and son of the pioneering chronicler of the Fauves—and his wife, Barbara. The late Pierre Matisse had been a friend since 1978, and the interview we had shortly before his death is one that I will always treasure. Recently I have come to know both Mme Jean Matisse and Gérard Matisse and his family, and they have been generous in their cooperation with this exhibition. The ever-resourceful Wanda de Guébriant brings order to the world of Matisse and has proved an endless source of information and verification. Many of the Matisse scholars assisted in this enterprise, though the Fauve years are a tiny portion of Matisse's career. I thank Marina Bessanova, Jack Cowart, Hanne Finsen, Jack Flam, Dominique Fourcade, Sir Lawrence Gowing, Albert Kostanevitch, Isabelle Monod-Fontaine, and Pierre Schneider for providing innumerable suggestions and ideas.

The circle of devotees to the work of André Derain and Maurice de Vlaminck has expanded in recent years, and I have benefited from this growing interest. I have been fortunate in knowing Geneviève Taillade, Derain's niece, and Edwige and Godeliève de Vlaminck, Vlaminck's daughters. The author of Derain's long-awaited catalogue raisonné, Michel Kellermann, has generously made available all of his files and photographic records, and his stepson and collaborator Robert Stoppenbach has offered considerable assistance in locating paintings. Jane Lee, who is currently organizing an exhibition of later work by Derain, offered insights into the relevance of Derain's writings to his Fauve years as well as her thoughts on redating Derain's letters to Vlaminck. Michael Parke-Taylor, an obsessed Derain-phile for the past ten years, retrieved file after file to locate arcane information that proved essential to this exhibition and catalog. I have also benefited from discussions about Derain with Patrice Bachelard. I am grateful to Gilbert Pétrides for making available the files of the Vlaminck catalogue raisonné, which he and his father are preparing. I am equally indebted to Maïthé Vallès-Bled, whose pioneering work on Vlaminck for her 1987 exhibition on the artist illuminated much that had remained obscure about him.

Henri Manguin, in many ways, was a center for several in the Fauve orbit, as the extensive documentation preserved by his family attests. I have been honored to know Lucile Manguin, the artist's daughter, and Jean-Pierre Manguin, the artist's indefatigable grandson, and his wife, Arlette. Jean-Pierre Manguin has made accessible—into the wee hours of the morning—the rich resources he has amassed, and he has plumbed its depths to check, recheck, and verify yet again myriad questions raised in the course of preparing this catalog. Marie-Caroline Sainsaulieu has also been a well of information about Manguin and this period in general.

For the Fauves Havrais I have been fortunate that Denise Laurens has been focusing her attention on Georges Braque's Fauve years. I have appreciated the assistance of Claude and Denise Laurens, the Braque heirs, as well as of Nicole Worms de Romilly and Robert Füglister. Judith Cousins's meticulous research concerning Braque and Picasso's collaborative years has overlapped with my own work in beneficial ways, and I am grateful for her thorough documentation and her willingness to share her sources with me. On Dufy, I am deeply grateful for the resources shared by the late Maurice Laffaille and his daughter Fanny Guillon-Laffaille, as well as Mme van Leer, the artist's niece. For Friesz, I appreciate the information shared with me by Robert Martin, the author of the forthcoming catalogue raisonné on the artist.

My work on Albert Marquet has been greatly facilitated by the activities of the Fondation Wildenstein, and I am grateful to Daniel Wildenstein, Michèle Paret, and Nicole Castais for their information on him. Annie Grammont-Camoin, the granddaughter of Charles Camoin, and Danièle Giraudy have been particularly forthcoming on the subject of that artist, as has Louis-André Valtat on his grandfather Louis Valtat. Jacqueline Munck has advised on the work of Jean Puy.

The early dealers of the Fauve painters played vital roles in the dissemination of their work. In unearthing their contributions I have relied heavily, as in so much of my other research over the years, on the kindness of Maurice Jardot, Quentin Laurens, and the late Louise Leiris in sharing the archives of the legendary dealer Daniel-Henry Kahnweiler. I am also indebted to Christian de Galea and Louis and Hélène Sébastian, the heirs of Ambroise Vollard. If only such resources existed for Berthe Weill and Eugène Druet.

Research for this exhibition has taken place in collections and archives throughout Europe and the United States. I am indebted for their assistance to the staff of the Musée National d'Art Moderne's Documentation; Anne Roquebert and Monique Nonne at the Musée d'Orsay, Paris; Claude Massé at the Musée Hyacinthe Rigaud, Perpignan, France; Janis Ekdahl and Rona Roob at the library and archives of the Museum of Modern Art, New York; Beatrice de Boissesson at the Musées Nationaux de France for access to the Fonds Vizzavona, Paris; the staffs of the Bibliothèque Nationale and Roger-Viollet, Paris; Kathleen Hartt at the archives of the Museum of Fine Arts, Houston; and Carol Detnon at the Greater London Photographic Library. In Los Angeles significant assistance has been provided by the staff at the Getty Center for the History of Art and the Humanities; Joyce Ludmer and Ray Reece at the art library of the University of California, Los Angeles, and my home library at LACMA and its dedicated staff: Eleanor Hartman, Carl Baker, John Barone, Anne Diederick, Grant Rusk, and Nancy Sutherland.

With all of the essential elements in place, it remained to find the paintings to tell the Fauve story. Above all, I am grateful to the more than one hundred twenty-five lenders throughout the world. Their willingness to part with these magnificent paintings for nearly a year is deeply appreciated. These lenders are individually acknowledged on pages 336–37. I am especially indebted to the following colleagues and collectors for their generous contributions to the exhibition: Jessica Boissel, Richard Brettell, Marie-Odile Briot, John Bryan, Françoise Cachin, Nicolas Cendo, Philippe Chabert, Francine Dawans, Barbara Divver, Richard Feigen, Jean Forneris, Christian Geelhaar, Léonard Gianadda, Eric Hild, David and Tania Josefowitz, Laurence Kantor, Christian Klemm, Rudolf Koella, Sandor Kuthy, Serge Lemoine, Michael Levin, Jean-Hubert Martin, Karin von Maur, Roland May, Gabrielle and Werner Merzbacher, Jacques du Mons, Suzanne Pagé, Inge-Vibeke Raaschou-Nielsen, Antoinette Reze-Huré, Didier Schulmann, George T. M. Shackelford, Michael Shapiro, Charles Stuckey, Geneviève Testanière, Kirk Varnedoe, Germain Viatte, Alan Wilkinson, and the Honorable Franklin Williams.

Numerous individuals unearthed canvases squirreled away in the oddest of places and facilitated their viewing, located others, provided leads, and encouraged loans. Among them I wish to acknowledge generous assistance from the following: Rachel Adler, Colin Anson, C. Apsis, Jacob Baal-Teshuva, Joseph Baillio, Vivian Endicott Barnett, William Beadleston, Jean-Claude Bellier, Catherine Benkaim, Jacqueline Georges Besson, Ernst Beyeler, Sylvie Blatas, Flip Bool, Francis Briest, John Caldwell, Carol Ciccarelli, Robert Clementz, Guy-Patrice Dauberville, François Daulte, Jeffrey Deitch, Philip Diotallevi, Noelle del Drago,

Marina Ducrey, Caroline Durand-Ruel Godfrey, Lois Earl, Peter Fairbanks, Clarisse Gagnebin, Hilde Gerst, Stephen Hahn, Jurgen Harten, Robert Henning, Susan Hirschfield, Ingrid Hutton, Didier Imbert, Suzanne Julig, Simone Karoff, Diane Kelder, Billy Klüver, Raoul Laurent, Helen Lee, Michael Levin, Jean de Loïsy, Mary MacNaughton, Moira McAndrew, Edda Maillet, Daniel Malingue, Julie Martin, Josephine Matamoros, Marion Mester, Chris Middendorf, Charles Millard, Daniel Moquay, Yoshitono Nakano, Roger and Monique Nellens, Claudia Neugebauer, Sasha Newman, Hervé Odermatt, Amanda O'Neil, Barnett Owen, Penelope Pepper, Klaus Perls, Ivan Phillips, Kurt Prantl, Frank Razor, Robert Gore Rifkind, Chris Robinson, Deborah Ronnen, Annette Sarantis, Bertha Saunders, Scott Schaefer, Robert Schmit, Shinichi Segi, Susan Seidel, John Somerville, David Steadman, Ellen Storck, Michel Strauss, Martin Summers, E. V. Thaw, Diane Upright, and Judith Zilczer. Each of these contributors merits a sentence or two summarizing the tale associated with each; perhaps these are best saved for a sequel. Loans for the exhibition have been especially enriched by the energies and resources of William Acquavella, Michael Findlay, Paul Josefowitz, Ellen Kyriazi, and Guy Loudmer, and I am truly grateful to them.

The exhibition benefited significantly from the involvement of the French diplomatic corps in the United States. I would especially like to thank the Honorable Jacques Andreani, French ambassador to the United States; Gérard Coste, the French consul general in Los Angeles; and Annie Cohen-Solal, French cultural attaché, and Jean-Claude Terrac, cultural attaché in Los Angeles, for their assistance.

What will remain of this exhibition once its fleeting year concludes is this publication. Its eloquence and elegance have been enhanced by the exceptional abilities of the editor Nancy Grubb and of the designer Tracey Shiffman. The countless hours that Nancy Grubb has devoted and the astute suggestions and clarification she has offered have greatly enriched this catalog. Tracey Shiffman has perceptively interwoven the ideas and the images throughout this handsome volume, creating a sensitive, intelligent design, appropriate to the book's content. The museum's team of Managing Editor Mitch Tuchman and Head Designer Deenie Yudell capably oversaw this process with great diplomacy and good judgment. I am especially indebted to Mitch Tuchman for his thoughtful, incisive comments on my own contributions to this catalog. Nancy Carcione impeccably typed much of the manuscript. A tip of the hat goes to Bettina Kaplan and Rosemary Graham-Gardner at Air France, whose resourcefulness resulted in the retrieval of the lost manuscript for this entire book from the chaos of the international arrivals' hall at Los Angeles International Airport.

At the museum the onerous task of taking care of, among other things, the unceasing mail, phone calls, and logistics necessitated by all of the above fell to my able assistants, Ulrika Brand and Trudi Casamassima, whose active concern and scrupulous attention to myriad details ensured that this exhibition and catalog were produced. Ulrika Brand also worked on the exhibition's publicity, and Trudi Casamassima conducted much last-minute research for the exhibition and catalog. Three volunteers dedicated countless hours and inexhaustible good will to this undertaking over a four-year period: Catherine Cottet, our resourceful French-language expert; Lois Sein; and Penny Stanley. I also thank Grete Wolf for her aid in unraveling German.

Andie Zelnio and Christian Hubert designed the understated and elegant setting that houses the exhibition. Collaborating with them has, as always, been a pleasure. Their sensitivity to the requirements of these paintings has been echoed in the handsome graphics for the exhibition created by Jeffrey Cohen.

The team of professionals that produce LACMA's impressive cycle of exhibitions have, as always, fulfilled their roles to perfection. I am grateful to Elizabeth Algermissen, Arthur Owens, and John Passi, respectively, for managing the tour, installation, and budget for this exhibition, and to Ronald Bratton and Mark Mitchell for enduring our inability to adhere to the rules 100 percent. Julie Johnston, Tom Jacobson, and Dana Hutt of our Development Department edited the successful grant applications and resourcefully garnered the funds that made this project fiscally feasible. Renee Montgomery and Lisa Kalem ably handled all the complex details that go along with packing, shipping, insuring, and touring these exceptional works of

art. Joseph Fronek, Marcelle Andreasson, and Virginia Rasmussen oversaw necessary conservation of works in the exhibition. Barbara Lyter supervised the photography for the catalog. Pam Jenkinson and her staff tended to the considerable demands of press and publicity. Lisa Vihos directed all of the educational materials, lectures, and audio-visual programs associated with the exhibition. Feroza Vimfandel dealt with the complex requirements of often last-minute travel throughout the United States, Europe, and the USSR with great care and good humor. My curatorial colleagues Philip Conisbee, Ilene Fort, Thomas Lentz, and Robert Singer have offered significant assistance and information. The staff of the Department of Twentieth-Century Art has tolerated and assisted with the many demands of this exhibition. Above all, I am indebted to Curator Stephanie Barron, my esteemed colleague and valued friend, whose wise counsel and astute curatorial talents I much admire.

Legend has it that when Matisse was creating his 1907 sculpture, *Reclining Nude 1*, he was working so hard and with such energy one morning that the base of the sculpture slipped out of his hands and the piece fell to the ground. I know the feeling. According to Jack Flam, Matisse wailed so loudly that his wife, Amélie, came running, only to find him consumed by despair. It was she who soothed him and took him for a long walk to calm him. Far be it from me to compare myself to Matisse, but my Amélie in this instance has been Kenneth Slade, whose patience, forbearance, and sense of perspective have significantly enriched this project.

Judi Freeman

Lenders to the Exhibition

Albright-Knox Art Gallery, Buffalo
Art Gallery of Ontario, Toronto
Bridgestone Museum of Art, Ishibashi Foundation, Tokyo
Cleveland Museum of Art
Fondation Pierre Gianadda, Martigny, Switzerland
Glasgow Art Gallery and Museum
Kunsthalle, Bielefeld, West Germany
Kunsthaus, Zurich
Kunstmuseum, Bern
Kunstmuseum, Winterthur, Switzerland
Kunstsammlung Nordrhein-Westfalen, Düsseldorf, West Germany
Los Angeles County Museum of Art
The Metropolitan Museum of Art, New York
The Metropolitan Museum of Art, New York, Robert Lehman Collection
Milwaukee Art Museum
The Minneapolis Institute of Arts
Musée Cantini, Marseille
Musée Cantonal des Beaux-Arts, Lausanne, Switzerland
Musée d'Art Moderne, Liège, Belgium
Musée d'Art Moderne, Troyes, France
Musée d'Art Moderne de la Ville de Paris
Musée de Grenoble, Grenoble, France
Musée de l'Annonciade, Saint-Tropez, France
Musée des Beaux-Arts, Bordeaux, France
Musée des Beaux-Arts, La Chaux-de-Fonds, Switzerland
Musée des Beaux-Arts, Nancy, France
Musée des Beaux-Arts, Nice, France
Musée des Beaux-Arts, Pau, France
Musée des Beaux-Arts, Quimper, France
Musée des Beaux-Arts André Malraux, Le Havre, France
Musée d'Orsay, Paris
Musée du Petit Palais, Geneva
Musée Fabre, Montpellier, France
Musée National d'Art Moderne, Centre Georges Pompidou, Paris
Musée Toulouse-Lautrec, Albi, France
Museum Boymans-van Beuningen, Rotterdam, The Netherlands
The Museum of Fine Arts, Houston
The Museum of Modern Art, New York
National Gallery of Art, Washington, D.C.
National Gallery of Canada, Ottawa

New Orleans Museum of Art
Saint Louis Art Museum
San Francisco Museum of Modern Art
Scottish National Gallery of Modern Art, Edinburgh
Shizuoka Prefectural Museum of Art, Shizuoka, Japan
Solomon R. Guggenheim Museum, New York
Staatliche Museen Preussischer Kulturbesitz, Nationalgalerie, Berlin
Staatsgalerie, Stuttgart, West Germany
The State Hermitage Museum, Leningrad
State Pushkin Museum, Moscow
Statens Museum for Kunst, Copenhagen
Stedelijk Museum, Amsterdam
Tel Aviv Museum
Thyssen-Bornemisza Collection, Lugano, Switzerland
The Trustees of the Tate Gallery, London
Worcester Art Museum, Worcester, Massachusetts

The John A. and Audrey Jones Beck Collection
Mr. and Mrs. Robert A. Belfer
David Bonderman
Dr. and Mrs. Steven Cooperman
Collection Alain Delon
Former collection of Boris Fize
Theodore J. Forstmann
Fridart Foundation
Galerie Jean-Claude Bellier, Paris
Galerie am Lindenplatz, Schaan, Liechtenstein
Galerie H. Odermatt–Ph. Cazeau, Paris
The Jacques and Natasha Gelman Collection
Arnold and Anne Gumowitz
Hilde Gerst Gallery, New York
Josefowitz Collection
Joanne and Ira Kirshbaum, Los Angeles
Collection of Samuel J. and Ethel LeFrak
Mr. and Mrs. Jean-Pierre Manguin, Avignon, France
Mr. and Mrs. Werner Merzbacher
Nippon Autopolis Co., Ltd.
Perls Galleries, New York
Private collection, courtesy Barbara Divver Fine Art
Gabriel Sabet, Geneva
Sara Lee Corporation, Chicago
M. Schecter
The Evelyn Sharp Collection
Marion and Nathan Smooke
Mrs. John Hay Whitney
The Wohl Family
Mr. Christopher Wright
and numerous private collections

Index

Credits

Most of the photographs in this volume have been provided by the owners or custodians of the works, indicated in the captions. The following list applies to photographs for which a separate acknowledgment is due.

Hélène Adant, Paris: page 69 (upper left, courtesy of Jack Flam), page 109 (right); American Stock Photo: plate 15; Archives Camoin, Paris: plate 91, page 64 (lower left); Archives Laurens: plate 212; Archives Matisse, Paris: pages 69 (lower left), 90 (upper left three), 105 (left two), 106 (upper right), 108 (lower left), 109 (lower left), 111 (upper right); Archives Signac-Cachin, Paris: plate 78, page 63 (center left); © 1990 The Art Institute of Chicago, all rights reserved: plates 192, 237; © Atelier 53, Paris: plates 81, 257, page 64 (lower left); Atelier Walter Wachter, Schaan, Liechtenstein: plates 281, 287; The Baltimore Museum of Art, Cone Archives: pages 65 (center and lower right), 82 (lower left); copyright © 1990 The Barnes Foundation, Merion Station, Pennsylvania 19066: plates 176, 269; Bibliothèque Nationale, Département des Cartes et Plans, Paris: plates 224, 244, page 58; Peter Brenner, Los Angeles County Museum of Art: plate 124; Camerarts, Inc., Ali Elai, New York: plate 51; Carlo Catenazzi, Art Gallery of Ontario, Toronto: plates 62, 119, 306; Jean-Loup Charmet: pages 60 (right), 65 (left), 67 (upper right), 81 (left), 86 (right), 97 (lower left), 101 (left), 108 (upper left and right), 110 (upper left), 112 (upper right); Courtesy Christie, Manson & Woods: plate 93; Cliché du Musée de Bagnols-sur-Cèze, France: plates 65, 160, 270; Cliché Musées de la Ville de Paris: plate 277; Cliché Musées Nationaux, Paris: plates 3, 9, 19, 30, 122, 129, 169, 174–75, 200, 208, 280, page 61 (lower left); Color Copira AG, Zurich: plate 225; Colorphoto Hinz, Allschwill-Basel, Switzerland: plates 4, 252, 301; A. C. Cooper Ltd., London: plate 67; © 1990 Dallas Museum of Art: plate 291; M. Daspet, Villeneuve lez Avignon, France: plate 40; Courtesy, Denver Art Museum: plate 1; Brenda Dereniuk, Art Gallery of Ontario, Toronto: plate 324; Fotoatelier Gerhard Howald, Bern: plate 318; Jean Foultier, Le Havre, France: plate 231; Rick Gardner Photography, Houston: cover and plate 41; Photographie Giraudon, Paris: plate 273; Greater London Map Library: plates 185, 194; Greater London Photographic Library: plates 187, 197, 201, 204–5; David Heald: plates 143, 153, 282; Frédéric Jaulmes, Montpellier, France: plate 312; Tom Jenkins: plate 246; D. La Nevé: plates 165, 186; Michel de Lorenzo: plate 127; Barbara Lyter, Los Angeles County Museum of Art: plates 117, 319; Wayne McCall, Santa Barbara, California: plate 102; Gilbert Mangin, Nancy, France: page 11; Jean-Pierre Manguin, Avignon, France: pages 67 (lower right), 68 (upper right), 72 (right), 94 (right); Claude Mercier, Geneva: plate 313; L. Mercier & Fils, Geneva: plate 123; Courtesy, The Museum of Modern Art, New York: plate 183, pages 61 (lower right), 62 (upper left), 87 (right); Courtesy, The Museum of Modern Art Library, Gift of Joy S. Weber: page 113 (left); Godfrey New, Sidcup, England: plates 185, 194; Courtesy, Perls Galleries, New York: plate 24; Hans Petersen, Copenhagen: plates 166, 220, 285; Photorama S.A., Le Havre, France: plates 81, 310; Photostudio Heinz Presig, Sion, Switzerland: plate 79; Roger-Viollet: plate 189 (© 1990 Viollet), pages 59, 81 (lower right), 90 (lower left), 92 (lower right two), 97 (center right), 110 (lower left and lower right), 112 (lower left); Stadsarchief, Antwerp, Belgium: plates 210–11; Studio Lourmel 77, Photo Routhier: plates 164, 193, 320; Studio Yves, Chatou, France: plates 141, 148, 151, 157; Joseph Szaszfai: plate 18; © Malcolm Varon, New York: plates 195, 254; Von Uslar Foto-Design: plate 322; Jeanine Warnod, Paris: page 60 (upper and lower left); John Webb, London: plates 26, 38, 55, 180, 235, 297; West Park Studios, Ltd., Leeds, England: plate 203; Bruce M. White, New York: plates 63, 333; Carmel Wilson, New York: plate 43.